The NEW ENCYCLOPEDIA *of* SOUTHERN CULTURE

VOLUME 21 : ART & ARCHITECTURE

Volumes to appear in

The New Encyclopedia of Southern Culture

are:

Agriculture and Industry	*Law and Politics*
Art and Architecture	*Literature*
Education	*Media*
Environment	*Music*
Ethnicity	*Myth, Manners, and Memory*
Folk Art	*Race*
Folklife	*Religion*
Foodways	*Science and Medicine*
Gender	*Social Class*
Geography	*Sports and Recreation*
History	*Urbanization*
Language	*Violence*

The NEW

ENCYCLOPEDIA *of* SOUTHERN CULTURE

CHARLES REAGAN WILSON General Editor

JAMES G. THOMAS JR. Managing Editor

ANN J. ABADIE Associate Editor

VOLUME 21

Art &
Architecture

JUDITH H. BONNER &

ESTILL CURTIS PENNINGTON

Volume Editors

Sponsored by

THE CENTER FOR THE STUDY OF SOUTHERN CULTURE

at the University of Mississippi

THE UNIVERSITY OF NORTH CAROLINA PRESS

Chapel Hill

This book was published with the generous assistance of the
JOHNSON COLLECTION.

The Anniversary Endowment Fund
of the University of North Carolina Press provided
additional support for publication of this book.

Designed by Richard Hendel
Set in Minion types by Tseng Information Systems, Inc.
Manufactured in the United States of America
The paper in this book meets the guidelines for permanence and durability
of the Committee on Production Guidelines for Book Longevity of the
Council on Library Resources.
The University of North Carolina Press has been a member
of the Green Press Initiative since 2003.
Library of Congress Cataloging-in-Publication Data
Art and architecture / Judith H. Bonner and Estill Curtis
Pennington, volume editors.
p. cm. — (The new encyclopedia of Southern culture ; v. 21)
"Published with the assistance of the Johnson Collection and of the
Anniversary Endowment Fund of the University of North Carolina Press."
"Sponsored by The Center for the Study of Southern Culture at the
University of Mississippi."
Includes bibliographical references and index.
ISBN 978-0-8078-3717-7 (alk. paper) —
ISBN 978-0-8078-3718-4 (pbk.: alk. paper)
1. Art, American—Southern States—Encyclopedias. 2. Architecture—
Southern States—Encyclopedias. I. Bonner, Judith H. II. Pennington, Estill
Curtis. III. University of Mississippi. Center for the Study of Southern
Culture. IV. Series.
F209 .N47 2006 vol. 21
[N6520]
975.003 s—dc22
2012473070
The Encyclopedia of Southern Culture, sponsored by the Center for the Study
of Southern Culture at the University of Mississippi, was published by the
University of North Carolina Press in 1989.
cloth 17 16 15 14 13 5 4 3 2 1
paper 17 16 15 14 13 5 4 3 2 1

Tell about the South. What's it like there.

What do they do there. Why do they live there.

Why do they live at all.

WILLIAM FAULKNER

Absalom, Absalom!

CONTENTS

In 1989 years of planning and hard work came to fruition when the University of North Carolina Press joined the Center for the Study of Southern Culture at the University of Mississippi to publish the *Encyclopedia of Southern Culture*. While all those involved in writing, reviewing, editing, and producing the volume believed it would be received as a vital contribution to our understanding of the American South, no one could have anticipated fully the widespread acclaim it would receive from reviewers and other commentators. But the *Encyclopedia* was indeed celebrated, not only by scholars but also by popular audiences with a deep, abiding interest in the region. At a time when some people talked of the "vanishing South," the book helped remind a national audience that the region was alive and well, and it has continued to shape national perceptions of the South through the work of its many users—journalists, scholars, teachers, students, and general readers.

As the introduction to the *Encyclopedia* noted, its conceptualization and organization reflected a cultural approach to the South. It highlighted such issues as the core zones and margins of southern culture, the boundaries where "the South" overlapped with other cultures, the role of history in contemporary culture, and the centrality of regional consciousness, symbolism, and mythology. By 1989 scholars had moved beyond the idea of cultures as real, tangible entities, viewing them instead as abstractions. The *Encyclopedia*'s editors and contributors thus included a full range of social indicators, trait groupings, literary concepts, and historical evidence typically used in regional studies, carefully working to address the distinctive and characteristic traits that made the American South a particular place. The introduction to the *Encyclopedia* concluded that the fundamental uniqueness of southern culture was reflected in the volume's composite portrait of the South. We asked contributors to consider aspects that were unique to the region but also those that suggested its internal diversity. The volume was not a reference book of southern history, which explained something of the design of entries. There were fewer essays on colonial and antebellum history than on the postbellum and modern periods, befitting our conception of the volume as one trying not only to chart the cultural landscape of the South but also to illuminate the contemporary era.

When C. Vann Woodward reviewed the *Encyclopedia* in the *New York Review of Books*, he concluded his review by noting "the continued liveliness of

interest in the South and its seeming inexhaustibility as a field of study." Research on the South, he wrote, furnishes "proof of the value of the *Encyclopedia* as a scholarly undertaking as well as suggesting future needs for revision or supplement to keep up with ongoing scholarship." The two decades since the publication of the *Encyclopedia of Southern Culture* have certainly suggested that Woodward was correct. The American South has undergone significant changes that make for a different context for the study of the region. The South has undergone social, economic, political, intellectual, and literary transformations, creating the need for a new edition of the *Encyclopedia* that will remain relevant to a changing region. Globalization has become a major issue, seen in the South through the appearance of Japanese automobile factories, Hispanic workers who have immigrated from Latin America or Cuba, and a new prominence for Asian and Middle Eastern religions that were hardly present in the 1980s South. The African American return migration to the South, which started in the 1970s, dramatically increased in the 1990s, as countless books simultaneously appeared asserting powerfully the claims of African Americans as formative influences on southern culture. Politically, southerners from both parties have played crucial leadership roles in national politics, and the Republican Party has dominated a near-solid South in national elections. Meanwhile, new forms of music, like hip-hop, have emerged with distinct southern expressions, and the term "dirty South" has taken on new musical meanings not thought of in 1989. New genres of writing by creative southerners, such as gay and lesbian literature and "white trash" writing, extend the southern literary tradition.

Meanwhile, as Woodward foresaw, scholars have continued their engagement with the history and culture of the South since the publication of the *Encyclopedia*, raising new scholarly issues and opening new areas of study. Historians have moved beyond their earlier preoccupation with social history to write new cultural history as well. They have used the categories of race, social class, and gender to illuminate the diversity of the South, rather than a unified "mind of the South." Previously underexplored areas within the field of southern historical studies, such as the colonial era, are now seen as formative periods of the region's character, with the South's positioning within a larger Atlantic world a productive new area of study. Cultural memory has become a major topic in the exploration of how the social construction of "the South" benefited some social groups and exploited others. Scholars in many disciplines have made the southern identity a major topic, and they have used a variety of methodologies to suggest what that identity has meant to different social groups. Literary critics have adapted cultural theories to the South and have

raised the issue of postsouthern literature to a major category of concern as well as exploring the links between the literature of the American South and that of the Caribbean. Anthropologists have used different theoretical formulations from literary critics, providing models for their fieldwork in southern communities. In the past 30 years anthropologists have set increasing numbers of their ethnographic studies in the South, with many of them now exploring topics specifically linked to southern cultural issues. Scholars now place the Native American story, from prehistory to the contemporary era, as a central part of southern history. Comparative and interdisciplinary approaches to the South have encouraged scholars to look at such issues as the borders and boundaries of the South, specific places and spaces with distinct identities within the American South, and the global and transnational Souths, linking the American South with many formerly colonial societies around the world.

The first edition of the *Encyclopedia of Southern Culture* anticipated many of these approaches and indeed stimulated the growth of Southern Studies as a distinct interdisciplinary field. The Center for the Study of Southern Culture has worked for more than three decades to encourage research and teaching about the American South. Its academic programs have produced graduates who have gone on to write interdisciplinary studies of the South, while others have staffed the cultural institutions of the region and in turn encouraged those institutions to document and present the South's culture to broad public audiences. The center's conferences and publications have continued its long tradition of promoting understanding of the history, literature, and music of the South, with new initiatives focused on southern foodways, the future of the South, and the global Souths, expressing the center's mission to bring the best current scholarship to broad public audiences. Its documentary studies projects build oral and visual archives, and the New Directions in Southern Studies book series, published by the University of North Carolina Press, offers an important venue for innovative scholarship.

Since the *Encyclopedia of Southern Culture* appeared, the field of Southern Studies has dramatically developed, with an extensive network now of academic and research institutions whose projects focus specifically on the interdisciplinary study of the South. The Center for the Study of the American South at the University of North Carolina at Chapel Hill, led by Director Jocelyn Neal and Associate Director and *Encyclopedia* coeditor William Ferris, publishes the lively journal *Southern Cultures* and is now at the organizational center of many other Southern Studies projects. The Institute for Southern Studies at the University of South Carolina, the Southern Intellectual History Circle, the Society for the Study of Southern Literature, the Southern Studies Forum of the Euro-

pean American Studies Association, Emory University's SouthernSpaces.org, and the South Atlantic Humanities Center (at the Virginia Foundation for the Humanities, the University of Virginia, and Virginia Polytechnic Institute and State University) express the recent expansion of interest in regional study.

Observers of the American South have had much to absorb, given the rapid pace of recent change. The institutional framework for studying the South is broader and deeper than ever, yet the relationship between the older verities of regional study and new realities remains unclear. Given the extent of changes in the American South and in Southern Studies since the publication of the *Encyclopedia of Southern Culture*, the need for a new edition of that work is clear. Therefore, the Center for the Study of Southern Culture has once again joined the University of North Carolina Press to produce *The New Encyclopedia of Southern Culture*. As readers of the original edition will quickly see, *The New Encyclopedia* follows many of the scholarly principles and editorial conventions established in the original, but with one key difference; rather than being published in a single hardback volume, *The New Encyclopedia* is presented in a series of shorter individual volumes that build on the 24 original subject categories used in the *Encyclopedia* and adapt them to new scholarly developments. Some earlier *Encyclopedia* categories have been reconceptualized in light of new academic interests. For example, the subject section originally titled "Women's Life" is reconceived as a new volume, *Gender*, and the original "Black Life" section is more broadly interpreted as a volume on race. These changes reflect new analytical concerns that place the study of women and blacks in broader cultural systems, reflecting the emergence of, among other topics, the study of male culture and of whiteness. Both volumes draw as well from the rich recent scholarship on women's life and black life. In addition, topics with some thematic coherence are combined in a volume, such as *Law and Politics* and *Agriculture and Industry*. One new topic, *Foodways*, is the basis of a separate volume, reflecting its new prominence in the interdisciplinary study of southern culture.

Numerous individual topical volumes together make up *The New Encyclopedia of Southern Culture* and extend the reach of the reference work to wider audiences. This approach should enhance the use of the *Encyclopedia* in academic courses and is intended to be convenient for readers with more focused interests within the larger context of southern culture. Readers will have handy access to one-volume, authoritative, and comprehensive scholarly treatments of the major areas of southern culture.

We have been fortunate that, in nearly all cases, subject consultants who offered crucial direction in shaping the topical sections for the original edi-

tion have agreed to join us in this new endeavor as volume editors. When new volume editors have been added, we have again looked for respected figures who can provide not only their own expertise but also strong networks of scholars to help develop relevant lists of topics and to serve as contributors in their areas. The reputations of all our volume editors as leading scholars in their areas encouraged the contributions of other scholars and added to *The New Encyclopedia*'s authority as a reference work.

The New Encyclopedia of Southern Culture builds on the strengths of articles in the original edition in several ways. For many existing articles, original authors agreed to update their contributions with new interpretations and theoretical perspectives, current statistics, new bibliographies, or simple factual developments that needed to be included. If the original contributor was unable to update an article, the editorial staff added new material or sent it to another scholar for assessment. In some cases, the general editor and volume editors selected a new contributor if an article seemed particularly dated and new work indicated the need for a fresh perspective. And importantly, where new developments have warranted treatment of topics not addressed in the original edition, volume editors have commissioned entirely new essays and articles that are published here for the first time.

The American South embodies a powerful historical and mythical presence, both a complex environmental and geographic landscape and a place of the imagination. Changes in the region's contemporary socioeconomic realities and new developments in scholarship have been incorporated in the conceptualization and approach of *The New Encyclopedia of Southern Culture*. Anthropologist Clifford Geertz has spoken of culture as context, and this encyclopedia looks at the American South as a complex place that has served as the context for cultural expression. This volume provides information and perspective on the diversity of cultures in a geographic and imaginative place with a long history and distinctive character.

The *Encyclopedia of Southern Culture* was produced through major grants from the Program for Research Tools and Reference Works of the National Endowment for the Humanities, the Ford Foundation, the Atlantic-Richfield Foundation, and the Mary Doyle Trust. We are grateful as well to the College of Liberal Arts at the University of Mississippi for support and to the individual donors to the Center for the Study of Southern Culture who have directly or indirectly supported work on *The New Encyclopedia of Southern Culture*. We thank the volume editors for their ideas in reimagining their subjects and the contributors of articles for their work in extending the usefulness of the book in new ways. We acknowledge the support and contributions of the faculty and

staff at the Center for the Study of Southern Culture. Finally, we want especially to honor the work of William Ferris and Mary Hart on the *Encyclopedia of Southern Culture*. Bill, the founding director of the Center for the Study of Southern Culture, was coeditor, and his good work recruiting authors, editing text, selecting images, and publicizing the volume among a wide network of people was, of course, invaluable. Despite the many changes in the new encyclopedia, Bill's influence remains. Mary "Sue" Hart was also an invaluable member of the original encyclopedia team, bringing the careful and precise eye of the librarian, and an iconoclastic spirit, to our work.

INTRODUCTION

This volume of *The New Encyclopedia of Southern Culture* offers factual and interpretive information on one of the most significant areas of southern creative achievement. The South's literary and musical traditions have received more sustained scholarly study than its visual and building traditions, but the latter are rich and provide the most revealing access to the region's aesthetic sensibilities. *Art and Architecture* surveys the sweep of history, from the colonial era to the 21st century, capturing the enormous diversity in the region as seen through its artwork and building styles. All major genres of painting and building have been represented in the South, and these are detailed herein, as is the relationship of art and architecture to broader southern cultural themes. The region's painters, for example, have often practiced a narrative style, reflecting the same storytelling instincts seen in the region's writers. Painters have shown their pronounced affinity for the land, with agrarianism and the pastoral often portrayed and seen in tension with aspects of modernity, again as in many areas of southern cultural expression. The region itself, in other words, has mattered to visual artists. The South's buildings have often served as symbols of its identity—from Greek Revival with its classical attachments in the early 19th century to postmodern eclecticism appropriate to the rapidly changing contemporary South. Although the stress in this volume is on fine and formal art, entries cover vernacular achievements as well. A separate volume on folk art will point the way to appreciating the scale of the accomplishment by the South's artists and architects.

Overview essays chart the history of art and architecture in the South, discuss differing genres of painting and building, and assess the importance of these traditions to the region. Thematic essays provide a thorough structure, with six articles on painting covering that topic from 1564 to 2012 and numerous entries on differing architectural styles. Articles on decorative arts, gardens, photography and photographers, and sculpture place those topics in relationship to other aspects of the region's life. Biographical entries give precise information on artists working in landscape, portraiture, nature, and other genres. Such prominent African American painters as Benny Andrews, Romare Bearden, and Aaron Douglas are here, as well as the lesser-known Florida Highwaymen. Thematic and biographical entries acknowledge the multiculturalism that has long been at work in the South, through contributions of German, French,

and other ethnic artists. Abstract expressionists like Jasper Johns and Robert Rauschenberg have entries that place them not only as international artists but also as specifically southern ones, while 20th-century regionalists like Thomas Hart Benton and John McCrady are represented as well. Browsing through this volume will lead you to read about the Virginia house, the dogtrot house, the shotgun house, and the Creole house; the stone houses of Kentucky and the log structures of the Upland South suggest regional diversity within the South. State capitol buildings and country courthouses symbolize the way architecture can evoke southern connections, as buildings become visual statements of the shared tastes of an era.

Since the *Encyclopedia of Southern Culture* appeared in 1989, the South has undergone notable changes in its aesthetic commitments, with the growth of interest in the arts and increased resources devoted to them, at both the public and the private levels. Art museums have larger, broader, and more distinguished collections and exhibitions than ever before, and certain museums have specific missions to collect specifically southern art. State and community art councils, college and university art departments, and other institutions provide leadership to keep the South abreast of the latest artistic interests, nationally and internationally. The editors hope this volume will allow readers to experience the range and depth of artistic and architectural achievement in the region, past and present.

The NEW ENCYCLOPEDIA *of* SOUTHERN CULTURE

VOLUME 21 : ART & ARCHITECTURE

ARCHITECTURE IN THE SOUTH

Combining art and architecture in a single encyclopedic reference book is problematic. Artworks are deeply personal expressions of the artist's imagination, created by an individuated craft. Architecture is a collective expression of design, spatial occupation, material resource appropriation, and the deployment of a labor force. Though space, material, and labor are all factors of the socioeconomic construct, they are not the usual candidates for aesthetic evaluation. However, as part of the socioeconomic history of architecture the critical issues they provoke have been addressed in several individual entries in this volume. At the same time it is also important to note that the history of architecture is also the history of style. The history of style is also the history of taste, and taste is an ephemeral human consciousness compounded from longing and desire, ambition and intent, the past and the present, the secular and the spiritual. As architectural designs take on form and leave behind structures upon the landscape, they command visual attention and stir that most basic question of art historical interest: What informs the object and how does the object inform us?

Despite the fact that a high proportion of the buildings in the South today are relatively new, the survival of older buildings plays an important role in the way southerners envision their own environment and in how others see and understand it. Most surviving older buildings are still in use and are therefore part of contemporary life and culture. Some few have been set aside as museums. In each case they give distinctive, particular character to a sense of place. Once church towers, schools, county courthouses, and state capitols were the dominant features of town and city landscapes. Now office towers, hotels, and high-rise apartment buildings define the urban skyline. New building types and contemporary urban planning are also changing the relationship between the individual and the built environment. An obvious example is the development of the shopping mall—which is replacing, or has replaced—Main Street, one of many changes brought about by the automobile and population growth.

Though a few 17th-century structures survive, much of the historic fabric of southern architecture dates from the 18th and 19th centuries. These building styles include the classicism inherent in colonial Georgian design, which morphed into the neoclassicism of the Federal period; the romantic styles to

be seen in the historically influenced "columnar" orders of the Greek Revival, the sober spires of the Gothic Revival, and the various picturesque tastes of the late 19th century, especially the Italianate of the post–Civil War period; and the didactic styles of Beaux-Arts formalism that arose in the early 20th century. There are conspicuous southern examples in each of the stylistic phases that have enjoyed popularity in this country. Among the most familiar are Drayton Hall in South Carolina, an example of an architectural choice and symbol of the wealthy landed planters on the 18th-century Atlantic seaboard whose life-style had close parallels with English counterparts; the Virginia State Capitol in Richmond and the complex of buildings at the University of Virginia, delib-erately designed to serve and to symbolize the functions of democratic gover-nance and learning in the new Republic; the Tennessee State Capitol, another "temple of democracy" of a slightly later date; and the great columnar houses found in Natchez, Miss., the result of the prosperity of a slave-owning class of cotton planters and merchants in the Deep South.

In addition to these conspicuous structures, other modest examples exist, less familiar to a wide public but well known within a limited area. The distinc-tive "Virginia house," developed in the early 17th century, and the T-shaped plantation houses or farmhouses found in the Carolinas (which provide an abundance of cross-ventilation) are cases in point. The raised cottages of the Deep South, sometimes called "mosquito" cottages in the Carolinas and "Creole" cottages on the Gulf Coast and in Louisiana, are of several different types and hence of different plans but constitute a recognizable genre. They in-clude humble one- or two-room structures lived in by poor African Americans and whites, as well as cottages of considerably larger scale. Among urban struc-tures, the "singles" and "doubles" of Charleston represent particular types, as do the distinctive row houses of Baltimore, the French-influenced cottages of New Orleans, and the long, narrow shotgun houses of the late 19th century. In some cases, the consistent or distinctive use of materials identifies, in a general way, other characteristic regional building traditions. The stone houses of Ken-tucky and the varieties of log structures, particularly in the Upper South, are examples. Many of these were built by frontiersmen as sturdy utilitarian struc-tures in the late 18th and early 19th centuries and have since become symbols of an era.

From the outset of the federal republic, the predominant semiotic and archi-tectural devices were drawn from classical sources. George Washington was imagined as the Roman gentleman farmer Cincinnatus, called from the field to battle, only to return to his agrarian origins at war's end. Planners for the na-tional capitol, guided by the Masonic order, envisioned temple-fòrm structures

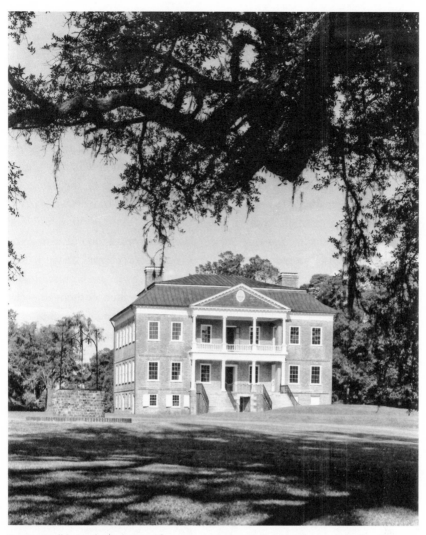

Drayton Hall in South Carolina (1738–42), an exemplary Palladian design on the Ashley River (National Trust for Historic Preservation, Washington, D.C.)

to house the seat of government. As Eugene and Elizabeth Fox-Genovese have observed, it was from the "Greeks and the Romans" that "Southerners . . . drew a profound sense of cyclical time: That which has been will recur; the archetypal forms of human character, the havoc wreaked by human passions, and the configuration of events would all reappear with regularity." Of those reoccurrences, classical architecture, as seen in the plastic manipulation of the historic orders, proved to be the most lasting, reappearing in statehouses, schools, grand houses, and modest cottages.

No apostle of classicism was more devout, or more persistently innovative, than Thomas Jefferson, who said, "You see I am an enthusiast on the subject of the arts," an enthusiasm whose "object is to improve the taste of my countrymen" in classical style. During his tenure as ambassador to France, 1784–89, he was also an astute student who toured southern France and Italy in search of classical architecture. His favorite building, the Maison Carrée, in Nîmes, France, as illustrated in Charles-Louis Clérisseau's *Antiquités de la France*, became the source for the Virginia Statehouse in Richmond. His familiarity with Andrea Palladio, as derived from the English edition of Giacomo Leoni's 1721 edition of Palladio's *Four Books of Architecture*, inspired his planning for the University of Virginia. There, the lawn was surrounded on two sides by terraces of pavilions designed as manifestations of the vocabulary of classical form, utilizing in correct, and eclectic, fashion, Doric, Ionic, Corinthian, and Tuscan composite orders. He wrote to university proctor A. S. Brockenbrough in April 1823: "I have examined carefully all the ancient Corinthians in my possession and observe that Palladio, as usual, has given the finest members of them all in the happiest combination." Like Palladio, Jefferson was also a profound admirer of the domed rotunda format as seen at Monticello and in the center Rotunda at the University of Virginia.

The Palladian tradition was perpetuated by several architects working along the southern coastal terrain from Baltimore to Savannah. In Maryland, Joseph Clark's William Paca House in Queen Anne's County, 1790, has a central block fronted by a one-story portico supported by Corinthian columns and flanked by two hypens with tripartite Venetian fenestration, the central arched window flanked by two lower rectangular windows. Homewood, the Charles Carroll Jr. House, in Baltimore, 1801–3, has a monumental portico whose height is offset by downscaled demilune dormer windows. James Hoban incorporated two-story porticos based on Palladio's Villa Conaro into plans for houses in Charleston as well as in his designs for the White House, 1790. Other examples of the monumental two-story portico found in the interior South include Mount Nebo, the David B. Mitchell House, Baldwin County, Ga., ca. 1823; Belle Mont, the Alexander Mitchell House, Tuscumbia Ala., 1828–32; the Andrew Scott House, Columbia, Tenn., 1830; and the Thomas Andrews House, Clinton, Miss., 1830.

Palladian precedents are also apparent in houses built in a more sweeping five-part horizontal format in which the mass of the large-scale central portion of the building is offset by two flanking hypens leading to symmetrical end sections. One notable example of that style is Ashland, the original Henry Clay House in Lexington, Ky., built in 1810 with input from Benjamin Henry Latrobe. Other examples include the Grange, built by Edward Stone in Bourbon

County, Ky., 1812–16, and Woodlawn, built by Hugh Roland, in Nashville, 1822–23. Three-part Palladian houses feature a two-story central block with a front-facing tympanum gable surmounted by a single-story porch and flanked by single-story wings at each side. This intriguing style, whose visual impact often exceeds the actual scale of the house, enjoyed particular popularity in North Carolina, where examples include the Sally-Billy House, Scotland Neck, 1808, and the Reid-William-Macon House, Airlie, ca. 1810.

In 1803 Jefferson appointed Benjamin H. Latrobe surveyor of public buildings at Washington, D.C. Professionally trained as an architect in London with the S. P. Cockerell firm, Latrobe returned to America in 1796 and designed houses in Norfolk and Richmond. His early designs there evince his innovative use of the circular format, as later seen in the Circular Church, Charleston; the Monumental Church, Richmond; and the First Baptist Church, Baltimore. All mark departures from the cruciform shape, as an affirmation of that symbolic Unitarianism inspired by classical unity. Latrobe's crowning achievement is the Basilica of the National Shrine of the Assumption of the Blessed Virgin Mary in Baltimore. That structure is especially distinguished by the series of low domes, bordered by pendentives embellished with Corinthian foliate devices. Indeed, Latrobe's subtle use of curvilinear form and pendentive devices prefigures the accomplishments of the great Edwardian British architect Sir Edwin Lutyens by more than one hundred years.

Latrobe's most noted student was Robert Mills, a Charleston native often called the first native-born American architect. After his work at Charleston College came to the attention of President Jefferson, Mills was invited to Washington, D.C., and received an introduction to Latrobe. The architect and historian Fiske Kimball has noted that Mills owed to Latrobe "not only his knowledge of Greek forms but his principles of professional practice and his scientific engineering skill." Mills's demure Fireproof Building in Charleston is an endearing and tidy piece of classical design, but his principal legacy is to be found in the nation's capital. The towering obelisk he designed, as a monument to President Washington, remains the focal point of the national mall, structurally intact despite a recent earthquake. His plan for the Patent Office Building is one of the foremost heralds of the Greek Revival style, a building whose chaste Doric porticos enshrine the offices of creative innovation in American industry and design.

One might imagine that the aesthetic achievement of the classical movement in historical southern architecture was to be seen in the learned integration of decorative form into the balanced mass of the structure's integrity. However, by the 1820s that learned sense of proportion increasingly gave way to a romantic

infatuation with large-scale temple-form designs in which a monumental portico spans the entire width of the entrance mass. If the southern imagination was indeed preoccupied with the recurrence of classical order, then we can see a steady transition from the segmented forms replicated from Palladio to more ambitious plans drawn along the lines of the Parthenon in Athens and the Pantheon in Rome.

Many of the structures designed at the height of the romantic era reflect international trends in Western civilization. The exalted role of the individual, the sanctity of nature, and the virtually divine inspiration of the past were all themes in the arts and literature of the South. The 20th-century intellectual historian Clement Eaton wrote that "the romantic spirit . . . subtly permeated the society of the Old South. It made men touchy of their honor and impelled them to do things that were the negation of economic realism. . . . It nourished the illusion at the time of the Civil War that the Southern spirit could prevail against tremendous economic odds. . . . It infused Southern religion with a mystic quality that enabled weak human beings to triumph over the Devil, the flesh and the world. The romantic spirit expressed itself most patently in the arts and social manners."

Nowhere are those infatuations to be seen more clearly than in the Greek Revival architecture of the South. One of the earliest and most important manifestations of that style was built as early as 1817 by Daniel Park Custis at Arlington, on the hill above Washington, D.C. Custis worked with English architect George Hadfield in the design and construction of a house whose center section was defined by a massive temple-form portico with Doric ornamentation featuring eight columns some five feet in width. That this section was intended as a shrine to house Washington family memorabilia is an indicator of the commemorative aspect of the Greek Revival style as it evolved in civic and domestic structures of the South throughout the 19th century and well into the 20th century.

A similar use of a monumental portico to span and define the mass of a civic structure is to be seen in Gideon Shryock's Kentucky Statehouse, built between 1827 and 1830. Shryock was the son of a master builder whose education included a period of work with William Strickland in Philadelphia in 1823. Strickland was the architect of the Second Bank of the United States, an homage to the Parthenon. Though only 25 years of age, Shryock designed a building of impressive scale and proportion, whose fluted Ionic columns support a dentil-decorated entablature and blank tympanum. The building is surmounted by a dome whose interior rotunda contains pendentives embellished with scrolling foliate devices protruding from gigantic cornucopias. This structure is widely

considered to be the first example of classic Greek Revival design as it came to be practiced in the South. The success of this building led to a design commission from Sen. John Pope of Arkansas for a new statehouse in Little Rock. The result is a graceful temple-form structure flanked by hypens connecting legislative wings whose facades are adorned with engaged Doric pilasters. Shryock went on to design several other landmark Greek Revival buildings in Kentucky, including old Morrison Hall at Transylvania University in Lexington and the Louisville Medical Institute. His Franklin County Courthouse in Frankfort has a towering attenuated dome whose eclectic massing echoes the designs the young architect diligently copied from Abraham Swan's *British Architect*. His last significant design, for the Jefferson County Courthouse in Louisville, proved to be his downfall. Enormously ambitious for the site, and subject to material deterioration, it proved to be too expensive for the city fathers and was completed in a much-reduced form.

William Nichols, a native of Bath, England, was an architect whose work reflects the transition from chaste Palladianism to full-blown Greek Revival romanticism. He immigrated to the United States in 1800, settling in North Carolina, where he became state architect in 1818. In 1822 he supervised a complete remodeling of the North Carolina Statehouse by adding classical elements, notably the low dome surmounting the roof. In 1827 he moved to Alabama, where he built the new state capitol in Tuscaloosa. His designs for the University of Alabama, whose construction began in 1828, were inspired by Thomas Jefferson's great lawn plan. Those buildings were destroyed by Federal forces during the Civil War. Nichols's most lasting contributions to romantic architecture in the South are to be found in Mississippi: his Old Mississippi State Capitol in Jackson, the Governor's Mansion there, and the Lyceum at the University of Mississippi in Oxford.

However, as Rollin Osterweis has observed, several southern architects were also sympathetic to romanticism as "a revolt of sensibility and imagination against a receding age of form, symmetry, precision, balance, and reason," which included "a rejection of neoclassical esthetic conventions." This revolt embraced the Gothic Revival spirit of the Oxford and Cambridge movements in English ecclesiastical design, resulting in several rather astonishing churches built in the urban and rural South. Some were monumental structures in stone and plaster, such as James Dakin's 1837 St. Patrick's Church in New Orleans, which featured crockets, finials, and pendentive quatrefoils in the English decorated mode. Others were modest frame structures, like St. Andrew's Episcopal Church in Prairieville, Ala., constructed by local builders and hence called "carpenter gothic." Many of these frame churches were inspired by

Richard Upjohn's influential publication, *Upjohn's Rural Architecture*, especially ones in Alabama and North Carolina.

The Gothic Revival style was also used for important civic structures. Beginning in 1827, a series of architects and builders, including John Marlor, Charles Birch, and Samuel Tucker, added pointed arches, drip moldings, and battlements to the Georgia Statehouse in Milledgeville. Robert Mills's design for a gothic marine hospital in McDonoghville, La., was completed in 1837. James Dakin's monumental Louisiana State Capitol of 1847–50 in Baton Rouge was more Tudor palace than hall of legislative deliberation. Buildings of this type inspired Mark Twain's reference to them as "little sham castles . . . complete with towers, turrets, battlements, Gothic doorways and windows . . . placed in a melancholy setting of shady trees." Domestic structures in the gothic taste were especially popular in central Kentucky, in Fayette and Boyle counties, where the designs of John McMurty culminated in a quantity of houses with tripartite spire-form dormer windows on the second floor.

Nowhere is the recurrent interest in classical design more apparent than in the building taste of the late 19th- and early 20th-century South. Architects of this era were likely to have been trained in the didactic traditions of the Beaux-Arts school with its emphasis on close copying of ancient design modes and detailed knowledge of extant historic structures. Much of the interest in older structures, and the realization of their importance and relevance to understanding ourselves and our past, was stimulated by the movement for historic preservation. Various forces have motivated this interest in architectural preservation. These include respect and love for major historical figures or for buildings associated with historical events; a nostalgia for the past; respect and feeling for distinctive architecture and buildings of a place or period, be it an elaborate mansion or a simple log cabin or dogtrot; and a desire to preserve the consistent appearance or fabric or a section of a community.

The South has actively participated in the historic preservation movement. The earliest successful effort of this kind in the United States is generally identified as the effort to preserve Mount Vernon, the home of George Washington, and to open it to the public, an effort initiated in 1853. The most conspicuous and perhaps most extensive example of historic preservation is Colonial Williamsburg, where an entire community has been restored to its 18th-century ambiance. This project was inaugurated in the 1920s. Thanks to relatively little change there during the 19th century, there were 81 intact 18th-century buildings that needed little more than modest renovations and the removal of additions. At the same time, several of the more important buildings, particularly the Capitol and the Governor's Palace, both of which had totally disappeared,

were reconstructed on the basis of careful study of documents and archaeological research.

The Capitol and the Governor's Palace are among the most impressive buildings at Williamsburg, but the restoration as a whole is significant for its inclusion of a wide range of forms—small and medium-sized houses, outbuildings, shops, and gardens. Increasingly, emphasis has been placed on interpretations of the manner of living and the values of the inhabitants, as well as on the physical nature of the built environment. Moreover, although it was once true that only the roles of the political, social, and intellectual leaders of the community were examined, there is now a more evenhanded approach in which the lives of all classes, including slaves and servants, are studied and interpreted. Williamsburg, because of the scale of the restoration and the disciplined research that has characterized the organization, has had a profound effect on the standards of historic preservation and also on the consciousness of both the nation's and the region's architectural history.

Other restored areas that have had a similar, if more limited, influence include the Old Salem restoration at Winston-Salem, N.C., which helped to bring to the fore the Germanic heritage of the South, and Westville, near Lumpkin, Ga., a re-creation of the buildings, sights, and smells of a rural mid-19th-century village. Cities with distinct architectural characters in which there has been controlled preservation and restoration include Charleston, Savannah, and New Orleans. They are among the most attractive cities in the country and are seen as emblems of the rich and complex history of the South. The influence of Williamsburg and the enthusiasm for architecture in a historical idiom go far beyond simple historic preservation. Reinforcing the slightly earlier Colonial Revival architectural style, the Williamsburg work is echoed throughout modern suburbs and in numerous historic architecture projects.

Despite the dicta of early and mid-20th-century architectural theorists and practitioners concerning purity and simplicity of form and the need to build for a machine age, a large number of builders and developers in the South (and elsewhere) opted for modifications of traditional architecture, particularly in residential architecture. In some cases, the plans may have changed significantly—front-door access but also side- and back-door access through garages, more "family" rooms, a high proportion of one- or one-and-a-half-story ranch houses—but the surface embellishment is an interpretation of traditional forms, albeit sometimes very free. Among these traditional types in the South is what could be called Antebellum Revival, that is, the columnar-fronted mansion.

Though often working in the classic idiom, southern architects of the first

half of the 20th century were not out of step with modern advances. In the fore-word for the *Official Catalog* of the Southern Architectural and Industrial Arts Exposition held at the Memphis Municipal Auditorium in November 1929, M. H. Furbringer noted that displays of contemporary design should "reflect the march or progress of civilization" and the "changing conditions which affect the environments in which we live, the homes in which a people dwell, the buildings that house their activities, and the edifices erected for commerce, worship and education."

Participants in this exposition included many architects whose firms designed buildings with subtle proportions and fluid use of decorative detail that increasingly inspired admiration from architectural purists. Hentz, Adler & Shutze nurtured the young Neel Reid, whose Beaux-Arts houses and apartment buildings defined the Atlanta style in the mid-20th century. Philip Trammel Shutze was the architect of the Swan House, now home to the Atlanta Historical Society. The partnership of Armstrong & Koch in New Orleans became the firm of Koch and Wilson, whose restorations garnered much admiration for integrity and sensitivity to the historic fabric of existing structures in the French Quarter. Other architects of note who were not part of this exposition included Lawrence Bottomley of Richmond, Edward Vason Jones of Sparta, Ga., and Stratton Hammond of Louisville.

Most of the homes in the South today were built after the beginning of World War I. A large number of public buildings, office towers, and industrial structures were also built after that time. What is true of the nation as a whole is equally true of the South, especially in such urban centers as Atlanta, Jackson, Birmingham, Nashville, Charlotte, Richmond, New Orleans, and others that have greatly expanded in size and population from the 1940s through the early 21st century. We are still perhaps too close to this recent run of building to see it in historical perspective and to see how and if it has distinct regional qualities. A present consensus would probably be that the majority of styles and building types represent national rather than regional choices. Art and architecture are often, by their nature, national and international in character, but with regional accents. Modern technology and materials (including air-conditioning), modern communication systems, and a highly mobile population have abetted this tendency.

The advent of air-conditioning, especially from the 1940s onward, when it began to be affordable both in the workplace and in residences, even of many poorer people, has done much to cause the built environment of the South to conform even more closely to national patterns. Earlier, long hot summers virtually forced the builders of southern homes to find ways of coping with

the heat—dogtrots, wide central halls, porches, verandas, piazzas, galleries, cupolas on large houses, attic vents, raised cottages with air circulation underneath, and T-shaped house plans, to name a few. These devices were often concealed so that a given building might appear in shape and detail to conform to a particular style or taste.

Although summers are hot in other parts of the country, too, and many of these devices were used elsewhere—the porch, for example, was a ubiquitous feature on houses in the United States during the second half of the 19th century—the porches, swings, hammocks, and other accoutrements were important for longer periods of time in the South. Air-conditioning has thus been a factor in changing the pace of American life and especially life in the South, in ways both overt and subtle. Life in summer is more enclosed and private. New houses seldom have the porches or the overhanging roofs that used to be typical. Where once businesses, schools, and colleges closed down or operated at a much slower pace for four months in the summer, they now follow the same schedules as their counterparts throughout the nation.

The large hotel with central multistory lobby or atrium is a characteristic modern building type. The spectacular open spaces of hotels of this kind lend a sense of drama and theater to one's visit to a strange city. The Hyatt-Regency Hotel in Atlanta, designed by John C. Portman and Associates and completed in 1967, was the first of this genre. The fashion for and appreciation of a variety of such open, interior public spaces have now spread throughout the land. Although it originated in the South (scholars can always identify precedents for each new building type—the much earlier Brown Palace Hotel in Denver is a case in point), one would not identify this fashion as specifically southern. Rather, it seems to represent an innovative impulse in design and form associated with a place undergoing great commercial and economic expansion.

Buildings completed in the modish style of a given time are important not only for the functions they serve but also for the way they demonstrate the shared tastes of an era. They are important symbols or visual statements of what both parties, the owner or patron and the designer or architect, conceive to be the role of the building in that time and place. They reflect, in turn, the status and role of those who live in or use the building. Furthermore, the buildings reflect the status of the occupants or users of the building and also the aspirations and achievements of the entire community. Also included now as older and historic are such relatively recent modes as the art deco and art moderne of the 1920s and 1930s. The extraordinary cluster of art deco hotels and residences in Miami is a reminder of that area's spectacular growth during those two decades.

More recently, popular magazines have shown examples and plans of such vernacular types as Louisiana colonial structures with double-pitched sheltering roofs. The recent "postmodern" architectural movement has in a sense taken note of what developers and builders have understood—that a certain amount of ornament and embellishment and playful manipulation of spaces is pleasing to the eye and the spirit. They in turn are trying to create buildings in which some traditional forms and ornament are used in both functional and appealing ways. This is a very self-conscious movement.

One of the critical elements of recent architectural history has been the growing awareness of the profound diversity in design sources. In some cases, different building traditions in different regions developed out of the traditions familiar to the earliest settlers, such as English, French, German, Spanish, and Scottish. Certain construction methods were also assimilated from the Indian and African populations. A growing body of research into the nature and uses of vernacular structures exists. Such research is fueled by a desire to formulate a more accurate picture of the nature of the built environment and to study more than structural types and architectural modes. Farm buildings and industrial and commercial buildings are, and were, a conspicuous part of the built environment of the South, as elsewhere. Here, too, further study of the variety of forms, tastes, and traditions is needed.

Less self-conscious artistically is another new trend that may or may not have an important effect on the nature of architecture and the built environment in the South and elsewhere—the increased awareness of the need for energy conservation. A notable example of the way in which the shape and appearance of the building have been determined by energy and environmental considerations is the Jones Bredge Headquarters of the Simmons Company in Atlanta, Ga., designed by Thompson, Hancock, Witte, and Associates and completed in 1975. This building, roughly the shape of a parallelogram, rests on steel trusses (thus it is raised up from the ground—a traditional southern practice) and is designed to take advantage of solar and ecological factors. The need to make specific adaptations in order to save energy and materials may reshape, once again, the forms of our shelters.

Whether in vernacular idioms or in more self-conscious architectural styles and designs, whether serving private or public, commercial or industrial needs, buildings are important statements of status, symbols of cultural aspirations, and statements of community pride. Some are personal statements by architect or patron, and some now seem to be distinctive period statements. The architecture of the South, as elsewhere, is complex and many layered. In considering the achievements of a vast array of builders and buildings, we might reach out-

side the South for a trenchant observation. As Gertrude Stein recited at the conclusion of her poetic tribute to Pablo Picasso, "Let me recite what history teaches. History teaches."

JESSIE POESCH
Tulane University

ESTILL CURTIS PENNINGTON
Paris, Kentucky

Wayne Andrews, *Pride of the South: A Social History of Southern Architecture* (1979); Catherine W. Bishir, *Southern Built: American Architecture, Regional Practice* (2006); Mary Wallace Crocker, *Historic Architecture in Mississippi* (1973); Henry Glassie, *Folk Housing in Middle Virginia: A Structural Analysis of Historic Artifacts* (1975); Charles B. Hosmer Jr., *Presence of the Past: A History of the Preservation Movement in the United States before Williamsburg* (1965); Clay Lancaster, *Ante-Bellum Architecture of Kentucky* (1991); Mills B. Lane, *Architecture of the Old South* (1996); John Linley, *The Georgia Catalog: Historic American Buildings Survey, A Guide to the Architecture of the State* (1982); William Mitchell, *Edward Vason Jones* (1995); Lewis Mumford, *The South in Architecture* (1941); James Patrick, *Architecture in Tennessee, 1768-1897* (1981); Jessie Poesch, *The Art of the Old South: Painting, Sculpture, Architecture, and the Products of Craftsmen, 1560-1860* (1983); Leland M. Roth, *A Concise History of American Architecture* (1979); Kenneth Severens, *Southern Architecture: 350 Years of Distinctive American Buildings* (1981); Dell Upton and John Michael Vlach, eds., *Common Places: Readings in American Vernacular Architecture* (1986).

ART IN THE SOUTH

Art in the South, 1800–1920. Though H. L. Mencken's oft-quoted and much-lamented reference to the South as the "Sahara of the Bozart" has long been refuted by the achievements of the southern literary renascence, his stinging comments on the visual arts are worth revisiting as a prelude to an entire volume focused upon that very subject. From his perspective in 1917, "there is not a single picture gallery worth going into[,] . . . a single public monument that is worth looking at, or a single workshop devoted to the making of beautiful things," and "when you come to . . . painters, sculptors, architects and the like, you will have to give it up, for there is not even a bad one between the Potomac mudflats and the Gulf." Even as he wrote, the Telfair Academy in Savannah, with the assistance of Julius Garibaldi "Gari" Melchers, was assembling a fine collection of contemporary academic and impressionist art for its "picture galleries." John Russell Pope's architectural plans for Richmond ensured that "public monuments worth looking at" would indeed transform the old Confederate capital. Meanwhile, in New Orleans, artisans in the New-comb Pottery workshop were busy producing wondrously painted and glazed art pottery that seemed to capture the actual moisture of the local atmosphere. To challenge the expansive dismissal of creative individuals working from the Potomac to the Gulf, one might simply recall John Ross Key's monumental view of Washington, D.C., as seen from Arlington above the Potomac, or linger over one of Richard Clague's tonalist landscapes set so near the Gulf and New Orleans.

For the past 30 years, many collectors, academics, and museum professionals have brought the vast and diverse assortment of southern artistic material culture to greater attention. This first overview, of the years between 1800 and 1920, highlights four expressive categories representing the rise and progress of 19th-century southern art, which spilled into the early 20th century. As the South expanded from colonial tidewaters and coastal plains to alluvial basins and mountain terrains, so too can the art of the South be seen as expanding from mimetic portraiture to more sophisticated responses to national and international avant-garde movements. In rough order, the demand for antebellum portraiture passed with the introduction of photographic technique, even as a growing awareness of natural beauty inspired several schools of landscape painting at midcentury. In the aftermath of the Civil War, conflicting issues in

the sociocultural construct became subject matter for genre painting. Late in the 19th century, the introduction of international impressionism in schools and art academies coincided with an era whose creative individuals had begun to probe the complex mind and consciousness of the South.

Antebellum Portraiture. Portraiture in the antebellum South may be best explored in three categories that define the artists according to their travel and residency patterns. "Birds of passage"—a term coined by esteemed art historian Anna Wells Rutledge—are artists who may have visited the South only once but who left behind a body of work whose merit and popularity ensured imitation. "Seasonal itinerants," whether native southerners or outside artists with long-standing ties to the South, often established temporary studios in certain recurring locations with favorable climate conditions. Many of these artists often fled the harsh winters of the North for the more moderate temperatures and active social life in the South. "Resident artists" were those whose long-term tenure in one urban area fostered a clientele that often returned for sittings, even in subsequent generations.

Birds of Passage. Birds of passage may be seen as artists who traversed the South in pursuit of commissions while imparting to a local community the international values and aesthetic tastes then current among artists and patrons in more sophisticated urban centers. These painters were more likely to seek out commissions in the more established and prosperous cities of the coastal South, notably Charleston and New Orleans, between 1790 and 1840. James Earl visited Charleston in 1794 and was praised in the local papers for "giving life to the eye, and expression of every feature." Samuel Finley Breese Morse worked in Charleston in 1818, drawn by his extended connections in the Allston and Pinckney families, and he left behind an impressive body of work in the grand manner. Other artists of note who visited the city between 1818 and 1830 include John Wesley Jarvis, Cephas Thompson, John Vanderlyn, and miniaturist Benjamin Trott. New Orleans attracted itinerant painters from both the Upper South and abroad. In 1821, John Wesley Jarvis, having acquitted himself of several commissions in Louisville, took the downriver path to New Orleans. Once there, he established a studio, where he painted renegade general James Wilkinson and interviewed John James Audubon. Having examined some of Audubon's drawings, he pronounced himself "unable to help him in the least." Audubon had also arrived in New Orleans from Kentucky, where he had sustained his ambitions as a painter of wildlife by creating profile portraits, often in black-and-white chalk. Vanderlyn, discouraged in his efforts in Charleston, sought out work in New Orleans that same year, and he also viewed, with much greater courtesy, Audubon's drawings. Although he admired their "beautiful

coloring and good positions," he did not feel they expressed any "knowledge of natural history." Undeterred, Audubon could only wonder if all "men of talent were fools or rude naturally" and soon departed for England and fame eternal with the publication of *Birds of America*.

In the years following Audubon's visit, New Orleans became fertile ground for ambitious itinerant artists. Drawn by the prosperous Creole families who continued their ties to France, Jean-Joseph Vaudechamp and Jacques Guillaume Lucien Amans visited the city several times between 1829 and 1856. A student of Anne-Louis Girodet de Roussy-Trioson, Vaudechamp worked in the French neoclassic spirit. His portraits are highly finished, with strong facial modeling, deep glazing, and a minute attention to costume detail. Vaudechamp's figures are often turned away from the *planar field* (the surface of the painting) in a subtle and evocative *contraposto*, giving them a slightly distant, formal air. Amans also painted in the neoclassical style, and like Vaudechamp, he often worked in a larger, three-quarter-length format. This increase in size affects the presentation of the figure, making it larger and bolder. With their strong coloring, heavy modeling, and spatial dimensions, his figures are harbingers of the full-blown romanticism of the 1840s and 1850s — a style that might be called *plantation baroque*. Other French painters of note who worked in New Orleans include Louis Antoine Collas, who painted a rare portrait of a free woman of color, as well as François Bernard and Franz (François Jacques) Fleischbein.

George Cooke was among the most significant American painters to visit New Orleans in the age of the French itinerants. Following a European study tour, he returned to his country in 1832 with aspirations to create a "national gallery" of art. His writings on art for the *Southern Literary Messenger*, published in the spring of 1835, combine his thoughts on the mortality of life with the immortality of art. In these articles, he expresses concern that the viewing public is often more interested in the subject than in the execution of the artwork. He goes on to note that too great an emphasis upon content demeaned the true role of the artist — not to shock, excite, or entice the audience but rather to soothe and inform it with the collected knowledge gleaned from long observation. For Cooke, the artist functioned in the role of aesthetic preservationist, one who "by the magic of his pencil" captures "the very faces and persons of the fair and the brave of ages gone by." In 1844, with the assistance of Daniel Pratt, an Alabama businessman, and James Robb, a New Orleans collector and financier, Cooke opened a "National Gallery of Painting" at 13 St. Charles in New Orleans. There he displayed works of art by some of the leading American painters of the day, including Thomas Sully, Emanuel Leutze, and Daniel Huntington. He continued to keep the gallery open until 1848, but his

efforts to sustain the gallery on a long-term basis were not successful. While on a visit to New Orleans to conclude his project, in March 1849, he contracted Asiatic cholera and died. His ambitious intent and his published aesthetics place him amid the most important artists of the era.

Seasonal Itinerants. Following the purchase of the Louisiana Territory by President Jefferson in 1803, a large number of Kentucky families migrated to Mississippi, especially to the Natchez region. Those families and the growing economic ties between the upper Ohio Valley and the lower Mississippi Valley inspired the Kentucky-Mississippi itinerant portraitists. Their ability to travel was greatly improved when the first steamboat to descend the Mississippi, the *New Orleans*, began operations in 1812. Kentucky painter William Edward West was one of the first artists to take advantage of this travel and trade route when he went south from Philadelphia to Natchez and New Orleans in 1817. West was an astute observer in the Philadelphia studio of Thomas Sully, where he had as-sisted the master by painting background details. Sully's portraits of Jean Ter-ford and Mary Sicard David, with their faint echoes of French neoclassicism, provided the anatomical formula that West deployed in several Natchez and New Orleans works. Thomas Sully's posthumously published "hints to young painters" reveal the artist's impact upon his young followers. These "hints" are concerned with techniques of medium and support, preparing the canvas, ordering the palette, mixing color, gathering and laying out the artist's tools, and varnishing the finished artwork. They reflect certain ongoing traditions in Western art instruction, dating from the Renaissance, offering in writing what had been an oral tradition, spoken in studios and ateliers.

A fellow Kentuckian, Matthew Harris Jouett, began to pursue a southern itinerancy in 1819, after West's departure for Europe, taking advantage of the same acquaintances and family connections in the Natchez region. Jouett had worked with Gilbert Stuart in 1816 and kept notes on their encounter. "Rude hints & observations, from repeated Conversations with Gilbert Stuart, Esqr. In the months of July, August, September, & Oct. 1816 under whose patronage and care I was for the time" is that rare document, a firsthand account by an impres-sionable student working with an established master. The young artist admired Stuart as someone with a "singular facility in conversation and powers of illus-tration." Jouett's work from the 1820s demonstrates a fine command of style, especially seen in the ambitious compositions in his renderings of mothers with their children.

Slightly younger than West and Jouett, another Kentuckian, Joseph Henry Bush, began his itinerancy in 1818. Bush was more truly a wandering itinerant than either West or Jouett, who tended to establish "painting rooms" in local

hostelries and steadily painted a group of sitters prearranged by word of mouth of their coming, as evident by multiple portraits of members of one family. Rarely resident in one locale, Bush worked from plantation to plantation, particularly among the extended Chotard families of Natchez and the Flowers family of Vicksburg. In later years, 1831–48, he gave up this wandering itinerancy and consistently spent his winters at the St. Charles Hotel in New Orleans.

Kentucky artists were not the only portraitists to pursue work along the Ohio-Mississippi Rivers trade route. James Reid Lambdin, resident in Louisville after 1832, pursued a seasonal itinerancy in Natchez from 1832 to 1837. Artists from Cincinnati who worked in the Deep South included James Henry Beard, intermittently active in New Orleans from 1838 to 1858; Minor Kellogg, who was there in 1840; and Joseph Oriel Eaton, active there in 1855 and 1857. It was not a one-way stream. Painters who came upriver to Kentucky include C. R. Parker, 1832–48, and the team of Theodore Sidney Moïse and Trevor Thomas Fowler, 1840–54.

Comparing and contrasting the recorded remarks of Sully and Stuart gives insight into the stylistic shifts then transforming American portraiture—from the forthright perspective of the young republic into the romantic expressionism of a rapidly expanding nation. While Stuart consistently advised his students to work from nature in order to create a painterly foundation for the "equal" application of paint, Sully assumed that the fledgling artists had "acquired the power to draw from memory the human figure in any position." Stuart's portraits began with observation, but Sully subjected the sitter to anatomical conventions absorbed from the Italian drawing master Pietro Ancora. Stuart encouraged Jouett to begin in paint; Sully began with a study "made in charcoal, with its proper effect of shadow relieved with white chalk." Stuart prompted Jouett to paint from nature, observing character as he went. Sully advised adopting attitudes. Stuart was not interested in flattering his subjects, but Sully made his reputation on portraits that did just that, albeit with a masterful warmth of color and painterly detail.

Sully was quite honest about flattering his subjects. "From long experience I know that resemblance in a portrait is essential: but no fault will be found with the artist, at least by the sitter, if he improve the appearance." This advice was well taken by William Edward West, whose early imitations of Sully's compositional formulas matured into the much-demanded, and very lush, romanticism he practiced during his Baltimore period. While it would be far too simplistic to see the stylistic concerns of portraiture in Kentucky and the Ohio River Valley as rendered between these two dialectics of taste, the currents of style they inspired would linger until the outbreak of the Civil War. The dia-

metric opposition of Stuart's insistence upon honesty and truth to nature and Sully's unabashed willingness to flatter can be revisited in the later careers of Oliver Frazer, Joseph Henry Bush, and George Peter Alexander Healy in Kentucky and in those of Joseph Oriel Eaton and the Soule family across the river in Ohio.

Resident Artists. By the mid-19th century, many urban centers in the South had resident portrait painters with an extended and loyal clientele. A native of England, William James Hubard began to work as an itinerant portraitist in Virginia in 1832, with residencies in Norfolk, Williamsburg, and Gloucester County. By 1836 he had acquired a settled residence with the purchase of The Retreat, a house in Gloucester Court House, Virginia. In the late 1840s Hubard and his family settled in a permanent residence on the edge of Richmond, near the home of the artist Edward F. Peticolas. During the next decade, Hubard became the portraitist of choice in the Richmond area, patronized by Virginia's most prominent families, including sitters from the extended connections of the Tabb, Mayo, Randolph, Bolling, Cushing, Cocke, and St. George Tucker clans. At the same time he also became a close associate of Mann S. Valentine II, a writer and antiquarian with pronounced artistic interests. Hubard's association with Valentine resulted in some of his most interesting work, notably the illustrative drawings he made for Valentine's gothic romance *Amadeus, or a Night with the Spirits.* In 1852 Hubard announced that he would conduct art classes in his painting rooms at 11th and Broad Streets. He would not teach by the method of copying, "which leaves the pupil as much in the dark as to a knowledge of nature and art," but rather by instruction, which would teach the student "to use his eyes, hands, and understanding in a way tending to remove the awkwardness arriving from that ignorance of nature and art."

Charleston's most famous resident artist was the miniaturist Charles Fraser, who was born there and then orphaned at the age of nine. During the 1790s, he attended the Academy of Bishop Smith in the company of Thomas Sully, who subsequently remarked that Fraser "was the first person that ever took the pains to instruct me in the rudiments of . . . art, and, although himself a mere tyro, his kindness and the progress made in consequence of it determined the course of my future life." His first notice as an artist, published in the *Charleston Courier* on 29 November 1816, noted that "twenty very beautiful drawings of scenes, in different parts of the United States . . . have been purchased by the proprietors of this Journal," who found them to be as "fine as any we have ever had occasion to inspect." He was active in Charleston's civic affairs throughout his life. Toward the end of his life he was lauded as Charleston's most-beloved artist. The *Charleston Courier,* on 14 December 1856, announced

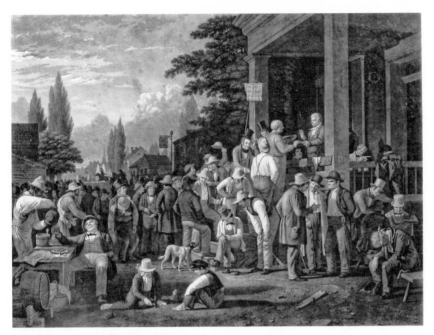

Engraving by John Sartain, from a painting by George Caleb Bingham, The County Election, 1854, 22¼" x 30" (Collection of Warren and Julie Payne)

an exhibition of his works held in local collections, which opened in February 1857 in the great hall of the South Carolina Society, at which 313 miniatures and 139 paintings were shown, accompanied by a catalog with an introduction by Samuel Gilman. Later, Gilman recalled that Fraser, "leaning on the arm of a young companion, or old friend . . . walked around the gallery, calling up reminiscences of his artistic life, criticizing his own pictures . . . pausing with a dreamy wonder as if he were in some enchanted vision."

Upcountry in South Carolina, William Harrison Scarborough established a portrait studio in Columbia. He was born in Dover, Tenn., and originally began his studies in medicine in Cincinnati, in 1828. While there he decided to become an artist instead. His most thorough training in the technique of portrait painting came from his work with John Grimes in Nashville in 1830. After the death of his young wife during childbirth in 1835, he and his infant son, John, left Tennessee, first for Alabama and then to Charleston, where he settled in 1836. John Miller, a wealthy planter and lawyer, provided him with his first commission—to paint some of his seven daughters while living in the family home at Sumpterville. One, Miranda Eliza, married the artist on 28 November 1838. The Miller family connections provided Scarborough with a large number

of sitters for the studio he had opened in Cheraw, S.C., in 1836. By 1843, patronage at that location had played out, and Scarborough moved to Columbia, S.C., where he would remain for the rest of his life. Scarborough kept a very meticulous account book of his sitters and proceeds. At the time of his death, his estate was valued at $20,000, giving a sure indication of prosperity, which eluded many of his contemporary painters.

Oliver Fraser, the first Kentucky painter to study in Paris, was the resident portrait artist in Lexington during the antebellum era. He came from a family of prosperous silversmiths. After some early study with Matthew Harris Jouett, he made the obligatory trip to Philadelphia to study with Thomas Sully in 1828. In May 1834 he sailed for France, where he sought instruction in the Paris ateliers of Baron Antoine-Jean Gros and Thomas Couture. During that time he also made copies of old master paintings, notably one of a Titian, *Madonna and Child*, commissioned by Richard Higgins of Lexington. Upon his return to Kentucky in 1838, Fraser established a studio in Lexington and became the last permanent resident portraitist in the Kentucky tradition. Through his marriage to Martha Bell Mitchell, Mrs. Matthew Harris Jouett's niece, he received multiple commissions from the political and social establishment of the inner bluegrass. He became the house favorite of the Henry Clay family, painting several portraits of the famous politician. In later years the artist's eyesight began to fail, with the result that some of his late works have a slightly dim, murky appearance, giving them a vague, romantic cast. While he continued to paint, he also nurtured associations in the nascent community of daguerreotypists, whose rising popularity would sound the death knell of the antebellum portrait tradition.

Though lesser known, several resident painters worked in the more remote urban areas of the South. Joseph Thoits Moore, originally an Ohio painter, settled in Montgomery, Ala., in 1830 and is reported to have painted over 400 portraits there during his career. William Carroll Saunders, who had pursued training in Florence, was the resident portrait painter in Mobile from 1842 to 1847. Three cities in Mississippi enjoyed the services of long-term resident portrait artists. Louis Joseph Bahin fled the European upheavals in 1848, eventually settling in Natchez in 1850, where he produced a number of vividly colored and highly detailed society portraits. Upriver in Port Gibson, Thomas Cantwell Healy, brother of the better-known George Peter Alexander Healy, painted a large number of portraits after taking up residency there in 1863 and remaining until his death in 1889. Jackson was home to Charles F. A. Weigand from 1846 until he was forced to flee the devastations of the Civil War in 1863, after which he settled in Athens, Ga.

In Tennessee, there were two highly productive portrait artists, brothers Washington Bogart Cooper and William Browning Cooper. After early studies with Ralph Eleaser Whiteside Earl, a portraitist and kinsman of Andrew Jackson, in Murfreesboro, in 1822, Washington Bogart Cooper relocated to Nashville in 1830, where he was based for the remainder of his professional career. His younger brother, William Browning Cooper, once reported that he had worked with Thomas Sully and Henry Inman during a trip east in 1831. Washington Cooper kept a detailed account book of portrait commissions, from which the years 1837 to 1846 survive in the Tennessee State Library in Nashville. In these account books, he lists the prices he charged for various sizes, rare information for the time. He was also active as an itinerant in middle Tennessee, 1830–85, and made several trips to Kentucky and to Cincinnati in 1842. He also made frequent itinerant visits to Alabama in the 1840s. He is said to have painted 30 to 35 portraits a year and thus became known as "the man of a thousand portraits." Among his most notable series of portraits were images of the governors of Tennessee before 1858, the early bishops of the Methodist Episcopal Church in Tennessee, and the Masonic grand masters of Nashville. His success enabled him to send his younger brother, Browning Cooper, to the National Academy of Design in New York City. His most consistent period of residency occurred in Memphis, where he was active from 1840 to 1853. Following a period of itinerancy in northern Alabama, broken by the Civil War, he returned to Memphis, where he was again based from 1867 to 1882.

The Ascent of Landscape Painting. Not until after the Civil War would painters in the South seek out and find the transcendental virtues of the southern setting as a source for landscape painting. While there were artists who made brief visits to specific locales of scenic note, their work tended to be limited in scope and volume. Though primarily known as a portrait artist, George Cooke painted several Georgia landscapes between 1834 and 1849, including a view of Athens and Tallulah Falls in northern Georgia. In 1858, Flavius J. Fisher, a Virginia native, painted the Great Dismal Swamp on the Virginia–North Carolina border. On the eve of the Civil War in 1860, David Johnson, a lesser light of the Hudson River school, painted several views of the Natural Bridge of Virginia, which attracted considerable attention when exhibited in New York. Yet no real school of southern landscape painting emerged until Thomas Addison Richards began writing and painting in Georgia in the early 1840s.

Richards's formative years were spent in Georgia, whose scenic wonders he celebrated in both prose and painting. Following his father's appointment to the Penfield Academy in 1838, Richards spent seven years writing, teaching, and painting in Augusta and Athens. At the same time he made sketching trips to

the "charming Blue Ridge landscape" in north Georgia, where he found the falls of the Toccoa River to be "beautiful, surpassingly beautiful . . . the silver cascade foaming o'er the brow of the hill, the troubled waves of the mimic sea beneath, the lulling sound of the falling water, and the call of the mountain birds . . . all come with a soothing power upon the heart." In 1842 *Georgia Illustrated* published steel engravings based on Richards's sketches. In 1845 Richards moved to New York, where he studied at the National Academy of Design, whose instructors included several artists of the Hudson River school. The focus of such fellow artists as Asher Durand and Thomas Cole led Richards to wonder why so "little has yet been said, either in picture or story, of the natural scenery of the Southern States; so inadequately is its beauty known abroad or appreciated at home." Writing of the South for *Harper's New Monthly Magazine* in 1853, the artist drew colorful distinctions: "For the verdant meadows of the North, dotted with cottages and grazing herds, the South has her broad savannas, calm in the shadow of the palmetto and the magnolia; for the magnificence of the Hudson, the Delaware, and the Susquehanna, are her mystical lagunes, in whose stately arcades of cypress, fancy floats at will through all the wilds of past and future." For Richards, the exotic southern landscape of Georgia and the Carolinas was a mysterious locale awaiting discovery. It was undetected by those "led hastily by business errands over highways which happen for the most part to traverse the least interesting regions." Nor was it likely to be found by that "censurable blindness which overlooks the near in its reverence for the remote."

Richards's observance of the habitual, and ongoing, southern infatuation with the remote rather than the native is also apparent in the architectural styles of the period. The passionate taste for Greek Revival architecture in the days of King Cotton ensured an abundance of temples on the landscape. Some, like the frame houses in Madison, Ga., Eutaw, Ala., and Enterprise, Miss., were high-country interpretations of the formal Greek vernacular as erected by local builders. Others, like Melrose in Natchez, Miss., Rattle and Snap in Columbia, Tenn., and Belle Meade in Nashville, were entirely correct examples drawn from the architectural pattern books of Minard Lefever and others. These houses differed from their northern counterparts. "While northern rooms were often cramped in space and the high parlors chilly and dark, the Southerner could expand his floor plan and raise his ceilings in the interest of coolness and circulation; master of many servants, he could multiply his rooms." To this day, it is these houses, and not the landscape, that spring to mind as the visual image of the romantic South in popular culture.

Following the Civil War, several areas of scenic wonder inspired schools of landscape painting. Richard Clague became the first artist trained in the

Barbizon tradition to render the moist and languid settings of the Louisiana lowlands. His followers included William Henry Buck and Marshall Joseph Smith Jr. Luminist painter Joseph Rusling Meeker, who had served on a Union gunboat in the Mississippi swamps during the war, produced a large volume of work from the sketches he made there. Artists of the southern highlands included William Charles Anthony Frerichs, who explored the Blue Ridge range of western North Carolina, and Carl Christian Brenner, whose vast unpopulated landscapes of eastern Kentucky evoke an Edenic sense of wonder.

During the last quarter of the 19th century, the exotic subtropical terrain of Florida and the Gulf Coast began to attract northern artists and developers. Between 1872 and 1875, Boston artist William Morris Hunt made several exploratory trips to Florida that resulted in several moody works in the American tonalist style. In 1878, Thomas Moran visited St. Augustine and rendered a portfolio of drawings upon which he would later base his paintings *Ponce De Leon in Florida* and *Bringing Home the Cattle, Coast of Florida*, both of which mark a departure in scale and color from his vast, brilliantly lit views of the American West. In the early 1890s, sporting artist John Martin Tracy moved to the Gulf Coast, where he departed from his usual format to paint several landscape scenes of moss-hung farmlands attended by young women in pastoral attire.

George Inness Sr. and his son, George Inness Jr., created a large body of work based on their seasonal residency in Tarpon Springs, Fla. The senior Inness had visited France and, like Richard Clague, acquired a personal knowledge and taste for art in the Barbizon mood. His vaguely hazy scenes of the languid waterlands of Florida are often lit by the soft glow of light in transition from dusk to dawn. Although trained in France and active in New York, in the years after his father's death in 1894 George Inness Jr. made Tarpon Springs his base of operations while summering at the arts colony in Cragsmoor, N.Y. He painted the Florida landscape in the style of his father, but he also created several mystical scenes based on the life of Christ. The Unitarian Universalist Church in Tarpon Springs contains an impressive collection of this work.

The Issues of Genre Painting. The enormous changes wrought by the loss of life, destruction of property, and rending of the social fabric following the Civil War provided the genre painter with an enduringly haunting source of subject matter. American art historian Oliver Larkin has defined genre painting as a "stage for human comedy, tragedy, or melodrama." All of those themes are to be found in the art of a number of artists who worked during the last quarter of the 19th century. Two paintings created during the last days of the Civil War, *The Burial of Latané* and *The Lost Cause*, captured the public imagination and

set the tone for much of subsequent 19th-century genre painting in the South. These paintings inevitably evoked the Lost Cause of southern secession or attempted to address the integration of the African American figure into the cultural landscape, attempts whose visual manifestations were both benign and startlingly malignant.

William Dickinson Washington's *Burial of Latané* was the first truly southern genre painting. It was based on the melodrama spun from the death of William Samuel Latané, son of a wealthy Virginia plantation owner and slave owner. At the outbreak of the Civil War he formed the Essex Light Dragoons, of which he was captain. While supporting Stuart's offence against Union general George McClellan, Latané was ordered to engage Federal forces near Old Church in Hanover County. He "singled out the Federal commander, and dashing at him, cut off his hat close to his face with a blow of his saber. The latter dodged the blow . . . and turning quickly, fired two revolver loads at Latané, killing him instantly." As his brother John sat holding his dead body, a cart from the Brockenbrough plantation, Westwood, came by and was commandeered to carry the body to an appropriate place for burial. When confronted with his remains, the plantation mistress, Catherine Brockenbrough, vowed to have him "buried as though he were her own brother and at the risk to her life if necessary." Unable to secure an Episcopal priest, Mrs. Willoughby Newton read the burial office from the Book of Common Prayer, and the girls on the plantation covered the grave with flowers. News of the tragic death and heroic burial effort spread to Richmond through Newton relations. Inspired by reports of the event, William D. Washington began work on *The Burial of Latané* late in the summer of 1864. From the moment it was first exhibited, there was no doubt that *The Burial of Latané* was meant to compare the suffering and death of the valiant young officer with the fate of the Confederacy. An engraving of the painting made by Pate and Company, New York, in 1868 was widely distributed by the *Southern Literary Messenger*. The print's popularity ensured the painting's place as an iconic image of the Lost Cause movement. To the public, it was a poignant reminder that, although Christ was resurrected, the Confederacy would not be.

The Washington painting has a symbolic partner in Henry Mosler's *The Lost Cause*. For more than 140 years Mosler's painting has been an iconic presence in southern culture. It has been widely distributed as a chromolithograph and cherished for the tender sense of loss it conveys. Mosler began his career as an illustrator and war correspondent for *Harper's Weekly*. In that capacity he came to know the Ohio River Valley, the West Virginia region near Huntington, and the south-central area of Kentucky—locales he would later use as the setting for *The Lost Cause*.

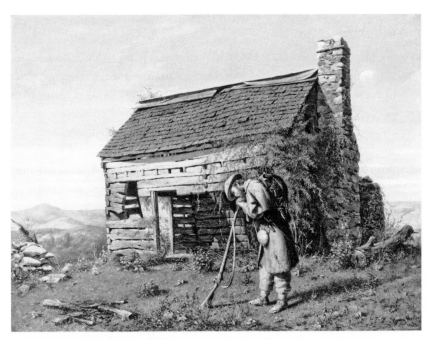

Henry Mosler, The Lost Cause, 1868, oil on canvas, 36″ x 48″
(The Johnson Collection, Spartanburg, S.C.)

Mosler's great requiem for the vanquished South rests on a visual construct heavily invested with subliminal themes of loss and survival. As Bruce Chambers has noted, "[It] takes as its subject the devastation of the war in the South as it affected, not the wealthy plantation owner, but rather the yeoman farmer of the highlands." In *The Lost Cause*, Mosler has placed his sagging veteran — head down, leaning on his musket, and awkwardly attired in heavy seasonal gear — against an uninhabited and decrepit log cabin. *The Lost Cause* is a reference to that cabin and the yeoman soldier who pauses, sadly, before it. *The Lost Cause* commemorates a sense of duty with hope for the survival of a vanquished people. Though well worn, the cabin still stands upon a yard covered with lush spring wildflowers and beneath a brilliant blue sky imbued with an ethereal transcendental spirit. Mosler's romantic style of artistic expression flavors the subliminal suggestion of *The Lost Cause*. It is a painting that evokes nostalgia and regret even as it affirms the ongoing spring of life. When issued as a print by Currier and Ives in 1871, it became a symbolic pendant to the *Burial of Latané* and a banner for the Lost Cause movement.

Not all genre painting of the era was awash in Old South sentimentality. In the decade after the war Thomas Satterwhite Noble created a series of works that

faced, with searing honesty, the base inhumanity of the slave trade. Noble was born in Lexington to a prosperous family who kept ropewalks for the twisting of hemp into binding cords for southern cotton. Following study in Paris he returned to America in 1858 with a heightened artistic and social consciousness. Upon his return he joined his family in St. Louis. While Noble may not have supported the institution of slavery, he did enlist in the Confederate army's corps of engineers and served three years, operating ropewalks and building pontoon bridges in Louisiana.

From 1866 to 1869 Noble painted five works dealing with slavery and abolition. *The Last Sale of Slaves* was painted in St. Louis in early 1866, not long after the Emancipation Proclamation of December 1865. The central figure is a young woman of mixed race holding a baby while an auctioneer seeks to incite the crowd. Some groups attend the sale and some ignore it, suggesting the variations of opinion on the issue itself. *John Brown's Blessing*, painted in New York in 1867, features the abolitionist insurrectionary being led from prison. As he pauses to bless a young Negro child held up by his mother, a phalanx of armed guards, bayonets stiffly erect, seem to stand at attention to the white-bearded old prophet figure before them instead of escorting him to his death.

Margaret Garner, also from 1867, tells the tragic story of a slave who escaped across the river with her children into Cincinnati in 1856, only to be tracked down by callous bounty hunters. She kills her children rather than return them to slavery. Two children lie dead at her feet as two others cling to her skirts in terror. It is a horrific picture—Garner confronts her pursuers with the fury of a Medea as they gape in stunned amazement. *The Price of Blood* is the crowning work in this series, one that depicts a father selling his half-caste son into slavery. Symbolic elements of the sacrifice of Isaac and the selling out of Jesus Christ for silver add to the painting's drama. Noble painted one last painting in the series, *Fugitives in Flight*, in 1869, which combines references to the trans-Ohio flight of slaves with the mythic twilight crossing of the River Styx. These paintings provide the only visual evidence of a southern painter attempting to confront the slave issue.

Thomas Waterman Wood, a northern painter who lived in Nashville and Louisville, was the first painter to depict the plight of the newly freed slave. In 1865, as Kentucky struggled with readjustment, Wood saw a one-legged African American war veteran struggling to cross a street in Louisville—unaided and supported only by a set of improvised crutches. This experience moved him to begin to paint a series of works called *War Episodes*, first exhibited in New York in 1867. These paintings focus upon the dynamic theme of promises made and promises broken or unfulfilled. Most are set against an architectural back-

ground detail, for example, the wall of a provost marshal's office plastered with an announcement for volunteers, pierced by an open door through which one sees Union Stars and Stripes displayed. The two best-known works from this series, *The Volunteer* and *The Veteran*, function as allegories in much the same way that Henry Mosler's paintings did: the exuberant rush to war followed by the sad return. Wood was not a cruel caricaturist like the artists of the Currier & Ives *Darktown* series, nor had he the condescending view and thinly veiled agenda of the artist William Aiken Walker. Rather, they are touching scenes of the plight faced by those in search of assimilation into a culture wherein they were formerly enslaved.

In the art of Edward Lamson Henry, African American figures are often used to punctuate nostalgic settings. Born in Charleston and orphaned at an early age, Henry had sufficient means, family, and social connections to enter the art circles of New York at the highest level. He received some juvenile training in New York and Philadelphia, but his most formative period occurred in Paris between 1860 and 1862. Henry enrolled at the prestigious École des Beaux-Arts, where he worked with the academicians Robert Fleury and Charles Gleyre. Henry returned home in 1862 and opened a studio in the legendary 10th Street Studio Building prior to joining Federal forces on board a supply ship in the occupied waters of the James River in 1864. He "desired to see the pictorial side of the Civil War," and what he saw was the destroyed terrains of Westover and Berkeley plantations. From his detailed sketches, Henry painted *The Old West- over Mansion* in 1869, by which time he had launched a career as a genre painter of nostalgic tributes to vanishing modes of travel and commerce.

These works, and the many that followed, mark Henry's place in a great shift in the tone and tenor of American genre painting. Artists of the previous gen- eration, notably George Caleb Bingham and William Tylee Ranney, had cre- ated works in the spirit of manifest destiny, set in a land of endless opportu- nity. Sobered by the monumental loss of life and the sweeping changes brought on by the war and emancipation, the national mood took on an air of gra- vitas, of sober reflection upon days gone by. "Rather than pursuing the national historical narrative so comforting to his countrymen," Henry enmeshed him- self in "'reflective nostalgia,' confronting the ambivalence of modern selfhood through the medium of memory." He became a determined antiquarian whose late 19th-century work was often praised for its careful attention to historical detail. In her autobiography, his wife noted that his "frequent use of Negro sub- ject matter is significant as suggesting a widespread interest in Negroes in that period. He painted 30 known pictures in which Negroes appear prominently."

William Aiken Walker remains the best-known southern genre painter, and

his art continues to provoke an intense dialogue on race. In the aftermath of emancipation, the former slaves faced critical challenges of survival and integration. Walker's observation of this population began to emerge in the late 1870s when he shifted the focus of his genre paintings from white street urchins to black field hands. In 1881, Stephen Minot Weld commissioned Walker to paint *Big B Cotton Plantation*—the first documented work in a series of large landscapes juxtaposing the renewal of cotton cultivation with the tattered elements of the black labor force. The critical and art historical legacy of these paintings opens an extended dialogue on visual acuity and the social construct. Noted African American art historian Guy McElroy has written that Walker's "conception of black life is one-sided and subtly insidious . . . commemorating a way of life that remained largely intact despite the trauma of the Civil War." Martha Severens takes a more philosophical view: "The original intent" of late 19th-century genre painters of black subjects, "all of whom would have been products of their milieu, is understandably hard for later audiences to ascertain." English art historian Hugh Honor has written about the semiotics of black images by white artists as being "of a characteristically personal and ambiguous Romantic type, rendering in form and color what words cannot express . . . with no simple one-to-one relationship between image and idea." Walker subjected his subjects to an acute, relentless gaze, one that documents, in detail, their presence in an ongoing socioeconomic construct while avoiding addressing any issues of personal identity in their daily life. At the same time, their disheveled apparel and dazed faces emphasize their condition as segregated agrarian workers.

The Arrival of Impressionism and the Avant-Garde. The impressionist style in art began to appear in the South during the 1880s through the auspices of several rather daring and nonconforming painters. Little in Gilbert William Gaul's education and his well-deserved reputation as an illustrator gives any indication of his sensitivities as a naturalistic impressionist. However, when students disgruntled with the more staid aspects of the National Academy of Design founded the Art Students League in New York in 1879, he subscribed. Under these auspices, he was exposed to the teachings and ideas of William Merritt Chase, freshly returned from his experiences in Europe, notably in Munich. Once Chase returned to New York in 1878 Gaul's association with the younger generations of European-trained American painters through the Art Students League led him to become a principal exponent of nascent impressionism. In 1881 Gaul inherited a farm in Van Buren County, Tenn., from a maternal uncle, with the stipulation that he build a home and reside there for five years. Complying, Gaul took up residence in middle Tennessee during the years

1882–87. During that time he painted several impressionistic landscapes, which represent one of the first manifestations of the style in the South. While there is no evidence to support the notion that these works were rendered *en plein air*, their freshness and panoramic sweep does imply on-site observation. As with many of his colleagues working in the early 1880s, Gaul's work combines a Barbizon interest in the ideal pictorial values of the scene with an impressionistic brushstroke. Like many of the Barbizon artists, notably Constant Troyon, Gaul establishes atmospheric mode through a blue-green color harmonic, setting apart the complementary values of water and sky with a broad band of deeper hue in the mid-ground. These paintings lack the tinge of nostalgia or the subliminal suggestion of heavy-handed sentiment to be seen in the cult of the scenic South, elsewhere dominant in the region's pictorial format. Though peopled by the requisite figures of agrarian piety, there is an integration of figurative elements and landscape texture, which gives the work a sense of wholeness that defies mere chromolithographic sensationalism.

Two Kentucky artists also absorbed impressionism from impressive sources. In June 1878, Hattie Hutchcraft Hill and her sister, Mattie, sailed for Europe to visit the Great Exposition in Paris, where the thrusting arm holding a flaming torch later to be assembled into the Statue of Liberty was unveiled. This trip seems to have stirred the greater ambition of becoming a recognized painter of landscape and still life works suitable for inclusion in the Paris Salons. In October 1888, with funds she had inherited from her parents and letters of introduction from former senator John Stuart Williams, she returned to France. At first she traveled through Italy, Spain, and France, visiting the painter Rosa Bonheur in the forest of Fontainebleau. In 1890 she took up residence at 38 Rue du Dragon and enrolled in the famous Académie Julian, located in the same block, at number 31. Hill's most influential instructors there were Benjamin Constant and Jules Lefebvre, artists whose calm close color harmonics influenced many of the American artists who worked in the Barbizon mood. Her younger contemporary, Paul Sawyier, first studied art in the impressionist style at the Cincinnati Art Academy, under the instruction of Frank Duveneck, before working with William Merritt Chase in New York in the late 1880s.

The art of Claude Monet and the influence of the art colony that sprang up around him and his garden in Giverny can be seen as the seminal source for impressionism in America, as well as the South. The shadows of Monet's Giverny fell far across American art, finally coming to rest in the decided preference of many of the genteel southern romantic-impressionists for scenes cast in a warm, evocative late light. While they may not have been purist practitioners of the Giverny mood, they do summon its spirit, in that they willfully created

what Monet sought to sensitively observe. If there is a distinct character to southern impressionism, then it may be seen to proceed from the use of local color, literary and geographic, to represent a terrain and a culture existing outside the prevailing national pattern. New Orleans, in particular, provided fertile ground for impressionist expression.

By looking very carefully at the cultural forces at play in the intellectual origins of the southern impressionists, it may be possible to conclude that they were more in accord with the spirit of Giverny than with their counterparts in the Northeast. Drawing upon symbolic local color, as defined by the popular literature of record, many of the southern impressionists depict a terrain as temporal and mutable as that which Monet saw in fleeting glances toward his garden. In the southern instance, mutability sprang from the anachronistic existence of actual structures, manners, customs, and picaresque individuals more often than from a site-specific view of an actual fleeting moment of light. William Woodward's record of vanishing structures in the French Quarter, William Posey Silva's mysterious landscape paintings of private gardens, and Helen Maria Turner's impulse to dissolve form in light are illuminations of this theory.

Light, in all its shadings, becomes a very extensive and evocative metaphor in late 19th- and early 20th-century southern art and literature. Like a curtain drawn aside to reveal the dramatis personae on stage, light in southern impressionism serves to perpetuate those notions of alienation and disregard that haunt the southern imagination in the 75 years subsequent to the Civil War. William Posey Silva's garden paintings can be seen in that light. After spending 48 years as an executive with the family business in Chattanooga, he resigned, moved to Paris, and enrolled in the Académie Julian. Upon his return to America, he settled, briefly, in Charleston, S.C. He thereafter moved about the Deep South searching for exotic locales with all the vigor of an antebellum itinerant portrait artist in search of commissions. Like many southern landscape painters of his time, Silva developed something of a formulaic approach to his subject matter. Unlike Alexander John Drysdale, this did not take the form of a repetitious compositional format but rather of a consistently brushy application of paint, which often covered the surfaces of his work with a spattered impasto intended to suggest both atmospheric moisture and that mysterious sparkle of light in swamps and lowlands so admired by previous generations of painters, notably those artists working in the Mississippi River Valley during the late 19th century.

One of Silva's favorite terrains was Magnolia Plantation, outside Charleston, on the Ashley-Cooper River, near Drayton Hall and Middleton Place. Mag-

nolia Plantation has been in the possession of the Drayton family since the late 1680s. Initially it was laid out in a very formal French manner, but in 1820 John Drayton began to introduce planting the grounds in the fashionable romantic English picturesque garden style. Following terrible devastation in the Civil War, the plantation's garden was renewed and sustained by opening it to "tourists who came by paddle steamer from Charleston. As a result, Magnolia became the first man-made tourist attraction in the United States."

It may well be that what struck Silva most about the garden was its wild naturalistic mood. In several of his works he chose to paint a portion of Magnolia Plantation known as the Audubon Swamp Garden. "Long boardwalks lead the visitor into the mystical swamp, where time seems to stand still. A quiet stillness pervades, broken only by the shrill cry of a bird. Here one is abruptly reminded that formal gardens can only imitate the beauty that nature lavishly displays." Silva called this series *The Garden of Dreams*, and the paintings represent his most expressive symbolic work.

If impressionism in the South can in fact be seen as a distinct expression set apart from mainstream American impressionism, then perhaps it should be read as a bountiful radiance transfiguring local color. Readings of southern impressionism will profit less from a formalist connoisseurship that evaluates the painterly abilities of earnest provincials in comparison to far more mature, and worldly, practitioners than from a more generous view of the transfiguration: the late shadow. However, a more considered regard for southern impressionism might spring from the extent to which a verisimilitude of detail between the metaphoric imagery of a substantial literary tradition and the fantastic portrayals by practitioners of a lingering artistic convention may be seen and acknowledged.

Questions remain as to whether a "school" of southern art existed in the South during the period under discussion. Strong crosscurrents of national and international styles entered the stream of southern aesthetic consciousness. While it would be difficult to assert a unique southern style, the paintings that emerge from southern sources do reflect values at once elusive, close at hand, and distinct from northern counterparts. As late as 1957, Walker Percy could still identify cultural distinctions between the regions. "Surely it would be better to cherish rather than destroy the cultural cleavage between the North and the South, a cleavage which accounts for the South's preeminence in creative literature and the North's in technics, social propaganda, and objective scholarship. The difference has been traced to a southern preoccupation with the concrete, the historical, the particular, the immediate; and the northern passion for the technical, the abstract, the general, the ideological." Symboli-

cally, if the North is a vast factory whose front offices await the decorative devices of impressionism as a sign of taste, then the South is a private garden passively awaiting depiction by the local Monet and the ambitious generations who followed him.

Art in the South, 1920–Present. Inevitably, the question "What is southern?" persists. The answer is as elusive and complicated as the diverse geographic regions of the South, and the reason for this lies at the very roots of the establishment of the United States. The precise delineation of the South is elastic, with terms like "Dixie," "Solid South," "Southland," "Old South," and "New South" being applied to the entire region made up of the southeastern states. Various historical sources through the years have included Maryland, Delaware, and Missouri as part of the South: the former two were slaveholding states in 1776, and the Compromise of 1820 outlawed the introduction of more slaves into Missouri and freed the slaves' children at age 25.

Perhaps the broadest definition of the geographic South comes from the U.S. government. The U.S. Census Bureau divides the country into four official regions: northeastern, midwestern, western, and southern, with the southern region, per the official census map, including the District of Columbia and 16 states: Alabama, Arkansas, Florida, Georgia, Kentucky, Louisiana, Mississippi, North Carolina, South Carolina, Tennessee, Virginia, and West Virginia, as well as Maryland, Delaware, Texas, and Oklahoma. Aligned with the Confederacy, Oklahoma was Indian Territory, which was originally part of the Louisiana Purchase in 1803 and then was set aside by the Indian Intercourse Act of 1834. Oklahoma did not enter the Union as a state until 1909.

Washington, D.C., was appropriately named for the nation's first president and preeminent military leader of the American Revolution. Originally known as the "Federal City," it was established in 1791 as the capital by the U.S. Constitution. The name "Columbia," an old poetic name for the country, was a concession to those who wished to name the country for Christopher Columbus and his voyage to this new land 300 years earlier. The location on the banks of the Potomac River, carved from the lands of Virginia and Maryland, was a compromise between northern and southern interests. The northern states, under the leadership of Alexander Hamilton, wished for the new federal government to assume the debt from the Revolutionary War. The southern states, with Thomas Jefferson as spokesman, preferred the capital to be situated in a site favorable to agricultural interests and their dependence upon slavery. George Washington chose the specific site, located 16 miles from his Virginia estate at Mount Vernon. In 1791 Frenchman Pierre Charles L'Enfant designed

the Federal City with spacious boulevards and parkways as a new Paris. The freeborn son of slaves and a native of Baltimore, Benjamin Banneker, an astronomer and mathematician, served as city surveyor.

The very beginnings of the nation's capital exemplify the development and history of the South—its economics, politics, conflicts, and tensions, the undercurrents of which still characterize the divide between North and South. Despite the division, great similarities typify Americans throughout the country. Societal characteristics of the South, like being family oriented, self-consciously history oriented, and economically dependent on agriculture, can also be applied to other areas of the country. Yet the South is the region most strongly associated with these traits. Some writers cite southerners' love of music, food, and cultural traditions as distinctions; others cite fervent religiosity as a commonality. While these observations are true, they are not exclusive to the southern region. Rather, it is the intensity of these composite qualities that resonates throughout the South. Of foremost importance, however, are southerners' strong ties to the land, ancestry, and ethnicity. Today, as electronic media, social networking communication systems, and other technological advances draw people closer together on an international level, the once seemingly insurmountable chasm between the two regions has diminished considerably.

While there has never been a universal aesthetic that unifies the South, visiting and resident artists have focused nearly continuously on the land, its people, and scenes of everyday life. In its early years, artists educated in Europe and New England continually visited the South, which led to an awareness of national and international art trends. As a consequence, art in the South reflected artistic trends of Europe and the Northeast, but southern visual arts would evolve in the mid-20th century until they not only kept abreast of international trends but were even in the vanguard.

Artists have long sought institutions with an established reputation for excellence in art instruction. Logically, because New York became ensconced early as a leader in artistic development, southern artists would look to that city's established schools for their training, particularly the National Academy of Design and the Art Students League. Others attended the Art Institute of Chicago or the Pennsylvania Academy of the Fine Arts. By the 20th century, however, most southern universities had established art programs. Additionally, there are a number of art institutes in the South, including Ringling School of Art, Savannah Art Institute, and Memphis College of Art. The art instruction in these institutions in the late 20th century customarily represents artistic development on a global level; nonetheless, an intangible manifestation of the

South—its culture, history, geography, and social issues—appears in the works of some artists who, like Francis Speight, Carroll Cloar, and William Dunlap, develop works that replicate recollections of their formative years.

Dunlap, who maintains studios in Mississippi, Virginia, and Florida, often produces dramatic landscapes populated by churches, farm buildings, hunting dogs, wildlife, and equestrian riders accompanied by indecipherable symbolism. Surprisingly, reminders of his childhood in South Carolina are visible in some of Jasper Johns's canvases. While not a southerner, abstract artist Larry Rivers also painted works with sentiments closely identified with the South. Edward Hopper captured a sense of place in works inspired by his visits to Charleston and Chattanooga. Though born in Ohio, Charles Ephraim Burchfield, a colleague of Hopper, executed canvases with kinetic energy that are described as "mystic" and "transcendental," with haunted houses having halolike auras. Artists who developed religious themes include Robert Loftin Newman, James Oertel, Henry Ossawa Tanner, and Sr. Agnes Berchman. William H. Johnson, who also painted works with religious overtones, focused on African American life in Harlem and South Carolina.

The National Academy of Design in New York, founded in 1825 and highly influential in art circles, continues to play a critical role in the education of southern artists, as well as in their subsequent careers. National academicians are professional artists elected to membership in the academy's honorary association by their peers in one of four artistic fields: painting, sculpture, graphic arts, and architecture. Member artists and architects who lived or worked in the South are far too numerous to list, but many are discussed within the pages of this volume.

Through the years, art and architecture produced by these academicians parallel the work of their counterparts on a national and international level. Early 20th-century landscape painting in America, including the South, reflected the artistic training of the late 1880s and 1890s, especially that of artists who studied in Paris and Munich. Just as the French Barbizon painters had broken with the rigorous academic tradition of neoclassicism in favor of going outdoors and drawing inspiration directly from nature, the next generation of landscape painters would seek their own manner of artistic expression. Works produced by artists associated with the Barbizon school, which roughly spanned the period from 1830 to 1870, generally feature verdant wooded scenes rendered in a dark palette with deep green and umber. The succeeding generation of painters working in France, particularly those born after the mid-19th century, abandoned these somber compositions in favor of poetic, lighter-toned atmospheric paintings.

Tonalist paintings, as well as impressionist paintings, found favor among American artists who eschewed the then-prevailing concept of large panoramic views of the American landscape espoused by the Hudson River painters. Many landscape painters working in the South preferred these more intimate, expressive scenes with soft contours rendered in broadly painted tonalities. Their moody, bucolic, contemplative compositions often depicted dawn or dusk enveloped in mist; their preferred palette was cool, ranging from a single dominant tone of grayish blue or green with neutralized warm tones.

Two of the foremost tonalist painters, both of whom worked in the South, were Elliot Daingerfield and George Inness, the latter of whom was a decisive influence on many tonalist painters. The extent of this influence is manifest in Daingerfield's 1911 publication, *George Inness: The Man and His Art*. Daingerfield, who was also heavily influenced by American tonalist painter Ralph Albert Blakelock, is best known for his poetic moonlight scenes, many of which have religious overtones. A native of Virginia who grew up in North Carolina, Daingerfield studied with William Satterlee in New York, where he taught still life classes and first exhibited his work at the National Academy of Design. Daingerfield was elected associate academician in 1902 and received the academy's Clark Prize for best figure composition. He would also teach at the Philadelphia School of Design and the Art Students League. An illness led him to recuperate in Blowing Rock, N.C., where he became known as "the American Millet." Daingerfield had become friends with Inness after moving in 1884 to the Holbein Studios on 55th Street in New York City.

Born in New York and educated in Newark, N.J., Inness was a regular exhibitor at the National Academy of Design. His international journeys included England, Italy, France, Mexico, and Cuba. He traveled to the American South, especially Florida and New Orleans. In New Orleans, he was a visitor to the regular gatherings at the home of art patron William E. Seebold, where he gave a lecture on impressionistic art. Inness's presence in late 19th-century New Orleans was a contributing influence on the development of Louisiana landscape painting, an impact that continued well into the 20th century. His protégés include his son, George Jr., who asserted his individuality through the inclusion of figures, animals, and religious subjects.

Well into the early 1930s, Alexander John Drysdale exemplified the elder Inness's manner of expression in his misty blue-green, turpentine-thinned minimalist Louisiana bayou scenes. William Posey Silva's atmospheric treatment of Tennessee and Georgia forests is deeper in tone, more textural, and more complicated compositionally. Although his career was brief, Texas painter Robert Julian Onderdonk rendered views of the expansive southern wilderness

with poetic sensibility. Presently, Gail Johnson Hood, Roy Pfister, Tony Green, and Phil Sandusky create solidly constructed plein air landscapes focusing on Louisiana's waterways, each in a distinctive artistic manner.

Many southern artists were proponents of impressionism, which was formally introduced to American artists during the 1893 World's Columbian Exposition in Chicago. Landscape painter Eliot Candee Clark, an admirer of James Abbott McNeill Whistler and a strong proponent of impressionism, produced a conscious linkage to this European artistic tradition when he wrote about the movement's leading American exponents, including three of the ten American painters—John Henry Twachtman, Julian Alden Weir, Frederick Childe Hassam—as well as Theodore Robinson and Robert William Vonnoh. Hassam produced impressionistic views of New Orleans. Clark, who moved to Virginia in 1932, also wrote two books on tonalist painter Alexander Helwig Wyant. In 1954 Clark wrote the *History of the National Academy of Design, 1825–1953*, which underscores the continuing importance of that institution for American art.

Numerous painters of the early 20th century followed traditions established by Winslow Homer, the foremost painter of realistic rural and recreational scenes. Elizabeth Nourse, who has been described as the "forerunner of social realism," painted a wide variety of subjects but is known for her soft-edged portrayals of domestic interiors with women and children. In her landscapes and street scenes, modernist Nell Hinton Choate Jones minimized detail, instead emphasizing abstract elements of form, contour, and movement.

Tennessee native Anna Catherine Wiley's impressionist canvases underscore her studies at the Art Students League with Frank Vincent Dumond and William Merritt Chase. Similarly, the broken brushwork in the landscapes and figurative work of Savannah-born Hattie Saussy point to her studies at the Art Students League and the National Academy of Design, as well as with fellow Georgia painter Emma Cheves Wilkins.

Anthony Thieme's views of Charleston and St. Augustine are characterized by radiant color and strong light effects. Portraitist-genre painter Wayman Adams became noted for his broadly brushed canvases characterized by a sense of immediacy and vitality. Adams and Wilkins were among a number of artists who rendered African American subjects with restraint and dignity. Alexander Brook depicted impoverished people engaged in daily activities. Howard Norton Cook's canvases portray rural blacks, remote mountain people, and laborers.

Charleston and Savannah were important art centers in the mid-20th century. Collectively, major figures of the Charleston Renaissance, Elizabeth

O'Neill Verner, Alice Ravenel Huger Smith, Anna Heyward Taylor, and Alfred Heber Hutty, left a legacy of highly appealing, competently produced views of that city, its architecture, and its people. Their influence is observable in plein air paintings by Mabel May Woodward and in William Lester Sterns's views of Charleston's historic buildings and gardens. Invited to South Carolina by George and Ira Gershwin to assist in set designs, George Biddle made sketches of African Americans for the folk opera *Porgy and Bess* and was befriended by author DuBose Heyward.

Anne Taylor Nash, who studied at the Pennsylvania Academy of the Fine Arts and with Alice Ravenel Huger Smith, produced competent figurative works. Savannah artists include Emma Cheves Wilkins, Hattie Saussy, Myrtle Jones, and the Murphy family: Christopher P. H. Murphy and Lucile Desbouillons Murphy and their children, Margaret A. Murphy and Christopher Aristede Desbouillons Murphy (Chris Jr.). Atlanta artists included Horace Badley, Adelaide Everhart, and Lucy May Stanton. Everhart and Stanton laid the groundwork for the Atlanta Art Association. The Southern States Art League, a cooperative venture established in 1921, provided support and exhibition venues for artists throughout the South.

In the late 1940s and early 1950s, while many artists were turning toward abstract expressionism, a group of artists who favored representational art called themselves the Bayou Painters and formed an art colony in Coden and Bayou la Batre, Ala. The artists' subjects of choice were moss-laden oak trees, meandering bayous, and local sites rendered in vivid colors. The group evolved from the Dixie Art Colony, which was established by John Kelly Fitzpatrick, Sallie B. Carmichael, Warree Carmichael LeBron, and Frank Woodberry Applebee. By 1937 the Dixie Art Colony had found a permanent location on Lake Jordan near Wetumpka, Ala. Guest artists at the colony included Anne Wilson Goldthwaite, who taught at the Art Students League in New York, Lamar Dodd, who later chaired the University of Georgia art department, and Karl Ferdinand Wolfe and Mildred Nungester Wolfe. Furthermore, Carlos Alpha "Shiney" Moon, William Bush, and George Bryant painted views of the area that was destroyed in 2005 by Hurricane Katrina—works that now serve as important documents of the land as it existed before the destruction along 250 contiguous miles of the Gulf Coast.

Another artist associated with the colony, John Augustus Walker, painted brightly colored canvases that reflect his travels to Cuba and Key West, Fla. Walker painted a wide variety of subjects, including portraits, landscapes, historical themes, views of Mardi Gras, and fantasies, as well as murals in public schools throughout Alabama, notably the old City Hall in Mobile (now the Mu-

seum of Mobile), the Smith Bakery on Dauphin Street in Mobile (now lost), the Federal Building Courtroom, and the Historical Panorama of Alabama Agriculture. He also designed Mardi Gras floats, stage sets, and costumes—artistic opportunities available in the Mobile and New Orleans areas. Walker was a founder and original member of the Mobile Art Guild, for which he served as an instructor. Although the art colony was short lived, its members produced a significant body of landscapes that would attract the attention of younger artists.

Portraitist–landscape painter Louise Lyons Heustis was one of Alabama's most prominent artists. She studied in Philadelphia, in Paris at the Académie Julian, and with Tony Robert-Fleury, Jules Bastien-Lepage, Charles Lassar, and William-Adolphe Bouguereau. Heustis continued her training in Switzerland and Italy, at the Art Students League with Kenyon C. Cox and Julian Alden Weir, and with William Merritt Chase at the league and at his Shinnecock, Long Island, art school. She painted prominent personages in New York, Norfolk, New Orleans, Cleveland, Philadelphia, and Mobile; many of these portraits appeared on magazine covers. Additionally, Heustis painted historic sites in Newport and Mobile and in other cities. She exhibited widely, including at the National Academy of Design, the Pennsylvania Academy of the Fine Arts, and the Chicago Art Institute.

Alabama native Charles Eugene Shannon portrayed emotionally charged rural genre scenes of African Americans in a rhythmic, elongated mannerist style; his color palette, however, was restricted and subdued. Although Shannon exhibited in New York at the Jacques Seligmann Gallery in 1938, he returned to his native Montgomery and established an art center called the New South to call attention to southern art. Shannon became known as the person who discovered, documented, and promoted folk artist Bill Traylor, a fellow Alabamian. Margaret Moffett Law rendered unsentimental African American genre scenes. Frank Weston Benson, one of the New York–Boston based Ten American Painters, produced a number of impressionistic views of Alabama.

Two of Mississippi's best-known painters, Karl Ferdinand Wolfe and Mildred Nungester Wolfe, established their studio in Jackson. Both artists worked with ceramics, sculpture, and stained glass. As a student at the Art Institute of Chicago, Karl became friends with artist William R. Hollingsworth Jr., who worked for the Federal Emergency Relief Administration and founded the art department at Millsaps College in 1941. Hollingsworth, whose intuitive drawing skills were highly developed, captured the essence of the gestural figures populating his scenes of urban and rural life. Artist-teacher Marie Atkinson Hull painted portraits and landscapes, including some executed in Florida. Her works

Frank Marsden London, Hi-diddle, the Cat's the Fiddle, 1943, *oil on canvas,*
24⅛" x 28¾" *(The Johnson Collection, Spartanburg, S.C.)*

ranged from realistic to modernist. Impressionist painter Kate Freeman Clark,
a colleague of modernist painter Anne Wilson Goldthwaite from Montgomery,
Ala., has had a continuing influence through a museum-gallery established
through her bequest of artworks to her native Holly Springs. More progressive
in its artistic development, Goldthwaite's approach to her work ranged from
realism to abstraction and expressionism.

Easel painters found sporadic opportunities to paint murals, including
Goldthwaite, Conrad Alfred Albrizio, Walter Inglis Anderson, Julien Binford,
John Biggers, Aaron Douglas, Leonard Theobald Flettrich, Robert Gwathmey,
Hans Mangelsdorf, Julius Garibaldi "Gari" Melchers, Archibald J. Motley Jr.,
William Steene, and Olin Herman Travis. Pastellist-portraitist painter Clara
Weaver Parrish, a native of Alabama, designed not only murals but also mo-
saics and stained glass windows. Conversely, Frank Marsden London began his
career designing stained glass windows and ecclesiastical art and then devel-
oped into a well-recognized modernist painter.

Feeling defensive about his native land, New Orleans artist-photographer

George Joseph Amedé Coulon wrote in an 1888 publication, *350 Miles in a Skiff through the Louisiana Swamps*, that although the South did not have the grandeur of mountainous terrains it had considerable visual beauty to commend it and that it offered much artistic inspiration. From the earliest years, artists sought aesthetic appeal in the large port cities of Baltimore, Charleston, Savannah, and New Orleans. Indeed, the South would continue to draw artists and writers through the 19th and 20th centuries until the present. And, invariably, visiting artists found the land and the people rich subjects for paintings, prints, and photographs.

Despite the geographic variation in the vast area encompassed by the southeastern United States, there is a shared eerie beauty and a sense of mystery—in the swamps of Louisiana and Mississippi, in the Everglades in Florida, in the Okefenokee Swamp in Georgia and Florida, and in the Dismal Swamp in southeastern Virginia and northeastern North Carolina. Louisiana's open marshes are as peaceful as those in the Lowcountry of South Carolina, Georgia, and the Sea Islands. The vast ecosystems of the South's picturesque coastal beaches, marshes, estuaries, and mangrove forests serve as subjects for artists who endeavor to capture the mystery and beauty of these scenic landscapes.

Artists and photographers have found visual subjects in the South's luxuriant forests continually from the earliest discoveries, including major naturalists Mark Catesby, John Bartram, William Bartram, André Michaux, John Abbot, Alexander Wilson, John James Audubon, Hardy Bryan Croom, Alvam Wentworth Chapman, John Muir, John Kunkel Small, Roland Harper, and Frances Harper. Painters, especially, have been drawn to the verdant tropical landscape, notably Winslow Homer, George Inness, Titian Ramsay Peale, Martin Johnson Heade, Hermann Ottomar Herzog, John Singer Sargent, Norman Rockwell, Hal Riley Burris, and Albert Ernest Bean Backus. The latter artist proved to be the leading figure for the Highwaymen, a group of academically untrained African American painters who from the 1950s into the 1980s mass-produced gestural landscapes featuring warm sunsets, palm trees, and expressionistic views of the beaches around the small community of Fort Pierce on Florida's east coast. Harold Newton was the first of these painters, but Alfred Hair, perhaps the most energetic of the group, organized the sale of the works, primarily to tourists who drove along the highway. These rapidly executed landscapes, the sale of which reportedly numbered between 100,000 and 200,000 works, exhibit an astonishingly profound sense of compositional design and understanding of color theory.

The mountainous terrain of the Ozarks and Ouachita mountains in Arkansas and northeast Texas, though considerably smaller in acreage, compares

favorably with the densely forested Appalachians and its succession of valleys and ridgelines running through nine southern states from Maryland to Alabama. Through the years, artists have found inspiration in the serene beauty of the swamps and mountains, especially the mountains in North Carolina. The Tryon Art Colony, established in 1892 in the Appalachian Mountains of western North Carolina, attracts painters, sculptors, illustrators, photographers, artisans, and prominent cultural figures seeking inspiration and invigoration. Some of the better-known artists associated with the scenic mountainous colony include Daingerfield, tonalist-impressionist Lawrence Mazzanovich, figure-scenic painter and sculptor Josephine Sibley Couper, figure and portrait painter–sculptor William Steene, portraitist George B. Shepherd, landscape painters Diana L. Nash and Louis Rowell, figural sculptor Lorado Zadoc Taft, and realist-figural sculptor Harold Perry Erskine.

While some artists focused primarily on the scenic beauty around Tryon, Augustus Vincent Tack's subjects progressed beyond the traditional landscape and portraiture. His work ranges through symbolism, spiritualism, realism, and abstraction. During the interwar years, he produced mystical landscapes and abstract works on the themes of religion and creation. His symbolist works were inspired by Christian theology and mysticism, Oriental art and philosophy, medieval stained glass, and moral allusions in paintings by James Abbott McNeill Whistler. Tack's compositions featuring faceted forms of color with subtle tonal transitions have been compared to the ageless spirituality in poetic works by Albert Pinkham Ryder, as well as Georgia O'Keeffe and abstract expressionist–color field painter Clyfford Still.

In 1933 Black Mountain College, an experimental school based on John Dewey's principles of progressive education and the belief that the study of the fine arts is essential to a liberal arts education, was founded outside of Asheville. Josef Albers, who left Germany after the Nazis closed the Bauhaus, was hired to head the program. The college was managed and operated by faculty members committed to democratic governance, who also shared in all manual chores. Artists associated with the school, who would become leaders in American art, fully represent all the modernist art movements. The list reads like a veritable who's who of American artists: Annelise Fleischmann "Anni" Albers, George Charles Aid, Ilya Bolotowsky, abstract expressionists Elaine Marie Fried de Kooning and Willem de Kooning, William John Edmondson, landscape and genre painter Homer E. Ellertson, action painter–abstract expressionist Franz Josef Kline, Jacob Lawrence, Robert Motherwell, Kenneth Noland, Robert Rauschenberg, social realist painter-photographer Ben Shahn, Will Henry Stevens, Henry Ossawa Tanner, Edwin Parker "Cy" Twombly Jr.,

sculptors Leo Anino, Jose de Creeft, and Ossip Zadkine, and photographer Orcenith Lyle Bongé.

Innovations and relationships formed at Black Mountain had a lasting effect on postwar American art trends, including pop culture. The futurist-inventor Richard Buckminster Fuller, who is credited with creating the geodesic dome, improvised the prototype from wooden slats he found on the grounds of the college. Avant-garde choreographer-dancer Mercier "Merce" Philip Cunningham formed his dance company at Black Mountain, and conceptual artist John Cage staged his first "happening" at the school. Decades after its closing in 1956, the influence of Black Mountain College continues to be alive in the fine arts and in architecture throughout the country.

Landscape painter Thomas Addison Richards was also active in western North Carolina, as were Robert Scott Duncanson and William Charles Anthony Frerichs. Excellently produced crafts were introduced in the art colony with designer-woodcrafter Eleanor Vance, who established Biltmore Estate Industries and Tryon Toymakers and Wood Carvers. Charlotte Yale supervised a weaving operation using fleece from purebred sheep from the Vanderbilt estate. Artists and writers continue to visit these mountainous regions for rejuvenation, contemplation, reflection, and introspection. Not all artists had felicitous visits to the area, however. Alabama native Zelda Sayre Fitzgerald, who was hospitalized for mental health treatment, died in the deadly Highland Hospital fire in 1948.

Other art colonies developed in the South, most of which led to a significant flourishing of the arts, including the decorative arts. After the establishment of Newcomb College in 1886, the cultural environment improved in post-Reconstruction New Orleans and the city became an art center. The Art Nouveau movement would become most apparent in New Orleans through the Newcomb Pottery enterprise, which was founded in 1895 and operated until 1940. Newcomb's art craftsmen, particularly metalworker Rosalie Mildred Roos Wiener, created works featuring art deco motifs through the 1930s. Concurrently, brothers William Woodward and Ellsworth Woodward produced impressionist and postimpressionist paintings and encouraged their students to observe the tenets of these styles, so much so that their artworks are collectively referred to as the Newcomb school.

Cubism would be introduced in Louisiana through the work of artists associated with the Arts and Crafts Club of New Orleans and its School of Art: Josephine Marien Crawford, Paul Ninas, and Will Henry Stevens. Stevens also taught at Newcomb from 1921 to 1948 and traveled annually to North Carolina. A prolific artist, he produced both representational and abstract compositions and exhibited them side by side. His paintings often combined fragmented

figural forms with abstract designs in vertical or horizontal divisions across the canvas. Stevens, more than any other southern artist, consciously observed the tenet that any good work of art should be viewed from all points of view. Indeed, his abstract compositions can be turned vertically, horizontally, or upside down, with each viewpoint presenting a perfectly balanced composition.

Through the years, another artist comes to mind in consideration of this precept, although the geometric divisions of his canvases differ dramatically from Stevens's works. John Franklin Clemmer, a painter and sculptor who maintains studios in New Orleans and Wisconsin, produces carefully balanced lyrical works in which the observer senses subtle transitions in time and dimension. Clemmer, who served as director of the Arts and Crafts Club, later chaired the Newcomb art department. During the years of its existence from 1922 to 1951, the Arts and Crafts Club (later the Arts and Crafts Gallery) exhibited the work of numerous modernist artists, and Clemmer was a staunch supporter of avant-garde art movements. Early on, he recognized the ascendancy of decorative arts as legitimate art forms. During his tenure at Newcomb, Clemmer conceived of and promoted the traveling exhibition of Newcomb Pottery sponsored by the Smithsonian Institution in 1984.

Regionalism, or scene painting, is best known through the work of Thomas Hart Benton, who traveled throughout the South, including New Orleans, painting and sketching its land and its people. Perhaps the southerner most influenced by Benton, John McCrady produced paintings and prints portraying life in the Mississippi hill country. McCrady won the Arts and Crafts Club's scholarship to the Art Students League in New York for his markedly sensitive portrayal of a young man, but his studies there with Benton and Kenneth Hayes Miller brought on a pronounced departure from his early work. In the 1930s there developed in America a renewed interest in the medieval technique of tempera painting. Benton and Miller were among the proponents, and they influenced their students—including McCrady, Jackson Pollock, and Paul Cadmus. McCrady developed a "multistage" technique by which he layered oil paint over a tempera underpainting. His later portrayals of African Americans, rendered in this manner, received criticism for being caricaturish, an accusation that caused him to stop painting for a period of time, after which his painting style changed again. Although based in Chicago, New Orleans–born genre painter Archibald J. Motley Jr. advocated that African Americans devote themselves to portraying black subjects in scenes of contemporary life in order to promote a better understanding between white and black artists.

Social realist Robert Gwathmey, a native of Richmond, Va., was one of a number of white artists, including Georgia painter Andrée Ruellen, to portray

African Americans in a dignified manner. Maryland artist Ruth Starr Rose captures a sense of intimacy and poignancy in her paintings. Gwathmey's compositions depicting southern rural life were interpreted with simplified geometric shapes. Realist painters James William "Bo" Bartlett and Shirley Rabé Masinter celebrate the commonplace in canvases with remarkable restraint and eloquence. Likewise, Henry Casselli and Stephen Scott Young produce watercolor portraits and genre scenes that bespeak an empathy with their sitters. Augusta Denk Oelschig's expressive representational works were informed by her studies of Mexican mural paintings focusing on social themes.

Arshile Gorky, born Vosdanig Manoog Adoian, changed his name to honor Russian author Maxim Gorky. The artist's work progressed from cubism and surrealism to abstraction; his subjects had their source in the personal traumas and tragedies he had endured in his native Armenia. Working at times in Virginia on his wife's family farm, Gorky is considered a seminal figure in the movement toward abstraction in post–World War II American art. Although associated with the abstract expressionists, Hale Aspacio Woodruff, who worked in Georgia and New York, created abstract paintings to express his heritage, particularly scenes portraying poverty among southern African Americans. Woodruff's compositions compare favorably with those of Alma Thomas, a native of Georgia, who became a nationally respected artist despite the barriers of race, gender, and age that hindered her career.

Photography in the 20th-century South concentrates heavily on the people and the land. William Eggleston, in particular, focuses on seemingly insignificant elemental facets of life, like a pair of shoes under a bed. Birney Imes became known for his photographs of juke joints in the Mississippi Delta. Margaret Bourke-White, Lewis Hine, Roy Stryker, Walker Evans, and Eudora Welty turned their lens on the common man with objectivity and restraint, often making a profound statement about the condition of the working class. Frances Benjamin Johnston documented architecture across the South, as did Clarence John Laughlin, who later turned to surrealistic works.

The 1913 Armory Show, which introduced Marcel Duchamp and modernism to American audiences, served as a catalyst for American artists who sought the freedom to express themselves individually. Momentum gathered in the move away from impressionism and postimpressionism and emerged in the 1940s and 1950s with abstract expressionism, a resounding response to European modernist art movements. Influenced by existential ideas, American artists applied paint rapidly as a means of expressing emotion and spontaneity in all types of nonfigural and nongeometric abstraction. The first American art movement to achieve international status, abstract expressionism received its

name in 1946 from an American art critic in reference to the work of three artists associated with the South: Arshile Gorky, Jackson Pollock, and Willem de Kooning. Hans Hofmann, as painter and teacher, was the chief proponent of abstract expressionism, which falls into two categories: gestural paintings and color fields, the latter of which explored the effects of pure color applied to a canvas. Gestural, or action painting, is based on the physical action involved in painting. Pollock, the artist most associated with energetic action painting, was noted for his seemingly random method of applying paint to his canvases with vigorous swings of his arm.

Color field painter Mark Rothko, formerly Marcus Rothkowitz, was a co-founder of The Ten in New York, a group of artists who espoused expressionist or "emotive" styles, in contrast to abstract artists, whose work was removed from emotional content. As Rothko's paintings became larger and less figurative, the colors became brighter and deeper and eventually became rectangles of color. His 14 massive, dark, moody paintings in the Rothko Chapel in Houston are completely devoid of imagery, in keeping with the concept of the chapel as a nonsectarian space for worship. Also known for color field paintings, minimalist painter-sculptor Ellsworth Kelly was influenced by the work of Audubon and incorporated avian themes into his hard-edged structures.

North Carolinian Hobson Lafayette Pittman experimented with impressionism, realism, and abstraction in works that appear simplified but which have strong underlying compositional arrangements. Texas modernist Olin Herman Travis painted a full range of subjects in a style that developed from impressionism to realism. A group of avant-garde printmakers and artists known as the Fort Worth Circle, with William Kelly Fearing as one of its core members, was a motivating force in introducing modernist concepts into Texas art. Fearing, who produced surreal landscapes with religious themes, has alternately been termed "magical realist," "mystical naturalist," and "romantic surrealist." The work of Texan painter Everett Franklin Spruce features near-primitive stylized forms. The near-surrealistic drape paintings of Mississippi-born color field painter Sam Gilliam merge painting with sculpture, while Donald Clarence Judd departed from expressionistic paintings to minimalist geometric sculptures and large architectural installations like those in New York and Marfa, Tex.

West Virginian Blanche "Nettie" Lazzell first studied with cubist painters Ferdinand Leger and Andre Lhote—and later with Hans Hofmann, after which her works differed in the relationship of form, interplay of space, rhythmic movement, color intensity, and value. Adele Lemm, who also studied with Hofmann, depicted representational subjects with contemporary sensitivities toward composition, handling of paint, and a sense of whimsy. Robert

Gordy executed a large number of compositions based on complex, repetitive rhythmic design with stylized human figures.

Conceptual art, which is based upon a near-total negation of aesthetic principles, promoted artistic representation in which a specific concept or idea takes shape in an abstract or nonconforming manner. The mere documentation that an idea was conceived becomes the artwork itself. During the latter half of the 20th century, conceptual art, minimalism, installations, performance art, happenings, disposable art, and body art were promoted as serious art forms throughout the country. As the "Shock of the New" faded, the public and artists lost interest in these ephemeral art movements in favor of an art that had greater substance and endurance.

Art critic Clement Greenberg eschewed figural art and all forms of art with narrative or other content. The most influential critic of the 1950s and 1960s, Greenberg advocated focus on the pure elements of art: color, line, shape, space, form, value, and texture. He introduced the concept of "medium specificity," whereby the medium itself dictated the development of an artwork. Associated with Black Mountain College in the early 1950s, Greenberg promoted the abstract expressionists, particularly Pollock, Gorky, Willem de Kooning, Robert Motherwell, Barnett Newman, and Clyfford Still. Greenberg's rigid aesthetics and opposition to postmodernist theories and emerging artistic trends, as well as the discovery of his unethical behavior in writing art criticism that created a market for artwork he was selling, lessened his influence among artists, particularly those who identified closely with their southern roots. Often those artists moved away from nonrepresentational art altogether.

Postmodernism can be defined as a cyclical period of reexamination in response to the elemental question "What is art?" as formulated by Russian author-philosopher Leo Tolstoy in his 1897 essay "What Is Art?" and then further questioned by succeeding generations of artists who preferred originality, diversity, and distinctness, gradually manifesting their nonacceptance of artificial restrictions placed upon artists. These artists felt the overwhelming need to speak with "one's own" voice rather than to merely follow the dictates of arbitrary national and international trends. Recurring questions posed by Tolstoy became critical, especially in the South, in revisiting and reassembling the question of what is art and why it is necessary. Tolstoy argued that art was one of the essential conditions of human life and that it served as a means of intercourse between artist and mankind.

Southern artists, in particular, explored various forms of realism, photorealism, superrealism, and hyperrealism, all of which focused on the human form and nature delineated in photographic detail. This renewed interest in

a recognizable subject reverberated through the South. Photorealism by artists like Louisiana painters Auzeklis Ozols, Rolland Harve Golden, and Adrian Deckbar has been superseded by Mississippi–North Carolina artist Glennray Tutor, who terms his work "metarealism," a metaphor for the subjects of his paintings. Tutor's son, Zachary, who matured in his father's studio with a brief period of study at the University of Mississippi, has recently emerged as an artist with a distinctive voice in skillfully rendered naturalistic subjects.

Late 20th-century sensibilities regard decorative arts equally with the fine arts, including fields formerly relegated to the term "minor arts," particularly pottery, basket making, needlework, metalwork, and woodwork. Throughout the South, artisans have created a legacy that continues for decades, often because a number of family members are involved in the endeavor. The commonality among most of the decorative arts is their functionality. Gee's Bend quilts are increasingly more and more known by the general public. The quilts take the name from a rural community southwest of Selma, Ala., in the bend of the Alabama River, which was formerly the site of cotton plantations owned by Joseph Gee and later by his relative Mark H. Pettway, who marched a caravan of about 100 slaves from North Carolina to Gee's Bend. After the Civil War, the freed slaves took the name of Pettway, and many of the quilters, now in the sixth generation following emancipation, still bear this surname. The women of Gee's Bend have passed their skills and aesthetic down through succeeding generations to the present. Many of the quilts feature traditional patterns, while others have bright colors and abstract designs reminiscent of the crisply rendered geometric canvases of Dutch neoplastic painter Piet Mondrian.

Gee's Bend quilts carry on the custom of a community, but the Baltimore album quilt manifests an entirely different approach. The Maryland women who make this type of inscribed album quilt create a diary of daily life and special events in textile form. The best-known textile artist of the 20th century, however, is Anni Albers. Of German heritage, Albers immigrated to Black Mountain College in North Carolina with her husband, Josef, and worked there from 1933 to 1949, publishing and lecturing about the art of weaving. Ethel Wright Mohamed of Belzoni, Miss., was nationally recognized in the 1970s and 1980s for the needlework stories of her family created in more than 125 pictures of embroidery on fabric.

Inspired by the arts and crafts tradition begun in England with emphasis on excellently produced artifacts, Newcomb Pottery would emulate these philosophies from 1895 to 1940. Newcomb Pottery, with original designs featuring Louisiana's indigenous flora and fauna, earned awards in national and international competitions from its earliest years. Joseph Fortuné Meyer threw

the majority of the pots, and women decorated and glazed the pieces. Also at Newcomb, the eccentric George Edgar Ohr, the "Mad Potter of Biloxi," whose paper-thin pottery pieces appeared to collapse upon themselves, explored the physical properties of his clay to produce what has been called the most expressive American pottery through the mid-20th century. Ohr defied the very function of his pieces by rendering them nonutilitarian—for example, making a cabin-shaped inkwell that had no aperture for filling the well with ink. Although Ohr's tenure at Newcomb was terminated because his erratic behavior was deemed unsuitable for the emerging pottery enterprise, his ability to manipulate clay has never been surpassed.

McCarty Pottery, founded in 1954 by Lee McCarty and Erma "Pup" Rone McCarty in Merigold, Miss., shares the theme of nature with Newcomb Pottery, with many pieces featuring animals, particularly rabbits. The success of all of these potteries depends on their high quality in the forming, firing, and glazing of the individual pieces. Similarly, Shearwater Pottery was established in Ocean Springs near the Mississippi Gulf Coast by Peter Anderson, with his brothers Walter Inglis Anderson and James McConnell Anderson as pottery designers. Shearwater's reputation comes from quiet forms and glazes.

A North Carolina pottery of note, Jugtown Pottery in Seagrove, was founded in 1917 by portraitist–impressionist painter Jacques Busbee and photographer-illustrator Juliana Royster Busbee, two artists from Raleigh, N.C. Europeans first brought their pottery traditions to the Piedmont area in the late 1700s, and since then the community has expanded to nearly 100 operating potteries in Seagrove and the surrounding rural area, which the state has designated as "the official North Carolina Pottery Highway 705." The various workshops produce utilitarian ware as well as artistic pieces. A relative newcomer, Mark of the Potter, was founded in 1969 in Clarksdale, now the oldest craft shop in the same location in the state of Georgia. Reminiscent of the Newcomb Pottery enterprise, approximately 30 artisans associated with Mark of the Potter produce ceramic jewelry and handmade crafts in metal and hand-blown glass.

A 1955 graduate of Newcomb College, Mignon Faget studied in Paris at l'Atelier de la Grande Chaumière and in New York at Parsons School of Design. Faget, who also studied printmaking under Sue Ferguson Gussow, created hand-printed clothing with an undercurrent of architectural structure; these she later developed into sculptural nail-studded textiles. She began designing jewelry in 1970, a return to her undergraduate specialty in metalwork at Newcomb. Although unaware of the Newcomb Pottery enterprise, which ended in 1940, Faget was inspired by indigenous architecture and nature. She examined the European and American past in her *Romanesque Return* collection. These

sculptural works were inspired by the medieval-styled architectural detail of dragonlike beasts, engaged columns, medallions, and voussoirs (wedge-shaped stones) on the entry arch of the library designed by architect Henry Hobson Richardson, now the Ogden Museum of Southern Art, New Orleans. The library was based on a plan by Richardson, whose distinctive architectural style became known as Richardsonian Romanesque. Faget has followed her own creative instincts for over four decades; she typifies the artist who explores the natural world enveloping her with an enquiring mind and creative soul. Her perseverance in a male-dominated field outside the influential environment of New York opened the field for other designers of art jewelry.

African American artists have made considerable advances in American art, the most prominent being Richmond "Ray" Barthé, Romare Bearden, and Elizabeth Catlett. Their experiences and the obstacles they overcame paved the way for other artists of color. A Mississippi native, Barthé was a pioneer in focusing on African American and African subjects. His career began when a Catholic priest took an interest in his work, sought a school where young Barthé would be accepted, and paid for his art training at the Art Institute of Chicago. An exhibition at the Art Institute led to a commission to sculpt portrait busts of African American painter Henry Ossawa Tanner and Haitian revolutionary leader Toussaint L'Ouverture. Following the successful reception of these works, opportunities began to open for Barthé and other African American artists, many of whom worked in several different media. These artists are distinguished by the manner of individual interpretation of their subjects, whether figural or nonrepresentational.

Many of these artists studied first at historically black universities, after which they continued their studies at other schools. Sculptor-painter-printmaker Elizabeth Catlett, who was born in Washington, D.C., also surmounted innumerable roadblocks, not all of which were in the South. She persevered, however, to become one of America's leading artists during the late 20th century. Catlett studied design, printmaking, and drawing at Howard University, a historically black university in her native city, where she majored in painting because sculpture was unavailable. The granddaughter of slaves, Catlett became the first African American student to receive an M.F.A. degree in sculpture from the University of Iowa, in 1940, and the first female professor of sculpture at the National University of Mexico School of Fine Art, in 1958. For a time she taught at elementary schools in Durham, N.C. She subsequently chaired the art department at Dillard University in New Orleans, from 1941 to 1942, and championed the cause for African Americans' admittance to the city's premier art museum, an institution that was closed to them.

In 1946, Catlett received a Rosenwald Fund Fellowship, which allowed her to travel to Mexico, where she studied woodcarving and eventually took up permanent residence. She joined a group of printmakers at the Taller de Gráfica Popular (People's Graphic Arts Workshop), organized in 1937 and dedicated to using art as a catalyst to promote social change. Catlett and other artists created a series of linocuts portraying black heroes and other works that manifest bold social comments. Once summoned to testify before a McCarthy era hearing and refused entry to the United States as an "undesirable alien," Catlett was later assured of her U.S. citizenship by the Clinton administration and was recently named an honorary citizen of New Orleans. Catlett's 1975 statue of trumpeter Louis Armstrong stands in Louis Armstrong Park in New Orleans, and her 10-foot sculpture of gospel singer Mahalia Jackson, finished in 2010, is installed nearby in the Tremé neighborhood. That same year the Chrysler Museum, in Norfolk, Va., recognized her accomplishments with a solo exhibition.

African American sculptor Jack Jordan taught at Southern University in New Orleans, another historically black institution, where he was head of the art department from 1961 to 1990. Also a painter and graphic artist, he gained further recognition when he served on the State of Louisiana Commission of Creative and Performing Arts. Jordan received a B.A. in 1948 from Langston University in Langston, Okla., an M.A. in 1949 from Iowa State University, and an M.F.A. in 1953 from the University of Iowa. Jordan's works address religious, mythological, and social realist subjects. He completed murals for several Baptist churches in the South.

Internationally recognized artist Frank Hayden created numerous sculptures with African American or religious themes, many of which are installed in Baton Rouge churches and on the campuses of Louisiana State University and Southern University. A native of Memphis, Hayden earned a B.A. from Xavier University of Louisiana, a historically black Catholic university. A Fulbright scholarship recipient, Hayden then earned an M.F.A. from Notre Dame University, where he studied with Croatian sculptor Ivan Mestrovic. Hayden, who taught at Southern from 1961 until his death in 1988, was named the university's first Distinguished Professor in 1986. One of Hayden's most prestigious commissions was a bronze sculpture of St. Martin de Porres, which he presented to Pope John Paul II on behalf of African American Roman Catholics to commemorate the pontiff's 1987 visit to New Orleans and the 25th anniversary of the saint's canonization.

A student of Hayden, Baton Rouge native Emerson Bell became recognized for African-influenced wood sculpture, bronzes, and paintings. Through his studies with Hayden and sculptor John Payne, Emerson mastered the media

of plaster, copper, metals, stone, and clay. Also a painter and printmaker, Bell cited the European artists Modigliani and Rouault as inspiration. He was the first artist in residence at Baton Rouge Parish schools, a program supported by the National Endowment for the Arts.

John Tarrell Scott, a printmaker, sculptor, and painter who taught at Xavier from 1965 to 2005, incorporated African, Caribbean, and Louisiana traditions in his work, including his *Diddlie Bow* and *Circle Dance* series. The *Diddlie Bow* sculptures refer to a type of wall-mounted one-string guitar. The *Circle Dance* series was inspired by dances performed by slaves in Congo Square (now Louis Armstrong Park) outside the Vieux Carré in New Orleans. These dances also inspired 19th-century Louisiana composer-pianist Louis Moreau Gottschalk, who combined classical, folk, and Caribbean music in his compositions. Gottschalk's first masterwork for piano, *Bamboula*, has recently been revived and restored to the canon of classical American music. E. W. Kemble's illustration of the dance and George Washington Cable's articles "The Dance in Place Congo" and "Creole Slave Songs," published in *Century* magazine in 1886, called further attention to this practice. Interest in the dance was revived by late 20th-century scholars, which attracted Scott's attention and influenced his work. Scott's life's work was recognized nationally when he received the 1992 "genius grant" from the John D. and Catherine T. MacArthur Foundation. Scott's large sculptures are prominently installed. His 1990 *Ocean Wave* stands in Woldenberg Park in New Orleans, and his 1994 *Spiritgates* frames the entrance to a courtyard at the New Orleans Museum of Art.

Tennessean Joseph Delaney, another African American artist, gained considerable recognition, painting portraits of Eleanor Roosevelt, Tallulah Bankhead, Arlene Francis, and Eartha Kitt. He studied at the Art Students League with Thomas Hart Benton, Kenneth Hayes Miller, and George Bridgman. Because of the past accomplishments of these artists, who struggled to examine the identity and civic and legal standing of their race, today's artists of color endeavor to look to the future and to convey a new aesthetic and awareness of life's issues as related to family, class, religion, politics, health, and death. Presently, Kara Walker uses black paper silhouettes to confront issues of race and gender.

Women sculptors have also had an arduous uphill battle, but Louisiana has produced five women sculptors in the history of the state to achieve international fame: Elizabeth Catlett, Angela Gregory, Ida Rittenberg Kohlmeyer, Clyde Dixon Connell, and Lin Emery (Braselman). Gregory's success began at Newcomb College, after which she worked in the Paris atelier of Antoine Bourdelle. She taught at the Arts and Crafts Club, Newcomb, and Dominican Col-

lege. Gregory's commissions include the Louisiana State Capitol and the Bienville Monument on Decatur Street in the Vieux Carré.

Louisiana native Clyde Dixon Connell created large-scale sculptures, exhibiting in Louisiana and Texas in the 1960s and 1970s. By the early 1980s she had become known for using primitive imagery to articulate surrealist-derived abstract expressionist principles. Her solo shows include the Clocktower Gallery in New York in 1981, the 1987 National Sculpture Conference, and the Hirshhorn Museum in Washington, D.C., in 1988. Connell's numerous national awards include a 1982 Adolph Gottlieb Foundation award, the 1985 Distinguished Woman Artist award from the Women's Caucus for Art of the College Art Association, and a 1986 Award in the Visual Arts. By the 1970s, Connell had developed a technique of applying gray papier-mâché to wooden armatures to produce the effect of ancient monoliths. A number of Louisiana's women artists introduced new media into the art world. At the zenith of her career, Caroline Wogan Durieux developed the printmaking process of electron printing, which involved radioactive ink, as well as a method of adding color to cliché verre. In 1979 painter-printmaker Dorothy Furlong-Gardner pioneered the encaustic monotype, which eliminated toxic inks and solvents integral to making prints on a press.

Lynda Benglis, a native of Lake Charles, La., earned a B.F.A. from Tulane University in 1964. She studied briefly at the Brooklyn Museum Art School, after which she worked at the Bykert Gallery. In the late 1960s Benglis became known for controlled, poured-latex "spills" and in the late 1970s for decorative gilded knots. An exhibitor in the Whitney Museum's *Anti-Illusion: Procedures/Materials* show, she was included in their 1990 survey, *The New Sculpture, 1965–75: Between Geometry and Gesture*. In 1991 Benglis held her first solo show at the Paula Cooper Gallery in New York.

Lin Emery (Braselman) studied at the Sculpture Center in New York (1951–52) and with cubist sculptor Ossip Zadkine in Paris (1949–50) while she worked for *France Dimanche*. Emery, who has exhibited her large kinetic sculptures internationally, has received numerous awards, including the New Orleans Mayor's Award for Achievement in the Arts (1980) and the Louisiana Women of Achievement Award (1984). Emery creates aqua mobiles, magnet mobiles, wind-powered sculptures, and musical sculptures. Her 1988 wind-driven sculpture, *Wave*, is installed in the fountain at the entrance to the New Orleans Museum of Art. In the late 1950s Emery was one of the founders of the Orleans Gallery, a cooperative in the French Quarter established for the exhibition and promotion of contemporary art.

Ida Rittenberg Kohlmeyer, who began her artistic career in her late 30s,

studied at Newcomb with Pat Trivigno and later with Hans Hofmann in Provincetown. Kohlmeyer studied in the French Quarter at the John McCrady School of Art in 1947. Her first paintings were exhibited at the Delgado Museum of Art (now the New Orleans Museum of Art) in the 54th Annual Spring Exhibition. After Kohlmeyer met Joan Miró, she began exploring abstract expressionism, creating sculptural works in wood and Plexiglas and, later, painted figurative imagery and nonobjective subjects.

Perhaps the most prominent and extensive evidence of the accomplishment of artists and architects working in the South is visible in three memorial monuments in Washington, D.C., at the National Mall, which evokes the essence of American history: the Washington Monument, the Lincoln Memorial, and the Vietnam Veterans Memorial. The Washington Monument, designed by South Carolina architect Robert Mills, was built as a tribute to Washington's military leadership from 1775 to 1783 during the American Revolution. The Lincoln Memorial was the last project of Beaux-Arts architect Henry Bacon, the monumental sculpture of Abraham Lincoln was created by sculptor Daniel Chester French, and the interior murals were painted by Jules Vallée Guérin.

The Vietnam Veterans Memorial (*The Wall*) in Washington, D.C., is one of the nation's most important sculptural monuments. Considering this country's origin and early development based upon the arrival of immigrants, it is inspiring to note that the monument was the conception of Maya Ying Lin, a first-generation American. Lin was born in Athens, Ohio, to parents who fled China just before the 1949 Communist takeover. She designed the Vietnam monument when she was a 21-year-old student at Yale University. Since the Civil War, no other war has split this country—North, South, East, and West—like the Vietnam War has. Despite heated objections to Lin's design, *The Wall* was completed in 1982, and it has been increasingly more appreciated by the general public. Lin subsequently received major commissions in the South, specifically the Langston Hughes Library for the Children's Defense Fund in Clinton, Tenn., and the Civil Rights Memorial in Montgomery, Ala. These two sculptures relate to the continuing struggle for racial equality in this country. All three of these important works were created within the early years of Lin's career, but it is for her first design that she has earned the highest recognition so far in her career.

The Wall, a mirrorlike, V-shaped wall of black granite inscribed with the names of more than 58,000 American servicemen and women who lost their lives in that conflict, merges sculpture with architecture, an occurrence that renowned architect Frank Owen Gehry later described as being inevitable. A native of Atlanta, sculptor Frederic Hart created the slightly larger than life-

size sculpture, *Three Servicemen* (also known as *Three Fighting Men* or *Three Infantrymen*), that completes the monument within its parklike setting. Its installation was a compromise with those contending that the wall was not heroic. *The Wall*, at its extremes, points to the Washington Monument along one length and the Lincoln Memorial along the other length. These two national memorials underscore the country's beginnings during George Washington's presidency and its subsequent division during Abraham Lincoln's presidency. Further considerations emerge when considering the national and global aspects of the physical aspects of the sculpture. The granite, which comes from Bangalore, India, was cut and fabricated at Barre, Vt. The names of the servicemen and women were grit-blasted in Memphis. In its entirety, the Vietnam *Wall* has led to the question of who we are as individuals and as a nation. Once derisively nicknamed "The Wedge," the monument has served to diminish the division that existed during the war and afterward.

Like their American counterparts, contemporary southern artists internalize and analyze these questions and explore these issues in their artworks. Their receptiveness and responsiveness to questions of the nature of art and societal themes has led them to explore these challenging issues, with art reflecting their southern experience.

JUDITH H. BONNER
The Historic New Orleans Collection

ESTILL CURTIS PENNINGTON
Paris, Kentucky

William Arnett, Paul Arnett, Joanne Cubbs, Eugene W. Metcalf, *Gee's Bend: The Architecture of the Quilt* (2006); Brent K. Ashabranner, *On the Mall in Washington, D.C.: A Visit to America's Front Yard* (2002); William S. Ayres, ed., *Picturing History: American Painting, 1770–1930* (1993); John Beardsley, *Gee's Bend: The Women and Their Quilts* (2002); Bertram Wyatt-Brown, *Southern Honor, Ethics, and Behavior in the Old South* (1982); Patti Carr Black, *Art in Mississippi, 1720–1980* (1998), ed., *American Masters of the Mississippi Gulf Coast: George Ohr, Dusti Bongé, Walter Anderson, Richmond Barthé* (2009); Lynne Blackman, ed., *Spot: Southern Works on Paper* (2008); Richard Brillant, *Portraiture* (1991); Mrs. Thomas Nelson Carter Bruns, compiler, *Louisiana Portraits* (1975); Theresa Dickson Cederholm, *Afro-American Artists: A Bibliographical Directory* (1973); Bruce W. Chambers, *Art and Artists of the South: The Robert P. Coggins Collection* (1984); J. Winston Coleman, *Mrs. Stowe, Kentucky, and Uncle Tom's Cabin* (1946); E. Merton Coulter, *The Civil War and Readjustment in Kentucky* (1926); Randolph Dalehantry, *Art in the American South: Works from the Ogden Collection* (1996); David C.

Driskell, *Two Centuries of Black American Art* (1976); William Dunlap, *History of the Rise and Progress of the Arts of Design in the United States* (1834, 1969); Clement Eaton, *The Mind of the Old South* (1964), *The Waning of the Old South Civilization, 1860–1880s* (1968); Catherine M. Enns, *The Journey of the Highwaymen* (2009); Mantle Fielding, *Dictionary of American Painters, Sculptors, and Engravers* (1988); William Barrow Floyd, *Jouett Bush Frazer: Early Kentucky Artists* (1968); Ula Milner Gregory, in *Culture in the South*, ed. W. T. Couch (1935); George Groce and David Wallace, *The New York Historical Society's Dictionary of Artists in America, 1564–1860* (1957); Allan M. Heller, *Monuments and Memorials of Washington, D.C.* (2006); Robert M. Hicklin Jr., *Calm in the Shadow of the Palmetto and Magnolia: Southern Art from the Southern Renaissance Gallery* (2003); Jesse J. Holland, *Black Men Built the Capitol: Discovering African-American History in and around Washington, D.C.* (2007); Harold Holzer and Mark E. Neely Jr., *Mine Eyes Have Seen the Glory: The Civil War in Art* (1993); Lisa Howorth, ed., *The South: A Treasury of Art and Literature* (1993); F. Jack Hurley, Nancy Hurley, and Gary Witt, eds., *Southern Eye, Southern Mind* (1981); Vincent Katz and Martin Brody, *Black Mountain College: Experiment in Art* (2003); James C. Kelly, *Tennessee Historical Quarterly* (Winter 1987); James C. Kelly and Estill Curtis Pennington, *The South on Paper: Line, Color, and Light* (1985); Donald B. Kuspit, *Art in America* (July–August 1976), *Art Voices South* (January 1979), Donald B. Kuspit et al., *Painting in the South, 1564–1980* (1983); Oliver Larkin, *Art and Life in America* (1960); Mrs. Orville Lay, *Alabama Portraits prior to 1870* (1969); David Madden, *Southern Quarterly* (Winter 1984); John A. Mahé II and Rosanne McCaffrey, eds., *Encyclopaedia of New Orleans Artists, 1718–1918* (1987); Guy C. McElroy, *Facing History: The Black Image in American Art, 1710–1940* (1988); Estill Curtis Pennington, *Downriver: Currents of Style in Louisiana Painting, 1800–1850* (1989), *Kentucky: The Master Painters from the Frontier Era to the Great Depression* (2008), *Lessons in Likeness: The Portrait Painter in Kentucky and the Ohio River Valley, 1800–1920* (2010), *Look Away: Reality and Sentiment in Southern Art* (1989), *Mississippi Portraiture* (1987), *Romantic Spirits: Nineteenth-Century Paintings from the Johnson Collection* (2011), *A Southern Collection* (1992), *Southern Quarterly* (Autumn 1985); Jessie Poesch, in *The Cultural Legacy of the Gulf Coast*, ed. Lucius F. Ellsworth and Linda K. Ellsworth (1976); Eleanor Swenson Quandt et al., *American Painters of the South* (1960); Michael Quick, *American Portraiture in the Grand Manner, 1720–1920* (1981); Martha Severens, *Greenville County Museum of Art: The Southern Collection: A Publication of the Morris Museum of Art* (1995); Robin Simon, *The Portrait in Britain and America* (1987); Joshua Taylor, *America as Art* (1976); Henry T. Tuckerman, *Book of the Artists: American Artist Life* (1867); *Southern Quarterly* (Fall–Winter 1985); John Michael Vlach, *The Painter's Prospect: Privilege and Slavery in Plantation Paintings* (2002), *Plain Painters* (1988); Edna Talbott Whitley, *Kentucky Ante-Bellum Portraiture* (1955).

Architects of Colonial Williamsburg

From the beginning of its restoration in the late 1920s, Colonial Williamsburg has been conceived as a place where Americans learn about their history. As early as 1932, its benefactor, John D. Rockefeller Jr., preferred the motto "That the future may learn from the past" to more esoteric statements of purpose. Since then, few fourth-graders or museum administrators have regarded Williamsburg as merely a preservation project. For more than 50 years, the town has maintained a powerful grip on the national consciousness. Accordingly, industrialist Lee Iacocca stated that the purpose of the Statue of Liberty and Ellis Island was to create "an ethnic Williamsburg." Similarly, modern art curator Henry Geldzahler made the somewhat eccentric assessment of artist Andrew Wyeth as "the Williamsburg of American painting—charming, especially when seen from a helicopter." Such references, as well as countless American buildings carried out in a "Williamsburg" style, reveal that the restored town is widely seen as an expression of American rather than regional culture. Some of the reasons for this lie in its Depression-era origins.

Just how the re-created community of Williamsburg achieved its present evocative condition is worth considering. The essential roles of Rockefeller and the visionary rector of Bruton Parish Church, William Archer Rutherfoord Goodwin, are well known, but those of the people who most directly created the place are much less so. Chief financial decisions were made by Rockefeller himself, advised by his corporate lieutenants and influenced by Goodwin and restoration architects. Certainly, Rockefeller's perception of history and politics affected the emerging museum, but there is little evidence that this perception was not shared by all the principals.

In the beginning, design decisions were made on a variety of levels by three groups: partners in the Boston firm of Perry, Shaw, and Hepburn, their representatives in residence at Williamsburg, and an advisory committee. Largely because of a chance meeting between Goodwin and architect William Graves Perry in 1926, the Perry, Shaw, and Hepburn firm was hired in 1927 to prepare proposals for restoration of principal parts of the town. The following year the identity of the benefactor was revealed, and Perry, Shaw, and Hepburn began plans for a number of buildings.

The firm, established in 1922, had primarily produced relatively modest New England buildings in competent, restrained renditions of historical modes. In 1927, for example, it was involved with a Charles Bulfinch–inspired classroom building for Radcliffe College, an Elizabethan or perhaps Jacobean academic building in Brookline, Mass., and a Norman-style Episcopal church in the

Old courthouse, erected in 1770, Williamsburg, Va. (Colonial Williamsburg, Inc., Virginia File, Library of Congress [LC-USW-33-26180-ZC], Washington, D.C.)

south end of Boston. At that time, the firm was small (about five draftsmen in addition to the three principals), and the partners were intimately involved in design. As in other architectural offices, varied personalities and talents resulted in the partners pursuing different parts of the firm's work. Employees remember Perry as a successful promoter, Shaw as a rational space planner, and Andrew H. Hepburn as the talented designer. Nonetheless, surviving drawings show that all three men had some drafting talent, and Perry's story of staying up until 4:00 A.M. in a New York hotel room doing bird's-eye presentation drawings for Goodwin and the still-anonymous Rockefeller reinforces the impression that he could turn out reasonably convincing images when the situation demanded. Daily management of various projects was carried out by job captains drawn from the drafting room.

With the advent of the Williamsburg restoration, the firm expanded significantly, and much administration and design work shifted to Virginia. In 1928, the firm hired Walter Mayo Macomber as "resident architect" and promptly shipped him off to Williamsburg. Largely self-educated through a series of jobs in New England architectural offices and a nearly obsessive recording of traditional buildings, Macomber brought to the project a concern for detail

in craftsmanship that long outlived his tenure. For Macomber, the essence of colonial buildings lay in the subtleties of their moldings rather than in their planning, and he encouraged a quickly assembled group of draftsmen to look for design inspiration in the countryside around Williamsburg.

The draftsmen were primarily young, imaginative, hard-drinking men with different backgrounds. Best known today (because of his later publications) is Thomas Tileston Waterman, who, like Macomber, had a nonacademic education. Waterman had worked for Boston ecclesiastical architect Ralph Adams Cram and with William Sumner Appleton, founder of the Society for the Preservation of New England Antiquities. He was on the island of Majorca preparing measured drawings of Palma Cathedral for Cram in 1928 when the call came from Perry, Shaw, and Hepburn. David J. Hayes, a young draftsman also without memories of college architectural classes, was already working for the partners in Boston, and John A. Barrows came from a Norfolk firm. They were joined by Samuel MacMurtrie, who was finishing architecture school at MIT, and John Henderson, from Georgia Tech. The quality of draftsmanship, as well as the spice of life in Williamsburg, was enhanced by George Campbell, who had recently graduated from a Dublin technical school and had left Ireland because of his antirepublican sentiments. Campbell had a grasp of 18th-century details learned in the streets of Dublin and, when found staying in Boston with William Perry's chauffeur, was sent south. Late in 1928 the group was joined by draftsman Singleton Peabody Moorehead, a young Harvard graduate who had experience at archaeological sites in the Southwest, had practiced with Macomber's old Boston firm of Strickland, Blodgett, and Law, and had developed skills at sketching old buildings on a grand tour of Europe.

The partners, Macomber, and the draftsmen all expected to have an initial period of time for study and design, but upon arriving they found representatives of the New York construction firm of Todd and Brown already present and anxious for working drawings. Antagonism with Todd and Brown, the necessity of dealing with an astonished but strong-willed Virginia community, and the rapid pace of work in what was largely a new idiom put extraordinary pressure on Macomber and the draftsmen. Early difficulties were exacerbated by the partners' insistence on living in Boston. The development of designs from schematics to final drawings, not to mention the resolution of political issues, was slowed by Perry, Shaw, and Hepburn's general absence.

A stabilizing influence appeared in the autumn of 1929, when the partners sent A. Edwin Kendrew to organize the architectural work. Systematic and eminently reasonable, Kendrew began to bring order out of chaos, and he hired additional staff to deal with the increasing workload. For a majority of them —

like Finlay Forbes Ferguson Jr., Francis Duke, Everette Fauber, and Milton Grigg, all from the University of Virginia—this was their first full-time job.

Despite Kendrew's efforts, working conditions contributed to disagreements over professional roles. Waterman was perhaps the most talented member of the group, and by almost all accounts he became the most aggressive. Drawings show that he produced a large percentage of the designs for reconstruction of the Governor's Palace, Capitol, and Raleigh Tavern, as well as the substantial restoration of the main building at the College of William and Mary. The drawings reinforce suggestions that other draftsmen were sometimes pushed aside to deal with less exciting subjects. Yet everyone present was involved in design development to some degree. Waterman's prominent role in the Palace project notwithstanding, for example, the principal outside elevations were developed from the now-famous Bodleian copperplate by Macomber and Barrows, most of the paint colors were chosen by Boston interior designer Susan Higginson Nash, and the rather lavish entrance hall was designed by Moorehead. Ultimately, Moorehead was the more resilient presence. His tenure at Williamsburg outlasted both Waterman's and Macomber's by 30 years. Kendrew remained even longer; he finally retired as senior vice president in 1968.

Arthur Asahel Shurcliff, a Boston landscape architect who developed garden and street planting schemes for the historic zone until 1941, further enlivened the hectic early scene. Shurcliff was a dramatic, Wildean character whose independence often overcame his official deference to Perry, Shaw, and Hepburn. Zealous enthusiasm led him to Williamsburg executives Arthur Woods and Kenneth Chorley, or directly to Rockefeller.

From 1928 until 1948 an advisory committee of nationally and regionally prominent architects reviewed projects and helped set architectural standards for the Williamsburg effort. Increasingly this committee came to rely on the local staff for most answers. Initially it helped resolve issues involving the extent of the work and lent support to the architects' efforts. In delicate matters involving the preferences of administrators and donors at the state-run College of William and Mary, for example, the committee occasionally nudged the parties toward a better standard of authenticity. This was particularly helpful in the first several years when the extent of future restorations remained unclear. In 1928, only buildings on the main street were considered crucial, and uncertainty existed about how to handle areas that had lost their 18th-century buildings. Even in 1928 Goodwin and Rockefeller were thinking in terms of a general environment for the principal buildings—Goodwin called it "the frame of the picture"—but the picture was still much smaller than it ultimately became.

As restoration proceeded the committee came to rely on those on the local

staff for most answers because their research at the site had made them even more expert in evaluating building techniques of colonial Virginia than outspoken committee member Fiske Kimball. Somehow, in spite of the hours spent drafting and drinking, the architects found sufficient time to explore the Tidewater countryside. As Macomber had done earlier in New England and Campbell had done in Ireland, they carefully observed the details of traditional buildings and recorded their observations in drawings rather than in text. By gradually developing an encyclopedic familiarity with early Virginia design, they were following a 19th-century historicist view that one could become entirely conversant in an ancient style and thereafter design in it much like its original practitioners did. In many ways, this approach reflected an Arts and Crafts fascination with local, indigenous character. Old vernacular design was seen as important because it embodied a preindustrial, regional personality.

Williamsburg held an appeal for these designers that ran somewhat counter to a vernacular mode. The buildings did not stand in an informal pattern like those in a picturesque English village but rather were arranged in a precise order along parallel streets broken by public spaces and designed with a strong sense of axis. This simple American Baroque plan brought order to the various vernacular parts, creating a coherent system that seemed very much like the studio projects Moorehead and other students had observed and executed in long, late-night charrettes. In many ways, the restored and re-created public buildings and vistas in Williamsburg seemed to offer an American antecedent for grander Beaux-Arts designs in cities like Chicago and Washington, D.C.

The partners in Boston and the respected review committee members, as well as the young draftsmen in Williamsburg, had a shared educational background, formal or not. It emphasized immersion in historical styles and their skillful use for modern buildings. Regional styles were viewed with favor, and modest handcrafted details were still seen as wholesome. Countering the picturesqueness of vernacular building was a fondness for grand, balanced Beaux-Arts planning.

All involved were unusually careful in following details of existing buildings and in employing specific evidence when it was available for reconstructions. When direct evidence could not be found, they drew on their understanding of the local style to create plausible reconstructions. They saw life in the 18th-century South as more homogeneous and certainly more genteel than late 20th-century historians do. As a result, their observations among the venerable buildings of Tidewater Virginia were selective, focusing on pleasant, well-resolved design rather than the confusion and cheapness that existed alongside it. The fine products of a slave economy were presented, but the system was

romanticized or left unacknowledged. Complex history was thus screened and sanitized and delivered to a nation receptive to its optimistic, patriotic message.

This approach is not the manner in which it would develop in the early 21st century; provocative economic theory, social history, and the civil rights movement would make that impossible. Yet the grand project that began in 1928 and continued along the same lines for the next 50 years holds an unusual appeal. Substantially the product of a particular time and educational system, Colonial Williamsburg is commonly seen as a graceful effort, a seamless whole. Perhaps it could not have been accomplished at another time. Yet because of its size and complexity, it clearly offers continuing opportunities for development and change.

EDWARD A. CHAPPELL
Williamsburg, Virginia

Anders Greenspan, *Creating Colonial Williamsburg: The Restoration of Virginia's Eighteenth-Century Capital* (2009); Charles B. Hosmer Jr., in *The Colonial Revival in America*, ed. Alan Axelrod (1985), *Preservation Comes of Age: From Williamsburg to the National Trust, 1926–1949* (1981); Fay Campbell Kaynor, *Winterthur Portfolio* (Summer–Autumn 1985); Michael Wallace, *Radical History Review* (1981).

Colonial Revival Architecture

The Colonial Revival subsumes what can be called the "antebellum revival." This would include 20th-century houses built in the Greek Revival or columnar styles of the 1840s and 1850s. By the 1930s and 1940s these original structures had become emblems of the image—real or imagined—of the South's white antebellum "aristocratic" culture, which by this time had gained national acceptance. This perceived image had some basis in fact but was considerably nourished by popular novels and films. In England the Queen Anne style revived vernacular English domestic architecture of the medieval period, but in America the style was related to colonial architecture. Beginning roughly in 1867 and gathering force in the early 1870s, the Colonial Revival met with favor in 1874 and enjoyed a nostalgic and antiquarian popularity in the South as well as in the rest of the United States.

Donald G. Mitchell, in his 1867 book *Rural Studies*, examined old American houses with "a character of their own" that should be respected. However, his proposals for new houses were scarcely influenced by colonial precedents, except for his advocacy of half-timbering, which he observed was rarely found in the North but commonly existed in Florida and Louisiana. Illustrated in the

book was an old and small building that he sketched near New Orleans; he would later propose that Louisiana erect a similar one at the Centennial Exhibition in Philadelphia in 1876.

Richard Upjohn, noted architect and the first president of the American Institute of Architects, wrote "Colonial Architecture of New York and the New England States" in 1869, one of the first such articles in a professional publication. In the 1870s laymen as well as architects enjoyed seaside vacations, which focused attention upon seaside resort towns, many of which had not changed since colonial days. This widespread exposure to colonial architecture helped to promote the style's popularity.

In 1876 one architect described the Colonial Revival as "no feeble copy of foreign styles of questionable fitness and in little sympathy with our institutions but distinctly American." Despite the interest in the American colonial past generated by the 1876 Centennial Exhibition, no structure at that exposition replicated any colonial structure. The Connecticut State Building came the closest. It was certainly not a strict copy of a Connecticut saltbox but was intended to evoke thoughts of the state's early history, according to architect Mitchell.

In March 1876 the *American Architect* suggested that architects spend their holidays making notes of colonial architecture, because it, "with all its faults of formality and meagerness, was, on the whole, decidedly superior in style and good building, if we may say so, to most that has followed it." The following year, noted architects Charles McKim, William Mead, Stanford White, and William Bigelow made a walking tour of colonial New England buildings that were attracting attention in such professional journals as the *American Architect*, which published Robert Peabody's "Georgian Homes of New England" in 1877. Sketching their way along the coast of Massachusetts and New Hampshire, the architects seemed to be searching for a national heritage on which to build an American architectural style. In later years, eclectic devotees would claim that this trip was the "discovery" of the colonial. The architectural firm of McKim, Mead, and White would dominate American architecture for years.

The Colonial Revival style began at first as an addition to the Queen Anne vocabulary; such details as Adamesque garlands, classical pilasters, and Palladian windows were common. But by 1879 the style had emerged in its own right. Shingles yielded to clapboards, picturesque massing to symmetry. The playful roof of the Queen Anne was replaced by a standard hipped or gabled roof. At the center of the facade, the symmetrical axis, was an elaborate doorway flanked by big broad windows with a single sheet of plate glass below

and many smaller panes above arranged in a pseudo-Georgian pattern. Details and massing in this initial phase were larger than their original colonial counterparts, with many of the elements oversized or exaggerated.

The 20th century brought a more academic approach, perfectly symmetrical, correctly proportioned, and more widely accepted. At first only Georgian and Federal precedents were used; however, as various regions of the country explored their colonial architecture, numerous variations became popular. In the Southwest, the Mission style (characterized by semicircular arches, low-pitched tiled roofs, and stucco surfaces) and the Pueblo style (characterized by massive-looking battered walls with round corners, flat roofs, and projecting roof beams called "vigas") evolved. In Florida, Texas, and California, the Spanish past was romanticized in the Spanish Colonial Revival style popularized by the 1915 San Diego Exposition. The Mar-A-Lago Club by Addison Mizner in Palm Beach, Fla., is a superb example of the style. White stuccoed Spanish-style cottages and churches and schools built in the Mission style are also to be found in Louisiana and Alabama, where the earlier Spanish period of domination was relatively short but nonetheless important. In Louisiana, Mississippi, and Alabama, the Creole colonial heritage was borrowed, while from New York came the Dutch colonial, and from Cape Cod, the style that bore its name. From Virginia, the Williamsburg style evolved after the reconstruction of that capital in the 1930s. Versions of Williamsburg-Georgian houses have appeared throughout the country, North and South, East and West, since the 1930s. Whether these have enjoyed more popularity in the South since that time is difficult to say. Certainly, they appear in significant numbers in affluent suburbs and sections of cities from Baton Rouge to Norfolk. Alongside the plans and external architectural features of the Williamsburg-Georgian style, the interior paneling and the "Williamsburg colors," for example, soft muted blues and greens, have been used in numerous interiors.

All of these styles were very popular in the South in early 20th-century neighborhoods, as housing demands created enormous pressures. The strong national sentiment, which resulted in the introduction of variations of what were originally regional forms into all parts of the country, served in part to blur the sense of regional architecture.

ROBERT J. CANGELOSI
New Orleans, Louisiana

Alan Axelrod, ed., *The Colonial Revival in America* (1985); Catherine Bishir, *Southern Built: American Architecture, Regional Practice* (2006); Donald W. Curl, *Mizner's Florida: American Resort Architecture* (1984); Robert Gamble, *Historic Architecture in*

Alabama (2001); Robert B. Harmon, *The Colonial Revival in American Architecture: A Brief Study Guide* (1983); Marian Page, *Historic Houses Restored and Preserved* (1976); William H. Pierson Jr., *American Buildings and Their Architects: The Colonial and Neo-classical Styles* (1970); Carole Rifkind, *A Field Guide to American Architecture* (1980); Leland M. Roth, *A Concise History of American Architecture* (1979); Richard Guy Wilson, *The Colonial Revival House* (2004).

Decorative Arts

In 1949 the American curator at the Metropolitan Museum of Art, speaking at the First Antiques Forum at Williamsburg, noted that "very little of artistic merit was made south of Baltimore." The history of southern decorative art is not, however, one of underachievement—but of underappreciation. Much of this neglect was at the hands of native sons and daughters—until the late 20th century. Well-assembled collections of antiques appeared in New England by 1793, but such collections were largely unknown in the South at that time, except for the occasional preservation of inherited family pieces or items belonging to Revolutionary War heroes.

Generally speaking, old furniture in the region was thrown or given away or stored and forgotten. Heat, humidity, and insects have taken their toll, as have fires, earthquakes, hurricanes, tornadoes, and wars. Charleston, S.C., for example, experienced so-called great fires in 1740, 1828, and 1861. Ironically, when the city was under siege from 1863 to 1865 Charlestonians who were able to moved prized family pieces to Columbia for safekeeping, only to see their state capital torched in 1865. Looting during the war contributed to the dearth of surviving southern-made objects. Economic depression followed the Civil War, forcing some southerners to move away and others to sell heirlooms that had survived the war. Continuing regional poverty in the 20th century was a major discouragement for serious interest in preserving craftsmen's fine products.

A new era of respect for southern handiwork began in 1952 when the Virginia Museum of Fine Arts at Richmond, the magazine *Antiques*, and Colonial Williamsburg jointly organized a major exhibition, *Southern Furniture: 1640–1820*. It was the first show of its kind and spawned many exhibits and studies thereafter. The Virginia Museum exhibition has been overshadowed by only one development—the founding of the Museum of Early Southern Decorative Arts (MESDA) in 1965 in Winston-Salem, N.C. MESDA has fostered a systematic approach to the study of regional decorative arts. Its 15 period rooms are arranged chronologically from 1690 to 1820, and it has four galleries and an outstanding collection. More ambitious, though not as visible, are MESDA's ongoing, long-

range projects, like the survey of regional decorative arts in public and private collections, to be published as the *Catalogue of Early Southern Decorative Arts* and the *Index of Early Southern Artists and Artisans*. The latter contains data on a wide spectrum of individuals from cabinetmakers to silversmiths and addresses questions regarding identification of craftspeople, use of technology, design, and materials, sources, education, apprenticeship experiences, and social customs. Since 1975, the public has been informed of MESDA's work through its quarterly periodical, the *Journal of Early Southern Decorative Arts*.

The scholarship of the last 30 years has promoted development of a comprehensive picture of the South's decorative arts, which have been geographically widespread and culturally diverse. Though fewer "schools" of artisans have been identified than in the Northeast, distinguishing design and construction techniques have been established. The dominant influence on the decorative arts along the southeastern seaboard and in many inland areas was English. However, the region's decorative arts are richer because of contributions from Moravians, Shakers, Swiss Protestants, African Americans, and French and Caribbean immigrants. In whatever period craftsmen have been active in the South, they have generally taken contemporary concepts of aesthetics and combined them with ideas remembered or inherited from their homelands, using available materials and tools. This has been true of goldsmiths, carriage makers, potters, needle workers, and many other craftspeople.

Valuable discoveries have been made regarding the location and output of individuals and workshops, and there is now a growing tabulation of southern-made artifacts. This research refutes earlier assumptions that southern production was meager and unrefined or that finely crafted objects in the South were imported from Europe in general and England in particular.

Decorative arts are often created more from necessity than from the urge to display. This was true for household items in the early South. After shelter, furniture was the most pressing need. Imported furniture was expensive, and only a limited amount could be brought with colonists by ship. Initially, the simplest of devices passed as furniture—benches, stools, chests, and trunks. These were made by carpenters, joiners, and turners, or by homeowners themselves. Resourcefulness was a necessity, and comfort was secondary.

When colonists settled the Tidewater sections of Maryland, Virginia, and the Carolinas, they found abundant hardwoods and soon favored oak and walnut for furniture. Secondary woods included yellow pine, maple, red cedar, and, in South Carolina, cypress. The need for storage and the absence of closets dictated the production of cupboards, clothespresses, and blanket chests. More complex but not at all beyond the abilities of turners was the gateleg table, par-

ticularly popular from 1675 through the early 1700s. Its side leaves could be raised when needed or dropped for placement against a wall, providing more space in modest-sized rooms.

The chair, so common and indispensable today, was less common in the 17th century than stools and benches. No single type of chair in the South may be called typical, but armchairs resembling the Brewster or Great Chairs of New England were known. They featured turned architectural elements throughout, caging the sitter upon a rush seat. Beds from the early colonial period are as rare as colonial-era chairs, and when equipped with bedstead curtains and valances, they were valued even then at more than their weight in tobacco.

From the 17th to the early 18th century, the desire of southerners for luxury goods was not substantial enough to support specialized artisans, but, as farmers and traders began to prosper, they sought such goods as table services. Silver pieces, sometimes engraved, survive from the Charleston, S.C., area. They approximate the form and embellishment of contemporary English work. Earthenware pottery from the mid-17th century has been found in Virginia. Utilitarian rather than ornate, it was made from Virginia clay banks, which later yielded good brick for permanent homes and civic buildings.

By the middle of the 18th century, dramatic changes had come to southern decorative arts. The colonies of the preceding century survived and stabilized, and some settlements even prospered. Soon thereafter some southerners desired to improve personal possessions and had the means to do so. English culture became even more dominant. Colonists, emulating prosperous merchant and manufacturing classes in England who aspired to aristocratic values, constructed imposing homes and purchased generous furnishings.

The cities of Baltimore and Annapolis, Md., Norfolk and Williamsburg, Va., Edenton, N.C., and Charleston, S.C., boasted active cabinet production. Colonial furniture workshops usually had English-trained craftsmen who instructed and supervised colonial apprentices or local artisans using English copybooks, with the most influential being *The Gentleman and Cabinet-Maker's Directory* (London, 1754) by Thomas Chippendale. Southern artisans soon achieved high levels of stylistic and technical ability. Their work and reputation led to sales in New England and exports to Europe. This success coincided with a proliferation of furniture forms that were more service- and comfort-oriented—easy chairs, tea tables, and several types of desks/secretaries.

Remarkable information has been pieced together concerning outstanding workshops in Williamsburg where craftsmen like Peter Scott, Anthony Hay, and Benjamin Bucktrout sharpened their skills in the 1700s. They created household furniture and ceremonial pieces, using mahogany when possible. Durable

and easy to carve, mahogany could be polished, revealing superb graining, and, though not a native material, it was easily imported from the Caribbean.

Eighteenth-century furniture from eastern Virginia combined mixed refinements with sound construction. Especially noticeable on case furniture and otherwise elaborate items were the standard features of full dust boards between drawers, paneled backs, and composite feet. Emphasis upon high quality construction was a trait of southern furniture and contributed to the longstanding perception of it as "plain but neat." By contrast, northern furniture was more flamboyant. In Virginia and elsewhere, Chippendale was followed by furniture resembling English Sheraton, Hepplewhite, and Regency styles. Although production increased, standards remained high.

If Virginia had an 18th-century rival in the decorative arts, it was indeed Charleston, S.C. Not only was Charleston the commercial, political, legal, and social center of South Carolina, but it rivaled Philadelphia culturally and was deservedly known as the jewel of the Southeast. Furniture had been produced in Charleston from shortly after its founding in 1670. High English tariffs (33 percent duty on imports by 1822) on finished products encouraged the resourceful Carolinians in their domestic arts.

Charleston furniture almost presumes mahogany. So much of this wood came from the West Indies that by 1740 all duties on it were repealed. A Charleston chair, for example, was easily distinguished from English imports by the amount of mahogany, by its thicker rails, and by heavier corner blocks. A Charleston double chest of drawers, a bookcase, or a secretary might be exceptionally tall, scaled to high ceilings. Likewise, Charleston beds sometimes had 9-foot posts and removable headboards to facilitate nocturnal breezes. By 1810, a Charleston directory listed 81 cabinetmakers, and the city's furniture making was at a high point. Work by the city's cabinetmakers declined in the mid-1820s, however, because of the acceptance of cheaper mass-produced pieces from England and New England.

Furniture making followed settlers as they pushed inland, upland, and over the tall line of mountain ranges. From the Germans in the North Carolina Piedmont to the French in lower Louisiana, national craft traditions were retained, at least in spirit. Moravian furniture, for example, redefined the term "spartan." Sawbuck tables and conservatively designed chairs met the utilitarian needs of a simple lifestyle. French settlements in the lower Mississippi Valley also produced relatively austere furniture. Large armoires distinctive to the area were made from fine-grained walnut that responded to polishing, as well as constructed from abundant supplies of cypress. Delicately carved, cloven-hoofed doe's feet supported tables, bedsteads, and case furniture. There has recently

been a dramatic increase in studies and discoveries of Louisiana furniture. Its difference from French or French Canadian work has been noted, and its similarity to furniture from the French islands of the West Indies has increasingly been recognized.

Late 18th-century silver from the southern colonies is a rarer commodity than furniture because it could be melted for other purposes. Fighting occurred in Charleston, S.C., and the surrounding countryside during the Revolutionary War, and it is a small miracle that any silver survived at all. The British forcibly took it by the rice barrelful, with one account suggesting that 500 rice barrels of silver were taken.

At least 35 silversmiths were active at the time, producing mugs, bowls, tankards, and coffee pots as well as occasional unusual items for the table. Craftsmen of note included Daniel and Thomas You and Alexander Petrie. The work of James Geddy II of Williamsburg is well known, too, and can still be appreciated through his re-created home and workshop at Williamsburg.

By the early 19th century, silversmith Charles Burnett of Georgetown in the District of Columbia was forming vessels that reflected the growing identification by the American republic with ancient Greek institutions and aesthetics. An affinity for objects influenced by Greek artifacts was even more noticeable in American furniture. French Empire styles also gained popularity, and American craftsmen synthesized English Regency and French Empire by looking at imported pieces and poring over fashion books like *Thomas Hope's Household Furniture*.

Baltimore was an active center during this period, and fine work also came from Alexandria, Va. Beyond chairs that were fashioned in the manner of Herculaneum and Pompeii, the most conspicuous changes could be seen in chests of drawers, often termed "bureaus" or "consol bureaus." Emblematic features included highly figured mahogany veneers accented by brass hardware, carved scrolls of bold proportion, and columns supporting an overhanging top drawer. Sofas featured ornamental scrolls on wooden back rails, as well as armrests with fanciful writhing creatures. The scale was generally masculine and vigorously imposing, all compatible with Greek Revival architecture, the best examples of which are in the South. Despite the hand-carved ornamentation, this furniture was remarkably inexpensive.

The pendulum of taste eventually swung from classical to other revival styles by the mid-1800s. Rococo Revival was especially represented in the South by the successful New Orleans firm of Prudent Mallard. Mallard was at various times listed as a furniture dealer, cabinetmaker, and upholsterer. Rococo furniture could be fancifully ornate, with seemingly endless pierced and carved

vine work. Mallard's bedroom sets were eagerly sought by those living great distances upriver from New Orleans. His half-tester beds featured dowels in the footboard finials that could be raised to support tentlike gauze curtains that served as protection against mosquitoes. Such pragmatic adoption of a high style to local conditions of climate was typical of southern ingenuity.

The Civil War and the Reconstruction period that followed disrupted patronage of most of the decorative arts in the South. But progress did not end altogether, as evidenced by the innovative Newcomb Pottery works at Tulane University.

Research into the decorative arts of the South is blossoming. Scholarly interest began with critical studies and exhibition catalogs published in the late 20th century. Magazines like *Texas Homes and Living* are popular forums for the decorative arts in the South, and such national periodicals as the magazine *Antiques* frequently publish articles on the South.

THOMAS DEWEY
University of Mississippi

E. Milby Burton, *Charleston Furniture, 1700–1825* (1955); George B. Cutten, *Silversmiths of North Carolina, 1696–1860* (2d ed., 1984); Marshall B. Davidson, E. Milby Burton, and Helen Comstock, *Southern Furniture: 1640–1820* (1952); William Voss Elder III and Lu Bartlett, *John Shaw: Cabinetmaker of Annapolis* (1983); Henry D. Green, *Furniture of the Georgia Piedmont before 1830* (1976); William Griffin et al., *Neat Pieces: The Plain-Style Furniture of Nineteenth-Century Georgia* (1983); Wallace B. Gusler, *Furniture of Williamsburg and Eastern Virginia, 1710–1790* (1979); Museum of Early Southern Decorative Arts, *The Regional Arts of the Early South: A Sampler from the Collection of the Museum of Early Southern Decorative Arts* (1991); Jessie Poesch, *The Art of the Old South: Painting, Sculpture, Architecture, and the Products of Craftsmen, 1560–1860* (1983), *Early Furniture of Louisiana* (1972); Page Talbott, *Classical Savannah: Fine and Decorative Arts, 1800–1840* (1995); Gregory R. Weidman, *Furniture in Maryland, 1740–1940* (1984); Betty K. White, *Great Road Style: The Decorative Arts Legacy of Southwestern Virginia and Northeastern Tennessee* (2006).

Farm Buildings

Farm buildings are working buildings. The number, kind, and arrangement of buildings on a farm vary regionally according to the type of agriculture practiced in a given locality and inherited ethnic and traditional ideas. Geographical diversity is complicated by change over time. Alterations in the agricultural system of a locality may result in nearly complete replacement of older

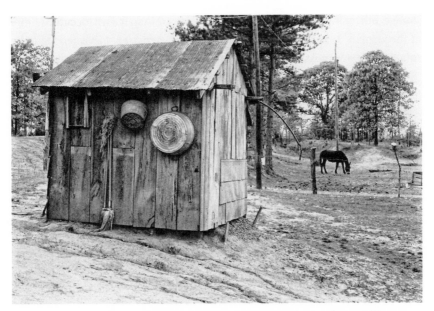

Outbuilding on a farm, Sharon, Miss., 1972 (William R. Ferris Collection, Southern Folklife Collection, Wilson Library, University of North Carolina at Chapel Hill)

farm buildings with newer ones. In some parts of eastern Virginia, for example, the change from tobacco to corn, peanut, and hog farming resulted in the nearly complete destruction of the area's 18th- and early 19th-century farm buildings. More commonly, changes in farming practices have altered the preferred types of farm buildings even though the crop has remained the same. Colonial tobacco-growing practices required different kinds of tobacco barns from those used since the early 19th century, so few tobacco barns survive from before 1800.

To lay observers, the most conspicuous farm building is the barn. In English tradition, a barn was a place to store unthreshed grain and to process it by threshing. Its plan consisted of large storage bays alternating with narrower runways fitted with doors at one or both ends for wagon entry and with wooden floors for threshing. The smallest version, consisting of a storage bay on either side of a runway, was known by the 18th century as an English barn. Large examples might extend seven to nine parts, with four to five storage bays alternating with threshing floors and runways. After threshing, the grain might be stored in chests in the barn or in separate granaries. Animals lived not in the barn but in other buildings.

There is little evidence that barns of this sort were built in the earliest Tidewater southern settlements. Little need existed for such large buildings for grain

storage; other crops, notably tobacco and maize, or Indian corn, occupied more of the farmers' time and resources. Where they were used, barns tended to be small. Grain was most commonly threshed in the field by horses or on portable threshing floors in the farmyard and only occasionally on permanent threshing floors in the barn.

Early barns are more common in the Upland South, and these have attracted considerably more study. Geographers and folklorists have labeled the most common of them single-crib, double-crib, and transverse-crib barns. All are one-story buildings, commonly augmented by open sheds on one or more sides to shelter animals and equipment. The single-crib barn contains one enclosed space; the double-crib barn has two enclosures, separated by a runway. In form it resembles the traditional English barn, although Terry G. Jordan has associated it with central-runway hay barns in Austria, and Martin Wright believes it has a Scandinavian ancestry. Surviving examples seem to have been built for mixed use, with grain storage in one bay, animal housing in another, and the dirt-floored runway used for vehicle loading and shelter below, with hay storage above. The form is an additive one, and examples with three cribs and two runways exist. Single-crib and double-crib barns normally have gabled roofs, with their ridges running parallel to the entry facades. The transverse-crib barn, on the other hand, has its entrances on the gable ends, as do other southern farm buildings of all sorts. It has three or more adjacent cribs, or enclosures, on either side of a wide runway. There are many theories about the origin of the transverse-crib barn, none conclusively established. Henry Glassie's hypothesis is the simplest; he has suggested that the transverse-crib barn was created in the early 19th-century Tennessee Valley through the construction of two parallel double-crib barns separated to create two runways at right angles. Ultimately, one of the runways was filled in, creating the transverse-crib barn. Whatever its origin, it seems likely that the transverse-crib barn is a creation of the Upland South. Like the double-crib barn, it was a mixed-use building, housing animals, hay, and farm implements.

In the eastern uplands between the late 18th century and the early 20th century, farmers also built forebay (also bank, or Pennsylvania) barns, a hybrid of English and Germanic traditions and probably created in Pennsylvania in the 18th century. Others used English barns, bank barns without forebays, and hybrids like the cantilever barns of east Tennessee and western North Carolina. In the latter, an upper level was deeply cantilevered beyond a lower level on two or four sides of a double- or transverse-crib barn. Few examples survive and their precise origins are uncertain, but they represent a localized combination of the

crib barn with the cantilevered appearance and framing of the forebay barn as a way of increasing hay storage capacity.

Specialized buildings on southern farms tended to be few and small, including barns. The most common buildings other than barns were small storage houses for field crops. Granaries about 20 feet wide and 20 to 40 feet long were used in the Tidewater for the storage of grain and field crops. The survivors, few of which date before 1800, tend to contain a single open space, sealed inside with flush boards about waist high to permit bulk storage. Most have gable-end entries. Equally prevalent are small, freestanding "cribs" (not to be confused with the cribs that are parts of a barn) for storing corn. One common form, which can be found all over the United States, is made of log or of frame covered with narrow, widely spaced slats. It is 3 or 4 feet high, about the same width, and 10 feet long. The entry is from the gable, and the sides slant in toward the bottom, giving the ends a pentagonal appearance. Along the Atlantic Coast, somewhat larger, gable-end, vertical-walled buildings, about 10 by 20 feet, were constructed. Usually they could be partitioned with loose boards into three parts for ease of loading. Since the late 19th century, many farmers have preferred tall, thin, slatted structures, loaded from the top. Frequently, "drive-through" cribs are created by placing under a single roof one or more cribs that alternate with wagonways for loading them.

Another important class consists of farm buildings that serve for processing agricultural products. Most common are small square buildings, 8 to 12 feet on a side, used in smoking or chemically curing meat and for storing dairy products and keeping them cool. These are usually included in the domestic complex and stand close to the house. From North Carolina southward, cotton gins in large buildings built for that purpose are common. Farther north, small gins can sometimes be found, installed in a corner of a granary or storage shed, indicating that cotton was a minor crop for the farmer.

The most recognizable and carefully studied of the processing and storage buildings found on southern farms are the tobacco "barns" scattered throughout the region. Southern farmers have cultivated tobacco as a market crop since the early 17th century, and a variety of barn forms have been created in response to changing methods of cultivation and curing. Before the early 19th century, tobacco farmers in the Tidewater and Piedmont regions prepared and partially dried their tobacco in open sheds before hanging it in long, narrow barns to finish curing. The tobacco leaves were tied in bunches, or "hands," and draped over sticks a little over 5 feet long. The inside of the barn was fitted with horizontal poles, running front to back, set at intervals of about 5 feet horizontally

and vertically. The sticks carrying the tobacco leaves were draped across these tier poles, which filled the barn from the ridge of the roof to within a few feet of the floor. There the tobacco was left to be dried by the air. After drying, it was taken down and pressed into enormous barrels, or hogsheads, for sale and shipping.

Methods of curing by heat have been used since the 18th century, when tobacco was exposed to damped open fires whose smoke was allowed to drift out through holes in the barn. Fire curing of dark tobaccos is still common in the Virginia Piedmont and in Kentucky, where square or oblong barns, respectively, are used for the process. About 1820, a technique was developed for curing bright tobaccos, grown in eastern Virginia and North Carolina, in small barns using the heat from enclosed fires. These "flue-cured" barns, which are still widely used, are cubical structures 16 to 24 feet on a side. Many are built of log, though frame and more recently concrete block structures can also be found. The earliest survivors are heated from long, low, open-topped, floor-level stone furnaces, resembling barbecue pits, which are stoked from the outside. From the far end of the furnace a metal flue protrudes, carried horizontally to the far corner and then up through the roof of the barn. This flue, together with the piece of sheet metal that covers the open top of the furnace, helps to diffuse the heat evenly through the barn, which, like its colonial predecessors, is filled with tier poles to carry the tobacco sticks. Flue-cured barns are customarily scattered over the farm, convenient to the fields. Open sheds on one or more sides provide shelter for workers who strip the plants and prepare the tobacco to be hung. In North Carolina, one occasionally sees long rows of these barns connected by a continuous arcade of open work sheds, but more often the barns stand singly or in pairs. In the 20th century, fuel-oil furnaces, recognizable by the fuel-oil tanks next to the barn, replaced coal- and wood-fired furnaces as the preferred heating method, and they in turn were supplanted by propane heating devices, identifiable by the sheet-metal monitor on the ridge of the roof. Most recent, "bulk curing" in small, tightly sealed metal boxes resembling trailers has begun to replace flue curing.

Air curing continues to be used for some tobaccos. In southern Maryland, long, narrow barns are common. These are usually covered with vertical-board siding in which every other board is hinged to allow the sides to be opened for greater air penetration when the building is full. In the Appalachian uplands, hay barns are often adapted to the purpose simply by removing most of their exterior siding.

A farm is an economic entity. Except, perhaps, for a small yard in front of the house, the farm buildings are a unit with the farmhouse, the yards, and the

fields. Together, they constitute a continuous group of related spaces carefully designed for the production, processing, and storage of agricultural products. The farmer must decide which necessary tasks require special buildings, which can be performed in multipurpose buildings, and which can be accomplished in the open. Thus, the open sheds that cluster around all southern farm buildings cannot be overlooked in an account of the architecture of the farm. They form transitional spaces between the tightly enclosed farmhouse and farm buildings and the open yards and fields; their use is encouraged by the mild climate of the region, which allows storage, equipment shelter, and even animal housing in sheds rather than in fully enclosed buildings.

The largest divisions of the farmstead are the yards and fields themselves. Here space is differentiated by the varied fences and walls that are in many cases the oldest forms to be seen on the southern farm. Picket fences for front yards and gardens and post-and-rail fences for gardens and farmyards were first recorded in the 17th century, and they are still used for these purposes. The snake (or Virginia) fence and its stake-and-rider variants have been used to enclose pastures and fields since the late 17th century. Their advantage is that they can be disassembled and moved as land use changes. Horizontal-board fences, a 19th-century innovation, are also common in prosperous areas of the South. In limestone regions of the Upland South, stone, or "rock," fences were popular. A striking form of Kentucky stone wall, in which the horizontal courses are capped by a row of jagged stones set on edge, is known as the Bluegrass fence, but it is a northern European form. As in other parts of the country, wire fencing and electric fencing have replaced wood and stone, particularly for farm fields, but the diligent observer can still find all of the traditional fence types.

DELL UPTON
University of California at Los Angeles

Eric Arthur and Dudley Witney, *The Barn: A Vanishing Landmark in North America* (1972); *Buildings and Landscapes* (formerly *Perspectives in Vernacular Architecture*) (18 vols., 1982–); Ligon Flynn and Roman Stankus, in *Carolina Dwelling: Towards Preservation of Place: In Celebration of the North Carolina Vernacular Landscape*, ed. Doug Swaim (1978); Henry Glassie, *Mountain Life and Work* (Spring 1964 and Summer 1965), *Pattern in the Material Folk Culture of the Eastern United States* (1969), *Pennsylvania Folklife* (Winter 1965–66 and Summer 1966); Terry G. Jordan, *American Log Buildings: An Old World Heritage* (1985); Marian Moffett and Lawrence Wodehouse, *The Cantilever Barn in East Tennessee* (1984); Karl B. Raitz, *Landscape* (Spring 1978); John B. Rehder, *Delta Sugar: Louisiana's Vanishing Plantation Landscape* (1999); Orlando V. Ridout, in *Perspectives in Vernacular Architecture*, ed.

Camille Wells (1982); Laura Scism, in *Carolina Dwelling: Towards Preservation of Place: In Celebration of the North Carolina Vernacular Landscape*, ed. Doug Swaim (1978); Dell Upton, *Architecture in the United States* (1998); John Michael Vlach, *Back of the Big House: The Architecture of Plantation Slavery* (1993); Michael Ann Williams, *Homeplace: The Social Use and Meaning of the Folk Dwelling in Southwestern North Carolina* (1991).

French Architecture

Although France's colonial domination of Louisiana lasted only from 1682 to the 1760s, French influence upon the architecture and culture of the region was profound. Encompassing all the territory drained by the Mississippi River, Louisiana was claimed by La Salle, who in 1682 had descended the river from the French holdings in Canada. Not until 1698, however, did Pierre le Moyne d'Iberville sail from France to build the first French outpost on the Gulf Coast. Situated on the eastern shore of Biloxi Bay, Fort Maurepas was a modest example of a system of fortifications developed by French military engineer Sebastien Vauban. Built entirely of timber, it consisted of a square palisade with pointed bastions at the corners designed to eliminate blind spots on the wall. Thus, the pattern of fortifications was strongly influenced by French military engineering theory. Many other forts followed, all employing the Vauban system to some degree.

In addition to fortifications, military engineers laid out towns (usually on a grid plan) and designed buildings for the crown, often guided by French precedent published in such books as *La Science des Ingenieurs* (Paris, 1729). Their designs were usually simplified adaptations of current Louis XV forms. The larger colonial structures were outwardly symmetrical and generally rectangular, with high-pitched roofs usually hipped at the ends. Moulded stucco details like quoins at the corners and horizontal bands were often used to imitate stone masonry construction. In massing and detail, they were similar to French buildings elsewhere, but the subtropical climate had a marked influence upon the local buildings. Unlike France and Canada, the southern colony had frequent, heavy rains and a long summer. Because traditional French building forms were better suited to northern latitudes, roofed galleries were added to shade the walls and provide sheltered outdoor living space. The gallery roofs were often framed from the tops of the turned or chamfered wood posts to a point about halfway up the slope of the main roof, giving the roof an unusual double pitch (for example, The Intendance, 1749).

The heavy timber building frame known as colombage was brought from

France, where it had been used widely since medieval times. It consisted of squared timbers pinned together at mortise-and-tenon joints. Continuous sills were laid upon the ground, and posts were set at the corners of the building and at the sides of all windows and doors. Across the tops of these posts, horizontal members formed the tops of the walls. For stability, diagonal members were added, and to achieve some insulation the walls were filled with soft bricks or with *bouzillage* or *bousillage* (a mixture of mud and moss or straw) and covered on the outside with wide boards or stucco. The roof-framing systems of even small French colonial buildings were usually well-crafted trusses pinned at the joints with wooden pegs. Dormers were small and attics were most often used only for storage.

French influence did not cease when colonial Louisiana was ceded to Spain in 1763. Although the government changed, many of those who designed and constructed the buildings were born of French parents, and they carried on the tradition that had already been established.

The greatest influence that the Spanish had on architecture was their enactment of laws governing building construction in the city of New Orleans. Until then, owners were free to build as they chose, which usually meant frame buildings roofed with flammable wood shingles. In 1788 and again in 1794, catastrophic fires leveled large portions of the city. After the second great fire, the Cabildo, or city government, mandated that all roofs be covered with slate or tile, that walls be constructed of brick or *brique-entre-poteaux* (brick between posts) covered with stucco, and that buildings be built up to the front property line, in effect creating a fire wall and giving the city its intensely urban character.

During the Spanish period, Americans began to filter into the former French colony, and many of them continued to build in the adapted French style. By responding to the problems of climate and limited available materials, the "typical" French house became an accepted form that survived long after the Louisiana Purchase of 1803. This type of house was rectangular and usually of two stories, and the rooms opened onto one another without halls. The first story was built entirely of stuccoed brick and was used for utility purposes; the second story was of colombage filled with brick or *bouzillage* and covered on the outside with stucco or wide ship-lapped boards. Interior walls were invariably plastered and painted. All wood, except the floors, was painted. Access to the second floor was by exterior stairs under the sheltering gallery roofs. Openings were protected by solid wooden shutters hung on strap hinges, and the first floor was paved with brick if it was paved at all. The second-floor joists and

floorboards formed the ceiling of the first floor. The principal floor was usually well finished, with French doors and casement windows hung on decorative wrought-iron hinges.

Top and bottom bolts, slide latches, and knob-operated bar latches completed the door and window hardware. The exposed second-floor ceiling joists (always beaded on the corners) supported the beaded attic floorboards. The plastered walls were usually adorned with a baseboard, chair rail, and cornice (always of wood). Ceilings on the principal floor were generally high (10 to 12 feet) to allow the summer heat to rise so that cross-ventilation could carry it out of the house.

The principal architectural feature of most rooms was the mantel. Fireplaces in buildings of this type were invariably on interior walls, and they were often paired back to back. Consequently, the fireboxes and breasts projected into the rooms. Mantels were paneled on the sides, and the shelf always wrapped around the breast, returning against the wall. Ornament on these "Creole" mantels varied from engaged turned posts to fluted pilasters. The more elaborate gougework on some Creole mantels was probably a result of influence from the Spanish. Sometimes, the breasts were also encased in paneling and the room cornice was carried out around them.

Variations of this perfectly adapted building form were used in towns and suburbs and in the country until the middle of the 19th century. The popularity of the great national building styles—Greek Revival, Gothic, and Italianate—ultimately overwhelmed the traditional local style, but even these were somewhat affected by the adapted French forms.

Combining as it did elements of Louis XV design and climatic adaptations to the southern latitude, expressed in indigenous materials, French colonial architecture left a unique and enduring impression upon the South—one that exists in no other place in quite the same way.

FRANK W. MASSON
New Orleans, Louisiana

Jay Dearborn Edwards and Nicolas Kariouk Pecquet du Bellay de Verton, *A Creole Lexicon: Architecture, Landscape, People* (2004); John H. Lawrence, *Creole Houses: Traditional Homes of Old Louisiana* (2007); Jessie Poesch, *The Art of the Old South: Painting, Sculpture, Architecture, and the Products of Craftsmen, 1560–1860* (1983); Italo William Ricciuti, *New Orleans and Its Environs: The Domestic Architecture, 1727–1870* (1938); Richard Sexton, *Vestiges of Grandeur: The Plantations of Louisiana's River Road* (1990); Samuel Wilson Jr., *Bienville's New Orleans: A French Colonial Capital, 1718–1768* (1968).

Gardens

The identity of the South, perhaps more so than in any other region of America, is inextricably associated with its physical environment. Over time, this relationship has produced distinctive expressions of culture, commerce, politics, and social perspectives emerging from numerous characteristics: geomorphic conditions that defined an agrarian economy, a capacity to live "on the land," a willingness to defend beliefs based on agrarian perspectives, the intergenerational associations among residents and their place of residence, and an appreciation for the land as an expression of cultural identity. These factors have created a culture of "place," the identification and celebration of which has, over time, become a defining characteristic of this region and its inhabitants.

Only recently have cultural historians begun to identify and examine what "place" means. New perspectives have unlocked new appreciations for the vernacular and the unique. The South is ideal for this investigation because an understanding of place is critical to an appreciation of this region. Typologies of scales, boundary, and form vary from geographical regions (Virginia's Piedmont, Louisiana's swamps, Mississippi's Delta) to arbitrary state lines, from the urban organization (town squares) to domestic landscapes (the family cemetery, the front yard). All offer fruitful opportunities to explore interactions between humans and environment, and through investigations of context and participants each landscape offers a vehicle through which we might gain new appreciation of this region's cultural heritage.

Early explorers found environments that were far different from their homelands in flora and fauna—exotic and intimidating. Survival depended upon the goodwill of natives, vagaries of the elements, controlling the wilderness, and a measure of luck. Early domestic gardens were for subsistence; gardens were small and cultivation techniques followed practices brought from home or acquired from natives. Life was not easy. It was only after the wilderness was tamed, safety was secured and maintained, and a degree of community was established that small-scale, domestic gardens would evolve from being production oriented to becoming decorative. Obviously, this happened at different times.

Like other arts, domestic gardens were expressions of economic success, and they became more sophisticated as populations acquired wealth and social standing. Throughout, early gardens reflected design traditions of the community's settlers. In the early decades of the 1700s, French maps of Louisiana's colony show rectangular, sometimes elaborate, parterres associated with most residential structures in Nouvelle Orleans. Elaborate gardens, commensurate with refinements in architecture and interior decorative arts and based on contemporary styles from England and Holland, may well have existed in mid-

18th-century Williamsburg, while elsewhere gardens were simple plantings of crops for the table. We may never know what, exactly, these gardens were, but the fact that they exist on paper suggests that the maps' delineators ascribed a measure of importance and urban sophistication to the presence of gardens. Among notable gardens from this period are Middleton Place (South Carolina) and Monticello and Mount Vernon (Virginia). Middleton's garden is thought to be America's oldest designed garden, and extensive documentation for Monticello and Mount Vernon exists. Today, these gardens reflect decades of stewardship and horticultural scholarship. These gardens, together with those at Williamsburg re-created in the 1930s, are among America's earliest efforts to examine its garden history. Important documentation, initiated by the Garden Clubs of Virginia, emerged at the same time. Recent revisions to narratives about gardens of this period reflect interpretations that include all who occupied these spaces, not just those of power and influence, thereby giving a more nuanced interpretation of garden life as it may have been.

As the 19th century evolved, communities in the South became established, but advances in residential garden design did not necessarily correspond with those elsewhere in urban areas. In rural areas, designs on the land reflected spatial organizations that facilitated production. Many areas along transit corridors reflected European land divisions and organizational patterns, resulting in rectangular lots much longer in one dimension than the other, thereby maximizing access to such corridors. Main houses faced the river or road, with kitchen gardens nearby, followed by servants' quarters and production fields beyond, planted for production efficiency. This pattern of spatial organization existed, with regional variations, throughout the rural South, and vestiges remain today.

Few gardens associated with plantations remain. Two notable examples, Afton and Rosedown, however, are found in St. Francisville, La. Afton's garden is composed of the gardens of relatively few owners; its most recent layer includes a garden (1970s) in the ruins of the plantation house. The garden at Rosedown, a Louisiana state park, existed from the 1840s and features a design that was possibly the work of an itinerant European garden designer. Parterres and plant material, notably camellias, date from this period. Until recently, gardens and horticultural activities associated with the enslaved have been largely unexamined. This situation will certainly change as garden historians delve deeper into the origins and traditions of these communities and tease out relevant practices.

In 19th-century urban areas (Charleston, New Orleans, Natchez, and Savannah), residential structures occupied much smaller plots than rural plan-

tations. Today, each community has iconic representations of its garden style; often these designs derive more from an imagined history than from archival documentation. Nevertheless, they are representative of time and place and have value, even if their accuracy is contested. While residential gardens started out as primarily utilitarian, urban growth brought increased access to external food supplies, domestic activities moved elsewhere, and trade with other urban centers facilitated horticultural variety. Middle-class affluence enabled residential gardens to become increasingly decorative. These evolutionary factors, together with the influential writings of Andrew Jackson Downing on domestic architecture and gardens, created new demands for residential gardens and horticultural variety. By the beginning of the Civil War, residential garden design was established in America.

During the 19th century, America's expanding populations moved into new territories in the West and South. Throughout, agriculture was the main source of income. Servicing these expanding markets were numerous agricultural publications, written by and for those who were eager to discuss such topics as innovative scientific methods of increasing production, a national agency for agricultural affairs, domestic matters, and even a nationalized agricultural educational agenda. Curiously absent was discussion of the slave-oriented agricultural economy. Agricultural newspapers flourished and were important means through which information about agricultural, horticultural, and domestic matters was transmitted. These papers paved the way for the works of midcentury journalists like Downing and Frederick Law Olmsted, a northern observer whose 1850s newspaper accounts of the South are a major description of that period. Later, Olmsted would almost single-handedly establish the American profession of landscape architecture, and the argument can be made that Olmsted's experiences observing the South and its landscape were instrumental in shaping theories later expressed in his professional projects. Less well known was Scotsman Thomas Affleck, who established perhaps the first commercial nursery in the South, near Natchez, growing and importing plants from suppliers in Europe and America. He maintained voluminous correspondence with constituents, championed advancements in agricultural technology, and published extensively on matters related to agriculture, horticulture, and animal husbandry.

The impact of the Civil War on the geographic and psychological landscape of the South cannot be overstated, and recovery was slow. From the residue of that experience grew attitudes about place that were later expressed in multiple ways: the reinterpretation of the defeat through the early 20th-century efforts of the United Daughters of the Confederacy to erect monuments to the

Lost Cause; political efforts, through Jim Crow laws, to maintain racial (and physical) separation; the Agrarian literary movement in the 1930s; and perhaps most dramatically, on film in *Gone with the Wind* (1939), when Scarlett vows, in the midst of the ruins of Tara's kitchen garden, "As God is my witness, I'll never be hungry again." A corresponding interest in preserving the "southern way of life" contributed to increasingly popular venerations of local narratives, historic sites, and customs through pilgrimages, festivals, grave markings, and battlefield reenactments. In retrospect, we see how these threads involve the landscape and evolve from interpretations of place, whether celebrated or contested.

In the second half of the 19th century and well into the 20th century, domestic gardens in the South responded to trends, horticultural availability, and economic conditions defined by gender roles. While farming tasks were likely shared by all family members, keeping house and tending the domestic garden were the wife's responsibilities, with traditions passed down from mother to daughter. Books began to appear by female authors for female audiences on plants and garden keeping, and garden clubs and civic beautification organizations, led by women, extended domestic roles of beautification into the public realm.

From the late 19th century onward, one agricultural newspaper, *Progressive Farmer* (established in Raleigh, N.C., in 1886), remained influential throughout the South. In the early 20th century it became America's most successful regional publication. In the mid-1960s *Southern Living* appeared as a spin-off of *Progressive Farmer*'s lifestyle and domestic sections, and it was an immediate success. Through its editorial direction from the early 1970s onward, *Southern Living* prominently featured horticultural stories, garden design projects, and the works of professional landscape architects working in domestic and community spheres. More than almost any other single force in the 20th century, *Southern Living* advanced landscape architecture in the South, the role of landscape architects, and the promotion of the region's cultural landscapes through its regular features on garden projects, communities, and tourist destinations.

Examples of the "country place era" of the early decades of the 20th century, with elaborate mansions and extensive gardens based on European precedents, were not as common in the South as in the East and Midwest, because concentrations of wealth that facilitated such developments were absent in the South. But they do exist, often with gardens designed by trained professionals. More widely influential in the South was the concurrent interest in America's past that led to the Colonial Revival period, expressed in Williamsburg and in the corresponding interest in documenting and restoring historic gardens.

Professional education in landscape architecture and the profession of landscape architecture itself would not become established in the South until after World War II. While the profession itself is relatively new in the South, landscape architects from elsewhere completed projects in this region; perhaps the most prominent example was Williamsburg. Other projects included municipal parks and parkways, numerous campus designs, and residential neighborhoods; and in the 1930s landscape architects from elsewhere were involved in Works Progress Administration projects, including ones for the Tennessee Valley Authority and the National Park Service. Only recently have many of these projects and their designers become recognized for their roles in the landscape heritage of the communities in which they exist.

Scholarship in American landscape architecture has advanced exponentially over the last four decades, and so has interest in the South's garden heritage. Representative examples have been investigations of rural African American garden practices, general surveys of southern landscapes, focused examinations of communities, and examinations of cultural landscapes. Numerous new venues and activities exist: botanical gardens and arboreta, featuring horticultural displays and native landscapes, offer opportunities for environmental education; local spring and fall garden and flower festivals abound in the South; and groundbreaking exhibitions of historic landscapes have also occurred. Garden-related libraries and archives have been created, and efforts are beginning to collect office archives of landscape architects. Along with the rise of appreciation for vernacular architectural expressions is interest in preserving landscapes created by "outsider" and folk artists, of which there are many.

In the 21st-century South, gardens are clearly composed of numerous threads, and, like other aspects of southern culture, they are diverse and informed by a multitude of cultural influences. Now as before, gardens are informed by an abiding appreciation of history, a knowledge and love of plant materials, and multigenerational relationships with the land and its heritage. The place of gardens *in* the South is at the core of being *of* the South: one cannot understand the South without understanding its landscape, and that landscape is one of memory, of promise, and of place.

LAKE DOUGLAS
New Orleans, Louisiana

Architectural Record (December 1935); C. Allan Brown, ed., *Journal of Garden History* (Summer 1996); James R. Cothran, *Gardens and Historic Plants of the Antebellum South* (2003); Lake Douglas, *Public Spaces, Private Gardens: A History of the Designed Landscapes of New Orleans* (2011); Mac Griswold and Eleanor Weller, *The Golden Age*

of American Gardens: Proud Owners, Private Estates, 1890–1940 (1991); Alice G. B. Lockwood, ed., *Gardens of Colony and State: Gardens and Gardeners of the American Colonies and the Republic before 1840*, 2 vols. (1931, 1934, reprinted 2000); Philip A. Morris and Marjorie Longenecker White, *Designs on Birmingham: A Landscape History of a Southern City and Its Suburbs* (1989); Elizabeth Barlow Rogers, *Landscape Design: A Cultural and Architectural History* (2001); Richard Westmacott, *African American Gardens and Yards in the Rural South* (1992).

Georgian Revival Architecture

Within the space of a quarter century, from the 1920s to the beginning of World War II, a body of truly distinguished domestic architecture was produced in the South. These structures, Georgian Revival houses, are distinct from those of the early 20th century and those of the post–World War II period. They occupy a place in the architectural history of the South—and particularly the Upland South—not unlike that of the houses of the mid-19th century. Both were products of a rapidly developing economy, and both were places on which owners had spent lavishly in the creation of a handsome home. Ultimately, both were brought to a halt by war: in the first instance by the Civil War; in the second by the prolonged economic effects of the Great Depression and then by World War II.

The Georgian Revival of the interwar period was separate and distinct from the Colonial Revival of the early 20th century, although it grew from many of the same impulses that had fostered the earlier effort and was the final or mature phase of the Colonial Revival. The character of the houses of the latter period is specific, definable, and discrete; and these houses are also extraordinarily beautiful buildings.

The personality of Georgian Revival houses is dominated by the architecture of 18th-century Virginia and Maryland, which, by a confluence of natural and contrived circumstances, came to be seen as an exemplar of the finest design. This borrowing represents one of the earliest instances in this country of a contemporary adaptation of older indigenous architecture. The upper middle class and aspiring aristocrats of the early 20th century—some of whom were the descendants of the middle class and aristocracy of the 18th century—were anxious to assume the trappings of their own, or collateral, ancestry and perceived the houses of the 18th century as appropriate settings.

The image of the Virginia house was strong and desirable, and its adaptation as a model was a deliberate decision by 20th-century southerners. Much was written about the 18th-century houses of Virginia during the interwar period. They were more celebrated than those of any other southern state. A few books

were written about the houses of South Carolina, Georgia, and Alabama, and Thomas Tileston Waterman's *Early Architecture of North Carolina* appeared, but none was so exhaustive an investigation of 18th-century houses as Thomas Tileston Waterman's *The Mansions of Virginia*. Published in 1945, the book did not influence designs of the 1920s and 1930s, but it showed the degree of scrutiny applied in that era to 18th-century houses.

An appreciation of the mansions of the James River is well stated and purposefully crafted in remarks that William Lawrence Bottomley, a leading architect of the Georgian Revival country house, made on the topic during an interview in 1929. Speaking principally of the great James River plantations, he observed that

> they have a marvelous natural advantage because of their location in a beautiful, in many ways romantic, country; but the point is . . . that this natural advantage has been turned to full account through the development of a splendidly sound architectural tradition . . . the direct outcome of a distinguished civilization, built up in two centuries or more of country life. . . . The Virginia families who maintained this tradition were careful to nourish it and to enrich it as much as possible, by drawing on inspiration outside. . . . But the importations were so thoroughly absorbed into the Virginia tradition that it remained absolutely American—American of the Old South. I believe we should do everything possible to preserve this old southern ideal of country house architecture because it is one of the finest things we have and it is still vital.

Bottomley was foremost among a group of architects, mainly from New York and Philadelphia, who designed buildings—typically Georgian Revival—for southern clients from 1910 to 1940, mostly in the 1920s. This group included Harrie T. Lindeberg, Robert Rhodes McGoodwin, Charles Barton Keene, Aymar Embury, Hobart Upjohn, William Adams Delano, Chester Holmes Aldrich, John Russell Pope, and Dwight James Baum. Each specialized in house types and styles related to the matter of "personality," a frequent topic of architectural writing of the period.

The houses of these architects were important in themselves, but their deeper significance lies in their influence. In Richmond, where the largest single group of Georgian Revival houses by Bottomley is located, and throughout Virginia, Bottomley's houses were emulated by local and regionally important architects, including Henry Baskervill, among others. Bottomley designed one of his finest Georgian Revival houses in the 1930s, Tatton Hall in Raleigh, N.C., for N. E. Edgerton. In Winston-Salem, Keene's houses were often the particular models

for those designed by the local architectural firm of Northrup and O'Brien and by C. Gilbert Humphries. In Atlanta and in the state of Georgia, the work of Neel Reid, which was distinguished by a lavish hand heavily influenced by a fondness for Italy and the classical devices of the Italian Renaissance, saw wide admiration and emulation there and in the states of the Lower South.

Other architects throughout the South also designed in the Georgian Revival style. In Virginia, perhaps the greatest local practitioner of the style, after Bottomley, was Duncan Lee, who took Carter's Grove, one of the landmark houses of the 18th century, and transformed it into one of the landmark houses of the Georgian Revival. He connected the wings to the main block, raised the roof, and added ranges of dormers, one of the hallmarks of the Georgian Revival. Stanhope S. Johnson was another Virginia architect who achieved great acclaim for his Georgian houses, including Galliston Hall in Farmington at Charlottesville.

Architects elsewhere in the South were also specialists in the Georgian Revival. Among them were James R. Edmunds and Herbert G. Crisp, who operated as the Office of Joseph Evans Sperry in Baltimore. One of their landmark houses is located not in Maryland but outside Chapel Hill, N.C. It was designed for David St. Pierre Du Bose, of a distinguished South Carolina family, and his wife, who, having lived for some time in Baltimore, chose architects of that city to create a house for their Meadowmont estate. The residence obviously borrows from Maryland houses, including the Hammond-Harwood House doorway, one of the most frequently copied features of the period, which appears at Meadowmont on the east entrance.

The Georgian Revival houses of these architects were found most commonly in two places in the South. They were located on large multi-acre lots in the upper-level suburban developments of the period, for example, Windsor Farms in Richmond and Biltmore Forest in Asheville; or they were the seats of large suburban or rural estates, where they were often accompanied by complementary outbuildings that, in Keene's work, create a harmonious assembly. These architects designed houses and other buildings that were not only built in the South but that in numerous ways reflected the southern climate, geography, society, and strong traditions. Those traditions and their imagery, illusionary or real, accounted for the success of Edmunds's and Crisp's work.

The principal Georgian Revival restoration project in the 1920s and 1930s was the restoration of Williamsburg, Virginia's colonial capital. Word of this project spread rapidly within the architectural community, and progress on the various buildings was widely reported in both professional and decorator magazines. Williamsburg was but the largest of many such efforts, which in-

clude the restoration of Stratford Hall by the Robert E. Lee Memorial Association, of Gunston Hall by the Colonial Dames of America, and of Monticello, on which Fiske Kimball advised. Other projects were Kenmore in Fredericksburg, Wilton in Richmond, and Christ Church, Lancaster County, Va. Among the last of these was the reconstruction of Tryon Palace in New Bern, N.C. Coinciding with these architectural restorations was an associated and closely related series of garden restorations by one of a series of men, including, principally, Charles Gillette, Arthur Shurcliffe, Umberto Innocenti of New York, and Thomas Sears of Boston. In 1923, the James River Garden Club published a seminal work, *Historic Gardens of Virginia*, which included period and documentary photographs of Virginia gardens, together with restored gardens of the 1910–20 decade and the early 1920s. It remains one of the most important works of the period, which also saw the publication of *Carolina Gardens* and *The Garden History of Georgia* (1933).

The success of the Georgian Revival was also influenced and enhanced by developments in brickwork. Herbert Claiborne Sr. was an acknowledged historian of Virginia brickwork, and his firm, Claiborne & Taylor, had executed work on a number of restorations. He brought his knowledge of 18th-century Virginia brickwork and his experience in repairing it to the construction of houses in Richmond and other parts of Virginia. As did the architects, Claiborne & Taylor set a high standard of excellence that became a model for emulation.

The people who commissioned Georgian Revival houses in Virginia and elsewhere in the South were of two types. Some, including most of those in Richmond, were prominent individuals in their states and the region, many having second-generation ancestors in Virginia. This group looked back locally to their 18th-century origins and tried to downplay the industrial 19th-century sources of their wealth and any associated Victorian manifestations. Another group of clients during the interwar period included nonsoutherners or relocated southerners, for whom farm seats and hunting boxes were expanded, overbuilt, or designed anew in Virginia, North Carolina, South Carolina, Maryland, and Georgia. Because of the social status of these house builders and the professional status of the architects, much of the best work in the Georgian Revival style was published, mainly in the 1920s and 1930s, in such national trade, professional, and related magazines as *House Beautiful, Architect, Architectural Record, House and Garden*, and *Country Life*.

One of the lasting contributions of the Georgian Revival to southern and American architectural history was a 1933 publication, *Great Georgian Houses of America*. The Great Depression led to much retrenchment in the architec-

tural profession. The chief response to the rising unemployment of draftsmen and apprentice architects was the organization of the Architects Emergency Committee beginning in 1930. In 1932 trained architects and draftsmen began producing measured drawings of the plans, plats, elevations, and details of America's historic houses, which appeared in *Great Georgian Houses* for the benefit of the Architects Emergency Committee.

Great Georgian Houses was published by subscription, with the names of subscribers listed at the front in the fashion of 18th-century English architectural book publishing, suggesting a parallel to the social status of the subscribers; 44 houses, representing 14 states and the District of Columbia, were illustrated in the first volume. Not unexpectedly, more residences were included from Virginia (9 of the 44) than from any other state. Maryland houses were second in number. The largest section devoted to a single building was given to Mount Vernon—16 pages—and its inclusion was the first time that the Mount Vernon Ladies Association had given permission for publication. Bremo, the Cocke family estate in Fluvanna County, Va., is shown on 11 pages. The prominence of the Virginia and Maryland residences reflected their significance as exemplars of the finest Georgian and Federal work. Volume 2 of *Great Georgian Houses of America* was published in 1937 and included illustrations of six houses in both Virginia and New York; otherwise, no single state was represented by more than three houses.

The seeds of change were, however, already in the wind. For architects who practiced after World War II and for the clients of those architects, *Great Georgian Houses* had a broad appeal and did serve as the inspiration and source book for the design of numerous Georgian Revival houses. But distinct changes in both the scale and the character of these postwar houses set them apart from those of the interwar period. The careers of most of the architects who had designed Georgian Revival houses in the interwar period were largely over by 1937, and few had work of any consequence after 1941. *Great Georgian Houses* is a fitting epitaph for their careers and for the Georgian Revival of the interwar period.

DAVYD FOARD HOOD
North Carolina Department of Cultural Resources
Raleigh, North Carolina

Catherine Bishir, *Southern Built: American Architecture, Regional Practice* (2006); Mary Wallace Crocker, *Historic Architecture in Mississippi* (1973); Charles B. Hosmer Jr., *A History of the Preservation Movement in the United States before Williamsburg* (1965); Marian Page, *Historic Houses Restored and Preserved* (1976); Steven Parissien,

The Georgian House in Britain and America (1995); William H. Pierson Jr., *American Buildings and Their Architects: The Colonial Neo-Classical Styles* (1970); Leland M. Roth, *A Concise History of American Architecture* (1979); Kenneth Severens, *Southern Architecture: 350 Years of Distinctive American Buildings* (1981).

German Architecture

Germanic settlement in the South had two main sources: movement south from Pennsylvania in the 18th century and immigration to Texas in the mid-19th century. The eastern Germans abandoned their distinctive architectural traditions early in the 19th century, while the Texas Germans maintained theirs only until the end of the century. Nevertheless, the diversity of Germanic regional traditions in Europe is reflected in the very different buildings that can still be seen in the two regions.

Germans settled in the South in the 17th century, and their names can be found in the record books from an early date. Architecturally, however, the Germanic groups who settled in Pennsylvania in the 1680s made the first notable marks on the landscape. In the 1720s, the descendants of those colonists, augmented by fresh arrivals from Europe, began to migrate down the Shenandoah Valley along the Great Valley Road, which stretches from south-central Pennsylvania through Maryland, Virginia, and Tennessee, with a branch into North Carolina. Although they have been called Germans, they were of diverse central and western European origins and included emigrants from the present-day nations of Germany, Switzerland, the Netherlands, France, the Czech Republic, Slovakia, and Poland. Scholars and antiquarians have given most attention to the architecture of those groups with origins near the Rhine River. They created a distinctive material legacy.

Central to their traditions was a kind of house, imported by German and Swiss immigrants, called the *Flurkuchenhaus* (hall-kitchen house), or Continental house. It was one- or two-stories tall and had two to four rooms in the main story. Its distinctive feature was an off-center interior chimney. To one side was a long, narrow kitchen (*Küche*), into which the front and rear outside doors opened. It had a large fireplace for cooking, and the stairs were located in one corner. Sometimes a secondary room was partitioned at the rear of the kitchen or in an entrance vestibule at the front. On the opposite side of the central chimney, a square or nearly square parlor (*Stube*) was heated by a metal or ceramic stove that was attached to the chimney and fed through a stoke-hole in the rear from the kitchen fireplace. By the end of the 18th century, iron Franklin-type stoves or small fireplaces were more common. Some builders

installed a fixed table and benches in the front outside corner of the *Stube*, although none now survive. Often there was a narrow sleeping and storage room (*Kammer*) behind the *Stube*.

The Continental house was very much a farmhouse: the cellar and the upper floors were as important as the main level. The cellar was devoted to food preparation and storage. Cellars were usually dug under only part of the house and, in many examples, included an outer room and an inner one, which might be vaulted or otherwise insulated for use as a cool storage space. If possible, the house was built over a spring to provide a water source. In recognition of the active use of the cellar, the house was frequently located on a bank in such a way that both the main floor and the basement could be entered at grade. The loft area of the *Flurkuchenhaus* was traditionally used for the storage of grain and other farm produce. Loose boards laid over the collar beams of the roof trusses increased the attic's storage capacity, and a fixed stair on one gable end gave access to this uppermost level. Some houses had small pent roofs that sheltered working spaces close to the outside walls, and others had large porches or piazzas in which, according to 19th-century accounts, saddles, bridles, and other equipment were hung. The domestic space might be extended farther into the yard by an outdoor bake oven. As the description suggests, the Germanic house was a rural building, although a few urban examples could be found in the South.

The *Flurkuchenhaus* was not the only dwelling used by Germanic farmers in the 18th-century South. Single-room houses were common but are not as conspicuous to the modern observer. Most of the survivors were sturdily built and bank sited in the customary fashion and had two full stories of living space. At the other extreme, a few very large houses separated the traditional ground-floor rooms with a narrow entry passage that might contain the stair. In the best surviving example, Schiefferstadt (mid-18th century) in Frederick, Md., the passage runs through the middle of the chimney stack. Fireplaces opening onto the passage were used to stoke the iron stoves in the living rooms.

Germanic farmers used distinctive structural systems to create their farmhouses and farm buildings. Among the surviving structures, log walls are most common. Log building was brought to America from central Europe, and Germans in the South maintained the tradition. Early German structures tended to use massive logs with full-dovetail notching, although half-dovetail and V-notched buildings can also be found. Finer buildings employed rubble, sometimes coursed limestone, walls. The German method of framing, *Fachwerk*, was rare in the South. *Fachwerk* is a timber-framing system distinguished by the use of square posts linked by intermediate horizontal rails about the

same size as the posts. No studs are used in *Fachwerk*. The most recognizable feature is the diagonal bracing that connects horizontal members at the top and bottom of the wall rather than running from a vertical to a horizontal timber as in English traditional building. Although the term is usually translated as "half-timbering" and the frame might be filled with brick or wattle-and-daub and exposed to view on the exterior, southern examples were usually covered with weatherboards.

Most Germanic buildings in the 18th-century South were built by individual farmers, yet the largest and most conspicuous groups of survivors are those of the Moravian communalists at Salem and Bethabara in the North Carolina Piedmont. The Moravians arrived at Bethabara in November 1753, but the principal Moravian settlement at Salem was begun in 1766. Although the Moravians carefully regulated building in their communities, traditional structural systems and traditional forms characterized their work. The early structures were built of *Fachwerk* or log; after the 1780s, brick was more common. Special plans were devised for the enormous communal dwellings that housed the single men and women, but the smaller 18th-century dwellings used the traditional plans employed by German farmers in Maryland, Virginia, and North Carolina, and 18th-century public buildings like the tavern, the boys' school, and the *Vorsteher*'s (civic leader) house used Anglo-American two-room-deep, central-passage plans.

Germanic ideas were also major components of a distinctive barn type brought into the Upland South. Called a bank barn, a forebay barn, a Pennsylvania barn, or a Switzer barn, it combined Continental siting and use with English interior arrangements. In Switzerland, a barn with its upper level overhanging the lower level along one long side was used to house farm animals below and the hay to feed them above. In Pennsylvania in the 18th century, the upper floor of the Swiss barn began to be arranged like an English barn, with openings in the center of both long sides affording access to a central threshing floor flanked by storage bays for grain. The bank barn was set into a hillside like the Continental house, so that both levels could be approached at grade. In the Upland South, the Pennsylvania barn was occasionally built in brick but more often in log or stone with frame overhangs, or forebays. The heyday of the bank barn in the South was the first half of the 19th century, although it continued to be built until the end of the century.

In the 18th century, Germanic groups in the South were known for avoiding contact with Anglo-Americans, but after the Revolution they were drawn into the larger society and their architecture began to show signs of assimilation. The forebay barn is the most obvious example of this fusion, although its effects

can be observed in Continental houses as well. They were made to appear more like large Anglo-American houses by increasing the number of openings and spacing them regularly and sometimes by moving the door closer to the center, either to achieve or to give the impression of symmetry. Other builders moved the chimneys to the ends. Household work was moved out of the house into separate kitchens and other domestic outbuildings. Eventually these groups substituted freestanding meat houses and smokehouses for vaulted cellars, and they built small outbuildings over springs to cool their dairy products instead of constructing their dwellings over the springs. With the importance of the house as a working building reduced, many builders abandoned bank siting and set their houses flat on the ground. The old narrow room that was once the kitchen was now used as a sitting room or dining room. Finally, the Continental plan itself was abandoned. After 1830 it was difficult to recognize any distinctive features in the architecture of those whose ancestors had come from central Europe in the 18th century.

There was a fresh German contribution to southern architecture in the mid-19th century when emigrants from many parts of present-day Germany came to Texas as part of a larger migration of Germans to the central regions of the United States. The first few arrived in 1831 and began to settle in the region between Austin and Houston. A larger group arrived between 1845 and 1860, settled in east Texas near their predecessors, and also went to the hill country of west-central Texas northwest of San Antonio. Impelled by overpopulation, the mechanization of German agriculture, and crop failures in the 1840s and 1850s, about 30,000 Germans immigrated to Texas before 1860. In Texas, they abandoned some distinctive architectural customs, including the building of house-barns, courtyard farmsteads, and tightly clustered agricultural villages, although Fredericksburg and New Braunfels in the hill country were envisioned as traditional farm villages. They tended to settle in dispersed farmsteads similar to other Texans, but their preference for mixed farming led to the construction of capacious barns that distinguished their farmsteads.

The Texas Germans built in log, frame, and stone. Their timber structures used *Fachwerk* frames similar to those found in the eastern South. Many were covered on the exterior with weatherboards, as in the 18th-century examples. But exposed and whitewashed frames, with either a rendered plaster protecting wattle-and-daub or pieces of limestone between the timbers, were more common than elsewhere in the South. In the hill country, limestone construction dominated after the Civil War.

Although the agricultural practices and structural systems of Texas Germans had European origins, this was less true with respect to their house forms.

On farms and in towns, Germans built one- and two-room houses with central entries and three-opening facades. Often there was a rear kitchen lean-to roof and a gable-end stair to the second story. When German farmers abandoned Fredericksburg to live on their agricultural tracts in the late 19th century, very small versions of these one-room houses were built as "Sunday houses" for use by the family when in town. The plan and appearance of Texas German houses are similar to those of Anglo-American Texans and very different from the postmedieval European farmhouses to which they have been compared.

DELL UPTON
University of California at Los Angeles

Edward A. Chappell, *Proceedings of the American Philosophical Society* (February 1980); Bernard L. Herman, in *Carolina Dwelling: Towards Preservation of Place: In Celebration of the North Carolina Vernacular Landscape*, ed. Doug Swaim (1978); Terry G. Jordan, *German Seed in Texas Soil: Immigrant Farmers in Nineteenth-Century Texas* (1966), *Texas Log Building: A Folk Architecture* (1978); William J. Murtagh, *Moravian Architecture and Town Planning: Bethlehem, Pennsylvania, and Other Eighteenth-Century American Settlements* (1967); Dell Upton, ed., *America's Architectural Roots: Ethnic Groups That Built America* (1995), in *Material Culture of the Wooden Age*, ed. Brooke Hindle (1981), *Notes on Virginia* (Summer 1979).

Gothic Revival Architecture

Despite a preoccupation with classical architecture and culture, the South has always flirted with a Gothic identity. The concepts of chivalry, feudalism, and aristocracy are so deeply embedded in the southern psyche that they remain there today. To truly understand the southern Gothic Revival buildings, they must be seen as part of a larger social as well as architectural phenomenon.

Southern interest in the Middle Ages expressed itself in numerous ways. One was an extravagant admiration for romantic-antiquarian literature like Sir Walter Scott's *Waverley* novels. A host of minor southern writers before the Civil War emulated Scott's style, and southern families even named their children after the titles and characters of Gothic novels.

Southerners wrote of themselves as if they were describing heroes of Gothic romance. In contrasting the northern and southern characters, Richmond newspaper editor and historian Edward Pollard spoke of a lack of congeniality between the Puritan colonists, who established themselves on the "rugged and cheerless soil of New England," and the colonists of Virginia and the Carolinas, who were, he said, "distinguished by their polite manners, their fine sentiments, their attachment to a sort of feudal life, . . . and the prodigal and improvi-

dent aristocracy that dispersed its stores in constant rounds of hospitality and gaiety."

Other 19th-century writers were less enthusiastic about the South's Camelot-like self-image. Mark Twain commented caustically on the phenomenon and blamed it on Sir Walter Scott, who "with his enchantments . . . sets the world in love with dreams and phantoms; with decayed and swinish forms of religion; with decayed and degraded systems of government . . . and the sham chivalrys of a brainless and worthless long-vanished society. . . . Most of the world has now outlived a good part of these harms, . . . but in our South they flourish pretty forcefully still." Twain blamed "the Sir Walter disease" for what he considered the worst traits of the southern character and manners, from jejune romanticism to duels, inflated speeches, and inflexible patterns of rank and caste. Twain concluded that, but for the influence of Scott, the southern character "would be wholly modern, in place of modern and medieval mixed."

If Twain felt that Scott's romantic-chivalric attitudes had retarded the South, he also did not fail to link Scott with southern Gothic architecture. One building he specifically attacked was the Louisiana State Capitol at Baton Rouge, by architect James Dakin. The Capitol, anathematized by Twain as "this little sham castle," was, in fact, the largest and most conspicuous Gothic public building in the antebellum South. As such, it was probably a more potent symbol than Twain realized. In addition to literary associations, it conjured up the image of a South with fortified castles as statehouses, suggesting decentralized, feudal governments and an individualistic-separatist mentality. Only two castellated statehouses were built in the United States, and both were in the Deep South (Louisiana and Georgia). It is difficult to suppose that southerners—and northerners as well—did not read political as well as literary symbolism into them.

Another context in which medieval imagery might have seemed symbolically appropriate was the southern plantation: the only true nonurban, decentralized, self-sustaining (that is, "feudal") social unit in 19th-century America. But Gothic plantation houses were a comparative rarity. The image of planters living like feudal lords in Gothic castles surrounded by a class of humans linked in an unending bond to the soil was perhaps too stark to be palatable. The Greek Revival plantation house, with its symbolic ambiguity, seemed to divert notice from the moral problems of a slave economy, whereas the Gothic would have called attention to them. Waverley (1852), near Columbus, Ga., seems to underscore the literary appeal but moral unsuitability of the Gothic castle for plantation architecture. It is a Greek Revival plantation house with a romantic name derived from Scott.

Despite the general reservations, however, a few planters had enough

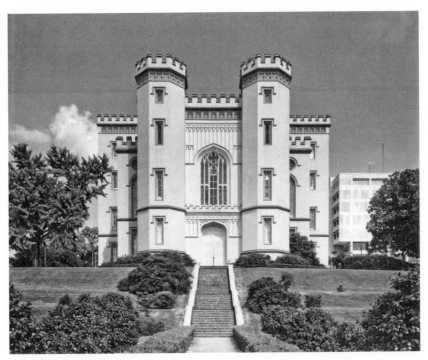

Louisiana State Capitol, Baton Rouge, 1847–49 (David J. Kaminsky, photographer,
Historic American Buildings Survey, Library of Congress, Washington, D.C.)

romantic enthusiasm to opt for Gothic. One example is Belmead, in Powhatan
County, Va., the castellated villa of Philip St. George Cocke, whose very name
tells us about his family's pretensions to an aristocratic-chivalric ideal (he had
a cousin named Richard Ivanhoe Cocke). Belmead, designed in 1845 by New
York architect Alexander Jackson Davis, is situated above the James River, from
which it is meant to be viewed. More than any other southern Gothic house,
it resembles the Gothic villas along the Hudson River in New York State. This
resemblance may help to explain the scarcity of Gothic castles in the South.
Large Gothic villas may have been stigmatized by wealthy yet socially conser-
vative southerners because of their implied connections to liberal and progres-
sive patrons in New York and the Northeast. Romanticism in the South seemed
to be of a nostalgic, backward-looking, Sir Walter Scott type, while northern
Romanticism was of a progressive, forward-looking character, expressing itself
in Transcendentalism, the Hudson River school of painting, and the American
park movement.

By choosing castellated Gothic for Belmead, Cocke exhibited a less regional,
more cosmopolitan sensibility than most southern planters were willing to

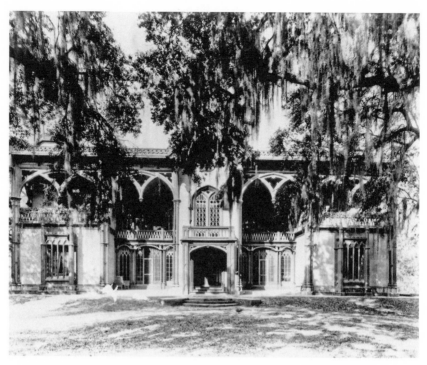

Afton Villa, a Gothic plantation house near St. Francisville, La., built 1849–early 1850s

(Photographer unknown, Historic American Buildings Survey, Library of Congress, Washington, D.C.)

evince. Yet despite its architectural cosmopolitanism, Belmead had regional touches, like window glass decorated with southern plantation crops: cotton, tobacco, wheat, and Indian corn. These, used in place of medieval heraldic devices, made the point that any claims the planter class had to being a "hereditary aristocracy" rested entirely on the land.

A Gothic plantation house of an alternate type was Afton Villa, at St. Francisville, La., built for the Barrow family. Rather than build a castellated villa, an unknown architect skillfully adapted the functional requirements of the plantation house to a vastly expanded version of a Gothic cottage. This symmetrical villa, with its steep overhanging roofs, wooden ornamentation, and inset galleries, was organized behind a regular vertical and horizontal grid not unlike a classical portico and used many of the climate-control devices of the southern Greek villas.

Despite the claim made by some 19th-century critics that Gothic, as a "northern" architectural style, was inappropriate to a southern geography, symmetrical Gothic villas and cottages proved a popular residential type in the South. These "pointed-style" houses were smaller, less expensive, and less

"feudal" than the castles and also did not seem to have the negative associations with northern liberalism that the larger villas did. Executed in a variety of sizes and materials, they appealed to a great socioeconomic range and, like Greek country villas, were usually found in rich agricultural regions of the South. Southern builders adapted the cottage designs from such northern journals and architectural pattern books as Andrew Jackson Downing's *The Horticulturist: A Journal of Rural Art and Rural Taste* or his better-known *The Architecture of Country Houses* (1850). These pattern-book designs were aimed at a rural audience, which explains their popularity in the agrarian South. Downing, although a New Yorker, was careful not to alienate his southern readers, and his writings on architecture, horticulture, and picturesque landscape became the model for many southern agricultural journals. Aside from these, the early 19th-century South had few architectural publications of its own.

Despite the numerous smaller Gothic residences, it was in ecclesiastical architecture that the South seemed most comfortable with its Gothic identity. Two churches in the South, the Episcopal and the Roman Catholic, had liturgical traditions reaching back to the Middle Ages and, by reference, to the architectural traditions of the English parish church and the European Gothic cathedral.

Episcopal congregations could look to the resources of the Cambridge Camden Society in England and its bimonthly publication on church building and ritual, the *Ecclesiologist*. The ecclesiological movement was, in one sense, the religious arm of British colonial expansionism, and the *Ecclesiologist* reviewed and criticized new church construction, not only in Britain but in the New World as well. Consequently, the use by the American Episcopal Church of "approved" Gothic architecture was an inescapable reality.

Southern Episcopal congregations frequently employed northern architects approved by the New York Ecclesiological Society, the American counterpart of the English ecclesiologists. The two architects who had the most influence on southern Episcopal churches were Richard Upjohn and Frank Wills, both of New York. Of the two, Wills was less well known but was perhaps the more sensitive architect. Among the southern churches Wills designed is Trinity Episcopal Church in Mobile, Ala., a fine version of the English 14th-century parish churches revived by British architect Augustus Welby Pugin and favored as models by the ecclesiologists.

Upjohn, renowned for such designs as Trinity Church in New York, had a major impact on southern Episcopal church building, through commissioned designs and his 1852 publication, *Upjohn's Rural Architecture*. This church pattern book provided modest wooden designs for rural parishes too poor to

Trinity Episcopal Church, Mobile, Ala., 1853–55
(Trinity Episcopal Church, Mobile, Ala.)

afford elaborate masonry structures and the fees of a professional architect. As a result of Upjohn's own designs and his pattern book, there are southern Episcopal churches by him in Alabama, North and South Carolina, Florida, Georgia, Maryland, Mississippi, and Texas.

Unlike the humble models for Episcopal parishes were the Gothic churches designed for southern Catholic congregations. The Catholic churches were larger, grander, cathedral-type structures, usually found in urban settings because of the large numbers of Irish, German, and other European Catholic immigrants who settled in southern cities. Between 1830 and 1850, the number of Catholics in America rose from 600,000 to 3.5 million. This vast increase in the Catholic population was given conspicuous physical expression in southern port cities by such Gothic monuments as James Dakin's St. Patrick's Cathedral in New Orleans. These huge Catholic churches were being erected at a time when anti-immigrant sentiment was at its height. There were anti-Catholic riots in some southern cities, and nativist political parties like the Know-Nothings sprang up on antiforeign platforms. It was no coincidence that the vast new Catholic cathedrals, often the most conspicuous monuments on 19th-century southern skylines, were raised in the very teeth of this discrimination as impressive statements in brick and stone of the solidarity of Roman Catholicism. Medieval forms were also used to house southern institutions. Architect James Renwick and Senator Robert Dale Owen, in their plan for the Smithsonian Institution, Washington, D.C., and Owen in his book *Hints on Public Architecture* (1849) proposed making an amalgam of picturesque Gothic and Romanesque

into a "national style" for public buildings. One of Owen's principal arguments for the revival of medieval architecture was its relative economy of construction. Medieval buildings were cheaper on a large scale because they did not require marble, their masonry could be roughly finished, and their walls were a simple two-dimensional "skin" thrown around the interior, with token pointed arches, towers, and crenelations to give "historical style." By contrast, classical public buildings required a high degree of finish, expensive materials, and dozens of carved steps, columns, and capitals.

The cheapness of castellated Gothic, combined with its planning flexibility, made it popular for large southern institutional structures where cost was a decisive factor. Dakin cited cost as one of the reasons for his selection of Gothic for the Louisiana statehouse, and the style was used for orphanages, schools for the deaf and mute, military academies, jails, prisons, and lunatic asylums. Frequently to be found in juxtaposition with these great, stripped-down Gothic institutional buildings were grounds landscaped in romantic or picturesque fashion, like English 18th-century parks. The picturesque grounds, in addition to being appropriate to Gothic Revival architecture, may have been seen as having therapeutic value for inmates of such institutions as the Nashville, Tenn., Hospital for the Insane, built between 1851 and 1854, by architect Adolphus Heiman. In any case, "institutional Gothic" was used to house many of 19th-century southern society's disenfranchised: the needy, the deaf, the dumb, the blind, the insane, the penalized, and, in the case of picturesque cemeteries, the dead.

Gothic was also used for southern educational institutions, a role that hints at Gothic scholasticism and English medieval campus planning. This trend continued into the 20th century, in such fine examples of collegiate Gothic architecture as those of architect Horace Trumbauer at Duke University, Durham, N.C.

Both Greek and Gothic in the South were aspects of a larger search for an architectural and regional identity. It was a quest not merely to house southern people and institutions but also to achieve for southern civilization a parity with the great civilizations of the past, whether classical or medieval. As a southern writer for the *Columbia (Tenn.) Guardian* put it in 1842, "We shall have our troubadours and our minstrels—and the banks of our Mississippi will become in song as classic as the Tiber, and in Romance as famous as the Danube."

PATRICK A. SNADON
University of Cincinnati

Catherine Bishir, *Southern Built: American Architecture, Regional Practice* (2006); Robert Gamble, *Historic Architecture in Alabama* (2001); Michael J. Lewis, *The*

Gothic Revival (2002); Francis Kervick, *Architects in America of Catholic Tradition* (1962); Caulder Loth and J. T. Sadler, *The Only Proper Style: Gothic Architecture in America* (1975); James Patrick, *Winterthur Portfolio* (Summer 1980); William H. Pierson Jr., *American Buildings and Their Architects: Technology and the Picturesque: The Corporate and the Early Gothic Styles* (1978); Phoebe B. Stanton, *The Gothic Revival and American Church Architecture: An Episode in Taste, 1840–1856* (1968); David B. Warren and Katherine S. Howe, *The Gothic Revival Style in America, 1830–1870* (1976).

Greek Revival Architecture

In the popular imagination, Greek Revival architecture, especially the great plantation house, is symbolic of the antebellum South. The potency of this image has discouraged not only analysis of its origins but also consideration of its validity. Most frequently, such architecture has been discussed in the context of romantic beauty, as the residue of an aristocratic culture somehow akin to the "Athenian Golden Age." At its best, this myth has created such visions as the neoromantic photographic studies of Clarence John Laughlin—themselves masterpieces of 20th-century southern art. At its worst, the image has obscured the complex forces that were at work in the South in the decades before the Civil War, producing diverse and expressive architectural forms overlaid with rich and often enigmatic meanings.

By the time of the American Revolution, neoclassicism held sway in the countries of western Europe. Highly educated and well-traveled men of the revolutionary generation, particularly Thomas Jefferson, employed Federal-style architecture as one means of expressing their status as creators of a new nation. Provincial only in its superficial native and patriotic motifs, this style's geometry, planning, and overall articulation reflected forms that had originated in Europe.

As Jefferson and his colleagues were replaced by younger men, the sense of a permanent and self-assured America increased. Americans felt confident enough to look closer to home in their search for aesthetic inspiration, with one result being the Greek Revival style in architecture, still attuned to international neoclassicism but now a more effervescent, innovative, idealistically chauvinistic, and diverse variation on that theme. Buoyant American nationalism was crystallized in the form of templed dwellings, churches, courthouses, and capitols.

This phenomenon was not identical in the North and South, however. The South continued to be agrarian in reality and aristocratic in aspiration, but it also continued to be necessarily international in outlook because of its em-

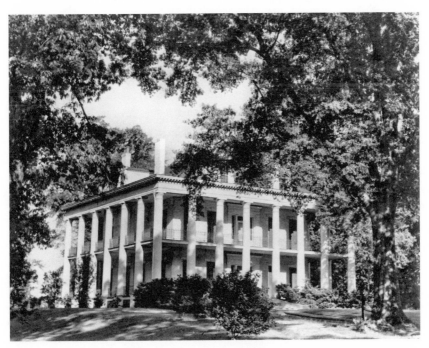

An old mansion in Natchez, Miss., photographed in 1940 (Marion Post Wolcott, photographer, Library of Congress [LC-USF-34-54827-D], Washington, D.C.)

phasis on direct European trading connections. The North, on the other hand, looked toward industrialization, egalitarianism, and urbanized self-sufficiency. Furthermore, the South's distinctive agricultural circumstance included regional variation, and it experienced a considerable evolution over the course of time. The 18th century was dominated by the coastal enclaves of tobacco-raising Virginia and rice-growing South Carolina and Georgia, but the 19th century saw the rising importance of sugar-producing Louisiana and later the inland "cotton kingdom." Here, as the frontier moved westward, the boom periods of the early 19th century produced the many great white-columned buildings amid an even greater number of crude one-room log cabins and dog-trot houses.

The philosophical differences between North and South were not profound before 1820. Only as southerners felt compelled to defend the institution of slavery did their region become isolated and their position intransigent. The southern mind became progressively sectional, then regionally nationalistic, and finally unilaterally expansionistic, culminating in the Confederacy and plans to annex Mexico, Cuba, and the rest of the Caribbean. As one concrete manifestation of this attitude, there appeared a nationalistic architecture.

Slavery, considered by many to be the central theme of antebellum southern culture, upset the equilibrium of southern life, creating an aberration that transfixed both North and South. The architectural parallel was a kind of fetish, what J. Frazier Smith has called the "white-pillared architecture." A paradox was created: The Orders, or columns with entablatures, were the formal basis of classicism and neoclassicism and were physical evidence of the ancient conception of proportion and balance in life as well as in art; in southern antebellum columnar architecture, however, that balance proved elusive. Rather than an ordering element, the column became a device of exhibitionism, a sectional emblem, and a symbol of paternalistic and chivalrous society, aristocratic rule, and hierarchical rigidity. This white-columned architecture might well have been exported, along with slavery, to any new lands the South claimed as it fulfilled its belligerent conception of manifest destiny. The Greek Revival style, declining in the North on the eve of the Civil War, remained integral to southern culture when apocalyptic external forces terminated its development.

Columnar plantation houses were being built in the South through the 1850s, although their details were becoming less archaeologically "Grecian" and more "baroque." While competing with other styles, like Gothic and Italian, the concept of the columned facade remained in favor in the South a decade after its demise in the North; and though acquiring a newer, more eclectic, ornamental, and aggressive vocabulary, the basic syntax was still in evidence and perhaps would have survived had the South been the victor in the Civil War.

Southern residential buildings displayed columns as profusely as did public architecture. In a decentralized agrarian economy, the plantation house was as much a symbol of stability and authority as was any seat of religion or government. That southern domestic architecture so universally appropriated the column did not, however, seem to reduce the significance of public buildings. If anything, the societal status of the domestic architecture was elevated well above that prevalent in the North, and that of public architecture was at least equivalent.

In molding public opinion and housing southern institutions, architects and patrons viewed Greek Revival public structures as eminently practical, modern buildings that made virile collective statements about southern cultural and economic attainment. To this end, of the 13 southern states, 8 had capitol buildings planned by legislative fiat (a much higher percentage than in any other region), itself a telling comment on the search for preordained order within the culture. Similarly, 8 of these 13 had one or more capitols in Greek-temple form. Rivaling the capitols in size and importance were such buildings as hotels, which served the same purpose as Roman triumphal arches—to act

as symbolic gateways and to impress travelers with the economic progress and cultural accomplishments of southern cities. The temple form was ubiquitous. But alternative Greek building types could serve with at least equal appropriateness—a stoa for a commercial block or a Greek treasury for a bank. Many of the most successful and least archaeological of the southern public buildings, far from being only "Grecian," included imaginative combinations of elements from other architectural vocabularies: Renaissance massing and wall division, Roman vaulting and domes, and more primitive Egyptian forms—all used not to supplant but to elaborate and energize the somewhat limited trabeated vocabulary of the Greeks.

This Greek Revival public architecture has been even less well investigated than domestic work. If this important, monumental neoclassical architecture is to be satisfactorily understood, it must be more carefully assessed within its southern context, and it must be compared to the European models created by such 19th-century classicists as Jean-Nicolas-Louis Durand and Karl Friedrich Schinkel.

The proliferation in recent years of books pretending to address southern domestic architecture but most often only recapitulating pallid myth has certainly done more harm than good. Even noted scholars have often purveyed anachronistic confusion. William H. Pierson Jr., in *American Buildings and Their Architects: The Colonial and Neo-Classical Styles* (1970), has written that southern domestic architecture "was dominated almost entirely by the peripteral colonnade," but this simply was not the case. The three original southern enclaves each developed distinctive domestic schemes. Throughout the 18th century, Virginians preferred the Georgian, two-story, two-room-deep residence having a brick mass of Palladian inspiration covered by a hipped roof and often provided with a two-story central pedimented bay or portico. During the Greek Revival period, this form was made more classically correct in both spirit and detail, and the result spread throughout the South as Virginians migrated into newly developing lands. In North Carolina and Georgia, a wide, one-room deep, two-story block with a low-pitched transverse-gabled roof was the most common form, unselfconscious at first, but gradually being furnished with a more pretentious one- or two-story porch or piazza across the long side; this piazza often employed columns with extremely wide intercolumniations to support a deep entablature, typically hiding the sloping roof behind. In Louisiana, the Norman French peasant's house, transported to and developed first in the West Indies and possibly in Canada, was enlarged and outfitted with galleries, often, but not always, on all four sides. To these three prototypes must be added the pattern-book buildings and those designed to individual specifi-

cations by professionally trained architects. All of these types were then intermingled with one another, producing almost endless variants.

In addition to stylistic developments, there were extensive environmental adaptations. Once again, many published materials have created confusion. Wayne Andrews, in *Pride of the South: A Social History of Southern Architecture* (1979), has suggested that in the South there were "not too many inventions that served the particular demands of Southern climate." This observation could hardly be more inaccurate. The list of sun- and heat-control devices perfected by southern designers and builders was impressive. These included raised first floors, high ceilings, belvederes, and stair-tower plenums to take advantage of air stratification and natural convection; windows, jib-windows, doors, transoms, and longitudinal and transverse halls, all carefully located to encourage cross-ventilation; and roof overhangs, shutters, and latticework positioned to prevent solar heat gain. Such features have been verified, using modern testing procedures, as conforming to current scientific energy conservation theory and application. Significantly, the Georgian, Federal, and Queen Anne styles, which preceded and followed the Greek Revival, never displayed an equivalent degree of environmental modification; these styles tended to be quite homogeneous in both North and South. And, after all, ancient Greek architecture was created for a hot, sunny climate; it was the North that never came to grips with environmental adaptation.

Some authors have attributed environmental features like the gallery to the influence of slaves' building experiences in Africa or the West Indies. The effects of slavery on the form of the southern plantation were, however, manifested in a much more calculated fashion. Planters sought to minimize or to conceal architecturally the negative aspects of slavery while calling attention to the number of slaves they owned, the primary indicator of their economic success. This complex pattern of behavioral control was accomplished by means of site planning, landscaping, spatial form and placement, and horizontal and vertical circulation elements, all subtly interconnecting layers and zones of family, guest, and servant spaces. Perhaps the greatest success of the southern Greek Revival plantation was its careful and tenuous accommodation of stressful social and environmental circumstances.

Finally, although southerners rarely spoke explicitly about their architecture, they built prolifically and on a grand scale. If one searches for incisive documentary evidence, especially among published materials, one searches almost in vain. This vacuum suggests not that southerners never thought seriously about architecture but rather that very subtle attitudes were at work that valued most not a house but a home, not buildings as volumetric space but buildings

as stages for human action, not landscape design but land itself, and so on. In the South, certain matters pertaining to taste, culture, and manners have traditionally been neither questioned nor spoken about openly, so much so that they may, to an outside observer, appear to have been unimportant or even unknown. The southerner, however, would probably prefer the term unselfconscious behavior—a code of unspoken but ever-present decorum in patterns of thought and personal interaction, ultimately much like the modular regularity of classical architecture itself. Both, however, were systems that allowed adequate flexibility of expression within a carefully defined grammar and syntax. In the end, the resolution of the enigma of southern life and the architecture that reflected and supported it must be sought through an understanding of these peculiar attitudes and institutions that blossomed and faded in the South like a strange, hybrid flower.

MICHAEL W. FAZIO
Mississippi State University

PATRICK A. SNADON
University of Cincinnati

James F. Barker, David Wallace Houston, Michael W. Fazio, Harlan Ewart McClure, and Vernon Hodges, *South Carolina Architecture, 1970–2000* (2003); James Robert Bienvenu, "Two Greek Revival Hotels in New Orleans: The St. Charles by James Gallier, Sr., and the St. Louis by J. N. B. de Pouilly" (M.A. thesis, Tulane University, 1961); Michael W. Fazio, *Landscape of Transformations: Architecture and Birmingham, Alabama* (2010); Talbot Hamlin, *Greek Revival Architecture in America: Being an Account of Important Trends in American Architecture and American Life prior to the War between the States* (1944); W. Darrell Overdyke, *Louisiana Plantation Homes: Colonial and Antebellum* (1965); William H. Pierson Jr., *American Buildings and Their Architects: The Colonial and Neo-Classical Styles* (1970); Jessie Poesch, *The Art of the Old South: Painting, Sculpture, Architecture, and the Products of Craftsmen, 1560–1860* (1983); J. Frazier Smith, *White Pillars: Early Life and Architecture of the Lower Mississippi Valley Country* (1941).

Historiography of Southern Architecture

The historiography of southern architecture has gone through three major phases. From its roots in local boosterism of the late 19th and early 20th centuries to the more formalized advent of architectural history as an academic discipline in the early 20th century to its theoretical expansion since the 1960s, the study of the history of architecture in the American South has gradually broadened its scope and reach. Southern architecture has traditionally been

neglected in surveys of American architecture, and most scholarly attention to its buildings has come from architects and scholars living in southern states. And although the historiographic methods and perspectives of architectural historians have changed across the past hundred years, the most heavily studied periods remain the colonial and antebellum periods. Much research and writing remains to be done on the advent of modernism in the American South.

The first histories of architecture in the South were inextricably bound up with the local-color movement and with the Southern Renaissance of the 1920s. As such, they are not "proper" histories but instead descriptions and catalogs of the colonial and antebellum buildings thought to be most typical of a particular place. Authors like George Washington Cable promoted romanticized images of an antebellum South, using descriptions of landscapes, people, and buildings, and he set the precedent for nostalgic interpretations of an idealized past, which continue today in the proliferation of series dedicated to "lost plantations" or "lost mansions" of the southern states.

Some of the earliest attempts at preservation in America also contributed to the region's mythmaking. In the late 19th century these efforts focused on George Washington's Mount Vernon and Thomas Jefferson's Monticello in Virginia, Andrew Jackson's Hermitage in Tennessee, and the Mission San Antonio y Valero, better known as the Alamo, in San Antonio, a generation later. The creation of national and regional histories using these early American buildings as "evidence" became a crucial first step in establishing a "canon" of American architecture that spurred large projects like the Rockefeller-sponsored reconstruction of Williamsburg, Va., beginning in the 1920s. Although the stories that early preservationists told were not always accurate, their efforts brought a clear focus on landmarks of southern architecture as crucial symbols of American history and national identity.

The practice of architectural history as an academic discipline has its roots in the founding of the first architecture schools in America in the late 19th century. By the 1920s the first architectural histories of America, distinct from art historical or local history texts, began to appear, and by 1940 the Society of Architectural Historians was founded to give clear focus to the discipline. Early studies of American architecture by such academics as Talbot Hamlin in *The American Spirit in Architecture* (1926) paid little attention to southern practices. When southern architecture did appear in these histories it was as a reflection of northern tastes. In other words, a building like James Gallier's New Orleans City Hall could appear in Hamlin's 1946 survey of Greek Revival architecture

because the quality of its design meant it could stand shoulder-to-shoulder with similar buildings in New York.

Local preservationists continued the process of documenting and interpreting architecture outside of this academic discourse. In New Orleans, for example, beginning in the 1920s, the architects Nathaniel Curtis, Richard Koch, and Samuel Wilson Jr. made enormous strides in studying the physical fabric of the city's French Quarter and in assembling archival research to document the names of previously unknown architects and builders. In Texas in the 1920s, architect David R. Williams documented the vernacular farmhouses of central Texas, many of which had been built by German and Czech settlers in the early 19th century. The Historic American Buildings Survey (HABS), a program established by the National Park Service in 1933 as a make-work program for architects during the Great Depression, formalized the documentation of representative works, state by state. Using photographs, measured drawings, and brief narrative histories, the HABS program documented hundreds of buildings throughout the South and provided material for several monographs and catalogs of southern architecture beginning in the 1980s.

Most architectural histories of the South focus on particular states or cities rather than surveying the region. Mills Lane's popular state-by-state series, *Architecture of the Old South*, published in the 1970s and 1980s, focused on major landmark buildings and consolidated then-current narratives with echoes of the romantic idylls of the 1920s. The series is now updated by the *Buildings of the United States* series, sponsored by the Society of Architectural Historians, which follows the model established by Nikolaus Pevsner's hallowed *Buildings of England*. These catalogs of significant built works in each American state include landmark buildings but, reflecting trends in the discipline, also include vernacular architecture and the larger cultural landscape; the volumes dedicated to Louisiana (2003), Virginia (2002), and West Virginia (2004) have appeared as of 2011. As a complement, a handful of monographs on southern architects have appeared, though many remain neglected, with publication focused largely on antebellum practitioners well known outside the region, including James Dakin, Robert Mills, and Benjamin Henry Latrobe.

Academic study of southern architecture began to expand after the rise of social history as a new methodological strategy for historians in the 1960s and 1970s. The founding of the Vernacular Architecture Forum in 1980 formally marks the influence of this theoretical expansion of the scope and methods of historians on the discipline of architectural history. A work like Wayne Andrews's *Pride of the South: A Social History of Southern Architecture* (1979)

could still restrict the narrative to major landmark buildings, but by the 1980s the long-standing narrative of southern architecture received much-needed expansion. Architectural historians began to look beyond traditional narratives of landmark buildings to reassess the impact of slavery, understand vernacular and folk practices, and look more inclusively at the everyday built environment.

Works like John Michael Vlach's *Back of the Big House* (1993) turned the usual historiography upside down, focusing not on the canonical "big houses," or plantation houses of the white planter class, but on the associated cultural landscapes of slavery. Colonial architecture was also reexamined and given a greater contextualization, accounting for the ways that new architectural traditions both drew on and modified European traditions. Jay Dearborn Edwards's investigations of Creole house types gave new evidence of the impact of African architectural practices as transmitted through the Caribbean and back to the southeastern United States, especially as shown in *A Creole Lexicon* (2004). Dell Upton's *Holy Things and Profane: Anglican Parish Churches in Colonial Virginia* (1987) explored the impact of colonial spatial and social experience on imported typologies.

Gabrielle Lanier and Bernard L. Herman's *Everyday Architecture of the Mid-Atlantic: Looking at Buildings and Landscapes* (1997) used the methods of material culture, as the title suggests, to look at anonymous architecture of agricultural and suburban landscapes. Catherine Bishir's *Southern Built: American Architecture, Regional Practice* (2006) examined the impact of regional craft and folk traditions and examined the role of African Americans and women in the making of architecture in North Carolina. Jessie Poesch's *The Art of the Old South: Painting, Sculpture, Architecture, and the Products of Craftsmen, 1560–1860* (1983) identified larger regional trends of patronage and taste, treating architecture as a commodity.

Social history also encouraged a recontextualization of urban architecture in the antebellum South. S. Frederick Starr's *Southern Comfort: The Garden District of New Orleans* (1989) and Maurie McInnis's *The Politics of Taste in Antebellum Charleston* (2005) took cues from urban history in reconstructing the spatial and architectural practices of urban patrons. The taste for Greek and Gothic Revival architectures is seen in these works not as a pure stylistic standard, as in the early architectural histories, but as evidence of cultural and political ideologies at play.

By comparison, 20th-century southern architecture remains relatively little studied. After World War II, the South became increasingly urbanized, and although some monographs on individual practitioners have appeared (for example, those on Arthur Q. Davis and John Portman), most scholarly attention

to architectural history in this period comes through works that address Sun Belt urbanism. The effects of segregation on southern cities have been considered more in the realm of urban than of architectural design, in such works as Charles Connerly's *"The Most Segregated City in America": City Planning and Civil Rights in Birmingham, 1920–1980* (2005) and the collection of essays edited by Christopher Silver, *The Separate City: Black Communities in the Urban South, 1940–1968* (1995). Here the dynamics of zoning, slum clearance, and urban renewal are examined in ways that suggest new avenues for architectural historians to understand the ways architecture has shaped the social environment.

KATE HOLLIDAY
University of Texas at Arlington

Catherine Bishir, *North Carolina Architecture* (2009); Robert M. Craig, *Atlanta Architecture: Art Deco to Modern Classic, 1929–1959* (1995); Michael Fazio, *Journal of Architectural Education* (August 1991), *Landscape of Transformations: Architecture and Birmingham, Alabama* (2011); Stephen Fox and Richard Cheek, *The Country Houses of John F. Staub* (2007); Robert Gamble, *Historic Architecture in Alabama* (2001); John Howey, *The Sarasota School of Architecture, 1941–1966* (1997); Clay Lancaster, *Antebellum Architecture of Kentucky* (1991); Carl Lounsbury, *The Courthouses of Early Virginia: An Architectural History* (2005); Cynthia Mills and Pamela Simpson, *Monuments to the Lost Cause: Women, Art, and the Landscapes of Southern Memory* (2003); John B. Rehder, *Delta Sugar: Louisiana's Vanishing Plantation Landscape* (1999); Lisa Tolbert, *Constructing Townscapes: Space and Society in Antebellum Tennessee* (1999); Gary van Zante, *New Orleans, 1867* (2008).

Industrial 19th-Century Architecture

No cohesive southern industrial architecture emerged during the 19th century. Despite the growth of sectionalism, the ornamentation and construction techniques of southern mills revealed that they were part of a national movement. The millwrights, engineers, and, in a few cases, architects who planned these structures copied earlier northern models and rarely incorporated any innovations. The configuration of many 19th-century factories was dictated by the manufacturing process, so that specific types of industries developed distinctive buildings with little regional variation. A company's wealth usually determined the degree of embellishment. Stone, wood, or brick covered early mills, but over time brick exteriors became nearly universal, and a standardized industrial style became ubiquitous. Bays separated by brick pilasters, windows and doors crowned with segmental arches, and corbelled cornices and gables characterized warehouses, factories, and related buildings throughout

the nation. Larger edifices exhibited the influence of current Victorian styles with Romanesque, Gothic, or Second-Empire features.

Given these national forces, most southern factories resembled those of their northern competitors. The construction of blast furnaces in North Carolina, Tennessee, Georgia, and Alabama mirrored that of earlier ones in New England and Pennsylvania. The walls of Richmond's Tredegar Iron Works, one of the region's most significant antebellum industries, showed no southern characteristics. Similar brick structures topped by monitors and flanked by squatty chimneys housed iron foundries in cities throughout the North and the South. Tobacco factories in Statesville and Mount Airy, N.C., and in Lynchburg, Va., processed a southern product, but their rectangular, multistoried buildings with embellished stepped-gabled fronts might have sheltered a myriad of other manufactories throughout the nation.

Perhaps the southern economic and physical environment influenced the architecture of some mills. The lack of capital after the Civil War and the abundance of yellow pine caused some southern builders to continue using hand-hewn timbers with mortise-and-tenon joints after they had been superseded by iron or machined posts. These earlier framing methods were employed in rural gristmills and other small factories and for wooden bridges—both covered ones and deck-truss railroad trestles. In some cases, African American craftsmen preserved these traditional techniques; Horace King, a former slave, and his sons built such structures in Alabama, Mississippi, and Georgia through the first decade of the 20th century. Climate probably dictated the configuration of the region's open-sided turpentine stills and sawmills.

Larger urban mills displayed more distinctive styling, which tended to reflect local influences, but such individuality disappeared with the onslaught of standardization. Richmond's Dunlop Mills structure (1853) rose seven stories above the James River. Its vertical emphasis typified flour mills, but its parapet end walls, with lunettes over each bay, gave the appearance of a late 18th- or early 19th-century Virginia building. In Lynchburg, Va., the Piedmont Mills building (ca. 1875), with its pilasters and arched windows, resembled gristmills in any other American city. This uniformity increased as national companies that manufactured milling equipment began designing and constructing complete mills.

Lacking any national models, the architecture of Charleston's three antebellum rice mills evoked the classical mood of the city. The most magnificent of these was Gov. Thomas Bennett's Italian Renaissance "palace," which began milling rice in 1844. Its rusticated lower level, large Palladian windows on the

front and sides, and Greek and Roman details on the remaining fenestration were all copied from various Italian palaces. Its elaborate surface contrasted starkly with the plain, massive timbers that supported it. The interior and exterior bays did not even correspond, and some of the rows of inside columns ended in window openings. Such an exuberant facade might have been an inappropriate screen for a steam engine and milling equipment and it might have been emblematic of the region's, or Charleston's, hostility toward industry, but its grand style was an appropriate reflection of the importance of rice to the city's economy.

Among the South's—and the nation's—grandest structures were those associated with railroads. Viewed both as a gateway to a community and as a symbol of a town's urban status, railroad stations, train sheds, and shop buildings were conceived with special attention to fanciful details. In Nashville, the antebellum Louisville & Nashville depot stood as a fortress, with battlements along the roof and the corner towers, and trains entered through Tudor arches. In Savannah's Central of Georgia complex, normally mundane structures— privies, a water tower, and a smokestack—were combined into an ornamental column. The Central of Georgia's depot, offices, warehouses, and shops were built between 1850 and 1890 and contained classical, Gothic, and Italianate components. Despite their stylistic differences, they collectively illustrated the continuing importance of the railroad to the city and asserted, in brick, the goal of making Savannah the leading cotton center. By the turn of the century, railroad stations in major southern cities resembled Romanesque cathedrals, Gothic castles, and Roman "baths." This railroad architecture was national, not southern; it revealed that southern cities shared the urban ethos that pervaded the rest of the nation.

Textile mills became symbolic of the South's drive to industrialize during the 19th century. Early southern entrepreneurs employed northern-trained millwrights, so the first southern factories repeated the characteristics of Rhode Island spinning mills—narrow buildings, three to five stories in height, with a front stair tower capped by a cupola. With exceptions like the Augusta Factory (1847), which resembled the massive structures of Lowell, most antebellum and the initial postbellum mills remained austere in decoration and limited in volume. After 1880 the scale of factories increased substantially because of improvements in motive power and illumination, but few innovations occurred in the system of interior supports; more wooden posts and beams were simply added to span the greater lengths. Mill engineers gave little attention to improving working conditions.

The design emphasis by the 1880s focused on the exterior of these mills. Decorative brickwork embellished many of their features, especially the cornices and the Romanesque arches of the massive towers that dominated most of these structures. The heavily ornamented mills conveyed a civic dimension by embodying the pride and aspirations of entire communities. Although Victorian in tone and similar to that on northern mills, the ornamentation may also have been an expression of the New South creed (or cotton mill crusade), which promised to transform the region. Ironically, like the corbelled and arched masonry, the impact of industrialism on the South—and on its poverty—was superficial.

Stylistically, the most distinctive New South mills appeared in Georgia and especially in Augusta. Having led the region in textile production for four decades, the Georgia corporations had sufficient internal expertise to design their own plants by the 1880s. Probably the South's most imposing industrial facade was Augusta's Sibley Mill (1880). Because of its crenellated parapet, decorative stair towers, and pavilions topped with finials, some historians have speculated that it was modeled after the British Houses of Parliament, but it probably was intended to imitate, and thereby memorialize, the Confederate Powder Works that had stood earlier on the site. At the same time, its exuberance appeared to have been inspired by the optimism of the New South creed.

By contrast, the Carolina and Alabama mills of the 1880s were built by national engineering firms like Lockwood and Greene, which used more restrained and more uniform designs. The firm planned the Columbia, S.C., Duck Mill (1893), the world's first textile factory to be powered by electricity, but its architecture failed to suggest its uniqueness, and it resembled all the other mills along the Atlantic seaboard. The 1890s publications of Daniel Tompkins, a southern mill engineer, reflected this standardization; his mills varied only in scale. By that decade the exuberance of the New South was waning—as plants grew in size, windowed areas expanded, and less corbelling appeared on the smaller brick areas of these more utilitarian structures. By 1900 the factory was a permanent part of the southern landscape. The triad of brick smokestack, water tank, and mill tower rising above a pine forest marked the location of a textile factory and its surrounding village. The workers and often their houses remained southern in style, but the architecture of the mill building was national in style. Southern sectionalism had been unable to stem the homogenizing force of the national economy.

JOHN S. LUPOLD
Columbus College

Catherine Bishir and Michael T. Southern, *A Guide to the Historic Architecture of Piedmont, North Carolina* (2003); Keith L. Bryant Jr., *Journal of Urban History* (February 1976); Stephen Goldfarb, *Industrial Archeology in Georgia* (1978); Clay Lancaster, *Antebellum Architecture of Kentucky* (1991); Samuel Lapham Jr., *Architectural Record* (August 1924); Theodore A. Sande et al., *Journal of the Society of Architectural Historians* (December 1976).

Nonresidential 20th-Century Architecture

The nonresidential southern architectural styles of the early 20th century can be divided into the same two categories as residential architecture—historic and nonhistoric. Period revivals were very popular in the conservative South. The same styles that adorned residential structures could also be found on nonresidential buildings. The French, Spanish, Dutch, and English Colonial Revival styles, as well as the Federal and Georgian, were very popular, as were the Renaissance, Tudor, and neo-Italianate styles. In addition, four other historical styles were commonly employed for nonresidential structures—Gothic Revival, neoclassical, stripped-down classical, and Beaux-Arts.

The Gothic Revival style (1900–1940) of the early 20th century was primarily used on public buildings, churches in particular. Precedents favored were the English perpendicular and Tudor styles, but the French Gothic was occasionally employed, alone or combined with the English style. The silhouettes of these buildings are very complex, although symmetry is common. These Gothic Revival structures are generally built of masonry stone when available. In commercial buildings, terra-cotta is often used. The most renowned Gothic architects of this period were Ralph Adams Cram and Bertram Grosvenor Goodhue. Cram developed the theory that Gothic architecture had "not suffered a natural death"; therefore, he intended to "take up English Gothic at the point where it was cut off." The Gothic Revival style was particularly popular for southern universities. Loyola of the South in New Orleans and the University of Florida in Gainesville are two such examples.

Neoclassical, stripped-down classical, and Beaux-Arts styles were used for monumental buildings in cities and towns throughout the South. All three are derived from the same source—classical Greek and Roman prototypes—but the manner in which the elements are used distinguishes each style.

Neoclassicism (1900–1940) encompassed Greek, Roman, and Renaissance elements and characteristics composed in the classical manner, with a monumental scale. The 1929 New Orleans Criminal Court Building by Diboll and Owen Architects is a typical example of the style.

Stripped-down classicism, sometimes referred to as fascist moderne, employed the same massing and scale as neoclassicism but made little or no use of historically derived details. Many such public structures throughout the South were built as Depression-era projects by the Works Progress Administration and Public Works Administration. The 1939 State Fair Exhibit Museum in Shreveport, La., is a good example of this style.

Beaux-Arts classicism (1890–1920) employs classical elements in a theatrical or baroque manner. The École des Beaux-Arts in Paris was directly responsible for the reemergence of classicism, but exhibitions like the World's Columbian Exposition (Chicago, 1893), the Louisiana Purchase Exposition (St. Louis, 1904), and the Panama-Pacific Exposition (San Francisco, 1915) propagated the style in the public's mind. Cities of white marble were preferred construction in the national City Beautiful movement.

All three classical styles were popular in the South for governmental and civic buildings, libraries, museums, colleges, theaters, banks, railway terminals, monuments, and memorials. Nonhistorically inspired styles popular during the early 20th century include the commercial, the decorative brick, storefront modern, art deco, and streamline moderne.

The commercial style (1890–1910) rose out of the ashes of the great Chicago fire, to spread across the nation. An anonymous editor of *Industrial Chicago* wrote in 1891, "The Commercial Style is the title suggested by the great office and mercantile buildings now found here. The requirements of commerce and the business principles of real estate owners called this style into life. Light, space, air, and strength were demanded by such requirements and principles as the first objects and exterior ornamentation as the second."

Commercial-style buildings were an early development of the high-rise office complex, and at least one example can be found in every southern city. They are generally 5 to 16 stories, with flat skylines, large windows, and an external structural expression. This style was made possible through such technological advances as steel-frame construction, the passenger elevator, fireproofing techniques, and mechanical ventilation. The Mills Building, designed by Frost and Frost Architects in 1910 in El Paso, Tex., and the Wainwright Building, designed by Adler and Sullivan in St. Louis in 1890, are typical examples.

The decorative brick style was an outgrowth of the commercial style. Whereas the commercial style shunned ornamentation, the decorative brick style used masonry products in an innovative decorative manner. Patterns of masonry pinwheels, sinkages, and polychromatic motifs were employed. The spandrels were generally recessed slightly behind the piers, and the skyline was often broken. Terra-cotta ornaments were sometimes incorporated. Examples

of this style can be found in the Historic Warehouse District in New Orleans, where the Woodward-Wight warehouse by Emile Weil is a typical example.

Many small commercial buildings and stores in small towns are in this idiom. Such buildings are the hallmarks of main streets throughout the nation, including, of course, the South. In many county seats, these are among the buildings that front the streets and the city square, where the county courthouse is situated. The core of small-town life was once centered here.

The storefront modern style developed simultaneously with strip shopping developments. The style, as its name implies, was one that simply addressed the front of the structure, ignored the unseen rear, and had no sides to contend with, except on corner buildings. Intended to be seen from the passing auto, the style used slick, clean materials with bold details and a profusion of neon lights. Opaque glass and baked-enamel panels were often used. The versatility and boldness of the style made it perfect for widespread use by chain stores. By its standardized design of red opaque glass and gold lettering, one recognized a Woolworth store in New Orleans as easily as in Macon.

Art deco (1920–30) was popularly used for high-rise buildings and movie theaters. Stylized ornamentation was perhaps its most recognizable feature. Motifs based on pure geometry, abstracted naturalistic forms, or stripped-down ancient decorative elements manifested themselves in hard-edged, low-relief ornamentation. As a style of ornamentation, art deco evolved in France during the early 1920s as a reaction to art nouveau. The 1925 L'Exposition des Arts Décoratif in Paris diffused a sentiment in America that there could be modern ornamentation. This concept bridged the gap between the Beaux-Arts philosophy, which contended that historical ornamentation was essential, and the Bauhaus philosophy, which renounced all ornamentation. Art deco structures are alive with bold colors, dramatic massing, picturesque skylines, and an emphasis on the vertical, making this style popular for resort areas like the Miami Beach Art Deco District.

Streamline moderne (1930–40) developed during a period of rapid social change. The worldwide Great Depression had caused disillusionment and confusion. The common desire to "get things moving again" demanded drastic solutions. Out of this confusion a new profession emerged—industrial design, which literally reshaped everything in order to stimulate a devastated economy. Industrial designers promoted streamlining as a symbol of the future—a future that combined art, engineering, design, processing, packaging, and sales. Instead of the applied art of art deco, streamlining preferred subtle meaningful forms of ornament. Although buildings were static, the principles of fluid dynamics were applied. Architects had to settle for an abstraction of motion, re-

sulting in slick, curved surfaces. The style was very popular for Greyhound bus stations and gas stations throughout the South.

The architect Theodore Flaxman, of Shreveport, La., was among those Americans who studied and responded early to this modern International style. A municipal incinerator built in the 1930s in Shreveport, and since destroyed, was cited at the 1937 World's Fair in Paris as one of the best examples of modern architecture in America. The Mayer House in Shreveport, built in 1930, is a fine surviving example of this genre.

The Louisiana State Capitol Building, designed by the New Orleans firm of Weiss, Dreyfous, and Seiferth, was one of two skyscraper capitols in the United States (the other is in Nebraska) built in the early 1930s. The architects called it "modern classic," and it used a restrained modern idiom, including symbolic low-relief sculpture on the outside and richly colored marble panels, with echoes of art deco detailing on the inside. Built while Huey Pierce Long was the governor of the state, it is, in a sense, his monument and a monument to his individual brand of populist politics.

ROBERT J. CANGELOSI
New Orleans, Louisiana

Catherine Bishir, *Southern Built: American Architecture, Regional Practice* (2006); Alastair Duncan, *Art Deco Complete: The Definitive Guide to the Decorative Arts of the 1920s and 1930s* (2009); William H. Jordy, *American Buildings and Their Architects*, vol. 3 (1972); Walter C. Kidney, *The Architecture of Choice: Eclecticism in America, 1880–1930* (1974); Carole Rifkind, *A Field Guide to American Architecture* (1980); Leland M. Roth, *A Concise History of American Architecture* (1979); G. E. K. Kidder Smith, *The Architecture of the United States: The South and Midwest* (1981); Dell Upton, *Architecture in the United States* (1998).

Painting and Painters, 1564–1790

The first two important, but unsuccessful, European attempts to establish colonies in the part of North America that is now the United States were in the South. In each of these, an artist-draftsman accompanied the expeditions and was charged with recording impressions of the peoples, the flora, and the fauna of the region, as well as with mapmaking. Thus, Jacques Le Moyne de Morgues in 1564 and 1565 accompanied the French expedition that established a short-lived Huguenot settlement on the St. John's River in Florida, and John White served as cartographer and draftsman to Sir Walter Raleigh's 1585 expedition that established the Roanoke colony. Only one of the original 42 watercolors by Le Moyne survives, while a portfolio of White's work, including 59 water-

colors, has survived. Among these are delicately rendered depictions of the Indian inhabitants, showing them at such tasks as cooking, fishing, and cultivating crops, as well as renderings of plants and creatures. The Indians are made to appear Europeanized, but there is nonetheless valuable ethnological information. These works were disseminated in Europe by Théodore De Bry, who published, in Germany, a series of volumes on the New World, reproducing the drawings of White and Le Moyne as engraved illustrations. De Bry's first volume, *A Briefe and True Report of the New Found Land of Virginia*, published in 1590, featured engravings based on White's drawings and was accompanied by Thomas Hariot's narrative, a somewhat optimistic account of a land with a mild climate like Persia. Between 1590 and 1620 this publication went through 17 printings. The volume with engravings based on Le Moyne's drawings and his text was published in German, French, and Latin some years after the artist's death in 1591. Thus, in the years between 1590 and 1620, when permanent colonies had been established, these volumes and engravings formed the English and European visions of America. Moreover, subsequent books— for example, John Smith's *The Generall Historie of Virginia* of 1624—had illustrations based on De Bry's engravings. Images representing America and extending well into the 18th-century, like that on an 18th-century Spanish tile, were drawn from Smith's *Generall Historie.*

Virtually no paintings or drawings survive from the first 60 or so years of permanent settlement in the South, years in which the settlers suffered from disease, high mortality rates, poor planning, inability to adjust to the hot climate, and poor relations with the Indians. It was far from a Persian paradise. Likewise, very few artifacts, particularly furniture or silver, survive from this period.

One cannot identify surviving paintings and graphic arts created in the South and find records of artists and their patrons before the early years of the 18th century, which brought the development of the plantation society and the growth of towns. Patrons were largely of the planter and merchant classes, and their choice was for portraits. This preference was shared with fellow colonists in the North and indeed with many English people.

A German-born artist, Justus Engelhardt Kühn, recorded the likenesses of several Maryland and Virginia planter families, often showing them posed in elegant settings whose source lay in remembered European scenes or in prints. In Charleston, Henrietta Johnston used pastels to render delicate interpretations of her patrons. She was the wife of a minister and supplemented her husband's income with her work. Charles Bridges was an agent for the missionary Society for Promoting Christian Knowledge and earned part of his income by

painting portraits of notables in the Williamsburg area. An unidentified artist working in the Jamestown area recorded the likenesses of members of the Brodnax and Ambler families. Mid-18th-century painter William Dering also worked in and around Williamsburg.

Another Englishman, John Wollaston, lived in Maryland, Virginia, and South Carolina intermittently from 1753 to at least 1767. His elegant, graceful renditions of his subjects helped to introduce the rococo taste. Swedish-born artist Gustavus Hesselius is known to have worked in Maryland, and possibly in Virginia, before settling in Philadelphia. His son, John, found patrons in Virginia and in 1763 settled permanently in Maryland. With these three artists one can begin to trace more clearly some of the interactions and interrelationships among artists in the southern colonies. Wollaston appears, for example, to have influenced in part the style of Hesselius. The latter no doubt taught his son something of the art and craftsmanship of painting. John Hesselius in turn is known to have been the first teacher of Charles Willson Peale, who was born in Maryland and was among the slowly growing number of aspiring young American-born artists who spent a year or more studying in England. In Peale's case, as with a number of his generation, he was taught by his fellow American, Benjamin West, who was only a few years his senior but well established in London. Peale returned and settled for a time in Annapolis; some of his finest works portray Marylanders and Virginians. He later moved to Philadelphia and made some visits to the southern states. Several of his children and nieces and nephews, who also became artists, visited the South in search of patrons. His son Rembrandt Peale lived for a time in Baltimore, where he established the short-lived Peale Museum in 1797.

In Charleston, artist Jeremiah Theüs enjoyed something of a monopoly of patronage from 1739 until his death in 1774. Born to a Protestant family in Switzerland, he immigrated with them as a youth to South Carolina, to escape religious persecution. There is a certain stiffness in many of his portraits, but this is often redeemed by his skillful use of color and his feeling for elegant fabrics. During the 18th century, southerners living on the Atlantic seaboard often maintained close business and personal ties with England; young men were sometimes sent there for their education. During visits to the homeland, they had their portraits painted, thus carrying artistic patronage beyond the borders of the region.

As one examines these portraits of the 18th century, it is fair to say that patron and artist alike wished for an image that was a likeness and a statement of the status of the sitter. Rich fabrics, satins, velvets, and laces were fashionable and are depicted in portraits. Often several members of a family were painted as a

group, thus emphasizing the importance and continuity of family ties. The first renderings of flora and fauna of the present United States, as done by Le Moyne and White, were based on those in the Southeast. Likewise, the first systematic study and publication of natural history in North America, Mark Catesby's two-volume *Natural History of Carolina, Florida, and the Bahama Islands*, drew upon this verdant region for most of its material. Catesby, an Englishman, first visited the American continent from 1712 to 1719. His interest in the natural history of the New World and his collection of its specimens led a group of naturalists to sponsor a second trip in 1722–25. Upon his return to England, Catesby learned to do engravings and embarked upon publication. His illustrations are among the first to depict animals and birds in their natural habitats. In his engraved depictions, he deliberately eschewed shadows, both because he felt they were beyond his competence and because he believed greater accuracy could be achieved without them. To the modern eye, his illustrations have an appealing naive quality. A three-folio collection of his natural history drawings on which his plates are based is now in the Royal Collection at Windsor Castle. Two other artist-draftsmen who may have hoped to achieve such publications as those given to White, Le Moyne, and Catesby are Alexandre De Batz and Philip Georg Friedrich Von Reck. De Batz was connected with the French military forces in Louisiana, and a small group of his surviving drawings, dated between 1731 and 1735, are in the Peabody Museum in Boston. They include a drawing of a temple and chief of the Acolapissa Indians and one showing Choctaw warriors and children. These are among the earliest surviving visual documents from the Deep South. (The numerous architectural plans and elevations done by the French engineers in connection with the colonies in Mobile, New Orleans, and the adjacent areas represent another group.) Von Reck's journal and drawings have only recently come to light; they have been stored in the Royal Library of Denmark, apparently since the 18th century. A Protestant German, Von Reck accompanied a group of Salzburgers who established a settlement in Georgia in 1734 and again in 1736. He stayed only a few weeks on his first visit and a few months on his second, but during these times he made a number of drawings of flora and fauna found in that region as well as several straightforward drawings of the Yuchi Indians. Some of these drawings are captioned in several languages — Yuchi, Greek, German, and French or English. The works of both Von Reck and De Batz are valuable documentaries of the first encounters of Europeans and the native peoples in the New World.

JESSIE POESCH
Tulane University

Francis W. Bilodeau and Mrs. Thomas J. Tobias, eds., *Art in South Carolina, 1670–1970* (1970); Cary Carson, Ronald Hoffman, and Peter J. Albert, *Of Common Interests: The Style of Life in the Eighteenth Century* (1994); Bruce W. Chambers, *Art and Artists of the South: The Robert P. Coggins Collection* (1984); Mary Weaver Chapin, *Catesby, Audubon, and the Discovery of a New World: Prints of the Flora and Fauna of America* (2008); David Driskell, *Two Centuries of Black American Art* (1976); James T. Flexner, *First Flowers of Our Wilderness: American Painting, the Colonial Period* (1969); Caroline M. Hickman, *Southern Quarterly* (Fall–Winter 1985); Donald B. Kuspit et al., *Painting in the South, 1564–1980* (1983); Jessie Poesch, *The Art of the Old South: Painting, Sculpture, Architecture, and the Products of Craftsmen, 1560–1860* (1983); Kim Sloan, *A New World: England's First View of America* (2007); Carolyn J. Weekly, *Antiques* (November 1976 and February 1977); Ben F. Williams, *Two Hundred Years of the Visual Arts in North Carolina* (1976).

Painting and Painters, 1790–1860

Portraiture was the most popular art form, in both the North and the South, during the early years of the rapidly expanding new republic. Portrait painters were legion, and the careers of many have not been examined. Even though the South was less densely populated than the North, many artists practiced their skills in local communities, both large and small. Thomas Cantwell Healy worked in Port Gibson, Miss., in the 1850s, and a number of French-born artists, especially Jean-Joseph Vaudechamp and Jacques Guillaume Lucien Amans, established themselves in New Orleans during the 1830s through the 1850s. Artists like Matthew Harris Jouett and Ralph Eleasar Whiteside Earl found their patrons in relatively new communities west of the Appalachians, for example, Lexington, Ky., and Nashville, Tenn.

Many portraits reflect changing tastes and values. The 18th-century feeling for elegance is seen in paintings by Thomas Sully's student, Thomas Story Officer, who was in Mobile and Richmond in the 1830s and 1840s. In general, however, painters moved toward the austerity of the neoclassical and an ever-greater emphasis on the very realistic. There was little idealizing. Though some paintings exist of young and beautiful women who might qualify as "southern belles," considerably more are of such unpretentious matrons as a stern-looking portrait of the wife of Isaac Shelby, a governor of Kentucky, painted in 1827 by Patrick Henry Davenport, now in the Kentucky Historical Society.

During this period one can trace a developing iconography of national and regional heroes. Gilbert Stuart was one of several artists who helped make George Washington's image familiar through the many copies of his portraits. Some of these found their way into the South, adorning county courthouses

or city halls. Legislative bodies commissioned portraits. North Carolina commissioned two full-length portraits of Washington from Sully. A misunderstanding occurred, and Sully produced a dramatic canvas of *Washington Crossing the Delaware* that was too large for the space; it was refused and now is in the Boston Museum of Fine Arts. The city of Charleston still owns a handsome full-length portrait of Washington, which was commissioned from John Trumbull and was completed in 1792. Charleston also has an excellent miniature painting of the Marquis de Lafayette by Charles Fraser. The city of Richmond and the state legislature of Kentucky were among other political bodies that commissioned portraits of the renowned General Lafayette when he made his grand return visit to the United States in 1825. Earl became the virtual court painter of Andrew Jackson after he attained fame. Other heroes who were portrayed a number of times include Thomas Jefferson, John Calhoun, Henry Clay, and Daniel Boone.

The painting of miniatures—small, intimate portraits in watercolor on ivory—enjoyed a special popularity in the early decades of the 19th century. One of the finest of the practitioners of this art was Charles Fraser of Charleston. In 1857 Fraser was given a retrospective exhibition in his native city, and over 400 of his miniatures were shown. He was particularly adept in painting the elderly, showing them in honest yet sympathetic likenesses.

Several artists, like Jacob Frymire, Joshua Johnston, and Charles Peale Polk, all of whom worked in the late 18th or early 19th century, might be classified as slightly naive painters. Polk and Johnston worked in and around Baltimore. Johnston is important as the first known professional African American painter in the European tradition. Both Polk and Frymire traveled in western Maryland and Virginia as itinerant painters.

The biracial and multiracial nature of southern society is visible in a number of paintings from this era. Several portraits of free people of color, particularly one ca. 1860 painting attributed to François Fleischbein, or the ca. 1824 portrait of James Armistead Lafayette by John R. Martin, show dignified and attractive individuals. George Catlin included Seminole Indians among the subjects he recorded in the 1830s. A handsome, full-length portrait of Creek Indian chief William McIntosh is attributed to Nathan Negus and Joseph Negus. The Seminole leader Osceola was painted by Robert R. Curtis of Charleston and by Catlin in 1838. Among the most poignant of paintings of African Americans is the large *Plantation Burial* executed in 1860 by John Antrobus in Louisiana. It is a sympathetic depiction of a moment in the private lives of members of a slave community.

During the late 18th and early 19th centuries, landscape painting gained im-

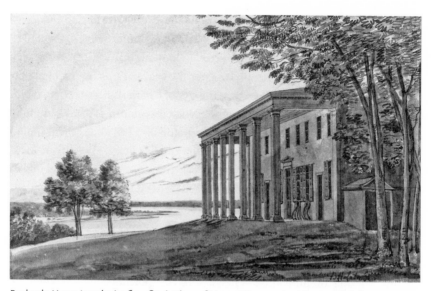

Benjamin Henry Latrobe (1764–1820), View of Mount Vernon, looking toward the
Southwest (Benjamin Henry Latrobe Collection, Maryland Historical Society, Baltimore)

portance as a genre in the United States, particularly in New York State and
New England. George Beck painted several picturesque views of Baltimore in
the late 1790s. George Washington was one of his patrons. The meticulously
rendered scenes by Francis Guy qualify more as portraits of cities than as land-
scapes proper. Both Beck and Guy helped launch the development of land-
scape painting. In general, however, this development in the South was fitful
until after the Civil War. George Cooke, working in the 1830s, and Thomas
Addison Richards were among artists who wrote on the virtues of scenery in
the South, and each executed cityscapes and landscapes. Richards, however,
candidly admitted that the terrain was difficult, distances too great, transporta-
tion poor, and access to urban centers limited. William Charles Anthony Fre-
richs was one who caught the drama of the North Carolina mountains on his
canvases. James Cameron, working in Chattanooga in the late 1850s, recorded
the dramatic terrain of that area. In an impressive painting showing Col. and
Mrs. James A. Whiteside, their children, and their servants, this artist com-
bined group portraiture and landscape. A large and richly detailed painting
of the New Orleans waterfront executed in 1853 by Hippolyte Victor Valentin
Sébron and now in the collection of Tulane University is another work that is
more cityscape than landscape. Influenced by Louis-Jacques-Mandé Daguerre,
it has an open-ended "slice-of-life" quality that presages compositional con-
cepts of the impressionists.

The most famous of all American painters of natural history, John James Audubon, made many of his preliminary studies for his *Birds of America* in the Deep South, particularly in Louisiana, Mississippi, and South Carolina. Outdoor life, sports, and horse racing were popular in the South, so it is no surprise that the most popular animal or horse painter in the United States in the 19th century, Edward Troye, spent most of his time in the South. Troye lived for some time in Kentucky and Alabama and traveled throughout the region. Many of his works, which often include depictions of jockeys and trainers, are still in private collections.

The lives of a number of painters were abruptly changed with the advent of the Civil War. Some artists left the region, others joined the military forces, and those who remained found few patrons in the years 1860 to 1865.

JESSIE POESCH
Tulane University

William S. Ayres, *Picturing History: American Painting, 1770–1930* (1993); Bruce W. Chambers, *Art and Artists of the South: The Robert P. Coggins Collection* (1984); James H. Craig, *The Arts and Crafts in North Carolina, 1699–1840* (1965); David C. Driskell, *Two Centuries of Black American Art* (1976); David Moltke-Hansen, *Art in the Lives of South Carolinians: Nineteenth-Century Chapters* (1979); Donald B. Kuspit et al., *Painting in the South, 1564–1980* (1983); Estill Curtis Pennington, *Kentucky: The Master Painters from the Frontier Era to the Great Depression* (2008), *Romantic Spirits: Nineteenth-Century Paintings of the South from the Johnson Collection* (2011), *William Edward West, 1788–1857: Kentucky Painter* (1985); Jessie Poesch, *The Art of the Old South: Painting, Sculpture, Architecture, and the Products of Craftsmen, 1560–1860* (1983); Eleanor Swensen Quandt et al., *American Painters of the South* (1960).

Painting and Painters, 1860–1920

The differences in circumstances between the South and its peoples and the rest of the nation were probably felt most acutely by southerners during and after the Civil War, extending until World War I. In many cases, these differences lasted until World War II—and, in part, still exist. They affected artists and their choices of subjects in subtle ways and significantly reduced their chances for showing and selling their works. Nevertheless, artists who worked in the South were influenced by the same artistic trends that influenced artists in other parts of the country.

During the Civil War, Winslow Homer, Edwin A. Forbes, Henry Mosler, Alfred Rudolph Waud, and William Waud were among artists who followed the troops and recorded day-to-day events for popular journals. Homer also cre-

ated oil paintings based on his observations in the South at this time, including *Defiance: Inviting a Shot before Petersburg, Virginia* (1864) and *At the Cabin Door* (1865–66). The first suggests the courage and sometimes foolhardiness of soldiers in that conflict; the second indicates the proud, quiet hopes and subtle defiance of African Americans at this time. Conrad Wise Chapman joined the Confederate army and, after being wounded, was reassigned to Charleston, S.C., and ordered to illustrate the city's fortifications. His series of 31 small oil paintings on board, though most frequently viewed for their historical content, are noteworthy for their freshness and clarity.

In Richmond, William Dickinson Washington painted the *Burial of Latané* in 1864, recording an incident of 1862 and showing white women and slaves performing a young war hero's burial service, a service attended by white children but by no adult white males. In 1869 Everett B. D. Julio painted a large-scale double equestrian portrait showing the imagined conference of generals Robert E. Lee and Stonewall Jackson on the eve of the battle of Chancellors-ville—a battle in which Jackson was mortally wounded. Prints based on these two paintings subsequently enjoyed wide circulation among white southerners and became symbols of the Lost Cause—the death of heroes and the role of women who carried on nobly in the absence of their men. Mosler's painting *The Lost Cause*, first exhibited in 1868, depicted a weary infantryman returning to his ruined cabin, thus focusing on the effect of the war on ordinary yeoman farmers of the highlands. This painting was reproduced in chromo-lithographs and widely circulated. In the late 1860s John Adams Elder's *Battle of the Crater* and a notable posthumous portrait, *Stonewall Jackson* (Corcoran Gallery of Art), were well known. In the decades after the war, still other artists painted imaginary episodes of the conflict, among them Gilbert William Gaul and Xanthus R. Smith. Alfred Waud was one of several artists whose drawings record the South during Reconstruction, and Forbes and Waud later contrib-uted illustrations for late 19th-century publications on the war. Consequently, a group of now little-known paintings and drawings formed an iconography of noble defeat, an ethos that helped salve the pride of white southerners during years of poverty and reconstruction.

Homer returned to Virginia in the 1870s and executed a group of paintings of southern African Americans, all characterized by quiet dignity and forth-right depiction. Richard Norris Brooke, Lucien Whiting Powell, and Elder were Virginia artists who painted everyday life of African Americans in the 1870s and 1880s. Lyell E. Carr painted a similar series of rural black Georgia life in the 1890s. The intent of the artists was to show "sober and truthful" depictions of these impoverished peoples. All of these artists were influenced in part by

changing European choices of subjects; the southern African American, for example, was equated with the picturesque laboring peasant and thus became an emblem of the South. To the 21st-century eye, some of these depictions have a sentimental quality—though they are a far cry from the caricature seen on minstrel show sheet-music illustrations. These artworks record blacks as a passive, untroubled people, a view shared by both northern and southern whites. They record the role of African Americans in the life of the South, and many are painted with great skill and present their subjects with great dignity. William Aiken Walker's small paintings of black families and their cabins frequently served as picturesque mementoes that northern visitors to the southern resorts took home. Less successful artistically, they too are known for their depictions of African American rural southerners and their heritage.

The southern landscape—particularly the quiet rural life along the bayous and streams of south Louisiana and the Gulf Coast—became the favorite subject for artists Richard Clague Jr., Marshall Joseph Smith Jr., and William Henry Buck. Joseph Rusling Meeker, who had served with the Union navy, returned again and again to the Deep South to paint the verdure and humid atmosphere of the wetlands. Flavius Fisher, living in Lynchburg, Va., made the open spaces of the Dismal Swamp his theme. Further north, such artists as Carl Christian Brenner and Clarence Boyd painted the characteristic woodlands of Kentucky in a style that has roots in the Barbizon school of France and in the reverent and meticulous response to nature articulated by Asher Brown Durand of New York. Though their paintings were based on the world around them, these artists were not self-consciously regional in the later spirit of the 1930s.

Occasionally their critics expressed a strongly regional attitude. Praising Clague's work on 21 January 1871, a reviewer in the *New Orleans Commercial Bulletin* spoke of his ability to capture "the characteristics of our peculiar scenery" and, in perhaps an oblique reference to the dramatic works of artists like Albert Bierstadt, said that "there is no meretricious glare about these fine studies, no straining after effect." In the early 20th century, Ellsworth Woodward of New Orleans, following the precepts of the Arts and Crafts movement and of educational reformer John Dewey, exhorted artists of the region to draw from their own environment for the subjects of their works.

During the 1870s Florida began to attract visitors; it was the "new Eden," the still-unspoiled paradise of the expanding industrial nation. Northern artists like Homer, with his brilliant late watercolors of the tropics (including Florida), Thomas Moran, and William Morris Hunt were among those who spent one or more winters there. Martin Johnson Heade first came to Florida in 1883 and later settled in St. Augustine, where he led a small artists' colony until his death

in 1904. His glowing landscapes of the wetlands of Florida show a still-primitive wilderness. George Inness, and then his son, George Inness Jr., found warmth and a sense of union with nature in Tarpon Springs, Fla. Elliot Daingerfield, a native of North Carolina, was a close friend and associate of the elder Inness in New York. In his mature years, he returned regularly to his summer home in Blowing Rock, N.C., where he painted the familiar contours of the land in muted tonalities, which also suggest his deep, religious feeling for the spiritual quality of the natural world.

Knowledge of women artists practicing in America in the late 19th and early 20th centuries is still somewhat limited, but at this time several women artists from the South emerged. Clara Weaver Parrish and Anne Wilson Goldthwaite, both of Alabama, were among artists who received their training and spent much of their artistic careers in New York, though each returned to the South with some regularity and included southern subjects in their works. This emergence of women artists coincided with the woman suffrage movement and the slow access to higher education gained by women at this time. Newcomb College of Tulane University, founded in 1886–87, was one of the first women's colleges in the South to have an extensive art training program. Painter Gertrude Roberts Smith and ceramic designer Mary Given Sheerer were both teachers at Newcomb College and important artists in their own right, and they helped to shape a generation of women artists after the college's founding.

Artistic organizations, formed from time to time in various southern communities, provided opportunities for meetings among artists, instructed aspiring artists, and provided occasions for exhibits. In New Orleans, for example, the Southern Art Union was organized in 1880, lasting until 1886. The Southern Arts League was organized in 1885, changed its name to the Artists' Association of New Orleans, and officially incorporated in 1886; by 1899, it had 63 members. In 1901 the Arts and Exhibition Club was founded, and by 1905 it had merged with the Artists' Association, thus forming the Art Association of New Orleans. The group still exists, although it is now one among many art groups in the city. The Arts and Crafts Club of New Orleans was incorporated in 1922 and continued as an exhibiting and teaching organization until March 1951. Similar organizations were formed in other cities and areas, some short lived, others surviving for considerably longer times, notably the Nashville Art Association, the Waco Art League in Texas, the Carolina Art Association in Charleston, and the Mississippi Art Association.

One national culmination of this local and regional artistic activity was the formation at a meeting held in Washington, D.C., in May 1909 of the American Federation of Arts, an organization that aimed to include "all institutions, soci-

eties, city and village improvement associations, and schools and other organizations in the United States, whose purpose is to promote the study of art, the cultivation of the public taste, and the application of art to the development of material conditions in our country." Though the majority of those attending the founding meeting were from New York, Boston, and Philadelphia, delegates included those from the Art Association of New Orleans, the Carolina Art Association, and the Waco Art League, as well as a number from Maryland organizations and a sizable group from private and public organizations based in Washington, D.C., then still a very southern city. William Woodward, representing both the Art Association of New Orleans and Tulane University, was one of the principal speakers.

Despite the efforts of local and regional organizations, artists in the South still found it difficult to find patrons and to exhibit their works. The area was still essentially rural, and the art groups were quite small. Another organization designed to help artists reach a wider audience was the Southern States Art League (SSAL), founded in 1921. One of its founders, Ellsworth Woodward, bemoaned the fact that so many of the South's best artists had found it necessary to leave the area and had achieved success only in the North. The SSAL regularly sponsored exhibits and meetings until its virtual demise in 1946. Its most successful exhibit was held in Nashville in 1935, when over 12,000 people attended.

Despite many artists' seeming isolation, the influence of the impressionists and the symbolists found its way into the South during the last decade of the 19th and the first two decades of the 20th centuries through the network of communication in the artistic world. Evidence of this influence is seen in the works of artists like William and Ellsworth Woodward, Alexander John Drysdale, and Gertrude Roberts Smith, all of New Orleans; Robert Loftin Newman, whose roots were in Tennessee; William Posey Silva, who depicted landscapes of Tennessee and Georgia; Julius Garibaldi "Gari" Melchers in Virginia; and Julian Onderdonk in San Antonio.

JESSIE POESCH
Tulane University

William S. Ayres, *Picturing History: American Painting, 1770–1930* (1993); Bruce W. Chambers, *Art and Artists of the South: The Robert P. Coggins Collection* (1984), *Southern Quarterly* (Fall–Winter 1985); David C. Driskell, *Two Centuries of Black American Art* (1976); Max Kozloff, *Artforum* (May 1973); Donald B. Kuspit et al., *Painting in the South, 1564–1980* (1983); David Moltke-Hansen, *Art in the Lives of South Carolinians: Nineteenth-Century Chapters* (1979); Estill Curtis Pennington,

Downriver: Currents of Style in Louisiana Painting, 1800–1950 (1991), *Look Away:*
Reality and Sentiment in Southern Art (1989); Pauline Pinckney, *Painting in Texas:*
The Nineteenth Century (1967); Eleanor Swensen Quandt et al., *American Painters*
of the South (1960); Ben F. Williams, *Two Hundred Years of the Visual Arts in North*
Carolina (1976); Peter Wood, *Near Andersonville: Winslow Homer's Civil War* (2010).

Painting and Painters, 1920–1960

The modern period in southern painting can be said to begin in the early 1920s
with the activities of the Fugitive group at Vanderbilt University in Nashville.
Although the Fugitives were essentially a literary group, they were also con-
cerned with theories of artistic expression in general, especially with regard to
the South. Their importance lies in their cosmopolitan attitude toward creative
expression. The four major figures in the movement were Donald Davidson,
John Crowe Ransom, Allen Tate, and Robert Penn Warren. Although re-
specting the new modernism that spanned national boundaries, they regretted
that southern culture, as they had known it, appeared to be dissolving under
the pressure of the new industrial age. Like the modern artist in general, the
Fugitives struggled with the rift between reason and the imagination, between
science and faith; they assumed the mantle of the modern sensibility but set out
to make it uniquely southern as well. Davidson, always the Fugitive with the
strongest sense of his southern roots, wrote an essay for the *Saturday Review*
in May 1926 titled "The Artist as Southerner." He felt that any artist who chose
his materials exclusively from his surroundings was provincial, not innovative
or modern, yet he recognized the peculiar clash between modernism and tra-
dition that marked the dilemma of the southern artist.

The Fugitives were not the only ones to recognize that a new period of ex-
pression was at hand. The circle of the *Double Dealer* magazine, published in
New Orleans from 1921 to 1926, sought to end the artistic backwardness that
they, like the Fugitives, had perceived as the South's lot since the end of the Civil
War. William Faulkner, who would best exemplify the new southern artist, was
among the younger southerners featured in this magazine. Another magazine,
the *New South*, begun in Chattanooga in 1927, turned matters in its first issue
more expressly to art. In a spirited essay, "The South in American Art," a writer
extolled the southern artists who painted the local yet American scene. "We
must build and maintain schools wherein Southern talent may be educated and
trained," he wrote, "and thereby interpret the spirit and traditions of the South,
which can only be expressed by native artists."

The call for painters of the southern scene was sparked by the activities of
Thomas Hart Benton, who traveled extensively in 1928 and 1929 over the back

roads of the Deep South, gathering material for his major mural programs in New York in the early 1930s on American history and culture. The paintings that Benton produced on his trip through the South were prophetic of the kind of work to which many southern painters would turn in the 1930s. One southern artist who echoed Benton's activity in the same period was Conrad Alfred Albrizio, who completed an important mural cycle in 1930 for the Louisiana State Capitol Building in Baton Rouge. The building was the brainchild of the flamboyant governor Huey Pierce Long and was one of the most successfully designed and decorated public buildings of its time. Albrizio's cycle of paintings, done for the governor's reception room, has unfortunately been lost; however, complete sketches survive to show that the artist executed a series of narrative scenes of the daily life of the state, including a panel depicting industrial activity.

Likewise, artist Roderick Dempster MacKenzie, working in Birmingham, Ala., completed four large panels depicting the history of that commonwealth for the domed central portion of the statehouse. This kind of artistic activity in the South increased markedly with the onset of the Great Depression and the art programs of Franklin Delano Roosevelt's New Deal. Between January 1933 and April 1939, the social service wings of the New Deal poured nearly $2 billion into the southern states, providing large-scale relief and resulting in many wide-ranging physical improvements. The federal art programs had a direct and profound effect on painting activity in the South. One result was the rapid emergence of an even greater sectional feeling with regard to the development of the arts. By encouraging a regional focus, the New Deal programs had the effect of turning many southern artists and communities inward.

In order to comprehend fully the nature of painting in the South in the 1930s, it is necessary to understand the Agrarian and regionalist movements. The Agrarian philosophy, which grew out of the earlier Fugitive movement in Nashville, had to do with the desire, in Allen Tate's words, for "getting back to the roots" of the southern experience. The Agrarians posited a duality between agrarian and industrial society, with the latter viewed as a threat to southern civilization. However, this movement was far from simplistic; the arguments of its best writers were often impassioned and stimulating. Davidson again set the tone in an article titled "A Mirror for Artists," in which he maintained that the duty of the southern artist was first to be an active member of his community. Seen in this context, one can understand the participation of an artist like Albrizio in a symposium in 1936 titled "The Arts in the Community." Albrizio echoed the aims of other southern painters of this period by calling for work that would "appraise the people of the community, their spirit, and their degree

of culture." He went on to execute mural programs in several southern cities throughout the decade, maintaining that the artist's role was to help the average southerner understand that "the real values of everyday life" and "the beauty of simple things" were the keys to lasting artistic expression.

Albrizio's beliefs were typical of the regionalist movement as a whole in the decade of the 1930s. Richard Blauvelt Coe, who painted the Birmingham steel mills in this period, had identical views. He headed the Alabama section of the Works Progress Administration (wPA), saying that "American art for and by the American people is a slogan worth heeding." Another Alabama artist who was equally active along these lines was John Kelly Fitzpatrick, who assisted in the establishment of the Alabama Art League in Montgomery in 1930. Three years later, on the banks of the Coosa River in Elmore County, Fitzpatrick founded the Poka-Hutchi Art Colony, which flourished during the summers until 1948. This art colony attracted some of the South's leading artists, many of whom were keenly interested in depicting the lives of the rural people, African American or white. Artists like Howard Norton Cook followed in Benton's footsteps and traveled through the region in order to portray the southern worker realistically, yet with sympathy and dignity. In many respects, the concerns of artists like Cook mirrored those of major regionalist thinkers like Howard W. Odum of the University of North Carolina at Chapel Hill, who steered the old southern sectionalism into a constructive investigation of local culture as a part of a larger national picture.

In 1936 a young painter named Lamar Dodd was appointed to the art faculty of the University of Georgia after winning an award at the annual exhibition of the Art Institute of Chicago for a painting depicting a slag dump and railroad cut near Wylan, Ala. Such a subject was typical for Dodd, who preferred to paint things that captured, in his words, "the mood of the place," the everyday South. Like many southern artists in this period, Dodd had trained at the Art Students League in New York before returning to his native area to paint and teach. He soon gained a reputation as the outstanding artist in Georgia, and he was active in many educational, civic, and professional groups, including the Association of Georgia Artists and the Southeastern Art Association. Thus an energetic artist like Dodd was able to found a large and important center for art at the University of Georgia, and the South began to have a generation of young artists trained largely in their native region.

Activity was under way in Mississippi as well. The Mississippi Art Association, founded in 1911, was followed by the Gulf Coast Art Association of Biloxi, with William Woodward of New Orleans as president. Individual painters in Mississippi, while not as numerous as in the neighboring states of Alabama

and Louisiana, nevertheless mirrored similar social concerns in their work, as in Marie Atkinson Hull's paintings of sharecroppers, which she painted after her return from extensive study in New York and Europe. Again, such depictions were meant to dignify, not demean, the individual. One contemporary newspaper account of Hull's sensitive portraits recognized their "clear sharp eye and indomitable spirit," with the subjects "slightly stooped by [their] toiling decades but strengthened rather than broken by them." The Mississippi artist who gained greatest recognition in the 1930s was John McCrady, who initially worked in Oxford, where he collaborated with Faulkner on student publications. McCrady was vocal about wanting to paint southern subjects, and he soon set up a studio in New Orleans, where he achieved a national reputation as a regionalist while completing work for the WPA. In 1937 he was featured in *Life* magazine, and the following year he helped found an association of artists called A New Southern Group. In 1939, he was awarded a Guggenheim fellowships to paint "the life and faith of the southern negro."

Clearly, the regionalist movement had an overriding effect on the painting of the South in this period, and just as clearly, to the artists regionalism was less a matter of blind nativism than cultural growth. This was nowhere more apparent than in Dallas, Tex., where strong new artistic activity centered on the events of the Texas State Centennial in 1936. A group of talented younger artists, who were informally labeled the Dallas Nine, rose to prominence and developed what became one of the most notable and original regional schools of southern painting. Dallas stood at the boundary of the Southeast and the Southwest, and the paintings of the Dallas Nine reflected that duality. The principal artists in the group were Alexandre Hogue, Jerry Bywaters, Otis Marion Dozier, William Lewis Lester, and Everett Franklin Spruce. All but Spruce, who hailed from Arkansas, had been raised in Texas in rural communities. Their paintings depicted rural and urban subjects, set against the Texas landscape, and were characterized by clarity and openness of space and light. No single artist dominated this important group, and they all were intensely active in community affairs, teaching, writing, and working with local galleries and the newly built Dallas Museum of Fine Arts. This group was active until the events of World War II forced them to go their separate ways; yet they exemplified the enormous impact that a regionalist aesthetic had on the development of southern culture.

Throughout the Depression era, many southern painters, including the members of the Dallas Nine, felt compelled to portray the southern black as a way of coming to grips with the reality of their own environment. In a similar way, the decade of the 1930s witnessed the expanding struggles of the African

American artist's search for his own roots—roots far deeper and harder to trace. As early as 1921 W. E. B. Du Bois, writing in the *Crisis*, maintained that "the transforming hand and seeing eye of the artist, white or black," were needed to help in the search for African American identity. Alain Locke's *The New Negro*, published in 1925, began to spur interest in African American folklore and art as a method of turning social disillusionment into racial pride. In 1931, Locke, then professor of philosophy at Howard University, published an article in the *American Magazine of Art* titled "The American Negro as Artist," in which he surveyed the work of the major African American artists of the period, many of whom had come from the South. He had warm words of praise for a younger generation of artists who aimed to express in their art the "race, spirit, and background as well as the individual skill and temperament of the artist." One of these artists was William Henry Johnson, who was just then beginning his remarkable career. Born in Florence, S.C., but associated with Charleston, Johnson studied at the Art Students League in New York and was awarded a William E. Harmon Foundation Prize for further study abroad. In 1938 he began teaching at the Harlem Community Center in New York and exhibited his works to increasingly wide acclaim; yet it was not to last. His color denied him the opportunity and recognition that he deserved, and his later life was marked by tragic circumstances. Other artists managed to turn such prejudices to their advantage. Aaron Douglas, who founded the department of art at Fisk University in Nashville and taught generations of students, is an example. Douglas was trained in New York and was an active member of the Harlem Renaissance; he furnished the illustrations for Locke's book *The New Negro*. With the help of Edwin Augustus Harleston, another African American artist from Charleston, Douglas completed a series of highly significant murals depicting the course of "Negro history" for the library at Fisk University. As an artist, Douglas maintained that he wanted to "place himself where the people are," and his selfless contributions to the development of African American art in the South cannot be overemphasized.

A number of young white southern painters were also interested in the sympathetic portrayal of African Americans along the lines suggested by Douglas and were committed to change during this period. Charles Eugene Shannon, who was born and raised in Montgomery, Ala., studied at the Cleveland School of Art and returned in 1935 to Butler County, where he built a log cabin and proceeded to paint a number of expressionistic works about southern African Americans. "I came to love this land," the artist wrote, "the plants and people that grew from it." In 1938 Shannon received a Julius Rosenwald Fellowship, "for Southerners who are working on problems distinctive to the South." The

following year Shannon and a group of friends organized a cooperative venture in Montgomery, which they called New South, designed to enrich the cultural life of the area by gathering together artists and artisans to work in a gallery and theater and to teach workshops and classes.

In Virginia a similar effort was made by Julien Binford, who had returned from his studies in New York to buy a piece of land in Fine Creek, where he busily converted the ruins of an old foundry into a house and studio. Binford was one of the first recipients of the Virginia Artist Fellowship, instituted by the Virginia Museum of Fine Arts in Richmond, and he used it to conduct classes at the Craig House Negro Art Center. In 1942 he produced a much-heralded mural for the African American congregation of the Shiloh Baptist Church near his home. Binford's contemporary, Robert Gwathmey (1903–88), a native of Richmond, infused social commentary into his work in a more overt fashion. In 1946 he told a writer for *ARTnews* that he would return to his home every summer after teaching in New York and see anew the deep social problems that affected his native South. Yet his paintings seemed to exude more pathos than hatred. As a southern painter, he was angry and critical, but he also seemed to shoulder some of the guilt.

The period of World War II activated a broad cycle of change in the South. The region was on the move, shifting, growing, and changing old and seemingly entrenched patterns. Sometimes the change was strongly resisted, often for the sake of an increasingly outmoded sectionalism. Southern painters became more concerned not with a sense of place but with a sensibility. Romare Howard Bearden, originally from Charlotte, studied and worked in New York and Europe before coming to the realization that his most evocative images came from "the people I knew and remembered down South." His work represents the essence of the migration of the southern black from the rural areas and traditions to postwar urban society. "I paint out of the tradition of the Blues, of call and recall," the artist has written. "I never left Charlotte, except physically."

Remembrances, visions, the mythology of place—these elements underlie much postwar southern painting. Carroll Cloar, an artist originally from Arkansas, moved to Memphis in 1955 and began a series of paintings based on his boyhood in the Arkansas Delta. "There is a joy in the sense of belonging, of possessing and being possessed, by the land where you were born." His meticulous, vibrant works evoke the spirit of folk art yet have a power that derives from sophisticated study of his surroundings. Likewise, Hobson Lafayette Pittman's paintings seem like dreamworlds of southern myths and impressions. Reared on a plantation near Epworth, N.C., Pittman became a noted artist and

teacher outside his native South, but the imagery and spirit of the region never left his work. All three of these artists—Bearden, Cloar, and Pittman—have created evocations, dreams, and remembrances of an otherworldly South that seems to exist mostly as fiction.

Some southern artists in the postwar period withdrew to create a world wholly their own yet inextricably part of southern culture. After studying art in Pennsylvania and in Europe, New Orleans native Walter Inglis Anderson moved to a tiny cottage in Ocean Springs, Miss., where, in virtual seclusion, he painted the local flora and fauna. Throughout the 1950s, Anderson spent most of his time on Horn Island, a small, ever-changing sandbar rich in plants and wildlife. He produced thousands of watercolors of this southern version of Walden Pond and kept detailed journals of his feelings and impressions as he explored every inch of its terrain throughout the seasons. Like Anderson, Will Henry Stevens adopted a uniquely personal vision, but one that embodied two separate styles. Stevens taught at Newcomb College in New Orleans from 1921 until his retirement in 1948 and spent nearly all his summers in western North Carolina painting the woods and hillsides. His "pastel paintings" of these southern woodlands, using a nonrubbing chalk of his own invention, were praised when they were first exhibited in 1941. Curiously, Stevens also painted in a more nonobjective style and exhibited those works separately. In December 1941 he went so far as to have two simultaneous exhibitions in separate galleries, which may suggest the dilemma that some southern artists faced regarding a search for a meaningful style in a period when southern culture was undergoing profound changes.

Stevens spent his summers close to an enormously influential school that was founded in 1933 near Black Mountain, N.C. It was an entirely experimental community, with shifting ideas and goals, but it attracted some of the brightest and most fertile artistic minds of the postwar era, including Josef Albers, Walter Gropius, Willem de Kooning, Robert Burns Motherwell, Clement Greenberg, Beaumont Newhall, and Buckminster Fuller. The only southern painter to receive an invitation to teach at this isolated outpost was Gwathmey; for the most part, the effect of Black Mountain College on the immediate development of painting in the South was minimal. Yet the artistic climate in the South changed drastically in this period, in part because of the influence of the New York School and of the art centers that had been established at southern colleges and universities. For the first time, the impetus for artistic change was generated from within the South itself.

The activity of artists like Ralston Crawford, based in New Orleans, is an

example of the newer acceptance of modernist styles in the region. Crawford, who had adapted a style of nonrepresentational geometric abstraction, began teaching at Louisiana State University at Baton Rouge in 1949. In his paintings of New Orleans, which were done in a series, he conveyed the hard light and busy rhythms of the city's industrial and maritime activity in color-filled forms and shapes that revealed his passion for jazz. Like Crawford, George Ayers Cress developed his art within the new idiom. Cress attended Emory University and then studied art under Lamar Dodd and Jean Charlot at the University of Georgia and was thus a member of the new generation of artists trained within the South. He began teaching at the University of Chattanooga and has served in the Southeastern College Art Conference as well as the Tennessee Arts Council. His painting style evolved out of the context of the second generation of the New York School, as he depicted the layered bluffs of his region in an abstract pattern of loose patches of color and texture. Cress's contemporary, Claude Flynn Howell, who has taught at the University of North Carolina in his native Wilmington since 1953, works in a more representational style, painting structured, austere views of his locale. Michael O'Brien, in his stimulating book *The Idea of the American South*, has written of the artist's need to see "the South itself as an idea, used to organize and comprehend disparate facts of social reality." Certainly the modern southern artist has assumed a southern sensibility in his work and has developed out of that position. Thus an artist like William Melton Halsey of Charleston could turn from early representational paintings of his surroundings to works that became increasingly abstract, without relinquishing the uniquely southern sensibility that some have sensed in his work.

Throughout the period herein reviewed, southern artists sought to preserve a regional aesthetic, as opposed to a more national one. It was a period of paradox and change, when older sectional desires clashed with national, and eventually international, artistic influences. Artists in the South in the period prior to World War II could not be classified in the avant-garde sense as independent; in the more traditional sense they thought of themselves as integral members of—even interpreters for—their own southern society. Only after the establishment of a comprehensive cultural network of museums and universities does one find the growth of the independent sensibility, the open acceptance of the broader framework of American culture, with the southern artist fully a part of the international art world.

RICK STEWART
Dallas Museum of Art

Amon Carter Museum, *Texas Painting and Sculpture: The Twentieth Century* (1971); Bruce W. Chambers, *Art and Artists of the South: The Robert P. Coggins Collection* (1984); Corcoran Gallery of Art, *American Painters of the South* (1960); Erica Doss, *Benton, Pollock, and the Politics of Modernism: From Regionalism to Abstract Expressionism* (1991); David C. Driskell, *Two Centuries of Black American Art* (1976); J. Richard Gruber, *Thomas Hart Benton and the South* (1997); Ralph H. Hudson, *Black Artists/South* (1979); Huntsville Museum of Art, *Contemporary Painting in Alabama* (1980); James C. Kelly and Estill Curtis Pennington, *The South on Paper: Line, Color, and Light* (1985); Donald B. Kuspit et al., *Painting in the South, 1564-1980* (1983); Jack Morris, *Contemporary Artists of South Carolina* (1970); Eleanor Swensen Quandt et al., *American Painters of the South* (1960).

Painting and Painters, 1960–1980

In studying contemporary art in the South, one must explore signs and symbols associated with the region in the popular imagination and pay particular attention to the manner in which these have emerged in the visual arts. If one is indeed shaped by the environment, daily life, and early experiences, then the concept of a "southern" type of art is as inevitable as history. The internal characteristics of southern art, especially when it comes to modern and contemporary paintings, present a far from tidy field, partly because the region itself is so heterogeneous. One can distinguish between the Deep South (South Carolina, Georgia, Alabama, Mississippi, and Louisiana) and the Southern Rim (Tennessee, Virginia, North Carolina, Florida, Texas, and sometimes Arkansas and others) on the basis of historical, sociocultural, and economic factors, all of which affect art and artists.

The *American Heritage Dictionary* defines the term "regionalism" in three ways, and art from the Southeast fits all three understandings. The first definition is "of, pertaining to, or characteristic of a large geographical region." In this sense of the term, 20th-century artists Nellie Mae Rowe, Sam Doyle, Robert Gordy, and Elizabeth Shannon, all southern artists, can be classified as regional. The second definition is "of, pertaining to, or characteristic of a particular region or localized district." Artists Donald Roller Wilson, Carroll Cloar, Romare Howard Bearden, and Juan Gonzales represent southern art in this aspect. Third, regionalism can mean something characterized by a particular language dialect in an area. The religious, social, and ethnic localism of Sister Gertrude Morgan, the Reverend Howard Finster, Jesse Poimboeuf, and Rise Delmar Ochsner exemplify regional art of this type.

To the extent that distinct regional subcultures exist, some aspects might be used by regional artists to evoke a sense of place, time, and geographical iden-

tity—for example, Doyle's "first black mid-wife, she was a slave." With respect to such factors in contemporary southern painting, one must look outside the field of art for clues. In *The Enduring South* (1975), John Shelton Reed isolates four influences he considers important in this region: familism, religiosity, localism, and a greater tolerance for violence than the rest of the country. To these, one might add the isolationism of the "old folks at home" mentality or what should be classified as the "South of the mind," which holds true in the social localism of such cities as Charleston, Mobile, and Savannah.

In southeastern painting, regional imagery abounds, as in the works of Patty Whitty Johnson, Sue Moore, and Douglas Bourgeois. A respect for custom and the past is still prevalent, affecting newcomers in a variety of ways, and a certain inclination remains toward representational images and a decorative unity of form, which appears to be a consistent shaping force in the art of such southerners as Jasper Johns, Kenneth Noland, Dorothy Gillespie, and Ida Kohlmeyer. Thus, a basis seems to exist for positing clearly identifiable qualities when it comes to southern art.

In the visual arts, the term "regionalism" presents additional problems. According to conventional wisdom, provincials are those people who do not live in or receive artistic truth from New York City. Much of the art produced outside of New York has its own roots, references, and traditions. When outsiders—mainstream critics, artists, and others—are brought in to judge exhibitions of "southern" art, they more often than not ignore these sharp differences, applying their own standards to the art they see. The problem with this, for example, may clearly be seen in the case of south Florida, which is the tropics, the gateway to the Latin Americas and the Caribbean. It is inconceivable that such factors would not exert considerable influence on the art of an impressionable generation of younger creators in the state. To ignore these realities on the grounds of mainstream standards would be neither responsible criticism nor a fair assessment of the surrealist-style art.

Doubtless, the setting of the South conjures up pictures in the popular imagination of weeping willows, cypresses, Spanish moss, plantations, and African Americans—not tropical iconography. The overall impression, as noted previously, can be deceptive. The art of this region is undeniably the product, like any serious art, of a search for meaning. Explicit in this definition is a decided concern with irrationality, ineptitude, banality, and deceitful fragility, on the one hand, and, on the other hand, a refined literary picturesqueness, with a special emphasis on representation and decorative embellishments. To these qualities one might add whimsicality; sly, humorous exaggerations concerning both Christian and pagan themes; and dashes of charm, irony, magic, quaint-

ness, directness, and naïveté; plus a startlingly crude, powerful, and often unexpectedly brutal primitivism.

Clearly, southern artists have been suspicious of established fashions and accepted fundamentals of modern style—that is, mathematical absolutes, a reliance on science and technology, and rational thought processes. Perhaps in terms of realism and neoexpressionism, their suspicion of the latter has been prophetic.

While there is at present no definitive southern school of painting, such exhibitions as *Black Folk Art in America, 1930-1980* (Corcoran Gallery of Art), *More Than Land or Sky: Art from Appalachia* (National Museum of American Art), and *Painting in the South, 1564-1980* (Virginia Museum of Fine Arts) focused critical attention on southern art. The reality is simply this: before one can begin to discuss southern art, it has to be seen and written about. In this context, the efforts of the Southeastern Center for Contemporary Art, the New Orleans Center for Contemporary Art, Nexus, the Atlanta Art Workers Coalition, the Southeast College Art Conference, the Southeastern Women's Caucus for Art, the Ogden Museum of Southern Art, the Morris Museum of Art, the High Museum, and a host of other art support systems are crucial. Primary among the regional journals is *Art Papers*, which gives serious review to states in the Southeast. These regional resources represent much more than a mere reflection of a mainstream with tributaries that once reached no farther than New York, Chicago, and California.

SANDRA LANGER
New York, New York

ARTnews (February 1983); Elizabeth C. Baker, *Art in America* (July–August 1976); Bruce W. Chambers, *Art and Artists of the South: The Robert P. Coggins Collection* (1984); Corcoran Gallery of Art, *American Painters of the South* (1960); David C. Driskell, *Two Centuries of Black American Art* (1976); Walter Gabrielson, *Art in America* (January–February 1974); James C. Kelly and Estill Curtis Pennington, *The South on Paper: Line, Color, and Light* (1985); Donald B. Kuspit et al., *Painting in the South, 1564-1980* (1983); Terry Smith, *Artforum* (September 1974); Anne Middleton Wagner, *A House Divided: American Art since 1955* (2012); *Women Artists News* (February 1980).

Painting and Painters, 1980–2012

Historically, artistic trends are cyclic in their progression from an emphasis on naturalistic and figural art to elongated or abstract figures, followed by a return to the subject of human forms. Studies have recorded the move from primi-

tively rendered Cycladic figures to Greek idealistic sculptures to overly naturalistic figures of the Roman period. Elongated Byzantine representations of the human form shifted to weightless bodies during the medieval period, followed by the Renaissance emphasis on humanism. Subsequently, elongated mannerist figures became dynamic baroque figures. The playful rococo style gave way to the gravity of the human figure in realism, and then to a lighter impressionist appearance, which further dissolved into softer, misty tonalist works. The playful Dadaist subjects and fragmented cubist views of modernism led to abstraction, and then a thorough moving away from any recognizable subject toward a simple emotional expression.

Finally, when elements of art were examined in a minimalist style, artists felt that that mode of artistic investigation had exhausted itself, and it was necessary to explore subjects cohesively. All subjects were open to artistic exploration, including portraiture, landscapes, still lifes, and genre scenes. The period from 1980 to 2010 saw a move away from the upheaval of Dadaism, surrealism, modernism, and abstract expressionism. Many artists eschewed the need to conform to prescribed manners of painting. Artists, particularly in the South, have gradually moved toward a passionate individualism. Where once art galleries shied away from representational art, unless it was surreal, witty, or contained social statement, today there is greater openness. Gallery owners across America, although sometimes confused, have come to recognize artists' needs to speak in original voices within and beyond the various traditions in art. This essay surveys artists through a combination of achievement, genres in which they painted, states in which they studied and worked, and art movements in which they participated.

Most of the prominent artists who shaped American art were born in the South or lived there. Southern art was not only in the mainstream; it was often in the vanguard. Texas native Robert Rauschenberg and Georgia native Jasper Johns, both proponents of abstract expressionism, were leading figures in contemporary art for over a half century. Their influence was felt intensely throughout the development of art into the late 20th century. An updated version of a Renaissance man, Rauschenberg was a painter, sculptor, printmaker, performance artist, and composer. A prolific artist, he worked until his death on Captiva Island, Fla. Johns's work, which calls to mind compositions that feature flags and numbers, is minimalist in approach. Both artists are represented in major museum collections. Like so many artists, they traveled and worked throughout the southern states. Many painters, however, like New Orleans abstract expressionist Ida Rittenberg Kohlmeyer, set up studios where they remained throughout their careers.

After World War II, Mississippi painters Mildred Nungester Wolfe and Karl Ferdinand Wolfe established Wolfe Studio in Jackson. Karl taught at Millsaps College, and his influence survives through his students. During their long careers, the couple portrayed the people and the landscape of the South. Karl, primarily a portraitist, painted an oil portrait of author (and photographer) Eudora Welty in 1982. His paintings are rendered with fluid brushstrokes that are often reminiscent of abstract expressionism; however, he also produced works with finely finished surfaces. Mildred's still lifes and landscapes reveal the influence of European impressionist and postimpressionist painting traditions. Like Rauschenberg, she worked in several fields, including printmaking, ceramics, and stained glass. She painted three portraits of Welty, including a watercolor portrait, which is in the collection of the Center for the Study of Southern Culture in Oxford, Miss. Her 1988 oil portrait of Welty, now in the National Portrait Gallery, shows the author with a book on her lap, open to her short story "Why I Live at the P.O." A later oil portrait of Welty by Mildred Wolfe is in the Mississippi Department of Archives and History in Jackson.

Born in New York City, Frank Rampolla trained in his native city at the Art Students League and Cooper Union. He taught at the Ringling School of Art in Sarasota, Fla., from 1960 to 1968. His figurative paintings and drawings, which are rendered in broad expressionistic stokes, are in the collections of the Mint Museum, the National Gallery of Art, and the Smithsonian American Art Museum. Alabama native Jere Hardy Allen, one of Rampolla's better-known students, was deeply influenced by Rampolla's figurative work, particularly the female nude. Allen also studied under Fiore Custode and credits his decision to pursue the field of painting to her enthusiasm and encouragement. After Allen earned an M.F.A. from the University of Tennessee, he taught at the University of Mississippi for 28 years. Currently, he is professor emeritus of art. His expressive work, which is often inspired by myths and legends, is characterized by broad, energetic, highly viscous, textural brushstrokes.

In 2003 the Meridian International Center in Washington, D.C., organized an exhibition as part of a cultural exchange program, *Outward Bound: American Art at the Brink of the Twenty-first Century*, which toured Southeast Asia, including Hanoi in Vietnam, Shanghai and Beijing in China, Manila in the Philippines, Jakarta in Indonesia, and Singapore. The exhibition featured Allen's work, along with that of Rauschenberg and other well-known artists, including Roy Lichtenstein, Wolf Kahn, Jacob Armstead Lawrence, Chuck Close, Audrey Flack, Faith Ringgold, and Sam Gilliam. Cocurated by Mississippi artist William R. Dunlap, the exhibition was planned as a contribution to greater global harmony in the 21st century, with the hope that people in Asian coun-

tries would gain an understanding and appreciation of the American spirit. Dunlap, who earned his M.F.A. from the University of Mississippi, taught at Appalachian State University in North Carolina from 1970 to 1979 and at Memphis State University (now University of Memphis) from 1979 to 1980. He maintains studios in Virginia, Mississippi, and Florida. In his paintings Dunlap combines realistic landscapes and private symbolism with boldly rendered expressionistic skies.

Three Florida artists, all of whom teach painting at Florida State University in Tallahassee, explore a wide range of complexities relating to the natural environment: Ray Burggraf, Lilian Garcia-Roig, and Mark Messersmith. Although Florida landscapes are central to their work, each of these artists takes a different approach in representing themes of nature. Messersmith, who earned an M.F.A. from the University of Indiana in Bloomington, joined the Florida State faculty in 1985. His compositions capture the underlying eeriness of dark, murky swamps with alligators and other predatory or deadly creatures lurking among tangled vines and cypress knees.

Lilian Garcia-Roig received a B.F.A. from Southern Methodist University in Dallas, studied at Skowhegan School of Painting in Maine, and earned an M.F.A. from the University of Pennsylvania in 1990. Garcia-Roig moved from the University of Texas to Florida State in 2001. She paints large-scale canvases *en plein air*, depicting tangled masses of branches and foliage. Her meticulously delineated surface detail, visible at close range, merges into a cohesive whole at a greater distance.

Ray Burggraf received a B.S. from Ashland University in Ohio in 1961 and a second undergraduate degree, a B.F.A., from the Cleveland Institute of Art in 1968. While at the institute, he absorbed principles of the 1930s German Bauhaus and the 1960s op art (optical art) movement. He earned M.A. and M.F.A. degrees from the University of California at Berkeley and joined the art department faculty at Florida State University in 1970. Burggraf's colorful sculptural biomorphic forms are created with layers of brightly painted wood, suggesting creatures whose natural habitat is a marine environment. Deriving from the Bauhaus tenets taught by Josef Albers at Black Mountain College, Burggraf focuses on the essential elements of shape without extraneous details. His innovative adaptation of optical art, the creation of a mathematically precise visual illusion that appears to be moving or breathing, takes on greater significance when he applies it to life forms like fish.

A native Floridian, John Westmark holds a B.F.A. from the Kansas City Art Institute and an M.F.A. from the University of Florida in Gainesville, where he joined the faculty of the art department in 2006 after teaching there as a

graduate assistant in 1999. Westmark states that he spent his childhood doodling during long Southern Baptist sermons. From this activity, he gives fresh interpretations to ordinary objects like tools, articles of clothing, or sewing patterns. Westmark is not confined to the concept of applying only pigment to his canvases in order to represent his subject; he applies the latter directly to the canvas in folded arrangements that create pictorial subjects unrelated to the paper patterns.

William Melton Halsey, who has been described as "dean of contemporary art in South Carolina" and "pioneer of abstract painting in the South," initially took instruction from Charleston artists Elizabeth O'Neill Verner and Alice Ravenel Huger Smith. Halsey was educated at the University of South Carolina and the School of the Museum of Fine Arts in Boston from 1935 to 1939. He won the James William Page Traveling Fellowship for European studies at the outbreak of World War II and thus diverted his travel to the University of Mexico from 1939 to 1941, where he studied the work of the Mexican muralists. Halsey was director of the School of Art, Telfair Academy (now Telfair Museum of Art). He served as artist in residence at several art institutions, including the College of Charleston, where the Halsey Institute of Contemporary Art, named in his honor, is administered by the School of the Arts at the College of Charleston. Halsey's wife, painter printer sculptor Corrie Parker McCallum, also a native South Carolinian, studied art at the University of South Carolina, where she met Halsey and then joined him for further studies at the School of the Museum of Fine Arts in Boston. Her painting style continued to develop, from works based on nature to abstractions to nonobjective works rendered in black and saturated colors.

Although he paints many portraits in oils, Henry Calvin Casselli Jr. also works in watercolors depicting figures and settings from his native New Orleans. From 1963 to 1967 he studied at the John McCrady School of Art in the Vieux Carré and was an assistant instructor during his second year at the school. He was a combat artist in the U.S. Marine Corps during the Vietnam War. Upon his return from the war he began painting empathetic portraits of African Americans. In 1987 he received the gold medal of honor from the American Watercolor Society for his painting *Echo*, which depicts an African American man in work clothing leaning against a post with a Y-shaped bracket that implies a crucifixion. The National Aeronautics and Space Administration commissioned Casselli to serve as official artist for America's first space shuttle launch in 1980–81 and again in 1998 to portray astronaut John Glenn on his final mission. Many of Casselli's works are part of the National Air and Space Museum in Washington, D.C. Casselli was also commissioned to portray Pres.

Ronald Reagan; the portrait hangs in the Hall of Presidents at the National Portrait Gallery in the nation's capital.

Another New Orleanian, Shirley Rabé Masinter frequently focuses on African American subjects. She portrays figures in realistic, near-grisaille paintings showing blighted cityscapes with decaying and graffiti-marked buildings posted with advertisements for cigarettes and political races. Although her work appears restrained and seemingly understated, her message is powerful. Virginia painter Julien Binford became known for his sympathetic renderings of African Americans engaged in work and other daily activities. Binford, who studied at the Art Institute of Chicago and in France, taught at Mary Washington College in Fredericksburg, Va.

Although Georgia artist Benny Andrews gave voice to social and cultural activism, much of which related to his African American heritage, his work is reminiscent of Romare Howard Bearden's narrative paintings, with simply shaped, childlike subjects. Roger Brown also created narrative scenes in the tradition of storytelling. His compositions feature simplified, isometric, cartoonish buildings and rural scenes that explore contemporary political, religious, social, and artistic issues. After his studies at the Art Institute of Chicago, he decided to remain in that city, which he felt had become the new art center in the 1960s. Although Brown was born and reared in Alabama, his name became synonymous with Chicago imagism, a movement emphasizing the making of art as an individual endeavor, independent of contemporary art trends in New York. Brown's aesthetic of narrative, which he attributed to his southern roots, was contrary to the tenets of Clement Greenberg, who advocated abstract expressionism and the avoidance of any recognizable subject.

Painter-teacher Lamar William Dodd's name dominates art and cultural circles in Georgia. His legacy survives in the Lamar Dodd School of Art, one of the largest university art programs in the nation. The school has a faculty of nationally recognized artists, more than 1,000 art majors, and a year-round Studies Abroad Program in Cortona, Italy, with similar opportunities in Japan, Cuba, and Ghana. Dodd's painting style developed from realism into symbolic, abstracted paintings wherein formal considerations dominated—for example, cotton pickers rendered sympathetically with long broad brushstrokes that emphasize the heaviness of their labors. Another Georgia artist, James W. "Bo" Bartlett III, creates large-scale figurative paintings that focus on his home, family, faith, the rural landscape, and everyday events depicted in heroic scale in the manner of American realist painter Thomas Eakins.

A native of Arkansas, Carroll Cloar was educated at Southwestern in Memphis (now Rhodes College), Memphis College of Art, and the Art Students

League in New York from 1936 to 1940. His genre scenes portray his native region and its inhabitants, many of whom are engaged in menial labor. Cloar employs the full range of the principles and elements of art. The viewer observes rhythmic strokes and patterns, the use of intensified light and color, and the influence of black-and-white photographs. George Ayers Cress, born in Alabama, studied with Lamar Dodd, Carl Robert Holty, and Jean Charlot at the University of Georgia. Cress, who shaped the art department of the University of Tennessee at Chattanooga and sat on the board of the Hunter Museum of American Art, was influential in the art community. He worked in a realistic manner, but his work became increasingly more abstract. In the 1960s he developed a mature style in painting abstract landscapes, in which he employed geometric forms and saturated colors as a means to capture the plains of the Tennessee Piedmont and river bluffs.

The career of painter-sculptor John Franklin Clemmer, who first studied at the Arts and Crafts Club of New Orleans and later became its director, spans seven decades. While serving in World War II, Clemmer sketched his fellow soldiers. He taught in the Tulane University School of Architecture and then served as chair of the Newcomb College Art Department. His works range from early modernism to abstraction with recognizable subjects, which are always rendered with meticulous attention to the fine points of his complicated compositions. He was honored with a retrospective exhibition at the New Orleans Museum of Art in 1999.

The work of Georgia painter Bill Turner, essentially self-taught, is comparable to that of academically trained artists. Turner, who has a baccalaureate degree in journalism, worked as an art photographer for a decade before he began to paint. He focuses on roadways that bisect the landscape, most of which could be identified as areas outside the South, and yet there is a distinct "southern quality" about his paintings. Roads meander through the land like dark ribbons curling through hilly woodlands. While the work has an affinity with photographs, Turner interprets these introspective views as though they are viewed through a soft lens at dusk, generally with the artist standing in the middle of the roadway. Invariably, asphalt thoroughfares appear without shoulders on each side and without the expected yellow line that usually divides American roadways; conversely, roads appear like dirt or dark-colored surfaces with a soft sheen that reflects misty skies.

James Dowell, a native of Greenville, Tex., received a B.F.A. from Southern Methodist University in Dallas in 1972 as well as M.A. and M.F.A. degrees from the University of Iowa in Iowa City in 1973 and 1974. Although Dowell lives in New York City, he also maintains a residence in Dallas. His earth-toned still life

paintings, which often feature skulls, dead wood, gourds, or animal horns, have underlying meanings regarding nature, sometimes relating to sexual and other biological processes. There is an implied reference to death, since all the vegetal motifs have a transitory nature.

A number of southern artists paint highly detailed, realistic works resembling photographs, called photorealism; most often these are painted from photographs. At the turn of the 21st century, a number of American artists began to increase the degree of detail in paintings that resemble high-resolution photographs, which they termed "hyperrealism." Several southern artists, like New Orleans artist Auzeklis Ozols, produced such works in advance of the movement. Ozols, who was born in Latvia, founded the New Orleans Academy of Fine Arts in 1978 and serves as its director. He works in the still life tradition of 17th-century Dutch painters, producing still lifes with trompe l'oeil effects. His subjects are all-inclusive, from flowers to fruit and vegetables to household objects — most of which are rendered with careful precision and a smooth surface finish.

Jacques Soulas also creates hyperrealistic works, including still lifes, genre scenes, and street scenes. A native of France, Soulas studied at the John McCrady School of Art in New Orleans, and he continues to paint and live in that city. Mississippi artist Glennray Tutor began painting photorealistic works in 1983. He was educated at the University of Mississippi, where he received a B.A. in Art and English in 1974 and an M.F.A., with a specialty in painting, in 1976. Today he is well known for his posters for the annual conference on William Faulkner. Currently his subjects often include contemporary commonplace items like marbles, crayons, toys, home-canned jars of vegetables, and other objects seen as though viewing a vignette of daily life in a child's room or kitchen. Tutor refers to his richly colored works, which create a tension between illusion and reality, as "metarealism," since they are metaphors for the objects themselves. His son, Zachary Tutor, is also an artist, with an interest in cityscapes; Zachary studied art as a youngster under his father's tutelage and then briefly at the University of Mississippi.

As artists reexamine the past, many return to works of the old masters. A recent exhibition of 68 landscapes, painted in oil by 21st-century artist Philip Juras, revisits 18th-century author-naturalist William Bartram's presettlement southern wilderness, as he described it in his 1791 *Travels*. Juras's paintings combine direct observation with research in history, science, and natural history to depict landscapes as they would have appeared in the 1770s. Southern artists of the last two decades of the 20th century and the first decade of the 21st century have found greater freedom in expression and in choice of sub-

ject. While they often share the national and international movements and traditions, their artistic responses to southern experiences reflect the timeless themes and issues of their region.

JUDITH H. BONNER
The Historic New Orleans Collection

John Clemmer, *John Clemmer: Exploring the Medium, 1940–1999* (1999); Marika Herskovic, *American Abstract and Figurative Expressionism: Style Is Timely Art Is Timeless: An Illustrated Survey with Artists' Statements, Artwork, and Biographies* (2009); Hiroko Ikegami and Robert Rauschenberg, *The Great Migrator: Robert Rauschenberg and the Global Rise of American Art* (2010); Jim M. Jordan, Hunter Cole, Roy Grisham, et al., *The Wolfe Years: A Collection of Millsaps Memoirs* (2003); Anne Middleton Wagner, *A House Divided: American Art since 1955* (2012); Elizabeth Wolfe and Mildred Nungester Wolfe, *Mildred Nungester Wolfe* (2005).

Photography and Photographers

"Southern photography" is a different thing from "photography in the South," yet in order to see the character of either, both should be addressed. Taken together, the photograph is a cloth woven of images by residents and visitors, artists and documentarians, opportunists, journeymen, professionals, savants, and amateurs. "Outsiders," that is, those not from the southern states, have often created compelling individual images or bodies of work that collectively portray the South—its people, its activities, its natural character. "Southern" is a big tent, with plenty of room for particular expressions, ideas, poses, and subjects. This photography is often about the sense of place, without, paradoxically, specifying that place. A portrait of a civil rights protester may be in Selma, New Orleans, Memphis, or Atlanta. But similar photographs were made in Detroit, Newark, and Chicago. A southern scene of pastoral tranquility might be in Florida, Tennessee, or Virginia. The activities of oil and gas production could be in Shreveport or Beaumont. Without specific visual clues or appended textual explanation, it is often hard to know. Indeed, a familiar lament is that the South is becoming just another region of the United States, indistinguishable from many others. Its attachments to its history, literature, arts, and traditions are looser, less certain, and not as often transmitted to succeeding generations as in the past. But something about a photograph—not always the same element from picture to picture—will usually reveal its southern pedigree.

Following the introduction of photography in the South in 1840 (through the process of the daguerreotype), evolution of both equipment and vision occurred. As the medium's apparatus became more portable, its chemistry more

sensitive, and the light-gathering power and resolution of its optics greater, photography's practitioners, it could be argued, became more inquisitive, if not downright more interrogatory. With the passage of time, a shift from a stance that offered mere descriptions of places and likenesses to one of addressing the ideas of people and events in those places is certainly one of the attributes of photography in the South, though this is surely not unique to the region. There, as everywhere it was practiced, photographic aesthetic began to take shape, based on the particular and unflinching recording capabilities of lenses, the visual reduction of real-life colors to a gray scale, and the notion, ever increasing, that ordinary subjects were worthy of both the recording and the scrutiny that followed such recording.

Beginning in the mid-1850s technological advances in photographic chemistry (notably the perfection of the collodion wet-plate negative) and finishing (widespread availability and use of commercially made albumen papers) were key elements in permitting the mass distribution of photographic images. The carte-de-visite format offered the opportunity for virtually anyone—famous or not—to give a likeness to a friend, a family member, or an intrigued public.

As time passed, what photographs and photography came to mean raised new questions and prospects for social- and artistic-centered discussions. Portraits came to be seen as analytical as well as representational; depictions of densely built cityscapes opened the door to consider the problems emanating from expanding urban areas; technologies propelling growth, from steamboats and railroads to mining and oil and gas exploration, embodied notions of progress and expansion. Depiction of racial differences, often grounded in caricature, gradually changed as ideas about race slowly shifted.

Camera images of Civil War carnage and destruction injected a sobering note into the national consciousness. George N. Barnard, working primarily in Georgia, and Alexander Gardner, who spent most of his time in Virginia, were but two of a corps of several photographers whose pictures show the aftermath of battles throughout the theater of war. Given the nature of warfare and the equipment used, "action" pictures of the fighting were nigh on to impossible to record. Fortifications, the toll exacted on buildings and people by the battles, and encampments with their accompanying personnel were often the subjects of the photographs. Though it was the Civil War that produced more (and more memorable) images of war, it could be argued that the seeds of war photography in the South were sown in Texas, exemplified by a handful of images related to the Mexican War.

Following the Civil War, photographs of southern scenes were produced and disseminated as single images and as stereographs. This latter form en-

joyed widespread distribution, not only in the South but around the world. In a particular sense, this visual cultural portability introduced many to picturesque southern scenes, ranging from agricultural activities to Mardi Gras, from landscapes and urban views to industrial and commercial enterprises. Both Samuel T. Blessing and Theodore Lilienthal, operating in New Orleans (Blessing also had studios in Texas), fed the mania of armchair travelers to experience places they might never visit. Georges François Mugnier, most active in New Orleans during the 1880s, also published sets of stereographs and single images of southern urban and rural scenes. In the decade following the Civil War, J. H. Lakin, of Montgomery, Ala., documented that city's commercial district. John Horgan Jr., a very fine Birmingham photographer about whom little is written or even known, created a series of mammoth plate photographs for the predecessor of the Illinois Central Railroad, covering a corridor across Alabama, Mississippi, and Louisiana, in about 1890. To the modern viewer, these pictures are spectacular in their presence and detail; for the railroad, their message was commerce.

The popularity of the stereograph over a period of some 75 years (ca. 1850 to the mid-1920s) and the ubiquity of its distribution by both local entrepreneurs and national corporations give many places in the South a visual past. The picture postcard, introduced in the early 20th century, also offered the prospect of visual posterity to everything from cotton in bloom and open-mouthed alligators to the local diner. These cards, either actual photographic images or mechanically reproduced from photographs, served to export southern scenes to all corners of the world.

Parallel with this stream of image dissemination is the notion that after the introduction of the Kodak camera in 1888, the role of photography was, if not rewritten, subjected to major reconsideration, as amateurs began to challenge the long-held notion of photography as the exclusive domain of the professional or wealthy dilettante. The billowing clouds of images that followed in the Kodak's (and instruments like it) wake launched a vernacular dialect of the medium that had been sorely lacking in the five previous decades, creating, alongside commercial portraiture, architectural photography, and documentation, a history of the personal, the familiar, and the everyday.

Snapshots of family gatherings, domestic interiors, leisure outings, pets, horticultural triumphs, and the family homestead began filling scrapbooks. Photography of this type put within nearly anyone's financial grasp the true possibility of a personal visual history and greatly enriched the social, documentary, and artistic possibilities of the medium.

The introduction of the Kodak notwithstanding, professional photographers

A traveling photographer in Durham, N.C., 1939 (Marion Post Wolcott, photographer, Library of Congress [LC-USF-33-30740-M3], Washington, D.C.)

continued to dominate certain southern markets and certain types of photography. Eugene Omar Goldbeck in Texas, Charles L. Franck in New Orleans, and Jasper G. Ewing Sr. based in Baton Rouge, La., and Jackson, Miss., offered an array of professional services, including the ability to make very large panoramic photographs showing throngs of posed soldiers, conventioneers, graduates, and other subjects. Though eminently suited to recording a large group of people, this format was also especially striking when applied to subjects such as a city skyline, a farm, or a large construction project.

A number of photographers (and their successors) became identified with certain places, often spanning generations of activity. In Baton Rouge, this role belonged to Andrew David Lytle, who showed the citizens of Louisiana's capital what they and their city looked like between the Civil War and World War I. In Natchez, Henry C. Norman and his son, Earl, traced the growth and enduring traditions of that river city. Another father-son team, Jay Dearborn Edwards and his son, had careers that went from the antebellum period to the time of World War I. The father's work is principally centered on views of New Orleans in the late 1850s and early 1860s. Both father and son settled in Atlanta following the Civil War and continued a wide-ranging practice in that city until a bankruptcy ended the business. Aubrey Bodine, working for the *Baltimore Sun* as a photojournalist, staked out the Chesapeake Bay area and pursued inde-

pendent projects in Maryland and elsewhere using a Pictorialist, or soft-focus, style. Eugene Delcroix's photographs, also split between sharply focused commercial work and softly rendered subjects of people, landscape, and architecture, often marketed to tourists, is identified with New Orleans and southern Louisiana. Portraitists, too, saw a parade of sitters through the decades, transmitting family likenesses across generations. Mike Myers, aka Disfarmer, of Heber Springs, Ark., demonstrated that the commercial portrait could be innovative and insightful as well as the transmitter of a likeness. Hundreds of such studios serving the needs of their neighbors from birth to death were spread throughout the South. The growing presence of the lightweight, consumer-oriented camera notwithstanding, many opted for the professional's services when the occasion demanded it.

As the 20th century passed its midpoint and photography became a more and more accepted part of fine art academic programs, colleges and universities throughout the South increasingly offered bachelor and advanced degrees in photography. Simultaneously, academic libraries and special collections divisions began to assemble photographic archives and collections, which permitted contemplation of both the historical and the artistic aspects of the medium and the reexamination of photographic collections as useful components in understanding the written narrative of history and for teaching, researching, and publishing goals. Art museums in the South, as elsewhere, began assembling collections of photographs made for aesthetic and social purposes grounded in artistic sensibilities. Clearly, the technologies of the past 25 years, in digital imaging and retrieval of information through the Internet, have provided unprecedented access to photographic holdings everywhere.

Within the South, lovers of art photography have access to the world-class collections at a variety of museums and archives. In Texas, the Museum of Fine Arts in Houston, the Amon Carter Museum in Fort Worth, and the Harry Ransom Center at the University of Texas are exemplary. In Louisiana, the New Orleans Museum of Art, the Louisiana State Museum, and the Ogden Museum of Southern Art hold exceptional collections, as do the William Ransom Hogan Jazz Archive at Tulane University, Hill Memorial Library at Louisiana State University, and the Historic New Orleans Collection. The High Museum of Art in Atlanta, the Southeast Museum of Photography in Daytona Beach, the Chrysler Museum in Norfolk, Va., and the Photographic Archives at the University of Louisville hold outstanding collections, and the Center for the Study of Southern Culture at the University of Mississippi and the Center for Documentary Studies at Duke University have photographic collections and activities central to their missions. Centered on the work of Frederick W. Glasier,

the John and Mabel Ringling Museum in Sarasota has a trove of circus-related images. The photographic holdings of federal repositories and museum collections in Washington, D.C.—the Library of Congress, the National Archives, and the Smithsonian network of museums, to name a few—and its environs are rich beyond description.

Whether such institutional holdings represent a cause-and-effect relationship or simply one that has developed hand in hand with academic photography programs, the offering of such courses of study in the fine arts and the acceptance of incorporating the visual aspects of history in a wide range of humanities-based degree programs have certainly made the institutional collection of photographic materials a consideration for nearly every institution of higher learning in the South.

Though many such programs and collections are of post–World War II vintage, an early adopter of a photography-inclusive fine arts curriculum was Black Mountain College in North Carolina, whose faculty included Aaron Siskind, Harry Callahan, and Ben Shahn. One of its students, Jonathan Williams, championed a number of cultural causes throughout the South, including its photographers and the subjects they recorded. Williams's Jargon Society Press began publishing in 1952, and many of its titles include photographs by southerners and about the South, including Paul Kwilecki, John Menapace, Guy Mendes, Orcenith Lyle Bongé, and Mark Steinmetz. Williams, better known as a poet, is an accomplished portrait photographer and has made hundreds of images depicting artists and writers, many of them southerners.

In 1975 a groundbreaking show at the Museum of Modern Art in New York featuring the work of Memphis native William Eggleston shattered the notion that artistic photographs could only be black-and-white images and that objects, situations, and environments encountered in everyday life were not legitimate subjects for serious photographic exploration. The sanctioning of artistic color photography resulted in a generation of practitioners, with some notable ones living in southern places and using southern subject matter in their works: Alabama's William Christenberry, Louisiana's William Kross Greiner, Mississippi's Birney Imes, North Carolina's Alex Harris, Arkansas's Dave Anderson, and Texas's Skeet McAuley are but a few whose careers are being defined by bodies of work executed principally or exclusively in color materials.

DOCUMENTATION OF ACTIVITIES. Southern customs, folkways, celebrations, peculiarities, and quotidian activities have been recorded extensively in singular images and focused bodies of work. The following recapitulation, more representative than exhaustive, suggests the breadth of "southernness" that exists in

the photographs made over a long period of time. New Yorker Doris Ulmann spent time in the South with a view toward documenting the craftsmen and crafts of the Appalachian area. Many of her pictures were published in Allen Eaton's *Handicrafts of the Southern Highlands* (1937). Ulmann's métier was portraiture, and another southern project that used her talent in this field was *Roll, Jordan, Roll* (1933), set in South Carolina and accompanied by writing from Julia Peterkin. Ulmann had two series of unpublished portraits of religious orders in New Orleans: the Ursuline nuns and the Sisters of the Holy Family.

Ernest J. Bellocq chose very different women as his subjects. The New Orleans photographer's commercial studio output is workmanlike, but his several dozen portraits of some of the women who made a living as prostitutes in Storyville, the Crescent City's sanctioned red-light district, are one of the landmarks of 20th-century photographic history. Savannah native John David "Jack" Leigh II investigated his coastal neighborhood with the familiarity of a native and the wonder of a stranger. His photographs of the oystering and shrimping industries, along with the landscapes, people, and architecture of that environment, have ironically frozen some traditions at the same time as they were passing away.

Southern music, in all of its varied forms, has attracted a number of photographers. New Orleanian Michael P. Smith and Canadian Ralston Crawford covered New Orleans jazz and rhythm and blues, respectively, and the neighborhoods that produced it, for more than a collective 70 years; New York–based Lee Friedlander has for nearly 60 years focused on portraits of jazzmen, often traveling to New Orleans to make the photographs. Frenchman Alain Desvergnes, while teaching at the University of Mississippi from 1962 to 1965, made memorable photographs of Mississippi Delta bluesmen and their surroundings. A number of these photographs are collected in the book *Yoknapatawpha* (1990). Jay Leviton accompanied a young Elvis Presley through a southern tour in 1956, documenting "the King" as he traveled from Jacksonville to New Orleans. The series shows the legendary singer at work and at rest.

The work of documentary photographers is often acclaimed as fine art as well. Geoff Winningham, who in the 1970s made important series of photographs of Texas's rodeo culture and high-school football activities and of professional wrestling matches at the Houston Coliseum, has since that time explored the Texas landscape and projects in Mexico. Bill Ferris's photographs of blues culture and other aspects of African American life in the Mississippi Delta appeared in his *Blues from the Delta* (1970) and more extensively in *Give My Poor Heart Ease: Voices of the Mississippi Blues* (2009). Tom Rankin has also photographed in the Mississippi Delta since the 1980s, and his images of black

churches and cemeteries appear in his *Sacred Space: Photographs from the Mississippi Delta*.

LANDSCAPES. As in the 19th century, the southern landscape and the activities that happen there, especially along the coastal margins, have intrigued photographers in the last five decades. In the 1950s and 1960s, Elemore Madison Morgan Sr. of Louisiana photographed the forests and timber industry of the South's piney woods, publishing that work regularly in trade journals and also in a series of books. Florida's Clyde Butcher, as a photographer and advocate for the preservation of fragile and unique landscapes, has, through the beauty of his black-and-white photographs, raised an awareness of that state's coastal margins. Georgia native Richard Sexton, based in New Orleans and an architectural photographer by trade, has wandered the Gulf Coast from Louisiana to Florida on his own, celebrating the quiet majesty of this landscape, which is threatened by commercial pressures and natural catastrophe. Photographic educator A. J. Meek has taught a generation of photography students at Louisiana State University. His photographs depict the state's flat landscape and the often-uneasy proximity of agriculture and petrochemical industries in the lower reaches of the Mississippi River Valley. Andrew Borowiec, on extended visits to the South, has explored much of this same material, emphasizing the invasive nature of industry on the landscape of the Gulf Coast, from Beaumont to Mobile. Virginian Sally Mann achieved initial recognition through the publication of unabashedly frank photographs of her immediate family, but less than 10 years later her interest turned to the subject of southern landscapes, which she recorded in the obsolete wet-plate collodion process and published in 1995. Her more recent work, begun following convalescence from a broken back, has returned to the figure. Mississippi native Maude Schuyler Clay strays little from her Delta environs, recording the seasonal changes of the landscape and the gradual disappearance of structures and traditions found there.

THE 1930S AND 1940S. The decades of the 1930s and 1940s saw the southern United States under more photographic scrutiny than at perhaps any other time in its existence. Various federal administrations operating under the New Deal programs of Pres. Franklin D. Roosevelt sent photographers throughout the country. The Resettlement Administration, the Rural Electrification Authority, the Farm Security Administration, and the Office of War Information were among the agencies whose men and women recorded aspects of the South. Walker Evans, Ben Shahn, Carl Mydans, Russell Lee, Peter Sekaer, John Vachon, and Marion Post Wolcott were among those who blanketed the region

and whose photographs helped define the South to the rest of the United States and beyond.

A different federal program, begun in 1933, the Historic American Buildings Survey (HABS), operated throughout the country and was meant to document through measured drawings and photographs the significant architecture of the United States. The program still operates today and is joined by the Historic American Engineering Record (HAER) and the Historic American Landscape Survey (HALS). In the 78 years since they began, HABS/HAER/HALS have produced thousands of technically consistent images of southern architecture, engineering feats, and landscapes, by a wide-ranging group of photographers.

Another federal program of the Great Depression, the Federal Writers Project, sought to publish guidebooks to each state (and some major cities). Though the resulting American Guide Series was principally a writing initiative, reproductions of photographs (and other artworks) are liberally included in many of the books. Sometimes drawn from photographs produced for federal projects and sometimes derived from other sources, the photographic images in these books are an important source of southern visual culture of the era.

The guides to the southern states were all published between 1938 and 1941. Southern cities represented in the series with separate volumes include Washington, D.C. (1937), Augusta, Ga. (1938), New Orleans, La. (1938), Lexington, Ky., and the Bluegrass country (1938), Beaumont, Tex. (1939), Louisville, Ky. (1940), Key West, Fla. (1941), Henderson, Ky. (1941), San Antonio, Tex. (1938/41), Houston, Tex. (1942), and Atlanta, Ga. (1949). Among the photographic contributors to the American Guide Series pertaining to the South are Eudora Welty, Daniel Sweeney Leyrer, Lincoln Highton, Carlisle Roberts, the Burgert brothers, and Willa Johnson. Photographic images in the American Guide Series are often attributed only to the institutional source (for example, the Tennessee Valley Authority) or not identified at all as to the maker.

In considering some aspects of southern photography, topical assessment would seem to be a productive path to travel, and the following paragraphs have, for purposes of convenience and organization, taken this approach.

ARCHITECTURE. The buildings of the South, individually and collectively, have been the subject of extensive photographic observation. In the 1920s, Robert W. Tebbs, an architectural photographer from New York, visited Louisiana and Kentucky and created extensive interior and exterior documentation of significant buildings in those states. The successful career as a portraitist of celebrated clientele in Washington, D.C., of West Virginia native Frances Benjamin

Clarence John Laughlin, "The Mirror of Long Ago," 1957, 14" x 11" (The Clarence John Laughlin Archive at The Historic New Orleans Collection, 1981.247.1.2369)

Johnston was eclipsed by her later architectural and garden photographs, which she began in the 1920s. Structures and landscapes in Virginia, North Carolina, Louisiana, and a number of other southern states passed before her lens. Spurred by the prospect of their disappearance, she was attracted to the mansions and gardens of the South rather than to more modest structures.

Clarence John Laughlin was more egalitarian in his approach to the subject of architecture, photographing the grand residences of the antebellum and late Victorian eras in Mississippi, Louisiana, and Texas but also giving attention to the smaller-scaled vernacular structures, both residential and ecclesiastical. In this respect, though their artistic motives could not have been more different, Laughlin has much in common with the southern architectural photography of Walker Evans from the 1930s.

EVENTS. A vibrant commercial gallery scene dealing in photographs of the South and of southern photographers exists in virtually any medium- or large-size metropolis from Washington, D.C., south to Florida and west to Texas. And in the last quarter century, regular events, many of them annual, dedicate a certain part of the calendar to celebrating the art and commerce of photography in southern locales. The biennial PhotoFest in Houston, New Orleans's PhotoNOLA, and Atlanta Celebrates Photography are but three such gatherings. Aside from these special events, commercial galleries provide the opportunity to see and acquire works both from earlier times by established masters and from image makers in early and mid-career.

INFLUENCE OF HURRICANE KATRINA. The South is no stranger to natural disasters: epidemics, forest fires, flooding, tornadoes, and hurricanes have been and, with the exception of epidemics, continue to be regular events in the region, with effects spanning the spectrum from minimal to very destructive. The massive Gulf Coast hurricanes of 2005, especially Katrina (29 August) and Rita (23 September), stand out for the reaction they produced, not only from news photographers (expectedly) but also from photographers who wished to accomplish more than just the documentation of the disasters. Among this group—and among those who continue to visit the affected regions—are Robert Polidori, Richard Misrach, Alex Harris, and Jane Fulton Ault. With the exception of Harris, and, to a lesser degree, Misrach, none of these photographers had made extensive use of southern subjects prior to 2005. Melody Golding's photographs from after the hurricane were shown at the National Museum of Women in the Arts in Washington, D.C., in the exhibition *Katrina: Mississippi Women Remember*, and then as a national traveling exhibition, and 70 images accompanied by oral histories were published in a book, with royalties devoted to assisting artists from the Gulf Coast.

CIVIL RIGHTS. This topic has had many fine photographers associated with it. As the 20th century began one of the prominent African American leaders,

Booker T. Washington, had his activities chronicled by Arthur P. Bedou. Bedou, from New Orleans, continued his photographic work following Washington's death in 1915, operating a portrait studio in his hometown. Prentice Herman Polk, of Bessemer, Ala., like Bedou, also worked at Tuskegee Institute, now Tuskegee University, from 1939 until his death, and, also like Bedou, Polk's work includes subjects outside of the campus community. Roland L. Freeman, of Baltimore, began full-time photography in 1963 with pictures of the March on Washington. Employed by the *D.C. Gazette* as a photographer and later as photo editor, Freeman had his photography published regularly. Though he was present at many important civil rights events, Freeman's passion was to observe and document the daily life of African Americans in the South, in both rural and urban settings. Danny Lyon was a photographer for the Student Non-violent Coordinating Committee (SNCC) and photographed throughout the South for that group in 1963. His book, *The Movement*, is based on those experiences and photographs. Ernest Whithers, of Memphis, Tenn., operating his own studio in the segregated South, saw much of the modern civil rights movement pass before his lens, and what did not come to him he went out to find and photograph. His output preserves a strong record of Memphis music and its place as a center for civil rights figures and activities, the Negro Leagues, and a host of other subjects who were the clientele of his commercial photographic enterprise. In 2010 a number of news sources reported that Withers had been a paid informant for the FBI as it monitored the key figures in the civil rights movement.

The subject of southern photography has become more complex over the years rather than less. The ubiquity of the medium is partly responsible for that, as are the many reasons why photographs are made and how they are used. Regional borders, once so clearly marked by shared cultural habits and dispositions, are more porous. Natural landscapes, with particular plants, animals, and topographies that define regional character, are ever eroding, from forces both natural and man-made. The challenge to maintain a "southern photography" exists both for those who wield the instruments of its creation and those in whose care the stewardship of the subject matter resides. The intelligence of the respective parties in these efforts will shape the outcome of southern photography as something distinctive from other photographies.

JOHN H. LAWRENCE
The Historic New Orleans Collection

James Agee (text) and Walker Evans (photography), *Let Us Now Praise Famous Men* (1941); A. D. Coleman, *The Southern Ethic* (1975); Ellen Dugan, ed., *Picturing the*

South: 1860 to the Present: Photographers and Writers (1996); Arnold Genthe, *Impressions of Old New Orleans* (1926); Irwin Glusker, ed., *A Southern Album: Recollections of Some People and Places and Times Gone By* (1975); Alex Harris and Alice Rose George, *A New Life: Stories and Photographs from the Suburban South* (1996); F. Jack Hurley, Nancy Hurley, and Gary Witt, eds., *Southern Eye, Southern Mind* (1981); Clarence John Laughlin, *Ghosts along the Mississippi* (1948), *New Orleans and Its Living Past* (1941); David Madden, *Southern Quarterly* (Winter 1984); Wendy McDaris, ed., *Visualizing the Blues: Images of the American South* (2001); Francis Trevelyan Miller, *Photographic History of the Civil War, in 10 Volumes* (1911); Museum of Modern Art, *William Eggleston's Guide* (1976); Margaret D. Smith and Mary Louise Tucker, *Photography in New Orleans: The Early Years, 1840–1865* (1982); Southern Photography, southphotography.blogspot.com (accessed 23 May 2011); Robert Taft, *Photography and the American Scene: A Social History, 1839–1899* (1938); Jonathan Williams et al., eds., *I Shall Save One Land Unvisited: Eleven Southern Photographers* (1978).

Queen Anne and Eastlake Styles of Architecture

The Queen Anne style of architecture was conceived in England by Richard Norman Shaw during the 1860s, and the term is a misnomer. Shaw at first borrowed details from the rural manor houses not of Queen Anne's reign but of Queen Elizabeth's sovereignty. The erroneous designation seems attributable to English architect John James Stevenson in the 1870s.

Shaw's houses were widely published in the architectural press and thus came to be imitated in the United States in the early 1870s. The popular acceptance of the Queen Anne style in America, however, can be attributed to the Centennial Exhibition of 1876 in Philadelphia. For this world's fair, the British government erected two buildings in the Queen Anne style, which received a good deal of critical acclaim.

The style flourished in America during the 1880s and 1990s, representing a renewed interest in the picturesque. The "[present] epoch of Queen Anne is a delightful insurrection against the monotonous era of rectangular buildings," declared one writer in an 1880s magazine. Irregular planning and massing accompanied by a variety of color, texture, and structural expressionism characterized the style.

Americans nationalized the style by the use of Colonial Revival details and regional materials like shingles and siding. Although the Queen Anne style was a mix of architectural details, the main theme was classical, and the style is sometimes called "free classic." Frequently, the style was combined with Eastlake and Romanesque detailing, creating unique designs. For added visual

interest, details were sometimes borrowed from Islamic and Oriental precedents.

The impact of the Queen Anne style on the southern housing stock was enormous because of the rapid growth of the southern economy during the post-Reconstruction period and because this style of residence could be erected inexpensively and quickly. The majority of the Queen Anne residences were constructed of wood, so the developing southern timber industry, especially in the area around Pensacola, Fla., provided an abundance of materials from which to draw. The Queen Anne house can be found throughout the South, particularly in the Savannah Victorian District, the New Orleans Uptown District, the Historic District of Pensacola, Atlanta's Sweet Auburn Historic District, and in East End Historic District in Galveston.

Because Queen Anne house designs were often chosen from pattern books of the period, for example, *Holly's Modern Dwellings*, and since details were mass-produced as a result of technological advances, a certain consistency in the style was achieved. Externally, Queen Anne houses are massive, irregular, and picturesque. Projecting elements—particularly cylindrical towers with conical roofs, polygonal turrets with distinctive roofs, tall, elaborate, decorative chimneys with large corbelled tops, and carefully detailed entrance porches, verandas, and bay windows—are featured elements.

Every surface of the Queen Anne house is textured or has applied ornament, making the house's exterior finishing the dominant decorative element. Windows come in a profusion of shapes but tend to be tall, thin, large, and double-hung. Frequently, windows have the top sash divided into small colored panes of glass surrounding a larger central field. The lower sash is a single large pane of glass or is divided by a single vertical muntin. This type of window has been designated the "Queen Anne window." Stained-glass windows are common, as are Palladian windows and other forms of grouped windows. Doors, which are usually deeply recessed under porch roofs and vestibules or second-story overhangs, have a large glass area. Roofs are steep and complex, with moderate overhangs, polychromatic slates, or patterned metal shingles and elaborate terra-cotta ridge tiles. Gables are common and often include a large porch gable, adding to the picturesque effect of the total design.

The floor plans are informal and asymmetrical. The featured room—the "living hall"—was introduced for the style and was designed to impress. This room was generally finished in dark oak or other wood and had an elaborate wooden staircase illuminated by staggered stained-glass windows. Often a large fireplace occupied a place of prominence. The dining room, parlor, and study were connected to the entrance hall by large sliding doors, which permitted a

relatively open place that could be divided into private rooms as necessary. The kitchen, with its accessory pantry and storage, opened to the dining room. Projecting and inserted verandas and terraces were integral parts of the total design. Bedrooms and baths were generally relegated to the second story but were sometimes confined to a rear wing.

The Eastlake style coexisted with the Queen Anne and shared many of its planning and massing characteristics; but this style is distinguished from the Queen Anne by its detailing, much of which can be traced to the neo-Greco style. Under the auspices of neo-Greco, the round forms and foliated ornament of the Italianate style took on a rectangularity and precision thought to be expressive of an increasingly mechanized and industrial society. Incised ornament was a hallmark. Stylized single-line flowers and long, parallel, narrow channels were favorite details.

The Eastlake style was named after Charles Locke Eastlake, an English architect who is more noted for his books than his architecture. Eastlake's *Hints on Household Taste* was first published in London in 1868 and made its American debut in Boston in 1872. The book was immensely popular, with six editions in the next 11 years. Eastlake promoted a style of furniture and interior detailing that was angular, notched, and carved. He wrote, "It is an established principle in the theory of design that decorative art is degraded when it passes into a direct imitation of natural objects. Nature may be typified or symbolized, but not actually imitated."

Other books, namely *Gothic Forms*, by Bruce James Talbert, which appeared in America in 1873, helped to formulate the style. While Eastlake concentrated on details, Talbert showed whole interiors. American architectural designers found their own interpretation of the style. Their ornament was largely the product of the chisel, the gouge, and the lathe. Details were massive, oversized, and robust. Designers placed no limits on the arrangement of forms or the amount of ornamentation on the exterior of the Eastlake house, much to the chagrin of Eastlake, who wrote, "I regret . . . that [I] should be associated . . . with a phase of taste in architecture and industrial art with which I can have no real sympathy and by all accounts seems to be extravagant and bizarre."

The Eastlake style was the product of industrialization, but ironically it was named for a leader of the Arts and Crafts movement who advocated a return to the craftsmanship of the past. Factory-made decorative elements could be ordered by mail from catalogs or bought from local distributors. The Orleans Manufacturing and Lumber Company published one such catalog in 1891. Even entire houses could be ordered prefabricated. The multitude of ornamentations resulted in a wide variety of combinations. Small cottages in places like Biloxi,

Miss., and large houses in New Orleans both commonly employed the Eastlake style.

ROBERT J. CANGELOSI
New Orleans, Louisiana

Alan Gowans, *Images of American Living: Four Centuries of Architecture and Furniture as Cultural Expression* (1964); Carole Rifkin, *A Field Guide to American Architecture* (1980); Leland M. Roth, *A Concise History of American Architecture* (1979); G. E. K. Kidder Smith, *The Architecture of the United States: The South and Midwest* (1981); Dell Upton, *Architecture in the United States* (1998); Richard Guy Wilson, *The Colonial Revival House* (2004).

Residential 20th-Century Architecture

The rapidly expanding middle class and the enormous mobility offered by the automobile created demands for suburban housing. Houses had to be flexible enough to accommodate a changing society and inexpensive enough to be affordable. Consequently, 20th-century houses differed immensely from 19th-century houses in scale and floor plan. Southern housing of the early 20th century can be divided into two categories—those free from historical precedents and those that rely on historical eclecticism.

The most popular nontraditional architectural style of the period was the California style (1900–1940), sometimes referred to as the Bungalow style. "California" seemed to be the preferred term during the heyday of the style, while "bungalow" simply referred to a small residence. The California style was an honest, bold expression of architecture that synthesized precedents from many sources without mimicking any one. These houses were basically wooden with such masonry complements as porches, chimneys, piers, and retaining walls. The style is unpretentious and distinguished by its clever use of wooden structural members as ornamentation. Building elements seem to flow from one to the next, with one element being an integral part of that which immediately precedes and follows. The massing of the style is very picturesque, with low lines. Roofs are generous, with broad sloping overhangs. Windows are commonly short and grouped together to take advantage of breezes. The floor plan is very informal, with spaces flowing from one room to another, rendering a feeling of openness. Typically, circulation is through the living room, which often has a large fireplace, setting the tone of the decor. Interior details reflect a strong "crafts" orientation. Front, side, rear, and sleeping porches are commonly used in order to keep interior spaces cool.

The architects of California formulated the style, giving it its innovative fea-

tures and design. The Greene brothers, Charles Sumner Greene and Henry Mather Greene, were its most influential architects. The style was a builders' style, which was promoted through numerous periodicals, including *Craftsman Magazine*, *Bungalow Magazine*, and *Ladies' Home Journal*. Even the Sears and Roebuck catalog carried California bungalow house plans, "direct from bungalow land," for the meager price of five dollars. With such inexpensive prices, identical houses can be found in widely separated locales.

Southerners eagerly accepted the bungalow, which had been designed for a similar climate, and it was built throughout the region for middle- and low-income housing, in small towns and large. One can readily date the period of growth and expansion of certain sections of cities by the presence of whole groups of these bungalows in a neighborhood. One such subdivision is that of Gentilly Terrace in New Orleans.

Another popular nonhistorical style was the Craftsman style. It had its roots in the English Arts and Crafts movement and was developed as a solution to the "corrupt" values of the Victorian styles. The movement's chief advocate was the English architect-turned-artist William Morris, who realized that he was unsuccessfully competing with machine art and began to write articles opposing the machine. In 1888, the English Arts and Crafts Exhibition Society was formed, which published articles and held exhibitions extolling the virtues of handcrafted art.

In Boston, the first American Society of Arts and Crafts was organized in 1897. But it was from Gustav Stickley's *Craftsman Magazine* and his two *Craftsman Home* books that the movement received its widespread acceptance in the South. Young architects took up the cause, rejecting machine aesthetics as impersonal. Their solution advocated greater honesty and sincerity in architecture, with artful attention to every detail. Southern homes constructed in this style tend to be modest in scale. Some of these are found among Gulf Coast cottages and in some summerhouses in the mountains of North Carolina, Georgia, and Virginia.

Other early 20th-century nonhistorical styles found in the South include the Prairie, art deco, streamline moderne, and International styles. The Prairie style (1900–1920) evolved on the prairies of the Midwest. It explored new ways of relating building to the landscape and new concepts of interior space. The master of the style was Frank Lloyd Wright, who described the Prairie-style house as "having sloping roofs, low proportions, quiet skylines, suppressed heavy-set chimneys and sheltering overhangs, low terraces and outreaching walls sequestering private gardens." Wright, who has been described as a 20th-century Jeffersonian agrarian, had only one Prairie house in the South, the

Ziegler House in Frankfort, Ky., but two of his Usonian houses (a variation of the Prairie house) are in Falls Church, Va. (the Pope-Leighey House, 1939–41), and in Florence, Ala. (the Rosenbaum House, 1939–40).

Art deco (1920–30), characterized by a vertical emphasis with highly stylized ornamentation, was commonly employed in commercial architecture but could also be found in large residences and apartment complexes. In the South this style was most popular in southern Florida.

Streamline moderne (1930–40) was inspired by America's love for the machine. Its shapes were guided by the principles of aerodynamics and hydrodynamics. Smooth white curvilinear shapes were used to try to capture the spirit of frozen motion.

The International style (1910–40), which originated in Europe, had limited acceptance in the South, chiefly in metropolitan areas. Henry-Russell Hitchcock and Philip Johnson described it as "first, a new concept of architecture as volume rather than as mass." In addition, "regularity rather than axial symmetry" was the main way of achieving orderly design. The style, finally, "proscribes arbitrary applied decoration." The Feibleman residence, constructed in 1938 in Metairie, La., is a good example of this style.

Although 20th-century revivals can be found for almost every previous architectural style, the Tudor, neo-Italianate, Renaissance, and Colonial Revival styles have been the most common in the South. The Tudor style (1900–1930) was originally based on English Elizabethan and Jacobean styles, and as a consequence it is sometimes referred to as the "Jacobethan" style. As the style matured it began to imitate the English medieval period with greater accuracy. Its most distinguishing feature is half-timbering with stucco or masonry infill. It was used on both modest and expensive houses throughout the South. The Wymond House in Louisville, Ky., is an outstanding example of a large Tudor Revival residence.

The neo-Italianate (1910–30) was a revival of the Italian villas of the Mediterranean, distinguished by shallow brackets and a large umbrella-type roof with barrel roofing tiles. It was very popular for large residences along the Gulf Coast because of its large protective roof and large windows and its air of opulence. The Rostrevor House in Louisville, Ky., is a good example of the neo-Italianate.

The Renaissance Revival (1890–1940) developed as an academic reaction to the free spirit of the late 19th-century styles. It borrowed Renaissance elements, details, and composition from England, France, Spain, and Italy. These residences tended to be large and elaborate and were more often than not designed by architects. The style's primary advocate was the New York City archi-

tectural firm of McKim, Mead, and White. Many such large residences can be found in the Swiss Avenue Historic District in Dallas and on Audubon Place in New Orleans. Outstanding individual examples include the Alexander House (1906), Dallas, Tex., the Hills House (1899), St. Louis, Mo., and the Armstrong House (1917), Savannah, Ga.

ROBERT J. CANGELOSI
New Orleans, Louisiana

Catherine Bishir, *Southern Built: American Architecture, Regional Practice* (2006); Alastair Duncan, *Art Deco Complete: The Definitive Guide to the Decorative Arts of the 1920s and 1930s* (2009); William H. Jordy, *American Buildings and Their Architects*, vol. 2 (1972); Walter C. Kidney, *The Architecture of Choice: Eclecticism in America, 1880-1930* (1974); Clay Lancaster, *The American Bungalow, 1880-1930* (1985); Leland M. Roth, *A Concise History of American Architecture* (1979); Dell Upton, *Architecture in the United States* (1998); Dell Upton and John Michael Vlach, eds., *Common Places: Readings in American Vernacular Architecture* (1986); Leila Wilburn, *Southern Homes and Bungalows* (1914).

Resort Architecture

Resort architecture developed as a moneyed leisure class developed in American cities, largely in the 19th century. Most of the earliest American resorts were concentrated in the Northeast within easy reach of large urban centers like New York and Boston. The famed resort hotels of Saratoga Springs and the Catskill Mountain House provided restorative and scenic respites from urban life. With the South's more sparse population, southern resorts developed contemporaneously but more slowly than their northern counterparts. The exploitation of existing natural landscapes, the development of the railroad, and the growing culture of the "winter vacation" transformed southern resorts from regional to national attractions by the last decades of the 19th century. While the context and style of these resorts has changed across time, their architecture has remained consistently grand in scale and escapist in character, providing a fantasy setting removed from everyday life.

As distinct from hotels, resorts by definition offer a broader range of services and activities to guests and typically depend for their success on the surrounding natural landscape and climate. Visitors to resorts typically seek good weather, healthful surroundings, and beautiful scenery, as well as luxurious service. In the South, there have historically been two landscapes that provide the setting for resort activities: the mountains and the coast. Major resort architecture has thus been concentrated in the Blue Ridge Mountains of

Virginia and North Carolina and to a lesser extent in the Ozark Mountains of Arkansas. Coastal resorts blossomed on the beaches of the east and west coasts of Florida, with development on the barrier islands along the southern Atlantic Coast as well.

MOUNTAIN RESORTS. The first resorts of the South developed in the early 19th century around a series of hot springs in Virginia and West Virginia in the Blue Ridge Mountains, which had been known since the middle of the 18th century for their healing capabilities. Drawing on current European medical practices, American doctors advised patients that various mineral waters, both warm and cold, had the potential to cure a wide variety of ailments, from skin diseases and gastrointestinal ailments to joint pain and stiffness. White Sulphur Springs, W.Va., was home to the grandest of these early resorts. It had humble beginnings, starting as a collection of cabins that surrounded a central lawn, with a springhouse added in 1817 by proprietor James Calwell. In 1844, accommodations were still described as "miserable-looking," but the springs had become quite popular. The "Queen of the Springs," as the springs at White Sulphur Springs was known, was a hub of elite southern social life before the Civil War. Each of the rows of cottages was known by a different name, including Paradise Row and Alabama Row, some of which were built by the proprietor and others by private owners. Baltimore-based engineer and architect John H. B. Latrobe built Baltimore Row, a series of seven cottages in a refined Greek Revival style, and Richard Upjohn, New York architect, designed a Gothic Revival six-cottage row (now demolished). In addition to the springs themselves, the picturesque lawn and curvilinear walking pathways through the surrounding woods were crucial to the resort experience. It was only in 1858 that a large resort hotel opened, named the Grand Central Hotel but widely known as "The White." The cottage rows were informal, but the new hotel introduced the most modern features of resort hotels in the North: a grand dining room, which seated 1,200, a ballroom, public reception rooms and parlors, and 228 bedrooms. Unlike its northern counterparts, the new hotel was an orderly Greek Revival structure with a grand pedimented central bay topped by a shallow dome and cupola. Verandas lined all three floors, providing covered porches for both the grand public spaces of the ground floor and the private guest rooms above. The hotel survived the Civil War and stood until 1922, when it was demolished. Today, the Greenbrier, a Georgian Revival hotel opened in September 1913 and designed by George A. Fuller Company of New York, remains the centerpiece of White Sulphur Springs.

Hot Springs in Arkansas was recognized as a national asset early on and

Alabama Row at the Greenbrier in West Virginia (The Greenbrier, White Sulphur Springs, W.Va.)

was transferred to federal ownership in 1832. From a few log cabins in 1804, the resort town became a center for midwestern travelers seeking a health cure by the late 19th century. It was not until the 1890s, however, after the railroad made Hot Springs more accessible, that an eclectic assembly of large-scale resort architecture developed along what came to be known as Bathhouse Row. The Hotel Eastman (1890), the New Arlington Hotel (1893), the Alhambra Bathhouse, and the Horseshoe Bathhouse (both ca. 1890) were all constructed with allusions to Spanish and Moorish architecture, from onion domes and *muqarnas* to the spatial integration of water pools and courtyards.

Thermal springs were not the only attraction that led travelers to mountain resorts. Golf by the late 19th century was established as an upper-class pastime for Americans, and some of the country's first courses were anchors for larger resort developments in the South. James Walker Tufts, a Boston businessman, established a resort community at Pinehurst, N.C., in 1895. Frederick Law Olmsted provided the master plan for the village based on a prototypical New England village. The Holly Inn, designed by Burr & Sise of Boston, was the first hotel in Pinehurst, and it was complemented by a series of private cottages for rent, croquet fields, tennis courts, and walking paths. Though originally in-

tended as a tuberculosis treatment center, in 1897 Tufts changed his focus to golf and recreation after learning that tuberculosis was a communicable disease. He quickly built the first nine-hole course, followed by nine more the next year. In 1900, Tufts hired Donald Ross, a Scottish-born golf course designer, who went on to design three more golf courses for Pinehurst. Ross's Pinehurst No. 2 remains a legendary course and cemented the resort's reputation. The architecture of Pinehurst is picturesque; it was derived from the language of New England's colonial buildings, which were in keeping with the aesthetics of the Boston architects who designed it as well as the tastes of the winter-weary northerners whom Tufts hoped to attract. Asymmetrical massing, gambrel roofs, and wood clapboards defined the Holly Inn. The grander Carolina Hotel (1901), symmetrical, with a central cupola, opened quickly thereafter, replete with a 500-person dining room, music pavilion, and sunrooms to entertain guests when not on the golf courses.

Asheville, N.C., like Pinehurst, developed in the late 19th century, after the railroad, which first arrived in 1880, provided improved accessibility to the region. Asheville capitalized on its beautiful natural setting in the Blue Ridge Mountains and marketed itself as having particularly healthy mountain air for weary or ill city dwellers. Asheville also benefited from association with the Vanderbilt family; in 1889, George W. Vanderbilt II began construction of the Biltmore Estate just outside of Asheville, cementing its status as a prime destination for the wealthy Gilded Age leisure class. The earliest resort hotels to open in Asheville were the Battery Park Hotel (1886, demolished 1924), followed soon after by the Kenilworth Inn (1890, burned 1909), designed by F. L. and W. L. Price of Philadelphia. Both hotels followed the fashion for asymmetrical, picturesque, Queen Anne–style architecture and would have been as at home in Newport, R.I., or Cape May, N.J., as they were in Asheville.

COAST RESORTS. Henry Flagler, New York–based railroad magnate, built the Florida East Coast Railway in the late 1880s and early 1890s and also several enormous, elegant resorts as destinations along his new line, an area that quickly became known as the "American Riviera." The first of these was located at St. Augustine, Fla., and was set back away from the coastline and near the city's historic Spanish colonial town plaza. The Hotel Ponce de Leon (1888) combined Gilded Age taste for high European fashion with a sense of local architectural culture and was built to draw northerners to the warm climate and historic geographies of the South. Designed by the New York firm of Carrère and Hastings, the Ponce de Leon (now home to Flagler College) is in a Spanish Renaissance style thought to complement the historic Spanish

colonial fabric of St. Augustine. To maximize the relationship of the hotel to its warm Florida climate, it was situated within a palm garden and arranged along a grand Beaux-Arts axis around a central courtyard with fountain, tumbling vines, trees, and sweet-smelling flowers. Carrère and Hastings used a modern version of *tapia*, a concrete mixed with *coqina* (a shell-infused local limestone), which was a staple material of Spanish colonial architecture in the region. The design was thus historical but also modern, as it was the first structure of this scale to be built entirely of poured concrete, used also because it was fireproof and to provide resistance to hurricane-force winds. The gray concrete walls were enlivened by a Mediterranean color scheme of red brick and orange terra-cotta details, along with wooden bracketing painted a warm yellow. The building's exotic character continued on the interior, with art glass designed by Louis Comfort Tiffany and murals by painter George W. Maynard depicting the Spanish conquest and colonization of the New World. The Ponce de Leon was a small city, with spaces provided for kitchens, barbershop, post office, quarters for staff, and grand entertaining areas, including artists' studios, a gymnasium, children's dining room, and a magnificent two-story dining room, which seated over 1,000.

The Ponce de Leon established an exotic and luxurious image, which became a source of emulation and competition from new hotels farther south along the Atlantic and Gulf Coasts of Florida. By 1910 Flagler had built additional hotels in St. Augustine as well as in Palm Beach, and the railroad developer Henry Plant had constructed a series of hotels on the western coast from Tampa to Fort Myers. Most of these resorts closed or were converted to government and college offices after the Great Depression of the 1930s.

By the 1920s the grandest new resort hotels had been built at the southern end of the rail lines in Florida in Coral Gables and Miami Beach. The 11-story Flamingo Hotel (1921), developed by Carl Fisher and designed by Price and McLanahan of Philadelphia, was located directly on Biscayne Bay in newly established Miami Beach. The Flamingo began to break with the tradition of Mediterranean and Beaux-Arts forms and became part of a new trend toward skyscraper tower hotels that directly addressed the waterfront. While Henry Flagler built the last of his great historicizing resorts, the Breakers, there in 1926, development of Miami Beach remains famous today for its art deco tropical modernism. By the late 1920s this proliferation of smaller, streamline moderne buildings in pink and greens with ornamentation provided by neon and chrome marked a new phase in the development of resort architecture in Florida and would eventually lead to the highest concentration of resort hotels in one area in the United States.

The barrier islands off the Atlantic Coast also provided locations for more private resort development once the railroad was complete. Jekyll Island, off the coast of Georgia, became home to the exclusive and private Jekyll Island Club beginning in 1886. Members of the club were largely wealthy New Yorkers, including members of the Vanderbilt, Morgan, and Rockefeller families, who built a clubhouse and enormous private winter homes. These residences were largely in the fashionable Queen Anne style reminiscent of contemporary summer mansions constructed in Newport, R.I. Nearby Sea Island developed as a more public resort accessible by automobile in the 1920s, when Ohio businessman Howard Coffin hired architect Addison Mizner to design the Cloister (1928, demolished 2003), as well as a series of private cottages, golf courses, riding stables, and shooting ranges.

While East Coast railroads made beaches accessible to northeasterners in Florida, as well as in smaller, more regional developments in places like Virginia Beach and Myrtle Beach, S.C., the railroad also allowed midwesterners access to the beaches of the Gulf Coast—though development never reached the scale of the East Coast corridor. In Galveston, the Beach Hotel (1883) was designed by architect Nicholas Clayton as a regional attraction and winter resort. The hotel was an enormous Queen Anne wooden structure painted in red and white stripes with green awnings; it burned in a reported 25 minutes in 1898. Lake Pontchartrain served as a regional resort beginning in 1831 with the building of hotels and piers at Milneburg, a popular port of entry via railroad to New Orleans. Ocean Springs, Miss., was the site of Chicago architect Louis Sullivan's self-designed winter home (1890), where he escaped from Chicago winters, enjoying "birds singing, waters sparkling."

POST–WORLD WAR II. Automobile culture had a major impact on the further development of resort architecture. After World War II, American prosperity expanded the scope of the leisure class and more Americans began to take extended vacations. The development of the motel, specifically developed as a lower-cost, automobile-oriented alternative to the grand resorts of the late 19th and early 20th centuries, changed the face of resort architecture. The Holiday Inn chain began in Memphis in 1952 as a response to the need for adequate lodging along the nation's interstate highways, as families took their new automobiles on long road trips with destinations far from home. The Days Inn chain was founded in Atlanta in 1970, focusing specifically on underserved locations outside of major cities. Both chains spread rapidly throughout the South, emulating the services provided at more expensive resorts, including maid service and swimming pools. As a result, the entire Gulf Coast along Highway 90 was

transformed into a series of motels and larger hotels that catered to the inexpensive automobile vacation, and the beach became a regional draw—from Mustang and Padre Islands in Texas, to Gulf Shores, Ala., and Fort Walton Beach and Panama City Beach in Florida.

Only beginning to receive scholarly attention is the manner in which issues of segregation and racism affected tourism and hotels. As a black middle class also began to become more mobile, lack of access to whites-only hotels, beaches, and parks meant that alternative spaces of leisure developed. American Beach, near Jacksonville, Fla., was one such example, where wealthy African Americans owned their own hotels, businesses, and houses.

With the rise of the automobile and a more mobile middle class, many of the late 19th-century grand resort hotels closed or were transformed into college or government administration buildings. But a new generation of luxury resort properties responsive to changing tastes also developed. In the 1950s Miami became a hub of glamorous urban beach resorts, with lavish hotels, their private beaches and gardens, and opulent ballrooms. Morris Lapidus, a New York architect, set the tone with his designs for the Fontainebleau Hotel (1952) and the adjacent Eden Roc (1953). Lapidus brought a sleek, exuberant modernism defined by elegant curves and amoeboid shapes, or "woggles," as he called them, which defined a modern escapist aesthetic for the beach resort. With interior fittings and lighting derived from Lapidus's experience in retail architecture in New York, their mirrored surfaces, brilliant colors, dramatic staircases, and clashing quotations from French baroque and modernist forms, the resorts of Miami Beach set a new standard of up-to-date opulence.

Golf resorts began to compete with beach and mountain resorts on a large scale by the 1950s. By contrast, Sea Pines Resort in Hilton Head, S.C. (1956), designed by architect Charles Fraser, was one of the first resorts to look back nostalgically to vernacular plantation architecture. A central clubhouse was initially surrounded by private cottages, all in a self-described Lowcountry architecture chosen as typical of the region's history. Here one could have golf, beach, and fresh air all in one location, an acknowledgment of the intense competition for vacationers that typified American resort architecture by the late 20th century.

The ultimate development in resort architecture combines all the elements discussed above. Walt Disney opened a theme park in Buena Vista, Fla., near Orlando in 1971, followed by Epcot in 1982. Here the traditional dependence on natural environment and pleasing climate was usurped by a completely manufactured artificial entertainment on a massive scale that has come to dominate much contemporary resort architecture. By leveraging a remarkable develop-

ment agreement with the city of Orlando, which was struggling economically, the Disney Corporation created the largest collection of theme parks and resort hotels in the United States. While the focus of Disney's development is theme parks, a series of resort hotels surrounding the parks emerged by the 1980s. Most notable are the cartoonish Swan and Dolphin hotels (1989–90), designed by architect Michael Graves, which were emblematic of the "entertainment architecture" commissioned by Disney during this period. Robert A. M. Stern's designs for Disney's BoardWalk Resort (1996) bring the story back to its beginnings, taking the language of 19th-century resort architecture at Coney Island and using it as the backdrop for a nostalgic pause from everyday life. The Saratoga Springs Resort at Disney World (2004), designed by Graham Gund Architects of Cambridge, Mass., is an imitation of the original grand resort in America, replete with artificial springs. While resort architecture has always been about creating an escapist experience, contemporary developments have increasingly used artificial landscapes and climates to provide context for the resort experience.

KATE HOLLIDAY
University of Texas at Arlington

Susan R. Braden, *The Architecture of Leisure: The Florida Resort Hotels of Henry Flagler and Henry Plant* (2002); Richard Foglesong, *Married to the Mouse: Walt Disney World and Orlando* (2001); Alice T. Friedman, *Journal of Decorative and Propaganda Arts* (2005); John A. Jakle, Keith A. Sculle, and Jefferson S. Rogers, *The Motel in America* (2002); Jean-Francois Lejeune and Allan Shulman, *The Making of Miami Beach, 1933-1942: The Architecture of Lawrence Murray Dixon* (2001); Charlene M. Boyer Lewis, *Ladies and Gentlemen on Display: Planter Society at the Virginia Springs, 1790-1860* (2001); C. Brenden Martin, *Tourism in the Mountain South: A Double-Edged Sword* (2007); William Barton McCash and June Hall McCash, *The Jekyll Island Club: Southern Haven for America's Millionaires* (1989); John C. Paige and Laura Soulliere Harrison, *Out of the Vapors: A Social and Architectural History of Bathhouse Row* (1987); Marcia Dean Phelts, *An American Beach for African Americans* (1997); Richard D. Starnes, *Creating the Land of the Sky: Tourism and Society in Western North Carolina* (2005), ed., *Southern Journeys: Tourism, History, and Culture in the Modern South* (2003).

Sculpture

The lack of sculpture was one item in H. L. Mencken's indictment of culture in the early 20th-century South, and scholars have generally echoed his sentiments. The South has had, however, a twofold tradition of sculpture—

monumental works on the grand scale and folk sculpture on a more humble scale, in the form of stone carving, wood carving, ironworking, and other crafts. Although the monumental work in the region is not categorized with the highest artistic achievements, it is a notable reflection of southern cultural values. The folk sculpture of the region is likewise rooted in regional life, and its aesthetic value is increasingly appreciated by critics.

The South has a long tradition of honoring its heroes through monuments. The South Carolina assembly authorized a statue of William Pitt, erected in Charleston in 1766, to commemorate the English hero of the French and Indian War, while Virginia officially honored its governor, Norborne Berkeley, in 1773 in Williamsburg. This tendency was even more pronounced after the American Revolution. Virginia took the lead in honoring heroes from that conflict. The Virginia legislature commissioned French sculptor Jean-Antoine Houdon to sculpt a bust of Lafayette and, later, a marble statue of George Washington dressed in the uniform of the Continental army, which was placed in the Virginia State Capitol Building in Richmond in 1796. In the Old State House in Raleigh, N.C., stands an 1821 statue of George Washington carved by Antonio Canova, who depicted Washington in another popular pose of the time— dressed as an ancient Roman, seated on a grand chair. Washington was the very image of Cincinnatus, an image reflecting the early southern, as well as American, attempt to see the new nation's culture in classical terms.

Although American neoclassical sculptor Hiram Powers was not from the South, he executed works immortalizing many southern heroes. He sculpted a bust of the aging Andrew Jackson in 1835 and, while living in Washington, D.C., fashioned works of southerners John Marshall and John C. Calhoun. Powers enjoyed the patronage of other southerners, especially the Preston family of South Carolina, who authorized him to sculpt a portrait statue of that state's Calhoun. Henry Clay was the subject of Kentuckian Joel Tanner Hart's full-length statue, completed in 1859, for the Ladies' Clay Association of Virginia.

There are two famed equestrian statues dating from the antebellum era. Clark Mills's bronze monument of Andrew Jackson was unveiled amid much fanfare in Washington, D.C., in 1853, and replicas were soon ordered for Nashville and New Orleans. In 1856, the equestrian monument of General Jackson was placed in the heart of the French Quarter, in an area known thereafter as Jackson Square. A second equestrian statue was Thomas Crawford's homage to George Washington, placed near the Virginia Capitol in Richmond. It was a sculptural group of Washington and other Virginia heroes. Frederick Law Olmsted called it "the highest attainment of American plastic arts."

Many of these works were by nonsouthern artists. John Cogdell, on the

other hand, was a Charleston lawyer who exemplified the southerner interested in sculpture as an avocation. Cogdell dabbled in painting but by the late 1830s was concentrating on sculpture. He visited Italy for inspiration and later was one of the few native-born Americans to exhibit in the Pennsylvania Academy of the Fine Arts in Philadelphia and the National Academy of Design in New York. He sculpted busts of the French general Lafayette and British novelist Sir Walter Scott. Most aspiring American artists, including a few southerners, lived in Italy, to be near ancient works, a supply of marble, skilled assistants, and the European appreciation of sculpture.

After the Civil War, poverty discouraged the commissioning of monumental sculpture. By the turn of the 20th century, however, a movement was under way to honor the Confederacy by erecting monuments to its heroes. For most towns and cities in the region, this meant the erection of a rather standardized monument of a Confederate soldier. These ubiquitous statues represented the idea of sculpture to most southerners. Their artistic merits were few, but culturally they were most significant in using artwork to convey regional values. Typically located on town squares, Confederate monuments were shafts topped by the image of an average soldier. Inscriptions at the base of monuments pledged loyalty to the Lost Cause, "Lest We Forget."

Some monuments to the Confederacy were more artistic than others in conception and execution. Sir Moses Ezekiel and Augustus Lukeman were among the best Lost Cause sculptors, but the most famous was Edward Virginius Valentine, who was born in Richmond in 1838, studied abroad, and then returned to the South in 1865. He became the most renowned artist of the Lost Cause, specializing in sculpting works to honor such Confederate heroes as Robert E. Lee, Thomas "Stonewall" Jackson, Jeb Stuart, and P. G. T. Beauregard. His best-known work is a recumbent statue of Lee in the chapel at Washington and Lee University. Richmond, Va., saw itself as the Rome of the South in nurturing monumental art, with sculptures of Jeb Stuart, Matthew F. Maury, and Hunter H. McGuire; its Monument Boulevard has statues to Confederate heroes Lee, Jackson, and Jefferson Davis, as well as one to George Washington. Stone Mountain in Georgia is the most grandiose monument to the Confederacy. The United Daughters of the Confederacy commissioned a carving of the images of Lee, Davis, and Jackson, which is a huge marble outcropping. The monument, with the three heroes depicted on horseback and sculpted in high relief as though emerging from the mountainside, was not completed until 1970. Mississippi sculptor William Beckwith's *Flag Bearer for the Mississippi 11th* was the most recent monument to be installed at Gettysburg National Military Park in Pennsylvania (2002).

The South has honored through sculpture cultural heroes other than the Confederates. Elisabeth Ney was a German-born artist who came to Texas in the 19th century and produced monuments to such Texas heroes as Sam Houston and Stephen Austin, along with Confederate general Albert Sidney Johnston. New Orleans was the home to many monuments, including the *Wounded Stag* near the Isaac Delgado Museum of Art (now New Orleans Museum of Art) and the symbolic fountain at Audubon Park. Thomas P. Minns executed a series of studies for Nashville honoring African Americans, farmers, and rural Tennesseans, while William M. McVey contributed a James Bowie statue in Texarkana and decorative sculpture on the San Jacinto Monument. Clyde Chandler's Sidney Smith Memorial Fountain is in Dallas, and southern gardens provide an attractive setting for much statuary. South Carolina's Brookgreen Gardens has over 300 pieces by Archer Milton Huntington and Anna Hyatt Huntington, all in an appropriate southern setting surrounded by live oaks and Spanish moss. Classical figures were executed for turn-of-the-century expositions at New Orleans, Atlanta, and Nashville; the Parthenon in Nashville is a lasting monument to such fairs.

Fewer monuments have been dedicated to World War I and World War II veterans than to those of earlier conflicts. Instead, needed structures like roads and bridges have often served as memorials. However, one of the region's most original pieces of sculpture was dedicated as a World War I monument on the University of Virginia campus—the McConnell Statue by Gutzon Borglum, who was the original carver of Stone Mountain and later Mount Rushmore. The Virginia monument is a bronze image of a World War I flying ace who sits poised on a globe, ready for flight. The memorial to World War I in Charleston, S.C., is a nude male figure adorning Battery Park.

In the contemporary South, modern art, including modern sculpture, is found in such large cities as Atlanta, Miami, Dallas, and Houston. There are examples of works by international sculptors like Alexander Calder, Joan Miró, and Henry Moore. Among the most prominent African American sculptors from the South, or using southern themes, are Richmond Barthé, Francis Marion Marche, Augusta C. Savage, William Ellsworth Artis, Selma Hortense Burke, Margaret Taylor Goss Burroughs, Elizabeth Catlett, and Marion M. Perkins. As part of the increasing memorialization of the civil rights movement, southern cities have sponsored monumental sculpture to such figures as Martin Luther King Jr. (Atlanta) and Medgar Evers (Jackson, Miss.).

In addition to creating a regional tradition of monumental sculpture, African American and white southerners have produced a wide variety of folk sculp-

ture. The South has had many craftsmen and -women who produced work that transcended the merely functional to become folk sculpture. These works are sometimes called primitive, eccentric, naive, or, most common, folk art. This category of sculpture includes commercial art, items with both utilitarian and aesthetic dimensions. It also includes the home sculptor who executes works for pleasure. Home sculpture is seen at craft stores, Christmas fairs, and flea markets.

A frequent southern image in film and literature is the whittler on a porch. Whittling, in fact, has had social, educational, and economic facets that make it a common activity, especially in the rural South. A representative of this tradition, Earnest Bennett, originally from Fairplay, Ky., was recognized with a National Heritage Award from the National Endowment for the Arts in 1986. The pocketknife, sometimes called a jackknife, was the simple, basic tool needed, and whittling encouraged qualities of resourcefulness and ingenuity in its use. Pocketknives are valued material culture artifacts among carvers, who sometimes collect and trade them. The skill of carving was typically passed from one generation to another, frequently from an elderly family member or neighbor to a young man coming of age.

The inspiration for such folk sculpture comes from the tasks, materials, and skills of everyday life—farmers and carpenters make art while working with wood; quarry workers create while working in limestone. Often these are communally shared skills applied to expressive forms, and they enhance the pride and prestige of the maker. A distinctive regional dimension comes also from the use of local materials. Southern folk sculpture has traditionally been crafted in wood, stone, iron, or clay.

Because the South has been a heavily forested area, the use of timber as a material for sculpture was natural, and the skills associated with carving were valued in the southern economy. Sometimes the folk artist used a knife and sometimes a chisel; the wood object might be painted or it might be left unfinished. Some woodcarvings were functional, others were simply for show, and still others were novelty items. Carved objects included musical instruments, apothecary mortars, barber poles, weathervanes, whirligigs, toys, shop signs, shop carvings, wildfowl decoys, furniture accessories, walking canes, and larger-than-life-size rifles.

Pierre Joseph Landry, a Louisiana planter, was an antebellum southern folk artist who carved in wood, apparently as a pastime after he became confined to a wheelchair. He carved works that told stories, especially allegorical ones and those with echoes of religious themes from medieval art. Other antebellum art-

ists carved wooden dolls and toys with movable parts. Religion has served as a prime theme for southern carvers, who have produced many church steeples topped by upward-pointing fingers.

Three-dimensional carved human figures were found in the South, many serving as shop signs. The carved Indian was a nationally popular wooden piece, displayed outside tobacco shops, and was one of the most common full-figured wooden pieces produced in the pre–Civil War South. Matthew S. Kahle, a Lexington, Va., furniture maker, produced a full-figured, standing George Washington for the Washington College Chapel in 1840. A carved black man stood as a symbol outside the New Orleans slave auction. Carved human figures also adorned the bows of ships.

Walking canes have often been carved. These were highly functional products for the elderly and handicapped, and folk artists gave them ornamental touches to make them artistic. Snake canes have been common, with serpents' bodies wrapped around the length of the stick and a head topping the cane. Three-dimensional animals have also been carved into canes, as have politicians and statesmen (shops near Monticello in Virginia sell Thomas Jefferson canes). Ceremonial staffs for lodges and fraternal groups have also been produced by folk sculptors.

Carved animals, in the form of domestic pets, livestock, and small animal wildlife, are commonly found in southern homes. They are a modern survival of the traditional southern pastoral ideal. Eagles are popular for interior decoration. Snakes are a favorite image, and the South has its fair share of carved serpents. A common form is a slithering toy—a jointed snake, with carved wooden pieces held together by string or wire. Carving wildfowl decoys began as a folk art by hunters who had a practical use for them. Ned Burgess of Currituck, N.C., for example, turned carving decoys into an art. He made more decoys between 1920 and 1945 than any other North Carolina carver, creating his works for hunters in sportsmen's clubs, for market hunters, and for subsistence hunters. He sculpted many species of local waterfowl, including swans, geese, canvasbacks, redheads, blackheads, pintails, pigeons, black ducks, mallards, ruddy ducks, and coots. Carved ducks are now a ubiquitous presence through much of the South, thanks to commercial marketing.

Among the South's first folk sculptors were the stone carvers who cut gravestones from slate, granite, marble, sandstone, and fieldstone. Limestone seems to have been the most popular rock form. These folk sculptors have usually been seen more as craftsmen than as artists, but many gravestones in the region exhibit aesthetic dimensions. Most, to be sure, repeat standard shapes and designs—weeping willow trees, cherubic angels, hearts and hands, crosses, skull

and bones, flowers, and lambs for children. Scholars have documented, though, the stylized, innovative work of creative stonemasons—for example, Laurence Krone, who carved tombstones for customers in southwestern Virginia in the early 19th century. Much stone carving for graves was, however, anonymous. In the modern South, Nashville, Tenn., carver William Edmondson achieved fame for his stone carvings of animals, angels, flowerpots, religious figures, and garden statuary. Edmondson died in 1951, by which time his work had been displayed at the Museum of Modern Art in New York City.

Appalachian folk craftsmen have sometimes carved in a distinctive regional material—coal. Around the turn of the 20th century, for example, a Bell County, Ky., miner created a replica of the Bible from coal. Coal carvings are available at mountain craft fairs and have become a commercialized product for sale at tourist stores.

Ironworkers frequently decorated their practical creations with artistic touches. One type of ironwork in the South involved casting, whereby molten metal was poured into a mold. Not all casting, to be sure, would be classified as sculpture, but the production of a prototype enabled a caster to produce an object for widespread duplication. Iron furnaces turned out a variety of designs for such objects as andirons, stove plates, cast animals, and various household ornaments and cooking utensils. Most cast iron in the South, however, was imported from the North and was more an industrial form than a fine or folk art.

Another form of southern ironwork was wrought iron. Blacksmiths were an essential figure in both rural and city life, and sometimes they embellished their creations with artistic touches. The blacksmith shaped his metal into such functional objects of daily living as andirons, pokers, gates, commercial signs, grave markers, and kitchen implements. Folk sculptors working in both cast and wrought iron used the same themes and designs as other southern sculptors—animal forms, especially snakes, the human form, and scenes of nature and of religious life. The cities of Charleston, S.C., and New Orleans contain the highest achievements of southern ironwork sculpture—in the lacelike gates and ornamental metal flourishes used in construction. South Carolinian Philip Simmons was one of the most famous and skilled of many black artisans who invested their utilitarian craft with artistic dimensions.

Sheet metal was another medium for southern metal sculptors. Tin and copper objects were common in southern households, and those objects with imaginative decorations of design or motif qualify as folk art. Weather vanes, among the most popular of sheet metal objects that have been documented and collected, were common everywhere. In the form of chickens, horses, cows, sheep, or hogs, they topped barns; angels adorned churches; fish and gulls ap-

peared along coastal areas; and arrows, Indians with drawn bows and arrows, and patriotic eagles were frequent.

Stoneware became the dominant form for traditional ceramics in the South by the early 1800s. Potter dynasties—particularly those of the Cole, Brown, and Meaders families—provide continuity in the tradition today. Much pottery would not rank as folk sculpture, given that its objects are purely functional or decorated only through painting. Nonetheless, many potters created artistic sculpture in the form of face jugs and highly decorated vessels. Some pots were mainly utilitarian, designed for storing food, churning butter, or watering plants, but potters would decorate even those by incising distinctive designs. Flowerpots and grave markers were inscribed with fluted rims and flaring forms. Potters sometimes had stamps with which they made whimsical designs, their signatures, or Masonic or other lodge symbols. Potters in the Shenandoah Valley of Virginia were particularly noted for creating molds in the form of animals and birds, fish and flowers, and human figures and then attaching them to pitchers, bowls, flowerpots, vases, and other vessels to create elaborate, three-dimensional works. Other artists in clay, like James "Son" Thomas of Leland, Miss., relied on dreams and visions for inspiration. Thomas created sculptured images of animals and distinctive human skulls.

In the late 20th century the South's sculptors received increasing recognition for their work in a variety of formats. Ida Kohlmeyer produced a range of sculpture and executed several major public commissions in New Orleans. Bill Beckwith of Greenville, Miss., has worked in styles ranging from surrealism to realism, most notably completing a statue honoring writer William Faulkner on the Oxford, Miss., town square. Several of the region's renowned artists in other media also completed sculptural works, including painter Jasper Johns and photographer William Christenberry. As with so many other areas of southern culture, Mencken would not recognize the contemporary South.

CHARLES REAGAN WILSON
University of Mississippi

Kate Langley Bosher, in *The South in the Building of the Nation*, vol. 10, ed. Samuel C. Mitchell (1909); Carl Bridenbaugh, *The Colonial Craftsman* (1961); Simon J. Bronner, *Chain Carvers: Old Men Crafting Meaning* (1985), *Grasping Things: Folk Material Culture and Mass Society in America* (1986); John A. Burrison, *Brothers in Clay: The Story of Georgia Folk Pottery* (1983); Charles Camp, ed., *Traditional Craftsmanship in America: A Diagnostic Report* (1983); Allen H. Eaton, *Handicrafts of the Southern Highlands* (1937); John Ezell, *The South since 1865* (2d ed., 1975); William Ferris, ed., *Afro-American Folk Art and Crafts* (1983); Henry Glassie, *Pattern in the Material*

Folk Culture of the Eastern United States (1968); Cynthia Elyce Rubin, ed., *Southern Folk Art* (1985); Robert Sayers, in *Festival of American Folklife, 1981*, ed. Jack Santino (1981); Allen Tullos, ed., *Southern Exposure* (Summer–Fall 1977); Donald Van Horn, *Carved in Wood: Folk Culture in the Arkansas Ozarks* (1979); John Michael Vlach, *The Afro-American Tradition in Decorative Arts* (1977), *Charleston Blacksmith: The Work of Philip Simmons* (1981); Charles G. Zug III, *Turners and Burners: The Folk Potters of North Carolina* (1986).

Social History of Architecture

What is "southern architecture"? In a series of lectures delivered at Alabama College on the eve of World War II, distinguished architecture critic Lewis Mumford declared that the best southern architecture fused adaptation to local social, economic, and geographic conditions with "universal" human values. He found these qualities in the work of southern-born architects Thomas Jefferson and Henry Hobson Richardson.

While one would want to think more broadly than Mumford did to understand architecture in the South, his lectures (later published as *The South in Architecture* [1941]) did point toward a significant characteristic of architecture in the South: that it has been synthetic more than pure, combining ideas from a variety of times, places, and cultures rather than constituting a uniquely regional form of building. To this, we might add a second observation: that the peculiar qualities of southern architecture are evident more in the aggregate than in individual structures.

On the eve of Afro-European colonization, a wide range of small societies that shared certain broad architectural traits inhabited what is now the southeastern United States. In the woodlands of the East, Native Americans built houses of various sizes and shapes, but most were supported on frames of light poles and covered with plant materials—leaves, thatch, and, sometimes, woven grass mats. As one approached the Mississippi River and the Gulf Coast, particularly at such places as the Grand Village of the Natchez in southern Mississippi, similar kinds of structures were sometimes supported on low platforms or mounds, the vestiges of the Mississippian cultures that had dominated the area in earlier centuries. Although mound building seems to have ended by the 18th century, indigenous Americans continued to erect these kinds of structures into the 20th century, sometimes side by side with others using technologies, notably log construction, learned from the colonizers.

When Europeans and Africans came, they created a new built environment that incorporated significant features of the existing native landscape. Indians'

clearings and paths often influenced the placement of colonists' fields and roads. Some Europeans built native-style wigwams, while others recognized the utility of such features as woven mats, with which Europeans furnished their houses as quickly, an early Anglo-Virginia chronicler confessed, as they could be bought or stolen.

Other aspects of early colonization along the eastern seaboard were shaped by economics and natural resources. British colonists shared a wood-building tradition but came from a homeland where wood was increasingly scarce and expensive. They came into a country where, as one wrote, "wasting of wood is an ease and a benefit to the planter." Drawing on expedient building technologies used for millennia in Europe, they constructed houses, farm buildings, and even civic structures using earthfast construction, which relied on prodigious use of materials to save on labor. Cheap construction of this sort was used for the largest buildings, as well as the smallest, but was eventually relegated to the least prestigious buildings and those of the poorest southerners, who called it "pole building" and used it into the 20th century.

A different synthesis characterized the early architecture of the Upland South. Colonists moving down the Great Valley from the northeastern colonies in the 18th century built structures that already melded a variety of European ethnic practices. Forebay or Pennsylvania barns combined English and Rhenish (Swiss and German) features, houses mixed various elements of English, Irish, and Rhenish architecture, and many builders preferred log construction, a technique known in many parts of the world but that seems to have come to the Americas from west-central Europe—the lands that now make up Germany, the Czech Republic, and Poland. Log construction is a sturdy technique that requires considerable skill to do well, and it was used for structures of all kinds, including large houses, churches, and public buildings. The Upland South was also home to a few religiously inspired ethnic enclaves with distinctive architectural traditions, the most notable of which was the Moravian community at Salem, N.C. Amish and Old Order Mennonites in the uplands continue to build distinctive types of meeting houses and combined dwellings and meeting houses in the region.

Along the Gulf Coast, the earliest architecture was even more eclectic. French and Spanish colonists and enslaved Africans brought a complex architecture to the mainland in the 18th century, which mixed, in varying degrees, European, West African, and indigenous Caribbean building technologies, architectural imagery, and spatial practices. The most notable were the domestic types that historians call Creole houses, Creole cottages, and shotgun houses. They also included the full-length or encircling porch or portico (also known

in English as a piazza and in French as a *galerie*), which entered the South along the southeastern Atlantic Coast, as well as through the Gulf Coast, and was used on houses of many forms and occupied by people of many ethnic backgrounds. The social and geographical origins of the piazza are highly complex and almost impossible to pin down precisely, enclosing houses of many different sizes, ethnic origins, and interior arrangements. The important point, however, is that it was carried from the West African coast to the Caribbean and the continental Americas and ultimately around the world as a corollary of the European presence.

Each of these hybrid architectures, particularly those in the coastal regions, was decisively shaped by the institution of African slavery, whose effect on the household was to disperse functions that had formerly been performed under one roof through a number of domestic outbuildings. The separation of served and servant spaces actually began in the Chesapeake region during a time when most agricultural workers were white. The separate spaces that were created became the precedent for the panoply of racially inflected agricultural buildings that characterized the South throughout the antebellum period and continued to serve large agricultural operations well into the 20th century, when rows of tenant houses nearly identical to (and in some cases adapted from) the rows of slave quarters found on large antebellum plantations were characteristic features of the Lowland and Piedmont southern landscapes until after World War II.

Slavery, with its successor, agricultural tenancy, was also responsible for the extreme stratification of the rural southern architectural landscape. The large plantation houses familiar from popular culture and even the smaller but still substantial houses that survive from the pre–20th-century South represent a tiny, and superior, sample of the preindustrial landscape. Most people, black and white, lived in small, poorly built houses, many with no more than a single room. The Ball-Sellers House in Arlington, Va., a single-room 18th-century house made of halved logs, sloppily joined, and covered on the walls and roof with split clapboards, survives almost alone as evidence of the housing of the majority of southerners before the modern era. These tiny houses existed at the edge of the economic universe, showing little sign of the popular architectural ideas that shaped their larger neighbors, although few were built, as is often alleged, entirely by their occupants. Skilled black and white artisans made the vast majority of southern buildings, including virtually all that survive.

For those who lived above a minimum standard, architecture from the 17th century on was shaped by popular architectural ideas available from publications imported from Europe. From these books, prerevolutionary builders

borrowed everything from small details to entire designs for mantelpieces and doorways to embellish their houses, churches, and courthouses. Very wealthy builders sometimes imported mantels and other architectural fittings from Europe. Others relied on immigrant craftsmen. William Buckland, an English joiner who was brought to America in the 1750s to create the interior woodwork for George Mason's Gunston Hall in Fairfax County, Va., went on to design the interiors of other houses in Virginia and Maryland before his early death. Ezra Waite created the woodwork for the Miles Brewton House in Charleston, S.C., in the 1760s. This practice of consulting European fashion is sometimes interpreted as "emulation" of overseas culture, but it should be seen as both an expression of builders' sense of being a part of that culture and a way that the wealthy differentiated themselves from their poorer neighbors, who had neither the money nor the knowledge for such indulgences. Thomas Jefferson, the South's most famous early builder, used architecture for both reasons.

After the American Revolution, the South's commitment to national and international popular culture intensified. Despite the myth of the antebellum South as an agrarian culture divorced from the capitalist world, southern builders eagerly used the fruits of industrial and commercial networks in their buildings. Publications by such popular northern authors as Andrew Jackson Downing and Samuel Sloan offered up-to-date architectural ideas to southern builders (and more practical building advice could be found in regional agricultural periodicals). The renowned white-columned plantation houses owed their appearance to these fashionable, nationally distributed ideas, as did the Gothic churches, Italianate villas, and commercial buildings of city and countryside. Those southerners whose wealth and personal contacts (and, usually, proximity to railroad lines) afforded them the opportunity were able to avail themselves directly of the services of prestigious northern architects. Philadelphians Sloan, Thomas U. Walter (designer of the U.S. Capitol dome), William Strickland, Thomas S. Stewart, and New Yorker Alexander Jackson Davis all worked for southern clients. Some, including Benjamin Henry Latrobe, James Dakin, James Gallier, and William Strickland, eventually moved their practices south—the first three to New Orleans. Strickland went to Nashville, where he died while supervising construction of the new Tennessee capitol that he had designed.

At the same time, manufactured architectural components—particularly the cast-iron balconies and fences popular in cities like New Orleans and Richmond—were imported from northern suppliers. As the region industrialized, southerners, particularly those living in urban areas, could obtain such fashionable architectural ornaments closer to home. Sash-and-blind facto-

ries, which produced finished building materials like doors, window sashes and frames, and mantels, which were sent to building sites ready to install, could be found in most southern cities in the 19th century. A few places, especially New Orleans, boasted their own iron foundries capable of producing the porches and other architectural hardware that were otherwise imported from the North.

Between the Civil War and World War II, southern architecture was even more closely integrated into the national scene. Industrial buildings—for example, the textile mills that began to be built in the Piedmont regions in the 1820s—flourished after the Civil War. These buildings followed national models devised to create layers of large, open, well-lighted workrooms with easy access to power sources. Typically built of brick and several stories tall, with banks of large windows and an attached stair tower, the mills in towns like Charlottesville, Va., Gastonia, N.C., West Point, Ga., and Prattville, Ala., were difficult to differentiate from their northern counterparts. That northern corporations owned many of these southern mills only reinforced the national similarities. The same could be said of the iron and steel works at Birmingham, Ala., founded in 1871 to exploit the ore and coal deposits on site. Other more regionally distinctive industries, such as sugar refining, tobacco processing, and cotton pressing, drew on nationally distributed architectural forms, as did the wholesale stores of southern waterfronts and the retail stores found along the main streets of large cities and small towns. These commonalities owed much to the spread of nationwide practices of construction and industrial and commercial organization and even to the construction standards enforced by fire insurance companies.

These post–Civil War commercial and industrial buildings were the economic engines of the New South of the late 19th and early 20th centuries. It is difficult to overstate their importance to southern architecture as we know it. With few and conspicuous exceptions, the pre–World War II architecture that is seen in the cities and countryside of the South today was created during the New South and interwar eras and reflects national and international flows of money and architectural ideas throughout the South. Southern cities were the products of combinations of local and outside capital—of timber companies, iron and steel companies, textile and railroad corporations that needed local bases of operation and of local bankers and merchants who served their needs. Around the beginning of the 20th century, the first tall office buildings, or "skyscrapers" (by the standards of their day), were built in such cities as Atlanta, Memphis, Birmingham, and New Orleans. Smaller cities tried to keep up, as tall buildings became signs of progress as much as real-estate necessities. In

The Mind of the South, J. W. Cash needled "every small town with its one heavily mortgaged skyscraper and its chamber of commerce with dreams of ten more." One can see what he meant in cities like Tuscaloosa, Ala., or Charleston, S.C., each with its single tall building rising modestly above a two- and three-story commercial core. Had Cash looked more closely, he would have seen that many larger towns have two: one built during a flush of prosperity around 1910 and another on the eve of the Depression. In Memphis, for example, the Cotton Exchange Building of 1911 was built at the tail end of the New South boom, while the Lincoln American Tower of 1924 (a smaller replica of New York's Woolworth Building) represents the pre-Depression spurt.

The distinctive aspects of the New South landscape lay less in the appearance of individual buildings than in the ensemble: the hardening lines of racial apartheid increasingly created a landscape of duplicates—duplicate schools, duplicate public libraries, duplicate banks, stores, and churches, which were arrayed not only in separate residential zones but in segregated business districts. Memphis's Beale Street, Birmingham's Fourth Avenue North, Dallas's Deep Elem are among the famous examples of these black main streets, but even the smallest towns had them. The spaces and institutions were duplicate but not equal, as a quick comparison—for example, of the architecture of early 20th-century Peachtree Street in Atlanta with that of nearby Auburn Avenue, the city's black main street—will show.

A similar dichotomy was evident in the educational institutions of the South. Where schools were offered to African Americans, they were distinctly inferior. Little Rock's two public high schools of the 1920s offer a revealing example, because formally they are very similar in form and organization. The white Central High School, infamous during the integration struggles of 1957, was one of the largest and most luxurious public high schools in the nation when it was opened in 1927. Across town, Dunbar High School, built for blacks at about the same time, was conspicuously smaller and more austere than Central. The same pattern holds true at the collegiate level. Large, architecturally ambitious campuses for white students, particularly the University of Virginia, a major landmark of American architectural history, stood in stark contrast to smaller, architecturally modest, often church-founded colleges for black students. At a few, notably Tuskegee Institute and Hampton Institute, northern donors and northern architects provided one or two buildings of architectural distinction. In the 20th and 21st centuries, when states began to fund colleges for African Americans, the architectural disparity between white and black institutions of higher education persisted.

The economic ferment of the late 19th and early 20th century affected

southern architecture in other ways. While continuing to consume architectural ideas and goods from the outside, the South began to produce both more actively. The antebellum South had a few professional architects—such men as the English émigré William Nichols, or native-born figures like Louisville's Gideon Shryock, Charleston's E. B. White, and, above all, South Carolinian Robert Mills, a nationally important figure—but architects began to proliferate after the Civil War. Some even made their mark in the North: Louisianan Henry Hobson Richardson became one of the most renowned American architects of the 1870s and 1880s while based in Boston. At the other end of the scale of reputation, Knoxville architect George Barber offered architectural pattern books and mail order plans that were widely used in the United States and Canada.

The duplicate architecture of the New South was often created by duplicate groups of professionals. The first professional African American architects, including Wallace A. Rayfield and Robert R. Taylor of Alabama and William Sidney Pittman of Washington, D.C., developed regional practices at the beginning of the 20th century that served African American clients almost exclusively. Significantly, these architects were trained in the North. Not until 1952, when John S. Chase was admitted to the University of Texas architecture school, were African Americans admitted to architecture schools in the South. In the meantime, Tuskegee Institute and Hampton Institute offered quasi-architectural training to blacks, often under the rubric of instruction in draftsmanship. Both Taylor and Rayfield taught at Tuskegee early in their careers, and Taylor designed many of that campus's buildings.

The New South's drive toward economic modernization was revitalized during World War I and even more strongly during the Depression by the intervention of the federal government. In no region of the nation is the evidence of feverish building by the Roosevelt administration more evident than in the South. The Tennessee Valley Authority (TVA) system is the most striking example, but the many New Deal post offices and courthouses throughout the region attest to the federal government's role in creating the South's architecture. Less conspicuous but equally noteworthy were the rural communities created by the Resettlement Administration and other federal agencies. The first of these was Arthurdale, W.Va., a settlement of subsistence homesteads built for impoverished coal miners. Because the project was a particular interest of the First Lady's, the houses resembled the colonial houses of the Roosevelts' Hudson Valley home. Resettlement communities in other southern states were less architecturally distinctive but were important efforts to reshape the region's built environment.

In addition to modernizing the South's infrastructure, the federal programs of the interwar period introduced significant examples of modern design to the region. The South is not usually considered a hotbed of architectural modernism, but in fact it was quite common, particularly in urban areas. Striking individual monuments—Richmond's Model Tobacco Factory, designed by a Chicago firm, and the Belgian Building at Virginia Union University in the same city, which was designed by a famous Belgian architect for the 1939 New York World's Fair and later moved to the Virginia Union Campus—and such renowned complexes as the apartments and hotels of Miami Beach were complemented by many smaller, less conspicuous, but no less modern buildings. The Greyhound and Trailways companies and the Kress and Woolworth's department store chains were responsible for many of the modern structures of the 20th-century South, but small merchants, factory owners, and housing developers also turned regularly to modernism as a form of advertising.

As in many parts of the world, the ethos of modernization propounded by New Southers, New Dealers, and architectural modernists was complemented among white southerners by a sentimental celebration of the antebellum South. The restored (and extensively reconstructed) 18th-century city of Williamsburg, Va., a project begun in 1927, was a prerevolutionary precursor of the best architectural values of the modern era, and by its administrators as a civic lesson to modern Americans. Colonial Williamsburg was a museum in a small, nearly moribund town, but preservation efforts were also undertaken in living cities like New Orleans, where local residents reacted in the early 20th century against a City Beautiful plan that would have destroyed much of the French Quarter, and particularly in Charleston, S.C., where preservation efforts began almost as early as they did in Williamsburg. These preservation efforts made obvious what was more subtly evident at Williamsburg: that the view of the antebellum past they offered was resolutely white. At Charleston, for example, nearly all physical evidence of the poor black residents who had occupied the restored neighborhood south of Broad Street was eradicated, leaving what appeared to be the antebellum equivalent of a gated community.

The many national, state, and local parks, lakes, and waterways, with their ancillary structures, that were constructed with federal monies throughout the South and that continue to provide most of the region's recreational facilities constituted a major transformation of the southern built landscape over the last century. Beginning in the late 19th century the South became one of the nation's most important recreation areas, and the Atlantic and Gulf Coasts from Maryland to Texas, as well as many interior waterways and the Appalachian Mountains, were transformed by the construction of individual vacation

houses and entire communities. Most were modest "shacks" erected by individual owners and unambitious developers, but occasionally prominent architects like Louis Sullivan, who built houses for himself (destroyed in Hurricane Katrina) and Chicago clients at Ocean Springs, Miss., were lured south. These small-scale operations presaged the large-scale development of the Sea Islands and the Gulf Coast later in the 20th century.

Among the most notable of the recent developments of this sort was Seaside, Fla., begun in the 1980s. An early landmark of the movement known variously as New Urbanism or Traditional Neighborhood Development, Seaside was meant to evoke the neighborly qualities of small southern towns before World War II. Racial apartheid was notably omitted from New Urbanists' nostalgic portrayal of that era. Seaside consists of relatively large houses, vaguely historicist in appearance, on relatively small lots, arranged in a radial pattern around a central green.

Seaside was a vacation community, but some southern developers at places like Harbor Town in Memphis, Atlantic Station in Atlanta, and, most notoriously, at the Disney Corporation's Celebration, near Orlando, Fla., have found the model attractive for year-round communities. In that respect, Seaside is also significant for the way it blurs the distinction between a purely recreational setting and one meant for full-time occupation. As vacation homes have become retirement homes and as the descendants of those who left the South during the early 20th century have begun to return, the most characteristic feature of southern architecture in the last 40 years has been its suburbanization, as tract homes engulf abandoned agricultural land and chain stores and restaurants line the freeways and suburban arteries of the region. Aside from the occasional half-hearted allusion to a Williamsburg house or a Creole cottage, little about contemporary southern suburban architecture sets it apart from any other region of the country. If we were to ask what is southern about it, we would have to fall back on our opening observation that distinction lies more in mixture than in form: a few more megachurches in the suburban mix, many more casinos than any other portion of the nation other than Nevada or Atlantic City.

Accompanying suburbanization was the radical transformation of urban cores. In many southern cities, notably Norfolk, Richmond, Columbus, or Mobile, the New South downtowns, the products of early 20th-century prosperity, were nearly eradicated in the 1970s and 1980s. In others, like Birmingham or Little Rock, they survived but were largely abandoned. The most conspicuous victims of urban renewal were the black business districts created during the Jim Crow era. Economically decimated by the changes of the civil rights era,

they were prime sites for redevelopment or freeway siting, which invariably completed their demise and served to separate black neighborhoods from downtowns. Ninth Street in Little Rock, Auburn Avenue in Atlanta, and Beale Street in Memphis are among the most devastated black main streets.

Perhaps the most important point of this narrative is that the South's architecture, particularly since the New South era, is much more varied than most accounts acknowledge. Little attention has been given to most of the region's recent architecture, although some scholars are beginning to take account of the New Deal heritage. At the same time it must be said that much of the architectural history of the South, even of the traditional variety, is still dispersed throughout guidebooks, historic preservation surveys, and archaeological reports, awaiting synthesis for a general audience.

DELL UPTON
University of California at Los Angeles

William Howard Adams, *Jefferson's Monticello* (1983); Catherine W. Bishir, Charlotte V. Brown, Carl R. Lounsbury, and Ernest H. Wood III, *North Carolina Architects and Builders: A History of the Practice of Building* (1990); Steven Brooke, *Seaside* (1996); John M. Bryan, *America's First Architect: Robert Mills* (2001); Robert M. Craig, *Atlanta Architecture: Art Déco to Modern Classic, 1929–1959* (1995); Walter L. Creese, *TVA's Public Planning: The Vision, the Reality* (1990); Allen R. Durough, *The Architectural Legacy of Wallace A. Rayfield: Pioneer Black Architect of Birmingham, Alabama* (2010); Jay D. Edwards, *Material Culture* (Summer 1989); Michael W. Fazio, *Landscape of Transformations: Architecture and Birmingham, Alabama* (2010); Friends of the Cabildo, *New Orleans Architecture*, 8 vols. (1971–89); Henry Glassie, *Pattern in the Material Folk Culture of the Eastern United States* (1968); Elizabeth Barrett Gould, *From Fort to Port: An Architectural History of Mobile, Alabama, 1711–1918* (1988); Bernard L. Herman, *Town House: Architecture and Material Culture in the Early American City, 1780–1830* (2005); Terry G. Jordan-Bychkov, *The Upland South: The Making of an American Folk Region and Landscape* (1968); Carl R. Lounsbury, *Essays in Early American Architectural History: A View from the Chesapeake* (2011); George W. McDaniel, *Hearth and Home: Preserving a People's Culture* (1982); Maurie D. McInnis, *The Politics of Taste in Antebellum Charleston* (2005); William R. J. Mitchell Jr., *Neel Reid, Architect of Heinz, Reid, and Adler, and the Georgia School of Classicists* (1997); Peter Nabokov and Robert Easton, *Native American Architecture* (1989); John B. Rehder, *Delta Sugar: Louisiana's Vanishing Plantation Landscape* (1999); Pamela H. Simpson, *Cheap, Quick, and Easy: Imitative Architectural Materials, 1870–1930* (1999); Dell Upton and John Michael Vlach, eds., *Common Places: Readings in American Vernacular Architecture* (1986); John Michael

Vlach, *Back of the Big House: The Architecture of Plantation Slavery* (1993); Ellen R. Weiss, *Robert R. Taylor and Tuskegee: An African American Architect Designs for Booker T. Washington* (2011); Michael Ann Williams, *Homeplace: The Social Use and Meaning of the Folk Dwelling in Southwestern North Carolina* (1991).

Vernacular Architecture (Lowland South)

The vernacular, or common, architecture of a region is an indicator of its economic development and changing social values. The realities of life in the 17th-century Lowland South shaped builders' choices of plan types and building technologies, and these have remained at the core of the region's vernacular architecture. The vernacular building system of the Lowland South has been greatly weakened since World War I, but it has never disappeared. Recent historians of the early South have emphasized the area's social instability. A high mortality rate during the first century of settlement, coupled with a high demand for agricultural workers in the labor-intensive tobacco economy, absorbed economic resources and altered social relationships as planters attempted to extract as much labor as possible from their employees. These strains affected southern architectural traditions in two ways.

First, because most early southerners preferred to devote their resources to agricultural production, they developed building systems that capitalized on plentiful supplies of timber to minimize the human investment in building. Crude buildings characterized the beginnings of all the colonies, but in the South they continued to be built long after the Chesapeake and Albemarle settlements were securely under way. The earliest structures were commonly made of rough timbers driven into the ground and covered with split boards nailed to these upright timbers. Later, 17th-century builders used mortise-and-tenon frames, simplifying them by omitting foundations and sinking the wooden uprights directly into the ground. There were several variations of the "post" building, as recent scholars have called it, ranging from the driven "puncheons" of the first buildings to carefully framed structures set on wooden-block foundations. Post building made it possible to build quickly and cheaply, conserving labor and capital for other uses. It was common even for public structures, including churches and courthouses in the 17th-century South. Post building required frequent repairs, and few post-built structures survived more than 20 years after their initial construction. Only two colonial post-built houses—Cedar Park in Anne Arundel County, Md., and Sotterley in St. Mary's County, Md.—still exist, and both owe their preservation to a protective casing of durable materials added early in their existence. In the early 18th century,

wealthy southerners began to build their homes more substantially, but post-built houses were erected for poor whites and African Americans until the end of the colonial period, and post, or "pole," construction is still widely used in southern agricultural buildings.

Although post building was no longer used for finer homes after the 17th century, a distinctive southern framing system grew out of it that embodied the labor-saving intention of post building in the use of a small number of relatively standardized parts, assembled with the simplest of mortise-and-tenon and notch joints. Whereas traditional Anglo-American frames of the type used in New England employ large timbers tied together by complex joints, southern frames consist of pairs of light walls linked at the top. Relatively small major timbers—about 4 by 8 inches in houses—were set at 10-foot intervals, with the spaces between filled with 3-by-4-inch studs. Often these were simply nailed into shallow notches chipped into the outer surfaces of the frame. Two long walls constructed in this manner were tilted up, and ceiling joists, notched at their undersides, were dropped on to hold the walls upright. The roof was most commonly formed of light 3-by-4-inch rafters pegged at the top. A light board laid across the ends of the ceiling joists enabled the builder to nail the rafters at any point along it, thereby eliminating the need for cutting joints to seat the rafters. In the southern frame, the parts were relatively unspecialized and could be cut out quickly and in numbers and assembled with equal ease. Yet the system was versatile enough that buildings as small as a smokehouse or as large as a mansion could be built using essentially the same approach. The southern framing system changed little between about 1720 and the Civil War and was used in some areas until the 20th century. It was carried west by southerners into the middlewestern and south central states, and its influence is apparent in 19th-century buildings as far west as California.

Thus, despite the stereotype of the South as a land of brick buildings, masonry walls have always been rare in the Lowland South, even for large structures; wood has been the characteristic building material. Although timber has most commonly been used in joined frames, log construction entered the Lowland South in the late 17th century. By the end of the 18th century, small log houses, often with wooden chimneys, were widely used by poor planters in the Tidewater South—George Washington reported seeing almost nothing else on a trip through Virginia and North Carolina in 1791—and they were the standard form of slave housing as well. In low-lying sections of east Texas and the Gulf Coast states, log construction came with the early settlers and was a common vernacular building technology through the 19th and early 20th centuries. In some parts of the East Coast, however, logs never made much headway, except

in small agricultural buildings constructed in the late 19th and early 20th centuries. In those areas, the frame tradition was nearly universal and prevailed even where logs were used. For example, late 18th- and early 19th-century builders in northern Maryland were fond of a hybrid log-frame system, in which horizontal logs were tenoned into corner posts.

The 17th century gave the Lowland South its principal rural domestic house plans as well as its building technology. At first, immigrants to the Chesapeake and Albemarle regions built many kinds of traditional English houses, but by 1680 single-story, one-room-deep houses had become the standard. Poorer colonists, constrained by a barebones existence, had no choice about house size. For middling or wealthy people, the choice of small houses was a product of the relationship between planters and their workers. Where most English agriculturalists in the 17th century were accustomed to employing familiar locals, who lived and worked in the farmers' own large houses, the presence of a constantly changing labor force of strangers prompted southern planters to abandon the custom and to move their laborers' working and resting areas to outbuildings. Consequently, most planters' houses were reduced to one- or two-room dwellings standing at the center of a large domestic complex. Since the late 17th century, this fragmentation of domestic functions into a complex of small buildings was one of the most striking aspects of the southern landscape to outsiders, whose published commentaries repeatedly compared planters' residences to small villages. The creation of the southern domestic complex in the 17th century arose from altered relationships among English people. Although it later became a distinguishing mark of slave society, the separation of dwelling house and domestic outbuildings antedated the adoption of slave labor throughout the Lowland South.

A typical domestic complex included a kitchen, usually a building similar in size and appearance to a one-room house; a milk house or dairy for the cool storage of dairy products, and a smokehouse for the preservation of meats. Larger complexes in the 18th and 19th centuries contained a laundry, often attached to the kitchen; an office; and in a few instances, a sunken icehouse, a school, or a small storehouse. Servants lived in the work buildings or in separate houses. In the 17th century, cellars were customarily separate from the house and were only moved under the dwelling in the 18th century. Even then they were often thought of as outbuildings and were provided with outside entrances facing the other outbuildings but with no access from inside the house.

At the core of the complex was the house itself. Two-room, or hall-parlor houses (the name is a modern one) consisted of a large main room, called the hall by its occupants, which was the principal center of activity. This room was

used for sitting and eating, and the head of the household sometimes slept there. Off this area was a smaller room, usually called the parlor or chamber, which shared many of the hall's functions. Its more secluded location made it the preferred sleeping room. The parlor often had a door in the end or rear wall leading to the outbuildings at the side or rear of the house. A few very large hall-parlor houses had projecting entry rooms that were called porches, although they were enclosed. Some, like Bacon's Castle (1665) in Surry County, Va., one of the finest houses in the colony when it was built, had a rear tower for the stairs as well.

The relative homogeneity of house size and plan in the late 17th and early 18th centuries dissolved in the mid-18th century. One- and two-room houses remained the staple of the housing stock, but wealthier southerners began to add other spaces to these. A room called the dining room, but serving as many different functions as the earlier hall and parlor, could be found in many large houses. The addition of rooms led many builders in the 18th century to build houses two rooms deep, although others preferred to maintain the traditional single-room depth and to attach the added rooms in ells at right angles to the main house. More important than the use of added rooms and the increased depth of large houses was the use of a passage into which the main door opened. The passage, which usually contained the stair as well, served as a buffer between the outside and the public rooms of the house and allowed circulation to each room of the house without the necessity of passing through any other. Passages made slow headway at first, but by the early 19th century they were common in most houses with more than two rooms and could even be found appended to one-room houses.

The use of passages, extra rooms, and two-room (or double-pile) depths is most striking in the so-called Georgian-plan house, usually a two-story structure with two rooms on either side of a central passage. Georgian plans were first used in the Lowland South in large mansions of the second decade of the 18th century. The smaller houses that used passages or two-room depths have been thought of as derivations of the Georgian form, but in fact a more complex process was involved in which traditional builders adapted the new ideas to traditional forms rather than merely imitating upper-class buildings.

Henry Glassie discusses the formal relationships between old and new ideas as they affected an area of Piedmont Virginia in his study, *Folk Housing in Middle Virginia*. There were clearly social components to the Georgian idea as well, although these have not received the same attention. Fieldwork suggests, however, that many areas of the South underwent a period of intense experimenta-

tion in house forms either just before or just after 1800. During that period, in addition to the traditional forms, houses with odd and unique plans were constructed. At the end of the period of experimentation, each area seems to have selected the same solution to rural housing, based on the central-passage idea. New houses were built with passages, and both older and experimental houses were converted to the newly popular forms. The most conspicuous of the new dwelling types of the early 19th century was a two-story, one-room-deep house with a central passage. Although I-houses, as geographers call them, were built by a few wealthy southerners as early as the 1730s, they were not common until the 1820s. After that, they enjoyed a nationwide popularity, although one-room versions of the same plan were probably more numerous in the Lowland South.

The high visibility of the I-house has obscured the continuing presence of single-room and hall-parlor houses. Moreover, the I-house is only one of many possible ways to arrange four rooms and a passage. In the Chesapeake-Albemarle region, a two-story, double-pile house, one room wide with a passage at the side, was popular between 1790 and 1850. In the region stretching south from southern North Carolina, a one-story house with a porch tucked under the roof was built from the late 18th century into the 20th century. Versions of this plan with hipped roofs in the 20th century are often referred to as pyramidal cottages.

Along the Gulf Coast, the earliest European builders constructed hybrid houses whose origins lay in the synthesis of African, indigenous, and European building shapes, spatial arrangements, and building technologies in the West Indies. One of the most common, the shotgun house, was a 19th-century import from the islands, but there were other houses that shared similar architectural genes. Many of these were one or two stories tall, with full-length porches tucked under the roof along the front wall. Larger houses sometimes had front and rear porches (also called *galeries* in French and *piazzas* in Italian), while in the largest houses they sometimes wrapped all the way around the structure. The similarity of these exteriors masked a bewildering variety of plans that testified to the diverse ethnic and regional backgrounds of their builders and residents.

Well into the 19th century, urbanites lived in the same kinds of freestanding houses that their rural cousins occupied. Yet characteristically urban forms—houses with their narrow ends turned toward the street, one or two rooms deep, and sometimes with a passage along one side—were introduced at Jamestown as early as the mid-17th century. The renowned Charleston single house is a version of this traditional plan. A few combined commercial and residential struc-

tures based on French urban models were built in New Orleans in the late 18th and early 19th century, but for the most part southern urban vernacular houses resembled those elsewhere in the United States.

In the 19th century, rural southern vernacular builders adopted another nationally popular house form. This was a T- or L-plan building, consisting of two wings set at right angles to one another. One section contained two rooms, one in front of the other, while the other wing contained one room and sometimes an entry passage. This form was adaptable to a large, stylish house or a very modest one. T-plan houses were commonly built in large numbers to house tenants and industrial workers in the late 19th and early 20th century. These present another opportunity for study, but the function of the rooms appears to have been traditional; only the picturesque appearance of the perpendicular wings was novel.

Rural builders constructed traditional buildings in the South much longer than in other parts of the country. By the early 20th century, even in relatively remote areas, houses based on bungalows and other popular types began to dominate. These structures testify to the reach of the national economy, especially the Agricultural Extension Service and other reformers.

DELL UPTON
University of California at Los Angeles

Catherine Bishir, *North Carolina Architecture* (1990); *Buildings and Landscapes* (formerly *Perspectives in Vernacular Architecture*) (18 vols., 1982–); Cary Carson, Norman F. Barka, William M. Kelso, Garry Wheeler Stone, and Dell Upton, *Winterthur Portfolio* (Summer–Autumn 1981); Edward A. Chappell, in *Of Consuming Interests: The Style of Life in the Eighteenth Century*, ed. Cary Carson, Ronald Hoffman, and Peter J. Albert (1994); Jay D. Edwards, *Winterthur Portfolio* (Summer–Autumn 1994); Henry Glassie, *Folk Housing in Middle Virginia: A Structural Analysis of Historic Artifacts* (1975); Bernard L. Herman, *Town House: Architecture and Material Life in the Early American City, 1780–1830* (2005); Carl R. Lounsbury, *An Illustrated Glossary of Early Southern Architecture and Landscape* (1994); Maurie McInnis, *The Politics of Taste in Antebellum Charleston* (2005); Doug Swaim, ed., *Carolina Dwelling: Towards Preservation of Place: In Celebration of the North Carolina Vernacular Landscape* (1978); Dell Upton, in *Material Culture of the Wooden Age*, ed. Brooke Hindle (1981); John Michael Vlach, *Back of the Big House: The Architecture of Plantation Slavery* (1993), in *Common Places: Readings in American Vernacular Architecture*, ed. Dell Upton and John Michael Vlach (1986).

Vernacular Architecture (Upland South)

Architecturally, the Upland South can be defined as the area lying between the Ohio River on the north, the Blue Ridge and Smoky Mountains on the east, the northern portions of the Gulf states on the south, and the Ozark Mountains on the west. Since the early 20th century, this region has been depicted as a repository of antiquated cultural forms. Students of architecture have tended to concentrate on exotic or archaic rural building practices, for example, log construction, dogtrot- and saddlebag-plan houses, and double-crib barns, and to neglect consideration of more ordinary vernacular buildings and particularly the patterns of architectural change. However, vernacular building in this part of the South, as in the Lowland South, is largely a product of the national popular culture of the 19th century.

Much of the distinctive architecture in the Upland South was brought into the region in the 18th century by the first European colonists, who entered the uplands through the Great Valley that stretches from central Pennsylvania into Tennessee or who crossed the Blue Ridge and Smoky Mountains from the east. Their architecture included log construction; several small house plans derived from English and Scots-Irish traditions and from Germanic architectural designs. Popular building types and technologies began in the early 19th century, through new migrants, popular publications, and in rare cases the direct importation of building parts and materials.

The best-known building technology of the Upland South is log construction. The origins of log building in the United States are uncertain. The dominant theory comes from Fred Kniffen and Henry Glassie, who suggest that log construction was brought from Europe to Pennsylvania by Germanic and central European settlers. In Pennsylvania, it was rapidly adopted by Anglo-American and Scots-Irish builders. More recently, Terry G. Jordan has returned to the earlier 20th-century theory that log construction was introduced into the Delaware Valley by Finns and Swedes in the mid-17th century. Although Jordan's argument is not entirely convincing, he has demonstrated that the log architecture of Europe is more varied and its patterns are less clear than Kniffen and Glassie believed. In America, the phrase "log building" conceals a complex group of independent traits that must be examined more closely than they have been.

Structurally, the distinctive characteristic of log buildings is that the horizontal logs interlock at the corners, which gives them their structural unity. In the standard form, where there are interstices of several inches between the individual logs, their only vertical support is at the corners. Consequently, log structures are often described according to the shapes of the notches that link

them at the corners. The most common notching forms in the Upland South are the V-notch and the full- and half-dovetail notches. Saddle, diamond, square, and half notches are less common. A log structure is stable only if there are four log sides that brace each other. This four-sided unit is traditionally called a pen or (for farm buildings) a crib and is the basic unit for the analysis of log building plans. Log construction has continued in the Upland South since the first settlement; traditional builders still construct and repair log houses and farm buildings.

Other building methods were equally early, if not as conspicuous. A few frame houses survive from the last quarter of the 18th century. Framing, using pit-sawn and water-mill–sawn materials, was common for large houses throughout the 19th century. In those parts of the uplands where timbering was commercially practiced in the late 19th century, steam-sawn, balloon-framed houses became common after the 1880s. Poorer builders took advantage of cheap mill-sawn materials to build single-wall (box or plank) buildings. These light structures lacked most standard framing members; they were supported by thick, closely set planks. Small horizontal pieces nailed to their inner faces at the top and bottom, and sometimes light vertical sticks at the corners, held the structural planks together. In houses, an outer covering of weatherboards was usually nailed directly to the supporting planks, and any interior finish—whitewash, paper, or plaster—was also applied directly to the structure. Box framing has been studied in Arkansas and Kentucky and undoubtedly was even more widespread, if unreported, in other parts of the South.

Masonry construction was preferred for the largest vernacular structures. Much of the Upland South contains rich stores of easily worked limestone, which was used for chimneys, foundations, and many large houses in the fertile valleys. Large houses and farm buildings built as early as the mid-18th century survive in upland Maryland, Virginia, North Carolina, and Tennessee. Brick structures survive from the 1790s, but they were rare before the second decade of the 19th century.

Vernacular house types were as varied as building technology in the Upland South. Among the earliest surviving houses there are small cabins, or houses of a single structural unit, one story high. The definition is Henry Glassie's, but the term was already identified in the 18th century as one favored by the English-speaking settlers in the Upland South. Glassie distinguishes two types of cabins—one with a gable roof parallel to the front, an end chimney, a single front entry, and a square plan, which is derived from English traditions; and another that may derive from Scots-Irish traditions, also with a parallel gable roof and end chimney but with both front and rear entries and a rectangular

plan. The interior is sometimes partitioned into a large room with a fireplace and a smaller one without heat. In addition, some early southerners built traditional Anglo-American hall-parlor (or hall-chamber) houses consisting of a large room—the hall—into which the front door opened, and a smaller room—the parlor or chamber—adjacent to it. Unlike the partitioned rectangular cabin, in the hall-parlor house both rooms were provided with fireplaces.

Other traditional house types are of less certain origin. These include the so-called saddlebag and dogtrot houses and the double-pen-plan house. The saddlebag house is distinguished by the "draping" of its rooms on either side of a large central chimney like saddlebags on a horse. Unlike central-chimney houses in the Lowland South or the northeastern United States, the rooms on either side form separate structural pens that lean against the chimney rather than enclosing the stack within a single unified structure. The units may resemble one or more of the simple cabin forms: a saddlebag house might consist of a square unit and a rectangular one, or of a square and a two-room rectangular one, or two square or two rectangular units. Many saddlebag houses were built in stages. In the dogtrot house, there are also two major sections, built at the same time and in most cases containing a single room each. They are separated by a passageway that has no front or rear walls, and all three sections are covered by a continuous roof. The enclosed rooms are entered from the passage—the dogtrot proper—rather than from the front of the house. Many dogtrot houses were altered by enclosing the open passage, creating a central-passage plan of a type familiar all over the 19th-century United States. In the third two-part form, the double-pen house, the pens or units are built adjacent to one another without an intervening passage or chimney. Unlike the hall-parlor house, both rooms are approximately equal in size—and, more striking, each has its own front door. All three of these Upland South plans were most commonly built as single-story or one-and-a-half-story structures, although two-story dogtrot houses can be found. All are stereotyped as log buildings, though they were built in frame, and occasionally in brick and stone.

The origins of these three distinctive plans are uncertain. The saddlebag house has been associated with Anglo-American central-chimney traditions as adapted to the exigencies of log-pen building. The double-pen house has similarly been attributed to the peculiarities of the log-pen structure. Another theory is that the double-pen house is an attempt to anglicize the appearance of a four-bay facade deriving from Germanic building traditions. A third attributes its identical pens to Scandinavian antecedents.

The dogtrot house has been the object of the most speculation. One of the earliest explanations was that of Martin Wright, who argued that, like

the double-pen house, the dogtrot derived from Fenno-Scandinavian traditions brought to the Delaware Valley in the 17th century. Others see it as a poor person's version of the Georgian central-passage house. Climatic explanations—that the open "breezeway" is an accommodation to the southern climate—are also popular. Unfortunately, the study of Upland South architecture has concentrated on the identification of typological examples through often-superficial field examination. No careful study of the physical histories of individual closely dated examples, of archival sources, and of socioeconomic or room-use patterns has been made, nor has there been direct field study of the proposed precedents. Consequently, scholars do not know how old these Upland South types are or what their history in the region is. All hypotheses about their origins are speculative, and none of the proposed theories seems convincing.

At the same time small house types appeared, several larger vernacular house plans were also imported into the Upland South. These include the so-called Quaker-plan house, another form of uncertain origins. The name derives from a description of an ideal house plan published by William Penn for the benefit of Quaker settlers in Pennsylvania, but no researcher has established any firm link between the 17th-century description and surviving examples, few of which date from before 1790 or after 1830. Quaker-plan houses are similar in plan to hall-parlor houses except that two small square rooms, one in front of the other, take the place of the parlor. These usually share a single chimney with fireplaces set diagonally against the partition separating the two small rooms.

Central-passage-plan houses, one or two stories high and occasionally two rooms deep, representing the popular culture of the Lowland South and Middle Atlantic source areas, were also introduced to the Upland South in the late 18th century. A few were built in log and limestone, but brick and especially frame were the favored materials. In the 19th century, central-passage, one-room-deep houses—the ubiquitous I-house described by geographers and folklorists—was the most common house for prosperous farmers and townspeople. As in the Lowland South, the traditional forms continued to be built, even as popular house types and new methods of manufacturing building materials and constructing houses and farm buildings spread through the Upland South after 1830. In many ways, the Upland South landscape was transformed by these forces even more rapidly than that of the Lowland South, owing to the presence of large-scale plantation agriculture and corporate resource extraction.

DELL UPTON

University of California at Los Angeles

Catherine Bishir, *North Carolina Architecture* (1990); *Buildings and Landscapes* (formerly *Perspectives in Vernacular Architecture*) (18 vols., 1982–); Henry Glassie, *Mountain Life and Work* (Winter 1963, Spring 1964, and Summer 1965), *Pattern in the Material Folk Culture of the Eastern United States* (1969), in *The Study of American Folklore: An Introduction*, by Jan Harold Brunvand (2d ed., 1978); Terry G. Jordan, *American Log Buildings: An Old World Heritage* (1985); Fred Kniffen, *Annals of the Association of American Geographers* (December 1965), with Henry Glassie, *Geographical Review* (January 1966); Charles E. Martin, *Hollybush: Folk Building and Social Change in an Appalachian Community* (1984); Karl B. Raitz, *Landscape* (Spring 1978); Dell Upton and John Michael Vlach, eds., *Common Places: Readings in American Vernacular Architecture* (1986); Michael Ann Williams, *Homeplace: The Social Use and Meaning of the Dwelling in Southwestern North Carolina* (1991).

Adams, Wayman Elbridge

(1883–1959) PAINTER, TEACHER, LITHOGRAPHER.

The son of an amateur artist/horse breeder, Wayman Elbridge Adams was born in 1883 in Muncie, Ind. He was encouraged in the pursuit of art by his father, and he won his first prize at the age of 12. Adams studied under William J. Forsyth at the John Herron Institute of Art in Indianapolis from 1904 to 1909. He continued his training in Florence, Italy, under William Merritt Chase in 1910, followed by studies under Robert Henri in Spain in 1912. During his time in Spain, Adams studied paintings by Diego Velázquez, as well as sketching everyday scenes of the Spanish people. Consequently, a number of his early works display the influence of Velázquez in subject and in treatment. While studying with Chase in Italy, Adams met Margaret Graham Burroughs, a fellow artist, whom he married in 1918. Although she was already an established artist in her native Austin, Tex., Margaret subjugated her art career to her husband's.

After their return from Europe, Adams opened a studio in Indianapolis and at one point maintained studios there and in New York and Philadelphia. He traveled to New Orleans, Texas, Mexico, and California. His first recognition came from his portrait of printmaker Joseph Pennell, illustrator of George Washington Cable's 1884 book, *Creoles of Louisiana*. The Art Institute of Chicago awarded Adams the 1912 prize for his portrait of Pennell. Adams, who advocated "exactitude in portraiture," became known for his portraits of prominent personages, including actors, artists, authors, musicians, university regents, sports figures, royalty, and civic leaders. His sitters included U.S. presidents Calvin Coolidge, Warren G. Harding, William Henry Harrison, and Herbert Hoover, as well as presidential family member Alice Roosevelt Longworth. His portrait of Booth Tarkington, one of Indiana's best-known authors, increased his reputation for his ability to portray notable sitters. He also portrayed "Hoosier poet" James Whitcomb Riley.

Adams, whose work reflects the teaching of Chase and Henri, worked spontaneously, with thick, broad, fluid brushstrokes combined with vivid color highlights. His ability to complete a portrait in a single sitting earned him a reputation as a "lightning" artist. Adams would, however, make two or more portraits until he was satisfied that he had captured the image he sought to achieve. He generally simplified his compositions, focusing on the sitter rather than unnecessary accessories. His portraits were characterized by a physical likeness and the essence of a sitter's personality, manner of pose, and gesture.

Beginning in 1916 Adams made frequent visits to New Orleans to paint, exhibit work, and give demonstrations on portrait painting. Among his sitters were local artists and African American subjects, most notably his sympathetic portrait titled *New Orleans Mammy*. The latter captures the moral fiber of the woman, who, despite the apron and tignon that characterize her lowly social stature, retains a sense of dig-

nity. Adams portrayed nationally recognized photographer Joseph Woodson "Pops" Whitesell, a fellow Hoosier, in at least two canvases. Whitesell, an integral member of a group of writers and artists living and working in the French Quarter, photographed artists, writers, and other notables. From the inception of the New Orleans Art League, Adams was an honorary member, an organization established in the Vieux Carré in 1927 for male artists. His portrait of Louisiana artist George Frederick Castleden was painted as part of a demonstration in portraiture before the Art League. Adams exhibited with the Art League, as well as with the Art Association of New Orleans at the Isaac Delgado Museum of Art, now New Orleans Museum of Art (NOMA).

Adams's most notable portraits of New Orleanians include author Grace King, artist-teacher Ellsworth Woodward, potter Joseph Fortuné Meyer, and Mayor Martin Behrman. At the time of the 1925 portrait of Behrman, the mayor was ill, and he died shortly afterward. Departing from his usual manner of focusing primarily on the sitter, Adams depicted the mayor working at his desk, upon which "official looking documents," including a roll of blueprints in the mayor's left hand, were rendered with minimal brushstrokes. Although Adams was cited as being gifted in "catching likenesses in a natural expression," when he returned 20 years later to see the portrait of Behrman in City Hall, Behrman's widow had replaced it with another painting.

The 1926 portrait of author Grace King (now in NOMA's collection), which also shows her two sisters in the background, depicted King's parlor with stacks of books at her elbow and pier mirrors behind her sisters. Adams included himself in this composition by painting his reflection in the mirror just above King's head. This hazy self-portrait is a reference to *Las Meninas*, Velázquez's 1656 portrait of the royal family, in which he included himself working at his easel in the midst of the maids of honor. In the painting, Velázquez, however, showed a reflection of the king and queen in a mirror above the head of the Infanta Margarita.

Adams painted at least two regional series, one documenting the people of Chinatown in San Francisco and another depicting life in New Orleans, a series of lithographs. Adams won numerous awards, including the Logan Medal of the Arts prize of $1,500; the 1914 Proctor portrait prize, National Academy of Design; the 1918 Art Institute of Chicago Prize; the 1924 International Expo, Venice; the 1925 Greenough Memorial Prize, Newport; the 1926 medal of the Sesquicentennial Exposition; the first Altman Prize of the National Academy of Design in 1926; the 1929 gold medal for watercolor from the Pennsylvania Academy of the Fine Arts; and the 1943 Carnegie Institute prize. In 1921, he was elected an associate of the prestigious National Academy of Design. Exhibitions include one at the Luxemburg Museum in Paris in 1919.

About 1920, the Adamses set up a studio in Austin, Tex., and in 1933 they opened an art school in Elizabethtown, N.Y., where they spent their summers teaching. In 1945, they retired

from teaching and remained in Austin. Adams died in 1959, and Margaret Adams died six years later.

JUDITH H. BONNER
The Historic New Orleans Collection

Edan Hughes, *Artists in California, 1786–1940* (1986); Judith Vale Newton et al., *The Hoosier Group* (1985); Judith Vale Newton and Carol Ann Weiss, *Skirting the Issue* (2004); Estill Curtis Pennington, *Downriver: Currents of Style in Louisiana Painting, 1800–1950* (1991); Susan Saward, Karin Watts, and Jean Bragg Gallery, *Knute Heldner and the Art Colony in Old New Orleans* (2000); Cecilia Steinfeldt, *Art for History's Sake: The Texas Collection of the Witte Museum* (1993).

Aid, George Charles

(1872–1938) PAINTER.

François Ayd emigrated from Alsace, France, in 1831, via the port of New Orleans. His grandson George Charles Aid was born in 1872 in Quincy, Ill. Aid grew up in St. Louis where he attended the School of Fine Art and became a newspaper illustrator. In 1899 Aid's precocious drawing, etching, and painting earned him a scholarship for further training in Paris. There he was accepted as *vrai français*—because of his language fluency and personal charm, Aid was well regarded in French art circles, as well as in the expatriate American community.

His skill in mimicking the artistic styles of Whistler, Daubigny, and Cézanne contributed to his reputation. Aid's elegant portraiture and output of accomplished etchings assured his financial success. The prestigious *Gazette des Beaux-Arts* honored Aid for his printmaking by including one of his etchings in a 1903 issue. He was influential and generous in mentoring other artists—for example, teaching young American painter John Marin how to etch. That same year, Aid's prints and paintings earned prizes at the Louisiana Purchase Exposition in St. Louis. In 1906, the Swedish government purchased his Salon entry and he enjoyed solo exhibitions in Paris and American cities. Additionally, Mary Orr arrived from Anderson, S.C., to study music; she and Aid were married in 1910.

In 1912 the Aids settled on the Mediterranean coast in the cosmopolitan artists' colony at Bordighera, Italy. Aid had his own etching press and pursued the medium with great success; his work was featured in international art publications. During a 1914 trip to Boston and St. Louis for Aid's solo exhibitions, the couple was stranded in America when World War I broke out, and they never returned to Europe. During the war they resided in South Carolina, New Orleans, and New York City and spent their vacations on the Mississippi coast and at a North Carolina mountain lodge owned by Mary's parents. Like a number of other artists and writers displaced by the war, the Aids resettled at Tryon in the mountains of North Carolina in 1919. In the company of other cosmopolitan people, they built a new life and enrolled their son in a local school requiring French beginning in the first grade.

The Aids owned one of the picturesque vineyards that made Tryon famous during that era. His studio became a magnet for the intelligentsia,

and he established a teaching atelier run according to the principles of French instruction. Most of Aid's teaching involved classical figure studies; the majority of his income came from painting sophisticated portraits of visitors who came to Tryon for vacations. As Tryon was relatively unscathed by the Great Depression, he continued to support his family through his portraiture and supplemented his income by traveling around the South to deliver lectures about printmaking.

In 1932 cultural leaders of Charlotte initiated a plan to renovate the city's historic United States Mint building for an art museum. In 1933 Aid accepted their call to come to Charlotte. Mary Aid stayed behind in Tryon for a year, finding its cultural and intellectual life richer than that in Charlotte, but eventually she joined her husband. The press extolled Aid as a distinguished personage and endorsed his credentials as a "true" southerner. He taught advanced art classes in the Woman's Club building, one course for amateurs and another for practicing professionals; he exhibited there and executed portraits of prominent personages. The new Mint Museum commissioned Aid to paint a major canvas, *The Baptism of Virginia Dare*, which commemorated a historical event in North Carolina. The 5-by-8-foot canvas harked back to the grand history paintings of Jean-Paul Laurens, Aid's instructor in Paris.

Before becoming a writer, DuBose Heyward studied painting in Tryon under Louis Rowell, and he continued to reside there through the 1930s. Hey-ward's 1936 novel *Lost Morning* focused on a successful but troubled North Carolina artist who cranked out etchings of popular American scenes, work that is esthetically and intellectually barren. In fact, Aid gave up etching after settling in North Carolina, thus suggesting that Heyward's plot was an endorsement of his decision not to rest on his artistic laurels. Aid continued to experiment with painting styles until his death in 1938. His last published works were architectural drawings for Davidson College and North Carolina State University.

MICHAEL J. MCCUE
Asheville, North Carolina

Lynne Blackman, *Southern Masters of Print-making* (2005); Michael J. McCue, *Paris and Tryon: George C. Aid and His Artistic Circles in France and North Carolina* (2003).

Aked, Aleen

(1907–2003) PAINTER.
British-born Aleen Aked immigrated to Canada with her parents in 1910. By 1918 the family had moved to Toronto, and at the age of 14 Aked won a scholarship to study with Arthur Lismer at Ontario College of Art. In the 1920s she received instruction at the college with other members of the famed Canadian "group of seven": Frederick Horsman Varley, Alexander Young Jackson, James Edward Hervey MacDonald, George Agnew Reid, John William Beatty, and Yvonne McKague. The technique of sculpting was taught by Sydney March and Emmanuel Hahn, and Aked graduated with honors in 1928.

An avid golfer, she was a junior girl's

champion in 1917, an honorary member of the Ladies Golf Club of Toronto from 1927, and its club champion from 1933 to 1936. From 1929 to 1944 she spent winters in Sarasota, Fla., with the hope that the warm climate would help her father's deteriorating health. There she studied at the Ringling School of Art in the winter of 1935. The following year she took private lessons with acclaimed American impressionist artist Abbott Fuller Graves, who instilled in her the subtleties of still life painting and the amount of colors used in depicting white, as well as the joys of restoring old houses.

From 1932 to 1939 Aked was a member of the Sarasota Art Association and served as its devoted secretary-treasurer for a number of years and as president in 1942. She also belonged to the Southern States Art League, an organization whose members traveled throughout the South promoting its uniqueness. Additionally, she was active with the Florida Federation of Art, which was established by the Florida Federation of Women's Clubs.

Aked's southern paintings reveal colorful, dramatically painted palms and other trees, either motionless or wind blown. Added to her work in the South were dignified portrayals of African Americans—wistfully polishing brass, leisurely reading by a sun-filled window, posed outside a lushly land-scaped Sarasota home, or grouped amid a desolate urban neighborhood of dusty streets and faded signs.

In 1935 Aked won a prize for the finest landscape painting at the Ringling Museum of Art, and she received another award there for the most popular oil painting in 1938. She was also represented by a solo exhibition at the New York City Public Library and at the Sarasota Art Association in 1940, with the proceeds donated to the Finnish Relief Fund. The same year, as a member of the Studio Guild, she participated in group exhibitions at the Studio Guild Galleries in New York and at the Studio Guild Country Art Center in Connecticut; a southern work by Aked was illustrated in the catalog. She also exhibited at the Allied Artists of America and the Royal Canadian Academy.

During World War II Aked stopped painting in order to contribute to the war effort by knitting and sewing, sending over 5,000 packages to the allied troops. From 1946 onward there was a continuous solo exhibition of her work at the Ladies Golf Club of Toronto.

In later life Aked retained the "passion for truth and fascination with nature" culled from her distinguished teachers. Aside from painting, golfing, and restoring an 1849 farmhouse, she was also an enthusiastic automobile collector. At the age of 82 she boasted of owning "a 1938 Cadillac, 1955 Chevrolet, 1959 Cadillac with fins, and a 1981 Oldsmobile."

A retrospective of Aked's work was held at Robert McLaughlin Gallery in Oshawa, Ontario, in 1989. Aleen Aked died in 2003, leaving a legacy of beautiful, sunny renderings of the southern landscape and its people. Fully aware of her work's impact upon the viewer, she

once said, "We all have creative powers which if developed bring not only personal satisfaction but afford pleasure for others."

DEBORAH C. POLLACK
Palm Springs, Florida

Catalog of Paintings in Oil and Watercolor by Contemporary American Artists, Studio Guild (1940); Joan Murray, *Art of Aleen Aked* (1989); Sarasota Art Association, *Exhibition of Oil Paintings by Aleen Aked* (1940).

Albers, Josef

(1888–1976) PAINTER, TEACHER, SCULPTOR, PHOTOGRAPHER, PRINTMAKER.

Born in Bottrop in the Ruhr River coal-mining region in North Rhine–Westphalia (Germany), painter-theorist Josef Albers became one of the most influential artist-teachers of the 20th century. He emphasized excellent craftsmanship as the basis for art, tracing this appreciation to his family lineage—his father was a craftsman and his mother was the daughter of a blacksmith. Albers's works manifest a highly disciplined intellectual inclination devoid of emotional attachment. He studied in Berlin, Essen, and Munich. His drawings made during his art training in Berlin at the Königliche Kunstschule from 1915 to 1918 reveal his natural tendency toward minimalism, a propensity that led him to advocate the "less is more" approach to art. This dictum would be felt at the Bauhaus and also after Albers began his tenure at Black Mountain College in North Carolina.

The Bauhaus, or "house of construction," was founded by architect Walter Gropius in 1919 in Weimar, Germany,

following the concept that all the arts be integrated as a cohesive unit. At first a student at the Bauhaus during the year after its founding, Albers later joined the faculty on the strength of work he created with glass shards or "found objects," which he scavenged from refuse piles. In these early works Albers developed an interest in light and optics and how the human eye perceives an object. His work in this field influenced op art and conceptual artists in the later 20th century.

Albers, who developed a glass workshop at the school, joined the Bauhaus faculty in 1923. He taught in the introductory course of the Department of Design, including drawing, calligraphy, and furniture design. He was promoted to professor in 1925, the year the Bauhaus moved to Dessau. Albers, who later served as assistant director, is credited with making the first bent laminated wood chair, as well as the first stacking tables. His credo was to design carefully constructed work of high quality and sturdy materials based on simple fundamental forms. He immigrated to the United States in 1933 when the Bauhaus was forced by the Nazi regime to close.

On the recommendation of staff at the Museum of Modern Art in New York, Albers went to teach at Black Mountain College. The school was formed near Asheville in 1933 as an experimental school in which the study of art was based on a liberal arts education. Anni Fleischmann Albers, whom Albers married in 1915, became a noted weaver and teacher at Black Mountain, where they taught for 16 years. There

Albers found the kind of environment he enjoyed at the Bauhaus, where architects, artists, and craftsmen espoused a creed merging proficiency in handcrafts with the components of fine art. His students at Black Mountain included Robert Rauschenberg and Edwin Parker "Cy" Twombly.

Albers eschewed abstract expressionism, particularly that which was created through chaotic application of paint. He is credited with influencing the art movements of geometric abstraction and minimalism. His early influences were Henri Matisse and Paul Cézanne, with some works revealing the influence of cubism. Like many American artists, Albers visited Mexico in the 1940s, where he was inspired by pre-Columbian architecture, sculpture, and textiles, particularly the luminous color. Albers created paintings, prints, photographs, furniture, sculptural constructions, and glass assemblages.

It is, however, in the verdant mountainous area of North Carolina in 1949 that Albers began his series of paintings titled *Homage to the Square*, which brought him international recognition. Over a quarter century, he produced more than a thousand paintings based on this single, elemental, man-made shape featuring flat, sharply delineated, concentrically arranged squares with dense colors, which led to his being known as "The Square Man." Albers recognized that light was the building block upon which art was created, and his compositions demonstrated an infinite variety in hue, tint, and value. Albers preferred using Masonite, a durable man-made support (invented

in Laurel, Miss.), prepared with a primary ground. He applied unmixed pigment directly from the tubes, spreading thin layers of paint evenly with a palette knife. Later abstract painters were influenced by his hard-edged patterns and intense colorations.

In 1950 Albers became chair of the Department of Design at the newly restructured Yale School of Fine Art in New Haven, Conn. Albers's *Homage to the Square* series served as the foundation for his teaching, as well as the subject of his 1963 publication on color theory, *Interaction of Color*. He designed abstract album covers for bandleader Enoch Light's records, minimalist works of art that were pronounced in their difference from other album covers.

A fellow at Yale, Albers received a grant from the Graham Foundation in 1962 for an exhibition and lecture on his work. He collaborated with Yale professor-architect King-lui Wu in creating decorative designs. These included geometric fireplaces for the Rouse and DuPont residences (1954, 1959), the facade of Manuscript Society, one of Yale's secret senior groups (1962), and a design for the Mt. Bethel Baptist Church (1973). In 1971, Albers became the first living artist to be given a solo retrospective exhibition by the Metropolitan Museum of Art in New York. Albers, who was also a poet, continued to paint and write, living in New Haven with his wife until his death in 1976. The Quadrat, a museum in his hometown of Bottrop, Germany, holds and exhibits works by Albers.

JUDITH H. BONNER
The Historic New Orleans Collection

Josef Albers and Casa Luis Barragán, *Homage to the Square: Josef Albers* (2009); Josef Albers, Karen E. Haas, John Stomberg, and Brenda Danilowitz, *Josef Albers: In Black and White* (2000); Josef Albers and Kenneth Price, *Josef Albers / Ken Price* (2010); Achim Borchardt-Hume, Josef Albers, and László Moholy-Nagy, *Albers and Moholy-Nagy: From the Bauhaus to the New World* (2006); Brenda Danilowitz, *Josef Albers* (2001); Isabelle Dervaux, Heinz Liesbrock, and Michael Semff, *Painting on Paper: Josef Albers in America* (2011); Frederick A. Horowitz and Brenda Danilowitz, *Josef Albers: To Open Eyes: The Bauhaus, Black Mountain College, and Yale* (2006); Thomas Gabriel Rosenthal and Josef Albers, *Josef Albers: Formulation: Articulation* (2006); Nicholas Fox Weber, *The Bauhaus Group: Six Masters of Modernism* (2009), *Josef Albers: Paintings* (2009); Nicholas Fox Weber and Jessica Boissel, *Josef Albers and Wassily Kandinsky: Friends in Exile, a Decade of Correspondence, 1929–1939* (2010); Nicholas Fox Weber and Martin Filler, *Josef and Anni Albers: Designs for Living* (2004).

Albrizio, Conrad Alfred

(1894–1973) PAINTER.

The son of Italian immigrants, Conrad Alfred Albrizio was born in New York City on 20 October 1894. Two of his brothers, Humbert and Joseph, became sculptors. He studied architecture and began working in 1919 as an architectural draftsman on the Hibernia Bank Building in downtown New Orleans. Inspired by the southern landscape, he took up painting. He studied at the Art Students League of New York and the Fontainebleau School of Art in France and had his first exhibition in 1925 at the Arts and Craft Club of New Orleans.

Albrizio, who traveled extensively throughout Italy and Europe, explored the atmospheric effects of light and weather in his paintings from the Majorcan coast. He studied the method of fresco painting in Rome and Fontainebleau; over his career he produced a series of murals rendered as frescoes or mosaics. His oeuvre reveals a continuous development of modernist art trends, particularly cubism.

Additionally, Albrizio became a proponent for a uniquely southern art. He was active in the art and literary circle in the Vieux Carré, teaching at the Arts and Crafts Club's School of Art, where he exhibited his artworks. Albrizio was funded through the Works Progress Administration (WPA) to paint murals throughout the South and is best known for his works in the New State Capitol Building in Baton Rouge and his four-panel series—each panel is over 60 feet in length—in the Union Passenger Terminal in New Orleans. The latter series traces four centuries of Louisiana history, beginning with Spanish conquests in North America and ending with contemporary events of importance and a suggestion of the possible conquest of space.

In 1931 Albrizio collaborated with architects working on the New State Capitol Building. Through this connection, he was commissioned to paint six murals in the interior of the building, four in the governor's reception room and two in courtrooms. The murals covered 900 square feet of space. The sole surviving panel, which was based on Psalms 94:15, depicts the corresponding personifications of justice, fate, and law.

In 1936 Albrizio became an instructor in fine arts at Louisiana State University, where he remained until his retirement in 1954. Albrizio's wife, Imogene Inge, was a writer from Mobile; they maintained a summer home in nearby Foley and a studio-apartment in New Orleans. In 1937 Albrizio exhibited his depiction of an African American baptism, titled *Jordan*, in New York at the Whitney Museum of American Art's sixth annual show of contemporary art.

Between 1936 and 1940 Albrizio completed five murals for the WPA — for the U.S. Post Office in DeRidder, the Iberia Parish courthouse in New Iberia, and the portico of the State Fair Exhibits Building in Shreveport. Albrizio's panels for the State Fair Exhibits Building, *North Louisiana* and *South Louisiana*, attempt to appeal to the two areas of the state, which are disparate in culture and temperament.

Albrizio was commissioned by Gov. Huey Pierce Long to paint murals in the lobby of the Louisiana State Capitol Annex Building, which was constructed in 1938. In 1945 he received a two-year fellowship from the Rosenwald Foundation for creative work. On leave from teaching in 1949 after the cessation of the WPA, Albrizio and his assistant, James Fisher, spent 13 months painting seven fresco panels in the Waterman Building in Mobile, Ala., headquarters for the Waterman Shipbuilding Corporation. Albrizio included the four elements of nature — earth, water, air, and fire — to symbolize the taming of nature that enabled men to make advancements alluded to in the other panels.

In 1951 Albrizio began work on more than 2,000 square feet of frescos depicting 400 years of Louisiana history for the New Orleans Union Passenger Terminal. The murals are divided into four chronological panels representing the four ages of Louisiana: exploration, colonization, struggle, and modernity. Despite the fact that the mural style no longer held great appeal for the public, Albrizio persisted in this form of artistic communication. He traveled to Mexico to study the mosaic murals and then to Europe to select Italian tile, which he shipped back to Louisiana.

Between 1955 and 1965 Albrizio completed nine mosaic murals in Louisiana and Alabama, after which he returned to easel painting. He was also active with the American Federation of Arts, National Society of Mural Painters, and the New Orleans Art Association. Albrizio died in Baton Rouge in early January 1973.

JUDITH H. BONNER
The Historic New Orleans Collection

Conrad Albrizio, *Mural Paintings in the New Orleans Union Passenger Terminal* (1955); Carolyn A. Bercier, "The Frescoes of Conrad Albrizio" (M.A. thesis, Louisiana State University, 1979), *Louisiana Cultural Vistas* (Spring 1998); Kathleen Orillion and Louisiana Arts and Science Center, *Conrad Albrizio, 1894–1973* (1985).

Alférez, Enrique

(1901–1999) SCULPTOR.

Enrique Alférez was born in 1901 to a Mexican father who was a sculptor from Zacatecas, the town that was the site of the bloodiest battle during the campaign to overthrow Mexican president Victoriano Huerta. There in 1914

Pancho Villa's División del Norte defeated General Luis Medina Barrón. Alférez, who reportedly was captured and given the choice of fighting with Pancho Villa's troops or execution, joined Villa's revolutionary army, for which he subsequently became a mapmaker. In 1993 Alférez would appear in a PBS documentary for an *American Experience* program titled "The Hunt for Pancho Villa."

Alférez, who attended El Paso High School, also worked in the gallery of El Paso artist Harry B. Wagoner, where he did framing and began his training in sculpture. Members of the El Paso Kiwanis Club raised money to support Alférez's studies with Lorado Zadoc Taft at the Art Institute of Chicago. Alférez worked while learning to sculpt, including architectural works.

In 1929 Alférez relocated to New Orleans and for seven years taught sculpture. He also researched the Mayan civilization in order to inform his work for the 1933–34 Century of Progress International Exposition in Chicago. One of his casts was used for the Mayan Building at the Exposition. He also executed a number of commissions for the state of Louisiana.

During World War II, in 1943, Alférez sculpted the first monument in the United States to represent a woman in service uniform. The original sculpture, titled *Molly Marine*, is located in New Orleans on the corner of Elk Place and Canal Street, and copies of the monument are in Quantico and on Parris Island. Because of wartime restrictions on bronze and other metals, Alférez used granite and marble chips

Enrique Alférez, Head of a Woman (Clayre Barr), circa 1939, plaster, 19½″ x 8½″ x 10¾″ (The Historic New Orleans Collection, 00.48)

in this sculpture. After World War II, he returned to El Paso. He traveled to New York, where he designed women's accessories, as well as living at times in Mexico and Louisiana.

Alférez's work is characterized by broad simplified geometric shapes, often with social comments or political overtones. His commissions include wood-carved elevator doors for the Palmolive Building in Chicago, as well as sculptural reliefs for Charity Hospital, New Orleans Lakefront Airport (formerly Shushan Airport), the Louisiana State Capitol, and Louisiana State University in Baton Rouge. One of New Orleans's most recognizable sculptors, Alférez also executed numerous freestanding sculptures around the city, including City Park, the *Fountain of the*

Winds at New Orleans Lakefront Airport, and colossal figures of *David* and *Woman with a Mandolin* in front of the old LL&E Building on Poydras Street. Alférez also produced a number of sculptures for the Works Progress Administration in the 1930s. Restoration of the Lakefront Airport has revealed friezes by Alférez and murals by artist Xavier Gonzalez created in 1934 and concealed during a 1964 renovation.

Also a painter and draftsman, Alférez painted an official portrait of Louisiana politician Huey Pierce Long. Alférez remained active into his later years, as working artist and as teacher. Alférez died in New Orleans in 1999.

JUDITH H. BONNER
The Historic New Orleans Collection

Matthew J. Martinez, "Enrique Alferez, Sculptor" (M.A. thesis, University of New Orleans, 1989); John E. Powers and Deborah D. Powers, *Texas Painters, Sculptors, and Graphic Artists: A Biographical Dictionary of Artists in Texas before 1942* (2000).

Allen, Jere Hardy

(b. 1944) PAINTER.

Jere Hardy Allen, an internationally known figurative painter who has been called "the Mississippi Rembrandt," was born on 15 August 1944 in Selma, Ala. Early on, inspired by the landscape and wildlife paintings of his great-grandmother Annie Bell Rives Hardy, he decided he too wanted to be an artist and began drawing constantly. He was often a challenge to his teachers—his fifth-grade teacher scolded him in front of his classmates for drawing a nude during school. Undaunted, Allen kept

drawing and completed high school, and then, after working at a television station in Montgomery and joining the U.S. Marine Corps Reserve, he decided to attend the Ringling School of Art and Design in Sarasota, Fla. He received his B.F.A. from Ringling in 1970, earned an M.F.A. from the University of Tennessee in 1972, and was an instructor at Carson-Newman College before joining the art faculty at the University of Mississippi in 1975. He taught painting and drawing there until his retirement in 2000 and continues to work tirelessly on his own creations and to maintain an active exhibition schedule. His wife, Joe Ann, a ceramicist and master gardener, and their son, Jeffrey, a still life painter, share Allen's Oxford studio.

Allen paints primarily in oil, using dramatic, electric colors and most often creating figures against backgrounds of black or red. His canvases, which range in size from 6 by 4 inches to 144 by 125 inches, tend to be large because, he says, "I prefer to react to the people in my paintings who are in a scale that approximates my own." Typically his works are inspired by myths and symbols, but they also represent political and social realities. Some compositions include animals, which Allen describes as "psychopomps," mythical spiritual guides to the human figures in the paintings.

"Allen paints in the tradition of the 19th-century portrait artist, but with an expressionistic flair," observes art historian Peter J. Baldaia, who comments on "the evocative and haunting elegance of his work" and notes that "his paintings present what the artist calls

'notions,' images that rise up from his subconscious and are usually explored in a series of a dozen or more works." Art historian Patti Carr Black describes Allen's work as "cooly sensual, presenting the figure more as a universal symbol than as a narrative device."

In 2007 Allen suddenly started painting with layers and layers of white, and his exhibitions of new works in 2008 and 2011 surprised admirers by showing figures appearing on backgrounds not of black or red but of white. The description by the owner of Oxford's Southside Gallery, Wil Cook, of one of the 23 paintings in the gallery's 2011 exhibition illustrates the nature and impact of Allen's oeuvre: "*Drummers*, a minimalist composition of three figures in a drum line, is evocative of cave paintings," Cook writes. "One of each of the three drummer's hands, palm open and extended toward the viewer, is raised about to beat his drum. . . . The hands of the three drummers have a primal quality to them. They appear to be actual handprints like those found in some cave paintings. . . . Each drum skin in the painting features the profile of an animal (the drum to the left of the canvas, a jaguar; the middle drum, a hummingbird; and the drum to the right, an ouroboros—an ancient symbol depicting a serpent eating its own tail). These could be psychopomps, but they may also be symbolic of a sort of atavism inherent in all of earth's creatures. If anything, the painting may simply be about the rhythm and reciprocity of life."

Allen is listed in *Who's Who in American Art*, studied on a Group

Studies Abroad Fulbright Grant in Costa Rica in 1979, and received the 1993 Visual Art Award of the Mississippi Institute of Arts and Letters. In 2003 his work, along with that of Robert Rauschenberg, Roy Lichtenstein, Wolf Kahn, and others, toured Southeast Asia in the Washington-based Meridian International Center's exhibition, *Outward Bound: American Art at the Brink of the Twenty-first Century*. Allen's paintings have been shown in 40 states, in Canada and Europe, and in the Far East. His work is in permanent collections at the Meridian Museum of Art, the Fine Arts Museum of the South in Mobile, the Huntsville Museum of Art in Alabama, the Tennessee Art League in Nashville, the Coos Art Museum in Oregon, and the Robert I. Kahn Gallery in Houston, among others.

ANN J. ABADIE
University of Mississippi

Peter J. Baldaia, *Resource Library Magazine* (2000); Patti Carr Black, *Art in Mississippi, 1720–1980* (1998); Charlotte Flemes, *Jere Allen: Bilder aus Amerika* (1989); Lawrence Wells, *Art and Antiques* (November 1999).

Allston, Washington

(1779–1843) PAINTER.
Washington Allston was born at Brookgreen Plantation on the Waccamaw River near Georgetown, S.C., to Capt. William Allston and his wife, Rachel Moore Allston. After his father's death in 1781, the artist's mother married Henry C. Flagg of Newport, R.I., an acquaintance through the network of South Carolinians who summered there. Young Allston's acquired relations

in the extended Flagg-Channing-Dana family became his closest associates for the rest of his life.

Upon graduation from Harvard University in 1800, Allston spent the following year in Charleston. In 1801 he traveled to London in the company of miniaturist Edward Greene Malbone, a friend from Newport. Allston was admitted to the Royal Academy in September of that year and began studies with Benjamin West.

West, an American expatriate, was a leading master of history painting, a form of art dedicated to large, dramatic re-creations of episodes from history and literature. Inspired by West, Allston determined to become a history painter, an ambition that would lead him to create vast, complex paintings whose elemental atmospherics were influenced by the works of Nicolas Poussin, Salvator Rosa, and Joseph Mallard William Turner.

From 1801 to 1818 Allston spent most of his time in Europe, where he made extended study tours of continental museums, notably those in Paris and Rome. On those journeys he met several fellow artists and writers, including John Vanderlyn, Washington Irving, and romantic poet Samuel Taylor Coleridge, all of whom became lifelong friends. His portrait of Coleridge, painted in 1814, is in the National Portrait Gallery, London.

Allston did return to Boston on at least two occasions: once in 1809 to marry Ann Channing and again in 1811, after which he brought the young artist Samuel Finley Breese Morse back to

London with him. He painted several members of the Channing family on that visit in 1811, including his brother-in-law, renowned Unitarian minister William Ellery Channing.

During his English sojourn, Allston painted several works, including *Rebecca at the Well* and *Uriel in the Sun*, which led to his being made an academician in 1819. He began his most ambitious project, the monumental painting *Belshazzar's Feast*, in 1817. Following his wife's death in 1815, Washington Allston became increasingly homesick for America and returned to Boston in 1818, taking up residence in Cambridge. In 1830 he married Martha Dana. During his last years, he struggled to complete *Belshazzar's Feast*, which remained unfinished at the time of his death. Allston was also a writer and produced several volumes of poetry and art criticism.

ESTILL CURTIS PENNINGTON
Paris, Kentucky

Washington Allston, *Lectures on Art and Poems, 1850* (1967); David Bejelac, *Millennial Desire and the Apocalyptic Vision of Washington Allston* (1987); Dorinda Evans, *Benjamin West and His American Students* (1980); Jared Flagg, *The Life and Letters of Washington Allston* (1969); William H. Gerdts and Theodore E. Stebbins Jr., "A Man of Genius": The Art of Washington Allston, 1779–1843 (1979); Richard Kenin, *Return to Albion: Americans in England, 1760–1940* (1979); Edgar Preston Richardson, *American Art: A Narrative and Critical Catalog* (1976), *Washington Allston: A Study of the Romantic Artist in America* (1948); Marc Simpson, *The Rockefeller Collection of American Art at the Fine Arts Museums of San Francisco* (1994).

Amans, Jacques Guillaume Lucien

(1801–1888) PAINTER.

Jacques Guillaume Lucien Amans was born in Maastricht, Netherlands, in 1801. Although the facts of his art education are unknown, Amans probably studied at the École des Beaux-Arts in Paris since he exhibited in the Salon from 1831 through 1837.

One of the most accomplished artists in New Orleans from the mid-1830s through the mid-1850s, Amans is believed to have traveled to New Orleans at the suggestion of French portrait painter Jean-Joseph Vaudechamp, with whom he sailed in 1836 and 1837. Both painters exhibited at the same Paris salons, and in 1837 they occupied studios in the same block of Royal Street in the French Quarter.

Meeting with immediate success, Amans was financially secure enough that he bought the Trinity sugar plantation on Bayou Lafourche in southern Louisiana in 1836, the year of his arrival. Living in the city during the winters, Amans avoided the yellow fever season during the summers by returning to his plantation, to other Louisiana plantations, or to France.

Amans, who was influenced by French painter Jean-Auguste-Dominique Ingres, favored three-quarter-length seated figures with emphasis on the head and hands and a smoothly finished surface. The primary emphasis in Amans's portraiture is on elegance and the sitter's pride of possessions. Amans's self-portrait, however, differs in that the brushwork is still evident. He portrayed himself in his artist's jacket, its collar curled upward. His hair is less than tidily arranged, his mouth is slightly parted as though about to speak, and the circles under his eyes bespeak fatigue. His commissioned portraiture includes a three-quarter-length portrait of Pres. Andrew Jackson, painted in 1840 for the 25th anniversary of the battle of New Orleans, and an 1844 equestrian portrait of Jackson, painted with Theodore Sidney Moïse. The latter portrait won a $1,000 prize from the city's Second Municipality. Amans's other important portraiture of political figures included a seated portrait of Zachary Taylor, which was painted from life in Baton Rouge.

The planter class sought Amans's services, and he portrayed a number of Louisiana's socially prominent citizens. One such portrait is that of Françoise Gabrielle "Rosa" Montegut Pitot, the daughter of François-Raimond-Joseph Montegut and Rose-Gabrielle Nicholas, who married Armand-François Pitot, an attorney and counsel of the Citizens' Bank. Pitot was the son of James Pitot, the first mayor of New Orleans.

Additionally, Amans painted companion portraits of sugar planter François Gabriel (Valcour) Aime and Aime's wife, Josephine Roman, whom he married on 3 January 1816. She was the sister of André Bienvenu Roman, also a sugar planter, who served as governor of Louisiana. Aime, who owned a large plantation with lavish gardens in St. James Parish, gave the plantation Felicity to his daughter Felicité Emma Aime as a wedding present.

Amans also exhibited at the North

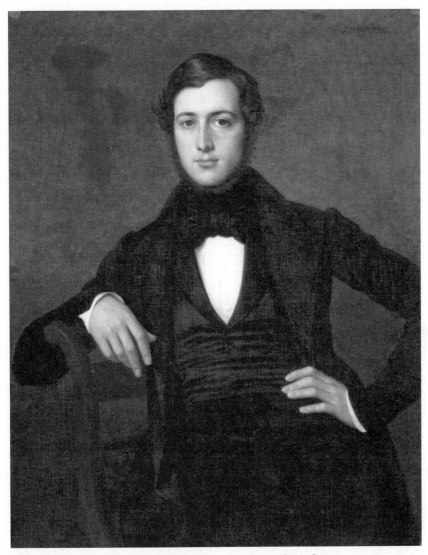

Jacques Guillaume Lucien Amans, Carl Kohn, *circa 1837, oil on canvas, 36¼″ x 28½″*
(The Historic New Orleans Collection, 2006.0425.1)

Central and South American Expo-
sition in 1885–86. He married Mar-
guerite Azoline Landreaux, a Louisiana
native. In 1856 Amans and his wife left
Louisiana for La Cour Levy near Ver-
sailles, France. They placed their real

estate and finances in the hands of
agents and closed their residence in the
United States. Amans died in Paris on
10 January 1888.

JUDITH H. BONNER
The Historic New Orleans Collection

Artists' Files, Williams Research Center, Historic New Orleans Collection; Judith H. Bonner, in *Collecting Passions*, ed. Susan McLeod O'Reilly and Alain Masse (2005); Thomas Nelson Carter Bruns, National Society of the Colonial Dames of America in the State of Louisiana, *Louisiana Portraits* (1975); W. Joseph Fulton and Roulhac Toledano, *Antiques* (June 1968); William H. Gerdts, George E. Jordan, and Judith H. Bonner, *Complementary Visions of Louisiana Art: The Laura Simon Nelson Collection at the Historic New Orleans Collection* (1996); John A. Mahé II and Rosanne McCaffrey, eds., *Encyclopaedia of New Orleans Artists, 1718–1918* (1987); Mary Louise Tucker, "Jacques G. L. Amans: Portrait Painter in Louisiana, 1836–1856" (M.A. thesis, Tulane University, 1970); Martin Wiesendanger and Margaret Wiesendanger, *Louisiana Painters and Paintings from the Collection of W. E. Groves* (1971).

Amisano, Joseph

(1917–2008) ARCHITECT.

Born in New York in 1917, Joseph Amisano became a leading designer of modern architecture in the South. He received his architecture degree from Pratt Institute in New York in 1940 and was a Fourth Year Design Medalist from that institution. Amisano won a Prix de Rome in 1950. In 1978 he was elected to the National Academy of Design as an associate member. Before joining the Atlanta firm of Toombs, Amisano, and Wells in 1954 he was associated with the firm of Harrison, Foulhoux, and Abramovitz in New York and in the Canal Zone. Later he joined the New York firm of Walter Sanders, where he met and worked with Buckminster Fuller.

Amisano's first national recognition came in 1942 with his design for proposed row apartments in New York City. His major recognition as a designer came with his work in Atlanta in the late 1950s and early 1960s. He played the major role in the design of Lenox Square, built in Atlanta in 1958 and soon recognized as one of the nation's most successful shopping malls. This "space for people," as Amisano called it, reflected Atlanta's growing importance as a major business center.

The mall contained 58 shops, most of them branches of Atlanta's established institutions, including Rich's and Davison-Paxon. The key to the design was the 1,014-foot-long central mall, which provided shoppers with insulation from automobile traffic. The open mall with its shops seemed to be very much in the spirit of the sunny Italian piazzas Amisano had come to know and love during the time he spent in Rome as a Fellow at the American Academy. Spanning the 55-foot width of the mall are arches of white concrete, folded and arched into shapes more sculptural than architectural. Plantings in boxes and pots mask the long perspective of the mall so that shoppers see only four or five storefronts at one time. The design was restrained by its basically stern and classical character and by the economy of the construction. Lavish as the design seemed at the time, the cost was 20 to 25 percent below that of comparable malls.

Amisano's firm designed the Village Shopping Center in Cleveland, Tenn. His design for the Science Center at the University of Georgia in Athens was

completed in 1957, and his designs for the Pharmacy Building and the Visual Arts Building on that campus were brought to fruition in 1962, the same year Harper High School was built in Atlanta from his design. In 1965 Amisano's plans for the Peachtree Palisades Building, a totally black structure, were completed in Atlanta.

During the late 1960s Amisano designed two distinctive churches in Atlanta. John Knox Presbyterian Church was constructed in 1967 in suburban Atlanta, and the Unitarian Church was built in 1968. Both were recognized for their distinctive central design. The decade of the 1960s was climaxed, however, by his design for the Atlanta Memorial Arts Center, which was dedicated in October 1968. The center housed the High Museum of Art, the Atlanta College of Art, Symphony Hall, and the Alliance Theatre. Again, the design of the buildings was distinguished by the stern classical character of its massively simple forms. The most important large structure designed by Amisano in the 1970s was the Peachtree Summit Building, constructed in 1975.

Amisano's design of Atlanta University Center Library was completed in the spring of 1983, and his design for the MARTA Peachtree Center station was also completed and won a Georgia American Institute of Architects award in that year. The unique feature of the design is the exposed granite of the tunnel, which was left unfinished as the main decorative element of the station.

MARIE HUPER PEPE
Agnes Scott College

American Architects Directory (3d ed., 1970); *Antiques* (July 1970); Rob Beauchamp, *Atlanta Journal/Atlanta Constitution Weekend* (10 August 1985); *Progressive Architecture* (April 1959).

Anderson, Walter Inglis

(1903–1965) ARTIST.

Walter Anderson was born in New Orleans on 29 September 1903, the second son of George Walter Anderson, a grain merchant, and Annette McConnell Anderson, an artist, who gave her son a love of art, music, and literature. He grew up valuing the importance of art in everyday life and developed what would become a lifelong interest in mythology. He attended grade school in New Orleans, went to boarding school in New York, was later trained at the Parsons Institute of Design in New York (1922–23) and the Pennsylvania Academy of the Fine Arts (1924–28), and received a scholarship that enabled him to study and travel in Europe. He read broadly in history, natural science, poetry, art history, folklore, philosophy, and epic narratives of journeying.

Anderson returned to Mississippi, working with his brother on earthenware at Shearwater Pottery in Ocean Springs. He married Agnes Grinstead Anderson in 1933, and they raised four children. His developing interest in murals coincided with his work on Works Progress Administration mural projects in Ocean Springs during the 1930s. The late 1930s saw the onset of mental illness, for which he was hospitalized for three years, after which he moved with his family to his wife's

family estate, Oldfields Plantation, in Gautier. He had long been interested in nature, but at Oldfields natural scenes begin to appear in his watercolors and tempera paintings and in the large linoleum block prints he created.

In 1947 he secluded himself in a cottage at Shearwater, where he wrote, painted, decorated pottery for the family business, and carved. More and more often, he rowed the 12 miles to Horn Island, one of the barrier islands off the Mississippi coast. This unspoiled natural landscape became his home for long stretches of time during the last decade and a half of his life. "So much depends on the dominant mode on shore," he wrote, "that it was necessary for me to go to sea to find the conditional. Everything seems conditional on the islands." Anderson's paintings and drawings captured the numerous species of flora and fauna in this pristine environment, as he illustrated birds, insects, animals, flowers, trees, shrubs, and any other natural life he saw in his exploration of the wild underbrush and coastal lagoons. He used the term "realization" to suggest his hope of becoming at one with the natural species he observed. In one episode he tied himself to a tree during a hurricane and experienced the fury of nature. He documented everything he saw, from the life of a spotted frog to the near extinction of the brown pelican due to the effects of the pesticide DDT, which in the 1940s and 1950s had even reached this isolated island. Anderson kept 90 journals and logs recording what he experienced, writings mostly for himself, which drew from his broad artistic and philosophical knowledge.

Walter Anderson died of lung cancer in New Orleans in 1965. During the centennial of his birth in 2003, the Smithsonian Institution honored his work with a major exhibition. The Walter Anderson Museum was established in Ocean Springs in 1991. Much of Anderson's work is there, but his family compound at Shearwater also housed many of his watercolors, paintings, and ceramics, which were damaged or destroyed as a result of Hurricane Katrina hitting the Mississippi coast in 2005. Conservators are working to save and restore his work.

CHARLES REAGAN WILSON
University of Mississippi

Christopher Maurer, *Fortune's Favorite Child: The Uneasy Life of Walter Anderson* (2003); Patricia Pinson, ed., *The Art of Walter Anderson* (2003); Redding S. Sugg Jr., ed., *The Horn Island Logs of Walter Anderson* (1985).

Andrews, Benny

(1930–2006) ARTIST.
One of 10 children, Benny Andrews was born on 13 November 1930 in Plainview, Ga. His father, George Andrews, was a farmer and a self-taught artist who was known as the "Dot Man." His mother, Viola Perryman Andrews, encouraged all of her children to write and draw daily. James Orr, his paternal grandfather, was the son of a prominent white plantation owner, and his paternal grandmother, Jessie Rose Lee Wildcat Tennessee, was, like his maternal grandparents, John and Allison Perryman,

of mixed race — African American and Native American.

Growing up in rural, segregated Georgia during the Great Depression and war years, Andrews and his brother, writer Raymond Andrews, learned mainstream American values by studying the popular culture of that era, including movies, radio, newspapers, comics, and magazines. Despite the racism and poverty he endured in these years, Benny Andrews developed a deep faith in the spirit and promise of America, a belief he maintained throughout his life and demonstrated in the primary subject of his art, life in America.

Andrews was the first member of his family to graduate from high school, and he attended Fort Valley State College. After serving as a military policeman during the Korean War, he attended the School of the Art Institute of Chicago on the GI Bill, graduating in 1958. That year, he moved to New York City, where he maintained a studio for the rest of his life. He began to exhibit at Bella Fishko's Forum Gallery in 1962.

Influenced by the civil rights movement and concerned about the racial, social, and gender inequities Andrews discovered in the art world by the late 1960s, he entered a period of social and cultural activism, which was reflected in his art. After he cofounded the Black Emergency Cultural Coalition (BECC) in 1969 and marched in protest outside the Whitney Museum of American Art and the Metropolitan Museum of Art, calling for the inclusion of women and artists of color, Andrews was often classified as a "protest artist." In 1970 he announced an ambitious concept — a six-year project entitled the *Bicentennial Series*, devoted to depicting the complex history of African Americans for the American Bicentennial in 1976.

After exhibiting this series Andrews returned to his studio and to his position as a member of the art faculty at Queens College, an appointment he held for almost three decades, during which he moved beyond the political activities of the previous years. Determined to explore artistic and social themes in an ongoing series of works, Andrews began a new series, *Women I Have Known*. From 1982 to 1984 he served as director of the Visual Arts Program for the National Endowment for the Arts (NEA), a position that brought him increased stature as well as a heightened national perspective in his vision and work.

Determined to return to his art and his studio, Andrews left the NEA in 1984 and entered the most productive stage of his career, evident in a series of evolving projects: the *Completing the Circle Series*, the *Portrait Series*, the *America Series*, the *Southland Series*, the *World Series*, the *Cruelty and Sorrows Series*, the *Revival Series*, the *Music Series*, the *Langston Hughes Series*, the *Musical Interlude Series*, the *Critic Series*, and, finally, the *Migrant Series*. He also broadened his emphasis on the culture of his extended family, including the creation of illustrations for his brother's novels, which fused fiction and nonfiction (and Andrews family history) in Muskhogean County novels,

including *Appalachee Red* (1978), *Rosie-belle Lee Wildcat Tennessee* (1980), and *Baby Sweets* (1983).

Also in 1984, working from designs created by his son, Christopher, an architect trained at the Rhode Island School of Design, Andrews and his wife, artist Nene Humphrey, built a studio and residence outside Athens, Ga. Here he was able to work more closely with his Georgia family, including his mother, a writer and storyteller, and his father, George, whose artistic career he actively advanced from 1984 until the elder Andrews's death in 1996. In 2001, after living and working in Manhattan for more than 40 years, Andrews and Nene Humphrey renovated and moved into a new studio and residential structure in Brooklyn, where he created a series of illustrated children's books as well as doing artist's book and print projects for the Limited Edition Press in New York.

The primary focus of Andrews's last years, however, was the *Migrant Series*, an ambitious, multiyear project intended to serve as a grand summation of the themes and issues that had dominated his life and career. Each of the three major components was planned to reflect one aspect of his own mixed heritage—Andrews was of African American, Scots-Irish, and Cherokee descent—and was to be related to a major migration in American history, beginning with the Dust Bowl migration to California (2004), continuing with the Trail of Tears migration (2005), and concluding with the Great Migration of African Americans to the North. In 2006, after repeated visits to New Orleans and the Gulf Coast, Andrews decided to add a concluding chapter, devoted to the mass migration that emerged in the wake of Hurricane Katrina.

The evolution of the project was suspended in the summer of 2006, after Andrews was diagnosed with the cancer that led to his death on 10 November 2006. He donated a major public collection of his art to the Ogden Museum of Southern Art, University of New Orleans, which dedicated a permanent gallery to it. Andrews also donated a major, related archival collection of Andrews Family research materials to the Emory University Library.

J. RICHARD GRUBER
Ogden Museum of Southern Art
University of New Orleans

Lawrence Alloway, "Introduction," *Benny Andrews: The Bicentennial Series* (1975); *American Visions: The Magazine of Afro-American Culture* (April 1988); Benny Andrews, *New York Times* (27 June 1970); Raymond Andrews, *The Last Radio Baby* (1990); *Atlanta Art Papers* (September/October 1980); Patricia Bladon, *Folk: The Art of Benny and George Andrews* (1990); Michael Brenson, *New York Times* (4 November 1988); J. Richard Gruber, *American Icons: From Madison to Manhattan, the Art of Benny Andrews, 1948–1997* (1997), *The Dot Man: George Andrews of Madison, Georgia* (1994); Janet Heit, in *Icons and Images in the Work of Benny Andrews*, ed. Raymond Andrews (1984); Lisa Howorth, *Reckon: The Magazine of Southern Culture* (Fall 1995); Donald Keyes, *Off the Wall: Benny Andrews and John Hardy* (1987); Edward S. Spriggs, in *Symbols and Other Works by Benny Andrews*, ed. Edward S. Spriggs (1971); Judd Tully,

American Artist (April 1988); William Zimmer, *Benny Andrews, the America Series* (1993).

Arnold, Edward Everard

(ca. 1816/1824–1866) PAINTER.
A native of the town of Heilbronn in Baden-Württemberg, Germany, Edward Everard Arnold arrived in New Orleans sometime between 1846 and 1850 and remained in the city until his death in 1866. Like many artists-craftsmen of the era, he divided his time as a sign painter, lithographer, genre and history painter, portraitist, and marine painter. Arnold probably learned the lithography trade as an apprentice in Germany, but he appears to have been a self-taught painter. Today, he is best known for the ship portraits that he painted most likely for New Orleans commission merchants, cotton factors, and masters of visiting ships.

The format and composition of his ship portraits demonstrate an intimate familiarity with the established tradition of English and American ship portraiture of the era, although Arnold's technique is, with a few exceptions, decidedly naive. Vessels in Arnold's paintings typically appear in profile in order to best illustrate specific attributes. Although sometimes integrated into their environment, the ships are treated in a glyptic fashion that emphasizes details significant to the mariner, particularly the configuration of sails and location of lines. He signed nearly all of his ship portraits, painting his name and other particulars in black borders along the canvas's lower edge on many of them. As Estill Curtis Pennington has noted,

one suspects that Arnold did not fully understand the origin of such *verre églomisé* legends, which frequently appear on China trade reverse-glass paintings. At any rate, Arnold's use of the black border demonstrates the vital exchange of artistic conventions among Europe, Asia, and the United States, made possible by the thriving international mercantile economy.

Arnold was described in the New Orleans press shortly after his arrival as a "talented young German artist" without equal in the branches of portraiture and marine painting. Although he may have been New Orleans's leading ship portraitist, claims about Arnold's skills as a portrait painter are probably hyperbole, given the superior work of Jacques Guillaume Lucien Amans and Theodore Sidney Moïse. However, precise assessment is difficult, as public collections currently exhibit none of Arnold's portraits.

In September 1850 Arnold entered into a short-lived partnership with James Guy Evans to produce a panoramic view of the city from Marigny, but the project apparently did not materialize. However, both Evans and Arnold signed several paintings—for example, *Levi Woodbury of New Orleans* (1850). Evans's reportedly erratic behavior and religious fervor may have contributed to the rapid dissolution of the partnership. The same year Arnold collaborated with R. W. Fishbourne on an ill-fated attempt to secure subscriptions for a lithograph of New Orleans. Arnold married Caroline Mary O'Reilly of Ireland in April 1851. A press notice suggests that he was now offering portraits at a price

so attractive that "no family should be without them."

Toward the end of his career Arnold painted several views featuring Civil War naval engagements, for example, *The Battle of Port Hudson, Louisiana, July 9, 1862* (1864). He died in New Orleans on 14 October 1866, a few days after the death of his three-year-old son. Arnold has the distinction of being the only antebellum artist in Louisiana to list his profession as marine painter in city directories, though not until 1860. Surprisingly, he is also one of the few 19th-century artists to have specialized in ship portraits in the thriving port of New Orleans.

RICHARD A. LEWIS
Louisiana State Museum
New Orleans, Louisiana

Alberta Collier, *New Orleans Times-Picayune* (20 July 1975); William H. Gerdts, *Art across America: Two Centuries of Regional Painting, 1710–1920* (1990); John A. Mahé II and Rosanne McCaffrey, eds., *Encyclopaedia of New Orleans Artists, 1718–1918* (1987); Louisiana State Museum, *250 Years of Life in New Orleans: The Rosemonde E. and Emile Kuntz Collection and the Felix H. Kuntz Collection* (1968); Roulhac B. Toledano, *Antiques* (December 1968).

Arnold, John James Trumbull

(1812–ca. 1865) PORTRAIT AND MINIATURE PAINTER.
Among the itinerant artists still working at mid-19th century, John James Trumbull Arnold was exceptional in that he promoted himself as a "Professor of Penmanship" as well as a portrait and miniature painter. The fine linear skills associated with pen and ink are reflected in the clean, simple outlines of his figures, and they also lend a touch of elegance to his distinctive style. The hallmarks of Arnold's work include soft gray-brown shading around the eyes, minutely painted eyelashes, and simple arched eyebrows. Arnold painted his sitters with minimal modeling. The flat, two-dimensional rendering of the hands, set in a frontal position with fingers straight or awkwardly bent, is another distinguishing characteristic of his portraits.

There is little information about the life of this painter, aside from the fact that he was born in 1812—one of eight children of Dr. John B. and Rachel Arnold of York County, Pa. According to an advertisement, it appears that Arnold had begun working at least by 1841. Approximately 35 portraits have been attributed to Arnold, most of them executed in Pennsylvania, although a number have also been found in Washington, D.C., West Virginia, and western Virginia. Although it is possible that sitters traveled to Washington to have portraits painted, it is more likely that Arnold was an itinerant painter. Like most itinerants, he left no diary or account book. Shortly after the Civil War, Arnold died, possibly as a result of alcohol consumption. His work is included in the collections of the Abby Aldrich Rockefeller Folk Art Center and the New York State Historical Association.

MARILYN MASLER
Brooks Museum of Art
Memphis, Tennessee

Paul D'Ambrosio and Charlotte M. Emans, *Folk Art's Many Faces* (1987); Beatrix Rumford, *American Folk Portraits from the Abby Aldrich Rockefeller Folk Art Center* (1981).

Audubon, John James

(1785–1851) PAINTER.

John James Audubon was a self-taught artist whose work art historians virtually ignored until the middle of the 20th century. Because Audubon claimed that he had "studied drawing for a short time while in youth under good masters"—he once claimed an early relationship with no less a master than Jacques-Louis David—his paintings are not often considered folk art. However, this claim was probably an attempt to establish an artistic pedigree after the fact. Theodore Stebbins wrote that Audubon may have "only admired [David] from a distance," and biographer Richard Rhodes declared that Audubon maintained this fiction to "pad his credentials." Like Davy Crockett, with whom he seems to have shared several personality traits, Audubon was the creator of his own myth. The world of folk art has as much right as the world of "high art" to claim him as its own.

Born out of wedlock in Haiti, Audubon was more at home in the American wilderness than in Europe. He depended on his charm, colorful image, and ability to "spin a yarn," and his writings reveal his core identity as a romantic artist. Audubon's combined genius as both a naturalist and an artist allowed him to interpret his observations as a woodsman within subtly manipulated compositions by superimposing anthropomorphic dramas onto his representations of "each [bird] family as if employed in their most constant and natural avocations." The most obvious of these avian dramas are those involving fathers, mothers, and either eggs or live young being threatened by an evil outsider, such as male and female brown thrashers protecting a nest from an invading blacksnake.

When Audubon presented these idiosyncratic groupings, he sought a visual parallel to the moral allegories and fables of Jean de La Fontaine, a volume of which was among his dearest possessions. Like contemporary folk artists who find inspiration in the Bible, Audubon, grounded in this folkloric moral structure, found constant inspiration in the behavior of the birds he painted. Just as the author of a fable defines symbolic characters, he gave birds—the blue jay, the fish hawk, the osprey—distinctly archetypal personalities. The blue jays were, to him, a "beautiful species—rogues though they be," and fish hawks were "of a mild disposition. These birds live in perfect harmony together."

Audubon's idiosyncratic visual interpretations of bird personalities are a natural reflection of his folkloric interpretations of bird behavior. For example, his painting of the peregrine falcon depicts two of these aggressive "pirates . . . congratulating each other on the savouriness of the food in their grasp. Their appetites are equal to their reckless daring." The falcon on the left confronts the viewer with a direct stare, beak wide open, hunched full length

over the duck it has killed, as if to pro-
tect it from being stolen. Its mate pauses
in the midst of tearing apart another
duck to give the viewer a wary one-eyed
glance, blood dripping from its beak.
As a woodsman and expert hunter,
Audubon undoubtedly identified with
these predators and enjoyed positioning
the specimens he collected in highly ex-
pressive poses. His method of pinning
their bodies, wings, and limbs allowed
him to create expressionistic paint-
ings of birds in dancelike positions, like
that seen in a group of "Virginian par-
tridges" (Northern bobwhites) being
"attacked by a hawk. The different atti-
tudes exhibited by the former cannot
fail to give you a lively idea of the terror
and confusion" of the prey.

Audubon's genius is revealed most
clearly in his ability to maintain the
attitude and message of the folk artist,
while veiling his work in the scien-
tific accuracy of an Enlightenment
naturalist.

JAY WILLIAMS
Museum of Arts and Sciences
Daytona Beach, Florida

John James Audubon, *Ornithological Biog-
raphy* (1999), *Writings and Drawings* (1999);
Annette Blaugrund and Theodore E. Steb-
bins Jr., eds., *John James Audubon: The
Watercolors for "The Birds of America"*
(1993); Mary Weaver Chapin, *Catesby,
Audubon, and the Discovery of a New World:
Prints of the Flora and Fauna of America*
(2008); Alice Ford, *John James Audubon:
A Biography* (1988); Waldemar H. Fries,
*The Double Elephant Folio: The Story of
Audubon's Birds of America* (1973, 2005);
Christoph Irmscher, ed., *Writings and
Drawings* (1999); Richard Rhodes, *John
James Audubon: The Making of an American*
(2004); Lee A. Vedder, *John James Audubon
and the Birds of America: A Visionary
Achievement in Ornithological Illustration*
(2006).

Baggett, William Carter

(b. 1946) PAINTER, PRINTMAKER,
MURALIST.
Born on 12 January 1946 in Mont-
gomery, Ala., William Carter Baggett
grew up and attended public schools
in Nashville, Tenn., before earning two
degrees in art from Auburn University
(B.F.A., 1968, M.F.A., 1973). He taught
in art and design programs at the Uni-
versity of Mississippi (1973–76), Auburn
University (1976–86), and the Univer-
sity of Southern Mississippi (1986–2010)
prior to retiring and returning to his
studio endeavors on a full-time basis.

Baggett worked primarily in water-
colors and printmaking in the 1970s
and, with many of his early works in-
spired by William Faulkner's real and
imaginary counties, Lafayette and
Yoknapatawpha, had exhibitions during
annual Faulkner and Yoknapatawpha
Conferences in Oxford. Baggett began
using egg tempera in his paintings in
the 1980s, continued his interest in
printmaking, and became known as a
master of color lithography. Baggett's
early work is usually labeled representa-
tional and figurative, realistic and tra-
ditional, but, as art historian and critic
Renata Karlin explains, "he employs the
structural world of forms, landscapes,
figures, and buildings to seduce the
viewer to enter the pictorial space" and
then see beyond the surface. "Painting
to Baggett is a way of seeing and about

the role of pictorial elements of—in his words—'creating a situation; where everything is posed and becomes significant.'"

From 1992 through 2005 most of Baggett's creative time was dedicated to designing and painting monumental murals for public spaces in Mississippi and Alabama. *The Spirit That Builds* depicts the history of south Mississippi in a circular panorama hanging 30 feet above the main desk of the Hattiesburg, Petal, and Forrest County Library. *Sharing Life*, at the University of Mississippi Medical Center in Jackson, celebrates the diverse roles of women. *Alma Mater*, displayed in the Jule Collins Smith Museum of Fine Art at Auburn University, evokes daily life on the campus and in the community. *The University's Bounty* is displayed in the Thad Cochran Center at the University of Southern Mississippi.

In 2006 Baggett returned to the small rectangular panels he had previously used for watercolors and egg tempera paintings but continued using alkyd oil pigments adopted for his murals. *The Intelligent Eye–Reality Re-seen*, an exhibition of 30 oils painted between 2006 and 2010, according to a press release, "reflects his pursuit of a contemplative and personal focus on landscapes and still life paintings, while maintaining his uniquely intimate organization of form and space, as well as his sense of nuance with color and surface." The exhibition previewed in Hattiesburg in September 2010 before beginning a tour of museums in the United States. An accompanying 48-page catalog includes full-color re-productions of the exhibition paintings and four examples of his earlier work, as well as Renata Karlin's text surveying the artist's career.

Baggett's paintings and his printmaking works are included in collections throughout the United States, Europe, and Japan. He has worked with both French and American art publishers to execute 15 original print editions in ateliers in Paris and New York. The U.S. Information Agency has placed his prints in U.S. embassy collections throughout the world. He currently maintains studios in Mississippi and Maine, where he continues to paint "reconfigured" landscapes and figurative images.

ANN J. ABADIE
University of Mississippi

Patti Carr Black, *Art in Mississippi, 1720–1980* (1998); Renata Karlin, ed., *The Intelligent Eye, Reality Re-seen: Recent Paintings by William Baggett* (2010).

Barthé, James Richmond (Ray)
(1901–1989) ARTIST.

A sculptor often associated with the later Harlem Renaissance, Richmond Barthé focused on the human form and on capturing both everyday scenes and iconic members of the African American community. His sculptures are often noted for their sense of fluid motion and sensuality, and his sensitive interpretations brought him international acclaim.

James Richmond Barthé was born in Bay St. Louis on 28 January 1901. His father died soon after; his mother, Marie Clementine Robateau, supported her family by sewing. While at work

she often gave paper and pencil to the toddler to occupy him. Robateau raised her son as a devout Catholic within their Creole community. Spirituality, race, and sexuality would influence his later art.

During his grade school years, Barthé's family, a teacher, and a priest all began to take note of his precocious drawing and painting talent. But as an African American Barthé was barred from pursuing formal art education. At age 14 Barthé took a job as houseboy in the home of a prominent white family in New Orleans, where noted figures like writer and editor Lyle Saxon encouraged his art and lobbied art schools on his behalf. Yet formal education was again denied to Barthé because of his race. Determined to help, his patrons next looked beyond the South. Despite a lack of both formal training and education, Barthé was admitted to the School of the Art Institute of Chicago in 1924.

In Chicago, Barthé's portraits soon earned him notice from important collectors. During his senior year, while taking a sculpture class in order to better understand perspective, he was encouraged to pursue the medium. In 1928 his sculptures were included in the Chicago Art League's "Negro in Art Week," which led to his first professional commissions and the promise of a solo exhibition.

In 1929 Barthé moved to New York City and settled in Harlem, quickly becoming a part of the well-established Harlem Renaissance scene. In 1930 he won a Julius Rosenwald Fellowship; in 1933–34 he was included in exhibitions at the Chicago World's Fair and New

York's Whitney Museum. The latter purchased several of Barthé's works and helped establish his reputation as the country's leading African American sculptor. Barthé remained in New York for nearly two decades.

In addition to the acquisition of his artworks by the Metropolitan Museum of Art and other museums, Barthé won two Guggenheim fellowships (1941, 1942). His subject was the everyday African American experience as well as the depiction of noted celebrities (black and white) like Josephine Baker, George Washington Carver, John Gielgud, and Paul Robeson. Many of the latter were also patrons or friends, as were Eleanor Roosevelt, Carl Van Vechten, and Langston Hughes.

Barthé's sculptures frequently focus on the human form in motion. His depictions of African American life manifest a classical influence. He entered a formal art world where African Americans were most frequently depicted in cotton fields or while performing other labor-related activity. Barthé broadened this approach, both aesthetically and in terms of social comment. His sculpture *The Negro Mother* transforms a classical Pietà into that of a woman holding the body of her lynched son. His sculpting of African American male nudes bestowed the classical ideal upon bodies that had been excluded from previous consideration. His most famous bronze, *The Boxer* (1942), is a lean, graceful depiction of a Cuban pugilist, known as "Kid Chocolate," who is shown in mid-swing.

Notably complex, Barthé's sculptures reflect his personal experience. Works like *The Negro Mother* not only engage

his spirituality—as a gay black male with strong religious convictions—but also articulate the pain associated with his lifestyle. *The Boxer* is classical homage but also serves as sensual representation of a black male frozen in a complex, perpetual fight. Scholars note that Barthé was at times torn between images and expectations. For example, his mostly white clientele often considered him a "race man" because of his subjects, while some of his African American counterparts labeled him an "Uncle Tom" because of his clientele.

In the late 1940s Barthé left New York City. After completing such commissions as the Toussaint L'Ouverture Monument and General Dessalines Monument for the Haitian government, he spent almost 20 years in Jamaica and then several years in Europe. Ever in the conflicted middle of social forces, during Mississippi's Freedom Summer of 1964 Barthé was invited back to Bay St. Louis, where he was publicly celebrated and given the key to the city by the town's white mayor.

In 1977 the University of Southern Mississippi bought two of Barthé's artworks, and he was honored by the governor of Mississippi. Barthé died in 1989 in Pasadena, Calif., while living on the then-renamed Barthé Drive. Barthé's life and oeuvre is celebrated in several biographies; his work continues to be exhibited in and beyond Mississippi.

ODIE LINDSEY
Austin, Texas

Patti Carr Black, *American Masters of the Mississippi Gulf Coast: George Ohr, Dusti Bongé, Walter Anderson, Richmond Barthé* (2009); Sheila A. Cork, *Richmond Barthé:*

Biography, Works, Criticism: A Collection of Ephemera (2000); Samella S. Lewis, *Two Sculptors, Two Eras: Richmond Barthé, Richard Hunt* (1992); Gary A. Reynolds, Beryl J. Wright, and David C. Driskell, *Against the Odds: African-American Artists and the Harmon Foundation* (1989); Margaret Rose Vendryes, *Barthé: A Life in Sculpture* (2008); Cary D. Wintz, *Harlem Speaks: A Living History of the Harlem Renaissance* (2007).

Bartlett, James W. (Bo), III

(b. 1955) PAINTER.

Bo Bartlett, a contemporary realist painter, was born James W. Bartlett III in Columbus, Ga., in 1955. He began his art career with private studies in Florence, Italy, and with Ben F. Long. In 1975 Bartlett moved to Philadelphia to attend the University of the Arts. From 1976 to 1981 he studied at the Pennsylvania Academy of the Fine Arts, where his instructors included Ben Kamihira, Morris Blackburn, and Sidney Goodman. Bartlett enriched his education with anatomy studies at the Philadelphia College of Osteopathic Medicine and later earned a certificate in filmmaking from New York University.

Early in his career, Bartlett was a fashionable portrait painter in Philadelphia, but he soon felt limited by the genre. Over the years, his paintings evolved from small canvases to the large-scale figurative works for which he has gained national attention. Childhood memories of Columbus and family members are frequent motifs in his work, as are the landscapes of the various places he has lived, including Georgia, Pennsylvania, Maine, and, most recently, Washington state. His

work shows a deep knowledge of such art historical styles as the American regionalism of Thomas Hart Benton and Grant Wood and the late 20th-century realism of Andrew Wyeth. Like early 19th-century French realists Gustave Courbet and Rosa Bonheur, Bartlett depicts everyday events in heroic scale, but he also injects a dreamlike note of surrealism. His interest in filmmaking lends a cinematic quality to his work, shown in the narrative content, staged groupings of figures, dramatic light, and film-screen-sized canvases.

Homecoming, a 1995 masterwork, shows a homecoming court standing in front of a blazing bonfire, a typical fall scene in the Southeast. But in Bartlett's complex narrative, the painting conveys a feeling of foreboding. The ritual may have been suggested by the memory of his sister being crowned homecoming queen at Columbus High School in the 1960s. At that time, a mixed-race couple would have been scandalous. Bartlett noted that the idea to include this pair came at the time of O. J. Simpson's trial for the murder of his wife, Nicole. Personal elements in the work also include portraits of his eldest son and his son's girlfriend as central characters, as well as the garb of the figure on the left, who wears a World War II–era trench coat like one that was a gift to the artist from his father. The mixture of different eras evokes the timelessness of Bartlett's scenes. Through these ambiguous visual narratives, Bartlett invites viewers to construct their own storylines for the works.

The Columbus Museum in Columbus, Ga., organized a traveling exhibition of Bartlett's work, *Heartland:*

Paintings by Bo Bartlett, 1978–2002, also featured at the Greenville County Museum of Art in Greenville, S.C., the Frye Art Museum in Seattle, the Santa Barbara Museum of Art in California, and the Pennsylvania Academy of the Fine Arts in Philadelphia. His work is featured in numerous collections around the country, including the Columbus Museum in Georgia, the Denver Art Museum, the Pennsylvania Academy of the Fine Arts, and the Santa Barbara Museum of Art.

KRISTEN MILLER ZOHN
Columbus Museum
Columbus, Georgia

Bo Bartlett, *Paintings and Drawings: Jan. 5– Jan. 26, 1991* (1991); Melonie Bartlett, *Bo Bartlett: P.P.O.W., New York, November 18– December 23, 1994* (1994); Charles T. Butler, ed., *American Art in the Columbus Museum: Painting, Sculpture, and Decorative Art* (2003), *Bo Bartlett: Heartland* (2003); Peter von Ziegesar, *Art in America* (March 1995).

Bartram, William

(1739–1823) WRITER, NATURALIST, ILLUSTRATOR.

American naturalist William Bartram is best known for his comprehensive accounts of the southern landscape and its environs and people in his narrative *Travels through North and South Carolina, Georgia, East and West Florida, the Cherokee Country, the Extensive Territories of the Muscogulges or Creek Confederacy, and the Country of the Chactaws: Containing an Account of the Soil and Natural Productions of Those Regions; Together with Observations on the Manners of the Indians* (the shorter title is simply *Bartram's Travels*). Bartram and

his twin sister, Elizabeth, were born to Quaker parents, John and Ann Bartram, in Kingsessing, near Philadelphia, on 9 April 1739. His father, naturalist John Bartram, was the founder of the Botanical Gardens near Philadelphia. At age 14 William showed an affinity for drawing, and in September 1753 he traveled with his father on a trip to the Catskill Mountains. As a young teenager Bartram enrolled in Old College, Philadelphia.

While working as an apprentice to a merchant in Philadelphia (1756–57), Bartram continued to sketch. His drawings completed during this time were sent by his father to London wool merchant and gardener Peter Collinson. They included illustrations of birds, turtles, and oak trees and were published in *Gleanings of Natural History* (1758–64) and in *Gentleman's Magazine* (1758). In 1761 Bartram left the mercantile business and traveled to Cape Fear River, N.C., to live with his uncle, Col. William Bartram. In 1765 John Bartram was named botanist to King George III and received a royal commission to travel south to the recently acquired British colonies to record and obtain samples from the natural environment. Bartram accompanied his father on his travels, where he continued to develop as an artist. In Charleston, S.C., the two Bartrams met and became acquainted with Henry Laurens, Dr. Alexander Garden, and John Stuart, affluent citizens who served as important contacts to the naturalists. Following their trip, William lived in Florida, where records show that in 1766 the naturalist attempted to operate a rice and indigo

plantation along the St. John's River, before departing for St. Augustine that same year.

Bartram returned to Philadelphia in 1767 and later became a member of organizations, including the American Philosophical Society. During this period he received commissions from several patrons, including Dr. John Fothergill, a physician and devoted horticulturalist, to provide sketches from nature. Bartram returned to Cape Fear River in 1770 and worked on the commission. In 1772 Fothergill again commissioned Bartram to travel and collect botanical samples and make drawings of particular flora and fauna. Fothergill asked Bartram to "keep a little journal" of his recordings. Bartram traveled through the South during 1773–77, stopping at Mobile, Ala., and parts of southern Georgia.

Following his successful trip south, Bartram returned to Philadelphia, where he presumably compiled his copious journal entries from his journey for the future publication of *Bartram's Travels*. He also maintained the family business, a nursery, with his brother and niece. Bartram remained actively involved with the Botanical Gardens, corresponded with Thomas Jefferson and others, and served as mentor to naturalists and botanists Benjamin Smith Barton, Alexander Wilson, and William Baldwin. Bartram was elected a member of the Academy of Natural Science of Philadelphia in 1812.

Bartram's Travels was published in 1791, with multiple editions published abroad for the European audience. Exceeding 400 pages, with eight engraved

plates, *Bartram's Travels* covered roughly 2,000 miles of the southern landscape. This widely disseminated account outlined his journeys, from encounters with alligators in the marshlands of Florida to a boat ride along the Pearl River and in the Mississippi Sound. Bartram recounted his experiences with the Creek Indians and various other tribes. His reflections on flora like the live oak and the *Magnolia grandiflora* with its "stately columns" show romantic sentiments, and his sketches of indigenous flowers like the *Andromeda pulverulenta*, or Zenobia flower, exhibit his skill as an artist. Bartram's approach was similar to that of fellow naturalists Mark Catesby, who communicated with William's father and influenced Bartram, and John James Audubon, both of whom traveled through the southern states in pursuit of knowledge of the landscape and its inhabitants. Bartram died on 22 July 1823. His extensive journals, which include actual botanical samples, are now in the collection of the British Museum.

KATE BRUCE

The Historic New Orleans Collection

Kathryn E. Holland Braund et al., *Fields of Vision: Essays on the Travels of William Bartram, 1739–1823* (2010); Francis Harper, ed., *The Travels of William Bartram: Naturalist's Edition* (1958); Jessie Poesch, *The Art of the Old South: Painting, Sculpture, Architecture, and the Products of Craftsmen, 1560–1860* (1989); Thomas P. Slaughter, *The Nature of John and William Bartram* (1996); Mark Van Doren, ed., *The Travels of William Bartram* (1928); Gregory A. Waselkov and Kathryn E. Holland Braund, eds., *William Bartram and the Southeast Indians* (1995).

Bearden, Romare

(1914–1988) PAINTER.

Born 2 September 1914 in Charlotte, N.C., Romare Bearden attended public schools in New York and Pittsburgh but returned south to spend summers with his great-grandparents in Mecklenburg County, N.C. He received a B.S. degree in mathematics from New York University in 1935, studied at the Art Students League in New York (1936–37), worked on advanced mathematics at Columbia University (1943), served in the U.S. Army (1942–45), and went to Paris after the war to study philosophy and art at the Sorbonne (1951). Bearden worked for the New York Department of Social Services periodically in the late 1930s and late 1940s and then from 1952 to 1966. He traveled widely and tried to write songs in the early 1950s. Beginning in 1964 he was art director of the Harlem Cultural Council for years and worked with the Alvin Ailey Ballet Company as artistic adviser. His works have been exhibited at the Carnegie Museum in Pittsburgh, the Institute of Modern Art in Boston, and the Corcoran Gallery in Washington, D.C., among other places. He wrote *The Painter's Mind* (with Carl Holty, 1969) and *Six Black Masters of American Art* (with Harry Henderson, 1972).

Bearden applied cubist techniques to portraying the life of African Americans. He executed large works combining collages, montages, and African imagery with the spatial ambiguity characteristic of cubism. Sophisticated and modern in structure, his work also contains a decidedly traditional narrative story line. His themes are not exclu-

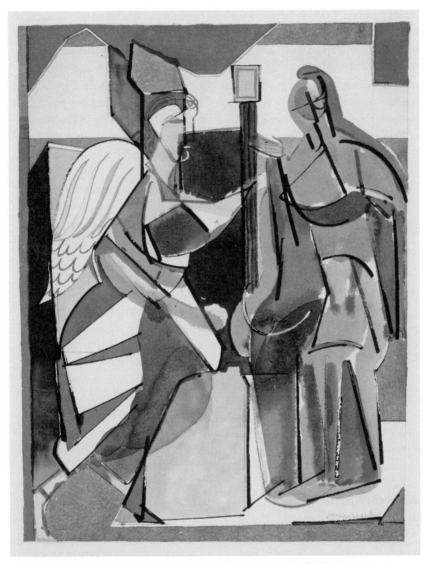

Romare Bearden, Untitled (Annunciation), circa 1940–46, watercolor, gouache, felt-tip pen, and graphite on paper, 26⅛″ x 20¼″ (The Johnson Collection, Spartanburg, S.C.)

sively southern, but many of his paintings treat the South explicitly. Typical subjects are jazz and blues, farm life, the rituals of baptism and voodoo, and, perhaps above all, homecoming. His works on the South tend to be lyrical and evocative, to portray mythic charac-

ters, and to deal with elemental human concerns. *Sunset-Moonrise with Maudell Sleet* pictures a North Carolina woman from his youth as a godlike figure in her garden. *Miss Bertha and Mr. Seth*, which portrays an elderly black couple posing, is also based on individuals he knew in

North Carolina. Critic Ralph Pomeroy has observed that Bearden's thematic interests are so universal that he can "equate a field hand with a god" and mix the races so that "it is no surprise in his work to come upon, say, a hand that has both black and white fingers."

CHARLES REAGAN WILSON
University of Mississippi

Mary Schmidt Campbell, *Memory and Metaphor: The Art of Romare Bearden, 1940-1987* (1991); Mary Lee Corlett, *From Process to Print: Graphic Works by Romare Bearden* (2009); Ruth E. Fine et al., *The Art of Romare Bearden* (2003); Ruth Fine and Jacqueline Francis, *Romare Bearden, American Modernist* (2011); Jan Greenberg, *Romare Bearden: Collage of Memories* (2003); Albert Murray, in *Romare Bearden: 1970-1980: An Exhibition Organized by the Mint Museum, Department of Art, Charlotte, North Carolina*, ed. Jerald L. Melbert and Milton J. Bloch (1980); Robert G. O'Meally, *Romare Bearden: A Black Odyssey* (2007); Ralph Pomeroy, *ARTnews* (October 1967); Richard J. Powell, *Conjuring Bearden* (2006); Lowery Stokes Sims, *Romare Bearden* (1993).

Beckwith, William Norwood

(b. 1952) SCULPTOR.

William Norwood (Bill) Beckwith was born in Greenville, Miss., in 1952 and educated in the public schools of that city, long known as an arts mecca of the state because of its many writers and artists, as well as the influence of planter, attorney, poet, and arts patron William Alexander Percy. As a memorial for his father, U.S. senator LeRoy Percy, Will Percy commissioned *Patriot*, a bronze statue of a medieval knight in armor, created in 1930 by Melvina

Hoffman, an internationally acclaimed sculptor who had studied with Auguste Rodin in Paris. Percy later sent his protégé Leon Z. Koury, son of Syrian immigrants and Greenville grocers, to study with Hoffman in New York. After returning to Greenville in 1961, Koury worked as a sculptor and a painter and was a leader in the local arts scene for three decades.

Beckwith became an apprentice in Koury's studio in 1966 and studied with him until moving to Oxford in 1970 to earn B.F.A. and M.F.A. degrees in sculpture at the University of Mississippi. There, under the guidance of art professor Charles M. Gross, he became "as hooked on casting bronze as an addict is to heroin. If you have ever poured molten metal or held the sun in your hand, you understand the power and the energy. I was hooked bad." In 1974, as his senior thesis, which earned him an award as the best student artist on campus, he built a complete foundry behind Koury's studio in Greenville. This became Vulcan Studios and Foundry, Mississippi's first commercial fine arts bronze foundry, an enterprise that enabled Beckwith to cast for other sculptors as a way of financing his own work. Vulcan was moved in 1976 to Greenwood and in 1982 to Taylor, a small village eight miles south of Oxford.

Beckwith operated the foundry until 1986, when he stopped casting for other sculptors and began working only on his own projects. He has shown his bronzes in numerous one-man and group exhibitions, including the Frank Marino Gallery and Splashlight Studios in New York, the 1984 World's Fair in New

Orleans, and the National Museum of American Art in Washington, D.C. His commissioned work includes several life-size or larger monuments, among them *William Faulkner*, Oxford, Miss.; *George Merrick*, Coral Gables, Fla.; *Chief Piomingo, Chickasaw*, Tupelo, Miss.; *B. B. King*, Indianola, Miss.; *Jefferson Davis*, Biloxi, Miss.; and *Flag Bearer, Mississippi 11th*, Gettysburg National Military Park in Pennsylvania. Beckwith has sculpted portrait busts of Jim Henson, Eudora Welty, Tennessee Williams, Richard Wright, Herman Melville, and numerous others. He received an artist's fellowship from the Mississippi Museum of Art in 1989 and was recognized with a Governor's Award for Excellence in the Arts in 2002.

"While his early work was autobiographical expressionism in which he used cast and found objects," art historian Patti Carr Black observes, "his later work is more traditional. Some pieces—for instance, his famous statue of Faulkner's character in *Sanctuary*, Temple Drake—are inspired by literature, and others by nature, particularly his visionary landscapes. Sometimes the work is autobiographical (his acclaimed statue of a hound dog), and sometimes biographical, as his portrait of William Faulkner seated on a courthouse bench."

Beckwith was on the art faculty at the University of Mississippi for many years and now serves as an adjunct assistant professor. He currently lives with his wife and son in Taylor, where he operates from a new 9,850-square-foot studio.

ANN J. ABADIE
University of Mississippi

Patti Carr Black, *Art in Mississippi, 1720–1980* (1998), *The Mississippi Story* (2007); Hank Burdine, *Delta Magazine* (September–October 2009); Barbara Shissler Nosanow, *More Than Land or Sky: Art from Appalachia* (1981); Arthur Williams, *The Sculpture Reference* (2005), *Sculpture, Technique, Form, Content* (1989).

Benton, Thomas Hart

(1889–1975) PAINTER, MURALIST, PRINTMAKER, TEACHER, WRITER, ARTS ADVOCATE.

Thomas Hart Benton was perhaps the best-known artist in America in the 1930s. Reflecting this stature, he was the first artist to be featured on the cover of *Time* magazine (1934). Born in Neosho, Mo., he later maintained his home and studio in Kansas City (1935–75). Though he is commonly associated with the Midwest and labeled a "regionalist" artist, his art reflects a much larger vision of America and of the American people. Benton's art was often inspired by American history and the spirit of the places he lived—including Washington, D.C. (1897–1904), Chicago (1907–8), Paris (1908–11), New York City (1912–35), Kansas City (1935–75), and Martha's Vineyard (where he summered from 1920 to 1975)—and the places he visited on his travels and sketching trips across America including the South, the West, and the Midwest.

Benton was prolific as an artist and writer. Born the son of a politician and lawyer, Maecenas E. Benton, and as the namesake of legendary senator Thomas Hart Benton, he was in many ways a historian as well. His autobiography, *An Artist in America* (1937), included

first-hand accounts of his observations on his American journeys. Throughout his career, he was a research-oriented artist who documented and recorded, as accurately as possible, especially in his murals, the historical and contemporary subjects of his art.

Benton was raised in Missouri by parents who were deeply rooted in southern culture. His father served in the Confederate army before he left Tennessee to settle in Missouri. The young Benton grew up in his father's Neosho law office, where Civil War veterans gathered to tell tales of the war. Benton's mother was raised in Texas after her parents left Kentucky, lived for a time in Missouri, then settled in Texas. Her father, known as "Pappy Wise," was a trader and river man in Kentucky, who built rafts and traveled regularly down the Mississippi to trade in New Orleans. Benton was steeped in the history of the South as a child, and later, during the 1920s and 1930s, when he began his exploratory trips across America, he often traveled the same southern roads, trails, and rivers used by his ancestors. From his father's political campaigns through the Ozarks, he developed an appreciation of backwoods travel, storytelling, and folk music. In 1896, after his father was elected to Congress, Benton moved with the family to Washington, D.C., and lived on Capitol Hill, near the new Library of Congress (1897), where he spent hours studying the murals and other art that filled the structure. He also studied the art at the Corcoran Gallery, while his mother enjoyed her new social status in Washington, then still a very southern city.

When his father was not reelected in 1904, the family returned to Missouri. Benton quickly became restless, left home in 1906, settled in nearby Joplin, then enrolled in classes at the Art Institute of Chicago (1907). In 1908, he left for Paris to study art at the famed Académie Julian, home to generations of aspiring American artists. There he met a number of Americans, including Stanton MacDonald Wright, who introduced Benton to the color principles he called Synchromism and encouraged Benton to create abstract paintings, which he did.

In 1912 Benton moved to New York, the city that was to be his home for 23 years (1912–35) and where his art and views of America were shaped by his experiences in the emerging art world. He met many artists and writers, visited galleries and museums, worked in the movie business, explored art theories and radical political ideas (including socialism and Marxism), and experimented with modernist and abstract art forms. His modernist works were exhibited in significant shows, including the Forum Exhibition of 1916. Benton also taught in immigrant neighborhood art centers, including the People's Art Guild and the Chelsea Neighborhood Association (1917–18), where he met his future wife, Rita Piacenza. Like many American artists active then, Benton explored a range of styles, techniques, subjects, and art theories. Though his works reflected notable skill, he never seemed comfortable with abstraction, and, despite his exploration of radical political theories, he never forgot his legacy as a Benton (in his autobiogra-

phies these experimental years were downplayed—they did not fit the spirit of 1930s, or 1950s, America).

In 1917, while Benton was serving in the U.S. Navy in Norfolk, Va., he read American history books and focused his vision on imagery that changed his art. He noted that his interests "became, in a flash, of an objective nature" and focused on "the new airplanes, blimps, the dredges, the ships of the base," making him decide, he said, to leave "the art-for-art's sake world in which I had hitherto lived." He explored Norfolk and the surrounding area in Virginia and found comfort in the southerners he discovered, reminding him of his own family. And he explored ways to develop a new kind of narrative and historical American art.

After the war, Benton returned to New York and soon began to take hiking trips out of the city, into New Jersey and into the Catskills, summering at Martha's Vineyard, discovering the lingering traditions and residues of colonial American history, and sketching there as well. Benton accepted a teaching position at the Art Students League in New York (1924–35), attracting a range of students from across the nation—including Jackson Pollock, Charles Pollock, Fairfield Porter, Herman Cherry, John Heliker, Archie Musick, Charles Shaw, John McCrady, and John Penney. In 1924, when his father was dying in a hospital in Springfield, Mo., Benton had reason to reconsider his family history and trips with his father, as well as their exploration of the Ozarks. After his father died Benton found that the South held particular appeal for him, and he began to explore, study, sketch, and paint the South. Even during the years from 1924 to 1935, when he lived in New York and reached his greatest national acclaim, Benton and his art were strongly influenced by the culture and imagery of the South. He also began to study folk music on these trips, playing the harmonica, and he developed his own musical notation system. Later he released a recording on Decca (*Saturday Night at Tom Benton's*, 1941) and used traditional songs as sources for his paintings (*The Ballad of the Jealous Lover of Lone Green Valley*, *The Wreck of the Old 97*, *The Engineer's Dream*, and others).

In 1929 he received his first major public mural commission, for the New School for Social Research in New York, *America Today* (1929). This project allowed Benton to use the drawings and research from his trips, bring together his compositional systems and theories with documentation of evolving American life in the 1920s, and also paint contemporary Americans in contemporary garb (a radical step at that time, when murals were often classical allegories). This was followed by a major mural commission from the Whitney Museum of American Art (1932), installed in its library, *The Arts of Life in America*. The following year he was commissioned to paint a massive mural series for the state of Indiana, to be displayed at the 1933 World's Fair, *The Social History of the State of Indiana*. During this same period, Benton turned to lithography and printmaking, creating readily affordable art for larger audiences.

By December 1934, when he was featured on the cover of *Time* magazine, these mural projects, his paintings and prints, his teaching, his publications, and his public speaking appearances made him one of the highest profile artists and individuals in Depression-era America. In *Time* magazine he was grouped with John Steuart Curry and Grant Wood, artists whom he did not know well then, suggesting that they were a triumvirate of "regionalist" artists. And, while Benton and Thomas Craven had advocated for a more American type of art (later associated with "the American Scene"), beginning in the 1920s Benton did not embrace the title of "regionalist," as he clarified in his 1951 autobiography: "The name Regionalism suggested too narrow a range of inspiration to be quite applicable. I was after a picture of America in its entirety. I ranged north and south and from New York to Hollywood and back and forth in legend and history."

In 1935 Benton decided to leave New York and return to the Midwest after he was offered a teaching position at the Kansas City Art Institute. He accepted a commission for a mural project, *The Social History of the State of Missouri*, which was painted in the state capitol in Jefferson City. In Kansas City, his travels and sketching trips shifted, focusing on the Midwest and West, often with students from the Kansas City Art Institute accompanying him. Benton was influential as a teacher at the Kansas City Art Institute (1935–41), and he became a mentor to students, including William Hayden, Frederick James, William

McKim, Roger Medearis, and Jackson Lee Nesbitt.

After World War II Benton's art and reputation underwent one of the most radical reversals in American art history. The emergence of abstract expressionism advanced, with strong support from leading art critics and writers, while American Scene and regionalist art of the prewar era was considered obsolete and outdated by critics and the advanced New York art world (then replacing Paris as the center of the international art world). Benton, with the highest profile of these artists in the 1930s, became a particular target, especially after Grant Wood and John Steuart Curry died. Benton, however, continued with his art, his travels, his lectures, his writing, and his advocacy. His American mural projects continued in these years, including *Old Kansas City (Trading at Westport Landing)* for the River Club in Kansas City (1956), *Father Hennepin at Niagara Falls (1678)* for the Power Authority of New York at Niagara Falls (1959–61), *Independence and the Opening of the West*, completed for the Harry S. Truman Library in Independence, Mo. (1959–62), and *Joplin at the Turn of the Century, 1896-1906*, completed for the Joplin Municipal Building (1972).

During the 1960s and early 1970s Benton also returned on a regular basis to the mountains and rivers of the Ozarks. These trips inspired his late art, reconnected him to the region of his birth, and also served as the subject of a film, *A Man and a River*, documenting one of his Buffalo River float

trips. In 1968 the final revised version of his autobiography was published, and he continued to paint in his studio and watch a revival of his art and reputation unfold. The next year, 1969, he published a new autobiographical book, *An American in Art: A Professional and Technical Autobiography*, and *Life* magazine printed an article devoted to him, "Tom Benton at 80, Still at War with Bores and Boobs."

His last painting was a significant public mural, titled *The Sources of Country Music*, commissioned by the Country Music Hall of Fame in Nashville (1975). It was based upon his decades of travel, research, and documentation of country music, as well as updated research and sketching of major figures for the mural. Benton died of a heart attack in his Kansas City studio, in front of this mural, on 19 January 1975, one day after its completion for the Country Music Hall of Fame.

J. RICHARD GRUBER
Ogden Museum of Southern Art
University of New Orleans

Henry Adams, *Thomas Hart Benton: An American Original* (1989); Matthew Baigell, *Thomas Hart Benton* (1975); Thomas Hart Benton, *An Artist in America* (1939), *An Artist in America: A Professional and Technical Autobiography* (1969); Thomas Hart Benton and Creekmore Fath, *The Lithographs of Thomas Hart Benton* (1969); Emily Braun and Thomas Branchick, *Thomas Hart Benton: The America Today Murals* (1985); Thomas Craven, *Men of Art* (1931); Erika Doss, *Benton, Pollock, and the Politics of Modernism: From Regionalism to Abstract* *Expressionism* (1991); J. Richard Gruber, *Thomas Hart Benton and the American South* (1997); Karal Ann Marling, *Tom Benton and His Drawings: A Biographical Essay and a Collection of His Sketches, Studies, and Mural Cartoons* (1985).

Bernard, François

(1812–1875) PAINTER.

Born in Nîmes, France, François Bernard studied with Paul Delaroche, a French academic artist who specialized in large historical tableaux. Delaroche, one of the most popular teachers of his time, trained with French masters Claude-Henri Watelet and Baron Antoine-Jean Gros. Additional encouragement came from Théodore Géricault, who had studied at the École Nationale Supérieure des Beaux-Arts in Paris. Bernard's classical instruction is evident in his work, particularly his portraiture, which is characterized by a smooth finish and attention to fine detail, notably in lace and jewelry. He found great appreciation for his art throughout Louisiana, a fact that is evident in his many surviving works.

Bernard's first documented visit to New Orleans occurred in 1856, although his earliest known portraits of Louisiana residents date from 1848. Encouraged by a group of sugar planters desiring to have their portraits painted, Bernard settled in the city in December 1856. Whether his wife moved to Louisiana is unknown, for his children were born in France, the first about 1857 and the second about 1862.

During yellow fever season, when the threat of disease drove many city

residents to the countryside, Bernard adopted an itinerant practice. He returned to France or spent his summers across Lake Pontchartrain, living around the small town of Mandeville. Many of his portraits of local Indians date to the Civil War period, when his travels took him to the Mandeville area. After the war Bernard returned to New Orleans and reestablished his studio. About 1865, Alexandre Alaux, a fellow Frenchman, studied with Bernard and advised him to take further studies in Europe. In 1875 Bernard left the city to travel to Peru.

Bernard also painted landscapes, genre scenes, religious subjects, and animal subjects, particularly dogs. His portraiture includes free people of color, including *Françoise Dugas Gaudet*, now in the collection of the Louisiana State Museum. In 1870 Bernard completed three portraits of the Alcès family, also in the Louisiana State Museum, including ones of Georges-Alcès, his wife, Elizabeth Alice Briot Alcès, and his mother, Darbeline D'Albert. All of these are rendered with the same empathy and dignity as for other members of the plantation class, including two 1856 oval three-quarter-length portraits, *Mrs. John MacDonald Taylor, née Basilice Toledano* and *Mary Campbell Strother Moore*.

One of the most poignant portraits by Bernard is *Mrs. James Belton Pickett, née Paulina de Graffenried and Sallie Pickett (Mrs. Robert C. Cummings)*, the first version of which was painted in 1854. This three-quarter-length double portrait depicts a seated woman with a young woman standing beside her while resting her left hand on her mother's shoulder, an opportunity to show the jewelry on her hand, particularly on the ring finger. Both women, holding fans in their right hands, wear black dresses—generally associated with mourning—with white lace collars and ruffled cuffs. The family lived at the Orchard Plantation in Bossier Parish in extreme northwest Louisiana. After Sallie's death from yellow fever within a few months of her marriage, her distraught widowed husband commissioned Bernard to paint another version of this oversize portrait, which he completed in 1858. Although Bernard remained true to the essentials of the original work, he varied the details of the women's hair, jewelry, lace trim at the collars and cuffs, and the background. He also turned the carved ivory fan, originally held in Sallie's hand at an angle, to point straight downward, a device artists had used in sepulchral art since antiquity to indicate death.

JUDITH H. BONNER
The Historic New Orleans Collection

William L. Gerdts, George E. Jordan, and Judith H. Bonner, *Complementary Visions: The Laura Simon Nelson Collection* (1996); John A. Mahé II and Rosanne McCaffrey, *Encyclopaedia of New Orleans Artists, 1718–1918* (1987).

Binford, Julien

(1908–1997) PAINTER AND SCULPTOR.

A much-acclaimed artist of Virginia, Julien Binford was born in Powhatan in 1908, the son of parents who traced their ancestry in America back many generations. At the age of 15 he moved with his family to Atlanta and eventu-

ally entered the premedical program at Emory University. He decided to become an artist and found encouragement from Roland McKinney, the newly appointed director of the High Museum of Art. On McKinney's recommendation, Binford went to Chicago and enrolled in classes at the Art Institute of Chicago under the Russian artist and stage designer Boris Anisfeld, who was known as an expressive colorist. In 1932 Binford won the institute's coveted Ryerson Traveling Fellowship, and after three years of classes in Chicago the young artist went to Paris, where he began experimenting with a variety of mediums and approaches, producing numerous ink sketches as well as a series of evocative gouaches that attracted the favor of French critics. His associates in Paris in this period included writer Lucien Fabre and poet Leon-Paul Fargue. In 1934 the dealer Paul Guillaume saw the artist's work and declared that Binford possessed "the qualities of a painter and his gouaches show great imagination, spirit, and originality." Binford was subsequently given a solo exhibition at the Galerie Jean Charpentier and began to sell some of his work.

Buoyed by his success, Binford ignored the advice of many of his Paris friends and returned to America in 1936. In May of that year he was given a solo show at the Karl Freund Galleries in New York, which brought positive reviews but, unfortunately, no buyers. He and his French wife, Elizabeth, bought a patch of land in Powhatan, Va., with their savings. The land was verdant with swamp laurel and jewel weed, cedar, and sycamore; on the banks of a stream named Fine Creek were the ruins of an old foundry, which the artist would later convert to a studio. He began painting the people and landscape of the area, mostly the African American farmers who lived in relative poverty.

In March 1938 the struggling artist signed on as an easel painter with the Federal Arts Project of the Works Progress Administration (WPA). He completed approximately 40 works prior to his termination with the arts project in August 1940. That year, his work was featured in one of the Virginia Artists Series exhibitions hosted by the Virginia Museum. The artist was lauded for his portrayal of the life of his native state by the museum's director, Thomas Colt. "Return to America has meant a return to realism, which, to him, possesses all the color, all the structure, and all the emotional content of abstraction," he wrote. Binford, who was awarded the first senior fellowship given by the museum, established an art class at the Craig House Negro Art Center and taught classes in mural painting at the Richmond School of Art.

During World War II Binford occupied a studio in Hell's Kitchen in New York City and established a lifelong relationship with Midtown Galleries, which subsequently exhibited his work. He was assigned to the U.S. Navy as a war correspondent for *Life* magazine and executed a number of sketches of New York Harbor in wartime and of convoy activities at sea, which now hang in the Pentagon in Washington, D.C. More significant, however, was his activity as a muralist in the same period. During his

WPA tenure, he had completed a mural depicting a logging scene in his native South for a post office in Forest, Miss. In 1942 the artist finished a powerful mural titled *The River Jordan* for the Shiloh Baptist Church, an African American congregation in his native area. His paintings from this fertile period often portrayed the powerfully expressive gestures of the simple rural people he had grown to appreciate and respect. As one critic tellingly wrote in 1943, "For us it is a record of a people and a time and a place which is part of the heritage of America."

After the war Binford was appointed professor of art at Mary Washington College in Fredericksburg, Va., where he organized a series of exhibitions that helped form the university collection. In 1951 he completed a mural depicting the signing of the Virginia Declaration of Rights for the State Library in Richmond. Later he completed several mural commissions and had numerous solo shows. He restored the ruins of the old mill at Fine Creek into a livable structure, where he set up a spacious studio within its 3-foot-thick blue granite walls. In his later work Binford reverted to limpid, colorful renditions of the cyclamens, irises, daisies, and violets that were abundant around his house in the backwoods country and that served as his source of artistic inspiration.

RICK STEWART
Dallas Museum of Art

Art Digest (August 1951); ARTnews (15 November 1942); Elizabeth Binford, *American Artist* (April 1953); Julien Binford, *Julien Binford: Paintings, Drawings, Sculpture* (1971), A Statement by the Artist

Concerning the Virginia State Library Mural Depicting the Enactment of the Virginia Declaration of Rights (1951); Donald B. Kuspit et al., *Painting in the South, 1564–1980* (1983).

Bottomley, William Lawrence

(1883–1951) ARCHITECT.
William Lawrence Bottomley made unique contributions to the practice of country house architecture in the South. Through the Georgian Revival houses he designed and through the publication of *Great Georgian Houses of America*, he exerted a distinctive and marked influence on country house design. Bottomley designed houses for clients in many southern states, including North Carolina, South Carolina, Florida, Alabama, Louisiana, Maryland, and West Virginia, but his reputation was made through his commissioned houses for clients in Virginia.

Bottomley was born on 22 February 1883 in New York City. He received his B.S. degree in architecture from Columbia University in 1906. For a time he worked in the office of Heins and LaFarge in New York, and in July 1907 he was awarded the McKim Fellowship in Architecture at the American Academy in Rome. He remained in Rome for just over six months before leaving in March 1908 for Paris, where he succeeded on his entrance exam for the École des Beaux-Arts.

After he returned to the United States in 1909, Bottomley married Harriet Townsend, an architectural writer whose mother was from Lexington, Va. Shortly thereafter, he formed a partnership, Hewitt and Bottomley, which continued until 1919, and

then he had a series of associates, including Edward C. Dean, with whom he worked on the Turtle Bay project. In 1928 he became the principal architect in the firm of Bottomley, Wagner, and White—which was formed largely to handle the design of River House in New York. Bottomley was made a fellow of the American Institute of Architects in 1944. He died on 1 February 1951.

Bottomley's early work had an eclectic flavor, influenced by his travels in Italy, France, and Spain, which is manifest in Turtle Bay Gardens and his stucco-covered houses. Another product of the early 1920s, his book *Spanish Details* (1924) included photographs and drawings of portals, courtyards, windows, loggias, doors, ceilings, and ironwork and became a sourcebook for other architects.

In 1915 Bottomley designed his first house in Virginia, a classical five-bay structure covered in stucco; its form and organization reflected Georgian principles, which would dominate his work for the next 20 years. The following year, he designed a residence for H. L. Golsan on Richmond's Monument Avenue, the first of his red-brick Georgian houses in Virginia and the first of seven town houses he would design for this prestigious residential avenue. After these two structures, he gained a series of commissions in Richmond for other country houses and estates, including a beautiful range of houses at Windsor Farms on the hill above the James River, culminating in Milburne, designed in 1934 and completed in 1935.

The Richmond houses became well known in Virginia and helped to secure commissions for Bottomley throughout the state and the South. His designs for farm seats and hunting boxes in the Warrenton-Middleburg area and in Albemarle County, Va., were also published and led to new commissions. Most of the Georgian Revival houses were executed in red brick, but notable exceptions included Lockerbie in Birmingham, Ala., and the William E. Chilton House in Charleston, W.Va., which are distinguished stone buildings. Tatton Hall in Raleigh, N.C., one of his important Georgian Revival Houses of the mid-1930s, has a soft salmon-colored brick.

Bottomley's work was a product of early 20th-century interest in the architecture and gardens of the 18th and 19th centuries. His fame rests on the creation of the "ideal" Georgian Revival country house, especially in Virginia. Although the great 18th-century Virginia residences were his models, he reinterpreted them in a manner appropriate to the 20th century. Bottomley also served as chairman of the editorial committee under whose auspices the two-volume *Great Georgian Houses of America* (1933, 1937) was compiled. In the hands of younger architects, these two volumes inspired a subsequent generation of houses.

DAVYD FOARD HOOD
*North Carolina Department
of Cultural Resources
Raleigh, North Carolina*

American National Biography 3 (1999); Susan Hume Frazer, *Architecture of William Lawrence Bottomley* (2007); Ralph Harvard and Erik Kvalsvik, *Antiques and Fine Art* (Summer–Autumn 2008); Davyd Foard

Hood, "William Lawrence Bottomley in Virginia: The 'Neo-Georgian' House in Richmond" (M.A. thesis, University of Virginia, 1975); William B. O'Neal and Christopher Weeks, *The Work of William Lawrence Bottomley in Richmond* (1985).

Bourgeois, Douglas

(b. 1951) PAINTER.

Douglas Bourgeois's art is an art of reverie and longing; it evokes the French aesthetic posture of artists from Poussin to Chardin to Matisse—a posture of painting-as-Eden, of painting as interminable *envie*. But Bourgeois's Eden is distinctly southern, and, moreover, it is the Catholic world of southern Louisiana.

Born in 1951 in Gonzales, La., between Baton Rouge and New Orleans, Bourgeois earned a B.F.A. degree from Louisiana State University and received several national fellowship grants during the 1980s and 1990s. He has shown his paintings regularly since 1978, including exhibitions at New Orleans's Arthur Roger Gallery and Galerie Simonne Stern. In 2002–3 an important retrospective exhibition, *Baby-Boom Daydreams*, was presented at the Contemporary Arts Center in New Orleans.

Bourgeois's paintings are meticulous, rich, and strange; they are less artwork than pictorial phenomena. Taken together, as in the retrospective, they suggest some hallucination that he fashions and then induces the viewer to share. In most instances he transforms native Louisiana images—figures and places—into a new, singular brand of "exotica." And, as such, they feel alien and implausible yet at the same time patently seductive. They pull viewers out of themselves and into a circumscribed terrain that is both familiar and not. Onlookers encounter Bourgeois's people, usually ordinary folk surprisingly exalted. He labors over his canvases with a rigorous, painstaking oil technique, effectively burnishing them to the point of lustrous "sainthood." Dwellings, too, are transformed; in this Louisiana, even squalid rooms seem magical, havenlike. What viewers see is an elusive, transcendent, and radiant environment—"Cajun land" as impossible dream.

A recurring subject in Bourgeois's work is the image of young blacks ardently depicted by his fastidious technique—and clearly transported from the world of cliché to his Eden. The 1991 painting *Woman from St. Gabriel* is perhaps the best example. It features a caramel-colored Medusa crowned with indigenous snakes, gracefully covered in a dress pattern of birds, frogs, caterpillars, and vines. The background is almost entirely magnolia leaves, impossibly glossy, completing a virtual mosaic of jewel colors. The only relief from this beauty overkill is a small slip of landscape behind the woman's shoulders. The drab gray props of industrial exploration sit there, acting as a meager compositional tool in this complex painting and, simultaneously, holding the line as an encroaching force within Louisiana's natural beauty.

This work encompasses what appears to be Bourgeois's apotheosis of blacks, reaching into the 1980s, when he concentrated on rhythm-and-blues celeb-

rities. As splendidly diverting as those paintings are, *Woman from St. Gabriel* assumes a larger, nobler objective. Here, Bourgeois equates the exalted woman with the land, both of them exquisitely strange and both of them imperiled.

Another of Bourgeois's notable subjects is one that seems profoundly personal. Still, the transcendent quality remains—together with a poetic moodiness. These are the paintings of young whites, often isolated in grubby bedrooms and kitchens. They possess none of the polish of his blacks. In fact, they frequently seem debased, somewhat consistent with their environments. But they too are exalted. Or at least their total situation is. In these interiors, Bourgeois makes no transformation from real to glamorous. Rather, the transformation is more like a collision of two distinct states: the wretched and the mystical. Despite the clutter of each room, the space and the event are utterly still. He creates a devotional milieu, and viewers catch it in the middle of some urgent ceremony. A lone figure, suspended in reverie, seems to undergo a religious experience. An aura of piety prevails. This is true despite chaotic details—overflowing sinks, cigarettes, trash-strewn bedrooms— and a half-dressed, motionless dark-haired young man. To this, add a Divine King—an infant one—floating by a kitchen window. All of it is in Bourgeois's exacting style. The result is something bizarrely ecclesiastical, something like Louisiana Catholicism.

Such magical figure-in-room compositions are as close as one can get to psychological autobiography without declining into cloying narrative. Much is implied here: the truth of detachment in an artist's effort to confront something as powerful as Catholicism, the sad truth of an artist's uneasy fit in normal society, and one man's private obsessions, laid before his audience because, as an artist, he has no alternative.

TERRINGTON CALÁS
University of New Orleans

D. Eric Bookhardt, *Gambit Weekly* (16 February 2009); Terrington Calás, *New Orleans Art Review* (January–February 2003); Doug MacCash, *New Orleans Times-Picayune* (11 February 2009).

Branson, Enoch Lloyd

(1853–1925) PORTRAITIST.
Enoch Lloyd Branson was born near Maynardville, Union County, Tenn., on 8 August 1853 to Enoch Branson and Altamira Gentry Branson. Under the patronage of John M. Boyd of Knoxville, Branson entered the University of Tennessee in 1870 and then pursued further study at the National Academy of Design in 1873. In 1875 he was awarded first prize in the antique school of drawing. With funds from that prize, Branson made a study tour of Europe in 1875–76. He first began to exhibit his historical genre paintings at the Paris Exposition of 1878, at the time of his second European trip.

Branson returned to Knoxville the following year and subsequently formed a partnership, McCrary and Branson Photographic & Portrait Artists, in downtown Knoxville, with the photographer Frank McCrary. In 1893 McCrary and Branson won a first prize for their entry in the Chicago World's

Fair Class E competition. Following a fire that destroyed his studio in 1903, Branson began painting portraits of prominent figures on a commission basis under the continuing patronage of Boyd and Frank H. McClung. During this time, Branson was also active in Knoxville art groups, including the Nicholson Art League, of which he was a founding member. The Nicholson Art League's efforts resulted in an art exhibition at the first Appalachian Exposition in 1910. Branson chaired the fine arts, and several local artists whom he had encouraged were selected, notably Ida Jolly Crawley, Mary H. Garrett, Robert Lindsay Mason, Mary Ogden Morrell, Charles Christopher Krutch, Adelia Armstrong Lutz, Lewis B. Rule, Charles Mortimer Thompson, and Catherine Wiley.

In 1916 Branson again suffered the effects of a terrible fire. When the Imperial Hotel in downtown Knoxville burned that year his monumental *The Battle of King's Mountain* was destroyed. Admired locally, this historical genre painting was one of a series of historical genre works that also included *United States Barracks at Knoxville* and *Gathering of the Overmountain Men at Sycamore Shoals*.

Though Branson's activity as a portrait artist lessened following World War I, two outstanding works from that time survive. His portrait *Ellen McClung Berry* incorporates a panoramic view of the Tennessee River with the elegantly languid figure of the subject, clad in a sweeping diaphanous gown. As Tennessee's most famous artist, Branson was commissioned in 1924 to paint the state's legendary hero Sgt. Alvin York, the most decorated soldier in World War I.

On 13 June 1925 Lloyd Branson died of a heart attack and was buried in the Old Gray Cemetery in Knoxville. He never married. Reports of the death of a Mrs. Lloyd Branson (Mollie Wilson) in 1957 confused the identity of the artist with that of his cousin, William Lloyd Branson of Knoxville.

ESTILL CURTIS PENNINGTON
Paris, Kentucky

Chip Brown, *Pathways History and Genealogical Journal* 11:3 (1999); *Catalog of the Fine Arts Section of the Appalachian Exposition, Sept. 12 to Oct. 12, 1910* (1910); James C. Kelly, *Tennessee Historical Quarterly* (Summer 1985 and Winter 1987); Frederick C. Moffatt, *East Tennessee Historical Society's Publications* 50 (1978); Charles V. Patton, *Knoxville Journal* (25 April 1954); W. M. Woodman, *The First Exposition of Conservation and Its Builders: An Official History of the National Conservation Exposition held at Knoxville, Tenn., in 1913 and of Its Forerunners, the Appalachian Expositions of 1910–11* (1914).

Brenner, Carl Christian

(1838–1888) PAINTER.

Carl Christian Brenner was born in Lauterecken, in Bavaria, Germany, on 10 August 1838. Brenner and his family were part of that influx of German craftsmen, artisans, merchants, and musicians who so greatly enhanced the cultural profiles of Cincinnati, Louisville, and New Orleans in the years following the European revolutions of 1848. A very young Brenner is reported to have studied with Phillip Froelig at the Royal Academy in Munich in 1854.

Carl's father, Frederick, brought his family to America with the intention of opening a household paint and supply shop offering glazier services, a skill he demanded his son learn as a means of having a practical source of income. Carl worked in his father's paint store as a sign and ornamental artist until 1878, when he was finally able to pursue easel painting full time. Most of his paintings feature the beech tree. Like his contemporary Harvey Joiner, Brenner could be quite formulaic in his approach to the subject matter, rendering dark masses of trees in dramatic colorations and registering deep shadows and vivid patches of light, yet he is also known to have worked *en plein air* in Louisville's Cherokee Park, in nearby Pee Wee Valley, and in eastern Kentucky.

C. C. Brenner was a regular and well-regarded exhibitor at the Southern Expositions between 1883 and 1886. During those years, he perfected his mature style, abandoning the colors of nature he observed on his nature walks. Brenner could be delightfully glib with the local press, willing to admit an inclination to enhance, as well as depict, nature. "Nature is not always in its most beautiful moods, even in the same spot. The artist must be subjective as well as objective. He must draw from memory and his heart experiences as well as from the scene before him." By adding a few personal touches of "slating sunlight, mist, clouds and other circumstances," he believed the artist was capable of making "a hundred pictures" from one scene, as he told the *Louisville Courier-Journal* in 1878.

Brenner's late work moves toward a more brightly colored impressionist palette, even as his brushstroke retains a thinly veiled Germanic veneer of clarity, and his paintings proclaim a new awareness of the rich potential of the Kentucky scene for landscape painters. Devoid of humanity, landscape painting in Brenner's era seems to present a world of natural wonder existing apart from man, a vision of paradise returned, if not regained.

Carl Christian Brenner died in his prime, without sufficient appreciation. Henry Watterson, commanding editor of the *Courier-Journal*, lamented that he did not receive "the sympathy and support from men of means and supposed art appreciation of Louisville to which his talent entitled him."

ESTILL CURTIS PENNINGTON
Paris, Kentucky

Justus Bier, *American German Review* (April 1951); Arthur Jones and Bruce Weber, *The Kentucky Painter: From the Frontier Era to the Great War* (1981); Estill Curtis Pennington, *Kentucky: The Master Painters from the Frontier Era to the Great Depression* (2008), *Lessons in Likeness: The Portrait Painter in Kentucky and the Ohio River Valley, 1800–1920* (2010), *A Southern Collection* (1992), *Subdued Hues: Mood and Scene in Southern Landscape Painting, 1865–1925* (1999).

Brown, Roger

(1941–1997) PAINTER.

Although he is best known as a member of the Chicago Imagists, artist Roger Brown's childhood in Alabama left a lasting imprint on his work throughout his life. Brown was born in Hamilton, Ala., and his family soon relocated to Opelika. As a young man, he drew all

of the time, and his parents encouraged his creativity. However, his family wanted him to become a preacher, and he enrolled in Bible school at David Lipscomb College in Nashville. While there, he decided to discontinue these studies and to change his life's course. Brown moved to Chicago in 1962 and attended the American Academy of Art, where he completed a commercial design program in 1964. He had also briefly studied at the School of the Art Institute of Chicago soon after his arrival, and he returned to become a full-time student in 1965, earning a B.F.A. in 1968 and an M.F.A. in 1970.

As a child growing up in Alabama, Brown developed a love of southern folk art, handmade objects, comic books, and art deco theater design. These interests led him to become a leading artist of the Chicago Imagist style. This group of like-minded painters and sculptors developed highly individualistic styles using popular culture and naive art as their inspiration. Beginning in the mid-1960s, Brown and his contemporaries were promoted by Chicago artist and curator Don Baum, who organized such exhibitions at the Hyde Park Art Center as *The Hairy Who* and *The Chicago Imagists*, the name that has become synonymous with the group. Brown had his first solo show at Phyllis Kind's gallery in Chicago in 1970 and exhibited regularly in New York after she opened a gallery there.

Brown's work received increasing critical recognition in the 1970s and 1980s. He became known for his color-saturated paintings featuring mysterious silhouetted figures set in patterned land-scapes with vibrating light. *Trailer Park, Truck Stop* shows an American mobile-home park at twilight, with implied domestic stories taking place within each vehicle. Brown's use of narrative scenes was influenced by the tradition of storytelling that he experienced as a child. He has stated, "The whole feeling of my work and what it is about comes right out of being a southerner. People telling stories about living in the hills of northern Alabama. It made me interested in being a narrative painter. Total abstraction was never enough."

In 1987 the Hirshhorn Museum and Sculpture Garden in Washington, D.C., hosted a retrospective of his work. Becoming widely accepted in the 1990s, his paintings entered public collections around the country and graced two covers of *Time* magazine. He had homes and studios in Chicago; New Buffalo, Mich.; and Carpenteria, Calif. He was in the process of opening a fourth home and studio in an old stone house in Beulah, Ala., when he died on 22 November 1997. In 1999 his family completed the restoration of the Stone House as a memorial to him. The School of the Art Institute of Chicago maintains the Roger Brown Study Center, which holds a large collection of his paintings, in addition to his three studio-homes, which remain much the way they were when Brown was alive. In 2007 the Jules Collins Smith Museum at Auburn University organized a retrospective, which toured nationally and brought renewed interest to Brown's art.

KRISTEN MILLER ZOHN
Columbus Museum
Columbus, Georgia

Dennis Adrian and Lisa Stone, *Roger Brown: A Different Dimension* (2004); Dana Boutin and Nicholas Lowe, *Artworks II: Roger Brown: Beyond the Picture Plane* (2010); Sidney Lawrence, *Roger Brown: Southern Exposure* (2007); Sidney Lawrence and John Yau, *Roger Brown* (1987); Roberta Smith, *New York Times* (26 November 1997); Lisa Stone and Nicholas Lowe, *Artworks I: Roger Brown's Virtual Still Life Object Painting* (2010); Robert Storr, *Roger Brown: The American Landscape* (2008).

Buck, William Henry

(1840–1888) PAINTER.

William Henry Buck, born in 1840 in Tromsø, Norway, immigrated to Boston, where he first studied painting. About 1860 Buck moved to New Orleans, where he continued his studies with painters Ernest Ciceri, Richard Clague, Andres Molinary, and sculptor-painter Achille Perelli. Upon his arrival in New Orleans, Buck took a position in the cotton brokerage business, and over the next 20 years he worked his way from clerk to commission merchant, cotton weigher, and cotton broker.

After 20 years in the cotton business, Buck turned to painting full time in 1880. He traveled throughout the state on expeditions, especially southwest Louisiana, making sketches and paintings of the Teche and Attakapas regions. Additionally, Buck painted scenes of the areas north of Lake Pontchartrain in Lewisburg, Madisonville, and Mandeville, as well as Biloxi on the Mississippi Gulf Coast. He also depicted the New England landscape, the area he had discovered when he first immigrated to America. Among his canvases are views of Canada, the Penobscot River, and Maine. Buck also painted scenes after prints by John Frederick Herring and others.

At various times Buck shared studios with Clague, Molinary, and New Orleans–born painter Paul E. Poincy. When Buck left the cotton business in 1880 to work full time as an artist, he shared a studio with Perelli at 26 Carondelet Street, just off Canal Street in the present-day central business district. Buck, who was one of the organizers of the Southern Art Union, along with Molinary, Poincy, Edward Livingston, and Charles Wellington Boyle, taught drawing, painting, modeling, and woodcarving at the Art Union.

Marshall Joseph Smith Jr. and Buck are Richard Clague's best-known students. Although Smith is considered to be Clague's favorite pupil, many of Buck's landscapes are highly reminiscent of Clague's. This is particularly true in the dark green and brown shades rendered in textural brushstrokes in his views of oak trees and bayous. In other scenes Buck renders fishermen's cabins with precise, pronounced contours. A number of Buck's later works are characterized by a warm light in the skies reflected in the water of the bayous. An 1883 painting of Beauvoir, Jefferson Davis's home on the Gulf Coast, is considered to be Buck's masterpiece. His painting titled *Scene in Cotton Field* was reproduced in the last issue of *Art and Letters*, a bimonthly magazine published in 1877.

Buck exhibited at Goupil's in New York City and in New Orleans at W. E. Seebold's, Wagener's, Lilienthal's, the Southern Art Union, the 1884–85

World's Industrial Cotton and Centennial Exposition, the Creole Exhibit at the American Exposition, and the Artists' Association of New Orleans, of which Buck was a founder. He won awards for his oil paintings, watercolor paintings, and pastel drawings. Buck made pictures in cut paper, probably silhouettes or "pasties," and was known for his expertise in restoring paintings.

On 29 April 1865 Buck married Marie Louise Fortin, daughter of New Orleanians Jean-Baptiste Edouard Fortin and Amenaïde Fortin. Of their three children, Laurence H. Buck, their only son, became an architect and watercolorist in New York and Chicago. William Henry Buck died in New Orleans on 5 September 1888 at the age of 48. He is buried in St. Louis Cemetery No. 2.

JUDITH H. BONNER
The Historic New Orleans Collection

Anglo-American Art Museum, *The Louisiana Landscape, 1800–1969* (1969), *Sail and Steam in Louisiana Waters* (1971); Artists' Files, Williams Research Center, Historic New Orleans Collection; Judith H. Bonner, *Arts Quarterly* (April–June 2008), in *Collecting Passions*, ed. Susan McLeod O'Reilly and Alain Masse (2005); Joseph Fulton and Roulhac Toledano, *Antiques* (April 1968); William H. Gerdts, George E. Jordan, and Judith H. Bonner, *Complementary Visions of Louisiana Art: The Laura Simon Nelson Collection at the Historic New Orleans Collection* (1996); John A. Mahé II and Rosanne McCaffrey, eds., *Encyclopaedia of New Orleans Artists, 1718–1918* (1987); R. W. Norton Art Gallery, *Louisiana Landscape and Genre Paintings of the 19th Century* (1981); Martin Wiesendanger and Margaret Wiesendanger, *Louisiana Painters*

and Paintings from the Collection of W. E. Groves (1971).

Bulman, Orville Cornelius Loraine
(1904–1978) PAINTER.

Orville Bulman believed that "being an artist not only opens doors, but minds as well." In his early years he dreamed of becoming a painter, but he was expected eventually to run his father's successful Grand Rapids, Mich., manufacturing business. Devoting himself to the company in the 1920s and 1930s, he also exhibited at New York's Society of Independent Artists in 1937, and around 1948 he showed his work with the Woodstock Art Colony. Although he was influenced by Arnold Blanch and Adolf Dehn there, Bulman is considered to be a self-taught artist.

He began wintering in Palm Beach, Fla., around 1946, after sustaining recurrent injuries to his neck. While living in the affluent town, he displayed his art at several sold-out, solo shows at the Worth Avenue Gallery and traveled extensively throughout Florida, Louisiana, and Alabama to paint regionalist African American–inspired genre scenes. These poignant paintings of the segregated South brought national attention to his work. He was also inspired to create numerous New Orleans jazz–inspired works from nightclubs he had frequented with his wife as early as the 1930s.

During the early 1950s Bulman happened to see pictures of Haiti and admired the island's style, verve, and gracefully trimmed houses with lacy appliqué carved wood. He painted seven imaginative works inspired by photo-

graphs and subsequently visited Haiti for the first time in March 1952. Bulman loved the island and its people and felt they were the best inspiration for further work. He lived with the islanders for a time in a rustic village in the hills, appreciating their humor and lifestyle, deeply experiencing and studying their religion, and respecting their way of life far better than had other Americans. In turn, the Haitians loved his art and encouraged him to continue creating his whimsical scenes of elegant women, men, and playful children.

In November 1952 a Bulman show was mounted at the prestigious Madison (Wis.) Art Association and was featured in *Newsweek*. The following year *Life* magazine published an article about the artist/businessman. In 1954 he held a solo exhibition at the Delaware Art Center (now the Delaware Art Museum), in Wilmington, called *A Businessman Paints*. His canvases again portrayed stark midwestern and southern towns and rural scenes with the addition of a few realistic island genre scenes. This was followed by a sold-out solo show at Grand Central Art Galleries in New York in 1955, the debut of one of his Caribbean-inspired paintings of islanders on a small boat. A subsequent exhibition sold out as well.

Bulman continued to create more and more colorful and fantastical paintings, establishing an imaginary world called "Bulman's Island." In the 1950s, 1960s, and 1970s his popularity burgeoned throughout Palm Beach, New York, California, the Midwest, and Europe. He became the darling of society and Hollywood, consistently selling out solo shows—some before they opened to the public. The Duchess of Windsor and Marjorie Merriweather Post became avid collectors of his works. Pres. Gerald Ford and Robert F. Kennedy owned Bulman paintings as well. Concurrently, Bulman moved to Manalapan, just south of Palm Beach. Here the lush foliage and tropical scenery (along with the work of Henri Rousseau) inspired meticulous paintings of jungles, in which Africans were portrayed as elegant soldiers, princesses, duchesses, kings, and queens.

From the beginning of Bulman's art career, proceeds from sold paintings were donated to artists or the museum in which his paintings were exhibited. Bulman would also purchase other artists' works and donate them to museums. Helping and encouraging artists to paint and promote their art was almost as important to him as his passion for painting.

By 1977 Bulman had exhibited in 41 solo shows and sold over 2,000 paintings. When he died in 1978 he was declared "one of the world's leading painters." His legacy continues, as does his wish "to bring more color and happiness to more patrons than any artist before me."

DEBORAH C. POLLACK
Palm Springs, Florida

Victor Hammer, "Orville Bulman," Hammer Galleries Catalog (1967); Madison Art Association, *Orville Bulman* (1952); Deborah C. Pollack, *Inspired Whimsy: The Genius of Orville Bulman* (2005), *Orville Bulman: An Enchanted Life and Fantastic Legacy* (2006).

Bultman, Anthony Frederick (Fritz)

(1919–1985) PAINTER.

Anthony Frederick (Fritz) Bultman's art evolved in three of the most significant American art centers of the 20th century—New Orleans, Provincetown, Mass., and New York. His early academic studies in Germany and architectural training at the New Bauhaus in Chicago during the 1930s brought him into contact with Bauhaus principles as well as modern art and architecture. A prominent artist in postwar New York, Bultman was also a long-term resident and central figure, along with his wife, Jeanne, in the Provincetown art world.

Bultman was born in New Orleans on 4 April 1919 to Pauline Bultman and A. Fred Bultman. The Bultman Funeral Home, the family's Garden District business since the 19th century, hosted services for prominent residents like Confederate president Jefferson Davis. Additionally, the family was active in the city's cultural activities, and young Bultman demonstrated an interest in art from an early age. Artist Morris Graves lived for a time with his family and became art teacher for the 13-year-old lad. Graves took young Bultman uptown to the Audubon Zoo, where they sketched birds and animals. He then studied art in the French Quarter at the Arts and Crafts Club of New Orleans, which was supported by leading artists in the city and surrounded by historic structures and neighborhoods that also attracted writers and musicians.

As a high school junior, Bultman went to Germany to study at the Bauhaus, but the school's programs were closing in response to the rise of the Nazi party. Instead, he studied at the Munich Preparatory School, and while there met Miz Hofmann, the wife of Hans Hofmann. After Fritz completed high school, his father refused to support his desire to attend art school, preferring that he become an architect. Fritz enrolled at the New Bauhaus (1937), becoming one of its first American students. Directed by Bauhaus veteran László Moholy-Nagy, the New Bauhaus opened in Chicago, operated under that name for one year, and then was renamed the School of Design and the Institute of Design at the Illinois Institute of Technology.

Bultman entered the New York art world during the last years of the Depression, a time of complexity and turmoil as regionalist, American Scene, and realist artists battled for dominance with emerging modernists, surrealists, and abstract artists. During these years, the federal government's art programs, including the Works Progress Administration and the Farm Security Administration, employed many artists, and, as a world war formed, numerous European artists and intellectuals migrated to American cities. In addition to Moholy-Nagy and Mies van der Rohe in Chicago, influential Bauhaus veterans who relocated included Walter Gropius and Marcel Breuer to Harvard and Josef Albers and Anni Albers to Black Mountain College in North Carolina.

Bultman studied with one of the most influential of these European artists, Hofmann, who operated his art school in Munich and taught at the Art Students League in New York. He opened the Hans Hofmann School

there in 1933 and a summer school in Provincetown in 1934. Bultman studied at both schools with Hofmann, who became a dominant influence and taught leaders of the abstract expressionist generation.

After completing his studies with Hofmann, Bultman became an increasing presence in the New York and Provincetown art worlds. In Provincetown, he met model-dancer Jeanne Lawson, who modeled for one of Hofmann's classes, and on Christmas Eve of 1943 they were married at St. Patrick's Cathedral in New York. In 1944 they bought a house and property near Hofmann's studio in Provincetown, where they moved the following year. In 1945 Bultman commissioned his classmate at the New Bauhaus, Tony Smith (later known as a sculptor), to design a modern studio structure, which Bultman rented for a time to Hofmann as a teaching studio. Hofmann maintained his New York and Provincetown schools until 1958, when he returned to painting full time. He and Bultman remained friends until his death in 1966. Among Bultman's many acquaintances was Tennessee Williams, whom he met in 1940. Williams later visited the Bultman home in New Orleans and wrote the play *Suddenly Last Summer* there in 1958.

Bultman knew many of the leading artists of the emerging abstract expressionist generation, including Jackson Pollock, and was regarded as a member of an increasingly significant New York School of artists. In 1950 Bultman joined a group, soon called the Irascibles, in signing a letter to the leaders of the Metropolitan Museum of Art protesting the conservative nature of a planned exhibition of contemporary American art there. However, he did not appear in the famous photograph of this group, published in *Life* magazine on 15 January 1951, which became a milestone in the emergence of the New York School. Though he was an intimate part of the group, Bultman was in Italy on a grant to study sculpture when the image was taken. Some critics suggest that his absence in this image reduced his profile when media focus on the New York School grew.

Relocating to New York in 1952, Bultman became increasingly active in New York, the critical years in the emergence of abstract expressionism and the Irascibles group. He also taught at Pratt Institute in New York from 1950 to 1959. Unlike some members of this group who focused on studio painting, Bultman was open to expressing his vision in diverse media, including painting, drawing, sculpture, collage, and stained glass. His eclectic tastes may have been nurtured by his exposure to the principles of the Bauhaus and his student experiences in Germany.

His diverse interests became evident with Bultman's unique role as a painter and sculptor in the abstract expressionist group of artists, marked by his search for expressive forms in stone, bronze, and other materials. He expanded his teaching to Hunter College (1960–69). In 1962, perhaps influenced by Matisse and his use of cutouts, Bultman began to construct abstract collages, using scraps of paper and more formal media. Collage became

a primary medium for Bultman over the next two decades and tied into his interest in stained glass, which he designed on an architectural scale. Beginning in 1963, during the civil rights era and the struggle for integration and voting rights in his native South, he and Jeanne organized a group of artists, curators, and critics, including Robert Motherwell and Dore Ashton, to build a modern art collection for African American students at Tougaloo College, in Jackson, Miss. In 1964–65 the Bultmans spent a year in Paris after he was awarded a Fulbright Scholarship (Jeanne Bultman studied at the Cordon Bleu).

In 1968 Bultman served as a cofounder of the Provincetown Fine Arts Work Center. During the 1970s he worked with stained glass, often with technical assistance from Jeanne. The largest Bultman glass project was created for Kalamazoo College, in Michigan (1981). Additionally, he designed a major stained glass windows series for the Bultman Funeral Home (the large paper collage studies are now in the collection of the Ogden Museum of Southern Art). In 1977 he was involved in the founding of another arts institution in Provincetown, the Long Point Gallery.

Active throughout his life as an advocate for Provincetown and its arts scene, Bultman died in Provincetown on 20 July 1985. He was the subject of a major exhibition, *Fritz Bultman: A Retrospective*, at the New Orleans Museum of Art (1993); the exhibition *Fritz Bultman: Collages*, at the Georgia Museum of Art (1997); the exhibi-

tion *Fritz Bultman: Irascible*, at Gallery Schlesinger in New York (2003, 2004); and focused exhibitions at the Ogden Museum of Southern Art (2003, 2009). Jeanne Bultman continued to advance his legacy until her death in their Provincetown cottage on 18 December 2008. Artist Robert Motherwell (1915–91) offered this reflection on Bultman's legacy: "After forty years of acquaintanceship with Fritz Bultman and his work, I am still convinced that he is one of the most splendid, radiant and inspired painters of my generation, and of them all, the one drastically and shockingly underrated."

J. RICHARD GRUBER
Ogden Museum of Southern Art
University of New Orleans

Fritz Bultman, *Art Journal* (Spring 1971); Randolph Delehanty, *Art in the American South: Works from the Ogden Collection* (1996); William U. Eiland, Donald Windham, and Evan F. Firestone, *Fritz Bultman: Collages* (1997); Fritz Bultman papers, 1921–87, Archives of American Art, Smithsonian Institution; April Kingsley, *The Turning Point: Abstract Expressionism and the Transformation of American Art* (1992); April Kingsley and Fritz Bultman, *Fritz Bultman: A Retrospective* (1993); Irving Sandler, *Abstract Expressionism and the American Experience: A Reevaluation* (2009); Martha R. Severens, *Greenville County Museum of Art: The Southern Collection* (1995).

Cameron, James

(1817–1882) PAINTER.

James Cameron lived in Chattanooga, Tenn., for less than 10 years, but he left behind a body of work that chronicled the people and landscape of eastern

Tennessee before the Civil War. His biography is sketchy; he was born in Greenock, Scotland, in 1817. His family immigrated to Philadelphia about 1833. In his early twenties Cameron moved to Indianapolis seeking work as an artist in a smaller market. By 1847 he returned to Philadelphia, where he married artist Emma Alcock. The newlyweds traveled to Italy for an extended period; in 1848 Cameron listed himself as a citizen of Rome when he sent a painting to an American Art Union exhibition in New York. He returned to the United States by 1851 and exhibited his "Italian scenes" in 1849 and 1851 at the Pennsylvania Academy of the Fine Arts.

In the early 1850s Cameron moved to Nashville, Tenn. There he soon met the redoubtable James A. Whiteside. A leading citizen of Chattanooga, Whiteside was always eager to enhance the reputation and fortune of the city, and he convinced the artist to move to Chattanooga under his patronage. Whiteside provided him with a place to live and sought out commissions for him.

By 1860 Cameron realized that he could not remain in Chattanooga with the Civil War looming, and he and his wife moved, probably to Philadelphia, for the duration of the war. When they returned to Chattanooga, he was horrified by the devastation of the city and discouraged by the lack of commissions in the shattered southern economy. After a brief, failed business, he decided to not only leave the South but also end his career as a painter.

About 1870 Cameron, who was always a religious man, became a Pres-byterian minister when he was near the age of 50. He and his wife moved to California, where they lived near San Francisco. When Cameron complained of gastric distress in 1882, rather than his usual tonic his wife mistakenly gave him carbolic acid—medication that had been prescribed after a foot surgery. Tragically, Cameron died from this treatment. At the subsequent inquest, his wife was acquitted of any responsibility in the matter.

Cameron painted both landscapes and portraits. The full extent of his artistic output is uncertain. Presently, about 20 paintings by Cameron are known, with a number of those held in the collections of the Hunter Museum of American Art in Chattanooga, Tenn., and the Tennessee State Museum in Nashville. While Cameron's compositions are sometimes sophisticated, elements of his style reveal a lack of training. His works are executed in minute detail. In his canvases he painstakingly delineated each leaf or all the intricacies of a lace collar. At times his use of perspective is awkward, particularly in more complicated figural arrangements. Perhaps the most distinguishing characteristic of his work is a dark outline around landforms as they recede into the distance. It is for his depictions of the land and the people of the South that Cameron is most remembered.

ELLEN SIMAK
Hunter Museum of American Art
Chattanooga, Tennessee

Penelope Johnson Allen, in *Genealogy of a Branch of the Johnson Family and Connec-*

tions (1967); William H. Gerdts, *Art across America: The South, Near-Midwest* (1990); William T. Henning Jr., *A Catalogue of the American Collection, Hunter Museum of American Art* (1985); James C. Kelly, *Tennessee Historical Quarterly* (Summer 1985 and Winter 1987); Elizabeth L. O'Leary, *At Beck and Call: Domestic Servants in 19th-Century Painting* (1996).

Catesby, Mark

(1683–1749) PAINTER AND ILLUSTRATOR.

Mark Catesby, an English naturalist and self-taught artist, traveled North America in order to document the South's "birds, beasts, fishes, serpents, insects, and plants." After exploring the fauna and flora along the James River between 1712 and 1719, Catesby returned to England to secure sponsorships from members of the Royal Society so that he could pursue a more comprehensive documentary project. Having secured the sponsorship of prominent backers, including the governor of colonial South Carolina, Catesby sailed to Charleston in 1722 and embarked upon four years of extensive outdoor sketching and note making. Painting from life whenever practical, he concentrated on the birds, snakes, reptiles, and amphibians that were least like animal life in Europe.

Depicting animals beside the plant forms with which they were naturally associated was one of Catesby's most notable innovations. Catesby's approach to his subject was guided by the spirit of British empiricism—an expression of Enlightenment values—as advocated by John Locke and George Berkeley.

The empiricism evident in the drawings and descriptions in his *Natural History of Carolina, Florida, and the Bahama Islands* was careful and in many ways systematic, but his intuitively expressive art retains a delightful sense of the irrational. Though empiricism and irrationality seem contradictory, Catesby's visual information—based upon his individual grasp of "truth"—was naturally and fortunately irrational. His illustrations *The Little Owl, The Goat-Sucker of Carolina*, and *The Rice Bird* combine a strong sense of personality conveyed by pose and facial expression with an intuitive sense of linear design and two-dimensional composition. When Catesby depicted snakes, he planned their forms and colors as part of an overall decorative design. His *Corn Snake, Green Snake*, and *Wampum Snake* are beautifully arranged in flowing linear patterns on, over, or around plant forms. Because his flora are shown as isolated cuttings or lab specimens, they often have the formality of an arrangement of pressed flowers.

One of Catesby's most amusing illustrations is *The Alligator*, "soon after breaking out of its shell," shown with mangrove seedpods and branches of the mangrove tree, which seem gigantic by comparison. The combination of a very small alligator with very large mangrove stems and leaves—although perhaps close to lifelike scale—projects a strange sense of the disproportionate. "As I was not bred a painter," Catesby apologized, "I hope some faults in perspective, and other niceties, may be more readily excused."

In 1726 Catesby returned to London

to seek subscriptions to support the publication of *The Natural History*. Volume 1 of this important work was published in installments between 1729 and 1732, and volume 2 was published from 1734 to 1743. Later editions were published after Catesby's death. In the introduction to volume 1, he described his 220 examples of southern fauna and flora as "a Sample of the hitherto unregarded, tho' beneficial and beautiful Productions of Your Majesty's Dominions." Until recently, this description might have applied equally to Catesby's creative work, as his contribution to the history of southern art has been overshadowed by the illustrations of the more flamboyant Audubon. Even though some writers, like Joyce E. Chaplin, insist that Catesby's standing as an "illustrator" has diminished his reputation as a naturalist, Catesby has not received art world attention either. His etchings and the watercolors deserve recognition as significant southern folk art.

JAY WILLIAMS
Museum of Arts and Sciences
Daytona Beach, Florida

Kristin Sullivan Amacker, *Mark Catesby's "The Natural History of Carolina, Florida, and the Bahama Islands"* (2003); Mary Weaver Chapin, *Catesby, Audubon, and the Discovery of a New World: Prints of the Flora and Fauna of America* (2008); Alan Feduccia, *Catesby's Birds of Colonial America* (1985); Gail Fishman, *Journeys through Paradise: Pioneering Naturalists of the Southeast* (2000); George Frederick Frick and Raymond Phineas Stearns, *Mark Catesby: The Colonial Audubon*; Henrietta McBurney, *Mark Catesby's Natural History*

of America: The Watercolors from the Royal Library, Windsor Castle (1997); Amy R. W. Meyers and Margaret Beck Pritchard, *Empire's Nature: Mark Catesby's New World Vision* (1998).

Champney, James Wells

(1843–1903) PAINTER, DRAFTSMAN, ILLUSTRATOR, WOOD ENGRAVER, PHOTOGRAPHER, LECTURER.

Born in Boston, James Wells Champney was the son of painter-illustrator Benjamin Champney, a cofounder of the Boston Art Club in 1855. Young Champney, called "Wells" by his family, would inherit his father's drawing skills. After his mother's death, he used his aunts and cousins as models. He studied drawing at the Lowell Institute; subsequently, in 1859, the 16-year-old lad was apprenticed to wood engraver Bricker & Russell. This preparation served Champney well, for it enhanced his drawing skills, his mastery of controlled line, and his understanding of chiaroscuro.

Enlisting in the 45th Massachusetts Volunteers, Champney saw brief military service at Gettysburg in 1863 and did garrison duty for nine months in South Carolina. Following his recuperation from malaria, Champney, who received a medical discharge, taught drawing at Dr. Dio Lewis's Seminary for Young Ladies, an exclusive school in Lexington, Mass. In 1866 he studied under genre painter Édouard Frère at Écouen, a village north of Paris. He continued his training under Josef Henri François Van Lerius at the Royal Academy of Fine Arts in Antwerp, Belgium. Champney, who won first prize in

drawing at the Royal Academy, exhibited at the Paris Salon in 1869 and 1875. He signed his name "Champ" to distinguish himself from other American artists with the same surname.

Champney, who made a trip home to Boston in 1870 to set up his studio, returned to France early the following year when the short-lived Paris Commune assumed governmental control after the Franco-Prussian War. He then made a sketching trip to Germany and studied the passion play at Oberammergau. Champney was so inspired by this experience that he lectured about the play in America.

In 1873–74 Champney traveled throughout the southern United States with journalist Edward King and made 536 sketches for a series of articles on the New South to be published in *Scribner's Monthly*. The editors announced the trip as a "record of an extensive tour of observation through what were formerly the Slave States of North America . . . a journey of more than twenty-five thousand miles. The journeys were undertaken at the instance of the publishers . . . who desired to present to the public, through the medium of their popular periodical, a series of illustrated articles giving an account of the material resources, and the present social and political people." The articles were reprinted in 1875 as *The Southern States of North America*.

King and Champney traveled by foot, ferry, horse, and railway, visiting major southern cities as well as frontier towns, rural and mountainous areas, carnivals, and tobacco auctions. They drifted 1,200 miles down the Mississippi

River to New Orleans, where Champney sketched the French Quarter—its architecture, residents, and genre scenes. His engravings depicted life along the levees, on plantations, and in the wilderness, including the territories of American Indians.

While traveling through Kansas on his trip through Louisiana Purchase areas for the New South drawings, Champney met Elizabeth Johnson "Lizzie" Williams, a former student from the Seminary for Young Ladies. Married in May 1873, they traveled through the South together. A member of the second class of Vassar graduates, Elizabeth received an A.B. degree in 1869. She wrote numerous articles and several books, many of which focused on European locations—some of which Champney illustrated. He also contributed drawings of American life to the French periodical *L'Illustration*.

Champney became a war correspondent and traveled to Europe in 1874–75. He sketched camp life in Spain during the Third Carlist War (1872–76) when Carlos VII was campaigning for the Spanish crown. The Champneys also lived briefly with gypsies.

Returning to the United States, Champney built a summer studio in Deerfield, Mass., while maintaining a winter studio in New York City. He exhibited at the 1876 Centennial Exposition in Philadelphia. A year later he became professor of art at Smith College in Northampton.

In 1878 Champney made a sketching trip to South America with author Herbert Smith for *Scribner's*. He directed the art classes of the Hartford

Society of Decorative Art. Champney exhibited in a group show at the Southern Art Union in New Orleans in 1882, along with William Merritt Chase, Jasper Francis Cropsey, Mauritz Frederik Hendrik de Haas, William Sartain, Frank Waller, James Henry Beard, John Carlton Wiggins, and others. In 1885 Champney began to make portraits in pastel, including of Hon. John Bigelow, explorer Henry Morton Stanley, and notables in the theater. Champney was represented at the 1893 Columbian Exposition in Chicago with portraits of his wife, Rev. Robert Collyer, and Susanna Sheldon. He made numerous studies in pastel after masterpieces in European galleries. His work was represented in the 1897 Tennessee Centennial Exposition. The following year he painted murals for the Hotel Manhattan in New York.

Champney was a member of the American Society of Painters in Watercolor and an associate member in the National Academy of Design (1882). He was one of the first American artists to comprehend and apply the system of chromatic values developed by French impressionist painters. During his career, he was compared favorably with James Abbot McNeil Whistler. Champney was killed in an elevator accident in New York City.

JUDITH H. BONNER
The Historic New Orleans Collection

Benjamin Champney, *Sixty Years' Memories of Art and Artists* (1900); John A. Mahé II and Rosanne McCaffrey, *Encyclopaedia of New Orleans Artists, 1781–1918* (1987); Estill Curtis Pennington and James C. Kelly, *The South on Paper* (1985); Regina Soria, *Dictionary of Nineteenth-Century American Artists in Italy, 1760–1914* (1982).

Chapman, Conrad Wise

(1842–1910) PAINTER.

Conrad Wise Chapman was born in 1842 in Washington, D.C., where his Virginia-born father, John Gadsby Chapman, painted murals in the Capitol. In 1848 the elder Chapman settled in Rome, Italy, where Conrad spent his youth. His early instruction in art was provided by his father. Fired with devotion to Virginia, young Chapman returned to America with the outbreak of the Civil War in 1861 and enlisted in the Confederate army. He prepared numerous sketches of war scenes, especially in Virginia and South Carolina. In 1863 and 1864 he was assigned to depict the batteries and forts at Charleston, S.C. There he executed his unique and celebrated series of paintings of the Charleston defenses. In 1864 Chapman returned briefly to Rome because of his mother's illness. After his Italian journey, he entered the United States through Texas, where he learned that the Civil War had ended.

Chapman joined Confederate general John B. Magruder in supporting Emperor Maximilian in Mexico. Magruder's group, however, soon disbanded. Enamored of the Mexican landscape, Chapman painted an impressive 14-foot-long canvas, *Valley of Mexico*, a panoramic view of the entire valley. Some critics believe it to be the finest painting of the Mexican landscape by an American and have compared it to works by José Maria Velasco, Mexico's greatest 19th-century land-

scapist. In later years Chapman resided in France, Italy, England, New York, and Virginia. Though he lived until 1910 (he died in Hampton, Va.), he had completed his most memorable work by the early 1870s.

Today Chapman is best known as the principal painter of the Confederacy. His small landscapes of Charleston are some of the most brilliant paintings associated with the Civil War. Each a masterpiece, these paintings—the result of Chapman's private romantic response to the call of sectional patriotism—are characterized by a freshness of color, an excellent use of the effects of light, a deftness of brushstroke, and a skillful use of minute detail. The Charleston paintings also demonstrate a rather extraordinary attitude toward the subject they depict. Though an ardent partisan of the Confederate cause, Chapman revealed in these paintings none of the propaganda elements that dominate many pictorial representations of wartime scenes. For his Charleston work and for his masterpiece, *Valley of Mexico*, Chapman deserves increased recognition as an important American landscape artist.

L. MOODY SIMMS JR.
Illinois State University

Ben L. Bassham, *Conrad Wise Chapman: Artist and Soldier of the Confederacy* (1998); Louise F. Catterall, ed., *Conrad Wise Chapman, 1842–1920* (1962); L. Moody Simms Jr., *Virginia Cavalcade* (Spring 1971); Lauralee Trent Stevenson, *Confederate Soldier Artists: Painting the South's War* (1997).

Chapman Family

JOHN GADSBY CHAPMAN
(1808–1889) PAINTER.
CONRAD WISE CHAPMAN
(1842–1910) PAINTER.

John Gadsby Chapman was born in Alexandria, Va., on 11 August 1808. His maternal grandfather was the proprietor of Gadsby's Tavern, one of the most celebrated establishments in the Tidewater, and he is thought to have had some early instruction from two local artists, George Cooke and Charles Bird King. Following a period of study in Philadelphia, in 1828 the young Chapman made the requisite artistic pilgrimage to Rome, where he copied old masters and learned traditional drafting techniques until 1831. The classical American sculptor Horatio Greenough was among his sitters and became a lifelong friend.

Upon his return to America, Chapman launched a career as a landscape painter and portraitist, working first in Alexandria, then in Washington, D.C., Richmond, Va., and Philadelphia. In 1834 he moved to New York, where he achieved great success as an illustrator and history painter. As a result, he was chosen to paint one of the four monumental murals commissioned for the rotunda in the U.S. Capitol building, *The Baptism of Pocahontas*, which he began in 1837. The finished work drew upon his heritage as a native Virginian familiar with the oral history of the colonial era.

Chapman returned to New York in 1840 and resumed his career as an illustrator, producing several hundred engravings for a large illustrated edition of

the Bible printed by Harper's between 1843 and 1847, as well as images for novels and books of popular verse. He also authored *The American Drawing Book*, first printed in 1847. Described as "A Manual for the Amateur, and Basis of Study for the Professional Artist," the well-regarded primer was reissued several times.

The Chapman family returned to Europe in 1848 and traveled in England and France before settling in Rome in 1850. John would remain in Italy until 1884, painting scenes of the Roman Campagna for the high end/grand tour trade. This was a successful venture until the Civil War curtailed American travel abroad. Thereafter, John Chapman's fortunes declined. He returned to America in 1884, spending the last years of his life with his son, artist John Linton Chapman.

Another son, Conrad Wise Chapman, born in 1842 and known as Wise, was also a painter. In February 1850, with his family, Wise began his long-term residence in Rome. The family apartment on the Via del Babunio would be a home base, classroom, and studio for Wise for the next 34 years. His art education, supervised by his father, was nurtured by the extended community of American expatriate artists in Rome, notably sculptors Thomas Crawford and William Wetmore Story and painters George Loring Brown and Cephas Giovanni Thompson. He completed a highly detailed sketchbook in 1855 while attending the Academy of St. Luke and participated in local life classes (figure drawing or painting) in the nearby Via Margutta.

When Pres. Abraham Lincoln called up troops to support the Union in 1861, Wise Chapman ran away from home, sailing for America from Liverpool in August 1861. After landing in New York, he made his way to Henderson, Ky., and joined the Orphan Brigade commanded by Gen. John Cabell Breckinridge. In 1862, at the battle of Shiloh, Chapman received a bullet wound to the back of his neck, an injury that would plague him for the rest of his life. While recuperating in the summer of 1862, he was transferred to the Wise Brigade of Virginia and, in the company of Lt. Richard Alsop Wise, proceeded to Charleston. Upon his arrival, Gen. P. G. T. Beauregard commissioned him to create a series of works illustrating the siege of Charleston. The resultant group of paintings provided the most detailed images of Confederate forces produced by a painter in the South. In March 1864 Chapman's appointment as secretary to Bishop Lynch of Charleston, Pres. Jefferson Davis's commissioner to the Papal States, led to a reunion with his family in Rome.

Although Chapman tried to rejoin Confederate forces in March 1865, a blockade kept him from entering Florida. He continued to Mexico, where he remained until November 1866, painting several large panoramas of the countryside, which account for some of his best-received work. For the next few years he worked on commissions and speculation in Rome, Paris, and London. While in London in 1871, he suffered a mental breakdown and was confined to an asylum directed by Forbes B. Winslow. Chapman's confine-

ment contributed to a sharp decline in the family fortunes. As compensation, he gave his father a large group of his Civil War paintings, 31 of which were subsequently acquired by the Valentine Museum in Richmond, Va., in 1898.

In 1874 Wise Chapman moved to Paris, where he supported himself by tinting photographs. While there, he married Anne-Marie Martin, and the couple returned to Mexico in 1883 with her sister and brother-in-law. After the death of Anne-Marie on 9 August 1889, Wise again experienced severe mental illness. He returned to Paris, where he remained until 1892. In 1892 he returned to Mexico, where he married Laura Seager. At the outbreak of the Spanish-American War, Chapman and his wife sought refuge in Richmond, Va., where he renewed his friendship with the Wise family. Although they returned to Mexico City in 1899, lack of work there forced their move to New York in 1901, where they remained until 1905, when they returned to Mexico City. While there, Chapman's health declined, and he and his wife returned to Richmond. Through the auspices of Eulillia Harris and Mary Jaiser, he was offered a small cottage in Hampton, Va. He died in Hampton on 10 December 1910 and was buried in the cemetery of St. John's Episcopal Church.

ESTILL CURTIS PENNINGTON
Paris, Kentucky

William Ayres, ed., *Picturing History: American Painting, 1770–1930* (1993); Ben L. Bassham, *Conrad Wise Chapman: Artist and Soldier of the Confederacy* (1998); William Pardee Campbell, *John Gadsby Chapman: Painter and Illustrator* (1962); Louis F. Catterall, *Conrad Wise Chapman, 1842–1910* (1962); Georgia Stamm Chamberlain, *Studies on John Gadsby Chapman: American Artist, 1808–1889* (1963); Bruce Chambers, *Southern Quarterly* (Fall–Winter 1985); Ruben C. Cordova, *Conrad Wise Chapman: The Valley of Mexico* (1997); James Bacon Ford, *Conrad Wise Chapman* (1942); Harold Holzer and Mark E. Neeley Jr., *Mine Eyes Have Seen the Glory: The Civil War in Art* (1993); Mark E. Neely Jr., Harold Holzer, and Gabor S. Borritt, *The Confederate Image: Prints of the Lost Cause* (1987); Estill Curtis Pennington, *Romantic Spirits: Nineteenth-Century Paintings of the South from the Johnson Collection* (2011); Jessie Poesch, *The Art of the Old South: Painting, Sculpture, Architecture, and the Products of Craftsmen, 1560–1860* (1983).

Christenberry, William

(b. 1936) ARTIST.

The art of William Christenberry is rooted in the landscape of the Deep South, specifically in Hale County and Perry County, Ala., the region of the Black Belt that is central to the history of his family. For more than five decades, Christenberry has focused on that region and its people, in diverse media including painting, sculpture, photography, drawing, printmaking, and environmental installations, as well as in storytelling.

One of three children, William Andrew Christenberry Jr. was born in 1936 in Tuscaloosa, Ala., to William Andrew Christenberry and Willard Smith Christenberry. Young Christenberry, who was educated in the Alabama public schools, regularly visited the working farms of his grandparents, located outside the nearby Hale County

William Christenberry photograph of a new-made grave, north Mississippi
(William Christenberry, University Museums, University of Mississippi, Oxford)

towns of Akron and Stewart. After graduating from Tuscaloosa Senior High School, he completed his undergraduate and graduate education at the University of Alabama (1954–59). In 1959, at the age of 23, Christenberry accepted a position in the university's art department and began a long career as a distinguished teacher and professor of art (at the University of Alabama, Memphis State University, and the Corcoran College of Art and Design).

Christenberry was trained in the theories and techniques of abstract expressionism at Alabama and came to be immersed in the history of the Dada and surrealist art movements. His focus on the South was initially influenced by southern writers, particularly William Faulkner and James Agee. A direction for his art was established in 1960 when he discovered a published edition of *Let Us Now Praise Famous Men*, by James Agee and Walker Evans. The book was produced in response to a trip Agee and Evans made to Hale County, to the Mills Hill Road area (near the farms of Christenberry's grandparents), during the summer of 1936, the year of Christenberry's birth. Recognizing the people and places in the book and the relationship to his life and family history, he used a Brownie camera to photograph the area (by 1977 he also began to use an 8-by-10-inch Deardorff camera), and created paintings in response to his observations, experiences, and memories.

Leaving Alabama, Christenberry

moved to New York, where he lived in Greenwich Village and immersed himself in that city's gallery and museum world (1961–62). He also met and became friends with Walker Evans, who encouraged his emerging photographic vision of Alabama. In 1973 Evans made his only return trip to Hale County, accompanied by Christenberry. In 1962, after accepting a faculty position at Memphis State University (now the University of Memphis), Christenberry worked in that city during a critical period of social change (1962–68). There he met his wife, Sandra Deane, and befriended emerging photographer William Eggleston. During his years in Memphis, Christenberry became more aware of the events associated with the civil rights movement and created his first *Klan Series* works, which evolved into his extensive *Klan Room* project.

In 1968 Christenberry and his family moved to Washington, D.C., where he became a professor of drawing and painting at the Corcoran College of Art and Design, retiring as professor emeritus. That year he began the first in an annual series of trips to Alabama in order to photograph Alabama houses, farms, towns, and landscapes. These visits provided the evolving subjects for his art, created in his Washington studio, including the completion of his first building construction, *Sprott Church*, in 1974–75. Afterward, he focused on new sculptural forms, including his first *Dream Building* (1979) and his first *Southern Monument* (1980). His photographs, sculptures, selected paintings, and the *Klan Room* were included in a major solo exhibition,

Southern Views, presented in 1983 at the Corcoran Gallery of Art, accompanied by the publication of his first monograph, *William Christenberry: Southern Photographs*.

Over the next decade, Christenberry held exhibitions at the Middendorf Gallery in Washington, D.C., and the Pace-MacGill Gallery in New York. He received the Alabama Prize (1989) and was honored as the Eudora Welty Professor of Southern Studies at Millsaps College (1991). The Amon Carter Museum (Fort Worth) organized the traveling exhibition and related publication, *Of Time and Place: Walker Evans and William Christenberry* (1990). In 1996 Christenberry's art and life entered a critical new phase, marked by a series of research, publication, and exhibition projects, including important national museum and gallery exhibitions. These included *William Christenberry: The Early Years, 1954–1968*, a traveling exhibition (1996–2000) and publication organized by the Morris Museum of Art; *Christenberry: Reconstruction: The Art of William Christenberry*, a traveling exhibition (1996–97) and publication organized by the Center for Creative Photography; and *Recent Work*, an exhibition organized by the Morgan Gallery in Kansas City. During this period, a major teaching and research collection of his art was assembled by the John and Maxine Belger Family Foundation in Kansas City, and a film devoted to his life and work, *William A. Christenberry Jr.: A Portrait* (1997), was released by Staniski Media in Washington, D.C.

In 2000 the Ogden Museum of Southern Art, University of New

Orleans, organized *William Christenberry: Art and Family*, an exhibition and publication devoted to art and creativity within his extended family. Significant European interest in the artist and his work has been demonstrated in projects that include *William Christenberry: Disappearing Places*, an exhibition and publication organized and presented in Cologne and Brussels (2001–2), and exhibitions organized in Cologne by Galerie Thomas Zander (2003). In 2006–7 he was featured in the reopening of the Smithsonian American Art Museum in *Passing Time: The Art of William Christenberry* and a related publication, *William Christenberry* (2006). Most recently he is the subject of *William Christenberry Photographs: 1961–2005*, organized by Aperture and traveling nationally from 2006 to 2010.

J. RICHARD GRUBER
Ogden Museum of Southern Art
University of New Orleans

Elizabeth Broun, Walter Hopps, Howard N. Fox, and Andy Grundberg, *William Christenberry* (2006); Richard Cravens, *William Christenberry: Southern Photographs* (1983); J. Richard Gruber, *William Christenberry: Art and Family* (2000), *William Christenberry: The Early Years, 1954–1968* (1998); Susanne Lange, Claudia Schubert, and Allen Tullos, *William Christenberry: Disappearing Places* (2002); Thomas W. Southall, *Of Time and Place: Walker Evans and William Christenberry* (1990).

Clague, Richard, Jr.

(1821–1873) PAINTER.
Artist Richard Clague Jr. was born in Paris, France, on 11 May 1821 to Justine de la Roche and Richard Clague Sr.

Clague's parents, both of whom were descendants of wealthy New Orleans families, also had living quarters in Paris and later returned to Louisiana. When Clague's parents separated in 1835, Justine Clague left New Orleans with her three sons to live in Paris near Montmartre. In 1836 the 15-year-old Richard and his 14-year-old brother, Edouard, were sent to school in Geneva, Switzerland, to study with animal and landscape painter Jean-Charles Ferdinand Humbert. During Clague's studies with Humbert, he developed a preference for certain subjects in landscape painting, but his style was modified after further experience.

The two brothers' art studies in Geneva were halted by the death of their father in December 1836, upon which they returned to New Orleans. His father's death brought the young Clague a sizable inheritance, which permitted him to travel extensively and to continue his art studies. At age 21 Clague and his brother resided in the French Quarter at 63 Dauphine Street. In 1842–43 Clague studied in New Orleans with Léon D. Pomarède, a well-known muralist and painter of panoramas who worked in the city and in St. Louis. With this period of study, Clague's interest in naturalistic landscape painting increased.

Clague further pursued his art studies in Paris with François Edouard Picot, which led to his registration at the École des Beaux-Arts with Émile-Jean Horace Vernet, Antoine-Auguste-Ernest Hébert, and Jean-Auguste-Dominique Ingres. Clague exhibited at the Paris Salon in 1848, 1849, and 1853. While

in Paris, Clague became familiar with paintings by French naturalist painters who eschewed the artificiality of history painting, including Theodore Rousseau and other naturalist artists who painted at the edge of the Fontainebleau Forest. Clague subsequently became strongly influenced by the rural subjects and the plein air method of the Barbizon artists.

In 1856–57 Clague was the draftsman on an expedition sponsored by Napoleon III to Algeria to discover the source of the Nile River, a trip so hazardous that of the original 40 men who began the trip, only 12 returned, including Clague. Shortly afterward, he settled in New Orleans. By late 1857 Clague had opened a studio with New Orleans–born painter Paul E. Poincy.

Clague is considered to be the first major Louisiana landscape painter. He is credited with introducing the tradition of European landscape painting, particularly that of the Barbizon school, to Louisiana during the late 19th century. He was a teacher and mentor to a small group of New Orleans artists, including landscapists Charles Giroux, William Henry Buck, and Marshall Joseph Smith Jr., the latter two of whom are most closely identified with Clague. This group has been referred to as the Bayou School of Painting, since members recorded in a "monumental and precise manner the distinctive Spanish moss and hazy atmosphere of the bayou region."

Clague's portraits are consistent with the neoclassical tradition prevalent in Louisiana during the 19th century. His landscapes typically feature moss-draped oak trees, fishing camps, hunting camps, trappers' cabins, and small boats on sluggish bayous. He frequently included cows in these dark green and umber scenes, with soft luminous light reflecting on bayou waters. Clague also painted in summer resort areas of southern Louisiana, on the Gulf Coast, and in Spring Hill, Ala.

In 1861 Clague enlisted in the Confederate army but resigned his commission after a brief service. He lost most of his money during the Civil War and afterward lived frugally and earned his living by painting landscapes and portraits as well as by teaching painting. Clague died of hepatitis on 29 November 1873 in Algiers, La., across the Mississippi River from New Orleans. He is buried in New Orleans in St. Louis Cemetery No. 2.

JUDITH H. BONNER
The Historic New Orleans Collection

Artists' Files, Williams Research Center, Historic New Orleans Collection; Judith H. Bonner, Arts Quarterly (April–June 2008), in Collecting Passions, ed. Susan McLeod O'Reilly and Alain Masse (2005); inaugural exhibition catalog, Louisiana State University Museum of Art (2005); William H. Gerdts, George E. Jordan, and Judith H. Bonner, *Complementary Visions of Louisiana Art: The Laura Simon Nelson Collection at the Historic New Orleans Collection* (1996); John A. Mahé II and Rosanne McCaffrey, eds., *Encyclopaedia of New Orleans Artists, 1718–1918* (1987); R. W. Norton Art Gallery, *Louisiana Landscape and Genre Paintings of the 19th Century* (1981); Roulhac Toledano, *Richard Clague, 1821–1873* (1974); Martin Wiesendanger and Margaret Wiesendanger, *Louisiana Painters and Paintings from the Collection of W. E. Groves* (1971).

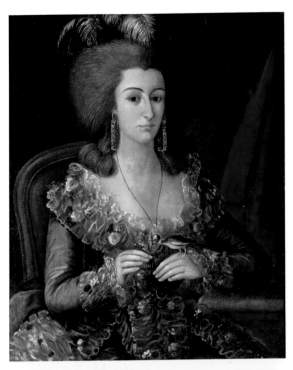

José Francisco Xavier de Salazar y Mendoza, Clara de la Motte, *circa 1795, oil on canvas, 30¹⁄₁₆″ x 24¹³⁄₁₆″ (The Historic New Orleans Collection, 1981.213)*

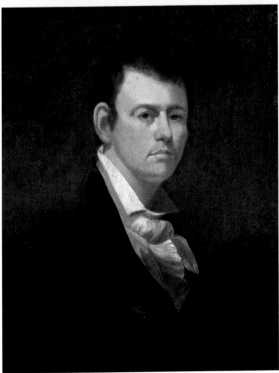

Matthew Harris Jouett, Self-portrait, *circa 1825, oil on canvas (The Collection of Sharon and Mack Cox, Richmond, Ky.)*

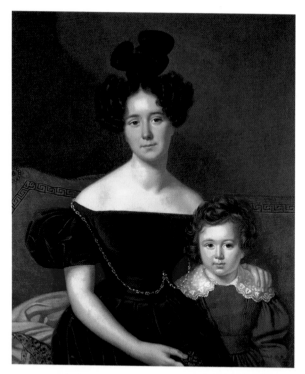

Jean-Joseph Vaudechamp, Marie Althée Joséphine d'Aquin de Puèch with son Ernest Auguste de Puèch, 1832, oil on canvas, 37" x 32" (The Historic New Orleans Collection, acquisition made possible by the Laussat Society, 2005.0340.1)

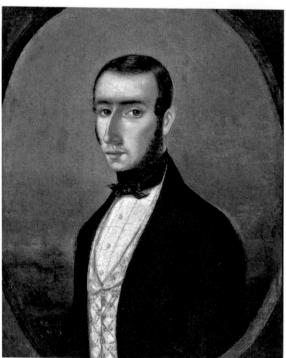

Julien Hudson, Self Portrait, 1839, oil on canvas, 8³/₄" x 7" (Courtesy Louisiana State Museum, New Orleans, 7526 B)

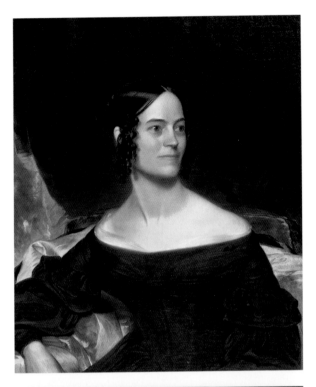

William Edward West,
Elizabeth Steuart Calvert,
circa 1839, oil on canvas,
30³/₈" x 25³/₈" (The Johnson
Collection, Spartanburg, S.C.)

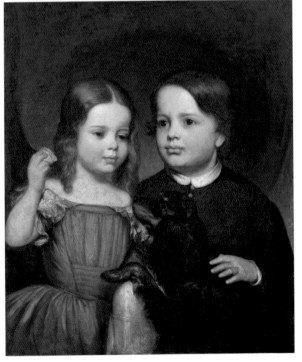

William James Hubard,
Willie and Ella Hubard,
Children of the Artist,
circa 1848, oil on canvas,
30" x 25¹/₈" (The Johnson
Collection, Spartanburg, S.C.)

William Charles Anthony Frerichs,
Falls of Tumahaka, Cherokee
County, North Carolina, *after
1855, oil on canvas,* 31⅞" x 54"
*(The Johnson Collection,
Spartanburg, S.C.)*

Richard Clague Jr., In Old Louisiana, *between
1859 and 1873, oil on canvas, 18" x 12"
(The Historic New Orleans Collection, 1989.96)*

Thomas Satterwhite Noble,
The Price of Blood, 1868,
oil on canvas, 39¼" x 49½"
(Morris Museum of Art,
Augusta, Ga.)

Joseph Rusling Meeker,
Mississippi Delta Bayou,
1872, oil on panel, 16⅛" x
13¾" (The Historic New
Orleans Collection, 1975.101)

(top) Gilbert William Gaul, Van Buren, Tennessee, *circa 1881, oil on canvas, 29⁵/₈″ x 44″*
(The Johnson Collection, Spartanburg, S.C.)

(bottom) Elliott Daingerfield, Madonna and Lamb, *1892, verso, oil on canvas, 22″ x 40″*
(The Johnson Collection, Spartanburg, S.C.)

William Aiken Walker, Cabin Scene
with Cotton Field, between 1895
and 1921, oil on board, 11″ x 14″
(The Historic New Orleans Collection, gift
of Laura Simon Nelson, 2006.0430.11)

Clara Weaver Parrish, The Sisters, circa 1910–20,
color drypoint on paper, plate mark: 11¾″ x 7⅜″
(The Johnson Collection, Spartanburg, S.C.)

Helen Maria Turner, Song
of Summer, *circa* 1915,
oil on canvas, 30¹⁄₈″ x 40¹⁄₈″
*(The Johnson Collection,
Spartanburg, S.C.)*

Anna Catherine Wiley, Lady with
Parasol, *circa* 1915, *oil on canvas,*
25¹⁄₈″ x 20¹⁄₈″ *(The Johnson
Collection, Spartanburg, S.C.)*

(top) John McCrady, Steamboat 'Round the Bend, 1920, colored pencil and wash on board, 7½" x 15" (The Historic New Orleans Collection, 1980.234)

(bottom) Alice Ravenel Huger Smith, Along the Beach, n.d., watercolor on paper, 16¾" x 20⅞" (The Johnson Collection, Spartanburg, S.C.)

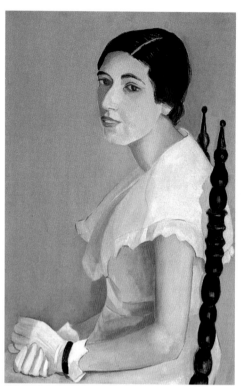

(top) Josephine Marien Crawford, Young Woman Wearing White Gloves, *between 1928 and 1935, oil on canvas, 28″ x 18″ (The Historic New Orleans Collection, bequest of Charles C. Crawford, 1978.23.4)*

(bottom) Alberta Kinsey, Shadows-on-the-Têche, *circa 1929, oil on canvas, 16¼″ x 21⅛″ (The Historic New Orleans Collection, 2008.0361.1)*

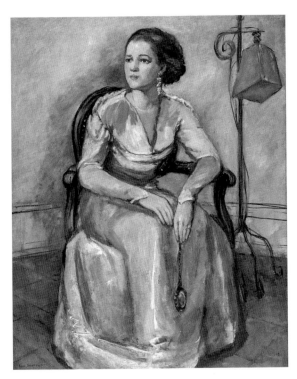

Anne Wilson Goldthwaite,
Portrait of Frances Greene
Nix, circa 1935–40, oil on
canvas, 49½″ x 39½″
(The Johnson Collection,
Spartanburg, S.C.)

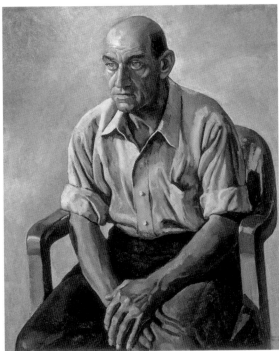

Daniel Webster Whitney,
Portrait of Man, circa 1939,
oil on canvas, 35″ x 29⅛″
(The Historic New Orleans
Collection, Gift of Mrs. Daniel
Whitney, 1984.231.4)

(top) Walter Inglis Anderson, Chicken and Chicks, n.d., circa 1940–45, watercolor and graphite on paper, 24⁷⁄₈″ x 19″ (The Johnson Collection, Spartanburg, S.C.)

(bottom) Fritz Bultman, Acteon Mask Still Life II, 1941, oil on canvas (The Ogden Museum of Southern Art, New Orleans, La. / Gift of the Roger H. Ogden Collection)

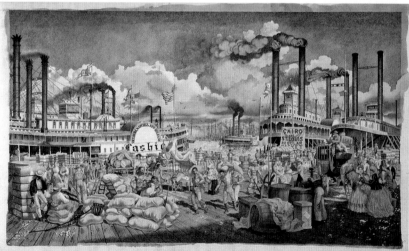

(top) Anthony Thieme, Charleston Doorway, 1946–47, oil on canvas,
30½″ x 36½″ (Morris Museum of Art, Augusta, Ga.)

(bottom) Boyd Cruise, The Levee at New Orleans, 1959, watercolor on paper, 20¾″ x 36″ (The Historic
New Orleans Collection, gift of Mr. and Mrs. Raymond H. Kierr in memory of Robert M. Kierr, 1992.94)

(top) Roger Brown, Trailer Park, Truck Stop, 1971, oil on canvas, 48″ x 60″ (© The School of the Art Institute of Chicago and the Brown family)

(bottom) William Eggleston, "Memphis (Woman with an Ankle Bracelet)," 1974, Dye-transfer photographic print (The Ogden Museum of Southern Art, New Orleans, La. / Gift of the Roger H. Ogden Collection)

Douglas Bourgeois,
Carson McCullers,
1981, oil on canvas,
12" x 12"
(Morris Museum of
Art, Augusta, Ga.)

Edward Rice, 923
Telfair, 1982–85,
oil on panel,
48" x 48"
(Morris Museum of
Art, Augusta, Ga.)

James W. (Bo) Bartlett III, Homecoming, 1995, oil on linen, 83″ x 125½″, (Collection of the Columbus Museum, Columbus, Ga.; Museum purchase made possible by Norman S. Rothschild in honor of his parents, Aleen and Irwin B. Rothschild, G.98.32)

Benny Andrews, Walkers with the Dawn, 2005, oil and collage on paper, 28″ x 22⅜″ (The Johnson Collection, Spartanburg, S.C.)

Clark, Eliot Candee

(1883–1980) PAINTER.

Eliot Candee Clark benefited greatly from being the son of an artist and from traveling as a child with his father's circle of friends. Clark's artistic education is directly linked to his proximity to successful American artists and his absorption of their working styles. As a mature and established artist, Clark was equally well known for his writings about art, his teaching, and his leadership in organizations founded to promote American art.

Born in New York City on 27 March 1883, Clark was the son of noted landscape painter Walter Clark and his wife, Jennifer. Young Clark's education included spending significant time on painting trips with his father and his father's contemporaries. By the time he was a young adult, he had traveled to the artist colony in Gloucester, Mass., as well as to the American West and British Columbia and throughout Europe. The only formal education Clark acknowledged was at the Art Students League in New York City, where he studied with John Henry Twachtman. Before he turned 18, Clark had had his landscape paintings accepted for exhibition at some of the most prestigious venues in New York: the National Academy of Design, the New York Water Color Club, and the Society of American Artists. His work showed the influence of French Barbizon painters and James McNeill Whistler.

In 1906 Clark returned from his European travels and established a studio in the Van Dyck building in New York City. This period, which lasted until 1922, was highly productive. He exhibited his work frequently, taught at the Art Students League, was elected an associate at the National Academy of Design (he became a full academician in 1944), and served as president of the American Water Color Society. Clark contributed articles about artists and art history to magazines and eventually wrote monographs on several leading artists and a history of the National Academy of Design. Clark made frequent trips, including to the Grand Canyon, Nova Scotia, and the Yosemite Valley.

Clark married in 1922, and the couple moved to Kent, Conn., but he continued to maintain a studio in New York City. He was a founding member of the Kent Art Association. When his marriage dissolved in 1932, Clark purchased a home in Virginia and became increasingly interested in Eastern philosophy, which prompted an extended visit to the Far East, including India and Tibet.

Englehard, an estate on the outskirts of Charlottesville, Va., became the home of Clark and his second wife, Margaret. He taught seasonally in several states, including two winters in Savannah, Ga. He lectured and wrote about art and the history of art, held leadership positions, including that of president, of the National Academy of Design, and exhibited widely, until he retired to his estate in 1959, where he continued to paint. Clark died in May 1980 at the age of 97. His work is found in many private collections and museums, including the Metropolitan Museum of Art, the Na-

tional Academy of Design, the Smithsonian American Art Museum, the Morris Museum of Art in Augusta, Ga., and the Woodrow Wilson House in Washington, D.C. His papers are found at Syracuse University Special Collections Research Center and at the Archives of American Art.

Augusta State University

Eliot Candee Clark, *Eliot Clark (1883–1980): Artist, Scholar, World Traveler* (1990); Gina Greer, *American Paintings, 1869–1940* (2000); Donald Keyes, *Impressionism and the South* (1988); Richard H. Love, *Walter Clark (1848–1917) and Eliot Clark (1883–1980): A Tradition in American Painting* (1980); Estill Curtis Pennington, *A Southern Collection* (1992); Ronald G. Pisano, *Eliot Clark, American Impressionist, 1883–1980* (1981).

Clark, Kate Freeman

(1875–1957) PAINTER.

In the early 1890s Kate Freeman Clark left her home in Holly Springs, Miss., and enrolled in drawing and painting courses at the Art Students League in New York, where she studied under John Henry Twachtman, Irving Ramsey Wiles, and William Merritt Chase. Initially Clark went to New York to attend the Gardner Institute, a finishing school, but her aptitude for drawing and painting impressed her mother enough to allow her to enter the Art Students League, where figure studies and still lifes dominated her artistic production under Chase's tutelage.

Enthralled with Chase's masterful approach and Munich school manner, Clark left the Art Students League in 1896 and began studies at his Chase School of Art. She then followed Chase to his first class of summer instruction at the Shinnecock Hills Summer Art School. Located on the eastern end of Long Island, the school became the first major summer art colony of its kind.

Clark relished the lectures and demonstrations in landscape painting and enjoyed painting *en plein air*. Like many other students, she was fascinated with Chase, a natural teacher full of enthusiasm. Leading by example, Chase encouraged his students to launch directly into a painting in order to realize an immediate response to the imagery without careful preliminary compositional layout or drawing. His art lectures were often peppered with admonitions, to which Clark gave careful thought. Her production of oil sketches and finished works was steady, disciplined, and perhaps even prodigious. She completed at least one work daily during the three- to four-month school period, executing large paintings as well as those that were painted on cigar box lids. Clark returned to this summer outdoor painting school for five consecutive summers.

As winter and summer studies with Chase became a routine for Clark, her works increased in number and competency. The majority of her landscapes were painted at Shinnecock Hills, many of which bear tangible similarities to those by Chase. Clark's landscapes reflect Chase's preference for persistent diagonals, undramatic scenery, the earthy color schemes of the French Barbizon painters, quick, confident brushwork, soft treatment of distant spaces, and genteel subjects.

268 CLARK, KATE FREEMAN

Although numerous similarities between these two artists might be comforting to some viewers, it might suggest instead that Clark was a follower not yet comfortable with her own viewpoint. Whatever the case, Clark tasted recognition. She exhibited in New York at the National Academy of Design, the Carnegie Institute in Pittsburgh, the Boston Art Club in 1905, the Buffalo Fine Arts Museum in 1910, and the Concord School of Art in Washington, D.C. One of her works was selected for the 1915 Panama-Pacific Exposition in San Francisco. In testing her abilities against her contemporaries, Clark, reserved by nature and social class, concealed her gender by signing works "Freeman Clark" and declined to sell her paintings.

Clark's promising career received a personal blow when her mentor, Chase, died in 1916 after a lingering illness. The health of her grandmother and mother declined, the former dying in 1919 and the latter in 1922. With the loss of her inner circle of support, Clark seemed to lose momentum and focus. She stored all of her paintings and drawings in a warehouse in the New York City area, returned to her family home in Holly Springs, and essentially stopped painting, despite the fact that she had basically no responsibilities and a generous inheritance. Clark, who died in 1957, left money to build a facility in Holly Springs to house and exhibit her works. The Kate Freeman Clark Art Gallery houses more than 1,000 oil paintings, watercolors, and drawings.

THOMAS DEWEY
University of Mississippi

Kathleen McLain Jenkins, in *Mississippi Women: Their Histories, Their Lives,* ed. Martha H. Swain et al. (2003); Cynthia Grant Tucker, *Kate Freeman Clark: A Painter Rediscovered* (1981).

Cloar, Carroll

(1913–1993) PAINTER.

As a young boy growing up in Earle, Ark., Carroll Cloar remembered the regional stories and folktales that his parents and others told him. "I could actually remember how I visualized those things when I was told about them, and I painted that way," Cloar later recalled. "I've tried to keep a child's point of view, the simplicity, the wonder."

Cloar graduated from Southwestern College in Memphis, and after two years as a student at the Memphis Academy of Arts he journeyed to New York and enrolled in the Art Students League, studying under Harry Sternberg and Ernest Fiene. In 1939, after nearly four years of study, Cloar was awarded a MacDowell Traveling Fellowship from the Art Students League and used it to travel through Mexico. After service in the U.S. Air Force during World War II, he received a Guggenheim Fellowship for 1946–47 and spent another year in Mexico painting in oil. Afterward, Cloar adopted tempera as his preferred medium, and between 1950 and 1954 he traveled to Central and South America and to Europe, intermittently living and working in New York. The European trip caused a significant change in his career. While there, the artist later recounted, "I just painted, copied things I thought were visually interesting—and then I began to have ideas for my paint-

Carroll Cloar, Where the Southern Cross the Yellow Dog, 1965, casein tempera on Masonite (Brooks Museum of Art, Memphis, Tenn.)

ings from childhood." Upon his return to America, the artist moved to Memphis and began to explore the roots of his upbringing, examining old photographs and reacquainting himself with earlier memories.

Cloar adapted his painting style to one based on the expressive color and linear design of folk paintings, but with very sophisticated results. "I had a whole series of ideas, which I called *Childhood Imagery*, remembering how I thought of things as a child." The first, *My Father Was as Big as a Tree*, depicted his father, a burly ex-logger, standing alongside a stylized tree of similar height, while showing himself as a grim-faced child in a soapbox racer, far smaller and distant. Cloar's colors grew luminescent and dreamlike, while natural features were rendered with otherworldly uniformity. He exhibited

at the Alan Gallery in New York and was praised by several critics as having a rare gift for observation and imagery. "The fact is, the image in art has neither beginning nor ending," Cloar wrote five years later. "It is a moment in time, isolated from the hours and days that surround it, and the vision comes to the artist whole." Cloar evoked vivid memories of his family and friends— their faces, dress, and customs locked in the eerie stillness of his paintings. Titles like *Panthers Chasing the Little Girls*, *Brother Hinsley Wrestling with the Angel*, and *Charlie Mae and the Raccoon Tree* are indicative of the rich lore that Cloar tapped in his art. In 1959 he purchased an old frame house in Memphis and remodeled part of it into a studio and gallery. Next to the front entrance, on the outside of the house, Cloar created a 14-foot-high mosaic titled *A Garden of*

Love, which depicted children against a patterned background of flowers.

Much of Cloar's work after 1960 portrayed the inhabitants of his native region doing such seemingly everyday activities as laboring in a cotton field, killing time in front of a local store, or walking along a narrow country road. The manner in which these scenes are rendered causes the ordinary to become extraordinary. The viewer loses the awareness of time or of a specific place in these paintings; instead, the observer's senses are sharpened by Cloar's use of rhythmic stroke and pattern and his intensified light and color. Shadows seem as palpable as solid forms, and the scenes take on a visionary resonance. Paintings like *Where the Southern Cross the Yellow Dog* re-create, in an unforgettable way, the legacy of an incident in southern culture.

In 1969, after Cloar was given a priceless hoard of photographs taken by an African American photographer in his hometown, he began to incorporate some of the unidentified, haunting images into his work. All types of people, from Works Progress Administration quilters to unidentified wedding guests, were transposed into the artist's dreamlike vision. "Cloar's real power, and it enables him to transcend mere eclecticism, derives from his feeling for time, especially past time," the painter and critic Sidney Tillim has written. "It is an identification so strong that even contemporary events or portraits, when represented by Cloar in his fastidious style, appear to have occurred long ago or seem to be passing into timelessness." Certainly Carroll Cloar, like William

Faulkner, evoked a South far beyond the mere commonplace and has elevated it to art.

RICK STEWART
Dallas Museum of Art

Catalog of Paintings by Carroll Cloar, Southwestern University Burrow Library Monograph No. 6 (1963); Paul Cummings, ed., *Dictionary of Contemporary American Artists* (4th ed., 1983); Beverly Joyce, *World in Art: Carroll Cloar and the Truths of Fiction* (1991); Guy Northrup, *Hostile Butterflies and Other Paintings by Carroll Cloar* (1977).

Cooke, George

(1793–1849) PAINTER.

George Cooke was born on 13 March 1793 in St. Mary's County on the eastern shore of Maryland and baptized in the Episcopal faith at St. George's Church, Chaptico. His earliest effort, a copy of a Gilbert Stuart portrait, came to the attention of Gen. John Mason of Leesburg, Va., who attempted to place him under the tutelage of the Peale family in Philadelphia. Rembrandt Peale's fee could not be met, however, and Cooke remained largely self-taught. By 1812 Cooke had settled in Georgetown, District of Columbia, where he became a partner in a mercantile venture selling housewares and groceries. On 13 March 1816 he married Mary Ann Heath, a union resulting in several patrons for his future career as a portraitist. Following the demise of his dry goods store, in 1819 Cooke purchased four versions of Gilbert Stuart's portraits of the first four presidents and copied them in oil. He then began his career as a portrait artist with itinerant visits to his wife's family in Richmond. In 1824

Cooke studied with Charles Bird King in that artist's gallery-studio in Washington, D.C., at 486 12th Street NW. By 1825 Cooke reported having made 130 portraits, including 40 in Richmond, of which the most notable extant work is that of the Mrs. Mann S. Valentine family.

With funds accumulated from commissions, in July 1826 the artist departed with his wife for Europe. After landing in Le Havre, France, and making stops in Paris, Dijon, and Milan, the couple took up residence in Florence in October. Following one year of study at the art academy of Florence, Cooke then moved on to Rome, where he remained through 1828. There he met Henry Wadsworth Longfellow, with whom he established a long-term correspondence. During his Roman sojourn, Cooke began making large copies of old master paintings, beginning with Raphael's *Transfiguration*. After a visit to Naples in 1829, he returned to Washington, D.C., and exhibited *The Conspiracy of Catiline* and the *Interior of St. Peter's Rome* in Chester Harding's studio. He traveled to Europe to paint a copy of Théodore Géricault's *Raft of the Medusa* on site in the Louvre, which was exhibited in New York in November 1831. After 1832 he began to paint landscape art and topographical views in the warm tones of the Hudson River school, spending some time in the Catskills and making a well-known image of West Point.

Throughout the years 1834 to 1837, Cooke traveled extensively, sketching in the Charlottesville vicinity in 1834, painting portraits in Raleigh, N.C., in 1835, exhibiting his work in Boston and New York that same year, and in 1836 making itinerant visits as a portrait artist to Virginia. Cooke also began writing articles for the *Southern Literary Messenger* in 1835. That same year, it is possible that Cooke made the acquaintance of Edgar Allan Poe, who was hired as an assistant editor.

In 1837 Cooke returned to Washington, D.C., where he assisted Charles Bird King in painting portraits of American Indians. Cooke's first visit to Athens, Ga., in 1840 so impressed the artist and his wife that it became a base for itinerant visits to several urban areas in Georgia, including Augusta, Milledgeville, Macon, and Columbus. Late in 1842 Cooke was in New Orleans for the first time, and in April 1843 he announced plans for a permanent gallery of art in that city, a project supported by Daniel Pratt, an Alabama industrialist, and James Robb, a noted local collector and financier. At his National Gallery of Painting, Cooke displayed works of art by some of the leading American painters of the day, including Thomas Sully, Emanuel Leutze, and Daniel Huntington. During this time he also made frequent visits to Prattville, Ala., to paint members of Daniel Pratt's extended circle of family and friends.

Late in 1848 Cooke decided to make Athens, Ga., his permanent home. While on a visit to New Orleans to close his National Gallery of Painting in March 1849, he contracted Asiatic cholera and died. He was buried in Prattville, where Daniel Pratt erected a gallery in his memory. The gallery in Prattville was demolished in the late

1860s. His monumental *Interior of St. Peter's Rome* remains in the chapel of the University of Georgia.

ESTILL CURTIS PENNINGTON
Paris, Kentucky

William Nathaniel Banks, *Antiques* (September 1972); Cooke Family Papers, Maryland Historical Society, Baltimore; George Cooke, *Southern Literary Messenger* (March, April, and May 1835); Andrew J. Cosentino and Henry Glassie, *The Capital Image: Painters in Washington, 1800–1915* (1983); Donald Keyes, *George Cooke, 1793–1849* (1991); Estill Curtis Pennington, *Romantic Spirits: Nineteenth-Century Paintings of the South from the Johnson Collection* (2011); Marilou A. Rudolph, *Georgia Historical Quarterly* (June 1960).

Cooper, Don

(b. 1944) PAINTER.

A native of Belton, Tex., Don Cooper moved to Georgia with his family as a small child. He was raised near the geographic center of the state, and he was deeply influenced by that physical environment, a fusion of the urbane, the industrial, and the utterly rural. Macon is the state's largest city, and the nearby Milledgeville was once the state capital. It is, as the designation "Middle Georgia" implies, central in practically every way. Cooper attended public schools in Madison, Milledgeville, Haddock, and Gray before matriculating at the University of Georgia, where he earned a B.F.A. in 1966 and an M.F.A. in 1968—both with an emphasis on painting and drawing. While at Georgia, his principal teachers were Sam Adler, Lamar Dodd, Jim Herbert, and Irving Marantz. Almost immediately after

he completed graduate school, he was drafted into the U.S. Army and saw service in the Vietnam War. His experience of Southeast Asia—particularly under the circumstances in which he encountered it—had a profound and lasting effect on the style, content, and intent of his work, as well as on him personally.

On mustering out of the army, Cooper took up his life's work as an artist and teacher, possessing experience and a worldview unusual in one so young. In 1971 he joined the art faculty at West Georgia College, where he remained until 1976. When the demands of an active career as a painter outside the classroom took precedence, he gave up teaching, returning to it only in 1990, and only in a part-time adjunct capacity for a semester at the Atlanta College of Art. In 1994 he became an adjunct faculty member at the Atlanta College of Art on a more committed basis and remained in that position until 2006. Cooper found that accepting teaching assignments, even on a limited basis, was a significant commitment, given the challenges of time management that he faced. Between 1973 and the present he has been represented in more than 70 group exhibitions, and his work has been the subject of more than 30 solo exhibitions in galleries and museums in Atlanta, New York, Chicago, and London, to cite just a few. He has also lectured widely.

Once thought a kind of "magic realist," Cooper's work through the 1990s incorporated suggestions of narrative that are supported by a visual vocabulary uniquely his own, combining, as it does, ghostly symbols of the Asia

that he read about as a youngster and later experienced firsthand as a young soldier. His mature work also incorporates some very specific references to the place he has chosen to make his home. The southern landscape, most particularly the vistas offered by south Georgia, provides imagery that is as evocative and suggestive as any subject apparently more "Zen-like" that he employs.

The work titled *Extreme Southeast Georgia* (1990) is suggestive of a reality that was determined by a Buddhist temple. The painting was, in fact, the direct result of a visit Cooper made to the old Andrew Carnegie family estate, which survives as a ruin on Cumberland Island, just off the coast of Georgia. Intrigued by a physical setting that seemed to have more in common with Angkor Wat than with Georgia, he sought to capture the setting's mysteriously evocative quality. He employed a symbol system and rich coloration to interpret the universality of the human need for a developed sense of place.

For several years, Cooper has painted concentric circles radiating from a tiny red dot called the *bindu*, varying the format ever so slightly in scale, color, and media. At first glance these paintings seem to be characterized by a visual illusion resulting from the interplay between complementary colors that appear almost to vibrate in rings of subtly increasing intensity. (*Bindu* is a Sanskrit term that means "point" or "dot." Cosmetically, in Hinduism, it is applied to the forehead to indicate a starting point. In metaphysical terms, *bindu* is held to be the point at which begins creation.)

Cooper sees these paintings as a sustained meditation on spiritual transcendence and the journey of life. To this artist, process is as important as product in his artwork. He begins a new work by making a pinprick in the very center of the composition. It serves as both a point of departure and as a visual metaphor for birth or beginning. Employing a compass, he begins to draw circles, moving outward in larger and larger concentric circles, which expand toward the physical edge of the surface — whether it is canvas or paper on which he is drawing. Each ring is painted with up to 60 layers of thinly pigmented acrylic or watercolor. Cooper states, "Going around and around in these circles is like reciting a mantra." His focused process produces images that are stunning in their visual complexity yet generous in their simplicity.

Cooper has been the recipient of many honors and awards, including fellowships from the Southeastern Center for Contemporary Art, the Fulbright Foundation, the Southern Arts Federation, and the Museum of Contemporary Art of Georgia. His work is held in the permanent collections of many museums, including the Albright-Knox Gallery in Buffalo, N.Y.; the Greenville County Museum of Art, Greenville, S.C.; the Lauren Rogers Museum in Laurel, Miss.; the Morris Museum of Art, Augusta, Ga.; and the High Museum of Art and the Museum of Contemporary Art of Georgia in Atlanta, Ga. Many important corporate collections number Cooper paintings among their holdings — among them Bell South in Washington, D.C.; Hos-

pital Corporation of America in Nashville; Prudential Insurance Company in Newark, N.J.; and Alston & Bird, Coca-Cola, Georgia Power Company, King & Spalding, and Troutman and Sanders, all in Atlanta. Annually, millions of travelers see his work in Atlanta's Hartsfield-Jackson International Airport, where it is part of the airport's permanent collection. Cooper continues to live and work in Atlanta.

KEVIN GROGAN
Morris Museum of Art
Augusta, Georgia

J. W. Cullum, *Art Papers* (November–December 1987); Catherine Fox, *Atlanta Journal-Constitution* (23 November 2001 and 3 August 2003); Peter Morrin, *Don Cooper* (1985); Debra Wolf, *Atlanta Journal-Constitution* (15 August 2008); John Yau, *Artforum* (October 1987).

Coulon, George David

(1822–1904) PAINTER.
At the time of his death, George David Coulon, who had painted in New Orleans for six decades, was referred to as "the Dean of Art Spirit in Louisiana." Coulon was born in France on 14 November 1822 and immigrated to New Orleans with his family in 1833. Educated in New Orleans public schools, Coulon subsequently studied art with Toussaint François Bigot, François Fleischbein, Antoine Mondelli, and Julien Hudson, a free man of color.

In his autobiographical notes, Coulon wrote that as a child he wished to become an artist and made "drawings and colored them with indigo, the juice of herbs and berries," the first known record of this type of innova-

tive chemistry in Louisiana. In 1839 Coulon assisted muralist Léon Pomarède in painting an over-life-size copy of Raphael's *Transfiguration* in the apse of St. Patrick's Church on Camp Street, a painting that is still extant. St. Patrick's, built for the English-speaking population, was the second Catholic church constructed in New Orleans. Coulon also assisted in painting a ceiling fresco (now destroyed) in the Old Criminal Court in the Cabildo, the seat of government during the Spanish colonial period.

In 1841 Coulon executed his first portrait "for Italy," the whereabouts of which is unknown. His second portrait, *Young Boy Holding a Rose*, painted the following year, is in the collection of the Louisiana State Museum in New Orleans. In 1845 Coulon began relining canvases and restoring paintings and, along with Aimable Désire Lansot, was one of the city's earliest artists engaged in "restoration." From 1851 to 1865 Coulon taught drawing and painting at "young Ladies' Institutions," where he gave private lessons. His known students include John Kingston, Marie Madeleine Seebold (Molinary), Marie Thérèse Bernard de Jaham, Eloise Walker Duffy, Adine Reed, and Carrie Trost.

A cofounder of the Southern Art Union (1880) and the Artists' Association of New Orleans (1885), Coulon taught with the Artists' Association and remained active with the organization in his later years. He painted portraits, still lifes, animal studies, genre scenes, religious scenes, and landscapes, especially Louisiana bayou scenes. Life in

Louisiana was precarious, and although Coulon painted portraits from life, he also made over 100 portraits from death masks. The meticulous finish of his portraits and his jewel-like landscapes underscore his early training under his father, a watchmaker. Coulon's wife, son, and daughter were also artists, and the extent of his family's joint efforts on portraits signed by him cannot be determined.

Coulon notes that he received commissions for charitable and religious institutions, including an 1848 nativity scene. After 1853 he painted portraits from photographs, working with photographer John Hawley Clarke. After he began working from photographs, Coulon's paintings became less painterly, more anatomically correct in their rendering, and more highly finished. From about 1885 through 1897 he painted portraits of eight Supreme Court justices, including Frank D. Chretien, Pierre Derbigny, Thomas T. Land, Joshua Lewis, François-Xavier Martin, Pierre Soulé, and James G. Taliaferro. Opera singer Adelina Patti, whom Coulon cited among his patrons, inscribed one of Coulon's drawings to her manager: "A Monsieur Engle Souvenir de la Louisiane par Adelina Patti-Nicolini."

In 1850 Coulon married Marie-Paoline Casbergue, a New Orleans native who had been one of his students. Paoline Coulon, as she was known, was born on 14 June 1831. She was active as an artist from 1867, but there are few surviving works signed by her. Known for her animal studies, especially *nature morte*, she contributed to her husband's commissioned portraits, particularly the detail work of the sitter's accoutrements. Forced by ill health to retire in 1901, she died in New Orleans on 3 July 1914 at the age of 83. The couple had five children—the two who lived past infancy were both artists, George Joseph Amedé Coulon and Mary Elizabeth Emma Coulon. In 1887 George A. Coulon was the first person to take a handheld camera into the Atchafalaya Basin. He published the outcome of his trip in *350 Miles in a Skiff through the Louisiana Swamps*, illustrated with his photographs. A painter of portraits, still lifes, and animal studies, he also painted a 28-panel series of fruit, fish, and game for Fabacher's Restaurant, located at 137 Royal Street in the French Quarter.

Emma Coulon studied under her father's tutelage, but her talent surpassed that of the other members of her family. She painted portraits, still lifes, and genre scenes, including life in rural Louisiana.

At the age of 79, and at the request of his artist-friend Bror Anders Wikström, Coulon made the first known effort to record early artists who worked in Louisiana. The sketchy notes, written on 24 March 1901, are based on Coulon's memory and at times are imprecise. Additionally, Coulon provided his own biographical notes.

JUDITH H. BONNER
The Historic New Orleans Collection

Anglo-American Art Museum, *The Louisiana Landscape, 1800–1969* (1969); Judith H. Bonner, in *Collecting Passions*, ed. Susan McLeod O'Reilly and Alain Masse (2005), "George David Coulon: A Nineteenth Century French Louisiana Painter and His Family" (M.A. thesis,

Tulane University, 1983), inaugural exhibition catalog, Louisiana State University Museum of Art (2005), *Louisiana Cultural Vistas* (Winter 2007–8), *Southern Quarterly* (Winter 1982); George A. Coulon, *350 Miles in a Skiff through the Louisiana Swamps: Views and Diary* (1888); Joseph Fulton and Roulhac Toledano, *Antiques* (April 1968); William H. Gerdts, George E. Jordan, and Judith H. Bonner, *Complementary Visions of Louisiana Art: The Laura Simon Nelson Collection at the Historic New Orleans Collection* (1996); John A. Mahé II and Rosanne McCaffrey, eds., *Encyclopaedia of New Orleans Artists, 1718-1918* (1987); R. W. Norton Art Gallery, *Louisiana Landscape and Genre Paintings of the Nineteenth Century* (1981); Martin Wiesendanger and Margaret Wiesendanger, *Louisiana Painters and Paintings from the Collection of W. E. Groves* (1971).

Couper, Josephine Sibley

(1867–1957) PAINTER.

A versatile and prolific painter who championed modernism, Josephine Sibley Couper was a leading figure in the Carolinas during the first half of the 20th century. For two decades a resident of Spartanburg, S.C., she was cofounder of its Arts and Crafts Club, predecessor to the city's present art museum. Her presence at Tryon in the North Carolina mountains during the final decades of her long and productive career affirmed that colony's important place in southern art.

Josephine Sibley was the 15th child in a wealthy family of Augusta, Ga. At the age of 12 she first toured Europe, where the splendid art made a great impression upon her. An art instructor was engaged for her and a studio was built for her on the grounds of the Augusta mansion, and in 1886 she enrolled at a Charleston art academy. But soon Josephine announced her desire for more challenging training in New York. There she studied at the Art Students League with William Merritt Chase. In 1890 she traveled in Europe. The next year she married Georgia cotton broker Butler King Couper and thereafter was known socially as Mrs. B. King Couper, though she signed her canvases "J. S. Couper." The couple lived in Marietta, near Atlanta, for nine years while Mr. Couper managed a knitting mill. In 1900 he started a textile firm at Spartanburg, a progressive city booming with investments by northern and southern capitalists.

Besides rearing her children, Mrs. Couper was heavily involved in charity work, donating money to good causes from her art sales. Margaret M. Law, scion of another prominent Spartanburg family, had studied under Chase, and she and Couper had a great deal in common. In 1907 they cofounded the city's Arts and Crafts Club, and from the outset its exhibitions were anything but parochial. The first show included paintings by such New York luminaries as Chase and Robert Henri. Couper's enthusiastic fund-raising enabled the club to purchase Henri's *Girl with Red Hair* for $500.

During her Spartanburg period, Couper traveled to the North Carolina mountains for study with Elliott Daingerfield, champion of women artists and instructor at the Philadelphia School of Design for Women, conducted at his summer studio at

Blowing Rock. Couper and Dainger-field also crossed paths at Tryon, at that time emerging as an important creative colony, situated 30 miles from Spartanburg on the Southern Railway to Asheville. Artists and writers could reach Tryon comfortably by rail the same day, or overnight, from major cities of the Northeast, Midwest, and South, at a time when other attractive mountain destinations not on railways, like Blowing Rock, involved time-consuming, arduous road journeys.

Her husband's death in 1913 changed Couper's life greatly. By the early 1920s she had relocated to Montreat, the resort of southern Presbyterians near Asheville. She spent summers in Massachusetts at the Gloucester colony, near where her son was enrolled at Massachusetts Institute of Technology. There she was in the circle of leading American modernists, and Couper's art went through a stylistic shift. In 1929 and 1930 she worked in France with André Lhote, who pushed her to experiment more freely with abstraction; one of the resulting canvases was included in the Salon d'Automne. During this feverish period she had a solo exhibition at Atlanta's High Museum and five solo shows in New York. A Couper mountain landscape depicting North Carolina was reproduced as a cover for the influential *Literary Digest*.

Gloucester and Montreat were "seasonal" places—Tryon less so, with many permanent residents gathered from numerous original locales. In 1934 Couper acquired the picturesque Rock House, originally constructed by her friend Margaret Law's family for a real estate venture, directly opposite Tryon's busy little train depot and adjacent to the popular Oak Hall Hotel. She renovated the log-and-stone building, designed by imaginative architect J. Foster Searles, for personal living space, commercial art gallery, and working studio. The studio's tall north window framed an impressive view of Tryon Peak, and the gallery showcased modern art in a space with unusual character. With great energy, Couper established her Rock House Gallery as an art magnet, orchestrating shows of important artists with Tryon connections. Her 1938 solo show for New York artist Charles Aiken, for example, came about as a result of his founding the Fifteen Gallery, where Couper had exhibited in Manhattan.

MICHAEL J. MCCUE
Asheville, North Carolina

Zan Schuweiler Daab, *Josephine Sibley Couper and the Southern Art Spirit* (2002); Suzanne Harper, Dorothy Joiner, and J. L. S. Jennings Jr., *Josephine Sibley Couper: Daughter of the Old South/Artist in a Modern World* (1992); Michael J. McCue, *Tryon Artists, 1892–1942* (2001).

Crawford, Josephine Marien

(1878–1952) PAINTER.
Josephine Marien Crawford's painting style is singular. Along with Paul Ninas, Crawford is credited with having introduced cubism to the city of New Orleans. Daniel Webster Whitney and Will Henry Stevens also painted in a cubistic style, but the work of each of these artists is distinguishable one from the other. Crawford's near-monochromatic faceted works and her transitional paintings are immediately

identifiable. Her painting skills developed late in life, with her earlier focus being on poetry. Born in New Orleans on 31 December 1878, Josephine was the middle child of seven children born to Charles Campbell Crawford and Louise Bienvenu Crawford. Josephine lived in the Vieux Carré at 612 Royal Street for her entire lifetime, with the exception of her period of study in France and her frequent vacations to visit family on the Mississippi Gulf Coast or in Indiana.

Crawford, who traveled widely through Europe, Central America, and Mexico, carried a sketchbook as early as 1888. Although she first learned to draw from instructional books she acquired at Libraire Français on Chartres Street, she received her secondary schooling at McDonogh High School No. 3. In October 1895 Crawford enrolled at Newcomb College to study modern languages, but she withdrew in April 1896.

By 1926 Crawford was studying at the Arts and Crafts Club of New Orleans at 520 Royal Street in the Vieux Carré, a block from her family home. After summer studies in Mississippi at the Ocean Springs Art Colony under Whitney, Crawford was one of seven modernist artists who exhibited at the Arts and Crafts Club in January 1927 and one of four students showing their works at the club's annual invitational later that year. Crawford skipped the opening reception and traveled to Paris to the atelier of cubist theorist André Lhote for a year of study that profoundly affected her artistic style. She kept journals of his teachings and aphorisms and adhered to his philosophies on art for the remainder of her painting career.

In November 1928 Crawford and Angela Gregory, both at home after their studies in Paris, had a joint show at the Arts and Crafts Club. Crawford, who exhibited there throughout her lifetime, received the 1934 Blanche S. Benjamin Prize for *Rue Kerlerec*, which depicted a widow wearing a dark veil and holding a palm leaf fan.

Crawford's portrait of Lydia Brown, a fellow artist and family friend, was probably painted before her studies with Lhote. Brown was on the board of the Arts and Crafts Club and was one of the first artists to exhibit there. This portrait, which is rendered in thickly applied oil paint with overlaying transparencies, is more tactile than her later work and conveys a greater sense of depth. The dappled watercolor washes in an early introspective portrait of a young woman bear a distinct kinship to the oil painting *Artist with Model*, possibly a self-portrait, particularly in the manner of applying mottled color.

As Crawford's artistic style developed, her canvases became more simplified. In one of her most minimalist compositions, *Her First Communion*, the geometric arrangement appears flat but at the same time suggests depth through the subtle use of a restricted band of warm color juxtaposed between modulated gray bands. An undated preparatory pencil drawing reveals the subtle changes Crawford made as she transferred the sketch to her canvas, further simplifying the composition.

Early in the development of Crawford's artistic style, art critic Vera Morel wrote of Crawford's "empty canvases" where "one may feel the stillness and

silence." By the time Crawford won the prestigious Benjamin prize in 1934, her quiet, simplified style was mature.

Between January 1927 and December 1934 Crawford made a series of eight over-life-size family portraits on the walls of her French Quarter home. Using photographs as models, Crawford worked diligently to simplify the compositions in order to capture the ethereal essence of her ancestors. She prepared the wallpaper with a thin coat of gray over a whitewash and limited her palette to restricted areas of color. These 14-foot-high wallpaper portraits include Crawford's mother, Louise Bienvenu, as a young girl with a watering can and rake; her father, Charles Campbell Crawford, with the spirit of his father behind him; and the family governess with two of the Crawford girls.

Josephine Crawford entered her painting of *Bonnets* in a members show at the Arts and Crafts Club. Sculptor Enrique Alférez praised Crawford's painting of a milliner's shop for its "combination of tone and masses sensitively arranged into a fine pattern." Alférez had served as a juror on the selection committee that awarded Crawford the 1934 Benjamin prize for her painting *Rue Kerlerec*.

In 1937 Crawford's painting *Girl under a Mosquito Net* was exhibited in New York at the Second National Exhibition of American Paintings, a show that was intended to represent a "cross section of the creative art of this country." Other New Orleans artists included in the exhibition were Conrad Albrizio, Caroline Wogan Durieux,

Xavier Gonzalez, Clarence Millet, Paul Ninas, and Will Henry Stevens.

After Crawford's death in 1952, her brother Charles Crawford inherited her artworks. In September 1965 the family home at 612 Royal Street sustained damage from Hurricane Betsy, after which Charles Crawford had his sister's wallpaper paintings removed from the walls of the French Quarter house and hung in his Garden District home. Crawford bequeathed the collection of his sister's paintings to the Historic New Orleans Collection, where they were exhibited in 1978. Josephine Crawford, who died on 25 March 1952, left a truly memorable mark not only on the French Quarter but also on the cultural life of the city.

JUDITH H. BONNER
The Historic New Orleans Collection

Artists' Files, Williams Research Center, Historic New Orleans Collection; Catherine Jean Farley, "The Life and Work of Josephine Marien Crawford, 1878–1950" (M.A. thesis, Tulane University, 1988); Louise C. Hoffman, *An Artist's Vision: Josephine Crawford* (2009); Greenville County Museum of Art, *Eight Southern Women: Blanche Lazzell, Josephine Marien Crawford, Nell Choate Jones, Clara Weaver Parrish, Alice Ravenel Huger Smith, Helen M. Turner, Mary Harvey Tannahill, Anne Goldthwaite* (1986).

Cress, George Ayers

(1921–2008) PAINTER.

For over 55 years as a teacher, George Cress helped shape the art department at the University of Tennessee at Chattanooga (UTC), influencing several

generations of artists in the city. As an artist, his lyrical abstract paintings reflect his continuing fascination with the landscape of his beloved eastern Tennessee and northern Georgia.

Cress was born in 1921 in Anniston, Ala. He studied art with Lamar Dodd, Carl Holty, and Jean Charlot at the University of Georgia (B.F.A., 1942; M.F.A., 1949). From 1945 until 1951 Cress taught briefly at several different colleges, when he went to the University of Chattanooga (later the University of Tennessee at Chattanooga) as the head of the department, a position he held for 32 years. The Cress Gallery of Art on the campus is named in honor of the artist's contributions to the university. Cress continued as Guerry Professor Emeritus, until his death on 1 January 2008.

Beyond his academic career, Cress was influential in the development of the arts community in Chattanooga and involved in a number of organizations throughout the Southeast. He sat on the board of the Hunter Museum of American Art and was active in several regional organizations, including the Southeastern College Art Conference and the Tennessee College Art Council, which he helped found. As noted in the landmark catalog, *Painting in the South, 1564–1980*, "Clearly, Cress was committed as an artist to the growth of an art audience not only in his own locality but also in the South as a whole. As such, he typifies the postwar southern painter's desire to encourage the development of cultural institutions in his native region." His work is in numerous private and public collections. He has exhibited throughout the Southwest in museums and galleries since the 1950s.

In the 1940s Cress worked in a realistic manner. His work gradually became more abstract, until the 1960s, when he developed his mature style in abstract landscape painting. Cress used geometric forms and saturated colors to capture the plains of the Tennessee Piedmont or the sheer faces of river bluffs or mountain escarpments. Cress created a few still lifes and portraits, but the bulk of his paintings, drawings, and watercolors focused on Appalachia. His works are not an exact transcription of the land but instead a subtle interpretation drawn from it. As the artist noted, "I still return to certain familiar locations in northeast Georgia to paint on site. In this outside studio, I paint not the landscape but from the landscape."

ELLEN SIMAK
Hunter Museum of American Art Chattanooga, Tennessee

Lamar Dodd, John Benz, and Gail Hammond, *George Cress: Twenty Years* (1971); William Henning Jr., *A Catalogue of the American Collection, Hunter Museum of Art, Chattanooga, Tennessee* (1985); Donald B. Kuspit et al., *Painting in the South, 1564–1980* (1983); Barry Moser, *George Cress: Paintings and Drawings, 1953–2005* (2006); E. Alan White, *George Cress: 50 Years of Painting* (1990).

Cruise, Boyd

(1909–1988) PAINTER.
Best known today for his carefully detailed renderings of historical French Quarter scenes, Boyd Cruise was born

on 20 October 1909 in Cains, Miss. His early childhood was spent in the small Louisiana town of Franklin and then in Crowley in the heart of Acadiana. In 1918 his family moved to nearby Lake Charles. While in high school Cruise worked as a window decorator at Muller's Department Store, as well as acting in theater productions and creating stage sets for the Lake Charles Little Theater. His art studies began in September 1928 at the Arts and Crafts Club of New Orleans School of Art, to which he had earned a scholarship. Cruise's classmates at the school were Jeannette LeBoeuf, Dorothy Spencer, Juanita Gonzales, and Mary Basso (McCrady), all of whom continued their art careers.

In 1930 Cruise won second place in an exhibition at the Arts and Crafts Club. The following year he won the Blanche S. Benjamin award and a scholarship to the Pennsylvania Academy of the Fine Arts. In Philadelphia he worked as a doorman and then switchboard operator at the Arts Alliance Club. During his second year at the academy, Cruise won the Charles M. Lea Memorial Award and the John M. Packard prize; in his third year he won the Cresson Traveling Scholarship Award, which allowed him to visit six European countries. The following year Cruise again received the Cresson award and honorable mention in the Charles Tappan prize. He completed his courses at the academy and traveled to Europe once more.

Upon his return to New Orleans, Cruise accepted a research position with the Works Progress Administration,

under the direction of architect Richard Koch. During this time Cruise was introduced to the watercolor drawings of the New Orleans Notarial Archives. Cruise executed hundreds of watercolor paintings for the Historic American Buildings Survey, 56 of which he exhibited in a 1936 solo exhibition at the Arts and Crafts Club, in addition to another solo that same year. After these two shows, Cruise took part in a group exhibition with LeBoeuf, Charles Hutson, and Alberta Kinsey.

Cruise also served as scenic director for Le Petit Théâtre du Vieux Carré and taught at the Arts and Crafts Club and Newcomb College. In 1938 Cruise held a solo show at the Isaac Delgado Museum of Art (now the New Orleans Museum of Art). He worked as an inspector for the Vieux Carré Commission and was represented by the Kennedy Gallery in New York City. During World War II, he worked for the Camouflage Division of the U.S. Navy in Washington, D.C.

In 1942 the Kennedy Gallery held a Cruise exhibition, *Old New Orleans and Flower Studies*, for which he received positive reviews. He also exhibited at the Arts Alliance Club in Philadelphia and in New Orleans at Lieutaud's, the Art Association of New Orleans, and the New Orleans Art League, the latter of which he also served as president. He became the curator for Leila and L. Kemper Williams's private art collection. After the Williamses established the Historic New Orleans Collection in 1966, Cruise became its first director, a position from which he retired as director emeritus in 1974. Although Cruise is better known for his

architectural renderings of historical French Quarter buildings, he also painted scenes of Mexico, still lifes, and vignettes of Louisiana life. Cruise died in New Orleans in early December 1988 at the age of 79.

JUDITH H. BONNER
The Historic New Orleans Collection

Artists' Files, Williams Research Center, Historic New Orleans Collection; Mary Louise Christovich, *Boyd Cruise* (1976); Florence M. Jumonville, *Manuscripts* (Fall 1990).

Daingerfield, Elliott

(1859–1932) PAINTER.

Elliott Daingerfield was born in Harpers Ferry, Va., in 1859, but his family soon moved to Fayetteville, N.C., where his father served as commander of the Confederate arsenal. Daingerfield grew up rooted in the traditions of the South, yet his artistic training and professional advancement took place in the New York art world. In the South of his youth, shaped by the Civil War and Reconstruction, Daingerfield had only limited opportunities to study art, which included training in china painting and in commercial photography, and for a time he worked as a sign painter.

At the age of 21, in 1880, after Daingerfield moved to New York to study art at the National Academy of Design, he became a studio assistant to Walter Satterlee and then an instructor in Satterlee's class. Before the end of his first year, Daingerfield exhibited a painting at the National Academy of Design. He studied at the Art Students League, as well as under Kenyon Cox, who became a friend and professional colleague.

Daingerfield married Roberta Strange French, the daughter of a judge from Wilmington, N.C., in 1884. In the fall of that year he moved to the Holbein Studios, where he met George Inness, one of the most successful painters of that era. Inness, who advanced the ideals of the French Barbizon school and advocated a subjective vision for American art, became a mentor and major influence upon Daingerfield and the development of his mature vision. Through Inness and the Holbein Studios, Daingerfield became friends with leading members of the city's intellectual and artistic elite.

In 1886 Daingerfield first ventured to Blowing Rock, N.C., searching for a place to recover from diphtheria. At Blowing Rock, he recovered his physical health and discovered an environment that would serve as a source of inspiration for the rest of his life. With the intellectual and artistic stimulation in his New York studio and the tranquility of his summer residence in the Blue Ridge Mountains, Daingerfield had discovered the sites that would govern the annual cycles of his artistic and personal life.

During the 1880s and 1890s Daingerfield's reputation advanced in New York art circles, and his skilled Barbizon-style landscapes earned him a reputation as the "American Millet." During these years he met Albert Pinkham Ryder and was influenced by this artist's paintings and aesthetic philosophies. By the middle of the 1890s Daingerfield focused on spiritual themes in his art, significantly influenced by the death of his wife, Roberta, who died in child-

birth in 1891, as reflected in a major painting, *The Mystic Brim* (1893). By 1893 Daingerfield's art had evolved to a mature state. His use of painting to express emotions as well as his visions of the spiritual world reflected his understanding of symbolist developments in European and American art.

From 1895 to 1915 Daingerfield entered a period of intense creativity, painting many tonalist and symbolist landscapes, as well as religious murals in churches like the chapel at St. Mary the Virgin in New York. He also painted the diverse atmospheric environments he discovered in Blowing Rock and the Blue Ridge Mountains, including *Sunset Glory* (ca. 1915) and related views of Grandfather Mountain. By 1910 his skills as a painter of landscapes, religious subjects, murals, and introspective imagery had earned him critical respect and public recognition. While he maintained studios in New York and Blowing Rock, he began to teach and write critically about art and artists. In 1902 he was elected to associate membership in the National Academy of Design, and by 1906 he achieved full membership in the academy.

Daingerfield was invited by the Santa Fe Railroad to accompany a group of artists, including Thomas Moran, Frederick Ballard, Edward Potthast, and DeWitt Parshall, on a rail trip to the Grand Canyon in 1910. This was a profound and spiritually inspiring trip for Daingerfield, leading to the creation of major symbolist paintings, including *The Spirit of the Storm* (1912), *The Genius of the Canyon* (1913), and *The Sleepers* (1914). Back in Blowing

Rock in 1916, Daingerfield completed the construction of his Greek Revival home and studio, Westglow, which is preserved as a spa outside of Blowing Rock today. In his later years he worked seasonally in his New York and Blowing Rock studios and traveled to Europe. He spent time in Venice and completed a series of notable, visionary views of that city, including *A Dream of Venice* (ca. 1924). Until the time of his death, in his New York studio in 1932, Daingerfield painted Venetian views, which continued the symbolist and architectural visions initiated in his unique paintings of the Grand Canyon.

J. RICHARD GRUBER
Ogden Museum of Southern Art
University of New Orleans

Bruce Chambers, *Art and Artists of the South* (1984); Elliott Daingerfield, "Sketch of His Life—Written by Elliott Daingerfield—in Response to a Request," unpublished and undated manuscript, Elliott Daingerfield files, Center for the Study of Southern Painting, Morris Museum of Art, Augusta, Ga.; Charles C. Eldredge, *American Imagination and Symbolist Painting* (1979); J. Richard Gruber and Estill Curtis Pennington, in *Victorian Visionary: The Art of Elliott Daingerfield* (1994); Robert Hobbs, *Elliott Daingerfield Retrospective Exhibition* (1971).

Dale, Ronald Guy (Ron)

(b. 1949) POTTER, CLAY AND WOOD SCULPTOR.

Ronald Guy (Ron) Dale was born on 26 January 1949 in Spruce Pine, N.C., and lived there for two and a half years before moving to Asheville with his parents and older brother (a singer-

songwriter who dabbles in clay). After graduation from high school and a turn in the U.S. Navy, he enrolled at the University of North Carolina at Asheville for two years (1973–75), before going to Vermont to finish a B.A. in art from Goddard College (1977) and then to Louisiana State University for an M.F.A. in ceramics (1979). He taught at the University of Mississippi from 1980 until becoming professor emeritus in 2005.

During these years Dale was a favorite professor of numerous students, art majors, and others who took his classes as electives, and he was named outstanding teacher of the year in 2002. He also taught ceramics at the Penland School of Crafts in North Carolina in the summers of 1985 and 1995, at Cortona, Italy, in the summer of 1987, and at Blackhills Pottery in Elgin, Scotland, in the fall of 2000. He has lectured and conducted ceramics workshops throughout the South and has received numerous awards, including a Southern Arts Federation Emerging Artist Award in 1985 and the Mississippi Institute of Arts and Letters Visual Arts Award in 1992. His work is in numerous private and public collections and has been shown in 25 solo exhibitions and in nearly 100 group/invitational exhibitions throughout the nation.

Dale works in two modes. One is making dinnerware, cups, pitchers, bowls, trays, and vases. "More than 30 years ago I began making useful pots," he says, inspired by his teachers Byron Temple and Cynthia Bringle and by the work and words of potter Bernard Leach. "Throughout these decades as an artist and a teacher I have learned to use many firing techniques . . . and try to combine strong tradition with an awareness of contemporary meaning in developing simple, straightforward forms. . . . The process is complete only when the pots are used."

Dale also uses clay and wood to create multidimensional sculptures. "My sculptural work has evolved out of the traditional vocabulary of the vessel," he explains. "Combined with architectural and furniture imagery, I am able to explore concepts of altered space and perspective, light and shadow, and the flattening of form while allowing for a more direct expression of ideas—ideas dealing with both social and personal issues."

Art critic Lisa Howorth illustrates Dale's social criticism through sculpture with her description of *Ain't Life Great (in the Big House)* (1991–92), a work that uses low-fired clay vases and a table and "mirror" made of wood: "Two classical amphorae refer to classical black-figure ware, but these are not Greeks: they are African Americans—one burdened with a bale, one with pregnancy. Reflected in the green mirror is an elegant, carpeted room opening out onto an airy balcony; beyond that is the relentless infinity of cotton fields. The imposing scale heightens the irony of experiencing material wealth and the dubious system of acquiring it."

Is This My Graceland? (1991–92) pays tongue-in-cheek homage to Mississippi artist George Ohr, known as the Mad Potter of Biloxi, who died in 1918. Dale duplicated 21 of Ohr's kinky and distorted vessels and arranged them on

shelves that lean perilously outward, typical of Dale's work. Among the vessels are some elegant pissoirs and the infamous vagina pots. Ohr also experimented with photography, and copies of his zany self-portraits hang in a gallery setting reflected in a mirror above the shelves. "It's a piece that's closer to me than any other I've done," Dale says, "since it's really autobiographical."

Art historian Patti Carr Black describes Dale's sculptures as "elegant and witty," and Howorth notes the animation that pervades his work: "'Cartooning was the only way I could draw when I was young,' Dale says, and he still relies on it to give his work whimsical, irreverent humor. Dining-room chairs are crowned with Mickey Mouse ears; a mirror is framed by ruby red lips; and some tables have ostrich legs for that same sense of a large, ungainly, flightless body poised atop absurdly delicate legs."

Dale admits that painting has had a greater influence on his work than ceramics, as his recent creations demonstrate. Inspired by Italian painter and printmaker Giorgio Morandi, Dale has created sculptures that are still life compositions of bottles and vessels in wooden frames of various sizes and shapes. The works appear two dimensional and flat when viewed from the front but are clearly three dimensional when approached from other angles.

After reading *The Good Life*, Helen and Scott Nearings' 1954 book on back-to-the-land self-sufficiency, Dale said he was determined to combine his life and working conditions as a way of life. He designed and built the home in rural Lafayette County near Oxford where he and his wife reared their daughter and son. With the opening of Irondale Studio in 1996 on land next to his home, Dale's dream is now being realized.

ANN J. ABADIE
University of Mississippi

Patti Carr Black, *Art in Mississippi, 1720–1980* (1998); Lisa N. Howorth, *Ceramics Monthly* (June, July, and August 1994), *The South: A Treasury of Art and Literature* (1993).

Delaney, Joseph

(1904–1991) PAINTER.
Joseph Delaney was born to the Rev. and Mrs. Samuel Delaney in Knoxville, Tenn., in 1904, the ninth of ten children and sixth of six boys. Samuel Delaney was a minister in the African American Episcopal Church, serving as a circuit rider in Harriman, Lafollette, and other small parishes near Knoxville before becoming the minister of Vine Avenue Methodist Church in Knoxville.

Delaney began drawing—on religious cards—in his father's church. After completing the ninth grade at Knoxville Colored High School, he left school and worked at odd jobs at the Cherokee Country Club and the Farragut Hotel. He traveled to Kentucky in 1922 seeking employment in a coal mine. When refused, he began a life on the road, gambling and working at odd jobs in the Midwest. He settled in Chicago in 1925, where he enlisted in the Eighth Illinois National Guard and entered the local jazz world, making the acquaintance of Albert Ammons, Ma Rainey, Peter Johnson, and Big Joe Turner. In 1929 he returned to Knox-

ville, where he sold insurance and founded a local Boy Scout troop.

Delaney was one of many young artists to be encouraged by prominent local artist Lloyd Branson. The Depression dimmed Delaney's hopes in Knoxville, and he moved to New York in 1930. After a brief stay in Harlem, he moved to lower Manhattan, a neighborhood where he would live and paint for the next 56 years. He enrolled in the Art Students League, studied with Thomas Hart Benton, and modeled for Kenneth Hayes Miller, an important teacher of figure drawing of that time. His fellow students included Jackson Pollock, Bruce Mitchell, and Henry Stair. He also studied with figure artist George Bridgman.

Delaney exhibited at the first Washington Square Outdoor Art Exhibition in 1931, a principal venue for exhibiting his work for the next 40 years. During those exhibitions he also made sketches of important visitors, including Eartha Kitt, Arlene Francis, Tallulah Bankhead, and Eleanor Roosevelt. He was accepted into the Works Progress Administration Artist's Project in 1935, with an assignment to the Brooklyn Boy's Club. He also worked as an assistant to Edward Laning, whose mural *Story of the Recorded Word* was created for the New York Public Library. Laning's panoramic historical perspective and sensibility would influence many of Delaney's later works. In another capacity he illustrated objects for the Metropolitan Museum's *Index of American Design*. Awarded the Julius Rosenwald Fellowship in 1942, he took off on a journey from Percy Rock, Maine, to Charleston, S.C., making sketches of local street life and nightlife along the way.

From 1943 to 1964 Delaney worked at various odd jobs while continuing to paint and model. He was a sketch artist for the Ghana Exhibit at the New York World's Fair, 1964–65. He taught in Art Students League workshops and at the Vermont Academy in the summer of 1968. Always in need and with scarce means, he was employed by the comprehensive Employment and Training Act, 1978–80, as artist in residence at the Henry Street Settlement in New York.

Delaney was a longtime resident of Union Square, New York. He remained in New York until 1986. Following a retrospective exhibition of his work at the University of Tennessee in Knoxville in 1986, he was named artist in residence for the University of Tennessee art department. He spent the remainder of his life in Knoxville and died at the University of Tennessee Medical Center on 21 November 1991.

Joseph Delaney is one of the most important African American artists to emerge from the South in the 20th century. His portrait sketches demonstrate the profound sense of line he developed in his studies with Thomas Hart Benton, Charles Bridgman, and Alexander Brook, even as his paintings offer an exceptionally individualistic approach to the expressionist movement. Many of his paintings elevate the dialogue about the conjunction between local-color artists in the South and national and international trends in the art of social concern and urban realism.

ESTILL CURTIS PENNINGTON
Paris, Kentucky

Romare Bearden and Harry Henderson, *African American Artists from 1792 to the Present* (1993); Joseph Delaney, *Thirty-six Years Exhibiting in the Washington Square Outdoor Art Show* (1968); David C. Driskell, *Two Centuries of Black American Art* (1976); Patricia Hills, *Social Concerns and Urban Realism* (1983); Frederick C. Moffatt, *The Life, Art, and Times of Joseph Delaney, 1904-1991* (2009), *Life in the City: The Art of Joseph Delaney* (2004); Sam Yates, *Joseph Delaney Retrospective Exhibition* (1986).

Dewing Woodward, Martha

(1856–1950) PAINTER.

At age 11 Martha Dewing Woodward vowed to never marry and instead focus on her art. She dropped her first name of Martha when she was in Europe because of the continental discrimination against female painters. As a result, she became known in biographical dictionaries as both "Dewing-Woodward" and "Dewing Woodward" and on occasion was erroneously referred to as "he."

Indefatigable in her artistry as well as in her extraordinarily active life, Dewing Woodward studied at the Pennsylvania Academy of the Fine Arts and in Europe. In Paris she experienced the tutelage of Joseph-Nicolas Robert-Fleury, Claude Lefebvre, and the great William-Adolphe Bouguereau, who advised her to "copy no one." She also received instruction at the Académie Colarossi.

From 1882 to 1886 Dewing Woodward held the position of dean of fine arts at Bucknell University. Later, prestigious European exhibition halls, including the Paris Salon in 1893 and 1895 and the Académie Julian, where she won a prize in 1894, mounted her work. She also displayed her work in Marseilles from 1897 to 1903 (earning a gold medal in 1903), in Nantes (winning another medal), and in Venice.

Dewing Woodward's brainchild was the Blue Dome Fellowship (also known as Blue Dome Frat or Fraternity), an association founded in Woodstock in 1913 while a group of artists roasted marshmallows. Earning money was a struggle, yet Dewing Woodward achieved much acclaim. In 1917 an entire article devoted to her portrait drawings was published in *International Studio*. About that time, curious to learn about Miami and anxious to be able to paint *en plein air* year-round, the monetarily deficient artist arrived in the area and soon took up residence with her close friend Louise Johnson. Dewing Woodward fell in love with the light and climate of Miami—it reminded her of Provence, France. She made the city her home and extended the Blue Dome Fellowship there, which became one of the longest-lasting art associations in Florida. In 1918 Dewing Woodward headed the Blue Dome Fellowship from its headquarters at 219 Twelfth Street in Miami.

By the 1920s Dewing Woodward had moved to Coral Gables, precipitated by her "admiration for its residential section and high moral atmosphere," and she brought along her Blue Dome Fellowship. She was "appalled" that there was no fine arts department at the University of Miami, so she helped create one. She taught pupils there and was its dean from 1926 to 1928. She proudly quipped that even "before the school

became a department, we graduated one student with the bachelor of fine arts degree." Her pupils were advised to not "worry about choosing a career. Let it choose you. Then set it up like a target for marksmanship. Take careful aim and fire. Whatever you do, don't scatter your fire!"

In the late 1920s Dewing Woodward's painting *Golden Warblers* was placed in Coral Gable's grand Biltmore Hotel. Concurrently, the Florida Federation of Women's Clubs founded the Florida Federation of Art, and in 1928 Dewing Woodward was named its president. Her New Deal commissions included a mural, titled *Migration*, of Seminole life for the Coral Gables Woman's Club and panels in the State College for Women in Tallahassee (now Florida State University). Her *Morning Song of the Pines* still hangs in the Miami Woman's Club. During the 1940s, her painting *Dragon Fly* brought $1,500 in an auction benefiting blind war heroes, and at a war bond auction, *Sunrise*, portraying a soaring egret, reached a then-astronomical price of $7,000.

Among other outstanding accomplishments, Dewing Woodward was a charter member in establishing the Tropical League of Fine Arts, which raised funds for the University of Florida; a founder of the Round Table of Southern Florida; the director of the Florida Society of Arts and Sciences; and the winner of many awards for furthering art and culture in South Florida. Shortly before she died in 1950, she said, "I know that somehow I shall always go on with my painting." In her obituary,

the *New York Times* described her as "one of the nation's leading painters."

DEBORAH C. POLLACK
Palm Springs, Florida

Lois M. Fink, *American Art at the Nineteenth-Century Paris Salons* (1990); Florence N. Levy, ed., *American Art Annual* (1919, 1920, and 1947); Maybelle Mann, *Art in Florida, 1564–1945* (1999); *Miami News* (29 July 1919); *New York Times* (14 June 1950); Ralph Rees, *Bucknell World* (November 1991).

Dodd, Lamar

(1909–1996) PAINTER.

Lamar Dodd, one of the preeminent painters of Georgia, was born in Fairburn and received a five-year Certificate of Art and diploma from LaGrange High School in 1926. After a short period as a student in the School of Architecture at the Georgia Institute of Technology, Dodd enrolled in the Art Students League of New York. He studied with Charles Bridgman and Boardman Robinson and privately with George Luks, who had achieved his reputation as a member of Robert Henri's circle of urban realists. After a year back in LaGrange devoted entirely to painting, Dodd had his first solo exhibition at the High Museum of Art in Atlanta. He then returned to the Art Students League for a period of further study with Jean Charlot and John Steuart Curry. The young Georgia artist was thus exposed to a range of gifted teachers who worked in traditional representative modes, most of whom believed in an art that depicted and elevated the everyday scene.

Dodd returned to the South in 1934 and spent the next three years honing his artistic skills, while holding down a job at an art supply store in Birmingham, Ala. His efforts were rewarded when he received an award at the annual national exhibition at the Art Institute of Chicago in 1936. His paintings in this period were portrayals of ordinary things in his environment that most people would overlook. For example, he made sketches of a slag dump—evocative paintings that seemed to convey more than just an outward appearance. "I wanted to create a feeling of solid forms," he recalled of this period, "to capture the mood of a place."

In 1937 Dodd joined the faculty of the art school at the University of Georgia at Athens. A short time later he became head of the art department and embarked on a distinguished career as a teacher active in many educational, civic, and professional groups. Within a few years he was named one of the outstanding artists in America, with successful solo exhibitions in New York at the Ferargil Galleries and in Washington, D.C., at the Corcoran Gallery. Dodd accepted a visiting professorship at the University of Southern California in 1942 and traveled through the Southwest. Similar jaunts in the Midwest followed, and he became president of the Association of Georgia Artists and of the Southeastern Art Association in 1946. Meanwhile, his painting continued to receive high praise. "What he portrays of Georgia is a more elusive and deeper quality, a turn of mind, a design for living, that may seem clan-nish to outsiders, but is rich in rewards for those born to it," his friend and former teacher Charlot wrote in 1944. In 1948 Dodd was named Regents Professor of Art at the University of Georgia and assumed the presidency of the Southern States Art League. Many painting awards followed, as the artist gained fame as one of the outstanding painters of the South. By 1950 he had been awarded two Carnegie grants and was elected president of the College Art Association of America.

Dodd's painting had developed from an initial style of realism based on the language of forms to a more abstract version in which formal considerations began to dominate. His paintings depicting cotton pickers toiling in a field, for example, conveyed their mood and situation by means of an expressionistic handling of form and color. "Dodd is a realist in that he finds his inspiration in his environing world," one critic wrote in 1949, "but his translation of his personal reactions to it reveal his subtle perception of the character of his visual experiences and of the relation of the things observed to one another." He was cited as a bold and vigorous colorist who achieved "poetry in the plastic language of the paint itself." Dodd continued to exhibit and lecture widely, including a stint in Europe for the United States Information Service in 1956. He was appointed a charter member of the U.S. Advisory Committee in the Arts the following year and participated in the first cultural exchange between the United States and the Soviet Union in 1958.

Perhaps one of the artist's most

interesting honors was his appointment in 1963 as an official National Aeronautics and Space Administration (NASA) artist for the Mercury astronaut project; he covered Gordon Cooper's orbital spacecraft launching at Cape Canaveral. His resulting work was included in the landmark *Eyewitness to Space* exhibition at the National Gallery of Art in 1965. Dodd again served as NASA artist in 1968 and 1969 for the Apollo 7 and Apollo 10 launchings. From this experience the artist produced a series of abstract works, some of which indicate his fascination with the idea described by one reviewer as the "poetic experience of men standing many thousands of miles outside the earth and looking back upon it as persons who are at once infinitely detached and yet very much of the earth." Dodd culminated his outstanding career by painting a frontier that is as yet unexplored; he succeeded in translating his southern environment into the universal language of art.

RICK STEWART
Dallas Museum of Art

Emily Ann Arthur, ed., *Lamar Dodd: The C. L. Morehead Jr. Collection* (1997); Lamar Dodd, *Lamar Dodd: A Retrospective Exhibition* (1970); William U. Eiland, *Lamar Dodd: Georgia's Own* (1996), *The Truth in Things: The Life and Career of Lamar Dodd* (1996); Anne King, *A Shared Vision: The Life and Art of Lamar Dodd* (1996); Gudmund Vigtel, *Lamar Dodd* (2008).

Dormon, Caroline

(1888–1971) PAINTER, WRITER, NATURALIST.

Born at Briarwood, her family's summer home near Saline, La., Caroline Dormon dedicated her life to the close study and protection of nature. Dormon felt compelled to share what she called "the gift of the wild things" through numerous paintings, articles, books, photographs, gardens, and a national forest shaped by her hand.

Dormon trained in fine art at Judson College in Marion, Ala., graduating in 1907, before returning to teach singing and drawing in Louisiana. Dormon spent most of her life in and around the hills and pine forests of north-central Louisiana. Here she developed her vast knowledge and appreciation for local flora and fauna, though she also explored extensively the marshes of south Louisiana. Dormon produced scientifically accurate and aesthetically beautiful records of her discoveries and compiled a set of these in her book *Wild Flowers of Louisiana* (1934). Dormon's watercolors, oils, pastels, sketches, and prose appear in periodicals and subsequent books, including *Forest Trees of Louisiana* (1941), *Flowers Native to the Deep South* (1958), *Natives Preferred* (1965), *Southern Indian Boy* (1967), and *Bird Talk* (1969). Dormon also illustrated *Gardens in Winter* (1961), written by Elizabeth Lawrence. Many of Dormon's original plates from *Wild Flowers* are housed at Longue Vue in New Orleans, the estate of Edith R. Stern, who helped underwrite the book's publication.

Stern also invited Dormon to collaborate with Ellen Biddle Shipman on the Wild Garden at Longue Vue. Landscaping with native plants was a particular delight for Dormon. Her philosophy in this regard required "doing

the work in such an artfully natural manner that it appears as if no planting has been done." In addition to Longue Vue, Dormon was involved in planting at Hodges Gardens in Many, La., and at Midstate Charity Hospital (Huey P. Long Medical Center) in Pineville; she applied her vision of natural beauty to roadsides through an appointment created specifically for her with the State Department of Highways in 1941.

Perhaps Dormon's best-known legacy is the more than 600,000-acre Kisatchie National Forest. Her passion for protecting the giant longleaf pines, sandy hills, and clear streams of the Kisatchie Wold inspired Dormon as a young woman to begin correspondence with public officials, foresters, oilmen, lumbermen, and women's clubs. It was typical of Dormon that many of her early initiatives were self-funded but resulted in paying positions. In this case, her drive to save Kisatchie led her to the Southern Forestry Congress in New Orleans and employment as the first female forester with the U.S. Forest Service (1920). Not one for publicity herself, Dormon, on behalf of her causes, accepted speaking engagements throughout the South, gave tours of Kisatchie, and implemented one of the first curricula of conservation education for schoolchildren. More than 10 years after her initial inquiries, tracts of cutover land were purchased and Kisatchie was designated a national forest.

Dormon's interest in her home state extended to its original inhabitants as well. She advocated for American Indian rights and worked to preserve Native American culture and archaeological sites. Her detailed descriptions, photographs, and drawings document important tribal traditions, including Caddo pottery and the double-walled baskets of the Chitimacha. Dormon's efforts earned her the friendship and professional respect of Dr. John Swanton, chief ethnographer for the Bureau of American Ethnology. Based on Swanton's recommendation, Dormon was appointed the only female member of Franklin D. Roosevelt's De Soto Commission (1936), a seven-member body charged with retracing Spain's earliest expeditions across the Southeast.

Although self-taught in many respects, Dormon's reputation as an authority on native plants was international. She received correspondence and visits from professors and directors of botanical gardens seeking her expertise and aid in obtaining rare specimens. Dormon was especially adept at cultivating and hybridizing species of Louisiana iris. Dormon garnered accolades from the American Horticultural Society and the Garden Club of America; in 1965 Louisiana State University awarded her an honorary doctorate of science.

Dormon also wrote poetry and short stories (largely unpublished) and enjoyed literary friendships with Lyle Saxon and Ada Jack Carver, among others. She was a frequent visitor to Cammie G. Henry's Melrose Plantation, a salon for the arts in Louisiana's Cane River region. For such a pioneering spirit, Dormon described herself as

"simple" and having "a sympathetic heart." Though she shared so much with people—including establishing Briarwood as a nature preserve shortly before her death—Caroline Dormon loved the solitude of the woods best of all, even as she realized that among birds, trees, and flowers she could never truly be alone.

DANIEL J. WEBRE
New Orleans Center for the Creative Arts

Fran Holman Johnson, *"The Gift of the Wild Things": The Life of Caroline Dormon* (1990); Dana Bowker Lee, in *Louisiana Women: Their Lives and Times*, ed. Janet Allured and Judith F. Gentry (2009); Donald M. Rawson, *Louisiana History* (Spring 1983); Bonnye E. Stuart, *More Than Petticoats: Remarkable Louisiana Women* (2009); Caroline Dormon Collection, Cammie Henry Research Center, Northwestern State University, Natchitoches, La.

Douglas, Aaron

(1898–1979) PAINTER.

Aaron Douglas is widely regarded as one of the most important figures in the history of African American art in the South, but his achievement is also part of the larger history of American art. Born in Topeka, Kans., Douglas graduated from the University of Nebraska School of Fine Arts in 1925. A short time later he moved to New York City, where he immediately came under the influence of Winold Reiss, who had done work based on a study of racial and folk types. Illustrations by both men appeared in Alain Locke's pioneering study, *The New Negro*, which

was published that same year and among many other things called for the reexploration of African motifs. Douglas's work appeared in many periodicals during the full flower of the Harlem Renaissance, including *Vanity Fair*, *Opportunity*, and *Theatre Arts Monthly* and important but short-lived little magazines like *Fire* and *Harlem*. In 1927 James Weldon Johnson published his book of sermons in verse titled *God's Trombones*, with striking illustrations by Douglas, whose modernist style had been firmly established.

The artist reexamined African and Egyptian forms and interpreted them by means of interlocking forms and colors based on a careful study of cubism and other modernist art movements. His paintings frequently depicted symbolic figures intertwined with planes and shafts of modulated light in subdued, yet rich color. Douglas attempted to convey the mystical or spiritual union of American blacks with their ancestral past through formal techniques that were richly evocative.

The most important work Douglas finished in this period was a series of murals, completed in 1934 under the auspices of the Public Works of Art Project of the Works Progress Administration, which portrayed the entire African American experience. Four panels, which the artist titled *Song of the Towers*, depict, in succession, the African heritage, the Emancipation, life in the rural South, and the urban dilemma. Douglas had been invited to execute a series of murals on black life for the library at Fisk University in

Aaron Douglas, The Athlete, 1959, oil on canvasboard, 24" x 20" (The Johnson Collection, Spartanburg, S.C.)

Nashville. In 1937 the artist accepted a teaching position there as head of the art department, a post he held until his retirement in 1966. Douglas's previous associations and friendships, as well as his outstanding ability as a teacher, enabled him to enrich the lives of generations of students, and he was one of the most respected, yet self-effacing, artists of the South in the modern period. To date, there has been only limited study and exhibition of his work, leaving a large gap in the art history of the South.

RICK STEWART
Dallas Museum of Art

Renée Ate, *Aaron Douglas: African American Modernist* (2007); Romare

Bearden and Harry Henderson, *A History of African American Artists from 1792 to the Present* (1993); David C. Driskell, Gregory D. Ridley, and D. L. Graham, *Retrospective Exhibition: Paintings by Aaron Douglas* (1971); Susan Elizabeth Earle, *Aaron Douglas: African American Modernist* (2007); Caroline Goeser, *Picturing the New Negro: Harlem Renaissance Print Culture and Modern Black Identity* (2007); Nathan I. Huggins, *Harlem Renaissance* (1971); Amy Helene Kirschke, *Aaron Douglas: Art, Race, and the Harlem Renaissance* (1995).

Drysdale, Alexander John

(1870–1934) PAINTER.
Alexander John Drysdale, who is known for his misty, tonalist Louisiana bayou scenes, spent his formative years in Marietta, Ga. He was born on 2 March 1870, the son of Rev. Alexander John Drysdale and Mary Davidson Drysdale. His father moved the family to New Orleans to accept a position as rector of Christ Church Cathedral on Canal Street at the corner of Dauphine. Young Alexander, who was 15 years old when he arrived in the city, received private tutoring in accounting from Professor Mehado and art lessons from Ida C. Haskell at the Southern Art Union. Drysdale later took instruction from portrait and genre painter Paul E. Poincy and subsequently studied art in New York, where he enrolled in the Art Students League under the tutelage of Bryson Burroughs, Frank Vincent DuMond, and Charles Courtney Curran. Drysdale spent five years in New York, during which time he became influenced by the works of American painters George Inness, Robert Henri, and William Mer-

ritt Chase, as well as those of French realist painter Jean-Baptiste-Camille Corot and French impressionist Claude Monet.

After Drysdale returned to New Orleans, he took a position as clerk at a hardware store and then as teller with the New Orleans Bank. He embarked on a career in art, initially listing himself as a portrait painter at 325 Camp Street in 1905 and later moving a few blocks away to 504 Camp Street. Both locations were in what is now called the central business district. Drysdale next had a studio nearby in the Board of Trade Building and later moved his studio to 320 Exchange Place in the Vieux Carré.

Eventually, Drysdale became inspired by the Louisiana marshes, bayou areas, and other desolate wetlands. He reportedly "drifted along the bayous in a boat, a mustachioed figure in old clothes, puffing on his pipe, and finding inspiration in Barataria, Teche, Chef Menteur, and the Black River." By 1916 Drysdale had developed the technique for which he is remembered today. He thinned his oil paints with kerosene in what he termed "a water color technique applied to oil." Reportedly, he lined up his canvases or watercolor paper and first painted in the sky, after which he painted in the land areas with quickly rendered brushstrokes to delineate tall swamp grasses and marsh flowers. His impressionistic landscapes frequently feature a single moss-draped oak tree or one prominent tree in the foreground, with another in the distance. Drysdale also painted portraits, as well as producing a number of charcoal drawings, some of which were published in

local magazines. Drysdale's portraits of known sitters include one of Justice Cornelius Voorhees, now in the collection of the Supreme Court. Portraits of family members include those of his wife and son, Walden Alexander Drysdale (now in the Historic New Orleans Collection).

Drysdale was a member of the Artists' Association of New Orleans, for which he served as vice president in 1899. He also had membership in the Art Association of New Orleans, the National Association of Newspaper Artists, and the Delgado Museum of Art (now the New Orleans Museum of Art). In 1911 Drysdale exhibited a painting titled *Autumn in a Louisiana Swamp* in the inaugural exhibition at the Delgado.

Two of Drysdale's important commissions were on view to the public for many years after his death. In 1927 he received a commission to paint a series of 22 paintings for the D. H. Holmes Department Store (established in 1842), a series that was on permanent display until the store was sold in 1989. Among Drysdale's last works was a mural for the restaurant of the Shushan Airport (now Lakefront Airport). Shortly before his death, Drysdale was employed as an artist by the Civil Works Administration.

After its formation in 1922, Drysdale became a member of the Arts and Crafts Club of New Orleans. At the time of his death, his work was in collections in England, France, and Germany, as well as in the United States in the Hall of Fame, the Civil District Courts Building, the Board of Trade Building, the St. Charles Hotel, and the Roosevelt Hotel and in the permanent collections of the Louisiana State Museum and Delgado Museum of Art (now the New Orleans Museum of Art). Drysdale died in New Orleans on 9 February 1934 at the age of 63.

JUDITH H. BONNER
The Historic New Orleans Collection

Artists' Files, Williams Research Center, Historic New Orleans Collection; Howard A. Buechner, *Drysdale (1870–1934), Artist of Myth and Legend* (1985); Isaac Monroe Cline, *Art and Artists in New Orleans during the Last Century* (reprinted from *Biennial Report, Louisiana State Museum*) (1922); Donald B. Kuspit et al., *Painting in the South, 1564–1980* (1983); May B. Mount, *Some Notables of New Orleans: Biographical and Descriptive Sketches of Artists in New Orleans* (1896).

Dunlap, William Ralph (Bill)
(b. 1944) PAINTER.
William Ralph (Bill) Dunlap is a contemporary artist and educator as well as a curator, writer, and media commentator. A Mississippi native, he has long served as an advocate for the art and artists of the South and maintains studios in McLean, Va., Mathiston, Miss., and Coral Gables, Fla.

Dunlap was born on 21 January 1944 in Houston, Miss. His parents came from families of old Webster County, Miss. His mother, Margaret Cooper Dunlap, was from Mathiston and Eupora; his father, Sam Coleman Dunlap Sr., was from Grady. After the death of his father in 1947 his mother moved the family to her parents' home in Mathiston. When Dunlap's mother remarried, the family moved across the South—to Texas, South Carolina, and

back to Mississippi—contributing to the artist's broader view of the South as well as his love of exploring the region and its history. Dunlap has stated that many of his creative ideas evolve from his drives through the southern landscape.

During his youth Dunlap spent summers with his grandparents and family in Mathiston and Grady, places that still attract him. His grandfather, Cas Cooper, raised Walker hounds, the dogs that are central characters in his art, often serving as surrogates for humans. Also vital to his history and memory is the Starnes house, a neighbor's house in Mathiston, which he now owns and uses as his Mississippi home and studio. Dunlap grew up during the 1940s and 1950s immersed in the realities of small town life in an older, segregated Mississippi, which included family, local characters, issues of race, storytelling, a chinaberry tree, his grandfather's Walker hounds, sports, music, the rhythms of farm life, and the natural world. His art is based on the power of memory and association, using objects "found and fashioned," in his paintings, collages, prints, drawings, constructions, and environmental installations.

Dunlap came of age in the 1960s and 1970s, attending Hinds College, Belhaven College, and Mississippi College (from which he graduated in 1967). He traveled as a musician in Tim Whitsett's Imperial Show Band before he enrolled in the M.F.A. program at the University of Mississippi. After graduating (1969), Dunlap taught at Hinds Community College (1969–70), Appalachian State University in Boone, N.C. (1970–79), and Memphis State University (1979–80). He hosted the Southern Rim Conference (1976) at Appalachian State, founded the Appalachian State study abroad program in New York City, and was the first director of the school's Washington, D.C., program (Appalachian House).

In 1980, after he left the academic world and moved to Ranleigh Manor House in McLean, Va., Dunlap began a period of travel and research devoted to the American Civil War. The Washington art world was supportive of southern art and artists then, and he joined rising national artists there, including William Christenberry, Ed McGowin, Sam Gilliam, Robert Stackhouse, and others. During the 1980s and 1990s his work was exhibited increasingly in national museums and galleries, especially after he completed his monumental *Panorama of the American Landscape*—a 14-panel, diorama-style painting offering his reflections on the Civil War and the American landscape, which was exhibited in the rotunda of the Corcoran Gallery (1985). He went on to create a series of *Landscape and Variable* compositions, began to travel and work abroad more extensively, and became an arts commentator on public television, WETA in Washington, D.C., beginning in 1988.

In 1988, while Dunlap was in Bellagio, Italy, on a Rockefeller Foundation Fellowship, he married his second wife, artist Linda Burgess. After returning from Italy, the two maintained a studio in New York. Splitting time between the New York and Washington art worlds and working in studios in both cities, they also began to write, curate, and

organize traveling exhibitions, including *A Winding River: Contemporary Paintings from Vietnam* (1996–97). During this period, Dunlap developed more series, including his *Object Lessons*, and was featured in traveling exhibitions, including *William Dunlap: In the Spirit of the Land*, which originated at the Corcoran Gallery in 1995.

After closing the New York studio in 1999 and moving to a new home and studio in Coral Gables, Fla., near the emerging Miami art world, Dunlap entered the current period of his career. Traveling exhibitions and projects have included *Objects: Found and Fashioned*, at the Ogden Museum of Southern Art (2001); *What Dogs Dream*, at the Morris Museum (2006); and *Panorama of the American Landscape*, installations presented in New Orleans and Charleston (2004–8). In 2009 *Panorama of the American Landscape* was acquired for the collections of the Mississippi Museum of Art, where it is now on permanent display.

Since he received the Mississippi Governor's Award for Excellence in the Arts in 1991, Dunlap has served as the annual master of ceremonies for this event and as an advocate for the arts of Mississippi. After Hurricane Katrina he also worked as an advocate for the recovery of New Orleans and the Mississippi Gulf Coast. In recent years he has placed a focus on traveling art and exhibition programs created in association with his wife, Linda Burgess, and their daughter, Maggie Dunlap, who creates books and drawings. Dunlap's organization of *Storming the Ramparts: Objects of Evidence* at the Ogden Museum of Southern Art, in association with Confederate Memorial Hall (2009–10), reflects his ongoing interest in the art and history of the Civil War.

J. RICHARD GRUBER
Ogden Museum of Southern Art
University of New Orleans

William Dunlap, J. Richard Gruber, and Julia Reed, *Dunlap: William Dunlap* (2006); Mary Lynn Kotz, *Museum & Arts* (March–April 1989); Jane Livingston, *William Dunlap: The Corcoran Panorama* (1985); Willie Morris, *Homecomings*, with the art of William Dunlap (1989).

Dureau, George

(b. 1930) PAINTER, DRAFTSMAN, PHOTOGRAPHER.

George Dureau, who has received international attention for his drawings and photographs, was born on 28 December 1930 in New Orleans and spent his formative years in his native city. After completing studies at Louisiana State University in 1952, he studied at the Tulane University school of architecture. He began his career as a window dresser at the D. H. Holmes Department Store, where he was encouraged by Bunny Scherzer, a colleague in advertising, to concentrate on his art. Through the years Dureau has exhibited in numerous New Orleans venues, including the Tilden-Foley Gallery, Downtown Gallery, Galerie Simonne Stern, Galerie Jules Laforgue, Gallery Deville, Academy Galleries, Contemporary Art Center, Louisiana State Museum, and Arthur Roger Gallery, where he has shown his work since 1988.

Dureau is skillful in his rendering of human anatomy; his works exhibit a

sure hand, an economy of line, and fluid strokes of his brush or charcoal. Many of his works are inspired by mythology or by allegories from masterpieces of European painting and sculpture. Dureau, who terms himself a "Classical-Romantic," first produced abstract expressionist works before determining to follow his natural inclination and pursue figurative work. He renders figures, landscapes, and still lifes with equal dexterity and a decided control.

A number of Dureau's works display physical struggle or inner turmoil, and there is a sense of intensity in his figures, even those who appear composed and serene. Dureau turned to photography following a negative review for his work at the Orleans Gallery, the first cooperative gallery in New Orleans that promoted modernism. His photographs of male nudes, which are frequently compared with those of Diane Arbus, were an influence on the early work of Robert Mapplethorpe. Between 1979 and 1981 Mapplethorpe visited the city several times to meet Dureau and observe his artistic technique. Dureau features white and African American subjects, many of whom have amputations or missing limbs; others focus on deformity or dwarfism.

Dureau's work has been published in a number of periodicals and books. *New Orleans: 50 Photographs* was published in 1985 with an introduction by British art critic Edward Lucie-Smith, who extolled Dureau's work for consistently conveying "the character of the sitter with dignity, intensity, and honesty." He exhibits frequently in Paris, London, and Frankfurt, Germany, and in major cities throughout America. In 1986 a retrospective of Dureau's paintings, drawings, and photographs was featured in the Martin Gallery in Washington, D.C. That same year the exhibition *George Dureau La Nouvelle-Orleans* was sponsored by Ministère de la Culture Reims, Metz, and Paris. His photoprints are represented in numerous public galleries, including the Musée de Photographie in Paris. A revival of commemorative posters began in the late 1970s, through the publisher ProCreations.

Dureau, whose commissions are varied, designed posters for the New Orleans Opera Guild (1977), Mardi Gras (1979), the New Orleans Jazz and Heritage Fair (1998), and the New Orleans Symphony. He received the 1990–92 Museum Gates Sculpture commission at the New Orleans Museum of Art, and his 1990 work *The Parade Paused* was commissioned for Gallier Hall by the Arts Council of New Orleans under the Percent for Art Program. Together with Paul Cadmus, Dureau was featured in a joint retrospective exhibition at the New Orleans Museum of Art in 2008. On 15 October 2011 Dureau received the Opus Award, given annually by the Ogden Museum of Southern Art to an artist whose work constitutes a major contribution to the cultural landscapes of the American South.

JUDITH H. BONNER
The Historic New Orleans Collection

Alain Gerard Clement, George Dureau, and Valerie Loupe Olsen, *Classical Sensibilities: Images by Alain Gerard Clement and George Dureau* (1997); Edward Lucie-Smith, *New Orleans: 50 Photographs* (1985); Estill Curtis Pennington, *Look Away: Reality and*

Sentiment in Southern Art (1989); Estill Curtis Pennington and Arthur Roger Gallery, *George Dureau* (1997); George Roland, *Gentlemen Callers: Paul Cadmus and George Dureau from the Collection of Kenneth Holditch* (2008).

Durieux, Caroline Spelman Wogan

(1896–1989) PRINTMAKER, PAINTER, CARICATURIST.

Caroline Spelman Wogan Durieux was born in New Orleans on 22 January 1896 and grew up on Esplanade Avenue. She made drawings as a child and kept a sketchbook, but her formal training in art began at the Newcomb College School of Art in 1912. There she studied drawing, perspective, design, and composition under Ellsworth Woodward and earned a bachelor of design degree in 1916, graduating with honors. She won the 1914 Neill Medal for excellence in watercolor painting. Continuing her education at Newcomb, she received a second bachelor's degree in 1917. Durieux then studied art in the Vieux Carré at the Arts and Crafts Club of New Orleans School of Art. She taught at Newcomb from 1919 to 1920 and was one of the early teachers at the Arts and Crafts Club, where she exhibited her work frequently through the years. Durieux left the city in 1918 to further her formal art training at the Pennsylvania Academy of the Fine Arts, where she studied until 1920. While at the academy, she gained exposure to modernist techniques and stylistic art trends. Additionally, she established a continuing relationship with the Philadelphia art community.

Durieux also wrote poetry, contributing at least one poem to the *Double Dealer*, published from 1921 to 1926. In 1920 Durieux and her husband, Pierre Durieux, a New Orleans exporter whom she married earlier that year, moved to Cuba for his business. They relocated to Mexico and remained there until 1936. While in Mexico in 1931, Durieux turned to lithography and developed a satirical style that characterized her later work. She worked with Mexican muralists David Alfaro Sigueiros and José Clemente Orozco and was influenced by Diego Rivera, who lauded her work and painted her portrait in 1929.

She exhibited her drawings and lithographs at the Arts and Crafts Club in 1937. Upon the illness of her husband, Durieux rejoined the faculty at Newcomb in 1937 as a substitute for Xavier Gonzalez, who was on leave. She taught design, composition, still life, and oil painting. In 1938 she was appointed director of the Louisiana Federal Arts Project of the Works Progress Administration (WPA), working toward equal opportunities for African American artists. The art project created public murals and exhibitions at a WPA art gallery in the French Quarter. When Conrad Alfred Albrizio went on leave in 1943, Durieux took a position on the faculty at Louisiana State University (LSU) as a visiting instructor in printmaking. Resigning from Newcomb in 1944, she became full time at LSU, where she revived the 19th-century Barbizon school's print process and expanded the cliché verre technique to incorporate color. In the 1950s she worked with the university's scientists to develop color electron printing, a process

that involved the use of radioactive ink. She earned an M.F.A. degree from LSU in 1949, where she continued to teach, becoming professor emerita in 1964.

Durieux's experiments with electron prints and other work earned widespread acclaim, and she exhibited her work internationally. She published two books illustrating her work: *Caroline Durieux: 43 Lithographs* (1949) and *Caroline Durieux: Lithographs from the Thirties and Forties* (1977). Her work is represented in the permanent collections of the Chicago Art Institute, Historic New Orleans Collection, Library of Congress, Museum of Modern Art, National Gallery of Art, New York Public Library Print Collection, Philadelphia Museum of Fine Arts, Smithsonian Institution, Tulane University, and La Bibliothèque Nationale de France. Durieux died in 1989.

JUDITH H. BONNER
The Historic New Orleans Collection

Judith H. Bonner, *Newcomb Centennial, 1886–1986: An Exhibition of Art by the Art Faculty at the New Orleans Museum of Art* (1987); Caroline Durieux, Louisiana State University at Alexandria, *Caroline Durieux* (1967); Earl Retif and Sally Main, *From Society to Socialism: The Art of Caroline Durieux: March 26–June 15, 2008, Newcomb Art Gallery, Tulane University* (2008).

Earl, Ralph Eleaser Whiteside, Jr.

(ca. 1785–1838) PAINTER.
The successful career of painter Ralph Eleaser Whiteside Earl Jr. can be attributed largely to his lifelong association with Pres. Andrew Jackson. Son of Ralph Earl, who had begun his career as a self-taught artist and whose art re-

tained naive qualities, Ralph E. W. Earl had initially taken lessons from his father before traveling to England in 1809. In London, young Earl studied for a year with Benjamin West and John Trumbull and then lived with relatives in Norwich before traveling to Paris in 1814. The following year he returned to the United States and began working as an itinerant portrait painter in the Southeast. Like his father's, Earl's portraits would retain some provincial characteristics, despite his professional training. Because of their proportionally incorrect or exaggerated anatomical features and shallow picture planes, Earl is often regarded as a naive or folk artist.

In 1817 Earl arrived in Nashville, intent on capturing a portrait of Jackson, but as a result of his ensuing friendship with the general and his subsequent marriage to Mrs. Jackson's niece, Earl remained in the city, where he established a studio. Considered the first of Tennessee's resident portrait painters, Earl developed his business in Nashville, painting likenesses of many of Jackson's relatives and friends. This included a number of his military comrades—Col. Isaac Shelby and brigadier generals James Winchester and John Coffee. In addition, Earl established the Nashville Museum in 1818, which displayed a variety of "natural and artificial curiosities" and also housed a group of his portraits of prominent individuals. But Earl's reputation throughout the South—from Nashville and Memphis to Natchez and New Orleans—was built upon his images of Andrew Jackson. More than three dozen were completed over the course of their 20-year friend-

ship. A few of these works, which were reproduced as engravings, were circulated in Tennessee and nearby states, where Jackson was celebrated as the great hero of the Battle of New Orleans in the War of 1812.

When Jackson was elected president in 1829, Earl joined him in Washington, D.C., continuing to fill requests for portraits of the popular statesman from Tennessee. Whether depicting Jackson as a military hero, a country gentleman, or a national leader, the artist accentuated Jackson's gallantry and strength through his subject's stance and facial features. Earl typically portrayed Jackson in a three-quarter portrait, highlighting the contours of his strong chin and nose and high forehead. Topped with thick billowy white hair, this stylized image of Jackson was replicated by Earl numerous times. Because of the great amount of time he spent painting canvases of Jackson, he gained the nickname "the King's painter."

Near the end of Jackson's second term in the White House, in 1836, Earl returned to the Hermitage, and Jackson joined him a year later. Earl, who spent the last few years of his life designing the gardens on Jackson's estate, died on 15 September 1938 and was buried on the grounds of the Hermitage. Many museums, including the North Carolina Museum of Art, the Tennessee State Museum, the Cheekwood Botanical Garden and Museum of Art, the Metropolitan Museum of Art, and the National Gallery of Art, have collected Earl's work.

MARILYN MASLER
Brooks Museum of Art
Memphis, Tennessee

American Naïve Paintings from the National Gallery of Art (1985); James G. Barber, Andrew Jackson: A Portrait Study (1991); Deborah Chotner and Julie Aronson, American Naive Paintings (1992); Earl Papers, Tennessee State Library and Archives, Nashville; James C. Kelly, Tennessee Historical Quarterly (Summer 1985); Jerome R. Macbeth, Antiques (September 1971); Jessie Poesch, Art of the Old South: Painting, Sculpture, Architecture, and the Products of Craftsmen, 1560–1860 (1983); William Benton Museum of Art, The American Earls: Ralph Earl, James Earl, R. E. W. Earl (1972).

Eggleston, William

(b. 1939) PHOTOGRAPHER.
Photographer William Eggleston, popularly known as the father of color photography, was born on 27 July 1939 in Memphis, Tenn. Raised on his family's plantation in Tallahatchie County, Miss., Eggleston attended classes at Vanderbilt, Delta State, and the University of Mississippi. Although he never received a degree, Eggleston was drawn intensely to modern art, particularly abstract expressionism, during his studies. Eggleston began photographing by 1957 and was soon inspired by the vision of photographers Robert Frank and Henri Cartier-Bresson.

Although his early work was traditional black-and-white photography, by the late 1960s Eggleston was working almost exclusively with color transparency film. As opposed to Gary Winograd's confrontational street photography or Diane Arbus's studied portraits, Eggleston chose to photograph the world *literally* around him. Ostensibly freed from photographic

convention, he eschewed the formulas of composition and simply observed his environment. Images of worn shoes under a bed, a freezer brimming with packaged foods, and the interior of an oven epitomize Eggleston's curious and probing eye. Similarly arresting are his photos of the rural South. "Black Bayou Plantation, near Glendora, Mississippi" depicts plastic white containers that appear to have just spilled from a cardboard box across a dirt road. A portion of a wood structure appears at the right in the frame, beside which the road recedes into the sun-drenched landscape. As in many of Eggleston's images, there is a sense of something ominous afoot, as if calamity lurks just out of the frame.

In 1967 Eggleston traveled to New York and met John Szarkowski, then director of the Department of Photography at the Museum of Modern Art. The exhibition that resulted several years later, in 1976, the first solo exhibition of color photographs in the history of MOMA, was a watershed moment in photography. The vibrant images of seemingly banal subjects both shocked and bewildered viewers. Eggleston's most arresting images are deceptively casual, yet recklessly engaging in their ineffable sense of peril. "Untitled (Greenwood, Mississippi)," more popularly known as "The Red Ceiling," is one of Eggleston's more celebrated images. From a garish red ceiling, a bare lightbulb dangles, from which the tendrils of white extension cords slither toward the walls of the room. "It is so powerful," Eggleston said of this photo, "that I have never seen it reproduced on the page to my satisfaction. When you look at the dye transfer print, it's like red blood that's wet on the wall. . . . It shocks you every time."

Perhaps it is no coincidence that Eggleston burst into the national consciousness as the South became increasingly urbanized. His images depict a region sliding ever closer to homogenization. "One of the first things that woke me up," Eggleston commented, "was walking into some alien place, a shopping center—one of the first ones in the country—and thinking, 'It's right here.'" Eggleston's juxtaposition of old money Delta interiors, newly constructed suburbs, and desolate rural landscapes suggests a land on the cusp of an uneasy transition. Furthermore, many of his environmental portraits are of individuals who appear to uneasily negotiate their personal spaces. A man leers sideways over his coffee cup; an elderly woman stares glumly from a household doorway, the room behind her both doleful and threatening. A restless anxiety pervades much of Eggleston's portraiture, as if the subjects themselves are wrestling with psychological turmoil.

Eggleston has published over 10 portfolios and numerous monographs, including *William Eggleston's Guide*, *Los Alamos*, *Ancient and Modern*, and *The Democratic Forest*. He is also the recipient of a National Endowment for the Arts Photographer's Fellowship and a Getty Images Lifetime Achievement Award.

MAURY GORTEMILLER
University of Georgia

Geoff Dyer, *The Ongoing Moment* (2005); William Eggleston, *Ancient and Modern*

(1992); Richard Grant, *Telegraph Magazine* (29 June 2002); Charles Hagen and Nan Richardson, *Aperture* (Summer 1989); John Howell, *Aperture* (Winter 2001); Mary Werner Marien, *Photography: A Cultural History* (2006); Sean O'Hagan, *London Observer* (25 July 2004); Ingrid Sischy, *Artforum* (February 1983); Constance Sullivan, ed., *Horses and Dogs: Photographs by William Eggleston* (1994).

Ellertson, Homer

(1892–1935) PAINTER.

An avant-garde painter and important figure in the Tryon Art Colony, Homer Ellertson was strongly influenced by cubism and used abstraction in depicting southern motifs. El Taarn, his art moderne residence and studio, was a magnet for connoisseurs and creative intellectuals. Ellertson was born in 1892 in River Falls, Wis., to parents of Norwegian background. He received a degree in art from the local normal school and continued his studies at Pratt Institute in Brooklyn, N.Y., which then had a sizable Norwegian community. After Ellertson's first year he won a scholarship to Paris. Among his teachers in France was Richard E. Miller, former roommate of artist George Charles Aid, who settled in Tryon about the same time as Ellertson. When war broke out in Europe, he returned and completed his degree from Pratt.

Ellertson found lucrative work in Manhattan designing fashionable carpets, wallpapers, and textiles. In 1920 he decided to leave commercial design to devote himself to fine art in Tryon. His North Carolina oeuvre is clearly informed by the abstractionist ferment then under way in New York and Europe. Alfred Stieglitz showed Ellertson's work at his Manhattan gallery. Duncan Phillips—who visited Tryon regularly during this time and was patron of the mystical modernism of Augustus Vincent Tack, also a Tryon habitué—acquired two Ellertson canvases for his museum in Washington, D.C.

Construction of El Taarn ("Taarn" is Norwegian for "tower" and "El" is a wordplay invoking the surname "Ellertson" and the Spanish masculine article "el"), three stories with a panoramic mountain view, began in 1923 shortly after the artist's return from a European jaunt. Inspired by the strong form of an old *donjon* he saw in France, Ellertson planned El Taarn, which he executed with a synthesis of Mediterranean motifs and colorful moderne detailing. He designed its unusual iron gates and balcony railings, built-in furnishings, and 7-by-11-foot arraslike hanging, which covered one wall of his bedroom. Done in batik, *Den Oprettelse af El-Taarn Aar 1923* depicts an avant-garde mélange of episodes during the construction. It is now at Asheville Art Museum. El Taarn was featured in national magazines, and curious cosmopolites visiting Ellertson's polygonal top-floor studio often departed with paintings.

In 1925 Ellertson's painting won a medal at the Norse American Centennial in Minneapolis, ceremonially attended by Pres. Calvin Coolidge's wife, who became a regular Tryon visitor. In 1926 Ellertson wed Margaret Law, daughter of a Spartanburg, S.C., de-

veloper of Tryon real estate and niece of artist Margaret M. Law. Because of family connections with the Low-country residents, the marriage brought him more strongly into the orbit of the Charleston Renaissance. The Ellertsons entertained the George Gershwins and the DuBose Heywards at El Taarn.

Ellertson was at ease around African Americans; their optimism even in poor circumstances fascinated his Norwegian soul. *African Nocturne*, depicting share-cropper shanties, parallels his French rural scene *Breton Lavoir*, both painted in 1922. Ellertson was a member of the Southern States Art League and participated regularly in its shows. By the 1930s he was fusing humor with abstraction and southern imagery; this made him a favorite with critics. The *Boston Transcript* called him "a talent of unusual felicity" and opined, "It is the tense compositions that make the work unusual. The artist used distortion on a clearly conceived scale, and filled out the planes and spatial relations with this overemphasis." About the time of the 1929 market crash, Ellertson began a series about circus life, a timely choice of motif and quite successful.

In 1927 Margaret and Homer spent an extended honeymoon in Europe. From this trip emerged some of Ellertson's most interesting canvases of Switzerland, Italy, Spain, and France. Two paintings from Paris, typical of his oeuvre, hang in Lanier Library in Tryon. The couple also traveled extensively in the South. Their 1933 trip to New Orleans gave Homer many fresh subjects. *Mute Bronze*, a large-format watercolor rendered that year,

humorously juxtaposes languid park-bench denizens and a "salute" from the well-known equestrian statue of Gen. Andrew Jackson by Clark Mills. A series of southern scenes was shown at Delphic Studios on 57th Street in New York that year, eliciting many positive reviews. Two years later, at the peak of his fame, Ellertson died unexpectedly of a heart attack, at age 42.

MICHAEL J. MCCUE
Asheville, North Carolina

Michael J. McCue, *Homer Ellertson: Retrospective of a Versatile Artist* (2000), *Paris and Tryon: George C. Aid and His Artistic Circles in France and North Carolina* (2003), *Tryon Artists, 1892–1942* (2001).

Faulkner, John Wesley Thompson, III
(1901–1963) PAINTER.
Falkner, Maud Butler
(1871–1960) PAINTER.

Writer-artist John Wesley Thompson Faulkner III was born to Murry Cuthbert Falkner and Maud Butler Falkner in Ripley, Miss. The spelling of John's name changed in 1940 when he published his first novel, *Dollar Cotton*, a spoof on the Works Progress Administration (WPA) program and its effects on uneducated rural people. His publishers advised adding the "u" for name recognition with that of his older brother, William Faulkner. There is evidence, however, that John was already using the spelling with the "u" in his engineering records in the 1930s. Like William, who made drawings and art books, John came to art early in life through the influence of his grandmother and great-grandmother, both

of whom were amateur painters. Their brother Dean also possessed artistic talent and had considered a career in commercial art before his untimely death in a plane crash. Their mother, Maud Butler Falkner, took lessons briefly with artist-teacher Ellen Bailey, whose home, the Shegog-Bailey House, was purchased by William and is now known as Rowan Oak.

Although Maud Butler Falkner began painting as a hobby, she ultimately produced over 600 paintings, including portraits, cabin scenes, genre scenes, still lifes, studies of birds and dogs, and copies after old masters. Between 1889 and 1895 she completed a three-year business degree program and enrolled for two weeks at Mississippi State College for Women (MSCW, now Mississippi University for Women) before her marriage. She took "an art course or two" at MSCW and a 1941 WPA art class, in which she received sufficient training to create credible artistic compositions. Falkner objected to being called a "primitive" because she had had art lessons. She clipped a wide variety of images from magazines to consider for artistic inspiration. Falkner used a grid on tracing paper to reproduce correctly proportioned paintings by the old masters. One of her favorite artists was Irish-born William Michael Harnett, whose still lifes served as visual inspiration, particularly his trompe l'oeil subjects with a single candlestick, snuffed candle, pipe, matches, porcelain decanter, and books resting atop a newspaper placed on a table. Her paintings are competent, especially in her rendering of detail and in her use of umber

to achieve the contrast between light and shadow.

John Faulkner was acutely aware of the rapid technological advances that occurred after World War II. In 1956 he planned a series of paintings he titled *The Vanishing South*. He created a complex view of the hill country of northern Mississippi, depicting the landscape with people engaged in activities that were typical of Lafayette County in the 18th through the early 20th centuries. Faulkner planned 26 compositions, of which he completed 13 watercolors and 10 oil paintings. His largest watercolor was approximately 27 by 28 inches and his largest oil painting measured 18 by 24 inches. He exhibited the original paintings at local venues, where he received commissions, painting many different versions of these genre scenes by altering the color scheme, value, and detail. Patrons made their choice of medium and dimensions, and his record books reveal significant earnings from these commissions. This revenue augmented the meager disability payments he received from the U.S. government after he was injured in a jeep accident during his military service in World War II. Faulkner retained his original paintings for posterity and maintained that he "improved" with each successive painting of a subject.

Although Faulkner referred to himself as a "self-trained artist," he does not fall into the category of most vernacular artists. He stated, "I paint a scene just as lifelike as possible, but I work from memory in my studio." Typical of self-trained artists, he creates a visual world in which people and animals are set

within a distinct landscape wherein architectural structures are emphasized by precise contours. He varies the position of these structures by placing them off center, in three-quarter view, or in the distance. Figures are simply delineated and correctly proportioned, shading is uncomplicated, and color is blended carefully for tonal harmonies. His works are unified and manifest an intuitive sense of compositional design. Most of his paintings are abundantly peopled and narrative in quality and appear as straightforward observations. There exists a definite sense of sympathy with his subjects, both black and white. He painted at least six landscapes without figures, although a human presence is implied in each. *The End of a Day* depicts a dogtrot house, a fast-disappearing architectural structure. An old buggy is parked in the breezeway between the two parts of a dilapidated building.

Git a Hoss shows a black car from the rear, stuck in the ruts of a muddy road. A mule standing near the car recalls the Faulkner brothers' attempt to raise mules—and its eventual failure, caused by the advent of automobiles and tractors. Two scenes were inspired by his brother William's short stories "The Bear" and "Red Leaves." One lively painting by John Faulkner, *Little Chicago*, parallels the roadhouse in his five-book *Cabin Road* series. A figure easily identifiable as Elvis Presley plays a guitar beside a jukebox as dancers and listeners form a circle around him. He introduces variety by showing another man, who stands behind a counter. John's understanding of shadows caused by strong light is evident; black shadows fall according to whether a figure stands at right or left of the overhead lamp. The most poignant of John's scenes, *Ploddin' Home*, shows a cabin in which a death, seen through an open door, has just occurred, with family members standing around a bed. A roadway in front of the cabin leads to a dark wooded area, and the dark form of a man rides a horse toward a brilliant dawn with a white cross in the center of a glowing light. This scene, John's only painting with a religious theme, was inspired by an old spiritual having the same name.

In 1958 Faulkner held an exhibition of his *Vanishing South* paintings at the Mary Buie Museum, about 100 yards away from his home near the University of Mississippi campus. Later he was one of seven artists participating in a 10-day workshop at Allison's Wells, including Andrew Morgan, chair of the art department at the University of Mississippi; Pat Trivigno, of the Newcomb College School of Art, Tulane University; Townsend Durant Wolfe, of the Academy of Arts in Memphis; Karl Ferdinand Wolfe, of the art department of Millsaps College; Dr. Gulnar K. Bosch, head of the art department at Louisiana State University in Baton Rouge; and Ralph Magee Hudson, chair of the art department at Mississippi State College for Women in Columbus. Faulkner left a body of works that document cultural practices and architectural landmarks that have now disappeared.

JUDITH H. BONNER
The Historic New Orleans Collection

Judith H. Bonner, *Mississippi Quarterly* (Fall 2001); Judith L. Sensibar, *Faulkner and Love: The Women Who Shaped His Art* (2009).

Faulkner, William

(1897–1962) ARTIST AND AUTHOR. William Cuthbert Falkner was born 25 September 1897 in New Albany, Miss., the first of four sons of Murry Cuthbert Falkner and Maud Butler Falkner (William later added the "u" to the name). After financial problems resulted in the loss of his job with the railroad owned by his grandfather William Clark Falkner of Ripley, Murry moved his family to Oxford, where he operated a livery stable and then owned a hardware store before becoming the business manager of the University of Mississippi. Maud Falkner, a talented painter and a devotee of the literary and visual arts, taught her sons to read at an early age and encouraged their interest in writing, drawing, painting, and photography.

Faulkner learned to draw as a young child and throughout his life made sketches—many quite sophisticated and elaborate and some humorous and some erotic. His artwork was first published at the University of Mississippi in the yearbook *Ole Miss* (14 cartoons and illustrations between 1917 and 1922) and the humor magazine *Scream* (four cartoons in 1925). He contributed poems, essays, and book reviews to the student newspaper, the *Mississippian*, and for the campus drama group wrote a one-act play, *The Marionettes*, which he produced in six hand-lettered, bound copies, each with 10 illustrations. He also wrote, hand lettered, and bound six other books that combined his interests in drawing and writing: *Dawn, an Orchid, a Song* (1918), *The Lilacs* (1919–20), *Vision in Spring* (1921), *Mayday* (1926), *Helen: A Courtship* (1926), and *Royal Street: New Orleans* (1926). Except for *Mayday*, an allegory in prose, the volumes are collections of poems. All but *Helen* and *Royal Street* contain illustrations in pen and ink and/or watercolors.

Between 1912 and 1924 Faulkner aspired to be a poet and a visual artist. Voracious reading and associations with family, friends, and the university community nurtured his talents, as did extended stays in places like New Haven with his hometown friend and mentor Phil Stone; in New York, thanks to the assistance of novelist, drama critic, and painter Stark Young, also from Oxford; and in the French Quarter of New Orleans, where his friends included author Sherwood Anderson and artist William Spratling, who taught architecture at Tulane and had studied painting at the École des Beaux-Arts in Paris.

In New Orleans, Faulkner wrote prose sketches for the *Times-Picayune* newspaper and the *Double Dealer* literary journal and began writing fiction. By 11 May 1925, he had, in five months, completed his first novel, *Soldiers' Pay*. Shortly thereafter, during a six-month trip to Europe, Faulkner explored Paris and, staying in a hotel near the Luxembourg Gardens, wrote fiction from which his novels *Flags in the Dust*, *The Sound and the Fury*, and *Sanctuary* eventually developed. During this year of extraordinary creativity, the poet and

visual artist was on his way to becoming one of the great novelists of the 20th century.

Although long neglected in the prodigious criticism and scholarship that has appeared since the publication of Faulkner's first book, *The Marble Faun*, in 1924, study of Faulkner's graphic work and its connections to his fiction has blossomed in recent decades. Noel Polk, in the introduction to his 1977 edition of *The Marionettes*, comments on common techniques and themes in the play and Faulkner's novels and concludes that "the germ of much that Faulkner would accomplish in his long and extraordinary career is already present in this apprentice work." In the first comprehensive study of Faulkner's graphic work, Lothar Hönnighausen relates it to international arts movements, modernism, and the Jazz Age in America and compares Faulkner's early artwork and poetry with his novels *Soldiers' Pay*, *Flags in the Dust*, *The Sound and the Fury*, *Light in August*, *Absalom, Absalom!*, *The Hamlet*, and *A Fable*. Ilse Dusoir Lind and Panthea Reid Broughton consider Faulkner's discovery of cubism during his 1925 visit to Paris and his adaptation of cubist theories and techniques in his fiction. M. Thomas Inge's "Faulkner Reads the Funny Papers" explores the impact of comic strips and cartoonists on Faulkner's early art and in his novels. The author's interest in photography and his use of photographs in his fiction is the subject of studies by Katherine R. Henniger, Thomas Rankin, and Judith L. Sensibar. Bruce Kawin and Peter Lurie

consider Faulkner's work in Hollywood and cinematic techniques in his fiction. Thomas S. Hines, in *William Faulkner and the Tangible Past: The Architecture of Yoknapatawpha*, looks at the built environment and the art of architecture in the author's life and works. Susan V. Donaldson, in "Cracked Urns: Faulkner, Gender, and Art in the South," adds new dimensions to southern literary and art history; and W. Kenneth Holditch, in "William Faulkner and Other Famous Creoles," gives a detailed portrait of New Orleans, which "has provided a home or a haven as well as inspiration to thousands of writers" and which in the 1920s gave a young man from Mississippi bohemian friends and an artistic community where he discovered his talent for writing the fiction for which he is known and revered.

ANN J. ABADIE
University of Mississippi

Joseph Blotner, *Faulkner: A Biography*, 2 vols. (1974); Panthea Reid Broughton, in *"A Cosmos of My Own,"* ed. Doreen Fowler and Ann J. Abadie (1981); Susan V. Donaldson, in *Faulkner and the Artist*, ed. Donald M. Kartiganer and Ann J. Abadie (1996); William Faulkner, *The Marionettes*, ed. Noel Polk (1920, 1977); Katherine R. Henniger, in *Faulkner and Material Culture*, ed. Joseph R. Urgo and Ann J. Abadie (2007); Thomas S. Hines, *William Faulkner and the Tangible Past: The Architecture of Yoknapatawpha* (1996); W. Kenneth Holditch, in *Faulkner and His Contemporaries*, ed. Joseph R. Urgo and Ann J. Abadie (2004); Lothar Hönnighausen, *William Faulkner: The Art of Stylization in His Early Graphic and Literary Work* (1987); M. Thomas Inge, in *Faulkner and Humor*,

ed. Doreen Fowler and Ann J. Abadie (1986); Bruce Kawin, *Faulkner and Film* (1977); Ilse Dusoir Lind, in *Faulkner, Modernism, and Film*, ed. Evans Harrington and Ann J. Abadie (1979); Peter Lurie, *Vision's Immanence: Faulkner, Film, and the Popular Imagination* (2004); Thomas Rankin, in *Faulkner and the Artist*, ed. Donald M. Kartiganer and Ann J. Abadie (1996); Judith L. Sensibar, *Faulkner and Love: The Women Who Shaped His Art* (2009).

Fink, Denman

(1880–1956) PAINTER, ILLUSTRATOR, DESIGNER.

Denman Fink left his native Pennsylvania to live in Haworth, N.J., in 1910. He studied at the Pittsburgh School of Design and Boston Museum of Art under the tutelage of American impressionist greats Edmund Charles Tarbell and Frank Weston Benson and later received instruction at the Art Students League in New York. At the age of 19 he was illustrating *Harper's* and *Scribner's* magazines. His paintings became nationally renowned, and Fink supplemented his income with other magazine, book, and advertisement illustrations—most notably for Cream of Wheat. Prestigious art halls in which he exhibited include the Pennsylvania Academy of the Fine Arts, National Academy of Design, and the Corcoran Gallery of Art. Fink achieved international acclaim when his grand painting of Portuguese life, exhibited in the Fifth Avenue Library's Astor Collection around 1921, was purchased by the government of Portugal.

Fink's nephew George E. Merrick (six years Fink's junior) commissioned his artist-uncle to illustrate a book of Merrick's poems about Florida. And in 1920 it was again Fink who first developed on paper Merrick's visionary ideas of building a suburb of Miami called Coral Gables. In 1921, while living in Haworth, Fink, as artistic designer, explained the plans for Coral Gables and wrote that he essentially did not approve of out-of-place "lovely New England" houses in south Florida, when they are "longing to be back in the shade of the elms or among Berkshire hills." Therefore, he was thrilled to work with Merrick in building the city of Coral Gables out of coral rock (oolitic limestone), which is natural to the area. Fink predicted that Spanish-style Coral Gables would be "a spot that is going to bring a very marked new luster to Miami's already fair repute" and added that he was "fortunate to play some part in its development."

As a consequence of a sinus condition, Fink moved to the Miami area about 1923. He continued his association with George Merrick and worked with architect Phineas Paist and designer Paul Chalfin to design City Hall and the Venetian Pool—Fink's "baby"—built with materials from a coral rock quarry and reported to be the largest open-air pool in the nation. He also designed the city's entranceways, fire station, and the University of Miami campus, including its stadium. He created the city seal, and his artwork decorated City Hall, including the popular *Four Seasons* in its tower. In 1925 it was announced by Merrick that Fink would again be working

with Paist and Chalfin in building 5,000 Coral Gables homes, thereby doubling the population of the city.

During the Depression, Fink earned income from illustrating magazines, including the *Saturday Evening Post*. He was also commissioned by the New Deal's Section of Fine Arts to paint regionalist murals, including *Harvest Time—Lake Wales* (1942) in the Lake Wales post office and *Law Guides Florida Progress* (1940) in the Miami post office and courthouse. In *Law Guides Florida's Progress*, a history of the state is illustrated—from primitive paradise to agricultural and industrial thriving center, with the entire scene dominated by a judge who listens to Florida citizens' pleas.

Fink was occupied with other works commissioned in the 1930s and 1940s—many of them in private homes, as well as in public buildings, most notably St. Francis Hospital, the Eastern Airlines ticket office, and the Surf Club in Miami Beach, which features a 36-foot-long mural, *The Vintage*, depicting wine workers.

At the Blue Dome Fellowship, started by Fink's colleague Martha Dewing Woodward, a solo show of Fink's work was mounted. He was a member of the Blue Dome and the Florida Federation of Art, as well as head of the art department of the University of Miami, ca. 1929–52. As art director of the University of Miami's Civic Theater, Fink designed its theatrical productions. He was known to have a good sense of humor, was an avid tennis player, and preferred "nontouristy restaurants."

Years later, when asked his opinion about the designing of Coral Gables, Fink said "it was an architectural fling . . . and inspirationally wonderful."

DEBORAH C. POLLACK
Palm Springs, Florida

Denman Fink, *Miami Metropolis* (18 November 1921); Donald M. Kuhn, *Tequesta* (2000); *Miami Daily News* (7 December 1925 and 7 June 1952); Joan Nielsen, *Miami Daily News* (31 October 1956); Arva M. Parks, *Coral Gables: Where Your Castles in Spain Are Made Real* (2006).

Fleischbein, Franz (François Jacques)

(1801–1868) PORTRAITIST.
Franz Joseph Fleischbein, better known in the United States as François Jacques, or simply François, was born in Godramstein, Bavaria, Germany. He is purported to have studied painting in Paris with Anne-Louis Girodet de Roussy-Trioson, among others at the Académie royale de peinture et de sculpture in Paris in the early 1820s. He married Marie Louise Tetu about 1828–32; they would later have four children. In 1833 Fleischbein and his family moved from France to New Orleans, where he remained until his death.

Fleischbein was among the most successful portraitists in antebellum New Orleans, competing with Jacques Guillaume Lucien Amans and Jean-Joseph Vaudechamp. George David Coulon studied painting briefly with Fleischbein about 1837. Fleischbein specialized in portraiture but also executed a number of genre, mythological, and history paintings.

Although Fleischbein apparently had

some academic training, his paintings bear a formal resemblance to the work of the early 19th-century New Orleans portrait painter Feuille (known only by his last name). Two sketchbooks, dating from his student days and the early years in New Orleans, reveal an artist thoroughly steeped in European academic practice. Fleischbein's deft handling of paint, especially his manner of applying highlights to gold and silver jewelry, also suggests academic training. The mannerisms evident in many of his early works are a direct reflection of German Biedermeier representational conventions, which share with 19th-century American folk portraiture an interest in domesticity and middle-class comforts. Fleischbein's impact on New Orleans portraitists grew from such formal similarities as schematic drawing, suppressed shading, and odd proportions. An early advertisement promises that "greatest correctness of drawing and painting is guaranteed, as well as the likeness of Portraits," repeating the phrases itinerant plain painters typically employed as they sought the patronage of middle-class clients, who valued a true likeness above an aristocratic style.

Fleischbein's paintings of women and children have attracted a great deal of attention, notably the early 1840s portraits of seated ladies with complicated French Creole hairstyles. These portraits establish a tension between the message of simplicity and refinement. Like the landscapes glimpsed through the windows, the women in Fleischbein's portraits are constrained, as much as they are defined, by their complex costumes, elaborate hairstyles, and immaculate domestic spaces. Fleischbein's mannerisms have been misinterpreted by some commentators as a problem with his eyesight, which was indeed very poor at the end of his life. More likely, the artist's failing vision may explain in part why he is listed as a purveyor of daguerreotypes and ambrotypes shortly before his death on 16 November 1868.

RICHARD A. LEWIS
Louisiana State Museum
New Orleans, Louisiana

Randolph Delehanty, *Art in the American South: Works from the Ogden Collection* (1996); John Burton Harter and Mary Louise Tucker, *The Louisiana Portrait Gallery: The Louisiana State Museum, Vol. 1, to 1870* (1979); Donald B. Kuspit et al., *Painting in the South, 1564–1980* (1983); John A. Mahé II and Rosanne McCaffrey, eds., *Encyclopaedia of New Orleans Artists, 1718–1918* (1987); Estill Curtis Pennington, *Downriver: Currents in Style in Louisiana Painting, 1800–1950* (1991).

Fraser, Charles

(1782–1860) MINIATURE PORTRAITIST.

During the antebellum period, Charleston was often referred to as the "Queen of the South," an indication of her commercial as well as cultural position in the region. Lawyer, author, miniature portraitist, and landscape painter Charles Fraser was very much a mirror of the city's accomplishments and aspirations. He was born in Charleston, S.C., the 14th child of Alexander Fraser and Mary Grimke, and lived there his entire life. He attended

the College of Charleston in 1792 (at the time more like a grammar school) and was a lifetime supporter of the college, which he served as trustee, from 1817 to 1860. He studied with Thomas Coram, engraver and painter of small landscape vignettes. Fraser studied law from 1798 to 1801 and from 1804 to 1807 in the law offices of John Julius Pringle and was admitted to the South Carolina bar in 1807. He practiced law until 1818, at which time he had earned enough money to devote himself to painting full time. He never married and died in Charleston in 1860.

Through his miniature portraits, which he systematically recorded in an account book, Fraser has provided posterity with a pictorial social register of Charleston's planters and merchants of the antebellum period. Working in watercolor on ivory, in a small format, which would be presented in either a locket or a leather case, he captured the city's elite, including members of the Rutledge and Pinckney families as well as the Marquis de Lafayette, a distinguished visitor to Charleston in 1825. Over an active career of 30 years, Fraser painted approximately 400 portraits, many of which remain in Charleston in the hands of descendants or are in the collection of the Gibbes Museum of Art.

By the late 1830s Fraser began to diversify by painting still lifes and landscapes. This shift reflects the artist's failing eyesight, a change in taste among his patrons, and a reaction to the invention of the daguerreotype. The late landscapes are a return to an earlier interest, from his student days, when he filled

sketchbooks with watercolor views of area plantations. In 1857 Fraser's accomplishments were celebrated in an ambitious exhibition, *The Fraser Gallery*, which included 313 miniatures and 139 other works.

Highly regarded locally and nationally as a painter, Fraser was also a noted orator, delivering many speeches, including the address at the dedication of the College of Charleston's main building. In 1850 he spoke at the inauguration of Magnolia Cemetery, endorsing the rural cemetery movement. Three years later he presented to the Conversation Club his recollections, later published as *Reminiscences of Charleston* (1854), which provided an insightful and accurate description of postrevolutionary and antebellum Charleston.

MARTHA R. SEVERENS
Greenville, South Carolina

Roberta Sokolitz Kefalos, *The Poetry of Place: Landscapes of Thomas Coram and Charles Fraser* (1998); Martha R. Severens and Charles L. Wyrick Jr., eds., *Charles Fraser of Charleston* (1983), *The Miniature Portrait Collection of the Carolina Art Association* (1984); Alice Ravenel Huger Smith, *A Charleston Sketchbook* (1940).

Frerichs, William Charles Anthony

(1829–1905) PAINTER.
William Charles Anthony Frerichs was born in Ghent, Flanders, Belgium, but moved with his family to The Hague in the Netherlands while still a small child. He is reputed to have begun his studies at the Royal Academy in The Hague around 1835 with noted Dutch romantic landscape painter Andreas

Schelfhout. Frerichs enrolled in the medical training program at the University of Leiden in 1843, but he returned to the Royal Academy three years later. Maj. August Davies, the American chargé d'affaires, saw Frerichs's work at the Royal Academy and encouraged the artist to immigrate to the United States. He arrived in New York in 1850 and began to exhibit at the National Academy of Design in 1852 from an address on East 24th Street.

Frerichs married Mrs. Clara Branwaite Butler, a widow, in 1858, and the couple moved to the area near where he had been hired as a drawing master, the Greensboro Female College in North Carolina. A fire destroyed the school in 1863, along with all the artwork Frerichs had created during his time there. He then taught for short periods at the Edgeworth Female Seminary in Greensboro and the Quaker College in New Garden, N.C. Late in the Civil War, he was conscripted by Confederate forces as a civil engineer in the Sauratown Mountains, an area north of Greensboro, where he had frequently hiked and sketched. Frerichs was one of the first artists to sketch and paint the mountains and valleys of the southern Highlands. He painted the falls of the Tamakaka several times, and the site provided him with many of his favored elements, notably the waterfall.

As evident by the extant body of work based on his observations and sketches in western North Carolina, Frerichs continued to paint that vibrantly animated territory for the rest of his active career. More than half of his oeuvre is based on southern material, quite a tribute, considering the brief time he spent there and the nearly 40 years he worked in the Northeast. By 1865 the artist had returned to New York, where he was active until 1869. He lived on Staten Island from 1869 to 1880, when he moved to Newark, N.J., following his marriage to a Miss E. Whalen.

Frerichs frequently exhibited his work at Charles G. Campbell & Sons Frame Shop on Broad Street in Newark. When his health began to decline in 1900, he moved to Tottenville, N.Y., to live with a son. He died there and was buried in Bethel Methodist Church Cemetery on Amboy Road.

ESTILL CURTIS PENNINGTON
Paris, Kentucky

Bruce Chambers, *Art and Artists of the South* (1984); Estill Curtis Pennington, *Romantic Spirits: Nineteenth-Century Paintings of the South* (2011), *A Southern Collection: A Publication of the Morris Museum of Art* (1992), *Subdued Hues: Mood and Scene in Southern Landscape Painting, 1865–1925* (1999); Hildegarde Safford, *Staten Island Historian* (October–December 1970); Hildegarde Safford and Benjamin F. Williams, *William C. A. Frerichs, 1829–1905* (1974); Martha Severens, *Greenville County Museum of Art: The Southern Collection* (1995).

Frymire, Jacob

(b. between 1765 and 1777; d. 1822)
PORTRAITIST.
Details about Jacob Frymire's place and date of birth have not been found, but he is known to have been the son of Henry Frymire, who lived in Lancaster, Pa., during the 1760s and 1770s. Also not known is when and from whom he

received his training as a painter. More details emerge from the 1790s, when his father moved to Hamilton Township, Franklin County, near Chambersburg in the Cumberland Valley.

The next year, in May, at the same time his father bought 200 acres of farmland, Frymire began work as an itinerant painter in New Jersey, where he executed portraits of the Clark family of Cumberland County. The compositions and stylistic elements he would utilize throughout his career are seen in these portraits: architectural settings, furniture, and objects specifically associated with the sitter surround the figure, all painted in thin layers of oil pigment on canvas. The description of the portrait of young medical student Charles Clark, unlocated in recent decades, sounds like many of Frymire's other works: a young man stands beside a table with eagle-patterned inlay holding medical books and instruments. In like fashion, the portrait of Clark's half-brother Daniel shows a young man seated in front of a curtain and column before a house in a landscape. The half drop-leaf table beside him holds an inkwell and a note reading "Virtue and Industry are the springs of happiness." Both brothers are depicted as active young men industriously making themselves part of that new postrevolutionary American middle class.

Equally industrious as a painter, Frymire, in his subsequent career as an itinerant, journeyed to communities in Pennsylvania, Maryland, Virginia, and Kentucky seeking work. His sitters included merchants, sea captains, and landowners, who frequently commissioned portraits of more than one family member. Groups of family portraits have survived for the McKnights and Marstellers of Alexandria, Va., the Laucks of Winchester, Ky., and the Calmes of Woodford County, Ky. The artist frequently signed on the reverse with the phrase "Painted by," after which he used one of three spellings of his last name—Frymeier, Frymier, or Frymire (with the last used most frequently)—followed by a date and often the location where he had painted the work. By the early 19th century he was also working in watercolor on ivory creating miniature portraits. One notable example, signed and dated "J. Frymire 12th Octbr 1801," is of Peter Lauck, a prominent Winchester, Ky., innkeeper whose wife, Amelia Heiskell Lauck, was painted in oil on canvas about two months later, adding credence to the frequent speculation that itinerant artists bartered for their room and board.

Frymire is of considerable interest—as a painter whose career and style can be linked to other nonacademic or folk artists active at the same time and places, particularly Charles Peale Polk and Philippe Abraham Peticolas. Both Frymire and Polk painted members of the Lauck family, which include some of Frymire's delightfully perceptive portrayals of children with pet animals and link him to a late 18th- to early 19th-century interest in childhood, found also in the work of painters like African American portrait painter Joshua Johnson.

Frymire maintained a residence in Pennsylvania during the first two de-

cades of the 19th century. He owned land in Shippensburg, where the Federal Census of 1810 listed him living with his wife, Rachel, and two young children, and it is there between 1807 and 1820 that he was taxed a number of times as a limner—a contemporary term for a portrait painter—and as a freedman. After his father's death in 1816 he inherited land in Hamilton Township, where he lived and apparently worked as a farmer for the rest of his life. Frymire wrote his will on 22 May, a few months before his death in July 1822. He provided for his wife and eight children (soon to be nine) to inherit the farm, but he made no mention of his career as an itinerant portrait painter.

LINDA CROCKER SIMMONS
Corcoran Gallery of Art

Linda Crocker Simmons, "Early American Portrait Painter" (M.A. thesis, University of Delaware, 1975), *Jacob Frymire: An American Limner* (1974); *Winchester-Frederick County (Va.) Historical Society Journal* 4 (1989); *Southern Quarterly* (Fall 1985).

Gaul, Gilbert William

(1855–1919) PAINTER.

Gilbert William Gaul, arguably the most important painter to reside in Tennessee during the late 19th century, was born in Jersey City, N.J., on 31 March 1855, the son of George W. and Cornelia A. Gilbert Gaul. He attended school in Newark and at the Claverack Military Academy in Columbia County, N.Y. In 1872, at the age of 17, he entered the prestigious National Academy of Design, the youngest student admitted to the academy up to that time, studying

with Lemuel E. Wilmarth until 1876. He also studied with noted genre painter John George Brown at the newly opened Art Students League of New York during 1875. He emerged as one of the era's leading illustrators.

In 1876 Gaul visited the American West for the first time, and on his return to New York, he began to exhibit the military and western paintings at the National Academy of Design and elsewhere that had resulted from his travels. He maintained a long association with that institution, exhibiting in its annual shows from 1877 to 1902. He was elected an associate of the academy in 1879 for his painting *The Stragglers*, and in 1882 he was elected a full academician for *Charging the Battery*. At the age of 27 he was the youngest artist ever to attain that status.

Gaul published illustrations in *Harper's Weekly*, *Century Magazine* (especially for its lengthy series of Civil War memoirs), *Scribner's Monthly*, and *Cosmopolitan*—all of which helped him to achieve an extraordinary level of popular success, which was matched by the response from official art circles in the United States and abroad. His dramatic skill in capturing the telling moment when describing the chaos of battle, as well as his innumerable anecdotal genre scenes depicting the soldiers of both sides and the farmers, hunters, explorers, and adventurers whose company he often shared, were grounded in both the solid academic realism imparted by his instructors at the academy and the sentiment that resulted from the influence of J. G. Brown. Unlike the work of many of his contemporaries,

Gaul's Civil War paintings depict a broad range of experiences, everything from the fiercest engagements in battle to quiet moments in camp.

In addition to the many illustrations that were published in some of the country's most popular periodical publications, three of Gaul's paintings were used as frontispieces to *Battles and Leaders of the Civil War* (1887–88), the four-volume history of the war by Robert Underwood Johnson and Clarence Clough Buel. *Battles and Leaders* remained for many years the most authoritative treatment of the subject and served as the direct inspiration for such seminal works as Stephen Crane's *The Red Badge of Courage*. In paintings like *Holding the Line at All Hazards* and *Charging the Battery*, his unusual ability to capture war's intensity brought him awards from the American Art Association — specifically, a gold medal for the former in 1888 and a bronze medal at the 1889 Paris Exposition for the latter. In 1893 his paintings won medals at the World's Columbian Exposition in Chicago and in 1901 at the Pan American Exposition in Buffalo, N.Y.

Gaul's mother was a Tennessean, and, on the death of her brother, Hiram Gaul, Cornelia A. Gilbert inherited a farm and 5,000 acres of land in rural Van Buren County, Tennessee. Located southeast of Nashville on the rugged and rural Cumberland Plateau, it is the site of Fall Creek Falls; even now, the population of the county barely exceeds 5,000. Since the inheritance was conditional on his occupying the property for a period of five years, Gaul moved there with his wife in 1881, converted a barn into a studio, and built a cabin for their home. This represented no small risk on his part, as he was already well established in New York and enjoyed a reputation as one of the highest earning artists in America. During his early years in Tennessee, Gaul continued his military and genre work but also began to explore more pastoral views of nature that evoked the beauty of the heavily wooded countryside. He often employed his neighbors and other denizens of the region as models, both in their own clothing and in Civil War uniforms, producing some of his best paintings. His experience of the landscape and culture of the South informed his art through the remainder of his career.

When he completed his five-year stay in Van Buren County, Gaul returned to New York City, bringing with him many of the paintings produced during his country sojourn. Once again, he was as sought after as before his temporary dislocation, and he returned to his steady production of magazine and book illustrations. In 1886 his painting *John Burns at Gettysburg* was selected for reproduction by Philadelphia publisher J. B. Lippincott in his ambitious book *American Figure Painters*.

Beginning with Gaul's first trip to the West in 1876, he was an enthusiastic and indefatigable traveler. He had a special fondness for the West and its peoples, both indigenous and immigrant. Gaul toured the West many times in subsequent years, producing photographs and drawings of people and sites that he later developed as paintings in his studios in New York and Tennessee. For

a time in 1890 he worked for the U.S. Census Bureau on the Cheyenne and Standing Rock Native American reservations in North Dakota, a time and experience that produced some haunting images. Later, his wanderlust took him to Mexico, Panama, Nicaragua, and the West Indies. *Century Magazine* published an illustrated account of his travels in 1892.

In 1898 Gaul returned with his second wife, Marian Halstead, to live in Van Buren County. With the passage of time and the advent of new styles of painting, interest in his work, particularly in his depictions of the Civil War, began to wane, leading to financial stress. For the first time in his professional life, Gaul felt constrained to seek employment. He taught at Cumberland Female College in McMinnville, Tenn., until 1905, when he joined the faculty of Watkins Institute in Nashville. He made his home around the corner over a dry goods store, where he kept a studio and offered private painting lessons. He also produced illustrations for a series of novels by Nashville author Thornwell Jacobs.

The Southern Publishing Company was formed in 1907 for the express purpose of publishing *With the Confederate Colors*, which was to include a set of twelve chromolithographic reproductions of paintings by Gaul. Some of them, *Holding the Line at All Hazards*—the painting for which he was awarded a gold medal in 1881—for example, were not new. Others, including *Leaving Home, Waiting for Dawn*, and *Playing Cards between the Lines*, were original to this publication.

As a commercial enterprise, the publication was a failure. Gaul, his health beginning to fail, left Tennessee for the last time. He moved temporarily to Charleston, where, while ill, he lived for a time with his stepdaughter. By 1910, however, he had returned to his native New Jersey, living out his remaining years in Ridgefield, where he continued to paint, producing some paintings of World War I, which lacked the immediacy and success of his Civil War work. After a long illness, he died on 13 December 1919.

Paintings by Gilbert Gaul are included in the permanent collections of many major museums, including the Blanton Museum, University of Texas at Austin; the Brandywine River Museum, Delaware; the Cheekwood Museum, Nashville; the Corcoran Gallery of Art, Washington, D.C.; the Georgia Museum of Art, Athens; the Gilcrease Museum, Tulsa; the Greenville County Museum, Greenville, S.C.; the High Museum, Atlanta; the Morris Museum of Art, Augusta, Ga.; the National Academy, New York; the National Portrait Gallery, Washington, D.C.; and the New-York Historical Society, New York.

KEVIN GROGAN
Morris Museum of Art
Augusta, Georgia

William Dunlap, Winston Groom, and J. Richard Gruber, *Storming the Ramparts: Objects of Evidence* (2009); James A. Hoobler, *Gilbert Gaul: American Realist* (1992); James C. Kelly, *Tennessee Historical Quarterly* (Summer 1985); Donald B. Kuspit et al., *Painting in the South, 1564–1980* (1983); George Parsons Lathrop, *Quarterly Illustrator* (October–December

1893); James F. Reeves, *Gilbert Gaul* (1975); Karin L. Sack, *Tennessee Historical Quarterly* (Spring 2002).

Goldthwaite, Anne Wilson

(1869–1944) PAINTER.

Born into a prominent Montgomery, Ala., family just after the Civil War, Anne Wilson Goldthwaite was well acquainted with the way of life, strong sense of family, culture, and environs of the South. She was also well aware of the difficulties endured by the region during Reconstruction; her father, a veteran Confederate artillery officer, moved his family to Texas in the hope of finding better economic circumstances.

The Goldthwaite children lost both of their parents in the 1880s, and arrangements were made for them to return to Montgomery to live with their aunt, Molly Arrington. Surprisingly, considering the acceptable roles for women in the late 19th century, Arrington encouraged her niece's interest in art. Goldthwaite's bachelor uncle, Henry Goldthwaite, generously offered to financially support her art training and education for 8 to 10 years.

Goldthwaite, escorted by her uncle, moved to New York City and enrolled in the prestigious National Academy of Design, where she studied under Walter Shirlaw and Charles Frederick William "Frank" Mielatz. In pursuit of a part-time job at the fledgling Chelterham Press, she was introduced to printmaking, which would become an integral and important part of her work as an artist.

After studying at the National Academy of Design for six years,

Goldthwaite lived in Paris from 1906 to 1913 to further her education at the Académie Moderne and to experience the European modernist movement of the early 20th century firsthand. As a single woman in Paris, she took up residence at the American Girls' Club and developed friendships with other artists who introduced her to life in Paris and also to the famous expatriate, Gertrude Stein. Goldthwaite became a part of the coterie of artists who met at Stein's home.

With the impending threat of World War I, Goldthwaite resettled in New York City, where she immersed herself in the artistic community. She exhibited two landscape paintings at the landmark 1913 Armory Show and developed a friendship with Katherine Dreier, the founder of the Société Anonyme, Inc. Additionally, she earned a bronze medal at the San Francisco Panama-Pacific Exposition, won the McMillan landscape prize from the National Association of Women Painters and Sculptors, both in 1915, and exhibited at the Montgomery Museum of Art and in New York City with Brummer Gallery, the Downtown Gallery, M. Knoedler and Company, and American Printmakers Annual Exhibitions.

In 1921 Goldthwaite began her 23-year teaching tenure at the Art Students League, which provided her with the financial means to support her career as an artist. During the Great Depression she was assigned to paint two murals for Alabama post offices under the Section of the Fine Arts of the Federal Works Agency.

Every summer Goldthwaite left the

city to return to the South, visiting her family in Montgomery. There she painted, sketched, and etched the familiar sights of her youth. Frequently, her etchings were based on sketches or paintings. An accomplished modernist artist, her work always retained representational imagery. For inspiration in her paintings and prints, she drew on the sights of New York and Paris, portrait commissions, pets, and her remembrances of her childhood in the Deep South.

CLAUDIA KHEEL
Neal Auction Company

Margaret Lynne Ausfeld, *Eight Southern Women* (1986); Martin Birnbaum, *Jacovleff and Other Artists* (1946); Adelyn Dohme Breeskin, *Anne Goldthwaite: A Catalogue Raisonné of the Graphic Work* (1982); Donald B. Kuspit et al., *Painting in the South, 1564–1980* (1983); Anne Kendrick Walker, *Tuskegee and the Black Belt* (1944); Lynn Barstis Williams, *Imprinting the South: Southern Printmakers and Their Images of Region, 1920s–1940s* (2007).

Grafton, Robert Wadsworth

(1876–1936) PAINTER.

Robert Grafton is well known in the Midwest for his portraits of governors, presidents, and prominent locals, as well as for his numerous mural commissions for public buildings. He was a frequent visitor to New Orleans, where his impressionistic paintings of the French Quarter and the neighboring Old Basin Canal remain highly prized. When he began his annual winter painting expeditions in 1916, he was already an established artist and was readily accepted by the community of bohemian artists

and writers who gathered in the historic Vieux Carré. He exhibited with the Art Association of New Orleans and was a charter member of the Arts and Crafts Club, where he was an early organizer of art classes.

Grafton studied at the Art Institute of Chicago from 1895 to 1899; he continued his studies in Paris at the prestigious Académie Julian and later in England and Holland. In Chicago he maintained a studio at the Tree Studio Building and was an active member of the Painters and Sculptors Club, the Chicago Society of Artists, the Palette and Chisel Club (serving as president and vice president), and the Chicago Art Club.

In 1908 Grafton settled in the nearby community of Michigan City, Ind., where he married Elinda Oppermann; they had one daughter, Elinda Patricia. The newlyweds traveled to Holland for their honeymoon, where Grafton painted views of the harbor, fishmongers, and interior genre scenes; he often used his wife, dressed in traditional Dutch costume, as the model. In 1910 he won the Mary T. Foulke prize from the Richmond Art Association, in Indiana, and in 1925 he was awarded the Leroy Goddard prize from the Annual Hoosier Salon with a portrait of Indiana humorist George Ade.

During his early visits to New Orleans, Grafton was accompanied by his friend and fellow midwesterner, artist Louis Oscar Griffith. The historic sights of the city, particularly the luggers and schooners that traversed the Old Basin Canal, inspired both artists; they appear to have sketched and painted side by side on numerous occasions.

New Orleans's St. Charles Hotel commissioned the artists to collaborate on two horseracing murals for their Men's Café. The artists set up a temporary studio in the lobby of the hotel and worked in tandem on the companion murals, entitled *The Start* and *The Finish*. The murals were completed in the winter of 1917 to rave reviews from *New Orleans Times-Picayune* newspaper columnist Flo Field. With the destruction of the St. Charles Hotel in 1974, the well-known and highly acclaimed murals were assumed to be lost. But in 2006 the Morris Museum of Southern Art in Augusta, Ga., acquired *The Start* from the Neal Auction Compnay.

In December 1918 the Thurber Art Galleries of Chicago organized a well-received solo show of Grafton's work, including many of his recently completed views of New Orleans. In 1922 the St. Charles Hotel invited Grafton and Griffith to exhibit their New Orleans paintings in the mezzanine gallery. An illustrated catalog, *New Orleans, the Paris of America*, and a set of postcards accompanied the exhibition.

At the time of his sudden death, Grafton was in the process of completing a large commission of 250 portraits for the Saddle and Sirloin Club of the Union Stockyards in Chicago. A devastating fire had destroyed the club's collection of portraits of local leaders of agriculture and the meat-packing industry, and in May 1934 they hired Grafton to re-create the entire collection.

CLAUDIA KHEEL
Neal Auction Company

Flo Field, *New Orleans Times-Picayune* (18 February 1917); Judith Vale Newton and Carol Weiss, *A Grand Tradition: The Art and Artists of the Hoosier Salon, 1925–1990* (1993); Estill Curtis Pennington, *Downriver: Currents of Style in Louisiana Painting, 1800–1950* (1991).

Gregory, Angela

(1903–1990) SCULPTOR AND PAINTER.

The first Louisiana woman sculptor to earn an international reputation, Angela Gregory was born in New Orleans on 18 October 1903 to William B. Gregory and Selena Elizabeth Brès Gregory. Angela's father was a professor of engineering at Tulane University; her mother was an artist and graduate of Newcomb College. Brès, who was in the first pottery decoration class, reportedly sold the first piece of Newcomb pottery and the first souvenir postcard of New Orleans. From 1914 to 1921 young Gregory was educated at the Katherine Brès School, where her mother taught art. Obviously inspired by her mother's instruction, Gregory accompanied her on sketching trips and took summer courses in clay modeling and relief casting at Tulane University with William Woodward. Enrolling at Newcomb, Gregory won the 1924 Mary L. S. Neill Prize for proficiency in watercolor painting and earned her Bachelor of Design degree in 1925. She studied at Parsons School of Design in New York with sculptor Charles Keck and took instruction in sculpture from German sculptor Albert George Rieker at the Arts and Crafts Club's School of Art in the French Quarter.

Gregory earned a scholarship for postgraduate study in 1925–26 in Paris at L'Académie de la Grande Chaumière and in Italy. In Paris she worked with sculptor Émile-Antoine Bourdelle and his assistant, Swiss sculptor Otto Banninger, from 1926 to 1928; she was one of only a few Americans who learned to cut stone in Bourdelle's atelier. Bourdelle was a protégé of François-Auguste-René Rodin, whose 19th-century aesthetic descended from Bourdelle to Gregory. Her limestone *Beauvais Christ* was exhibited at the Salon des Tuileries in 1928. She returned home in 1928, exhibited her work at the Arts and Crafts Club in a joint show with painter Josephine Marien Crawford, and established her studio behind the family home on Pine Street in uptown New Orleans.

In the summer of 1935, Gregory continued her training at the New York State College of Ceramics at Alfred University. After the untimely death of modernist sculptor-teacher Juanita Gonzales, Gregory became an instructor in ceramics at Newcomb, a position she held from 1935 to 1937. From 1937 to 1938 she worked as a sculptor at the Silver Burdette Company in New York. She returned to New Orleans and earned a master of architecture degree from Tulane in 1941. Gregory, the first sculptor at Newcomb, was a lecturer in art and sculpture in 1940; in 1941–42 she became the sculptor in residence.

Gregory received commissions from most of the leading architectural firms in New Orleans. In 1941 she was appointed state superintendent of the Federal Arts Project and technical consultant for the Works Progress Administration. She taught at Dominican College on St. Charles Avenue from 1962 until 1976, when she retired as professor emerita.

In New Orleans, Gregory executed commissions for the Cabildo, the Criminal Courthouse on Tulane Avenue, the Archdiocese of New Orleans, the Isaac Delgado Museum of Art (now the New Orleans Museum of Art), Tulane University, the First National Bank of Commerce, and Union Passenger Station. Her colossal *Bienville Monument*, now on Decatur Street, shows the city's founder standing with the American Indian who welcomed him to the area and Father Athanase Douay, the French monk who guided Bienville's expedition. Other works include busts of Gov. Henry Watkins Allen, philanthropists William J. Warrington and John McDonogh, and a 1965 medal to commemorate the sesquicentennial of the Battle of New Orleans. Gregory also sculpted a bronze portrait bust of John Edmond "Jack" Sparling, a student of the Arts and Crafts Club's school, who became a cartoonist and illustrated comic books. She made four versions of the bust of Sparling, the others being executed in plaster and marble. Other sitters included authors Joseph Campbell and Harnett Kane and art historian John Canaday.

Gregory's architectural sculptures around the state include the Louisiana State Museum in Shreveport, the State Capitol in Baton Rouge, St. Landry Parish courthouse in Opelousas, and St. Gabriel's Catholic Church—the oldest surviving church in the Mississippi

River Valley—as well as sites in San Antonio and New York. Her international commissions are installed in Paris and New Zealand.

One of the early 20th-century artists to portray African Americans, Gregory created sympathetic sculptures, paintings, and prints of people of color. Two of these bronze portrait busts were exhibited at the 1930 Salon d'Automne in Paris and the Art Club in Washington, D.C., in 1931. Her 1929 *Faithful George [Lewis]*, portraying a custodian at Tulane, is masterfully produced and highly tactile. Another empathetically produced bust, *La Belle Augustine*, manifests the sculptural style of Rodin and Bourdelle. This 1928 bust was purchased in 1941 by IBM for a collection, *Sculpture of the Western Hemisphere*, which was exhibited in Canada, Latin America, South America, and in each American state; in May 1942 it opened at the Corcoran Gallery. In 1981 the Newcomb Department of Art held a retrospective exhibition of works by Gregory and Brès. Gregory died on 13 February 1990.

JUDITH H. BONNER
The Historic New Orleans Collection

Angela Gregory, a Sculptor's Life: An Exhibit Sponsored by the Southeastern Architectural Archive, Newcomb College Dean's Residence (1981); Judith H. Bonner, *Newcomb Centennial: An Exhibition of Work by the Art Faculty, 1886–1986* (1987); Suzanne Ormond and Mary E. Irvine, *Louisiana's Art Nouveau: The Crafts of the Newcomb Style* (1976); Charlotte Streifer Rubinstein, *American Women Sculptors: A History of Women Working in Three Dimensions* (1990).

Griffith, Louis Oscar

(1875–1956) PAINTER AND PRINTMAKER.

Painter-printmaker Louis Oscar Griffith was born in Greencastle, Ind., on 10 October 1875. He began his art career as a youth working as a bellhop in Texas. Griffith made drawings and paintings late at night in a nook provided for him at the hotel. He first studied art seriously in Dallas with Frank Reaugh, continued his studies at the St. Louis School of Fine Arts in 1893, and then returned to study with Reaugh intermittently from 1896 through 1903. Subsequently, Griffith studied at the Art Institute of Chicago during the evenings in 1906. In 1908 he pursued further studies in Paris and in Brittany, as well as at the National Academy of Design in New York.

Griffith is noted for his impressionistic city scenes, landscapes, portraits, marine scenes, and genre scenes, which are rendered with moderately loose brushwork. Griffith also mastered the art of etching and produced a number of views of French Quarter street vendors. During his visit to New Orleans in 1916, Griffith exhibited two oil paintings at the Art Association of New Orleans, as did his artist-friend Robert Wadsworth Grafton.

The following year Griffith and Grafton held a joint exhibition at the Art Association. Grafton exhibited 44 paintings, and Griffith displayed 18 paintings and 18 etchings. The two artists lived in the Garden District at 2532 Chestnut Street. They painted a series of New Orleans scenes for permanent exhibition on the mezzanine of the St. Charles Hotel in the central business

district in New Orleans, including two large scenes in the hotel's café that depicted horse races at the New Orleans Fairgrounds. In 1916 Griffith painted a view of the hotel, *The St. Charles Hotel*, portraying the third hotel built on the site of the present Place St. Charles. The painting, which formerly hung at the hotel, is now in the Historic New Orleans Collection. Later the St. Charles Hotel published *New Orleans: The Paris of America*, a book featuring some of Grafton's and Griffith's paintings, in which they also offered a set of 12 postcards that reproduced some of their impressionistic paintings of the city. While in New Orleans, Griffith also exhibited at the Isaac Delgado Museum of Art (now the New Orleans Museum of Art).

Griffith received numerous honors and awards, including the bronze medal for an etching at the 1915 Panama-Pacific Exposition in San Francisco, a gold medal from the Palette and Chisel Club, several awards from the Hoosier Salon in Indiana, the 1938 Frederick Nelson Vance Memorial Prize at the Brown County Art Association, the 1949 First Blue Ribbon, Chicago Society of Etchers, and the 1953 Prize at the Chicago Society of Etchers.

Over the years Griffith lived in several cities, including St. Louis, Chicago, and Nashville, Ind.—the latter noted as the site of the Hoosier Artists Colony, where he exhibited his paintings. His work was also shown at a variety of places, including the 1933 Century of Progress exhibition in Indiana, the Art Institute of Chicago's Society of Etchers, its Art Students League and its Palette and Chisel Club, the Canadian National Exposition, the Second International Print Show in Florence, Italy, and the Smithsonian Institute.

Griffith, who married Carolyn Maulsby in 1920, died in Franklin, Ind., on 13 November 1956 at the age of 81. His considerable body of work is celebrated in a recent biography and in an exhibition catalog of his prints.

JUDITH H. BONNER
The Historic New Orleans Collection

Anglo-American Art Museum, *The Louisiana Landscape, 1800–1869* (1969); Artists' Files, Williams Research Center, Historic New Orleans Collection; Judith H. Bonner, *Arts Quarterly* (April–June 2008), in *Collecting Passions*, ed. Susan McLeod O'Reilly and Alain Masse (2005); Joseph Fulton and Roulhac Toledano, *Antiques* (April 1968); William H. Gerdts, George E. Jordan, and Judith H. Bonner, *Complementary Visions of Louisiana Art: The Laura Simon Nelson Collection at the Historic New Orleans Collection* (1996); Rebecca Lawton, *Kevin Vogel (1875–1956): Rediscovering a Texas Printmaker* (2004); R. W. Norton Art Gallery, *Louisiana Landscape and Genre Painting of the Nineteenth Century* (1991); Frank Reaugh, Gardner Smith, and Robert Reitz, *A Pleasant Memory and a Pair of Old Shoes: The Letters of Frank Reaugh to Louis Oscar Griffith, 1895–1940* (2008).

Guilford Limner (Dupue)

(active 1820s) PAINTER.
Although records show that a number of itinerant portraitists worked in North Carolina and Kentucky between the 1770s and the mid-19th century, scholars have not yet discovered the name of the artist known as the Guilford Limner. This artist, active during the 1820s in the vicinity of Greens-

boro, Guilford County, N.C., and also in Kentucky, signed none of the watercolor portraits attributed to him. The artist did not advertise services in local newspapers as did many itinerants, and since newspapers did not report the visits of female painters, it is unlikely that the Guilford Limner was a woman. Indeed, the only hints at the artist's identity come from a letter by the granddaughter of a North Carolina client referring to "a traveling French artist" and a note on the back of the portrait of Mr. and Mrs. James Ragland of Clark County, Ky., that reads "taken August 1820 on Clark Co., Kentucky by Dupue." The stylistic similarities between the North Carolina portraits and the Kentucky works are sufficient to attribute the portraits to a single artist or perhaps to an artist and a close follower.

The Guilford Limner's watercolor portraits, more affordable than oil paintings, depict middle-class patrons who lived in a time of community growth and increasing prosperity. Whether the sitters were men, women, or children, the Guilford Limner paid close attention to the subjects' faces, and even though almost all have rounded eyes, well-defined eyebrows, short straight noses, diminutive cherub lips, and self-contained expressions, the artist manages to differentiate subjects one from another. Sometimes the artist also personalizes the portraits by painting the patrons' names within a cartouche or within the composition as though the name were a wall decoration. The number of commissions the artist received in Guilford County—

some 30—implies that patrons were pleased with their likenesses.

The conventional settings of the portraits undoubtedly fulfilled the desires of relatively affluent middle-class patrons to document their worldly and spiritual successes. Just as the artist repeated a limited repertoire of stylistic devices to render faces, he also placed most of his sitters within conventional and well-furnished 19th-century interiors, which may not have reflected the actual possessions of the sitters or the décor of their individual homes but which may suggest affluence. Wainscoted walls, Windsor chairs, fauxpainted decorations, and carpets with exuberant designs all display middleclass comforts. The sitters' manner of dress likewise indicates social status, age, and gender roles. Men wear white stocks, waistcoats, and cutaway jackets, while women wear modest but fashionable clothing.

The portraits of members of the four generations of the Gillespie family are excellent representations of social identities. Colonel Gillespie, "Gilaspi" in the artist's spelling, has chosen to present himself in the uniform and highfeathered hat of a Revolutionary War officer. Margaret, Daniel's wife, wears a ruffled cap, wide scarf, and dark dress to display the modesty and rectitude of a grandmother. The Gillespie daughters, Nancy and Thankful, wearing jewelry and slightly less concealing clothes and sewing or knitting, advertise their industry and piety.

In the portrait of Robert Gillespie, the married son of Daniel and Margaret, the Guilford Limner indicates

the young man's success as a farmer through an unlikely display of corncobs, which lie upon a sitting room's paint-grained table. Robert's wife, Nancy Hanner Gillespie, sits beside an abundant arrangement of flowers. The youngest member of the family, John Patterson Gillespie, wears a dark suit and carries a book, both conventional emblems of a boy's preparation for adulthood.

Other portraits contain additional emblems of attainment and virtue. Men may sit at desks and review their account books. Women holding bouquets and children standing in gardens are conventional depictions that represent the children's flourishing and their parents' careful nurture. The Raglan portrait places the couple out of doors; a winding road leading into the distance may represent the extent of their property. Works by the Guilford Limner, or Dupue, are held in the Greensboro Historical Museum and in private collections.

CHERYL RIVERS
Brooklyn, New York

Karen Cobb Carroll, *Windows to the Past: Primitive Watercolors from Guilford County, North Carolina, from the 1820s* (1983); Nina Fletcher Little, *Antiques* (November 1968), *Little by Little* (1984); McKissick Museum, *Carolina Folk: The Cradle of a Southern Tradition* (1985).

Gwathmey, Robert

(1903–1988) PAINTER.
Robert Gwathmey is a major exception to the assertion that the 20th-century renaissance in southern culture had little impact on the visual arts. His paintings reflected the same fascination with the South, its people, and its traditions that was found in the writing of novelists, poets, journalists, and historians of the Southern Renaissance. Like these writers, Gwathmey also felt the need to break free of the oppressiveness of the inherited southern culture and social order. Because his art often depicted sharecroppers and white planters in juxtaposition, it was first characterized as merely a southern version of the social realist painting of the 1930s. Only a few southern museums included his works in their collections, compounding the general problem that paintings were not very accessible to most southerners. This created the phenomenon of an artist who was better known and recognized in New York than in his native region.

Gwathmey, however, always considered himself a southerner. He was born in 1903 in Richmond, Va., where he was educated through high school. By the time he began attending North Carolina State in 1924, he had already held several jobs as a laborer. He received his first formal training in art at the Maryland Institute in Baltimore in 1925 and 1926, but he soon transferred to the prestigious Pennsylvania Academy of the Fine Arts. While there, he learned art technique well enough to be awarded two European summer study fellowships. He taught at Beaver College and the Carnegie Institute in Pennsylvania and at the Cooper Union in New York City. A Rosenwald Fellowship enabled him to spend part of 1944

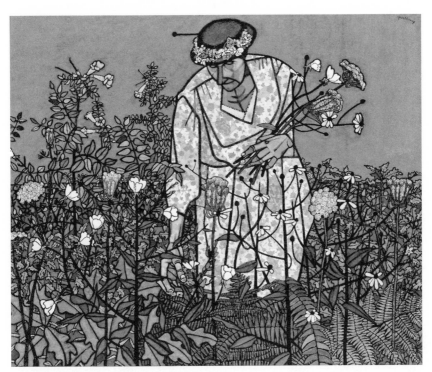

Robert Gwathmey, Flowers for the Pulpit, 1959, oil on canvas, 40⅛″ x 48¼″ (The Johnson Collection, Spartanburg, S.C.)

living and sketching on a farm in North Carolina.

In the late 1930s Gwathmey destroyed all his previous paintings and began to focus on southern themes. Some, for example, *Poll Tax County* (1945), were bitter critiques of the white-controlled caste and political systems. Others, like *Painting of a Smile* (1953), were more subtle examinations of the vitality of African American culture and the decadence of the white ruling class.

Gwathmey believed that the South provided an ideal source of inspiration for the visual artist because of the region's colorful vegetation and soil, as well as its striking contrasts of black and white, past and present. His complex painting *Space* (1964) incorporates commentary on southern involvement in space exploration as well as on the Freedom Rides and a decaying Confederate cannon and monument. Gwathmey's acceptance in the art world of New York led to a comfortable later life on Long Island with his North Carolina–born wife. His political activism brought him under FBI surveillance during the post–World War II period, and he remained a dissenter, particularly during the Vietnam War era. Gwathmey is represented in such major collections as the Whitney Museum of American Art, the Smithsonian Institu-

tion's Hirshhorn Museum and Sculpture Garden, the Philadelphia Museum of Art, the Los Angeles County Museum of Art.

CHARLES K. PIEHL
Mankato State University

Lynne Blackman, ed., *Southern Masters of Printmaking* (2005); August L. Freundlich, *Robert Gwathmey, Master Painter* (1999); Michael Kammen, *Robert Gwathmey: The Life and Art of a Passionate Observer* (1999); Charles Piehl, *Robert Gwathmey: Works from Southern Collections* (1999); Paul Robeson, *Robert Gwathmey* (1946).

Halsey, William

(1915–1998) ARTIST.

Long considered the dean of 21st-century South Carolina art, William Halsey was given a chance to move to New York City at the height of abstract expressionism, but he decided instead to remain in Charleston, where he felt he could have greater impact. Educated in local schools, as a teenager Halsey became a youthful protégé of Charleston Renaissance artist Elizabeth O'Neill Verner. He attended the University of South Carolina for two years before going to the Boston Museum School, where he studied anatomy and fresco painting. In 1939 he married Sumter native and fellow artist Corrie McCallum and spent 18 months in Mexico on a Paige Fellowship from the Boston Museum School. Returning to the Southeast, he taught for a short period in Charleston before moving to Savannah to direct the art school at the Telfair Academy. He settled in Charleston permanently in 1945 and supported himself

by teaching, first at the Gibbes Art Gallery and then independently.

From 1972 until 1984 Halsey was artist in residence at the College of Charleston, where the Halsey Institute of Contemporary Art is named in his honor. He traveled extensively, funded by friends and supporters, who were rewarded with a work of art in return for their modest subventions. The Yucatán peninsula in Mexico was one of his favorite destinations, but he also went to Greece, Spain, and Morocco. In 1971 he and McCallum published *A Travel Sketchbook*, an annotated selection of their drawings, and in 1976 he issued *Maya Journal*. Unlike his predecessors who emphasized charm and sunlight, Halsey reveled in the decay, colors, and textures offered by the old city. It was precisely these qualities that inspired the nonrepresentational work that dominated his mature output. Instead of painting conventionally in oil on canvas, he elected to use Masonite, which provided a firm surface for his frequent reworkings of the surface. The firmness of the support was advantageous when he added collage elements, like old paint rags, torn and stained bits of his own clothing, and African textiles. About 1964 Halsey began to translate his collages into three-dimensional sculptures, largely totemlike assemblages, made from scraps of wood and later metal. Late in his career he worked with oil pastels on paper in a bright range of colors enlivened by expressionist gestures. A prolific artist, Halsey was active in arts organizations in the state (for example, the Guild of South

Carolina Artists), and his work was regularly included in a broad range of exhibitions across the Southeast.

MARTHA R. SEVERENS
Greenville, South Carolina

Jack A. Morris Jr., *William M. Halsey: A Retrospective* (1972); Martha R. Severens, *William Halsey* (1999).

Hamblett, Theora
(1895–1977) PAINTER.

Theora Hamblett was born on 15 January 1895 in the small community of Paris, Miss. Hamblett lived the first half of her life on her family's modest farm in Paris. Her experience as a white woman growing up and living in the impoverished rural South was typical of her times, with the exception that she never married or had children. From 1915 to 1936 Hamblett taught school intermittently in the counties near her family home. In 1939 she moved to the nearby town of Oxford, where she supported herself as a professional seamstress and converted her home to a boardinghouse.

Hamblett began painting in the early 1950s, fulfilling an interest in art that had begun in her youth. Although she enrolled in several informal art classes and a correspondence course during her later life, Hamblett was largely self-taught. Her first paintings depicted memories of her childhood, and she painted scenes of southern country life for the next two decades, culminating in a series of paintings about children's games. Hamblett's most unusual works are the more than 300 religious paintings representing biblical subjects and Hamblett's own dreams and visions. These paintings began in 1954 with *The Golden Gate*, later renamed *The Vision*. Today, this first painting is owned by the Museum of Modern Art in New York; most of Hamblett's religious paintings and many memory paintings were never available for sale and were bequeathed by the artist to the University of Mississippi Museum in Oxford.

Hamblett's religious paintings and interpretations of her dreams and visions were firmly rooted in her personal religious history. The popular, transdenominational southern Protestantism practiced in the churches, revival meetings, and hymn sings Hamblett attended in and around Paris, Miss., all emphasized the possibility of unmediated encounters between God and communicants, usually taking the form of visionary or dreamlike experiences. Church services were often structured around testimonies in which the worshippers described these experiences, and hymn lyrics regularly referred to them. Hamblett's vision and dream paintings bear structural similarities to traditional testimonies, and many of her paintings employ images from the popular southern hymnody.

Hamblett's aesthetics and working methods were also largely products of her background. The needlework skills she learned as a southern rural woman, and with which she occasionally supported herself, are evident in her art. Hamblett's characteristic tiny brushstrokes of unmixed color resemble embroidery stitches, and many of her images suggest lacework and tatting.

Hamblett's interest in painting was not unusual, but the dedication with which she pursued that interest and the role it played in her life were exceptional. The record her work provides of a vanishing regional history and the complex associations of her religious paintings raise Hamblett from the status of an amateur to that of a significant artist of popular southern traditions.

ELLA KING TORREY
Philadelphia, Pennsylvania

William Ferris, *Four Women Artists* (1977), *Local Color: A Sense of Place in Folk Art* (1983); Theora Hamblett, in collaboration with Ed Meek and William S. Haynie, *Theora Hamblett Paintings* (1975); Ella King Torrey, "The Religious Art of Theora Hamblett, Sources of Attitude and Imagery" (M.A. thesis, University of Mississippi, 1984).

Heade, Martin Johnson

(1819–1904) PAINTER.
Martin Johnson Heade was fortunate that his father, a successful lumber dealer and farmer, funded his son's early art study with Edward Hicks, sometime around 1837. Heade met Hicks's brother Thomas, who may have further influenced the young artist. Additionally, Heade's father bore the expense of Martin's study in Italy in 1838, as well as trips to England and France.

From 1840 to the late 1850s Heade was a portrait, allegorical, and genre painter, during which time he changed the spelling of his name from Heed to Heade. He traveled in the South from late 1857 to April 1858 in the hope of obtaining portrait commissions, making stops in Mobile and New Orleans

(where he sketched a market scene) and "caustically" commenting on slavery and southern hotels. After moving to New York in 1858, he exhibited and painted with the Hudson River school, whose members, particularly Frederic Church and Sanford Gifford, were influential. Also inspiring Heade and other American artists of the period was the Pre-Raphaelite movement, whose leaders stressed intimate study of nature. Subsequently, Heade became noted for his luminist landscapes of salt marshes and somber coasts, as well as Victorian paintings of flowers, especially roses.

Heade was a naturalist who explored far beyond the United States to study and capture nature's beauty. The epitome of someone consumed by 19th-century "orchidmania," a widespread obsession with orchids, Heade satisfied his fascination with the air plant by several travels in South America, beginning in 1863. These sojourns resulted in numerous, passionate orchid and hummingbird paintings as well as meticulous renderings of butterflies, adding to his acclaim.

In 1883, having already earned recognition as a significant American artist, Heade convinced his wife, Elizabeth, to move to St. Augustine, Fla., in the hope of the city becoming a winter resort. In the "Ancient City" that year he met art lover Henry M. Flagler. Heade set up a residence in St. Augustine, invested in properties, and obtained the patronage of Flagler.

After Flagler opened his palatial Ponce de Leon hotel in 1888, which included artists' studios, Heade became

the most famous member of the group who painted and exhibited there. The artists' exhibitions in their studios became highlights of the St. Augustine social season, and Heade continued producing and successfully selling works of orchids and hummingbirds. Adding to Heade's income were sales of Florida landscapes—largely of marshes near the city, the St. Johns River, the San Sebastian River, and Lake Alto near Gainesville. Heade's paintings portrayed Florida as what it was essentially—an exotic, primeval, paradisiacal wilderness. Flagler was quite an admirer of these works, especially the oils depicting dramatic sunsets. In fact, Heade reported in 1887 that he was creating two 8-foot-long Florida landscapes for Flagler, "which will take some thousands out of his pocket, but I think he can stand it."

The St. Augustine media gushed over Heade's work and described his studio as "one of the favorite resorts of the city, not only on account of the beautiful reproductions of flowers and field to be found there, but on the account of Mr. Heade's social popularity who together with his wife, make a social center for that city." Southern flowers rendered by Heade included luxuriously painted magnolia blossoms, in which the highly detailed flower was placed on draped velvet, in a shimmering glass vase, or on a gleaming tabletop reflecting light—with the light also defining the magnolia's silky petals and polished leaves. Other southern-inspired paintings were tabletop Cherokee roses and lotus lilies. It was declared that Heade's flower paintings "were depicted with such truthfulness, such attention to detail that it is hard to realize they may not be picked and worn."

An environmentalist before the notion became fashionable, Heade consistently wrote letters to *Forest and Stream* under the pseudonym "Didymus," concerning the defense of wildlife. Nonetheless, Heade is most well known as one of Florida's finest painters.

DEBORAH C. POLLACK
Palm Springs, Florida

Sandra Barghini, *Henry M. Flagler's Paintings Collection: The Taste of a Gilded Age Collector* (2002), *A Society of Painters: Flagler's St. Augustine Art Colony* (1998); Linda S. Ferber and William H. Gerdts, *The New Path: Ruskin and the American Pre-Raphaelites* (1985); *St. Augustine News* (25 January and 22 March 1891); Theodore E. Stebbins Jr., *Life and Work of Martin Johnson Heade: A Critical Analysis and Catalogue Raisonné* (2000), *Martin Johnson Heade* (1969); Henry T. Tuckerman, *Book of the Artists: American Artist Life* (1867, 1967).

Healy, George Peter Alexander

(1813–1894) PORTRAITIST.
George Peter Alexander Healy was born in Boston to William Healy, a sea captain, and his wife, Mary Hicks. After his father's death he opened a portrait studio in Boston at the age of 18, where he attracted the patronage of Mrs. Harrison Gray Otis. With his initial earnings he traveled abroad for further study, working in Paris from 1834 to 1836 with Thomas Couture and Baron Antoine-Jean Gros. Healy was in

London from 1838 to 1839, where he became an associate of the Royal Academy and married Louisa Phipps. He returned to Paris in 1840 and became a favorite of Louis-Philippe, the French "citizen King."

While living in Paris, Healy returned to America in 1840 and visited Louisville, Ky., in 1840 and 1842. In fulfillment of a commission from Louis-Philippe to paint portraits of prominent Americans, in 1845 he visited Lexington, Ky., to portray Henry Clay. While there, Healy used the studio of local portraitist Oliver Frazer, a friend from his student days in France. He also assisted Frazer, whose health and eyesight were failing, to complete a portrait of Mrs. Samuel McKee. Healy, having just left the deathbed of Clay's nemesis Andrew Jackson, went to Ashland, Clay's home in Lexington, to paint the Great Compromiser. As told by Healy, after Jackson's and his last encounter, the artist, having accomplished all he could do in this final sitting, prepared to take his leave. Yet Old Hickory asked him to stay. "Please come in. I wish it." And so Healy was there to hear the last words, "Why do you weep for me? I am in the hands of the Lord, who is about to release me. You should rejoice that my sufferings are at an end."

Once at Ashland, Healy found that the "contrast was great in every respect. Instead of tears, suffering, of death, I found happiness, luxury, and joyous life." He painted Clay as rather worn, perhaps as a result of empathetic response from his sitter. Clay is said to have remarked, "You are an indifferent courtier; though you come to us from the French King's presence, you have not spoken to me of my livestock. Don't you know that I am prouder of my cows and sheep than of my best speeches?" Though the two men parted in peace, Clay had little further interest in sitting for Healy. When the artist visited Washington, D.C., in later years he sent a card into Clay's office, only to hear him exclaim "What! Another?"

Healy and his family relocated to Chicago in 1855, which was to become his base of operations for the rest of his life, though he continued to travel and paint abroad. He was very popular in the South and made much-touted itinerant trips to New Orleans from 1857 to 1860 and to Charleston in 1861. He was often in Kentucky, where he painted in Louisville, Lexington, and Bardstown in 1859, 1860, and 1865, resulting in a large body of work based on Kentucky sitters. One of his most famous portraits depicted a Kentucky sitter in New Orleans. Sallie Ward was the daughter of a rich Louisville businessman who married Robert Hunt and moved to New Orleans, where she was known for her lavish hospitality and sensational beauty. Healy's portrait gives evidence that he admired the work of the French master Jean-Auguste-Dominique Ingres, with its echoes of that artist's coquettish *Baroness d'Haussonville* and the elaborately garbed *Madame Moitessie*. He is said to have "rapturously insisted that [she] was the most elegant and beautiful woman that ever lived."

Healy's posh style was always more popular in the cavalier South than it was in the more pious precincts of back bay Boston, where he is never noted

as having been a favorite son. His contemporary, Henry Tuckerman, wrote that the "vigor of execution in the best of Healy's work is not less remarkable than his facility and enterprise: his likenesses often want delicacy, but seldom lack emphasis." He became active again in Europe after 1866, notably in Spain in 1871 and Romania in 1872.

While he was abroad with his family, the great Chicago fire of 1871 destroyed his home and studio. He was the first American artist to be asked to donate a self-portrait to the Uffizi Gallery collection in Florence. The rise of the impressionist movement in France during the early 1870s depressed him deeply, leading to feelings of isolation. He returned to America and retired in Chicago in 1892, where he died. His most famous work may well be the seated Lincoln portrait in the White House collection.

ESTILL CURTIS PENNINGTON
Paris, Kentucky

Mary Healy Bigot, *Life of George Peter Alexander Healey* (1915); Vaughn Glasgow, *G. P. A. Healy: Famous Figures and Louisiana Patrons* (1976); George Peter Alexander Healy, *Reminiscences of a Portrait Painter* (1970); Estill Curtis Pennington, *Kentucky: The Master Painters from the Frontier Era to the Great Depression* (2008), *Lessons in Likeness: The Portrait Painter in Kentucky and the Ohio River Valley, 1800–1920* (2010); Michael Quick, *American Portraiture in the Grand Manner, 1720–1920* (1981); Henry T. Tuckerman, *Book of the Artists, American Artist Life* (1867); Edna Talbott Whitley, *Kentucky Ante-Bellum Portraiture* (1955).

Heldner, Knute

(1877–1952) PAINTER.

The life and career of Knute Heldner reflect the range and complex backgrounds of the artists who were increasingly active in the American South during the 20th century. Sven August Knut Heldner was born in 1877 in Vederslöv Småland, Sweden. His father was a farmer who encouraged his son's artistic interests, including his early training in drawing and wood carving at Karlskrona Technical School and the National Royal Academy of Stockholm. Young Knute was a cadet in the Swedish Royal Navy and later served as a cabin boy. He worked his way to America around 1902 and, attracted by its Swedish communities, went to Minnesota. There he found employment as cobbler, miner, and lumber camp cook. Heldner received art training from Robert Kohler at the Minneapolis School of Fine Art, and after submitting paintings to a competition at the Minneapolis State Fair in 1915 he won two prizes for his works.

Heldner became an active figure in the art worlds of Minneapolis and Duluth, Minn., and exhibited his art whenever possible in that region. He was active with the Raethel McFadden art studio in Duluth, where he maintained a working studio. There Heldner met a young artist and studio resident, Colette Pope, and in 1923 they were married in Virginia City, Minn., soon after moving to New Orleans on their first trip south.

Knute and Colette Heldner quickly embraced the history and spirit of the French Quarter, as well as its bohemian

art society, and both became active participants in the art world of the historic neighborhood. Since the 1890s, brothers William Woodward and Ellsworth Woodward and others had advocated for the preservation of the French Quarter and its architecture. The preservationist activities of the 1920s increasingly attracted artists, writers, musicians, and performing artists, including artists Alberta Kinsey, George Frederick Castleden, Morris Henry Hobbs, the Woodward brothers, and their students, as well as writers William Faulkner and Sherwood Anderson. Knute Heldner joined the Southern States Art League and the New Orleans Art League. In 1926 he was given his first solo show, organized by the Art Association of New Orleans, at the Isaac Delgado Museum of Art (now the New Orleans Museum of Art). He also worked as an art teacher in the French Quarter at the School of Art, founded by the Arts and Crafts Club of New Orleans.

Even while he was teaching, Heldner continued his study of art during the 1920s and 1930s with artists and private teachers, as well as at schools like the Art Institute of Chicago. In 1929 he and Colette went to Europe, traveling to Germany, France, Norway, and Sweden. During this time, Heldner studied privately with French artists and at the Academy of Scandinavian Art in Paris. In 1932 he was featured in solo exhibitions in Paris and Stockholm and afterward returned to New Orleans, where he was given a solo show that year at the Arts and Crafts Club. He and Colette established their French Quarter studio at 732 St. Peter Street and main-

tained their annual schedule, returning to Duluth, Minn., in the summer and spending winters in New Orleans.

Knute Heldner painted numerous views of the French Quarter over the years. One of his best works, *French Quarter Roof Tops from His Studio*, now in the collection of the Ogden Museum of Southern Art, was executed during his first year there in 1923. Heldner is also recognized for his landscape paintings of Louisiana and Minnesota—swamp scenes (*Crawfish Shack*), nautical scenes (*Melon Boats on Lake Pontchartrain* and *Sailboats on the Mississippi*)—and his portraits and genre scenes. Many of his views related to the evolving American Scene and regionalist directions in the American art world. During the years of the Great Depression, Heldner was employed under the Works Progress Administration's Federal Arts Project (directed in the Gulf Coast region by Ellsworth Woodward), painting landscape scenes and portraits. Over an extended period, Heldner created a series of approximately 50 dry-point etchings of the French Quarter.

Heldner later built upon his early training and skills as a wood-carver, producing a broad range of elaborately carved and decorated objects, many of them functional, including a carved and painted trunk (1928) now in the collections of the Ogden. Although national art styles changed and the appearance of abstract expressionism evolved in the years after World War II, Heldner continued to paint many of the same subjects throughout his career, including works like *The Pig Woman—A Southern*

Idyll in 1932 and a related agrarian scene, *Love in the Cotton Patch*, which was completed in 1951 just one year before his death. Knute Heldner died in New Orleans on 5 November 1952. Colette Heldner lived and worked in New Orleans for several more decades, dying there in 1990.

J. RICHARD GRUBER
Ogden Museum of Southern Art
University of New Orleans

Jean Bragg and Susan Saward, in *Knute Heldner and the Art Colony in Old New Orleans* (2000); Randolph Delehanty, *Art in the American South: Works from the Ogden Collection* (1996); Knute A. Heldner Papers, Special Collections, Louisiana State University Libraries, www.lib.lsu.edu/special.

Hesselius, John

(ca. 1726–1778) PAINTER.
Around 1711 Gustavus Hesselius and his wife, Lydia, were among a large number of Swedes who settled in the Christiana-Wilmington area of Delaware. Others in the family went first to Pennsylvania. Gustavus moved to St. George's County, Md., at an undetermined date and sold his land there in 1726. John Hesselius, his son, was probably born that year, presumably in Philadelphia, where his parents had moved and would live until their deaths.

John's father painted portraits in Maryland and Pennsylvania—and possibly a few in Virginia, since one work from that colony is attributed to his hand. In Philadelphia, Gustavus advertised that he was from Stockholm and that, in addition to painting portraits, landscapes, coats of arms, signs, and showboards, he was skilled in ship and house painting, gilding, and restoring pictures. He learned all of these branches of painting, decorative and utilitarian, from his father. John's earliest likenesses, however, show the strong influence of another artist, Robert Feke, who visited Philadelphia in the 1740s. Feke's rich colors and more fashionable compositions impressed the younger, ambitious painter, who quickly adopted them in a number of his earliest portraits.

Hesselius may have painted in Virginia as early as 1748. As many as 12 portraits have been identified as his work for the 1748–49 period in Virginia; many others were painted after this. His father's death in 1755 apparently provided a greater opportunity for the young Hesselius to make painting trips to Virginia and Maryland. By 1759 he had moved his residence to Maryland. On 30 January 1763 he married Mary Young Woodward, the widow of Henry Woodward of Anne Arundel County. The couple reared eight children, including a son named Gustavus. Either in this year or the previous one, Hesselius traded painting lessons to Charles Willson Peale for a saddle.

Sometime around 1756 Hesselius's portrait compositions and painting style changed dramatically and became based on the highly successful work of the London-trained painter John Wollaston. The latter worked in the mid-Atlantic region from about 1755 to 1758. Hesselius softened his colors to more pastel shades and switched to more graceful, flowing poses for sitters in imitation of the rococo style that Wollaston practiced.

Hesselius continued to work in this fashion until the last years of his life, changing his approach to one of greater realism and eliminating the opulent and mannerist characteristics associated with the rococo. The artist's late work was probably influenced by neoclassicism, first introduced in America by studio-trained painters like Henry Benbridge and Hesselius's former pupil Charles Willson Peale.

At the time of his death, on 9 April 1778, Hesselius left an impressive estate of household furnishings, cash, and land holdings. Many museums, including the Baltimore Museum of Art, the Metropolitan Museum of Art, the National Gallery of Art, the Corcoran Gallery of Art, and the Abby Aldrich Rockefeller Folk Art Museum, hold Hesselius's works.

CAROLYN WEEKLEY
Colonial Williamsburg Foundation

Richard K. Doud, "John Hesselius: His Life and Work" (M.A. thesis, University of Delaware, 1963), *Virginia Magazine of History and Biography* (April 1967); Elisabeth Louise Roark, *Artists of Colonial America* (2003).

Highwaymen

The story of the Highwaymen is an unlikely one. This group of young African American artists living near Fort Pierce, Fla., during the early years of the civil rights movement rose above existing societal expectations and produced a large body of oil paintings that document the mid-20th-century landscape of the Sunshine State. For most of their careers, the artists worked anonymously, remaining unrecognized and uncelebrated until they were given the name "Highwaymen" in a magazine article in 1994, some 30 years after the beginning of their loose association.

Alfred Hair, who had begun painting on his own in 1955, enlisted and encouraged friends and family members to join him, so that they might escape their likely destinies working in Florida's orange groves and packinghouses. They painted in their yards, often collectively through the night, and then took their still-wet creations to the streets to sell. These self-taught painters were entrepreneurs who became artists by default. Creating fine art was never their objective; their goal was acquiring wealth.

The artists worked feverishly for more than a decade. To them, time was money. The haste with which they painted each picture, often in less than an hour, resulted in a distinct style that was misunderstood by many art fanciers. Characterized by early critics as "motel art," the images of wind-swept palm trees, billowing cumulus clouds, moody seas, and intensely colored sunsets idealized Florida in generic but archetypal tropical scenes intended to appeal to the masses. The paintings became popular representations of the manner in which residents and tourists alike viewed the state.

Through their practice of fast painting, the Highwaymen created, or at least contributed to, a fresh approach to the tradition of American landscape painting. Their images are not generally detailed or treated in a grand manner; rather, they reveal temporal places in the process of becoming fully formed. The gesturally painted images, stripped

of artifice, encourage viewers to lend their own inspirational meanings to these works of art.

Today the story of the Highwaymen is a significant part of Florida's folklife and history. Even larger, perhaps, is the contribution that this tale makes to our national story: a saga about American dreams realized by a disenfranchised group of young people during a most oppressive time. Their visual legacy of Florida, depicted in as many as 200,000 paintings, has come to symbolize not only the beauty of the area but also the hopes and aspirations of its inhabitants.

GARY MONROE
Daytona Beach Community College

Gary Monroe, *Extraordinary Interpretations: Florida's Self-taught Artists* (2003), *Harold Newton: The Original Highwayman* (2007), *The Highwaymen: Florida's African-American Artists* (2001).

Hill, Harriet "Hattie" Hutchcraft

(1847–1921) PORTRAITIST.

Harriet Amanda Hutchcraft was born at Stony Point, Bourbon County, Ky., to James and Eliza Williams Hutchcraft. After studying at Stony Point School she attended Daughter's College, Harrodsburg, Ky. By November 1865 she had graduated, married William A. Hill, and been certified to teach first grade in Danville, Ill. She lived in Danville until 1870, when William died and she returned to Kentucky. For the next eight years she filled various teaching positions in Paris and Georgetown, Ky.

In June 1878 Hattie Hill and her sister Mattie sailed for Europe to visit the Great Exposition in Paris. Until that time Hill had been content to teach painting and drawing to young ladies in the genteel academies and seminaries of the day. The visit to Paris stirred her ambition to become a recognized painter of landscape and still life art for submission to the Paris Salons. While on that trip, she painted her first important work, a monumental view of Mt. Wetterhorn in Switzerland.

Upon Hill's return home, she resumed teaching young ladies the more pragmatic arts and crafts. An undated clipping in her scrapbook, from a Danville, Ill., newspaper notes that "pupils . . . working under Mrs. Hill's supervision . . . are making rapid progress" in making "pretty specimens of decorated china," a "profitable employment for a class composed of housekeepers who love to surround their tables with congenial friends" and "to decorate, with their own hands, the cups and plates."

In October 1888, with funds Hill had inherited from her parents, she returned to France and took up residence at 38 Rue du Dragon. She enrolled in the famous Académie Julian, located in the same block, at number 31. Founded in 1868, the Académie Julian was quite popular with Americans, and, unlike the competing École des Beaux-Arts, it admitted women, including Cecilia Beaux and Lila Cabot Perry. The academy also included members of the Nabis (Prophets) group of painters, whose stylistic innovations greatly influenced what we now know as the post-impressionist movement. Their ranks included Pierre Bonnard and Édouard Vuillard, whose heightened color values and richly patterned brushwork can be seen in some of Hill's later landscape

paintings. Her most influential instructors were Benjamin Constant and Jules-Joseph Lefebvre, artists whose calm close color harmonics influenced many of the American artists who worked in the Barbizon mode.

While in Paris, Hattie Hill received her most important commission. Early in 1893 a group of ladies in Bourbon County formed a committee to assist in the decoration of the Kentucky Room for the World's Columbian Exposition in Chicago. Under the leadership of Mary Harris Clay and Florence Kelly Lockhart, this committee wrote to ask Hill to paint a monumental portrait of Judge William Garth, whose financial legacy had created the Garth Education Fund in the aftermath of a family tragedy. Clay had stipulated that any funds raised in Bourbon County could only be used for a work of art that would be returned to Bourbon County and hung in the courthouse. Writing in May 1893, after the work had been shipped, Hill again sent her earnest wish that the portrait would please all the committee members, even "those who voted against me. I did my best and feel safe in saying" that if it has "passed the judgment of the masters of Paris, France, it certainly should those of Paris, Kentucky."

Hill remained in France until 1895, exhibiting works at the Paris Salon. When her funds dwindled, she returned to America and settled in Los Angeles, where she was active as a portraitist under the patronage of the Otis family. Illness forced her home to Bourbon County in 1898, where she lived another 23 years, teaching china painting and

grinding out souvenir watercolors of the Cane Ridge Meeting House for sale in the local Ladies Exchange. She also painted portraits—notably those of five Bourbon County judges important to the construction of the new courthouse in 1905, which hang there still.

Hattie Hill died in her "ivy covered cottage" on 8th Street in Paris, Ky., and was buried in the Paris Cemetery beneath a granite marker carved like an artist's palette and inscribed with her signature.

ESTILL CURTIS PENNINGTON
Paris, Kentucky

Archives of American Art, Smithsonian Institution; Estill Curtis Pennington, *Kentucky: The Master Painters from the Frontier Era to the Great Depression* (2008).

Hubard, William James

(1807–1862) SILHOUETTIST AND PORTRAITIST.

William James Hubard was born in Whitchurch, Shropshire, England, to William J. and Jane Hubard. The artist's father was a modest provider who apprenticed his son at an early age. When young Hubard began to exhibit his extraordinary talent in cutting silhouettes, Smith, a neighbor whose full name is unknown, offered to undertake his management. Taking Hubard under his wing in 1824, Smith started the lad on a cross-country tour as a member of his *Papryotomia*, an exhibition that conflated a musical, *Panharmonicum*, with a demonstration of cutting profile portraits. While they were in Ramsgate, Hubard and Smith attracted the attention of the Duchess of Kent and her daughter, Princess Victoria, whose

profiles Hubard cut on black paper heightened by gold coloring. Hoping to attract an American audience fascinated by native genius, Smith took Hubard to Boston in 1825. Like other prodigies compelled to perform by a demanding manager, Hubard rebelled, and in 1826 he left Smith's regime, setting out to establish himself as a portraitist in oils.

Hubard's first efforts drew the attention of several noted artists, including Gilbert Stuart and Thomas Sully. In 1832 John Sartain made an engraving of Hubard's portrait of Andrew Jackson. After 1832, Hubard began to spend much of the year as a portraitist in Virginia, with residencies in Norfolk, Williamsburg, and Gloucester County. Restless itinerancy and irresponsibility seem to have plagued Hubard throughout his life, although by 1836 he had acquired a settled residence with the purchase of "The Retreat," a house in Gloucester Courthouse, Va. In 1837 he married Maria Tabb, and the couple departed on an extended trip to Europe. While in Florence, Hubard painted a portrait of the sculptor Horatio Greenough and also made copies of early Renaissance paintings. The Hubards returned to their home in Gloucester Courthouse in 1841, but by the late 1840s they had made a permanent residence on the edge of Richmond, near the home of the artist Edward F. Peticolas. During the next decade, Hubard became the portraitist of choice in the Richmond area, patronized by Virginia's most prominent families, including sitters from the extended connections of the Tabb, Mayo, Randolph, Bolling, Cushing, Cocke, and St. George Tucker clans. Hubard also became a close associate of Mann Satterwhite Valentine II, a writer and antiquarian with pronounced artistic interests. Hubard's association with Valentine resulted in some of his most interesting work, notably the illustrative drawings he made for Valentine's gothic romance *Amadeus; Or, a Night with the Spirit.*

By 1852 Hubard announced that he would conduct art classes in his painting rooms at Eleventh and Broad Streets. At the same time, doubtlessly buoyed by his popularity and prosperity, Hubard began his most ambitious project. He undertook to make copies, in bronze, of Jean-Antoine Houdon's monumental statue of George Washington, which stood in the vestibule of the Virginia State Capitol. At great expense, Hubard built a foundry on the site of the Peticolas home, which he had purchased. His first attempts at copying the statue were unsuccessful, and it was not until 23 February 1856 that he produced his first salable variant, purchased by the Commonwealth of Virginia and placed at the Virginia Military Institute in Lexington. Though Hubard made five additional castings, his efforts to market these works failed. As the Civil War erupted he was in dire financial straits, sustained largely by the patronage of Valentine and other loyal followers. Hubard attempted to transform his foundry into a munitions works for the casting of guns and the manufacture of explosives, and on 13 February 1862 a shell exploded in the foundry, severely wounding him. Though amputations were made to his leg and hands

in an effort to save his life, he died two days later. In the extravagantly lavish prose of the day, the Richmond papers mourned him as an artist "distinct from the common world in person, in mind, in manners," distinguished by "tenderness and generosity of soul in which self seemed to hold literally no place." In private writings, Mann Valentine offered a more balanced view of the artist. While recognizing that he was "familiar with all the shades of sensibility, thought, and feeling, [and] can give the most delicate touches of pen and pencil fancy," Valentine also felt that there "seems to have been something wanting . . . a moral energy. He has been endowed with a wanton fickleness in pursuits and a childish equivocation of character."

ESTILL CURTIS PENNINGTON
Paris, Kentucky

William Dunlap, *History of the Arts of Design in the U.S.* (1918); Alexander G. Gilliam Jr., *Virginia Cavalcade* (Autumn 1961); Helen G. McCormack, *William James Hubard, 1807–1862* (1948); Estill Curtis Pennington, *Romantic Spirits: Nineteenth-Century Paintings of the South from the Johnson Collection* (2012); Mable Munson Swan, *Antiques* (October 1931); Lewis R. Wright; *Artists in Virginia before 1900* (1983).

Hudson, Julien

(ca. 1811–1844) PAINTER.
Most likely the son of London-born ship chandler and ironmonger John Thomas Hudson and Suzanne Désirée Marcos, a free quadroon, Julien Hudson is thought to have been a free man of color. However, he is not listed in the 1838 *New Orleans City Directory*

as "f.m.c.," as was the custom. His racial identity has been a matter of intense scrutiny for many years. The date of his birth is a matter of contention as well, but it was likely 9 January 1811. Hudson's father apparently did not live with the family after about 1820, but his mother maintained a comfortable standard of living, owing to presumed support from her husband in addition to her and her mother's real estate investments.

Young Hudson probably studied grammar, mathematics, and other subjects with a private tutor in the French Quarter at their home on Bienville Street near Bourbon. In 1826–27 he studied art with Antonio Meucci, a drawing instructor, restorer, and painter of miniatures and opera scenery. Upon his grandmother's death, Hudson inherited part of Françoise Leclerc's $7,000 estate, in 1829, which allowed him to pursue further study in Paris. When he returned in 1831, Hudson advertised his services as a portrait painter, noting both his training with Meucci and a "complete course of study . . . as a miniature painter" in Paris.

Hudson remained in New Orleans until at least 1832. He may have traveled to other cities in the United States before returning to Paris in 1837 to study with Alexandre-Denis Abel de Pujol, a student of Jacques-Louis David. The second trip was cut short, perhaps because of the death of his sisters and the legal difficulties of his mother, and Hudson returned to New Orleans. He maintained a residence at 120 Bienville Street, though he only appears in the city directory as an artist in the years 1837 and 1838. All of the surviving paint-

ings with secure attributions date to the late period. George David Coulon studied, at least briefly, with Hudson in 1840. Hudson died in 1844.

Only five works can be securely attributed to Hudson; one portrait has been identified since the 1930s as a self-portrait, and another is a verified likeness of Jean Michel Fortier III. Two additional paintings have recently been discovered with plausible attributions to Hudson's hand. Hudson's portraits possess a stasis and rigidity that betray an intractable connection to folk painting. Strikingly absent is any sign of Parisian academic training. The *Self Portrait* in particular, given its tiny scale and cut-off oval format, suggests Hudson's training as an artisan maker of miniatures. Minute wisps of paint delineate each hair with the rigorous precision of one accustomed to working on a very small scale. Hudson's crisp modeling and the unflinching gaze of his sitters imbue his polished, gemlike compositions with an undeniable power and make compelling statements about self-perception, identity, and social status.

RICHARD A. LEWIS
Louisiana State Museum
New Orleans, Louisiana

Patricia Brady, *International Review of African American Art* 12:3 (1995); *New Orleans Bee* (6 June 1831); Ann C. Van Devanter and Alfred V. Frankenstein, *American Self-Portraits, 1670–1973* (1974); David C. Driskell, *Two Centuries of Black American Art* (1976); Robert Glenck, *Handbook and Guide to the Louisiana State Museum* (1934); John Burton Harter and Mary Louise Tucker, *To 1870*, vol. 1 of *The Louisiana Portrait Gallery* (1979); John A. Mahé II and Rosanne McCaffrey, eds., *Encyclopaedia of New Orleans Artists, 1718–1918* (1987); Regenia A. Perry, *Selections of Nineteenth-Century Afro-American Artists* (1976); James Amos Porter, *Ten Afro-American Artists of the Nineteenth Century* (1967); William Keyse Rudolph, Patricia Brady, and Erin Greenwald, *In Search of Julien Hudson: Free Artist of Color in Pre-Civil War New Orleans* (2011).

Hull, Marie Atkinson

(1890–1980) PAINTER.

Coming from an old Mississippi family, Marie Atkinson Hull maintained a deep appreciation for strong ties to the South. She was born Marie Atkinson in the rural community of Summit, 80 miles south of Jackson. Her initial interest in the arts was music. Upon her graduation from Belhaven College with a degree in music, she taught piano and played the organ for several local churches.

A year later, Atkinson began to study drawing and painting with Jackson's only academically trained artist at the time, Aileen Phillips. With the encouragement of her teacher, Atkinson pursued a formal art education at the Pennsylvania Academy of the Fine Arts in Philadelphia. There she studied with Daniel Garber and Hugh Henry Breckenridge, who provided her with a strong foundation in painting and drawing. Returning to Mississippi, she taught art at Hillman College in Clinton, Miss., and later gave private lessons.

In 1917 Atkinson married local architect Emmett Johnston Hull and worked with him in creating architectural ren-

derings of his designs in watercolor. With the encouragement and support of her husband, Marie Hull furthered her studies by spending two summers at the Colorado Springs Art Center, attending workshops with artists John Carlson and Robert Reid. In 1922 she attended summer classes at the Art Students League in New York City, studying under Frank Vincent Dumond and with Robert William Vonnoh.

The young couple shared a passion for travel and made frequent road trips, with Emmett studying the local architecture and Marie sketching and painting the indigenous landscape. In 1925 they made an extended cross-country trip through the Southwest, California, and the Northwest. Emmett opened an architectural office in St. Petersburg for a year, and as a result Marie became well acquainted with the tropical flora and fauna of Florida, including the lively and colorful macaw parrots, which soon became a favorite and iconic subject of hers. The Hulls traveled to North Carolina, before returning permanently to Jackson, where they lived in a studio-home on Belhaven Street, designed and built by Emmett.

Winning the second prize in the 1929 Texas Wildflower Painting Competition validated Hull's artistic aspirations. Conceived and sponsored by Texas businessman Edgar B. Davis, under the auspices of the San Antonio Art League, the hallmarks of the short-lived annual exhibition included enlisting well-respected and prominent artists to serve on the juries with the intention of attracting talented artists to the competition, which awarded substantial financial prizes. Marie used the generous prize of $2,500 to accompany a group of 40 professional artists, led by George Elmer Browne, to Europe in the spring of 1929. During the eight-month stay in Europe, she produced a large group of watercolors, sketches, and paintings of street scenes, historic buildings, and landscapes.

In Jackson, Hull earned a living by painting portraits and producing her popular still life renderings of magnolias and other native southern flowers, but it was her images of life in the rural South, Mississippi landscapes, and portraits of African Americans that earned her national and regional acclaim. During the Great Depression she painted a series of moving and dignified portraits of sharecroppers and tenant farmers who had agreed for a small fee to pose for her. Hull exhibited in 1931 at the Paris Spring Salon, worked for the Federal Arts Project of the Works Progress Administration, and, in 1939, earned prizes at the nationally juried New York World's Fair and the Golden Gate Exhibition in San Francisco.

In the pursuit of broadening her artistic vision, Hull continued to travel extensively, visiting art shows and taking part in exhibitions. She was always open to new ideas, and unlike many of her male contemporaries, she embraced the modernist movement. Her work reveals a move from an earlier impressionist style toward abstract expressionism.

CLAUDIA KHEEL
Neal Auction Company

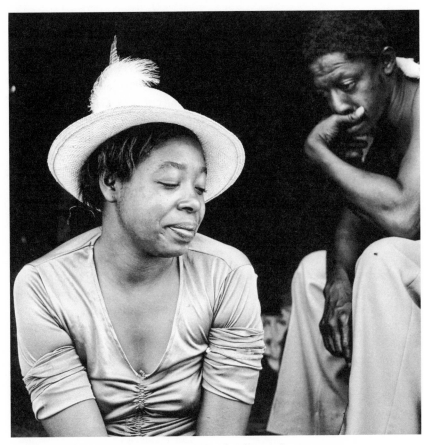

Birney Imes, "Joyce at Sugarhill, Crawford, Mississippi," 1982 (Birney Imes)

Patti Carr Black, *Art in Mississippi, 1720–1980* (1998); Malcolm M. Norwood, *The Art of Marie Hull* (1975), *Marie Hull, 1890–1980: Her Inquiring Vision* (1990); Nancy Rivard Shaw, *Spot: Southern Works on Paper* (2008).

Imes, Vinton Birney, III

(b. 1951) PHOTOGRAPHER.
Vinton Birney Imes III is a photographer whose endeavors include commercial and studio photography and photojournalism. He is a self-taught artist who depicts the people, places, and landscapes of rural Mississippi.

Museum collections in the United States and France contain his photographs. From coast to coast, galleries and museums have exhibited his pictures. His work has appeared alongside the finest of American photographers, including Walker Evans, Margaret Bourke-White, Clarence John Laughlin, and Robert Frank.

Mississippi-born writer Richard Ford introduced Imes's *Juke Joint*, a visual chronicle of African American taverns in the Mississippi Delta, by saying his photographs evoke a "thrilling otherness." That could mean

the color picture of a juke joint with a blue front and a blue truck by it. Or it could mean a black-and-white image of rabbits hanging lifeless from the waist of a young hunter, a close-up of his torso and torn and bloodied pants' legs. In the background another hunter, pants torn, too, rests a gun barrel on his shoulder.

The oldest of the five sons and one daughter of Vinton Birney Imes Jr. and Nancy McClanahan Imes, he was born 21 August 1951, in Columbus, Miss. Educated in Columbus public schools and at the University of Tennessee, where he majored in history, he points out: "When my high school was integrated in the late 60s, the veil began to part, and I started to see the richness and diversity of culture that till then had been hidden from me. When I began photographing six or seven years later, it was in part my wish and my need to overcome this ignorance that helped make my choice of subject an obvious one." As a young white man he increasingly photographed black people in northeast Mississippi and, to the west, in the Delta.

For a time, Imes worked in Columbus as a photojournalist for his family's newspaper, the *Commercial Dispatch*. He moved into commercial and studio photography and was drawn to photograph with black-and-white film. By 1983 he was photographing juke joints with a large-format camera, making long exposures with small apertures and color film. In her introduction to Imes's *Whispering Pines*, curator Trudy Wilner Stack wrote: "The camera allows him to cross the unseen lines of familial, racial, and class territory."

Popular singer Lucinda Williams in her concerts acknowledges the debt her songwriting owes to *Juke Joint*. An Imes picture, "Turk's Place, Leflore County" (1989), graces the cover of her Grammy-winning *Car Wheels on a Gravel Road*. The husband of Beth Hickel Imes, he dedicated *Juke Joint* to her, using her nickname, "Lizzie." Birney and Lizzie have two sons and a daughter. Like his father and grandfather, Imes became editor of the family newspaper (1966), where he also writes a column and frequently takes photographs.

Imes, who continues to exhibit his photographs, comments: "When I show these pictures or try to talk about them, someone invariably wants me to explain myself in terms of race—my being white and the subjects being black. Maybe the answer they are looking for is in the pictures."

BERKLEY HUDSON
University of Missouri

Debbie Fleming Caffery and Trudy Wilner Stack, *Picture Relations: Photo Essays from the South* (1992); Sylvia Higginbotham, *Time Passages: Looking Back at the Life and Times of Birney Imes, Jr.* (2003); Birney Imes, Oregon Center for the Photographic Arts, *Birney Imes III* (1984), *Juke Joint* (1990), *Partial to Home: Photographs by Birney Imes* (1994), *Whispering Pines* (1994); Estill Curtis Pennington, *Birney Imes III: An Exhibition of Photographs* (1984).

Johns, Jasper

(b. 1930) ARTIST.
Jasper Johns was born in Augusta, Ga., on 15 May 1930, the only child of William Jasper Johns and Jeannette Riley Johns, who lived in nearby Allen-

dale, S.C. Following his parents' divorce in 1933, he lived in Allendale with his grandparents until his grandfather died in 1939. Afterward, he lived with his mother and aunts in homes in Columbia, Lake Murray, and Sumter, S.C. Johns described his childhood as "entirely Southern, small-town, unsophisticated, a middle-class background in the Depression years of the thirties."

Johns studied at the University of South Carolina for three semesters and then moved to New York in 1948, studying at Parsons School of Design. Drafted into the U.S. Army in 1951, he started an art exhibition program for soldiers at Fort Jackson, S.C. In 1954 in New York City, Johns met John Cage and Robert Rauschenberg. Along with Merce Cunningham, they became influential and creative allies. Johns and Rauschenberg lived and worked together during the years when abstract expressionist painters dominated the art world. They absorbed and then moved beyond the influence of these painters and rediscovered the works of Dada and surrealist artists, especially Marcel Duchamp, whom they met, and they remained deeply influenced by his art. Johns and Rauschenberg designed and installed window displays for Tiffany and Bonwit Teller stores, using the name Matson Jones. Cage explained that during this period, "We called them the 'Southern Renaissance.'"

Johns had his first solo exhibition at the Leo Castelli Gallery in 1958. Beginning in 1959 his paintings included more painterly gestures, as in *False Start* and *Highway*. Johns began to break the picture plane and incorporated three-dimensional objects (steel balls) in works like *Painting with Two Balls*. He also produced small sculptural pieces, including *Light Bulb I* and *Flashlight I*. In 1960 Johns made his first print, a lithograph titled *Target*, working with Tanya Grossman at Universal Limited Art Editions (ULAE), a collaboration that continues to the present. Johns became an accomplished printmaker and a leader in the revival of printmaking, print collecting, and print exhibitions that evolved during the 1960s.

Artwork by Johns and Rauschenberg in the 1950s and early 1960s is often regarded as a bridge between abstract expressionism and pop art. Sometimes labeled Neo-Dada, it is notable for its use of found materials, everyday subjects, gestural brushstrokes, and bright colors. Johns's work evolved to incorporate darker colors and a dominant gray. He introduced body images, along with a range of diverse mechanical elements ("devices"), which became increasingly visible in his compositions.

In January 1961 Johns purchased a home in Edisto Beach, S.C., where he spent the spring–fall seasons (1961–66), returning to New York City for the winter. He painted *Figure 3* at Edisto in 1961 and eight related works, titled *0 through 9*. Later that year he took his first trip abroad, to Paris. Johns developed a new image—the map of the United States—in 1960 after Rauschenberg gave him a black-and-white map showing the outlines of 48 states without titles. The U.S. map became an intriguing image for him, and Johns completed three large map paintings (1960–63).

From 1964 to 1971 Johns focused increasingly on prints and printmaking. He also completed major paintings, specifically *According to What* (1964), *Watchman* (1964), *Souvenir* (1964), and *Voice* (1964–67), and sculptural forms, including *The Critic Sees II* (1964) and *High School Days* (1964). In 1966 his Edisto studio and many of his works, as well as his collection of works by other artists, were destroyed by fire. By 1967 Johns started to paint flagstone patterns, a recurring motif in his art, evident in *Harlem Light* (1967) and *Wall Piece* (1968). In 1968 he created his first prints with Gemini GEL in Los Angeles, which became another long-term collaboration.

In 1974 Johns started using cross-hatch imagery in his work, creating a significant body of paintings (including *Corpse and Mirror* and *The Dutch Wives*) and a related body of prints. He moved to a farmhouse in Stony Point, N.Y., and worked increasingly with Cage and Cunningham, as well as Samuel Beckett, during a period when performance art grew more important for him. Johns continued to create major works in New York and on the Caribbean island of St. Martin (*Barbers Tree, Usuyuki*) and had a traveling retrospective exhibition, *Jasper Johns*, organized by the Whitney Museum of American Art (1977–78).

During the 1980s there was a major shift in the images and figurative elements in his work. The importance of Japanese art and the study of old masters and art history influenced his imagery, and Johns also showed a renewed appreciation for Picasso, with references in his art. When he painted *Summer*, the first work in his major series *The Seasons* (1985–86), Johns entered a new stage of creating narrative, autobiographical imagery. He was influenced partially by Picasso's allegorical self-portraits, as well as his contemplation of his own age and the evolution of the stages in his career (marked by his references to his art in *The Seasons*). Johns expanded these ideas and imagery in a series of etching and aquatint prints of *The Seasons*, created with ULAE in 1987, then again in a cruciform print version of *The Seasons* in 1990. He also began to use an ambiguous and persistent "face" form, also inspired by imagery found in Picasso's art.

A major exhibition, *Jasper Johns: Work since 1974*, was installed in the U.S. Pavilion at the 1988 Venice Biennale. He was awarded the Biennale's Grand Prize, the Golden Lion, and the exhibition traveled to the Philadelphia Museum of Art. The next year he was included in an exhibition in London, *Dancers on a Plane: John Cage, Merce Cunningham, Jasper Johns*. In 1990 his use of art historically inspired images continued, with references to the works of Paul Cézanne, Hans Holbein, Matthias Grünewald, and others. Two years later, in 1992, Cage died at the age of 79 and Johns's mother, Jeannette Riley Lee, died at age 87 in Edisto. During this time Johns created two versions of a work, *Mirror's Edge* (1992, 1993), that included the floor plans of his grandfather's Allendale house, and in 1993 he began to use photographs of his grandfather's family in his works (referring to

his family's history and his childhood memories of South Carolina).

The Museum of Modern Art presented *Jasper Johns: A Retrospective* in 1996 and 1997. Johns has remained active and has been the subject of numerous exhibitions (and related publications) during the first decade of the 21st century, including *Jasper Johns: Prints from Four Decades*, organized by the National Gallery of Art (2001); *Past Things and Present: Jasper Johns since 1983*, organized by the Walker Art Center, in Minneapolis (2003); *States and Variations: Prints by Jasper Johns*, organized by the National Gallery of Art; and *Jasper Johns: Gray*, organized by the Art Institute of Chicago and the Metropolitan Museum of Art (2007–8). The National Gallery of Art acquired 1,700 proofs from Johns for its extensive collection of his prints and presented the exhibition, *Editions with Additions: Working Proofs by Jasper Johns* (October 2009–April 2010), to commemorate this event.

J. RICHARD GRUBER
Ogden Museum of Southern Art
University of New Orleans

Roberta Bernstein, Lilian Tone, Jasper Johns, and Kirk Varnedoe, *Jasper Johns: A Retrospective* (2006); Michael Crichton, *Jasper Johns* (1977); Douglas W. Druick, James Rondeau, Mark Pascale, and Richard Shiff, *Jasper Johns: Gray* (2007); John Elderfield, *Jasper Johns: An Allegory of Painting, 1955–1965* (2007); Richard S. Field, *The Prints of Jasper Johns, 1960–1993: A Catalogue Raisonné* (1994); Richard Francis, *Jasper Johns* (1984); Max Kozloff, *Jasper Johns* (1972); Carolyn Lanchner, *Jasper Johns* (2009); Fred Orton, *Figuring Jasper Johns* (1994); Leo Steinberg, *Jasper Johns* (1963); John Yau and Jasper Johns, *A Thing among Things: The Art of Jasper Johns* (2008).

Johnson, Joshua

(b. ca. 1762; d. unknown)
PORTRAITIST.

Joshua Johnson was born in Baltimore County, Md., about 1762, to an unknown slave woman owned by William Wheeler Sr. Joshua's white father, George Johnson, about whom very little is known, purchased the boy from Wheeler on 6 October 1764 for £25 current money of Maryland. On 15 July 1782 George Johnson manumitted his son, who was in the process of completing his apprenticeship to Baltimore blacksmith William Forepaugh.

Nothing is known of Joshua Johnson's activities in the years between his manumission and the appearance of his name in the first *Baltimore City Directory*, published in 1796. In 1798 Johnson placed an advertisement in the *Baltimore Intelligencer* in which he referred to himself as a "self-taught genius, deriving from nature and industry his knowledge of the Art; and having experienced many insuperable obstacles in the pursuit of his studies." His only signed work, a portrait, *Sarah Ogden Gustin*, is generally believed to have been painted sometime between 1798 and 1802 in Berkeley Springs, W.Va., where Sarah Gustin lived. A free man, Johnson could have traveled as an itinerant artist, although it is also possible that Sarah and her husband, Robert Gustin, traveled to Baltimore, where Johnson painted the portrait.

Johnson lived in Fells Point, a ship-

building and commercial center on Baltimore's waterfront. Many of the works attributed to him portray local merchants, mariners, or prosperous tradesmen. The only painting linked to him through documentary evidence is *Rebecca Myring Everett and Her Children* (1818). In a list of legacies made in September 1831 and revised on 22 August 1833, Rebecca Everett left "the large Family Painting of my self & 5 children Painted by J Johnson in 1818" to her eldest daughter.

Approximately 83 portraits are attributed to Johnson, none of them dating beyond 1825. His style is similar to that of other self-taught painters active in the mid-Atlantic region in the early years of the republic, including Charles Peale Polk, John Drinker, Jacob Frymire, Frederick Kemmelmeyer, and Caleb Boyle. Johnson's family group portraits also show similarities with those of Ralph Eleaser Whiteside Earl.

Joshua Johnson last appears in the Baltimore city directory for 1824. His place and date of death are unknown. Numerous institutions hold portraits by Johnson, including the Abby Aldrich Rockefeller Folk Art Museum, the Metropolitan Museum of Art, the National Gallery of Art, the Maryland Historical Society, the Museum of Early Southern Decorative Arts, the Baltimore Museum of Art, and the Chrysler Museum of Art.

JENNIFER BRYAN
Nimitz Library
U.S. Naval Academy

Jennifer Bryan and Robert Torchia, *Archives of American Art Journal* (1996); Deborah Chotner, *American Naive Painting* (1992); Regenia Perry, *Free within Ourselves: African-American Artists in the Collection of the National Museum of American Art* (1992); Carolyn J. Weekley and Stiles Tuttle Colwill, *Joshua Johnson: Freeman and Early American Portrait Painter* (1987).

Johnson, William Henry

(1901–1970) PAINTER.

William Henry Johnson was a prolific artist whose most important paintings, drawings, and prints concentrated on the history and culture of African Americans in the United States, especially in the South. Johnson was born in Florence, S.C., the oldest of four children (he had two sisters and a brother). His mother was part Sioux Indian and African American, and his father was white. His name was taken from a stepfather, William Johnson, a sharecropper who became infirm while William Henry was still a boy. The young Johnson left school to work and help support his family. His teacher recalled that he was too poor to afford pencils and paper but that he drew pictures in the dirt.

At age 17 Johnson left Florence, against the wishes of his family, determined to become a painter. He arrived in New York City and worked odd jobs, saving his money and sending some home to his family. In 1921 Johnson became the first African American to enroll in the National Academy of Design. During the next five years he won prizes for his achievements, while studying with noted American painter Charles Hawthorne. Johnson left for Europe to paint and remained there from 1926

until 1938, with the exception of one return visit to the United States in 1930.

In 1930 Johnson married Halcha Krake, a Danish ceramicist and weaver, and settled in Odense, Denmark. For the next eight years, the two worked in their studios and exhibited their artworks throughout Scandinavia and North Africa. By 1938 Johnson felt compelled to return home to the United States to paint the history of his people. Living in Europe had become more difficult as World War II approached. He and his wife settled in Harlem, where he began to produce his most important body of work. Most of his paintings, like *Chain Gang* (1939–40), drew on the southern black experience.

While in Europe, Johnson's work was expressionistic, influenced most by the works of Chaim Soutine, Van Gogh, Munch, and Gauguin. Once he returned to New York, Johnson's style shifted to a near-narrative appearance, almost cartoonish in its simplicity. Such works as *Jesus and Three Marys* and *Folk Family* particularly distinguish his style at this time, but the viewing public was shocked by this seemingly radical change.

By the time of his wife's death in 1945, Johnson had already begun to show signs of his own illness in his work, as well as in periods of irrational behavior. After his wife's death, he left the United States with all his works and was later found wandering on the streets of Oslo, Norway. Suffering from syphilis, he was sent home to the United States and hospitalized at Central Islip, Long Island. Johnson died in 1970. His entire collection represents one of the three largest holdings of a single American artist in the Smithsonian Institution in Washington, D.C.

LESLIE KING-HAMMOND
College of Art
Maryland Institute

Adelyn D. Breeskin, *William H. Johnson, 1901–1970* (1971); Lynda Roscoe Hartigan, *Sharing Traditions: Five Black Artists in Nineteenth-Century America* (1985); Robert Hughes, *Time* (31 August 1992); Alain Locke, *American Magazine of Art* (July–December 1931); Steve Turner and Victoria Dailey, *William H. Johnson: Truth Be Told* (1998).

Johnston, Frances Benjamin

(1864–1952) PHOTOGRAPHER.
A native of Grafton, W.Va., Frances Benjamin Johnston studied art in Paris and at the Art Students League in New York. She became dissatisfied with the state of academic American art, however, and turned to newspaper illustration. She sensed the potential of photography in journalism, believing that it was "the more accurate medium." Johnston acquired a camera and studied under the direction of Thomas William Smillie, who was then in charge of the Division of Photography at the Smithsonian Institution.

Johnston's first essays focused on political events in the capital. She also photographed the Kohinoor coal mines of Pennsylvania and the Mesabi iron ore range on Lake Superior, as well as female factory workers in Massachusetts. Johnston did not approach her assignments in the spirit of social reformer Jacob Riis but instead as an objective reporter. In 1899 she was invited by Hampton Institute, an indus-

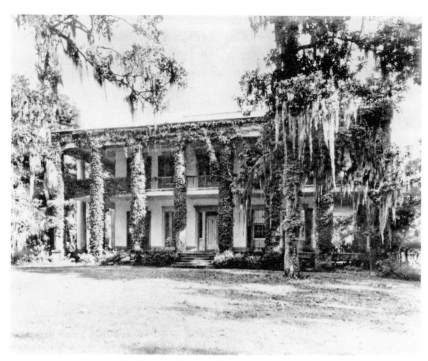

Frances Benjamin Johnston, "Ellerslie, West Feliciana Parish," circa 1944,
16" x 20" (The Historic New Orleans Collection, 2008.0361.3)

trial school for African Americans, to
dramatize the progress of educated,
upwardly mobile students and gradu-
ates. That public relations and fund-
raising project led to an invitation to
Tuskegee Institute in Alabama in 1902;
Johnston returned there and through
1906 photographed the students and
their renowned teachers Booker T.
Washington and George Washington
Carver. While in the area she also
photographed, with dignity and sen-
sitivity, poor rural people of Alabama.
Throughout her career Johnston made
portraits of outstanding Americans, like
Susan B. Anthony, Joel Chandler Harris,
Theodore Roosevelt and his family,
Samuel Clemens, Andrew Carnegie,
Alexander Graham Bell, and Jacob Riis.

An interest in architecture and hor-
ticulture led to Johnston's greatest com-
mission—she obtained a grant from
the Carnegie Foundation to record
southern colonial architecture. From
1933 to 1940, when Johnston was in her
late sixties and early seventies, she trav-
eled the Atlantic and Gulf Coast states,
documenting every aspect of historic
buildings and gardens, from mansions
to farm buildings, in all conditions of
repair. Her photographs convey a famil-
iarity with the places and an apprecia-
tion for the former inhabitants. Sev-
eral books resulted from the Carnegie
survey, *The Early Architecture of North
Carolina* (1941) and *Plantations of the
Carolina Low Country* (1938) among
them. In 1945 Johnston was awarded an

honorary membership in the American Institute of Architects. Johnston lived in semiretirement in New Orleans during her last years and died there in 1952.

MARY LOUISE TUCKER
New Orleans, Louisiana

Maria Elizabeth Ausherman, *The Photographic Legacy of Frances Benjamin Johnston* (2009); Bettina Berch, *The Woman behind the Lens: The Life and Work of Frances Benjamin Johnston, 1864–1952* (2000); Pete Daniel and Raymond Smock, *A Talent for Detail: The Photographs of Miss Frances Benjamin Johnston, 1889–1910* (1974).

Johnston, Henrietta Dering

(ca. 1674–1729) PAINTER.
Henrietta Johnston was the first known pastellist and professional female artist to work in the American colonies. She was born Henrietta de Beaulieu in France to French Huguenots Cézar de Beaulieu and his wife, Susannah. Cézar de Beaulieu was a Calvinist pastor who fled to England from Quentin, France (near Saint-Brieuc), about 1685. Although the sophistication of her pastel drawings suggests that she may have had some formal training, nothing is known of Johnston's education. Her work has been compared to the work of Irish-born artists Edmund Ashfield and Edward Luttrell, either of whom may have taught or influenced her.

In 1694 she married Robert Dering and moved to Ireland. The artist produced her earliest known works in Ireland after the death of her husband, about 1700. One of the most poignant of these is a recently discovered posthumous portrait of her daughter, Helena, drawn about 1704. In 1705 Henri-

etta married Gideon Johnston, who in 1708 became commissary for the bishop of London at St. Philip's Church in Charles Town, S.C. Evidence suggests that, once in Charleston, Johnston contributed significantly to the family income by drawing portraits of many of Charleston's French Huguenot residents and prominent members of St. Philip's Church. Disheartened by debt and misfortune in colonial South Carolina, Gideon acknowledged this support in a 1709 letter written to the bishop of London: "Were it not for the Assistance my wife gives me by drawing of Pictures (which can last but a little time in a place so ill peopled) I shou'd not have been able to live."

Johnston's work can be divided into three periods: the Irish period, the period in Charleston prior to Gideon's death, and the period between Gideon's death in 1716 and Henrietta's own death in 1729. The latter includes the times during which she worked in Charleston and then briefly in New York before returning to Charleston, where she lived until her death. The extant Irish works are all half-length portraits that show the most concentration on detail, with well-defined facial features, careful attention to the apparel of the sitters, and dramatic background shading. Some of the Charleston portraits retain the characteristics of these earlier works, but most are bust length and show less attention to physical features and clothing details. These works appear almost ethereal in the period immediately after Johnston's husband's death. In the final period, the portraits vary in the quality of detail. The New York

portraits are half length. The only land-scapes attributed to Johnston are those used as backgrounds in her portraits of children. Johnston is not known to have used any medium other than pastels.

Examples of Johnston's work are in the collections of the Museum of Early Southern Decorative Arts in Winston-Salem, N.C., the Carolina Art Association/Gibbes Museum of Art in Charleston, S.C., the Greenville County Museum of Art in Greenville, S.C., the Colonial Williamsburg Foundation in Williamsburg, Va., and the Metropolitan Museum of Art.

JOHANNA METZGAR BROWN
Old Salem Museums and Gardens
Winston-Salem, North Carolina

Whaley Batson, *Henrietta Johnston: "Who Greatly Helped . . . by Drawing Pictures"* (1991); John A. Herdeg, *Antiques and Fine Art* (Spring 2005); Frank J. Klingberg, ed., *Carolina Chronicle: The Papers of Commissary Gideon Johnston, 1707-1716* (1946); Margaret Simmons Middleton, *Henrietta Johnston of Charles Town, South Carolina: America's First Pastellist* (1966); Martha Severens, *Antiques* (November 1995).

Jones, Euine Fay

(1921–2004) ARCHITECT.
World-renowned architect E. Fay Jones gained early recognition for designing Thorncrown Chapel in Eureka Springs, Ark. The American Institute of Architects (AIA) voted the chapel as one of the top five buildings designed by an American architect in the 20th century.

Jones, named Euine Fay Jones Jr., was born of Welsh parents in Pine Bluff, Ark., on 31 January 1921. As a teen-ager he saw a film on architect Frank Lloyd Wright, after which he decided to pursue the profession. Since the University of Arkansas had no architecture program, Jones enrolled in its School of Engineering, studying there for two and a half years. At the outset of World War II, Jones interrupted his studies to join the U.S. Navy. He became a naval aviator and fought in the Pacific theater. In 1943, while still in military service, Jones married Mary Elizabeth (Gus) Knox. At the conclusion of the war, he reenrolled at the University of Arkansas, joining the first class of the newly established School of Architecture.

While still a student, in 1949, Jones met Wright at the AIA convention. After completing his degree, he attended graduate school at Rice University. He then taught for two years at the University of Oklahoma, where he met Bruce Goff, who became his friend and mentor. At the university, Jones again met Wright, with whom he apprenticed at Taliesin West in Scottsdale, Ariz., and at Taliesin East in Spring Green, Wis. Afterward, Jones joined the faculty of the fledgling architecture program at the University of Arkansas, where he taught for 35 years, becoming professor emeritus in 1988.

Jones established his practice in Fayetteville when he accepted a faculty position at the university. His earliest commissions included housing for university faculty. In the late 1950s Jones expanded his firm, choosing to keep the practice small and concentrating primarily on domestic buildings in Arkansas and surrounding states. In the

late 1970s Jones met a prospective client, Jim Reed, to discuss the possibility of a wayfarer's chapel in the Ozarks outside of the resort town of Eureka Springs: Thorncrown brought Jones's work to national prominence and also brought a new typology to his body of work.

After Thorncrown, Jones received commissions to design several chapels in Arkansas and in Texas. Additionally, he received two significant commissions in Mississippi that exemplify his chapel architecture. According to scholar Robert A. Ivy, Jones's design for Pinecote Pavilion at the Crosby Arboretum in Picayune "rivals Thorncrown Chapel." The function of the pavilion is to house exhibition and educational space for the arboretum. The pavilion itself, a light and transparent structure whose columns and roof beams evoke the canopy of trees under which it is situated at the edge of a pond, reflects in the still waters. The roof structure reveals itself toward the gable ends of the building so that the latticework of the underlying roof structure appears to dissolve into the surrounding forest.

Jones's second Mississippi commission is the Pine Eagle Chapel, a small, pagoda-like chapel on the shore of a lake at Camp Tiak in Wiggins. Both of his Mississippi commissions were gifts of L. O. Crosby Jr. Jones also designed two private residences in the state, one in Clarksdale and one in Iuka.

Eight of Jones's buildings in Arkansas are on the National Register of Historic Places, including Thorncrown. In 2009 the University of Arkansas's School of Architecture was renamed

in honor of Jones, who died at the age of 83 in Fayetteville, Ark., on 31 August 2004.

JUSTIN FAIRCLOTH
University of Virginia

Sheila Farr, *Fay Jones* (2000); Fay Jones Collection, University of Arkansas; Robert Adams Ivy Jr., *Fay Jones: The Architecture of E. Fay Jones* (1992); Euine Fay Jones, *Outside the Pale: The Architecture of Fay Jones* (1999).

Jones, Frank

(ca. 1900–1969) DRAFTSMAN.
Frank Jones was born around 1900 in Clarksville, Tex., a descendant of slaves whom early Anglo settlers brought to Texas from other regions of the American South to labor on cotton plantations. Abandoned by his mother as a small child, Jones was reared primarily by an aunt. He received no formal education and never learned to read or write. Jones did farm labor and yard work, occasionally traveling to nearby towns to pick up odd jobs.

As a child, Jones was told that he was born with a veil over his left eye and that this veil would enable him to see spirits. According to this well-documented and widespread African American folk belief, people born with the veil, or caul, a part of the fetal membrane, over their eyes can see and communicate with spirits—a gift known as second sight. Jones, who was around the age of nine when he saw his first spirit, described his visionary ability as "looking through a hole" into the spirit world. Throughout his life, Jones continued to see supernatural entities, which he interchangeably called "haints"

and "devils." Jones lived quietly for the first 40 years of his life, but a series of disastrous events beginning in 1941 resulted in his spending the rest of his life in and out of prison. In the early 1960s, while serving a life sentence in the Texas Department of Corrections Huntsville Unit known as "the Walls," Jones began salvaging paper and stubs of red and blue colored pencils discarded by prison bookkeepers. He began to draw images he visualized as the result of his veil. He asserted that he was drawing "devil houses."

The prison in Huntsville both inspired the concept of devil houses and provided the visual source for Jones's structures, always shown in cross section. Jones divided his structures into compartments, cells, or rooms and bordered each compartment with "devils' horns," protruding claw shapes that made the compartments impenetrable. Thus, the grinning haint figures that populated the compartments were at once confined and sheltered. By capturing the haints on paper and containing them in the devil houses, Jones believed that he kept them from doing harm. Although his haints appear friendly and playful, their benign expressions disguise their true objectives. Jones indicated that they smile because "they're happy, waiting for your soul." He also explained that they smile "to get you to come closer to drag you down and make you do bad things. They laugh when they do that."

Jones's color choices were originally determined by the discarded red and blue bookkeeping pencils available to him. Although he experimented with other colors, he never strayed far from his original scheme of blue and red, which he said represented smoke and fire. The alternation of these contrasting colors and the repetition of shapes create visual tension in the work and allude to the coexistence of the dual, opposing forces of good and evil.

In early 1969, Jones, suffering from advanced liver disease, was admitted to the Wall's prison infirmary, where he died on 15 February 1969. Today, Jones's drawings remain among the foremost examples of intuitive art and continue to serve as unique portals into our understanding of African American visionary traditions. Drawings by Jones are in the collections of the Smithsonian American Art Museum, the High Museum of Art, and the American Folk Art Museum.

LYNNE ADELE
Austin, Texas

Lynne Adele, "Frank Jones: The Psychology and Belief System of a Black Folk Artist" (M.A. thesis, University of Texas at Austin, 1987), *Spirited Journeys: Self-taught Texas Artists of the Twentieth Century* (1997); Newbell Niles Puckett, *Folk Beliefs of the Southern Negro* (1926).

Jouett, Matthew Harris

(1788–1827) PORTRAITIST.
Matthew Harris Jouett was born in Harrodsburg, Ky., to Jack and Sally Robards Jouett. His father was a local hero for having alerted Gov. Thomas Jefferson to Lt. Col. Banastre Tarleton's impending raid on Charlottesville, Va., during the American Revolution. Young Jouett studied law at Transylvania University in Lexington from 1804 to 1808

with George Bibb; upon his graduation, he married Margaret Henderson Allen, on 25 May 1812. Jouett enlisted in the Third Mounted Regiment, Kentucky Volunteers, War of 1812, and assumed the responsibility for replacing missing payroll funds of $6,000 lost in the battle of River Raisin, always noted as motivating him to become a portraitist.

Resigning from the army on 20 January 1815, Jouett opened a studio in Lexington, painting portraits of some of his military compatriots from memory. Seeking the sons of Edward West, his contemporary Lexington portraitists, he set out for Philadelphia. Not finding them, Jouett continued to Boston, where from July through October 1816 he worked with Gilbert Stuart, keeping an important record of his studies and their encounter: "Rude hints & observations, from repeated Conversations with Gilbert Stuart, Esqr. In the months of July, August, September, & Oct. 1816 under whose patronage and care I was for the time." That rare document is important as a firsthand account by an impressionable student working with an established master. The young artist admired Stuart as someone with a "singular facility in conversation and powers of illustration" whom he would not defame by anything except direct quotation. Accordingly, "I hereby so acknowledge that but in two pages have I given his words." It is a rambling account, punctuated with local color and highly charged with an apprentice's deep belief in his master's ability. The remarks may be considered as offering "hints" on three levels: the construction and composition of a portrait begin-

ning with the placement of the head on the picture plane, the coloration of the facial features and subsequent anatomical and background detail, and, finally, suggestions on how best to capture the character of the sitter.

Jouett's practice and communication of Stuart's naturalistic format, with its even color and strong characterization, remained in favor among Kentucky portrait artists long after northeastern artists had begun to paint with the lush coloration and elliptical lines of the romantic movement. Kentucky artists Alexander Bradford, John Grimes, Alonzo Douglas, Aaron Houghton Corwine, Joseph Henry Bush, and younger artist Oliver Frazer were all legatees of his stylistic formulations.

Upon his return from Boston, Jouett established a studio in Lexington, in 1816, initially charging $50 per portrait. He immediately attracted some of the most distinguished citizens of the commonwealth, notably Gov. Isaac Shelby and Sen. Henry Clay. An announcement in the *Lexington (Ky.) Reporter* for 16 June 1819 states that "Mr. Jouett has lately finished the Portraits of several of our distinguished fellow citizens," including the "full-length portrait of that eminent soldier, Col. Isaac Shelby."

Jouett worked as an itinerant artist during the winters in Natchez and New Orleans from 1817 to 1827. He held an exhibition of his work at the Kentucky Hotel in Lexington on 28 June 1817, charging an admission fee of 25 cents. From 1817 to 1825 he occupied a studio in the Kentucky Hotel, opposite Fayette Courthouse, on Short Street. He

visited Thomas Sully in Philadelphia in 1823. Beginning in 1825, Jouett's studio was on North Upper Street in a building owned by Henry Clay, with a temporary studio in Louisville in 1826. In late July 1827, Jouett returned to his home near Lexington from Louisville, "indisposed by an attack of bilious fever," according to a fulsome obituary published by "a friend" in the *Kentucky Reporter* in August 1827. That "bilious fever" is likely to have been typhoid, and after suffering for 10 days the artist died, but not before taking great pains to put his estate in order, as the lists in Jonas indicate. His anonymous mourner identified him as a genius, who "as if inspired by heaven, seized the bright spark in the character of the victim, fanned it into a flame, and placed it in propitious contrast to the dark shade," an apt metaphor for the quality of his portraits.

After his death in Fayette County in 1827, Jouett was buried at his farm. He was reinterred in the Cave Hill Cemetery plot of his grandson Richard Jouett Menefee in Louisville in 1893, at the time of Menefee's death. To this date no accurate catalogue raisonné has been compiled, and a corrective essay on the errors of his early biographers is much in need. All accounts of Jouett would seem to concur with William Dunlap's report that he "was a man of taste and possessed a vein of humor, copious and rich, but unaffected and innocent in its tendency, which made him a charming companion, and which will perhaps greatly add to the interest of his biography."

ESTILL CURTIS PENNINGTON
Paris, Kentucky

William Dunlap, *A History of the Rise and Progress of the Arts of Design in the United States* (1969); William Barrow Floyd, *Jouett-Bush-Frazer: Early Kentucky Artists* (1968), *Matthew Harris Jouett: Portrait Artist of the Old South* (1980); J. B. Speed Memorial Museum, *Centenary Exhibition of the Work of Matthew Harris Jouett* (1928); E. A. Jonas, *Matthew Harris Jouett: Kentucky Portrait Painter, 1787–1827* (1938); Estill Curtis Pennington, *Kentucky: The Master Painters from the Frontier Era to the Great Depression* (2008), *Lessons in Likeness: The Portrait Painter in Kentucky and the Ohio River Valley, 1800–1920* (2010).

Kemmelmeyer, Frederick

(ca. 1755–ca. 1821) PAINTER.
A self-taught artist, Frederick Kemmelmeyer was born in Germany and came to America sometime in the last quarter of the 18th century. He advertised his services in Baltimore in the *Maryland Gazette* through the years 1788 to 1803 as evening drawing school instructor, limner, sign painter, portrait miniaturist, and portrait painter. Kemmelmeyer also painted military insignia and transparencies used in celebrations, decorated cornices for beds and windows, and gilded mirror and picture frames. He is believed to have died in Shepherdstown, W.Va., in 1821.

The themes of Kemmelmeyer's best-known works are historical and military subjects, especially his portraits and signs of George Washington as military general. Washington sat for Kemmelmeyer on 2 October 1794, and the artist is among the few who depicted Washington's smallpox scars in his likeness. Examples of Kemmelmeyer's various versions of *General George Washington*

Reviewing the Western Army at Fort Cumberland, which were painted during the Whiskey Rebellion riots of 1794, are held by the Henry Francis du Pont Winterthur Museum and the Metropolitan Museum of Art and are also found in private collections. Other historical paintings include *First Landing of Christopher Columbus* (ca. 1800–1805), at the National Gallery of Art; General Wayne's victory over the Miami Indians in Ohio (ca. 1800), at Winterthur; and *Battle of Cowpens 17th of January, 1781* (1809) at the Yale University Art Gallery. Kemmelmeyer executed these works with oil paint on canvas, cardboard, or paper.

Kemmelmeyer's history paintings possess characteristics traditionally associated with folk painting: stylized forms—for example, his rendering of horses with perfectly C-shaped necks—attention to minute details, and a picture plane that appears flat. Elements common in his work include gilt lettering that explains the scene he depicts, a tree in the right of his compositions, and a rocky foreground with low vegetation.

After 1803 Kemmelmeyer worked as an itinerant portraitist throughout western Maryland, from Chambersburg to Hagerstown and into the upper Shenandoah region. He also worked in Winchester and Alexandria, Va., in Georgetown in Washington, D.C., and in Chambersburg, Pa. As an itinerant, Kemmelmeyer created many portraits in pastel, a medium that is less expensive than oil painting. His half-length portraits, created for a middle-class audience, were "as large as life," in the words of the artist in a 1790 Baltimore newspaper advertisement. Two such portraits, one painted about 1810 and the other about 1815, are held by the Maryland Historical Society. These likenesses, which capture idiosyncratic features like dimpled and double chins and graying temples, show greater naturalism than his earlier military paintings. Additional examples of Kemmelmeyer's work can be found in the Museum of Early Southern Decorative Arts and the Corcoran Gallery of Art.

JACQUELYN GOURLEY
Downingtown, Pennsylvania

Ann Uhry Abrams, *American Art Journal* 25:1 and 2 (1993); E. Bryding Adams, *Antiques* (January 1984); Robert Bishop, *Folk Painters of America* (1979); Deborah Chotner and Julie Aronson, *American Naive Paintings* (1992); Elizabeth Johns, in *350 Years of Art and Architecture in Maryland*, ed. Mary Dean (1984); Karen M. Jones, *Antiques* (July 1981); Cynthia Elyce Rubin, *Southern Folk Art* (1985); Jean Woods, *The Germanic Heritage* (1983).

Kinsey, Alberta

(1875–1952) PAINTER.

At the time of her death, Alberta Kinsey was referred to as "Miss Artist of the Vieux Carré." A native of West Milton, Ohio, Kinsey was born in 1875. She studied at the Cincinnati Art Academy and the Chicago Art School and later became a member of the Women's Art Club in Cincinnati. Kinsey was an instructor of art at Lebanon University in Lebanon, Ohio, a school to train teachers. When the university closed its doors in 1917, Kinsey traveled to New Orleans to attend the Newcomb College

School of Art and become a painter of flowers. She abandoned that course of action and set out to paint views of the French Quarter, with its narrow streets and colorful Old World architecture. Initially, her sale of paintings provided insufficient income, and she set out to teach in Alabama, where she saved enough money to allow her to return to New Orleans.

This time Kinsey sold her work successfully. She took an apartment at the Old Governor Claiborne House at 628 Toulouse Street in the Vieux Carré, with the encouragement of Louisiana author Lyle Saxon. In the early hours of 4 December 1917, the French Opera House, which was located at the corner of Bourbon and Toulouse Streets, burned to the ground. Since its construction in 1859, the Opera House had served as the cultural center of the city. Kinsey and Saxon, who watched the fire together, determined to attract artists and writers to the area and create an artists' colony in order to stimulate the revitalization of the French Quarter.

The first meeting took place in Kinsey's Toulouse Street apartment, with Saxon, as well as artists Harry Armstrong Nolan and Robert Wadsworth Grafton, in attendance. The group moved to three other locations before establishing its headquarters at the Arts and Crafts Club at 520 Royal Street. Kinsey taught at the club's School of Art from 1921 to 1922 before it was formally incorporated on 2 June 1922.

Dedicated to preserving French Quarter architecture, Kinsey purchased and renovated a building at 823 Royal Street, the old Daniel Clark home, which she opened to the annual Spring Fiesta Tour. She painted numerous scenes of historic Louisiana plantation homes and made regular sketching and paintings trips to Melrose Plantation. She is known for having left her paintbrushes behind at Melrose, an act of forgetfulness that introduced Clementine Hunter to the world of painting. Kinsey traveled extensively to paint in Spain, Italy, and Mexico, as well as in Taos, New Mexico.

In 1937 Kinsey exhibited her French Quarter scenes and flower studies in Monroe, La., under the auspices of the Monroe Federation of Women's Clubs. The following year she spent two months painting in Rockport, Maine, an artists' colony where she studied under modernist artist-writer Morris Davidson. While in the East, Kinsey visited the All American Show in New York. Upon her return to New Orleans, her paintings exhibited modernist tendencies. In 1944 Kinsey won first prize in the State Art Association exhibition in Baton Rouge, and in 1945 she sent a painting to the Cincinnati Art Museum for a critics' show. She exhibited regularly at the Isaac Delgado Museum of Art (now the New Orleans Museum of Art) and with the Art Association of New Orleans, of which she was a member.

In September and October 1950, Kinsey, who was among the first artists to exhibit at the Arts and Crafts Club, was among the last to exhibit with the Arts and Crafts Gallery, as it was then known, before it closed on 24 March

1951. Kinsey died on 20 April 1952 at the age of 77 after having painted in the French Quarter for 33 years.

JUDITH H. BONNER
The Historic New Orleans Collection

Artists' files, Williams Research Center, Historic New Orleans Collection; William H. Gerdts, George E. Jordan, and Judith H. Bonner, *Complementary Visions of Louisiana Art: The Laura Simon Nelson Collection at the Historic New Orleans Collection* (1996); Susan Saward and Karin Watts, *Knute Heldner and the Art Colony in Old New Orleans* (2000).

Koch, Richard

(1889–1971) ARCHITECTURAL DESIGNER.

During a 55-year career, Richard Koch established a practice that was diverse in its approaches to design and pioneering in its efforts to preserve and adapt the unique architectural heritage of the South. His knowledge of various styles was seen clearly in his reinterpretation of early 19th-century Louisiana building forms. His fusion of then-current ideas of modern design with traditional forms resulted in his being awarded the silver medal of the Architectural League of New York in 1938.

Koch was born in New Orleans on 9 June 1889, the son of Anna Frotscher and Julius Koch, an architect-builder from Germany. In 1910 Richard Koch received his architectural degree from Tulane University and then studied at Atelier Bernier in Paris. Between 1913 and 1915 he worked in the offices of Aymar Embury II in New York, of John Russell Pope, who designed in Washington, D.C., and of William Wells Bosworth in Boston. During this period Koch came to appreciate the architecture of colonial New England and New York.

In 1916 Koch returned to New Orleans and formed a partnership with Charles R. Armstrong, an association that lasted until 1935, interrupted only by Koch's serving as first lieutenant in the U.S. Army Air Service from 1916 to 1918. Early in his career Koch established a reputation for his sensitive renovations of several important buildings in the Vieux Carré and followed these with work on two noted Louisiana plantation houses, Shadows-on-the-Teche in New Iberia (1922) and Oak Alley in Vacherie (1926). He designed a new auditorium for Le Petit Théâtre du Vieux Carré in 1922 in a carefully detailed rendition of an earlier style—one of the first modern buildings in the French Quarter to be designed in this way.

The period 1933 to 1938 was a watershed in Koch's career; in 1933 he was appointed district officer for the Historic American Buildings Survey in Louisiana. In this capacity Koch directed teams of architects in making measured drawings of some of the finest early buildings in the state. Upon close examination of local historic buildings, he purged his original designs of elements that were not typical of the Creole and American Federal traditions—notably the Spanish influence seen in much of his work during the 1920s. Koch's sensitivity to the historic environment led him to design quite differently in the Garden District of

New Orleans than in his French Quarter work and to make the best use of the Anglo-American tradition in Mississippi and the French tradition in south Louisiana.

In 1935, when Armstrong left the partnership, a new associate, Samuel Wilson Jr., joined his firm; Wilson became a partner in 1955. Together, these two architects executed many restorations, renovations, and new designs (some in a modern manner, some in Koch's fusion style, and some in strictly historical styles). Koch's practice was always diverse—ranging from fine residences to offices, shops, banks, hospitals, and warehouses.

Koch served as president of the National Architectural Accrediting Board in 1954, and he was made a fellow of the American Institute of Architects in 1938. Koch continued to practice until his death on 20 September 1971.

FRANK W. MASSON
New Orleans, Louisiana

William R. Cullison, *Louisiana History* (Fall 1977); Bernard Lemann, Malcolm Heard, and John P. Klingman, *Talk about Architecture: A Century of Architectural Education at Tulane* (1993); *New Orleans Times-Picayune* (21 September 1971); Herman Boehm de Bachellé Seebold, *Old Louisiana Plantation Homes and Family Trees*, vol. 2 (1941).

Kohlmeyer, Ida Rittenberg

(1912–1997) PAINTER, SCULPTOR, PRINTMAKER, TEACHER.
Ida Rittenberg Kohlmeyer was deeply rooted in the culture of her native city, New Orleans. She was born in 1912, one of four children, to Joseph and Rebecca Rittenberg, immigrants from Bialy-

stok, Poland. When she was four, her family moved to a home on Rosa Park Boulevard in Uptown New Orleans, near St. Charles Avenue, Audubon Park, and Tulane University. She attended Henry W. Allen Elementary and then Isadore Newman School.

Kohlmeyer majored in literature at Newcomb College at Tulane University, where she obtained a B.A. in English literature in 1933. The following year she married Hugh Bernard Kohlmeyer, and they traveled to Vera Cruz and Mexico City on their honeymoon. This journey nurtured her interest in the art and culture of Central and South America. Before enrolling in art classes at Newcomb, she had studied in the French Quarter at the John McCrady School of Art. McCrady was a nationally recognized artist who was influenced by Thomas Hart Benton and the regionalist painters, and Kohlmeyer's less-known early paintings reflected her awareness of these styles.

In 1950 she enrolled in art classes at Newcomb and began her studies with Pat Trivigno, a painter, muralist, and teacher who was an important influence on her work. She studied at Newcomb from 1950 to 1956, as abstract expressionism achieved national prominence, and completed her M.F.A. in 1956. She went to Provincetown, Mass., to study with Hans Hofmann, which spurred her move toward nonobjective art. Later that same year, during a trip to Europe, she met Joan Miro in Paris, an artist who also had an influence upon her painting.

The abstract and nonobjective evolution in her painting was reinforced in 1957, when Mark Rothko was a visiting

Ida Kohlmeyer, Fantasy, No. 2, n.d., oil on canvas, 58″ x 50½″ (The Johnson Collection, Spartanburg, S.C.)

artist at Tulane University. While in New Orleans, Rothko lived in the house her parents had built on Iona Street in Metairie and used its garage as a studio. Inspired by his presence and the nature of his abstract vision, her paintings began to reflect his influence, including his use of rectangular abstract fields in his canvases.

Kohlmeyer absorbed a wide range of styles during the 1950s, including realism, regionalism, and abstract expressionism, but later her work evolved and transcended these influences as she incorporated abstraction, a strong color sensibility, and the system of glyphs and pictographs that are now identified with her work. Kohlmeyer became increasingly more active in the gallery world after her first exhibition was presented in 1959 at the Ruth White Gallery in New York.

Kohlmeyer began her teaching career at Newcomb, where she remained from 1956 to 1964, when she stopped teaching and built a studio at her home in Metairie, a suburb of New Orleans. In 1971 she was given a ten-year retrospective exhibition at the High Museum of Art in Atlanta. Two years later, in 1973, she accepted a position as an associate professor of art at the University of New Orleans. She also began to experiment with printmaking. Before the end of the 1970s she came to be associated with national galleries, including the Heath Gallery in Atlanta, the David Findlay Gallery in New York, the Elaine Horwitch Gallery in Scottsdale, Ariz., and Galerie Simonne Stern in New Orleans.

Kohlmeyer's abilities and reputation as a painter often overshadowed her skills as a sculptor, yet during the last 15 years of her career she produced an accomplished range of sculpture and a number of major public commissions. She began to experiment with wooden and Plexiglas sculptural forms in 1969, while she was exploring new directions in her work. Her first major public sculptural project began in 1981, when she was commissioned to create an architecturally scaled work for the new Equitable Life Assurance Society building on Poydras Avenue. The resulting project, completed in 1983, was composed of five painted steel sculptures, 40 to 45 feet tall, and titled *Krewe of Poydras*. That same year, she became affiliated with Arthur Roger Gallery in New Orleans, a year before the Louisiana World Exposition opened in New Orleans, which featured her work in its *Artworks 4* exhibition.

In 1983 a major traveling retrospective exhibition, *Ida Kohlmeyer: 30 Years*, accompanied by a full catalog, was organized by the Mint Museum in Charlotte, and it traveled nationally until 1985. She also became associated with the Jerald Melberg Gallery in Charlotte during this period. In 1987 she received a second sculptural commission to design a riverfront installation for the new Aquarium of the Americas and Woldenberg Park in New Orleans, and she later completed public sculptural projects for the Columbus Museum of Art, in Ohio, the Mobile Museum of Art, in Alabama, and the Springfield Museum of Art, in Ohio.

Kohlmeyer's work was prominently featured in the Morris Museum of Art when it opened in Augusta, Ga., in 1992. In 1996 the Morris Museum organized the last major museum exhibition of her life, *Ida Kohlmeyer: Recent Works*.

Kohlmeyer died in New Orleans on 24 January 1997. With support from the Ida and Hugh Kohlmeyer Foundation and her daughters, Jane Lowentritt and Jo Ellen Bezou, the Ogden Museum of Southern Art established its Ida Kohlmeyer Study Center, composed of paintings and more than 24,000 other items (including sculptural models, project studies, slides, travel journals, and publications). In 2004 the Ogden presented the exhibition *Becoming Ida Kohlmeyer*, and in that year the Newcomb Art Gallery organized the exhibition *Systems of Color*, accompanied by a book of the same name (2005).

J. RICHARD GRUBER
Ogden Museum of Southern Art
University of New Orleans

David Kiehl and Estill Curtis Pennington, *Ida Kohlmeyer: Recent Works* (1996); Mint Museum of Art, Department of Art, *Ida Kohlmeyer: Thirty Years* (1983); Michael Plante, *Ida Kohlmeyer* (2005), *Ida Kohlmeyer: Systems of Color* (2004).

Latrobe, John Hazlehurst Boneval

(1803–1891) PAINTER AND SKETCH ARTIST.

American artist-philanthropist John Hazlehurst Boneval Latrobe was born in Philadelphia on 4 May 1803 to English architect-engineer Benjamin Henry Boneval Latrobe and Mary Elizabeth Hazlehurst Latrobe. The elder Latrobe served as chief architect for the U.S. Capitol, designed the original House of Representatives wing, and supervised the rebuilding of the Capitol after it was burned by the British during the War of 1812. John H. B. Latrobe, who was the first son of his father's second marriage, was reared in Washington, D.C. He was educated at home, at schools in the District, in Baltimore, and afterward at Georgetown College, from 1815 to 1817. The following year Latrobe entered the U.S. Military Academy at West Point, where he studied civil engineering.

After his father's death of yellow fever in New Orleans in 1820, the family relocated to Baltimore. Forced by family circumstances to withdraw from West Point, Latrobe remained active in that community throughout his life. He designed the base and column for Kosciuszko's Monument, which was dedicated in 1828. (In 1913 a statue of Revolutionary War hero Tadeusz Kosciuszko was added to the monument.)

In Baltimore he studied law with Robert Goodloe Harper, an attorney who had been a close friend of the elder Latrobe. Admitted to the bar in 1825, Latrobe and his brother Benjamin Henry Latrobe opened a law practice in Baltimore, although the partnership did not initially provide sufficient income to sustain two attorneys. From 1828 until his death, Latrobe was regularly retained as counsel for the Baltimore & Ohio Railroad, as well as for cases that were independent of the railroad. Latrobe was a founder of the Maryland Institute for the Promotion of Mechanic Arts and of the Maryland Historical Society, for which he played an active role in establishing its gallery of paintings. After the building's destruction by fire in 1835, Latrobe worked toward its reorganization.

Latrobe was a renaissance man of his time: author, attorney, inventor, architect, and artist. In addition to his career in legal work, he was known as a landscape painter and illustrator. The invention for which he is best known is the "Latrobe" stove, also known as the "Baltimore Stove" or the "Parlor Stove." In 1924 Latrobe became a supporter of the African colonization of Liberia, a movement to colonize Liberia with freed slaves from the United States. His painting *Maryland in Liberia* depicts a group of people of color gathered by an inlet and looking across still waters toward a settlement, called Cape Palmas, situated high on a bluff above the open seas. Cape Palmas was part of a large area of Liberia named Maryland because of Latrobe's support of the society. Through the years he was a central figure, contributing his time and energy

to the American Colonization Society; accordingly, he was elected to succeed Henry Clay as president of the national society in 1853.

In 1828 Latrobe wrote and illustrated *Lucas' Progressive Drawing Book*, which he published under the pseudonym E. Van Blon, an anagram for his middle name, Boneval. The third section of the book, titled "Practical Perspective," consisted of artworks that depicted American scenery, including one called *The Balize, Mississippi River*, which Latrobe sketched after an 1819 watercolor made by his father the year before his death. Like his father before him, John H. B. Latrobe traveled to New Orleans. In 1834 he made a two-month sketching trip down the Mississippi, during which he made watercolor and pencil sketches of Louisiana and New Orleans scenery. Latrobe, who practiced law for over six decades, died in Baltimore on 11 September 1891.

JUDITH H. BONNER
The Historic New Orleans Collection

John Hazlehurst Boneval Latrobe, *Southern Travels: Journal of John H. B. Latrobe* (1986); John A. Mahé II and Rosanne McCaffrey, *Encyclopaedia of New Orleans Artists, 1718–1918* (1987); Eugene S. Van Sickle, "A Transnational Vision: John H. B. Latrobe and Maryland's African Colonization Movement" (Ph.D. dissertation, University of West Virginia, 2005).

Long, Benjamin Franklin, IV

(b. 1945) PAINTER.
Although born in Texas, Benjamin Franklin Long IV grew up in Statesville, N.C., the ancestral home of his family. His grandfather, McKendree Robbins

Long, was an evangelist and visionary artist whose fiery apocalyptic paintings fail to foreshadow the profoundly peaceful frescoes of his more neoclassically minded descendant. Ben Long entered the University of North Carolina at Chapel Hill at age 18, and while a creative writing student of Reynolds Price he began to develop his interest in the visual arts. When this distinguished heir of the Southern Renascence "slowly leafed through" Long's sketchbook, Price was amazed that the "all-but-silent boy from the Carolina foothills had recently laid down page after page of drawings . . . of a calmly assured and already enormous skill." Price subsequently encouraged the young prodigy to pursue his art.

In the following years, Long moved to New York and enrolled in the Art Students League, where he studied with Robert Beverly Hale and Frank Mason. Hale was a professed modernist, but Mason's art was more clearly identified with the American representational tradition of the Wyeth family, whom Long admired. In the mid-1960s, the heyday of late abstract expressionism, though not a nurturing time for traditional pursuits, Long persisted in honing his skills as a classical realist. In 1969 he enlisted in the Marine Corps, serving two tours of duty in Vietnam as a combat officer, followed by a stint as commander of a combat art team. His work from that time is now part of the national collection administered by the Smithsonian Institution.

When Long left the military, he moved to Florence to fulfill his ambition to study with the great Italian clas-

sical painter Pietro Annigoni, a signatory of the 1947 manifesto of modern realist painters eschewing abstraction. Long spent eight years as an apprentice in Florence with Annigoni, assisting him with frescoes. The only non-Italian artist to work at the legendary Abbey of Monte Cassino, Long and others created fresh work for the site so brutally destroyed by bombing in World War II. This pursuit culminated in his being awarded the 1976 Leonardo da Vinci International Art Award given by the Rotary Club of Florence. Long then moved to France and spent 14 years in a highly successful career as a fresco painter.

During the 1980s Long reconnected with Reynolds Price and painted several deeply sensitive portraits of the then wheelchair-bound poet. Price's enthusiasm for the experience was expressed in his sense of the "mutual affection, the unique bonds that only fellow artists seem able to establish: bonds of unstinting admiration" and "the will to help one another in a kind of work at least as lonely as the prayerful life of a desert monk."

In 1998 Long returned to the South, where he has continued to work as a fresco painter. His monumental, tripartite composition for the lobby of the Bank of America Corporate Center in Charlotte, N.C., has invited conspiratorial apocalyptic interpretations in line with his grandfather's own dire predictions about the fate of man in the modern age. In 2002 Jeanie Bridges, a friend and patron of Long, organized the Benjamin F. Long Fresco Trail consortium. As of 2012, Long and his assistants have painted 13 frescos in a geographical range that includes Ashe, Avery, Burke, Buncombe, Iredell, Mecklenburg, and Wilkes counties in western North Carolina.

Ben Long is widely considered to be the most accomplished classical realist of our time. He is known for easel paintings of portraits and nudes as well as for his work with frescoes. In recognition of his achievements as an artist and teacher, he received the 2001 Arthur Ross Award for Excellence in the Classical Tradition. In 2002 he founded the Fine Arts League of the Carolinas in Asheville, a school where the "names of the old masters haunt our halls. The words grace and beauty inspire, and we teach that craft is the first step towards respecting the wonder and awe of the world around us."

ESTILL CURTIS PENNINGTON
Paris, Kentucky

Richard Maschal, *Wet Wall Tattoos: Ben Long and the Art of Fresco* (2003); Reynolds Price, *Garden and Gun* (24 March 2007); Martha Severens, *Ben Long: Reality and Allegory* (2010).

Malone, Blondelle Octavia Edwards

(1877–1951) PAINTER.
Adventuresome and headstrong, Blondelle Octavia Edwards Malone took full advantage of the financial support her parents offered, a network of connections to international members of the art community, and a belief in her artistic talent, which she parlayed into a viable career as the "Garden Artist of America," though she rarely sold her paintings.

The only child of Miles Alexander

and Sarah Glenn (Jones) Malone, she was born 16 November 1877, near Bostwick, Ga. When she was an infant, the family moved to Augusta and resided there long enough for her to attend kindergarten. The family relocated to Columbia, S.C., where her father eventually established Malone's Music House, a highly successful store that sold pianos throughout the region and provided funds for Malone, who never married, to live a privileged and comfortable life.

Malone attended Converse College in Spartanburg, S.C., from 1892 to 1896 and in 1897 left for New York, where she studied at the New York School of Applied Design for Women, the New York School of Art, and the Art Students League. Her teachers included John Twachtman, William Merritt Chase, and Robert Blum. She spent the summer of 1899 at the art colony in Cos Cob, Conn. She returned intermittently to South Carolina when prodded by her parents but found ways to achieve her dream of seeing the world and practicing her art. In 1900 she exhibited original designs for book covers at the Architectural League of New York, and Charles Scribner's Sons, a New York publishing firm, purchased two of the designs.

In 1901, under the pretext of attending a religious convention, Malone left her parents' home for California. Her plans changed once she arrived at her destination, and she traveled throughout the state for a year, painting and making valuable contacts with people who would be helpful in her future travels. One contact was the wife of a judge, who planned a trip to Japan—Malone persuaded her parents that her friend would be a suitable companion. The two women embarked on a three-month voyage that ended in Yokohama. Malone visited and lived in several locations in the country and kept her parents and the readers of the *State* newspaper in Columbia aware of her experiences by writing a column, "A Columbia Girl in Japan." Determined to see more of the world, she convinced her parents that she should leave Japan for Europe, and once again they granted permission.

Malone left Japan in February 1904 and traveled throughout Europe, specializing in painting garden scenes in an impressionistic style, until 1915, when she was ordered home by her father following the death of her mother. She had returned to South Carolina only once during this time, despite pleas by her parents and the outbreak of World War I. Malone exhibited her work with the Independents in Paris and the New York Watercolor Society, at the Pennsylvania Academy of the Fine Arts, and in Holland and Great Britain. She met Claude Monet, the widow of Camille Pissarro, Auguste Rodin, and Mary Cassatt. Malone's reluctance to stay in Columbia caused an estrangement from her father, which was never resolved. Though she never returned to Europe, she maintained contacts with her international friends and chose not to stay in her hometown. Instead, she purchased a home, Bagatelle, in Aiken, S.C., in 1916, but sold it within four years and headed for New York.

Her New York years were successful artistically, and Malone continued to be supported by her father's funds. During this period, she became increasingly known for her garden paintings, still in the impressionistic style, which, by then, was passé. After her father's death in 1930, she moved to Alexandria, Va., and became active in the artistic and historic preservation community of Washington, D.C. She was a member of the Washington Social Register and the Washington Art Club. Known to petition the court in South Carolina for an increase in the stipend her father had bequeathed, Malone ended her years in a Columbia nursing home, where she died on 25 June 1951. Although desperate in life to leave her parents' home in South Carolina, Malone donated her papers to the Caroliniana Library at the University of South Carolina and her paintings to the Columbia Museum of Art, thus preserving her legacy in her hometown.

KAREN TOWERS KLACSMANN
Augusta State University

Louise Jones DuBose, *Enigma: The Career of Blondelle Malone in Art and Society, 1879–1951* (1963); A. Everette James, Dale Volberg Reed, and Everett Mayo Adelman, *Southern Women Painters, 1880–1940: The Collection of A. Everette James Jr. and Nancy Jane Farmer: The Four Sisters Gallery: Celebrating the Art of the Coastal Plain* (1999); Suzanne Kamata, *Sandlapper* (Summer 2008); Meg Moughan, *Caroliniana Columns* (Spring 1999); Chad Lee Underwood, "What Price Glory: The Life and Art of Blondelle Octavia Malone" (M.A. thesis, University of South Carolina, 2003).

Marling, Jacob

(ca. 1773–1833) PAINTER.

For 40 years Jacob Marling worked primarily in Virginia and North Carolina, painting genre and historical works, portraits, miniatures, landscapes, and still lifes. He also worked as an art teacher and museum director. In addition to his portrait of North Carolina governor Montfort Stokes (ca. 1830), Marling is best known today for an important Federal period painting now in the Chrysler Museum entitled *Crowning of Flora* (ca. 1816) and a scene of the first North Carolina statehouse (ca. 1820). A still life composition of a bowl of cherries is the only known work of art signed "Marling."

The first professional artist to practice in Raleigh, N.C., Marling claimed to have studied in Philadelphia with drawing master James Cox for seven years, from 1788 to 1795. He spent a brief time in New York City in 1795 before relocating to Virginia, where he advertised his services as a drawing and painting instructor in Fredericksburg, Richmond, and Petersburg. By 1805 the artist was living in Southampton County, Va., where he married Louisa Simmons, who also subsequently taught art to young ladies. During this period Marling painted quarter-length to full-length portraits of local residents, executed historical scenes after engravings by John Trumbull, *Battle of Bunker's Hill* and *Death of General Montgomery at Quebec*, and probably decorated at least one Masonic apron.

In about 1812 Marling and his wife moved to Raleigh, where, except for

a brief sojourn to Charleston, S.C., in 1819, the artist remained until his death in 1833. Chartered in 1792, Raleigh was the state's recently established capital and a thriving southern city when Marling moved to the region to teach art and become director of the newly founded North Carolina Museum. For the admission price of 25 cents, or $5.00 for the year in 1818, visitors, according to Marling's entrepreneurial advertisement for this burgeoning institution, frequented an "agreeable and useful place of resort," which maintained a reading room containing newspapers, maps, and curiosities, as well as drawings and paintings, including some by the artist. During this period, Mrs. Marling taught drawing and painting at the Raleigh Academy, where her husband occasionally assisted. It was at this time that Jacob Marling executed the scene entitled the *Crowning of Flora*, depicting young female students and faculty from the Raleigh Academy, all gathered outdoors at Burke's Square to crown the queen of their May Day celebration. Mrs. Marling, and possibly the artist himself, are included in this composition.

By 1825 Marling was renting rooms from John Goneke, who maintained an establishment made up of a concert hall, theater, musical instrument shop, reading room, dancing school, and liquor shop, in addition to letting rooms for North Carolina legislators. In this location, Marling advertised that he painted portraits and miniatures, hoping for the business of government officials. Marling stated that if clients called upon him early, he would com-

plete their likenesses by the close of session. Marling's works are in the collections of the Chrysler Museum of Art and the North Carolina Museum of Art.

CHARLOTTE EMANS MOORE
Wilmington, North Carolina

Davida Deutsch, *The Luminar: Newsletter of the Museum of Early Southern Decorative Arts, Winston-Salem, N.C.* (Summer 1988); J. Christian Kolbe and Lyndon H. Hart III, *Journal of Early Southern Decorative Arts* (Summer 1996); North Carolina Museum of Art, *Jacob Marling: Retrospective Exhibition, March 1–April 5, 1964* (1964).

Marschall, Nicola

(1829–1917) DRAFTSMAN AND PORTRAITIST.

Nicola Marschall was born in St. Wendel, Rhenish Prussia, to Emanuel Marschall, a prosperous tobacco and wine merchant, and his wife, Margaret Mohr. He was reputed to have had some training at the Düsseldorf Academy in Germany prior to his arrival in New Orleans in 1849. After a brief sojourn in Mobile, Ala., he became an art, music, and dance instructor at the Marion (Ala.) Female Seminary. He returned to Europe in 1851 for further studies at Düsseldorf and Munich, where he worked with Pieter C. Bernhard, a court painter to the Wittelsbach dynasty. Marschall came back to America in 1858, where he was again active in Marion and Mobile, as well as in New Orleans. During that time he painted several highly imaginative portraits of children that employed certain genre elements, including animals and allegorical landscape backgrounds. One of these works, *Girl with Cat*, in the Morris Museum

of Art collection, is particularly accomplished.

Marschall enlisted in the Confederate army in January 1861 and was made chief draftsman for the engineering corps. At the request of Mrs. Napoleon Lockett, he designed the Confederate gray uniform and the stars and bars ensign for the Confederate navy, which became the most recognizable flag of the southern states. The uniform design was based on an Austrian precedent worn by a group of sharpshooters the artist saw in Verona in 1857.

During the war Marschall became well acquainted with Nathan Bedford Forrest and Richard Taylor, the son of Pres. Zachary Taylor. Both men had Kentucky connections, which proved useful to the artist after the war. He was discharged in Meridian, Miss., on 11 May 1865 and married Eliza Marshall of Marion, Ala., a former student, in August of that same year.

The Marschalls moved to Louisville in 1873, where he had a studio at Fourth and Green Streets, until his death there. During those years he was the portraitist of choice for the city's Confederate veterans, an iconic participant in what Anne Marshall has termed "a strange conclusion to a triumphant war" for their revisionist efforts to perpetuate the idea of Kentucky as a Confederate state. Marschall was the last resident portraitist of note to have ties with the antebellum portrait tradition. In his later years he created a large body of work, much of it drawn from photographic sources and lacking the animation of his earlier style. He died in Louisville and is buried in Cave Hill Cemetery, final resting place of many Lost Cause fellow travelers.

ESTILL CURTIS PENNINGTON
Paris, Kentucky

E. Bryding Adams, ed., *Made in Alabama: A State Legacy* (1995); Mrs. Chapell Cory, *The True Story of the First Confederate Flag* (1931); John E. Kleber, ed., *The Encyclopedia of Louisville* (2001); Mrs. Orville Lay, *Alabama Portraits prior to 1870* (1969); Anne Elizabeth Marshall, *Creating a Confederate Kentucky: The Lost Cause and Civil War Memory in a Border State* (2010); Estill Curtis Pennington, *Lessons in Likeness: The Portrait Painter in Kentucky and the Ohio River Valley, 1800–1920* (2010), *A Southern Collection: A Publication of the Morris Museum of Art* (1992); Edna Talbott Whitley, *Kentucky Ante-Bellum Portraiture* (1956).

Mazzanovich, Lawrence

(1871–1959) PAINTER.
Lorenzo Mazzanovich came to the American South from the island of Hvar in the Adriatic to serve during the Civil War, in a "Slavonian" regiment composed of Croatians from Louisiana. After the war, Lorenzo took his wife and children to California, and they were among the earliest non-Hispanic families to settle in Los Angeles. During their relocation to San Francisco, which already had a Croatian community, Lorenzo's son Lawrence was born on a ship off the Golden Gate. Lawrence's mother died when he was very young; his father, a musician, was abusive, and the boy experienced a peripatetic youth of hardship.

Inspired by his older brother, John, a theatrical-scenery painter in New York, Mazzanovich began his artwork and

settled in Chicago. He shared a studio with artist William Wallace Denslow and Denslow's much younger wife, in the Roycroft colony near Buffalo. Shortly after the Denslows' divorce in 1903, Mazzanovich married Denslow's ex-wife and the new couple set off for Europe. They returned to America in 1909, settling in Westport on the Connecticut shore. During the next decade, as he became successful, with elegant tonalist and impressionist landscapes in oil of New England, he frequently exhibited and was represented by prestigious galleries in New York and Chicago.

Mazzanovich's marriage was stormy, however, and around 1923 he left his wife and son to travel alone to the Tryon colony of artists and intellectuals, in the mountains of western North Carolina, where his wife's relatives, who were writers, had settled in 1908. He was embraced by the community, not only for his art but for his baritone voice and social charisma. A wealthy Tryonite citizen designed a home and studio especially for Mazzanovich, and after his wife refused to move to the South, he obtained a divorce and married Muriel, an Englishwoman. In the 1930s Muriel became the piano instructor of Eunice Waymon, a young African American Tryon prodigy who went on to become famous singer and songwriter Nina Simone. During the Great Depression, Mazzanovich's admiring patron granted him a pension in the manner of the Renaissance, providing him with his quarters and a stipend in exchange for the products of his easel.

Long after most American painters abandoned impressionism, Mazzanovich continued to work in that style, through the 1940s, though his execution of it was often highly original, even moving toward cubism. His landscapes depict the lushly forested mountains of Tryon and its area, painted *en plein air* or from field sketches—and often from the higher elevations, where he liked to tramp to achieve panoramic views. His paintings are found in museums and private collections around the United States and are considered by connoisseurs as some of the finest canvases of the South in the impressionist idiom.

MICHAEL J. MCCUE
Asheville, North Carolina

Michael J. McCue, *Lawrence Mazzanovich: Impressionist Paintings of Tryon* (2001), *Tryon Artists, 1892–1942: The First Fifty Years* (2001); Charles Teaze Clark, *Antiques* (November 2006).

McCarty Pottery

Potters Erma Rone "Pup" McCarty and Lee McCarty lived and worked outside Merigold in the heart of the Mississippi Delta. For nearly 50 years the McCartys transformed the earth of Mississippi and its plants into clays and glazes. Perhaps it was the element of natural beauty mixed with the couple's creative spirit that attracted many visitors to the pottery; the product is not dull or uncultivated, nor is it overly refined. A combination of rusticity and grace makes their pieces suitable for everyday use, as well as visually appealing in art exhibitions.

Lee McCarty grew up in Merigold, and his wife, Pup, grew up in the town of Ethel near the Natchez Trace. The

two met at Delta State College and married in the 1940s. They later moved to Oxford, where they enrolled in pottery classes at the University of Mississippi. Lee had earned an earlier degree from the university and a master's degree in education from Columbia University. Ultimately, the two decided to continue with their art, and in 1954 they relocated to Merigold, where they bought a mule farm and converted a barn into their living space and studio. Their place in the Delta revealed years of hard work in the studio and gardens. They cultivated the area that the hayloft formerly overlooked with plants and vegetables and named it Mondrian Gardens. The property was interspersed with an occasional McCarty vase, handcrafted shell, or wind chimes among the greenery, bamboo, flowers, and birdbaths.

The McCartys dug their clay from land they owned near Macon, Miss. They fired their pots in an electrical local reduction kiln without pollutants, lead, or gas and threw their pots on a Soldner pottery wheel, which they had bought in 1949. They gave their glazes uncommon names, like matte nutmeg, tea, and waterbottom, which suggest their rural environment. Their pieces included vases, plates, bowls, wind chimes, and angels, as well as an assortment of animals, including birds, rabbits, cats, pigs, hippopotamuses, and fish. The McCartys, whose pottery is known worldwide, showed their work in the Smithsonian Museum, the Hamlin Museum in Germany, and the United Nations Educational Scientific and Cultural Organization offices in Paris, and they were exhibited in Japan and at the Samuel P. Horn Museum at the University of Florida and the Lauren Rogers Museum in Laurel, Miss. The McCartys, who received the Lifetime Achievement Award from the Mississippi Institute of Arts and Letters, also had a gallery in Monteagle, Tenn. As art historian Lisa Howorth notes, "A McCarty piece that becomes that 'little postage stamp of soil' . . . seems to suggest all the rawness and earthliness and endurance of Mississippi." Pup McCarty died on 8 February 2009.

CAROLINE MILLAR
Arkansas Historic Preservation Program

Lana Lawrence Draper, *Delta Magazine* (July 2003); Lee McCarty and Pup McCarty, *Masters of Merigold: 40 Years of McCarty Pottery* (1996); www.mccartyspottery.com.

McCrady, John

(1911–1968) PAINTER.
Mississippi artist John McCrady was born in the rectory of Grace Episcopal Church in Canton on 11 September 1911, the seventh child of Rev. Edward and Mary Tucker McCrady. Subsequently moving to Greenwood, Miss., the family relocated to Hammond, La., and then Lake Charles, La., eventually settling in Oxford, Miss., where Rev. McCrady assumed the rectorship at St. Peter's Episcopal Church, later becoming head of the Philosophy Department at the University of Mississippi. John finished secondary school in Oxford, graduating in 1930 from University High, where he was a star football player and occasional illustrator for the school's newspaper. His nascent artistic talent was further evident at the University of Mississippi

as he illustrated sections of the school's 1931 and 1932 yearbooks.

After his sophomore year, McCrady left the University of Mississippi to attend the Arts and Crafts Club of New Orleans School of Art but soon moved to New York after winning a one-year scholarship to the prestigious Art Students League, where he studied with Kenneth Hayes Miller and Thomas Hart Benton, two luminaries of the American Scene, a popular arts movement emphasizing native scenes and regional subjects. Yet McCrady felt uninspired by his urban surroundings and ultimately realized that his artistic muse would be the South, specifically Oxford and its surrounding Lafayette County. Consequently, he left New York at his scholarship's conclusion in 1934 and returned to New Orleans.

In his French Quarter studio, McCrady began to paint evocative representations of rural life, colorful scenes of the Oxford Square, and detailed renderings of the town's vernacular architecture. Although he spent only four years in north Mississippi, he identified intensely with the region and during his 35-year career made it the subject of nearly 50 works. McCrady was particularly drawn to Lafayette County's African American residents, whom he depicted in an affectionate, yet often caricatured manner.

Early in his career, McCrady joined the Federal Art Project of the Works Progress Administration in order to supplement his meager income. He had his first solo show in Philadelphia in 1936 and a year later an exhibition in New York. The shows brought him national recognition in *Newsweek*, *Time*, *Life*, and *New Republic* magazines. In 1938, amid his swift rise to fame, McCrady married Mary Basso, a former student at the New Orleans School of Art and sister of author and Faulkner cohort Hamilton Basso. Within three years the couple had their only child, Mary Tucker.

In 1939 McCrady received a Guggenheim Fellowship to document African American cultural and religious life in the South. Guided by his ecclesiastical upbringing, the artist was drawn to black spirituals and religious narratives, making them the subject of several paintings from this period. In 1941 one such work, *Judgment Day*, received significant attention when it was included in a Carnegie Institute exhibition in Philadelphia and a show at the Corcoran Gallery of Art in Washington, D.C.

When the United States entered World War II, McCrady joined the war effort by illustrating government propaganda posters and designing tools for a New Orleans's military seaplane manufacturer. Encouraged by the success of the evening art classes he held for his plant coworkers, in August 1942 he established the John McCrady Art School in the French Quarter, at 910 Bourbon Street. Many recognized Louisiana artists began their careers here before the school closed in 1983.

As abstract, European-influenced idioms gained artistic popularity and racial inequalities were less openly tolerated, McCrady's unassuming regional

aesthetic and often caricatured depictions of African Americans appeared increasingly provincial and outmoded. Thus, when McCrady exhibited his work in New York in 1946, the American Communist Party's *Daily Worker* called the show a "flagrant example of racial chauvinism." McCrady reeled from the criticism and, until receiving a 1949 grant from the National Institute of Arts and Letters recognizing his "warm poetic vision of life in the South," nearly ceased painting altogether.

During the two decades preceding his sudden death on 24 December 1968 in New Orleans, McCrady focused on teaching, but he continued to depict scenes of his beloved Oxford and Lafayette County in numerous easel paintings as well as in a large triptych, *The Square*, *The Courthouse*, and *The Campus*. McCrady's works are held by the Mississippi Museum of Art in Jackson, the New Orleans Museum of Art, the St. Louis Art Museum, and San Francisco Museum of Modern Art and in many private collections in Mississippi and Louisiana.

TERESA PARKER FARRIS
Tulane University

Patti Carr Black, *Art in Mississippi, 1720–1980* (1998); Judith H. Bonner, E. John Bullard, John Kemp, Naomi Marshall, Roger Houston Ogden, and Henry Casselli, *Xavier Review* (Fall 1993); Robert L. Gambone, *Art and Popular Religion in Evangelical America, 1915–1940* (1989); *Life* (October 1937); Keith Marshall, *John McCrady, 1911–1968* (1975); Matthew Martinez, *Louisiana Cultural Vistas* (Winter 1992); Tom Payne, *Oxford American* (February 1995); Patricia Phagan, *The American Scene and the South: Paintings and Works on Paper, 1930–1946* (1996); Stark Young, *New Republic* (November 1937).

Meeker, Joseph Rusling

(1827–1887) LANDSCAPE PAINTER. Joseph Rusling Meeker was born in Newark, N.J., in 1827 but moved to Auburn, N.Y., with his family the following year. His childhood efforts in watercolor were encouraged by a local carriage painter, Thomas J. Kennedy. Meeker was granted a scholarship for study at the National Academy of Design in 1845, and there he studied portraiture with Charles Loring Eliot and observed the work of academy director Asher Brown Durand, the noted luminist landscape artist.

Following his studies, Meeker moved to Buffalo, N.Y., where he painted his first landscapes. He was active in Louisville, Ky., from 1852 to 1859, teaching at a local academy and exhibiting his landscape art. From Louisville, he moved to St. Louis, where Thomas Satterwhite Noble, Charles "Carl" Ferdinand Wimar, and other artists had founded the Western Academy of Art. Meeker's work was shown in the Western Academy's first exhibition in 1860.

When the Civil War broke out in 1861, Meeker worked as a volunteer for the Union Aid Society before enlisting in the U.S. Navy. As paymaster aboard a Union gunboat, Meeker was deployed in the Louisiana swamp country, where he made sketches of the atmospheric environment. At war's end, he returned to St. Louis and set up a studio at Chestnut and Fifth Streets, creating oil

landscapes based upon those sketches, which he offered for sale at several local galleries, including Harding's, Zeeger's, and Pettes & Leathe.

From 1865 to 1878 Meeker is thought to have made intermittent sketching expeditions to the lower Mississippi River Valley, as well as to Pine Knob, Mo. Meeker soon began to write articles on his approach to composition in landscape art as well as his painterly inspirations, beginning with an essay on Turner prepared for the December 1877 issue of the *Western*. He exhibited several large works related to the lower Mississippi River Valley at the 1878 St. Louis Exposition.

Meeker was well known as a leader in the local art world, having assisted in the founding of the St. Louis Art Society in 1872 and the St. Louis Sketch Club in 1877. During the last decade of his life, he was confronted by changing trends in the local academic art world. Under the leadership of Halsey Cooley Ives, the School of Fine Arts associated with Washington University advocated the plein air style in contemporary European art, with particular reference to the Barbizon school in France. In opposition, Meeker and several other artists left the Sketch Club to found the dissident Salmagundi Sketch Club of St. Louis.

Critical taste changed as well. One critic, writing in the 8 January 1881 issue of the *Spectator*, had tired of the artist's source material, opining that it "will not do to go on in this easy-going careless way, painting from sketches made ten or fifteen years ago with all the freshness and beauty of the scene faded en-

tirely out of memory." Meeker retorted in the *Spectator*'s next issue that if he were "constantly painting swamps" it was because "those who buy my pictures naturally want my specialty." Deeply inspired by what he had seen in southern swamplands, Meeker felt that the "sketches and studies I made during the four years I spent in the South are sufficient to last me for forty years instead of fifteen, and I shall see to it that their freshness and beauty does not fade away."

He died at his home at 2902 Laclede Avenue in St. Louis on 27 September 1887. His widow, Nellie J. Meeker, left many of his effects to the Missouri Historical Society, including a portrait of the artist by John Mulvany.

ESTILL CURTIS PENNINGTON
Paris, Kentucky

Judith A. Barter and Lynn E. Springer, *Currents of Expansion: Paintings in the Midwest, 1820–1940* (1977); C. Reynolds Brown, *Joseph Rusling Meeker: Images of the Mississippi Delta* (1981); Bruce Chambers, *Art and Artists of the South: The Coggins Collection* (1984); Katherine Vogt Dixson, *Gateway Heritage* (Winter 1982–83); Arthur Jones and Bruce Weber, *The Kentucky Painter from the Frontier Era to the Great War* (1981); Estill Curtis Pennington, *Downriver: Currents of Style in Louisiana Art, 1800–1950* (1991), *Look Away: Reality and Sentiment in Southern Art* (1989), *Romantic Spirits: Nineteenth-Century Paintings of the South from the Johnson Collection* (2011), *A Southern Collection: A Publication of the Morris Museum of Art* (1992), *Subdued Hues: Mood and Scene in Southern Landscape Painting, 1865–1925* (1999); R. W. Norton Gallery, *Louisiana Landscape and Genre Paintings of the 19th Century* (1981).

Meucci, Antonio

(active 1818–1847/52) PAINTER.

Meucci, Nina

(active 1818–ca. 1834) PAINTER.

The historical record is surprisingly
detailed regarding Antonio and Nina
Meucci, a husband-and-wife team of
miniaturists and portrait painters with
an extended itinerary. Although many
miniaturists learned their trade as ap-
prentices to craftsmen, Antonio claimed
to have been a member of several aca-
demies in his native Italy. Newspaper
advertisements state that Nina, Meucci's
Spanish wife, learned to paint from
him. The couple's surviving miniatures
are charming though unremarkable
portraits that are stylistically indistin-
guishable from the work of their con-
temporaries. The Meuccis first appeared
in New Orleans in 1818, having arrived
from Rome. The earliest advertise-
ment states that each painted portraits
and miniatures "of every dimension"
and that they operated an "academy for
young ladies & gentleman, at [their]
dwelling in Bourbon St., in the house
belonging to Mr. Honoré Landreaux,
near the Orleans Theatre, No. 92." Be-
cause of the proximity, one may specu-
late that Antonio may also have worked
as a set designer.

From 1821 to 1822 the Meuccis lived
in Charleston, where they offered to
teach young ladies and gentlemen
to paint landscapes, portraits, and
miniatures in 15 weeks at their private
drawing academy. Antonio also adver-
tised his ability to "repair any minia-
tures damaged by weather, etc.," and
exhibited a panoramic canvas entitled
The Death of Hias (1822). Thus began

the couple's career as itinerant minia-
turists, landscape painters, portraitists,
restorers, and drawing instructors. In
1823 they appeared in New York City but
moved to Salem in 1825, returning to
New York in 1826. Family records indi-
cate that they also worked in Richmond
and Portland, Maine.

The Meuccis reappeared in New
Orleans in 1826, after a seven-year
hiatus, announcing that they had "a
great variety of specimens in miniature
and other style" that were to be exhib-
ited at Hewlett's Exchange Coffee House
and Davis's Coffee House at the Orleans
Theatre. The Meuccis also offered to
repair "all likenesses painted by them-
selves, which may be injured by the
weather, damp or otherwise."

Antonio is listed in the city directory
as a scenery painter for the Orleans The-
atre. A review of Antonio's "full scenery
& entirely new decorations" in February
1827, including a "Scottish view," was
praised in the press as presenting "the
most agreeable perspective." During
the couple's last visit to New Orleans,
Antonio Meucci gave painting lessons
to Julien Hudson, a free man of color.

Records suggest that the Meuccis
traveled to Havana, Cuba, and Kingston,
Jamaica. By 1830 they were in Cartegena,
Colombia, though they may have visited
Bogotá as early as 1828. It seems likely
that their daughter, Sabina Meucci, and
her husband, Richard Souter, a diplomat
or merchant in Colombia, encouraged
the move. However, it is unclear if Nina
accompanied her husband or continued
working after this event. She is not men-
tioned in subsequent advertisements. In
Cartegena, Antonio painted a portrait of

Simón Bolívar and made at least a dozen copies.

Antonio was in Rionegro in 1831, possibly in Medellín, and in Popayán in 1832. He advertised his skills as a miniaturist and portrait painter in Lima, Peru, on 27 February 1834. Except for occasional trips to Ecuador, Meucci seems to have spent his remaining years in Peru. No evidence of his artistic activity after 1837 has surfaced. According to family records compiled by Jorge Bianchi Souter, Antonio Meucci died in Lima or Guayaquil, Ecuador, between 1847 and 1852.

RICHARD A. LEWIS
Louisiana State Museum
New Orleans, Louisiana

Beatriz González, *Catálogo de Miniaturas* (1993); John Burton Harter and Mary Louise Tucker, *To 1870*, vol. 1 of *The Louisiana Portrait Gallery* (1979); Louisiana State Museum, *250 Years of Life in New Orleans: The Rosemonde E. and Emile Kuntz Collection and the Felix H. Kuntz Collection* (1968); John A. Mahé II and Rosanne McCaffrey, *Encyclopaedia of New Orleans Artists, 1718–1918* (1987); Carmen Ortega Ricaurte, *Dictionary of Colombian Artists* (1965); Anna Wells Rutledge, *Artists in the Life of Charleston* (1949).

Millet, Clarence

(1897–1959) PAINTER AND PRINTMAKER.

Clarence Millet was a fixture in Louisiana art circles for 45 years. He was born on 24 March 1897 in the town of Hahnville in St. Charles Parish and was educated in Louisiana's public schools. Millet took a position as a shipping clerk in a New Orleans store. After he copied a magazine illustration, he was encouraged to become an artist, an idea that he had previously nurtured. Largely self-taught, Millet held his first solo exhibition at the Artists' Guild, the forerunner of the Arts and Crafts Club of New Orleans, in the Old Mortgage Building at the corner of Royal and Conti Streets. Millet earned sufficient money from this show to allow him to study in the East. From 1922 to 1924 he studied at the Art Students League of New York under academician and anatomist George Brandt Bridgman.

In 1927 the Pennsylvania Academy of the Fine Arts exhibited Millet's *Antique Shop, New Orleans*, which portrayed Rau's Antique Store at 630 Royal Street in the French Quarter. This prestigious recognition served as a catalyst for Millet's career. Over 30 magazines and newspapers published illustrations of his French Quarter scenes and Louisiana views, including *American Magazine of Art, Chicago Evening Post, Houston Chronicle and Post-Dispatch, Richmond News Leader, Salt Lake Tribune, San Antonio Express, Christian Science Monitor, ARTnews, Art Digest, New Orleans Times-Picayune,* and *New Orleans Item.*

Subsequently, Millet exhibited widely, including at the Art Institute of Chicago and in New York at the National Academy of Design, the Montross Gallery, and the Second National Exhibition of American Art, as well as in 35 cities across the American South and West. He exhibited a painting titled *Saturday Night, New Orleans* at the 1939 World's Fair in New York. Millet relocated to New Orleans permanently

and took up residence in the Old Claiborne House at 628 Toulouse Street in the French Quarter. He held a solo exhibition at the Isaac Delgado Museum of Art (now the New Orleans Museum of Art) under the auspices of the Art Association of New Orleans (AANO) and the New Orleans Art League. He also exhibited in the 38th Annual Exhibition of the AANO held at Delgado. Millet won a number of prizes, including the Blanche S. Benjamin Prize and the Lyle Saxon Memorial Prize at the New Orleans Spring Fiesta, and awards from the Southern States Art League, the Mississippi Art Association, and at the Louisiana State Exhibit in Shreveport.

In the 1930s Millet found employment with the Easel Project of the Works Progress Administration. A member of the Arts and Crafts Club of New Orleans, he was on the faculty of its School of Art, where he taught the evening and Saturday classes, particularly the courses in outdoor painting. Millet was one of the founders of an offshoot of the Arts and Crafts Club, the New Orleans Art League (NOAL)—an all-male organization headquartered at 628 Toulouse Street, where Millet and other members maintained studios. Millet, who served a term as president of the NOAL, was also elected to membership in the Southern States Art League and in 1943 was elected an associate of the American National Academy. At that time the only other academician from Louisiana was painter Helen Maria Turner, who was elected to membership in 1921, the third woman elected to membership and one of the first in the South.

Millet was known for his quiet, gentlemanly manner and his refusal to subscribe to the Bohemian image frequently ascribed to artists, claiming that he valued "a shave and a clean shirt." As a native of St. Charles Parish, Millet focused on rural Louisiana landscapes, swamps, bayous, rivers, bridges, woodland scenes, fields, farms, barnyards, roadways, and architectural scenes on plantations and in the Vieux Carré. He claimed that the Mississippi River was his best subject, and a number of batture scenes attest to Millet's skill in depicting churches and fishing camps in the area between the levee and the river.

Millet died suddenly on 23 August 1959. He is buried in St. Louis Cemetery No. 3 in New Orleans. At his death he was called one of the artists "closely connected with the 'rise of art' in New Orleans." In November 1960 a memorial exhibition, organized by his artist-friend Charles Reinike and sponsored by the AANO, was held honoring Millet at the Downtown Gallery at 521 St. Ann Street in the French Quarter. Many of the buildings depicted by Millet in his canvases and prints had long vanished from the Louisiana landscape.

JUDITH H. BONNER
The Historic New Orleans Collection

Anglo-American Art Museum, *The Louisiana Landscape, 1800–1869* (1969); Artists' Files, Williams Research Center, Historic New Orleans Collection; Judith H. Bonner, *Arts Quarterly* (April–June 2008), in *Collecting Passions*, ed. Susan McLeod O'Reilly and Alaon Masse (2005), *Louisiana Cultural Vistas* (Winter 2007–8); Joseph Fulton and Roulhac Toledano, *Antiques* (April 1968); William H. Gerdts, George E.

Jordan, and Judith H. Bonner, *Complementary Visions of Louisiana Art: The Laura Simon Nelson Collection at the Historic New Orleans Collection* (1996); R. W. Norton Art Gallery, *Louisiana Landscape and Genre Painting of the 19th Century* (1991).

Mills, Robert

(1781–1855) ARCHITECT.

Born in Charleston, S.C., Robert Mills is often said to be the first native-born American to train specifically for a career in architecture. He served as an apprentice and draftsman under James Hoban during the construction of the White House and then enjoyed the use of Jefferson's architectural library and executed drawings for the new president. With letters of introduction from Jefferson, Mills toured the seaboard as far north as Boston. In 1803 he entered the office of Benjamin Henry Latrobe and worked in and around Philadelphia until 1809. In that year he married Eliza Barnwell Smith of Winchester, Va., and began his own practice as an architect and engineer in Philadelphia.

While he was still affiliated with Latrobe, Mills proved his competence with the plans for the South Carolina College (Columbia, 1802), the Circular Church (Charleston, 1804), the First Presbyterian Church (Augusta, Ga., 1807), and the Sansom Street Church and wings for Independence Hall (Philadelphia, 1808). Mills's reputation was established in 1812 when he won the design competition for the Monumental Church in Richmond, Va. Here, and in the Burlington Jail (Mount Holly, N.J., 1808), his commitment to fireproof construction was manifest.

Mills's design for the Washington Monument in Baltimore (1814) brought national acclaim. Based upon Trajan's Column in Rome, it was the first major monument to George Washington. Economic depression slowed construction of the monument, and in 1820 Mills moved his family to South Carolina, where he became the civil and military engineer for the state. During the ensuing decade he built canals, published an atlas and a description of the state, worked as a cartographer, and designed the South Carolina Insane Asylum (Columbia, 1821), the fireproof County Records Office (Charleston, 1822), and numerous less notable structures. This interlude in South Carolina may be viewed as a period of preparation for his return to Washington, D.C. (1830), and his subsequent service to the federal government.

Although working diligently on many projects, Mills skirted poverty for five years. Then in 1836 the final phase of his career began auspiciously with the design for the U.S. Treasury and his appointment by Pres. Andrew Jackson as federal architect, a post he held until 1842. For the federal government he developed a series of customhouses and marine hospitals, from Newburyport, Mass., to Mobile, Ala.; he designed the U.S. Patent Office (1839) and worked on various modifications of the U.S. Capitol. Mills also found time for private clients and for writing about municipal waterworks, navigation, railroads, and a route to the Pacific. In 1846 his design for the Washington Monument in Washington, D.C., was published. Despite significant modifications during construction (it was not com-

pleted until 1884), this remains his most famous work.

Mills's career mirrored the early evolution of architecture as a profession in America. Aesthetically, his work reflected the growing impact of American pragmatism upon the revival styles of the 19th century. He was a major force in shaping the architectural landscape of the South, and like other southerners in the early republic, Mills made vital contributions to the cultural form of the new nation.

JOHN MORRILL BRYAN
University of South Carolina

John Morrill Bryan, *An Architectural History of the South Carolina College, 1801–1855* (1976), *Robert Mills: America's First Architect* (2001), *Robert Mills, Architect, 1781–1855* (1976); Helen Mar Pierce Gallagher, *Robert Mills: Architect of the Washington Monument, 1781–1855* (1935); Rhodri Windsor Liscombe, *Altogether American: Robert Mills, Architect and Engineer* (1994).

Mr. Feuille

(active ca. 1834–1841) PORTRAITIST. The portrait painter Feuille, whose first name is unknown, is said to have been frequently conflated with his brother, Jean-François Feuille, a copperplate engraver who was active in New Orleans at the same time. Scholars have speculated that the Feuille brothers immigrated to the United States from France, although there is no solid evidence to support this contention. The name Feuille first appears in the records of the National Academy of Design in New York, where one of the two men was an associate member in 1832. The first record of the name Feuille in New Orleans is an advertisement that appeared in the *New Orleans Bee* on 5 March 1835. The last notice appears in the *New Orleans Courier* on 4 April 1841. Although his name does not appear in directories, the painter Feuille apparently lived with his brother at various addresses on Chartres Street near Canal Street in what is today the French Quarter. It is also possible that J. F. Feuille and the artist identified as "Mr. Feuille" are one and the same person.

The handful of portraits and miniatures signed or attributed to Feuille are characterized by the tendency, characteristic of plain or folk portraiture, to reduce volume to a series of flattened planes. There is a decided emphasis on the precise delineation of detail and pattern. The representation of fabric suggests a stiff, almost metallic appearance that readily marks the artist's work. Figures are set against a dark background in most portraits. Where suggested, linear perspective is skewed, and there is little evidence of atmospheric perspective. Nevertheless, Feuille's portraits are individualized likenesses of specific individuals executed with a high degree of competency and charm. Perhaps the best known of Feuille's portraits is the likeness of Nicolas Augustin Metoyer, the patriarch of the prominent Creole of color community near Nachitoches, La.

RICHARD A. LEWIS
Louisiana State Museum
New Orleans, Louisiana

John Burton Harter and Mary Louise Tucker, *To 1870*, vol. 1 of *The Louisiana Portrait Gallery* (1979); Louisiana State Museum, *250 Years of Life in New Orleans: The Rosemonde E. and Emile Kuntz Collection*

and the *Felix H. Kuntz Collection* (1968);
John A. Mahé II and Rosanne McCaffrey,
*Encyclopaedia of New Orleans Artists, 1718–
1918* (1987); Martin Wiesendanger and Mar-
garet Wiesendanger, *Nineteenth-Century
Louisiana Painters and Paintings from the
Collection of W. E. Groves* (1971).

Mizner, Addison Cairns

(1872–1933) ARCHITECT.

Born in Benicia, Calif., Addison Cairns
Mizner revived Spanish-style archi-
tecture in Florida and exerted a major
influence on the development of Palm
Beach. Although he had no formal
training in architecture and, in fact,
earned no academic degree, he did
study design in Guatemala and at the
University of Salamanca, Spain. More
important for his architectural career,
he acquired practical experience while
apprenticed from 1893 to 1896 to the
architect Willis Polk in San Francisco.
He also gained a broad knowledge of
architecture from his extensive travels
in China, Central America, and Europe.
While in Guatemala, Mizner began
trading in antiques and art. He finally
received his license to practice archi-
tecture in 1919 from the state of Florida
on the basis of the state's grandfather
clause.

In 1904 Mizner settled in New York.
From his society connections he soon
had an active practice, consisting prin-
cipally of additions, renovations, and
the design of new residences in New
York State and throughout the North-
east. But most of his work, and that on
which his fame rests, was done in the
South. In 1918 Mizner went to Florida
to convalesce from an accident. That

same year he designed the Everglades
Club in Palm Beach for developer Paris
Singer. The design of this exclusive
club, Spanish-inspired with a flavor of
Islamic culture, was a grand architec-
tural success, set the style for the rapidly
growing winter resort, and established
Mizner's reputation. During the 1920s
he designed more than 100 buildings,
including clubs, theaters, hotels, enter-
tainment complexes, and some of the
grandest estates and mansions in the
country. His designs are characterized
by the integration of interior rooms
with exterior patios and courtyards,
richly ornamented interiors, and elabo-
rate portals.

In order to build his designs accu-
rately, Mizner established his own facto-
ries for the manufacture of terra-cotta,
cast-iron, and cast-stone ornaments and
new and "antique" furniture. He also
ventured into the field of city planning.
He was responsible for the layout of the
new resort of Boca Raton. These recre-
ational facilities and hotels were fin-
ished before the Florida land collapse of
1926, which left Mizner bankrupt. While
he continued to receive some commis-
sions, he spent the last years of his life
writing *The Many Mizners* (1932), an
entertaining biography of his family.

Mizner single-handedly gave form
and style to Palm Beach; his theatrical
and picturesque architecture embodied
the extravagant vacation lifestyle of
the famous and wealthy. In the 1920s
Mizner ranked as one of America's most
prominent architects.

KAREN KINGSLEY
Tulane University

Donald W. Curl, *Mizner's Florida: American Resort Architecture* (1984); Addison Cairns Mizner and Ida M. Tarbell, *The Florida Architecture of Addison Mizner* (1928); Justin A. Nylander, *Casas to Castles: Florida's Historic Mediterranean Revival Architecture* (2010); Anona Christina Orr-Cahall, "An Identification and Discussion of the Architecture and Decorative Arts of Addison Mizner (1872–1933)" (Ph.D. dissertation, Yale University, 1979); Caroline Seebohm, *Boca Rococo: How Addison Mizner Invented Florida's Gold Coast* (2001).

Mohamed, Ethel Wright

(1906–1992) ARTIST.

At the age of 60, Ethel Wright Mohamed, of Belzoni, Miss., began to create pictures in embroidery, and by age 75 she had created over 125 extraordinary memory pictures. The Smithsonian Center for Folklife and Cultural Heritage invited Mohamed to participate in its 1974 Folklife Festival, which featured artists from Mississippi, and exhibited her work in its 1976 bicentennial festival. Mohamed's work was displayed at both the 1982 and 1984 World's Fairs.

Ethel Wright was born in 1906 and grew up near Eupora, Miss. Working at a local bakery at age 16, she met 32-year-old Hassan Mohamed, owner of the local dry goods store. The two married in 1924 and after a few years moved to Belzoni, where they opened the H. Mohamed general merchandise store and reared eight children.

After her husband died in 1965, Ethel Mohamed continued to run the family store, but she was lonely: "I was a successful businesswoman. I had brought up eight wonderful children. I had been married to a marvelous man for 41 years. Now here I was coming home at night to this big empty house. I needed a hobby." First Mohamed tried painting, but one of her grandchildren was embarrassed about his grandmother's art. "People will think you're weird," he said. Young Ethel Wright had been encouraged by her mother to draw and to embroider, to take scraps of cloth and make her own "coloring books." So Mohamed decided to take up embroidery instead. "That way I could fold up the work and put it away quickly when people came by." She kept her stitchery hidden in a closet.

Her secret art brought her great happiness; she said of her "hobby," "I began to stitch pictures, a family album of sorts, of my family's history. Of graduations, of family stories, of pets and trees and flowers in our yard. I felt a great joy when I was stitching, as if this was what I was meant to do. The needle sang to me." When Mohamed was persuaded to show her pictures to a local artist, she found a waiting audience for her work.

Mohamed created miniature worlds in her pictures of family and community events: births, holidays, and scenes at home and at the store. Twelve pictures tell sequentially the story of the Mohamed family farm. Some pictures are imaginative re-creations of local events; in one scene, an ancestor leaves home to fight for the Confederacy. A Sacred Harp singing group is the subject of another. *The Beautiful Horse* illustrates a favorite story that Hassan Mohamed brought from his native Lebanon.

The joy and the intimacy of Moha-

med's memories show in the animation, the brilliant colors, and the fanciful detail of each child, animal, plant, tree. In many of the works, the trees and plants are truly animated—each leaf has a smiling face. As Mohamed stitched, all parts of the needlework came to life to her, each tiny part of the picture with its own story. Mohamed never took out a stitch. If a face turned out ugly, she would tell it, "That's too bad; you were just born that way." She never sold her pictures, considering each a member of the family.

In 1991, the Mississippi Arts Commission presented Ethel Mohamed with the Governor's Lifetime Achievement Award for Excellence in the Arts. Mohamed's work is included in the permanent collections of the Smithsonian American Art Museum, the Ethel Wright Mohamed Stitchery Museum, and the Sarah Ellen Gillespie Museum of Art at William Carey University.

CHRISTINE WILSON
Mississippi Department of Archives and History

William Ferris, *Local Color: A Sense of Place in Folk Art* (1982); William Ferris and Judy Peiser, *Four Women Artists* (video) (1978); Ethel Wright Mohamed, *My Life in Pictures* (1976); Emily Wagster, *Clarion-Ledger* (7 February 1992); Christine Wilson, ed., *Ethel Wright Mohamed* (1984).

Molinary, Andres

(1847–1915) PAINTER, ART TEACHER, RESTORER, PHOTOGRAPHER.
The son of an Italian father and Spanish mother, Andres Molinary was born in Gibraltar in 1847. He studied with Lorenzo Valles at the Academia de Bellas Artes in Seville, at the Accademia di San Luca in Rome, and in East Africa and Morocco. Molinary toured Italy, Spain, and Africa with artist-friends, including Spanish painter Mariano José Maria Bernardo Fortuny y Carbo, sketching and painting exotic and historic vistas. Molinary also traveled in Mexico and Central America.

In 1872 Molinary traveled to New Orleans, where his uncle, John Brunasso, was a partner in the import company Fatjo and Brunasso. After additional travels to Mexico and Central America, Molinary returned to New Orleans. Despite family pressures for him to become a civil engineer, Molinary opened an art studio with encouragement from his uncle, who was impressed with his work.

Although Molinary preferred painting landscapes, genre scenes, and street life, as he had done in Egypt and Tangier, he turned to portraiture, which he stated was the only field open to artists in post-Reconstruction New Orleans. He painted portraits of numerous prominent citizens from New Orleans and other southern cities. After the death of painter Everett B. D. Julio, Molinary took over his studio and his art collection, where he organized the Cup and Saucer Club, so-called because its members were required to bring their own teacup and saucer for their refreshments.

Active in the art community, Molinary was a cofounder of both the Southern Art Union and its successor, the Artists' Association of New Orleans

(AANO). He was a painting teacher for both organizations and frequently exhibited his artworks at the annual shows. At the AANO he taught a number of students who later became prominent artists. One of his students, Marie Madeleine Seebold, was the daughter of art patron Frederic William Emile Seebold, who held regular gatherings for artists, writers, and literati of the time, including visiting artist George Inness and writers George Washington Cable and Samuel Clemens.

Molinary's works include an oversize portrait of Lawrence Fabacher, painted in 1906. Fabacher and his brother Joseph established the Jax Brewery in 1890, an industry that employed a high percentage of the city's German population. Other portraits include *Governor Esteban Rodríguez Miró*, painted in 1916 and now in the collection of the Louisiana State Museum. Miró, who held office from 1785 to 1791, was the sixth governor of the Louisiana Territory during the Spanish colonial period and is still remembered fondly by the Spanish residents.

One of only a few Louisiana artists to be included, Molinary exhibited paintings at the 1884–85 World's Industrial and Cotton Centennial Exposition in New Orleans, a fair for which Seebold was an organizing force. Molinary was honored with a retrospective exhibition of portraits at the Isaac Delgado Museum of Art (now the New Orleans Museum of Art). He maintained a friendship with Marie Madeleine Seebold, whom he portrayed a number of times, including a full-size, full-length portrait of the seated young woman. He married her, literally on his deathbed, on 11 September 1915.

JUDITH H. BONNER
The Historic New Orleans Collection

John A. Mahé II and Rosanne McCaffrey, *Encyclopaedia of New Orleans Artists, 1718–1918* (1987); Estill Curtis Pennington, *Subdued Hues: Mood and Scene in Southern Landscape Painting, 1865–1925* (1999); Martin Wiesendanger and Margaret Wiesendanger, *Nineteenth-Century Louisiana Painters and Paintings from the Collection of W. E. Groves* (1971).

Moreland, William Lee

(b. 1927) ARTIST.

Louisiana native William Moreland had a long and influential career in his home state as an artist, professor of art, and arts administrator at the University of Southwestern Louisiana, now the University of Louisiana at Lafayette. Active at the university from 1955 to 1986, during a critical period of transition in the art world and in the South, Moreland and this art program nurtured new generations of artists in the Acadiana region. In addition to the advancement of his own art over a period of more than 50 years, Moreland played a significant role, with his faculty and colleagues, in educating and supporting the evolution of regional art voices and visions in Louisiana.

William Lee Moreland was born in New Orleans on 25 August 1927. His parents, Charles Frederick Moreland, a professor at Louisiana State University (LSU), and Hilda Martinez Moreland, reared him in Baton Rouge. During his

early years he was strongly influenced by Catholicism, including its rituals and symbols. He graduated from Catholic High School in Baton Rouge in 1944. As a student, he watched a noted Catholic monk and artist, Dom Gregory de Wit, paint a religious mural in a new church in Baton Rouge. De Wit became a mentor and influence on the young Moreland, teaching him the basics of art and inspiring him to create his own religious imagery.

After graduation from high school, Moreland remained in Baton Rouge and enrolled in the fine art program at LSU, studying under Caroline Spelman Wogan Durieux, Conrad Alfred Albrizio, and others. During his undergraduate years at LSU, Moreland painted commissioned religious works for churches and chapels in New Orleans, Mobile, and Pasadena, Tex. At the same time, his professors at LSU were introducing him to new aesthetic visions, techniques, and challenges reflective of the contemporary American art world. Inspired by the landscape and pine forests of central and northern Louisiana during these years, Moreland completed a critical landscape painting, *Louisiana Pines* (1947), which suggested his later interest in painting the lush, complex environment of Louisiana but which he would come to portray in a more abstract manner. Moreland completed an M.A. at LSU in 1950 and then accepted a teaching fellowship at the university in geography and anthropology for the 1951–52 academic year. He later taught art at LSU.

In 1955 Moreland made a critical decision that changed the course of his career. He left LSU to accept a teaching position in the Department of Art at the smaller University of Southwestern Louisiana, beginning a "storied" career in Lafayette. Not long after he arrived in 1957, the name of the Department of Art was changed to the Department of Art and Architecture, and Moreland was made chair of fine arts and art education. That same year he met Muriel Kinnaird, who joined the staff of the school to coordinate and teach dance courses, and she and Moreland later married. During Moreland's tenure, the Department of Art and Architecture was changed to the School of Art and Architecture, in 1964. In response to the growing professionalism and success of the school, a new building, named Fletcher Hall, was constructed on the campus in 1977 for these programs.

During the 1950s, in addition to his interest in figurative, religious, and symbolic subjects, Moreland painted the landscape and natural environment of his state, including the nearby Atchafalaya Basin, where he discovered important abstract possibilities for his art. He later explained this interest and the perspective he discovered while traveling in cars. "The elevated highway with its railing cut off my vision with a clean line at the bottom and the trees seemed to line up on either side of the road . . . [and] passing by with some speed the landscape seemed to unfold like a scroll, with each view for a moment in the frame of the car window." Moreland recognized, over time, that this speeding automotive perspective on the natural and still-exotic Louisiana environment, seen and framed by an ele-

vated modern highway, was of importance to him, and "after many trips my experience of that landscape came to be internalized." It set the foundation for his continuing series of landscape paintings rooted in Louisiana's environment.

While Moreland enjoyed a growing reputation as a teacher and arts administrator, he was exhibiting his paintings in national gallery and museum exhibitions. He enjoyed some success in New York and other national venues, often with his figurative works. By the early 1960s, however, Moreland reduced these exhibition and gallery activities, feeling that his art needed to evolve in new ways. In addition to his university teaching and administrative activities, he began to explore the world around him, including the Louisiana landscape, in search of new directions in his art. A major work, *First Triptych*, was created at this time, using the landscape as a focus and incorporating the historic and spiritually charged nature of religious iconography in the triptych format. This began a period of new artistic activity, including experimentation with framing and compositional formats, in which he established new directions for his art during the 1960s and 1970s. Moreland remained at the University of Louisiana at Lafayette from 1955 to 1986.

After Moreland retired in 1986 he and his wife moved to New Orleans, to a home and studio located near the arts district and downtown. They traveled extensively during these years, and Moreland created few new paintings until around 1994, when he entered a period of newly energized production.

On a driving trip in Colorado, while examining a canyon wall near Boulder, Moreland experienced a creative revelation, which brought him back to painting landscape and natural imagery. In his New Orleans studio and out in the Louisiana environment, he explored these new directions, which he later described: "It now all fit together! The triptych had roots in my early love for religious imagery. It was all grounded in my personal experience in a car on the road, year after year, view after view. No more figures, no more geometric intrusions. I would try to do a landscape with that unity, that oneness, I'd longed to get at for such a time. Two natural landscapes [Louisiana and the West] had become my spirit brothers." Since then, he has created a significant body of new paintings, many installed in handmade frames created by John Richard, who works in collaboration with Moreland on framing each painting.

In 2003 Moreland's paintings were featured in the grand opening of the Ogden Museum of Southern Art, University of New Orleans. In 2004 he was the subject of a career retrospective exhibition at the University of Louisiana at Lafayette, *William Moreland: Between Psyche and Sight, a Fifty-Year Retrospective*, at the new Paul and Lulu Hilliard University Art Museum. In 2008 he was the focus of an exhibition at the Ogden Museum of Southern Art, *Southern Masters: William Moreland*, which presented works from the museum's Mary Lee Eggart Collection of William Moreland's art.

J. RICHARD GRUBER
Ogden Museum of Southern Art
University of New Orleans

Steven Breaux, *William Moreland: Between Psyche and Sight, a Fifty-Year Retrospective* (2004); Mary Lee Eggart Collection, Ogden Museum of Southern Art, University of New Orleans, www.ogdenmuseum.org/collections.

Morgan, Elemore, Jr.

(1931–2008) PAINTER AND PHOTOGRAPHER.

In one sense, Elemore Morgan Jr. was a traditionalist, perhaps the only traditional landscape painter who was fully embraced by the South's mainstream art world. This is because his Louisiana vistas of Acadiana prairies are far more than they seem. To be sure, Morgan is a part of the long expressionist tradition. One can easily cite historical analogues in the work of Vincent van Gogh, Edvard Munch, and André Derain—so much intense and exuberant brushwork, so much nondescriptive fauvist color. But there is also a distinct departure. Above all, his characteristic work focuses on a chosen segment of the South, a feeling that is successfully conveyed to the viewer.

Morgan was born in Baton Rouge in 1931. His long career included study at the Ruskin School of Fine Arts (Oxford University, England) and 30 years as professor of art at the University of Louisiana at Lafayette. A major retrospective exhibition was held in 2006 at the Ogden Museum of Southern Art in New Orleans. Earlier Morgan was included in the landmark *Louisiana Major Works* (1980) at New Orleans's Contemporary Arts Center. Also in New Orleans, he was represented by the Arthur Roger Gallery for 20 years.

Technically, Morgan's departure from conventional landscape is characterized chiefly by his idiosyncratic employment of color and the manner in which he re-created his revered south Louisiana. To him, the chromatic sense was "part of a personality profile," that which he called "your own frequency." This, apparently, is only tangentially related to the actual colors in nature. In a Morgan rendering of a Louisiana rice field, pinks and purples are as essential as blues and greens. And, ineffably, viewers perceive something both strange and familiar in the startling palette that results. The experience conjures memories of Willem de Kooning's abstract landscapes—instances where a broad slash of orange can intimate the exoticism of a tropical shoreline. In a signature work by Morgan, a hot violet flurry can seem just as exotic, suggesting that this vision of Louisiana is entirely personal, entirely creative.

A further singularity in Morgan's landscapes has to do with his penchant for atypical formats, usually fashioned of Masonite. Whether extreme panoramas or ecclesiastical arches or rearview mirror–shaped ovals, he conceived of these formats as connected to the spectacle of "Cajunland" flatness vis-à-vis the earth. He said, "One of the things that excites me about the prairie is that it's 80 percent sky and 20 percent land. Much of what you see is sky; it's a great dome. I swear, in my own little backyard I can almost feel the shape of the planet."

One consequence of this reaction is his depiction of cloud formations—but not the predictable clouds of a romantic

or a conventional realist. For Morgan, a cumulus formation was imbued with incendiary color—magenta, for example, or pale orange—and the technique is often a maze of thin, near-random brushstrokes. This lends a feeling of weightlessness to many of his paintings, like nature emblematized and suspended. At first it suggests a universal aesthetic impulse—perhaps a new and acutely expressionist view of the sublime. But ultimately the color overwhelms the viewer, who feels a fully sunlit day, a dizzying summer day in south Louisiana.

TERRINGTON CALÁS
University of New Orleans

Doug MacCash, *New Orleans Times-Picayune* (21 July 2006); Jan Risher, *Daily Advertiser* (19 May 2008); Karl F. Volkmar, *New Orleans Art Review* (Spring–Summer 2008).

Murphy Family

ARTISTS.
Savannah is the oldest city in Georgia, and 21 of the original town squares remain intact. One of them, Chippewa Square, contains a commemorative statue of James Oglethorpe, founder of the city. A home and adjacent commercial building facing that square, purchased in 1908 by Christopher Murphy, became a haven for a family of artists who were integral to the development of the visual arts in the region. Christopher and Lucile Murphy and two of their seven children were born in Savannah, and the four artists lived in that home until the ends of their lives. They each actively played a role in teaching and advocacy for the visual arts within the community and used their surroundings as inspiration and a source for their artistic subjects.

Christopher Patrick Hussey Murphy (1869–1939) joined his father's commercial painting business at the age of 19. The business, which was located in a small building adjacent to the family home, grew to include sign painting, paperhanging, fresco painting, faux techniques, and decorating. Murphy met his future wife, Lucile, prior to his service in the Spanish-American War, and the couple wed in 1902. Essentially self-taught as an artist, Murphy amassed a sizable collection of art books, which he used for study purposes; he befriended many artists, both natives and visitors, traveled in order to study murals and original works in museums, and participated in summer classes with Eben F. Comins at Gloucester, Mass., in 1915. His best-known artistic endeavor is the mural decoration on the interior of the Cathedral of Saint John the Baptist in Savannah. The cathedral, built in the 1870s, was destroyed by fire in 1898; subsequently, plans were made to rebuild it. In 1911 Murphy was commissioned to design and oversee the execution of complex mural decoration for the interior of the church. The interior decoration, completed in 1912, was recently restored. Befitting his ancestry, Murphy served as president of the Hibernian Society, as well as on the jury of selection for the Southern States Art League when its annual exhibition was held in Savannah in 1924. He preferred to submit watercolors for exhibition purposes, and he exhibited work with the American Watercolor Society and at

the Art Institute of Chicago, the Cincinnati Art Museum, the Washington Watercolor Club, the Southern States Art League, the Savannah Art Club, and the Association of Georgia Artists. The Telfair Academy of Arts and Sciences (now the Telfair Museum of Art) held a solo exhibition of his work in 1929 and a retrospective in 1985.

Her obituary made no mention of her artistic life, but Lucile Desbouillons Murphy (1873–1956) was well trained as an artist—although better known as a wife, mother, and French teacher at St. Vincent's Academy. Lucile's parents emigrated from France, where her father had trained as a physician. In Savannah, her father owned a jewelry store, which provided his livelihood and a home above the establishment for him, his wife, and his four children. Lucile studied art with Carl Brandt, the first director of the Telfair Academy, and in the summer of 1895 she studied in Paris at the atelier of Gustave Courtois, receiving additional criticism from Bernard Boutet de Monvel. Accompanied by her friend and fellow artist Emma Cheves Wilkins, Lucile resided at the American Girls' Club in Paris during her stay. Within the first decade of her marriage to Christopher, she became mother to seven children. She continued to produce watercolors, a medium well suited to short periods of creativity in a bustling household. Lucile was the first art instructor for her children. Though she rarely exhibited her work, two watercolors of flowers were included in the annual exhibition of the Southern States Art League in 1924.

Christopher Aristide Desbouillons Murphy (1902–73) was the oldest of the seven children in the Murphy family. Though his middle names honored his maternal grandfather, he was commonly known as Christopher Murphy Jr. The cultural climate at home was rich: there were an abundance of art books, parents who stressed the importance of the visual arts and who were willing teachers, and influential visitors with artistic reputations that reached well beyond the South. Murphy was especially influenced by one visitor, Hardesty G. Maratta, an artist and color theorist, who visited in 1918. Upon graduation from high school, Murphy headed to New York City for further study. He enrolled in the Art Students League and attended classes with George Bridgman, Frank Vincent DuMond, Henry Rittenberg, Adolphe Blondheim, and Joseph Pennell. He also studied with Lloyd Warren, the founding director of the Beaux-Arts Institute of Design in New York City. During his intermittent residence in New York from 1921 through 1930, Murphy attended the Beaux-Arts Institute of Design and was awarded a Louis Comfort Tiffany Foundation Fellowship in 1925. In Savannah, he studied with visiting artists Hilda Belcher, Eliot Candee Clark, and William Chadwick.

Savannah and the home on Chippewa Square was the base for his life's work, except for his time in New York and his tour of duty with the U.S. Coast Guard during World War II. He frequented the waterfront, historic district, and outlying areas for inspiration and subjects to paint. He taught privately and at the Telfair Academy of Arts and Sciences and Armstrong College (now

Armstrong Atlantic State University). He was a founder of and active in the Association of Georgia Artists, which was created during a meeting at his home in 1930. His paintings, etchings, and prints were widely exhibited nationally and internationally, and his work appeared in such popular publications as *Country Life, American Architect, House Beautiful*, and *Southern Architect*. In 1947 he collaborated with Walter Hartridge on a book about his native city, *Savannah*, in which he provided the etchings and drawings and Hartridge provided the text. Murphy married Ernestine Cole, and the couple had one son, Christopher Cole Murphy.

Margaret Augusta Murphy (1908–91), the fourth of the seven Murphy children, taught art in Savannah over the course of a 40-year career in the public school system. After initial art instruction at home, she went to New York, graduating from the Pratt Institute in 1931. Returning to Savannah, Miss Margaret, as she was known, initially taught at the elementary level and became the city's first art supervisor, a position she held until 1944, when she began to teach art at the high school level, doing so until her retirement in 1971. Murphy was a tireless advocate for art education in the public school system and equally tireless in her pursuit of additional education. She received a B.A. in 1942 from the University of Georgia, where she studied with Lamar Dodd. In Savannah she took classes with visiting artists, including Eliot O'Hara and Clifford Carleton. A Ford Foundation Fellowship in 1952 allowed her to spend an academic year in

New York City followed by a summer in Europe; she earned her M.A. degree from Columbia University in New York in 1955. Finally, she received a master of education, specialist in art, degree from the University of Georgia in 1971. After retirement from the public school system, Murphy taught at Georgia Southern College (now Georgia Southern University), Mercer University, and Armstrong College (now Armstrong Atlantic State University). Though known primarily as a teacher, Murphy exhibited regularly with the Savannah Art Club and the Association of Georgia Artists.

A comprehensive survey of the work of these four artists is in the permanent collection of the Morris Museum of Art in Augusta, Ga. Works by the artists are also included in the collection of the Telfair Museum of Art.

KAREN TOWERS KLACSMANN
Augusta State University

Walter C. Hartridge and Christopher Murphy Jr., *Savannah* (1947); Holly Koons McCullough and Feay Shellman Coleman, *Picturing Savannah: The Art of Christopher A. D. Murphy* (2008); Feay Shellman, *Christopher P. H. Murphy, 1869–1939: A Retrospective* (1985).

National Heritage Fellowships

The National Endowment for the Arts, established in 1965 by act of Congress, created the National Heritage Fellowships to recognize and preserve the rich and diverse cultural heritage of the United States. These fellowships are the highest honor this country can bestow upon master folk and traditional artists. The National Endowment for the Arts'

Folk Art Program, which granted its first fellowship awards in 1982, follows a folkloristic definition of folk art; honorees are more likely to be practitioners of local craft traditions than artists whose artwork is distinguished by idiosyncrasy or aesthetic value.

The number of awardees per year has varied from 11 to 17. As of 2007 more than 325 artists and groups have been recognized for their roles in practicing, conserving, reviving, innovating, and teaching their art forms. One of the fellowships awarded each year is named for Bess Lomax Hawes, the National Endowment for the Arts director of the Folk Arts Program who initiated the National Heritage Fellowship program. This particular honor is given specifically to recognize those who foster and promote folk and traditional arts in the public arena.

The fellowship comes with a stipend, which was $5,000 when the awards were inaugurated; by 2007 the amount had risen to $20,000. The amount of the one-time stipend is based on the premise that the monetary component of the award should make a significant statement that acknowledges the importance of the art and the master practitioner.

The awards are not open to application, and an individual may not nominate himself or herself. Instead, potential fellows' names are put forth by the public, with most being nominated by state or local public folklorists. No fellowships are awarded posthumously. An advisory panel of folklorists and traditional arts experts and at least one knowledgeable layperson submit their recommendations for the awards to the National Council on the Arts. The council then sends its recommendations to the chairperson of the National Endowment for the Arts, who makes the final decision regarding fellowships.

Recipients of the National Heritage Fellowships have included musicians, dancers, storytellers, craftspeople, and many others. Recipients have been gospel, Shaker, blues, and jazz musicians; Appalachian banjo and dulcimer makers and players; accordionists; Puerto Rican *bomba*, Japanese American *Kabuki*, Hawaiian hula, and Irish American dancers; weavers of African American sweetgrass baskets and Tlingit Chilkat blankets; Norwegian American rosemalers; woodcarvers; Czech American egg decorators; rawhide braiders; potters; Hmong embroiderers; Lakota porcupine quill medallion makers; Hawaiian appliqué quilters; lace makers; and Eskimo and Puerto Rican mask makers.

The practitioners of these art forms usually learn their craft by observation, conversation, and practice rather than through formal training. The local and regional community and the artists supported by it play a vital role in fostering the interaction between art and everyday life, which is the foundation of folk and the traditional arts. Often community members share a common ethnic heritage, religion, language, occupation, or geographic region. The awards serve to remind the nation how diverse and widespread indigenous and imported art forms are. The fellowships also serve as reminders that intangible cultural resources preserve America's

rich heritage as a melting pot of diverse cultures.

RHONDA L. REYMOND
College of Creative Arts

Robert Atkinson, *Journal of American Folklore* (Fall–Winter 1993); Steve Siporin, *American Folk Masters: The National Heritage Fellows* (1992).

National Society of the Colonial Dames of America

The National Society of the Colonial Dames of America (NSCDA), a voluntary organization for women, was established in 1891 to foster a national appreciation for America's early history and culture through patriotic service, educational projects, and historic preservation. An unincorporated association of 44 corporate societies with over 15,000 members, the headquarters is located at Dumbarton House in Washington, D.C. Membership is determined by established ancestral lineage to individuals who lived in the colonies before the American Revolution.

The NSCDA encourages responsible citizenship, educates new citizens, and supports classroom instruction on American history. It sponsors high school essays and offers scholarships to students of American history and, since 1927, to Native American women who study nursing. The NSCDA also honors the nation's military. Other endeavors include maintaining genealogical records, conducting oral histories, installing plaques and historical markers of local and national interest, and sponsoring an inventory of American paintings and sculpture. This inventory is an important repository for scholars,

aiding genealogical, historical, population, and art historical research. Many southern works, like portraits, remain in family hands, and the NSCDA inventories can help scholars locate specific works. Furthermore, as the identities of many southern portraitists remain unknown, the inventories, with images of portraits apparently made by the same hand, can serve as an impetus for new research on southern art. The recent inventory of Tennessee art, now available on the Internet, is a model for future art inventories.

With over 70 affiliated properties nationwide ranging in date from 1680 to 1930, the NSCDA owns or manages 42; others receive financial assistance, volunteer services, donations of furnishings, or funding for archaeology. In the South, the Dames are involved with approximately 25 properties in 14 states, documenting America's development from its pioneer settlements to westward migration. Among these properties are Charleston's powder magazine (1712) and eight other structures dating from the 18th century.

NSCDA interest in museums in the South extends to structures and their furnishings dating from the late 18th to the early 19th centuries, including the Ximenez-Fatio House (1798) in Augustine, Fla., Liberty Hall (1796) in Frankfort, Ky., the Greek Revival Craik-Patton House (1834) in Charleston, W.Va., and the Neill-Cochran House (1855) in Austin, Tex. Within these sites, the NSCDA maintains collections of American pictorial and decorative arts. Among these are a ca. 1849 double portrait of Frankfort, Ky., residents Mason

Preston Brown and his brother Orlando by the itinerant artist Trevor Thomas Fowler (1800–1881), a graphite drawing by an unidentified artist depicting Fort DeRussy, La., during the Civil War, and a late 18th-century redware dirt dish made in Randolph County, N.C. In accordance with its landmark publication, *American Samplers* (Ethel Stanwood Bolton and Eve Johnston Coe, 1921), the NSCDA is conducting a survey of samplers and pictorial embroideries, expanding upon the 2,500 descriptions previously recorded. This survey will be an invaluable resource for scholars of southern art, in an area that has often been ignored.

CHARLOTTE EMANS MOORE
Wilmington, North Carolina

Clarinda Huntington Pendleton Lamar, *A History of the National Society of the Colonial Dames of America, from 1891 to 1933* (1934); *Antiques* (July 2007); National Society of the Colonial Dames of America, *The National Society of the Colonial Dames of America: Its Beginnings, Its Purpose, and a Record of Its Work, 1891–1913* (1913); William Seale and Erik Kvalsvik, *Domestic Views: Historic Properties Owned or Supported by the National Society of the Colonial Dames of America* (1992); *Summary of the Histories of the National Society of the Colonial Dames of America and of the Corporate Societies, 1891–1962* (1962).

Newman, Willie Betty

(1863–1935) PAINTER.

At the turn of the 20th century, there was no more important or influential figure in the visual arts in Tennessee than Willie Betty Newman. Indeed, the 1910 *Who's Who in America* listed only one artist for the entire state of Tennessee: Willie Betty Newman of Nashville. She was born on Maple Grove Plantation, later known as Betty Place, on 21 January 1863, during her father's service as a second lieutenant in the 28th Regiment of the Army of Tennessee. Her grandfather, Benjamin Rucker, built the plantation near Murfreesboro, Rutherford County, Tenn., in 1832. She was the second daughter—her sister, Florence, was born in 1860—of Col. William Francis McClanahan Betty (ca. 1829–1902/3) and Sophie Burrus Rucker Betty (1839–66).

Willie Betty attended Soule College in Murfreesboro and Greenwood Seminary in Lebanon, Tenn. In 1881, at the age of 17, she married J. Warren Newman. A son, William Gold Newman, was born in 1882. Evidently, the marriage was not a happy one. The two soon separated, and by all accounts she never spoke of him again. In 1889, she left Rutherford County to study at the Art Academy of Cincinnati, and then at the museum school of the Cincinnati Art Museum under the tutelage of its founding head, Thomas Satterwhite Noble.

In 1891, at Noble's urging, Newman left Cincinnati for Paris, having earned a scholarship that provided her with three years of instruction abroad, although she remained in that city for 10 years. She enrolled at the Académie Julian, where she studied with Benjamin Constant. Though Constant was her principal teacher, she also trained with such distinguished faculty members as William-Adolphe Bouguereau, Jean-Paul Laurens, Robert Fleury, and Jules-

Joseph Lefebvre, all of whom were exponents of the academic style.

Like many American artists, Newman became comfortably at home in France. She maintained a studio in Paris, where she achieved acclaim for her artistic accomplishments. Newman was particularly well known for her sympathetic genre scenes depicting Breton peasants and peasant life. She exhibited in the Paris Salon annually from 1891 until 1900, when she was awarded an honorable mention for her portrait of the daughter of American consul John K. Gowdy. Newman was held in an enduring high esteem among her peers in Paris. After her return to America, she was awarded a medal by the Académie Julian, in 1903.

An implicit spiritual quality pervades much of Newman's work, apparently resulting from the inspiration of such Barbizon artists as Rousseau and Millet. This mystical quality is epitomized in what is, perhaps, her best-known painting, *The Passing of the Bread*, which is now owned by the Centennial Club of Nashville, Tenn.

Compelled by her father's failing health and financial difficulties brought on by her own extended illness (the result of a malfunctioning gas heater in her Paris studio), she returned to Tennessee in early 1901. Later in the year she traveled back to France. The following spring her painting *Rest in Brittany* was accepted in the Salon. Its treatment and subject, peasant life, had been successful for her in the past.

In the summer of 1902 Newman left Paris for the last time, returning to Nashville with her paintings. Upon her return, she worked to establish the kind of reputation that she had enjoyed in Paris. A large and impressive body of her work, consisting of more than 50 paintings, was exhibited at Straus Studio in St. Louis. Newman's works were included in the art pavilion of the Louisiana Purchase Exposition at the St. Louis World's Fair, held the following year.

In the fall of 1905 she opened the Newman School of Art in Nashville, where her teachings were based on the French methods of instruction she had learned at the Académie Julian. While Newman had a number of students, the venture was short lived. She began painting portraits, which turned out to be a more rewarding endeavor. This work sustained Newman for the rest of her career. She enjoyed great success as a portraitist, and among the many commissions that she executed over the next 30 years are portraits of such prominent Nashvillians as John Trotwood Moore, Joel Creek, Gov. James Frazier, Mrs. James C. Bradford, James E. Caldwell, and Oscar F. Noel. The U.S. Congress commissioned her to produce posthumous portraits of James K. Polk and John C. Bell.

With the passage of time and the advent of modernism, Newman fell into an obscurity that was briefly interrupted when the Nashville Museum of Art awarded her the Parthenon Medal, its highest honor. She painted little during the last years of her life as her health failed her. Willie Betty Newman died in Nashville on 6 February 1935.

KEVIN GROGAN
Morris Museum of Art
Augusta, Georgia

James C. Kelly, *Tennessee Historical Quarterly* (Winter 1987); *Nashville Banner* (26 August 1905); The Pantheon (Nashville), *A Passion for Paint: The Art of Willie Betty Newman, 1863–1935* (2002); Barbara J. Pryor, "Willie Betty Newman: Biographical Notes," in Willie Betty Newman Inventory, Tennessee State Library and Archives (1994); DeLong Rice, *Bob Taylor's Magazine* (August 1906); Karin L. Sack, *Tennessee Historical Quarterly* (Spring 2002); Stephanie A. Strass and Susan E. Shockley, *American Art Review* (January–February 2002); Charlotte A. Williams, *The Centennial Club of Nashville: A History, 1905–77* (1978).

Ninas, Paul

(1903–1964) PAINTER.

Modernist painter Paul Ninas was born on 7 May 1903 in Leeton, Mo., and reared in the Midwest and California. He traveled widely, including to Sardinia, Italy, Sicily, the Greek islands, Tunisia, Palestine, Egypt, Arabia, Cuba, Haiti, Mexico, and Algeria, deriving inspiration for his artworks. His training began at the University of Nebraska and Robert College in Constantinople in 1921, after which he received his M.F.A. from the Akademie der Bildenden Künste in Vienna in 1925.

In 1926 Ninas was selected by a committee, chaired by Isadora Duncan, as one of the first American artists honored with an exhibition at a Paris gallery. He studied in Italy with Ubaldo Oppi and in Paris at École des Beaux-Arts and the Académie Lhote. André Lhote, who founded his atelier in Montparnasse in 1922, was at that time the major proponent of cubism; his teaching also had a lasting influence on Ninas and native New Orleans painter Josephine Marien Crawford, who studied with Lhote in 1928. Ninas and Crawford are credited with introducing the cubist art movement to New Orleans. Cubist elements appear in Daniel Webster Whitney's work as early as 1926, but his work does not exhibit fully abstracted and fragmented forms until the 1930s.

Ninas's early career is reminiscent of postimpressionist painter Eugène Henri Paul Gauguin in his search for a tropical paradise as a source of visual inspiration. Influenced by Lafcadio Hearn's 1890 publication *Two Years in the French West Indies*, Ninas traveled to Martinique in 1926 and later purchased a coconut and lime plantation on Dominica, where he produced a number of landscapes and views of the native islanders. Ninas exhibited nationally and internationally, including the Feragil Gallery, the John Becker Gallery, and the Rehn Gallery in New York. After his father's death in 1932, Ninas returned to the United States. Although scheduled merely to travel through New Orleans, he remained in the city.

Reflecting a progressively modernist aesthetic, Ninas was appointed head of the Arts and Crafts Club's School of Art soon after his move to the city, a position he held until he entered military service in 1942. In the summer of 1933, he taught at the Sul Ross State Teacher's College in Alpine, Tex.

Despite the economic constraints of the 1930s, the Arts and Crafts Club formed a central core of cultural life in the city, bringing much-needed vitality to the French Quarter. Ninas exhib-

ited his work alongside that of other notable club members, including Xavier Gonzalez, William Weeks Hall, Will Henry Stevens, Alberta Kinsey, Enrique Alférez, Charles Bein, Boyd Cruise, and Julius Edwin Woeltz.

During the 1930s, Ninas, who has been called the "Dean of New Orleans Artists," was also an easel painter and muralist for the Works Progress Administration. His drawings and paintings often feature boldly colored flat forms with pronounced outlines. Ninas painted numerous marine scenes, especially boats docked along a wharf. He executed murals in the post office in Henderson, Tex., in the Maybin School in New Orleans, and for Delta Line luxury cruise ships *Del Norte*, *Del Mar*, and *Del Sud*. His best-known murals are in the Sazerac Bar at the Roosevelt Hotel in New Orleans. These four paintings depict scenes around New Orleans and southeast Louisiana, including the French Market, a cotton plantation, the French Quarter as seen from Algiers Point across the Mississippi River, and the St. Louis Cathedral with a group of people gathered outside. The latter mural depicts a number of prominent Americans, including Groucho Marx and Huey Pierce Long. In the autumn of 1933, just as Ninas was assuming leadership, the club moved from 520 Royal Street to 712 Royal at the corner of Pirate's Alley, a building owned by long-time patron and board member Sarah Henderson.

In New Orleans Ninas met and married Newcomb College graduate Jane Smith, who studied at the Arts and Crafts Club, where she won the 1932 Blanche S. Benjamin Prize. Until her marriage to Ninas, she worked for the easel project of the WPA. She exhibited in New York at the 1939 World's Fair—as did her husband—and at the Museum of Contemporary Art. The marriage failed, and Jane married Alabama photographer Walker Evans in 1941; Paul married Grace Chavanne in 1942.

Ninas, who also taught at Tulane University and at the University of Texas at Austin from 1949 to 1951, gave private art lessons. He continued to live and paint in New Orleans until his death, on 1 January 1964.

JUDITH H. BONNER
The Historic New Orleans Collection

Paul Whitfield Douglas, "Paul Ninas, Dean of New Orleans Artists" (M.A. thesis, Louisiana State University, 1997); Paul Ninas, *Paul Ninas, 1903–1964* (1986); Kathleen Orillion, *Paul Ninas, 1903–1964* (1986).

Noble, Thomas Satterwhite

(1835–1907) PAINTER.

Thomas Satterwhite Noble was born in Lexington, Ky., to a prosperous family who owned ropewalks for the twisting of hemp into binding cords for southern cotton. He grew up in an environment of slaveholders and slave traders, witnessing auctions on Cheapside in Lexington and listening to slave talk in the cabins behind his father's ropewalk.

Noble departed Lexington for art studies in Louisville with Samuel Woodson Price. Through Price, Oliver Frazer, and George Peter Alexander Healy, Noble learned of the atelier of Thomas Couture in Paris, France. In 1856 Noble enrolled in Couture's studio,

where he enhanced his drawing skills by working from plaster casts and life models. During his three years in Europe he would also have absorbed the painterly trends of naturalism apparent in his heavily glazed and textured surfaces.

Having been exposed to the haute monde of Paris, young Noble returned to America in 1858 with a heightened artistic and social consciousness. He joined his family in St. Louis, where his father had relocated the rope business. Though not a supporter of the institution of slavery, Noble enlisted in the Confederate army's corps of engineers and served three years, operating ropewalks and building pontoon bridges in Louisiana. When the war ended, he returned to St. Louis. Between 1866 and 1869 Noble painted five works dealing with slavery and abolition, including *The Last Sale of Slaves*, executed in St. Louis in early 1866. Noble took this canvas to New York when he moved there late in 1866, and it was the first work he exhibited at the National Academy of Design. He painted *John Brown's Blessing* in New York in 1867 — the work features the abolitionist insurrectionary being led from prison. *Margaret Garner*, also from 1867, depicts the tragic story of a slave who escaped across the Ohio River from Kentucky to Cincinnati in 1856 with her children, only to be tracked down by callous bounty hunters. She killed the children rather than return them to slavery. Next in the series, *The Price of Blood* (1868) represents a slaveholder selling his half-caste son into slavery. Noble painted one last painting in the series, *Fugitives*

in Flight, in 1869, which combines references to the trans-Ohio flight of slaves with the mythic twilight crossing of the river Styx.

Noble left New York for Cincinnati in 1869 when he was appointed professor of art and the principal of the McMicken School of Design. The proximity to Kentucky seems to have tempered his former revisionist zeal, as he turned to other subjects, notably history paintings that foreshadowed the Colonial Revival movement. After 1877 Noble kept a second home in New York City. In 1881 he returned to Europe for studies at the highly influential and avant-garde Munich Academy. When Noble retired from teaching in Cincinnati in 1904 he moved full time to New York, where he died in 1907. Late in the artist's life, one critic for the Cincinnati papers wrote that it was "easy to imagine that he felt at home" in the "rooms furnished with the silent and ghostly casts of antique sculpture," whose surfaces were "cold and rigid always."

ESTILL CURTIS PENNINGTON
Paris, Kentucky

Edward F. Baptist, *American Historical Review* (December 2001); James Birchfield et al., *Thomas Satterwhite Noble, 1835–1907* (1988); Albert Boime, *Thomas Couture and the Eclectic Vision* (1980); Estill Curtis Pennington, *Lessons in Likeness: The Portrait Painter in Kentucky and the Ohio River Valley, 1800–1920* (1992), *Look Away: Reality and Sentiment in Southern Art* (1989), *Romantic Spirits: Nineteenth-Century Paintings of the South in the Johnson Collection* (2011), *A Southern Collection: A Publication of the Morris Museum of Art* (1992);

Joshua Taylor, *American Historical Review* (October 1981).

Oelschig, Augusta Denk

(1918–2000) PAINTER.

Augusta Denk Oelschig, a native of Savannah, Ga., developed an artistic style that aligned closely with her personal resolve to say something visually about her intense feelings concerning the world around her. The fourth and youngest child of Carl Henry and Josephine (Denk) Oelschig, she was named after her maternal grandfather, August Denk, with whom she shared a 12 June birthday. The family had deep roots in the city; her father owned a nursery business that had been started by his father. Oelschig displayed a talent for drawing from an early age, something that may have been a familial trait, since she was a distant cousin of the artist Robert Rauschenberg. According to Oelschig, there were four Rauschenberg brothers who left Germany for the United States; she was related to the oldest of those brothers and Robert Rauschenberg was related to the youngest.

Educated in the public school system, Oelschig received encouragement from her art teachers Linda Trogden and Lila Marguerite Cabaniss. In 1935, when she graduated from high school, there were few financial resources within the family for one more child to go away to college, since her three siblings were in college at the time. Oelschig attended the newly opened and local Armstrong College (now Armstrong Atlantic State University) and became a private student of Emma Cheves Wilkins. After two years

of study and a certificate in liberal arts, Oelschig transferred in the fall of 1937 to the University of Georgia, where Lamar Dodd had recently formed the art department, and received a B.F.A. degree in 1939. She returned to Savannah and used a cash prize from her senior art show to fund private lessons with visiting artist Henry Lee McFee.

Oelschig quickly became part of the thriving art community of Savannah. She took over the studio that McFee vacated when he left Savannah in 1939, only to relinquish it upon the arrival of visiting artist Alexander Brook. She exhibited with the Southern States Art League, the Georgia Association of Artists, and the Savannah Art Club. The first solo exhibition of her work was held at the Telfair Academy of Arts and Sciences (now the Telfair Museum of Art) in February 1941, accompanied by a catalog with a foreword by Dodd. The exhibition traveled to the Gertrude Herbert Institute of Art in Augusta, Ga. Oelschig entered a national competition that year and was awarded a fellowship to the Art Academy of Cincinnati, but she declined the offer when Dodd recommended her for a wartime teaching position at Alabama Polytechnic Institute (now Auburn University), a position she held from 1941 to 1943. Her work was exhibited with the Alabama Art Association and the Southeastern Artists Association and at a faculty exhibition held at the Montgomery Museum of Fine Arts.

When the teaching position ended, Oelschig returned to Savannah and worked as a display manager at a department store. In addition, she estab-

lished a private art school with an initial class of 35 students. In 1947 she married James Petressen, and the couple left Savannah for a 10-month stay in Mexico. While living in Mexico City, Oelschig enrolled in classes at Mexico City College to study the history of modern art and the muralists of Mexico. She met José Clemente Orozco, who influenced her plans for a mural commission at Savannah High School depicting recent Georgia history. The sketches submitted by Oelschig contained Ku Klux Klansmen using red suspenders to beat an African American man—the suspenders were a symbolic reference to Georgia governor Eugene Talmadge, who was known to wear red suspenders. Oelschig's sketches were considered too controversial, and the commission was rescinded. The mural was never executed, and the sketches are now in a private collection and in the permanent holdings of the Morris Museum of Art.

From Mexico, the couple moved to New York City, where they remained for 14 years, from 1948 to 1962, at which time they divorced. Oelschig's artistic output during her New York years was limited, but she enrolled in classes at the New School for Social Research and wrote prose and poetry. Upon her return to Savannah, Oelschig taught privately, studied nonobjective painting with Bill Hendrix, and then briefly with William Scharf. Her work became more experimental in both subject and media, which included automobile lacquer, ink, acrylic, and papier-mâché. She exhibited her work with the Savannah Art Association and at the Columbia Museum of Art in South Carolina and the Hirschl and Adler Galleries in New York.

Chronic illness and the selling of her riverfront art studio put an end to her career. Her last major work, executed from 1972 to 1975, was a mural commission in celebration of the nation's bicentennial for the lobby of the main office of the Home Federal Savings and Loan Bank. The project, which consisted of 44 mixed-media images of historic buildings and sites in the Savannah region, presently hangs in the offices of the Savannah Area Chamber of Commerce.

On 4 March 1997 Oelschig was honored as one of Georgia's Women in the Visual Arts. She was the subject of a video produced by the Telfair Museum of Art in 1995. Oelschig died on 24 July 2000, while anticipating the retrospective exhibition of her work, which was held at the Telfair Museum of Art from September through November 2000.

The 67 artworks by Oelschig in the collection of the Morris Museum of Art span her entire career. The Telfair Museum of Art also has several of her works in its collection.

KAREN TOWERS KLACSMANN
Augusta State University

Harry H. DeLorme Jr., *From Darkness to Light: The Paintings of Savannah's Augusta Oelschig* (2000), *Something to Say: The Art of Augusta Oelschig* (film) (1995); Pamela King and Harry H. DeLorme Jr., *Looking Back: Art in Savannah, 1900–1960* (1996).

Ohr, George Edgar

(1857–1918) POTTER.
George Edgar Ohr, the self-proclaimed Mad Potter of Biloxi, was a ceramic

artist active in Biloxi, Miss., from 1882 to 1907. Born in Biloxi on 12 July 1857 to eastern European immigrants Johanna Wiedman Ohr and George Edgar Ohr Sr., he spent his early career training in his father's blacksmith shop.

The young Ohr quickly gave up smithing and went on to study pottery with Joseph Fortuné Meyer, a Biloxi native and New Orleans potter. During these early years with Meyer, Ohr learned the mechanics of the pottery trade. In 1881 he left New Orleans to begin a two-year trip across the eastern United States, during which he visited a variety of well-established folk potteries, such as the Kilpatrick Brothers pottery in Anna, Ohio. In 1883, after two years of travel, Ohr settled back in Biloxi and opened his first pottery studio selling utilitarian and folk pottery. The pottery studio was run exclusively by Ohr, who dug and processed his own local clay, built and stoked his wood-burning kiln, and prepared his glazes from traditional recipes.

Ohr married Josephine Gehring on 15 September 1886. The couple went on to have ten children, of whom five lived to adulthood: Leo Ernest, Clo Lucinda, Ojo J., Oto T., and Geo E. Ohr. In 1890 Ohr opened the Biloxi Art and Novelty Pottery, establishing himself not only as a craftsman of utilitarian pottery but also as a clay artist. On 12 October 1894, Ohr's Biloxi studio and an estimated 1,000 pieces of pottery were destroyed in a fire. Facing the destruction of much of his hometown, life's work, and family income, he proceeded to produce the most innovative work of his career. From 1894 on, Ohr created a variety of paper-thin vessels known for their undulating pinches, folds, and twists. Ohr borrowed shapes and lines from his early blacksmith training to create the curling ribbon handles of his vases, teapots, and mugs. The intensity and brilliant color of Ohr's glazes were much discussed in accounts of the day. Ohr represented the state of Mississippi at many world's fairs and expositions, including the World's Columbian Exposition in Chicago (1893) and the Louisiana Purchase Exposition in St. Louis (1904).

Sometime around 1905 Ohr stopped glazing his pottery, leaving it in the bisque form. Ohr's bisque pottery represents the most abstract, sculptural ceramic objects he created. Soon after his explorations with bisque, Ohr stopped potting altogether, and by 1910 his studio was disassembled and his work packed away. He spent the remainder of his life in Biloxi experimenting with motorcycles and automobiles. Ohr died in Biloxi on 7 April 1918 of throat cancer. The work of George Ohr stayed packed away on his family property until the 1970s. In 1972 Ohr's surviving children sold the entire collection of Ohr's pottery to antique dealer James Carpenter of New Jersey. Carpenter moved the collection to New Jersey and is responsible for the dissemination of Ohr's work to the New York City art world.

ANNA STANFIELD HARRIS
Biloxi, Mississippi

Garth Clark, Robert A. Ellison Jr., and Eugene Hecht, *The Mad Potter of Biloxi: The Art and Life of George E. Ohr* (1989); Robert Ellison with Martin Edelburg, *George Ohr, Art Potter: The Apostle of Individuality*

(2006); Eugene Hecht, *After the Fire: George Ohr, an American Genius* (1994); Richard D. Mohr, *Pottery, Politics, Art: George Ohr and the Brothers Kirkpatrick* (2003).

Persac, Marie Adrien

(1823–1873) PHOTOGRAPHER, ARTIST, LITHOGRAPHER.

French artist Marie Adrien Persac spent the majority of his lifetime in the American South, primarily in southern Louisiana. Persac, one of four children, was born in Lyon, France, on 14 December 1823 to Pierre Edouard Persac and Pauline-Sophie-Marie Falloux. He came to America about 1842 and married Odile Daigre in Baton Rouge, La., on 8 December 1851. Records indicate that at this time Persac was a resident of Jefferson County, Ind., though there are no records that indicate how and when the artist arrived in Louisiana or that provide information on his artistic training. The couple and their three sons resided west of Lake Pontchartrain in Manchac, Odile's hometown.

During this period Persac traveled often to Baton Rouge. In 1855 his drawing of that city was published as an engraving on Michael Gill's map *City of Baton Rouge, the Capital of Louisiana*. In 1856 Persac and William G. Vail opened a photographic studio on Florida Street in Baton Rouge, producing daguerreotypes. Shortly after this venture, Persac worked as an artist and lithographer with the firm Pessou & Simon. B. M. Norman's *Norman's Chart of the Lower Mississippi River by A. Persac* was published in 1858. His lithographs appeared in this steel-engraved publication,

which outlined sugar and cotton plantations and their owners along the Mississippi River, from Natchez, Miss., to New Orleans. Persac's *Port and City of New Orleans* (ca. 1858–59), a painted gouache on paper study for an insert to *Norman's Chart*, depicts steamboats that fill the river, a dry dock, and cotton bales stacked near the pier.

In 1859 Persac moved to New Orleans and remained in the South during the Civil War. While in New Orleans, he completed 43 identified property drawings designated for the New Orleans Notarial Archives spanning the years 1859–69. One such example is Persac's delineation of a cottage on Royal Street, completed on 8 June 1866. He collaborated on 21 of these drawings for the Notarial Archives with French civil engineer Eugène Surgi. Earlier, in 1860, Persac collaborated with Surgi to construct a monument in Lafayette Square honoring Washington and Lafayette. During the period 1857–61 he completed numerous gouache on paper drawings of Louisiana plantations, including *St. John* (1861), as well as architectural depictions of impressive municipal buildings, like his stylized drawing *French Opera House* (1859). In 1865 he opened a photographic studio with a photographer named Legras, about whom little is known, and eventually made the studio his own, opening at 130 Chartres Street that same year. Persac listed himself as an architect in the 1867 City Directory, with the address of "83, Exchange place, res. 148 Gasquet."

Persac traveled abroad to France in about 1867–68, undoubtedly con-

tinuing his work as an artist. *Almanach de la Louisiane* was published in 1867, which featured four lithographs of New Orleans by Persac. The artist opened the Academy of Drawing and Painting at 75 Camp Street in 1869, where he served as an instructor of portraiture and landscape painting. In the early 1870s Persac was listed in the city directory as "architect and artist" (1871) at 83 Exchange Place, "artist" at 12 Commercial Place (1872), and "civil engineer" (1873), also at 12 Commercial Place. In 1872 Persac worked with painter Paul Poincy to produce a portrait of presidential candidate Horace Greeley. Persac completed 20 sepia watercolors on linen for the *Illustrated Guide of New Orleans, Canal Street* (1873). These panoramic views of post–Civil War New Orleans show the bustle of Canal Street, from the fashionable storefronts to the moving streetcar, as shown in *South Side, 800 Block*. Persac's illustrations depict both sides of Canal Street from the perspective of the Mississippi River and from Basin Street. Persac's untimely death on 21 July 1873 is speculated to have been the result of yellow fever or cholera, both widespread in New Orleans that summer. He died in Manchac, at the Daigre family home, and is buried at the Baton Rouge Catholic Cemetery.

KATE BRUCE
The Historic New Orleans Collection

H. Parrott Bacot et al., *Marie Adrien Persac: Louisiana Artist* (2000); John A. Mahé and Rosanne McCaffrey, eds., *Encyclopaedia of New Orleans Artists, 1718–1918* (1987).

Rauschenberg, Robert

(1925–2008) PAINTER, PHOTOGRAPHER, PRINTMAKER, PERFORMANCE ARTIST, CHOREOGRAPHER, SET DESIGNER. Robert Rauschenberg rose to be one of the most influential artists in the world through his achievements in several genres of art. He was a painter, photographer, printmaker, performance artist, choreographer, and set designer. His refusal to follow traditional paths or to be limited by established artistic or critical categories was a central element in the evolution of his art and his career.

Born in Port Arthur, a struggling Gulf Coast oil refinery town, Rauschenberg had formative experiences in Texas essential to the development of the subjects and materials used in his mature art. Settling in New York in 1949, he became an independent, prominent figure in the city's art world during an era dominated by abstract expressionist painters. After two decades of innovation, critical recognition, and success in New York in the 1950s and 1960s, he moved his residence and studio to Captiva Island, Fla., in 1970, where he lived for the rest of his life.

Rauschenberg was the only son of Ernest and Dora Matson Rauschenberg. His sister, Janet, was born in 1936. Named Milton Ernest Rauschenberg by his parents, he changed his name to Robert Rauschenberg in 1947. Descended from German, Swedish, Dutch, and Cherokee stock, his maternal grandfather, Robert Rauschenberg, was a German doctor who moved to Texas and married a Cherokee woman.

Growing up during the Great De-

pression, Rauschenberg encountered little art and received little encouragement for his early drawing abilities. After graduating from Jefferson High School in 1942 he was enrolled in the pharmacy program at the University of Texas at Austin for six months. Drafted into the U.S. Navy, he trained as a neuropsychiatric technician at a navy hospital in San Diego. He visited the Huntington Library in Pasadena and for the first time saw original paintings, including Thomas Gainsborough's *Blue Boy* and Joshua Reynolds's portrait *Sarah Siddons as the Tragic Muse*, which inspired his artistic career.

After his discharge from the navy, Rauschenberg enrolled at the Kansas City Art Institute on the GI Bill in the winter of 1947. He then studied in Paris at the Académie Julian, where he met Susan Weil, a fellow student who would later become his wife. Weil was already enrolled at Black Mountain College, a progressive art school in North Carolina where the noted leader of the German Bauhaus, Josef Albers, directed the art department. Rauschenberg registered for the 1948–49 academic year and returned to the campus regularly until the school closed in 1956.

The college was a vital place of cross-cultural exploration for Rauschenberg. From the highly disciplined Albers he learned color theory and the *Werklehre* process in which students were encouraged to use found materials like junk and to explore the intrinsic beauty and design possibilities inherent in ordinary materials. He also studied weaving with Albers's wife, Anni, before the Alberses

moved to Yale University in the summer of 1949.

At Black Mountain, Weil and Rauschenberg were exposed to the photographic work of Hazel Archer, who encouraged students to develop a sense of personal vision with the camera. Here, in the summer of 1951, Rauschenberg took a seminar taught by three of the country's top photographers—Harry Callahan, Aaron Siskind, and Arthur Siegel. Rauschenberg was filled with enthusiasm for the seemingly limitless potential of the camera; thereafter, the camera and the photographic image became essential elements in the evolution of his work.

Rauschenberg studied in New York at the Art Students League with Morris Kantor and Vaclav Vytlacil and explored the city's many galleries and museums. Weil and Rauschenberg were married in New York in 1950; their son, Christopher, was born in 1951. During this period Rauschenberg experimented with all-black and all-white paintings. In the spring of 1951 he had his first solo exhibition at the Betty Parsons Gallery in New York. Back at Black Mountain that summer, he renewed friendships with John Cage, Merce Cunningham, and Cy Twombly. Cage became a frequent collaborator and major influence on his art. Twombly and Rauschenberg traveled together to Europe and Africa the next year. In 1952 Rauschenberg and Weil divorced but remained supportive of each other's work; their son Christopher is active as a photographer today.

In 1954 Rauschenberg met Jasper Johns, who, like Twombly, was also a

southerner. Johns was born in Georgia and reared in South Carolina before he moved to New York. The two, who became companions, encouraged each other in the exploration of new directions in art. They moved away from the influence of abstract expressionism and rediscovered Dada and surrealist artists like Marcel Duchamp, whom they met in 1960. Rauschenberg created a noted piece in 1953, titled *Erased de Kooning Drawing*, a self-portrait given to him by Willem de Kooning, which he methodically erased. Under the name Matson Jones, Johns and Rauschenberg designed and installed commercial windows for Tiffany's and Bonwit Teller.

During the 1950s Rauschenberg explored ways to incorporate collage and found objects into his work, leading to the creation of the first of his "combines," which he produced from 1954 to 1964. These include *Monogram* (1955–59), *Bed* (1955), *Odalisk* (1955), *Factum I* and *Factum II* (1957), and *Canyon* (1959). Like the dancers and composers with whom he worked, Rauschenberg learned to trust the mundane, allowing everyday objects and chance occurrences to offer direction and form to these works.

His inclination toward collaborative projects was enhanced by experiences in performance art and dance. At Black Mountain in the summer of 1952 Rauschenberg and his *White Paintings* were featured in what is known as the first "happening," a performance event staged by Cage (*Theater Piece No. 1*) and featuring Cunningham, David Tudor, M. C. Richards, and Charles Olson.

Back in New York, Cage and Rauschenberg printed *Automobile Tire Print*, a 22-foot-long work made by applying ink to the tires of Cage's car and then driving over paper to produce a "print."

Beginning in 1954 Rauschenberg designed sets and costumes for the Merce Cunningham Dance Company and later for the Paul Taylor Dance Company and the Trisha Brown Company. During the 1960s Rauschenberg choreographed and performed in his own original programs, including *Pelican* (1963), *Elgin Tie* (1964), and *Spring Training* (1965), which included flashlights attached to turtles.

In the late 1950s Rauschenberg explored transfer drawings, and in the 1960s he worked with silk screens, silk-screen paintings, and other printmaking—patterns that continued throughout his career. The transfers were created by using a chemical solvent to rub popular printed images from an original surface onto a sheet of paper, thus introducing into his work a new type of collage element and a range of popular images, a technique used in his series *Dante's Inferno* (1958–60). When he began to make prints with Tanya Grossman at Universal Limited Art Editions (ULAE) in 1962 (his first print was *Abby's Bird*), this technique became another natural step in his collaborative sensibility, following his use of collages and the evolution of his "combines." He worked at ULAE in 1962, with Gemini GEL (beginning in 1967), with Graphic Studio U.S.F. at the University of South Florida (beginning in 1972), and with Untitled Press at Captiva (in 1971).

One of Rauschenberg's earliest experimental prints, *Accident*, was created at ULAE in 1963, when the stone bearing his print image broke while it passed through the printing press. Reflecting his increasing faith in chance and spontaneity, Rauschenberg printed the broken stone and created an icon in printmaking. During the 1960s and 1970s he explored new directions, incorporating images on Plexiglas, aluminum, silk, cotton, satins, cardboard, and a range of other materials. Major printed works include *Shades* (1964), *Booster* (1967), *Revolver* (1967), *Autobiography* (1968), *Solstice* (1968), *Sky Garden* (1969), and *Earth Day* (1970).

After moving to Captiva Island in 1970, Rauschenberg explored new technologies and his ongoing interest in music and performance art as he produced numerous paintings, photographs, prints, sculptures, and mixed media projects. He began to experiment with cardboard scraps as a found material, making sculptures in a series he called *Cardboards*, which evolved into serigraphs on cardboard and on ceramic forms. He explored a series of experiments in papermaking in France (*Pages and Fuses*). In the 1970s he traveled to India to work with handmade paper and Indian textiles and created new series of works, including *Unions*, *Bones*, and *Jammers*. In 1978 he returned to photography, increasingly using photographs in new media and a variety of art forms, leading toward the later use of digital images and Iris printing.

Rauschenberg was affiliated with the Leo Castelli Gallery following his first showing there in 1958, and he exhibited at the Jewish Museum in New York City (1963), White Chapel Gallery in London (1964), and the Walker Art Center in Minneapolis (1965). His work was featured in a major retrospective exhibition at the Smithsonian's National Collection of Fine Arts in 1976. His photographs were highlighted in the exhibition *In + Out City Limits: Ft. Myers, Florida*, the first in an extended series of exhibitions and publications devoted to his photographs of American cities. In 1981 a major photographic exhibition, *Robert Rauschenberg fotografia*, opened in Paris and then traveled throughout Europe. The same year he began one of his largest and most ambitious projects, *The ¼ Mile or 2 Furlong Piece*, to be shown and completed over a period of years, ultimately reaching one-quarter mile in length. By 1997 this work consisted of 189 panels and sculptural elements and was approximately 1,000 feet in length.

During the 1970s and 1980s Rauschenberg produced new work in France, India, Japan, China, Thailand, and Sri Lanka. At the United Nations in New York in 1984 he announced the formation of his ambitious (and self-financed) international art program, intended to advance cultural understanding and world peace, known as the Rauschenberg Overseas Culture Interchange (ROCI) project and a planned tour. He traveled to Mexico and Chile that same year. The ROCI art residency and exhibition toured through China (1986), Japan (1987), Havana (1988), Moscow (1989), and Berlin and Kuala

Lumpur (1990). A retrospective exhibition of the ROCI project was presented at the National Gallery of Art in Washington, D.C., in 1991. That year he was featured in an exhibition at the Corcoran Gallery, *Robert Rauschenberg: The Early 1950s.*

Rauschenberg's Captiva Island property expanded to include 35 acres, nine houses, and studios, including a hurricane-proof studio designed by Rauschenberg and his companion, Darryl Pottorf. Completed in 1993, this two-story structure is the centerpiece of the complex, with large storage and workshops on the ground level and computer, printing, and technical spaces upstairs, adjoining his large, vaulted studio and workroom. Here Rauschenberg worked, accompanied by constantly playing televisions, on complex and technically advanced forms of his evolving transfer, print, and photographic projects, incorporating new developments in digital imagery and Iris printing techniques, which allowed him to advance his vision and philosophies of the 1950s and 1960s. Two years after the completion of the studio, a retrospective exhibition, *Robert Rauschenberg: Major Printed Works, 1962–1995,* was organized by the Morris Museum of Art (1995), traveling to the Kemper Museum of Contemporary Art and Design in Kansas City (1996), along with an exhibition of his photographs, *Robert Rauschenberg: Through the Lens,* which was shown at the University of Missouri at Kansas City Gallery of Art (1997).

In 1997 and 1998 a massive retrospective exhibition, *Robert Rauschenberg: A Retrospective,* was organized by Walter Hopps and Susan Davidson and presented at the Guggenheim Museum and two other locations in New York, then traveling to the Menil Collection in Houston (1998) and the Museum Ludwig in Cologne (1998), before opening the new Guggenheim Museum Bilbao, designed by Frank Gehry (1998–99). This exhibition and accompanying catalog sparked a major revival of interest in the art and life of Robert Rauschenberg, which continued into the 21st century.

In 2001 Rauschenberg broke his hip, and in 2002 he suffered a head injury and stroke that paralyzed his right side. Afterward he worked primarily with his left hand, accompanied by his studio assistants. He assigned photographic projects to others, continued his work, and introduced a series of paintings titled *Scenarios* in 2005. Major museum exhibitions evolved as well, including the organization of a show of his *Cardboards* at the Menil Museum in Houston (2007) and a retrospective of his *Combines,* organized by the Metropolitan Museum of Art, which traveled to the Museum of Contemporary Art in Los Angeles, the Centre Pompidou in Paris, and the Moderna Museum in Stockholm.

Rauschenberg saw the appreciation of his art during his final years, despite growing handicaps, as he created new art forms. On 12 May 2008 he died of heart failure on Captiva Island. A memorial exhibition of his photographs was presented at the Guggenheim Museum in the fall of 2008, and in 2009 the Peggy

Guggenheim Collection in Venice presented an exhibition of his sculptures, *Robert Rauschenberg: Gluts.* Writing about the impact of Rauschenberg's art at the time of the Guggenheim retrospective in 1997, *Time* critic Robert Hughes called Rauschenberg "the artist of American democracy yearningly faithful to its clamor, its contradictions, its hope and its enormous demotic freedom, all of which find shape in his work."

J. RICHARD GRUBER
Ogden Museum of Southern Art
University of New Orleans

Yve-Alain Bois, Josef Helfenstein, and Claire Elliott, *Robert Rauschenberg: Cardboards and Related Pieces* (2007); Centre Georges Pompidou, *Robert Rauschenberg fotografia* (1981); Jack Cowart, *ROCI: Rauschenberg Overseas Culture Interchange* (1991); J. Richard Gruber, *Robert Rauschenberg: Through the Lens* (1997); Walter Hopps et al., *Robert Rauschenberg: A Retrospective* (1997); Mary Lynn Kotz, *Rauschenberg: Art and Life* (1990, 2004); Carolyn Lancher and Robert Rauschenberg, *Robert Rauschenberg* (2010); Robert Rauschenberg et al., *Robert Rauschenberg: Gluts* (2009); Charlie Rose, "A Conversation with Artist Robert Rauschenberg," www.charlierose.com/view/ interview/5065 (1997); Paul Schimmel and Robert Rauschenberg, *Robert Rauschenberg: Combines* (2005); Calvin Tomkins, *New Yorker* (23 May 2005), *Off the Wall: A Portrait of Robert Rauschenberg* (2005).

Rice, Edward

(b. 1953) PAINTER.
Edward Rice grew up in North Augusta, S.C., just across the Savannah River from Augusta, Ga., and maintains his studio in a red-brick building that was at one time a city jail. His grandfather, former chief of police in the riverfront town, had renovated the decommissioned building into living space, where grandchildren were frequent visitors.

His parents, Patrick and Jane Rice, reared creative sons: twin brother Patrick is a musician, brother Matthew is an architect, and brother John is a cabinetmaker. Edward Rice's earliest forays into art came when he discovered he could earn more money by making sketches of his neighbors' homes than he could by mowing lawns after school.

Early in his career the young artist recognized architecture as an art form, which led to a lifelong fascination with the details of structure and the nuances of light and shadow that played on buildings, both high style and vernacular. Although Rice's range of work includes atmospheric landscapes, botanical paintings, and figure studies, his precisely detailed architectural paintings are his best-known and most sought-after works.

Writing in a 1988 exhibition catalog, David Houston called Rice's architectural paintings "carefully rendered evocations of place . . . [that are] at once specific and placeless" and "paintings that are precisely what they appear to be but also undefinably something else."

A meticulous researcher with a lifelong interest in history and natural sciences, Rice brings a patient methodology to his work, often using photographs taken over a period of time—sometimes over several years—as well as precise measurements and calculations to create and substantiate the exact effect he wishes to achieve.

In recent years many of Rice's paint-

ings have focused on details or fragments of structures. As Jim Garvey noted in a 2009 *Augusta* magazine profile, Rice "likes his renderings to approximate or at least suggest the actual mass of the thing being depicted. Thus he often picks a small detail of a building, a gable, a dormer, a pediment, something that suggests the whole building. . . . The shapes are often very simple: the parallel lines of clapboards, the triangle of a gable . . . but the light, the subtle gradations of shadow, the minute variations in color, the surface textures are the details Rice spends months to get right."

Rice studied art from an early age, first at the studio of Edith Alexander (20th century) in north Augusta and with Louise Mallard at the Gertrude Herbert Institute of Art in Augusta, where he would years later serve as director and artist in residence. At Augusta College he studied with Eugenia Comer, David Jones, and, most important, Freeman Schoolcraft, who became his mentor and for a time his father-in-law. Rice credits Schoolcraft as the major influence on his work, but it is his own studied concern for detail and balance that makes his paintings immediately recognizable and widely appreciated.

Since the early 1990s Rice has enjoyed increasing regional, national, and international recognition. Working with South Carolina master printer Phillip Garrett in Greenville, he has produced several series of monotypes that complement his more structured paintings and expand the scope of his work, and he has undertaken artist in residence appointments in this country and abroad. His paintings have been featured in gallery shows and exhibitions across the country and in England and Ireland, where he and longtime partner Anna El Gammal have established a second home, in County Cork.

He is represented in the collections of the Columbia Museum of Art, Columbia, S.C.; Georgia Museum of Art, Athens, Ga.; Gibbes Museum of Art, Charleston, S.C.; Greenville County Museum of Art, Greenville, S.C.; Mc-Kissick Museum, University of South Carolina, Columbia; Morris Museum of Art, Augusta, Ga.; Ogden Museum of Southern Art, New Orleans, La.; Ringling College of Art and Design, Sarasota, Fla.; South Carolina Arts Commission State Art Collection; and South Carolina State Museum in Columbia; and in numerous private and corporate collections.

LOUISE KEITH CLAUSSEN
Morris Museum of Art

Jim Garvey, *Augusta* (April 2009); Gertrude Herbert Institute of Art, *Edward Rice: Architectural Works, 1978–1998* (1998); J. Richard Gruber and David Houston, *The Art of the South, 1890–2003: The Ogden Museum of Southern Art* (2004); J. Richard Gruber and Wim Roefs, *Edward Rice: Paintings, 1996–2008* (2008); Alan Gussow, *The Artist as Native: Reinventing Regionalism* (1993); Alan Gussow and Gayle Mason-Edgerton, *Rediscovering the Landscape of the Americas* (1996); David Houston, *Southern Arts Federation–National Endowment for the Arts Fellowship Exhibition* (1989); Morris Museum of Art, *Edward Rice: Recent Monotypes* (2003); Estill Curtis Pennington, *A Southern Collection: A Publication of the Morris Museum of Art* (1992).

Richard, Jim

(b. 1943) PAINTER AND COLLAGIST.
Jim Richard is a tireless observer of
human environments. He watches the
way humans live, noting choices, chiefly
concerning domestic spaces—analyzing
people, and perhaps evaluating people.
Since the early 1970s, with extraordi-
nary acuity, he has recast what he sees
into minded ironies—both formal and
cultural. And the consequence is an
oeuvre that confronts American society
obliquely but surely.

Born in 1943 in Port Arthur, Tex.,
Richard studied at Lamar University in
Beaumont (B.S., 1965) and at the Uni-
versity of Colorado (M.F.A., 1968). His
exhibition history is extensive, in-
cluding the 1973 *Extraordinary Realities*
at New York's Whitney Museum, nu-
merous solo presentations at the Arthur
Roger Gallery and Galerie Simonne
Stern in New Orleans and the Oliver
Kamm 5BE Gallery in New York, and
important shows at New Orleans's Con-
temporary Arts Center and the New
Orleans Museum of Art. A key exhibi-
tion in his career was *Visionary Imagism*
(1984), which was held at the Contem-
porary Arts Center and featured several
artists who employed the neomannerist,
cartoonlike style long associated with
New Orleans. At that moment it became
clear that Richard's interpretation of the
style was singular: closer to realism and
perhaps with greater import.

Richard was a featured artist in the
1995 Triennial Exhibition at the New
Orleans Museum of Art. In that show
he was among several painters and
sculptors who, despite the pluralist
trend of the moment, seemed typi-
cally "southern." They eschewed clichéd
themes and subjects, the mainstay of
southern kitsch. The temper of the art
was, rather, the important element—
its separatist antivanguardism (which
sometimes amounts to eccentricity), its
grasp of a poetic kind of half-terror that
some would call gothic, its obsession
with technical refinement, its interest in
"beauty" remembered from early mod-
ernism.

Richard's work is almost defined by
much of that description. One painting
from the exhibition, *Owning Modern
Sculpture (Red Room)* (1995), proved
to be an aesthetic culmination of his
career. His sustained allusions to social
mores and private spaces and the lyrical
oddness of domestic objects all come
full circle in this work. He has continued
in this vein well into the 21st century.

Initially, the thrust of *Red Room*
seems almost the opposite of Richard's
interiors from the 1970s and 1980s.
In the well-known *Sunning the Glass
Brick* (1982) there is a Zenlike sense
of contemplation: a translucent green
glass brick sits on the dinette table of
a humble and darkened 1950s kitchen.
Through the window, a sunbeam spot-
lights the brick, rendering it as an ob-
ject on special display—something of a
majestic or sacred alien plopped into a
déclassé room, evidently to be revered.

Red Room depicts a vastly different
milieu—one adapted from photo-
graphs in a glamorous interior design
magazine. But Richard's tone persists.
Here, the chosen objects, modern ab-
stract sculptures, are visually impotent
among the clutter of extravagant high-
style decoration. Besides much crimson

velvet and gilt, there is a magnificent black and gold Boulle bookcase, a group of Regency chairs, scarlet carpeting. Thus, the clean-edged modern sculptures are effectively smothered.

Onlookers might question, "Are these two pictures social commentaries?" Indeed, they convey Richard's long-standing study of class and taste. Additionally, *Glass Brick* is a subtle comment. It is essentially a visual haiku, self-sufficient and somehow transcendent. Not unlike the interiors and still life paintings of Chardin, it locates a magical quality in ordinary domestic life.

Red Room, of course, is about social class, about class conflict. It posits geometric sculpture as a direct symbol of modernism's assault on the memory of ancien régime decadence—clean, Bauhausian lines pitted against the curlicue and ornament of the old European patriarchy. This concept of modernism as social reform is hardly new. But in Richard's apparent interpretation, it is linked to our abiding enthrallment with affluence, and perhaps to our own unwieldy aspirations. Images like this, and the success of the "shelter" magazines that publish them, cast contemporary Americans in the role of keyhole dreamers, compulsively needing to know the details of luxury and, worse, opting to live vicariously. In this continuing series Richard has established a latter-day pop aesthetic—offering the shelter page as an icon of our era. And the icon intimates that reform is fighting a losing battle.

TERRINGTON CALÁS
University of New Orleans

Brian Boucher, *Art in America* (February 2007); Terrington Calás, *New Orleans Art Review* (May–June 1996 and March–April 2001); Robert Hughes, *Time* (2 March 1981); John Russell, *New York Times* (8 February 1981).

Richards, Thomas Addison

(1820–1900) ARTIST AND TRAVEL WRITER.

Thomas Addison Richards was born on 3 December 1820, the son of a Baptist minister, who settled his family in Hudson, N.Y., following their arrival from London, England, in 1831. The Richards family, which included brother William Cary, then traveled south, stopping in Charleston, S.C., before settling in Penfield, Ga., in 1835. During his youth, Richards completed two works that showed his early dedication to the arts, travel, and nature. At age 12 he created a 150-page unpublished, illustrated manuscript of watercolors chronicling his voyage from England to America. In 1838, at age 18, the artist illustrated a book on flower painting, *The American Artist*, which was published in Baltimore. From 1838 to 1941 Richards spent time in Augusta, Ga., as an art teacher and contributed to the *Augusta Mirror*. In Augusta, Richards and his brother published a dictionary of southern flora accompanied with illustrations, titled *The Southern Flora; or New Guide to Floral Language*.

In 1842 the Richards brothers published *Georgia Illustrated, in a Series of Views*, which was described as "a series of views embracing natural scenery." Richards traveled, completing writings and sketches of historical and scenic

locations in Georgia, and his brother, William, served as editor. The brothers continued working together, forming the magazine *Orion* (1842–44). With William as editor, Richards extended his travels from Virginia to Louisiana, submitting romanticized and witty novelettes, as well as illustrations of various southern locales. Horace Greeley, founder of the *New York Tribune*, called him the "Thomas Doughty of the South."

Richards received formal training at the National Academy of Design in New York City in 1844. He later became the corresponding secretary of the academy, in 1852, a post he occupied for more than 40 years. Richards also served as the first director of the Cooper Union School of Design for Women, from 1858 to 1860. He was in New York during the Civil War and frequently exhibited at the academy and the Brooklyn Art Association during that time and afterward. Richards was appointed professor at New York University in late 1867, where he taught until 1887.

During the years 1846–56 Richards trekked the Hudson River and other places in the North, as well as to the regions of the Carolinas and Georgia, among others, in the South. He completed copious plein air sketches in graphite and pencil, now preserved at the Archives of American Art, Smithsonian Institution, in Washington, D.C. Publications completed by Richards during his travels through the South include *Tallulah and Jocassee* (1852) and *The Romance of American Landscape* (1854). In 1857 Richards served as editor for *Appleton's Companion Hand-Book of Travel*, which is noted for being the first comprehensive guidebook of America and Canada. *Appleton's* integrated verbal descriptions of notable American landmarks with accompanying imagery submitted by artists, including Frederic Edwin Church. For example, with an engraving of the Savannah River, Richards described in detail the journey between Augusta and Savannah, where he saw southern flora like the "luxuriant groves of live oaks." In 1858 he married an author of children's literature, Mary E. Anthony. The couple traveled to Georgia to see his family, thus expanding his portfolio of southern landscapes and writings.

The artist was a frequent contributor to *Harper's New Monthly Magazine*. Among his articles about the South were "The Landscape of the South" (1853) and "The Rice Lands of the South" (1859), commentaries accompanied by illustrations, like *Southern Swamp*. Richards completed several landscape paintings during his career, such as the picturesque *River Plantation* (ca. 1855–60). In this painting the artist follows conventional landscape compositional arrangements of the period. Richards depicts clear divisions in the foreground, mid-ground, and background with the use of coulisses. Verdant vegetation that follows the serpentine shape of the river, a large fertile oak tree with draping Spanish moss, figures in repose, and a columned antebellum home fill the composition.

Richards completed drawings of a specific southern plantation during the 1850s, that of friend and fellow southern *littéraire* William Gilmore Simms—his

Woodlands rice plantation in South Carolina. The drawing was published in the book *Homes of American Authors* in 1853 as an engraving, *Residence of William Gilmore Simms, Woodland, South Carolina*. Richards displayed seven southern landscapes at the National Academy of Design Exhibition of 1859, including the titled works *Bonaventure, Near Savannah, Georgia*, and *The Edisto River, S. Carolina*. His dedication to the South is exhibited through his documented travels, published writings, and copious paintings, often landscape scenes, which showcased and promoted the South's lush environs. Following the Civil War, Richards continued to exhibit at the National Academy of Design, entering paintings like *Basket of Peaches* (1865) and landscapes of the Swiss Alps, produced after his 1867 trip to Europe. He remained in the North, living in New York City, until his death on 18 June 1900.

KATE BRUCE
The Historic New Orleans Collection

Kate Bruce, "An Image of Southern Repose: Intentions and Implications of Thomas Addison Richards's *River Plantation*" (M.A. thesis, University of Georgia, 2007); Louis T. Griffith, *Georgia Museum of Art Bulletin* 1 (1974); Mary Levin Koch, *Georgia Museum of Art Bulletin* 8 (1983).

Rowell, Louis

(1870–1928) PAINTER.
A plein air landscape painter of the southern mountains, Louis Rowell (pronounced "role") was born in Vineland, N.J. He came to Tryon, N.C., in his early twenties with his tubercular mother and father, a violinist and Union veteran from Maine, whose health had been broken by military service during the Civil War. After the deaths of his parents, Rowell stayed on in the mountain village, earning his living as a musician and learning to paint from the artists who began congregating at Tryon in the 1890s.

Unlike the professional painters who mentored him in Tryon, Rowell had no benefit of art instruction in formal academies. He worked first in water-based media and later took up oils. Among his friends and visitors was Savannah-born painter Valentino Molina, then studying in Paris. The plein air style of Amelia Montague Watson, who wintered in Tryon and taught art at the Martha's Vineyard summer school, strongly influenced his oeuvre. Their studios were next to one another on a leafy lane, with panoramic views toward Tryon Peak. During hot summer weather Rowell would migrate to higher elevations, at Saluda, Balsam, and the Cashiers vicinity in the North Carolina mountains.

DuBose Heyward, a successful businessman in Charleston who was incapacitated by weak health and who turned to creative expression as a result, first tried painting after meeting Rowell in 1917. For a brief period of time Heyward attempted to become a serious visual artist by working with Rowell, before he decided to concentrate on writing. By this time Rowell was firmly established as an artist; he exhibited his work in Atlanta, Asheville, and elsewhere. His output was prolific, and he often bartered paintings, in part because of his alcohol habit, which be-

came increasingly expensive during Prohibition and which estranged him from his relatives. Rowell was one of the Tryon colony's most ubiquitous artists, in all seasons, and he seldom left North Carolina for very long. He was usually seen carrying an easel or seated and sketching on his lapboard. Rowell rented space annually at the Lanier Club, Tryon's little athenaeum, to exhibit and sell his work. These shows attracted out-of-state purchasers, who carried his art to faraway places and helped to publicize the beauties of the area's landscape around the nation.

Caroline Fuller, Boston author and critic and one of Rowell's most ardent supporters, described him as the "most loving interpreter" of the Carolina mountain landscape. In 1926 he went to New York for a solo show and apparently ran out of pure Carolina moonshine there. After purchasing badly distilled alcohol from a stranger in the city, Rowell arrived back in Tryon seriously ill. He spent the next two years in and out of an Asheville hospital, which ultimately bankrupted him. Rowell attempted to live and paint in a single room in downtown Asheville, but he accomplished little there. He died in a sanatorium of "exhaustion from mania" and was buried furtively in Tryon, the news not being made public until after he was laid to final rest. A second memorial exhibition was held at his New York gallery in 1928, and Rowell's friends in Tryon conducted another posthumous show and sale of his paintings.

MICHAEL J. MCCUE
Asheville, North Carolina

Frank Durham, *DuBose Heyward: The Man Who Wrote Porgy* (1954); Michael J. McCue, *Paris and Tryon: George C. Aid and His Artistic Circles in France and North Carolina* (2003), *Tryon Artists, 1892–1942* (2001).

Ruellan, Andrée

(1905–2006) PAINTER.

New York artist Andrée Ruellan lived her long life composing harmonic narratives with golden-hued colors and a strong sense of order. Born of French parents in New York in 1905, at a young age Ruellan attended the Armory Show, the groundbreaking event in 1913 that introduced modern art to a broad American public. The following year she contributed drawings and watercolors of city streets to a group exhibition in New York, invited by the renowned teacher, theorist, and painter Robert Henri, and published a work in the liberal magazine *Masses*.

In the early 1920s Ruellan studied at the important training ground for American landscape and portrait painting, the Art Students League, working under Maurice Sterne. Years of studying and drawing in Rome under Sterne, and then working in Paris at her own Montparnasse studio, followed, resulting in romantic views of European architecture and the countryside, innovative lithographs made at the Atelier Desjobert, and numerous friendships with writers and artists in the American art circle there, including Gertrude Stein, Adolf Dehn, and Yasuo Kuniyoshi. Indeed, Ruellan's first solo exhibition, of paintings, watercolors, and drawings, occurred at the Galerie Sacre du Printemps in Paris in the summer of 1925.

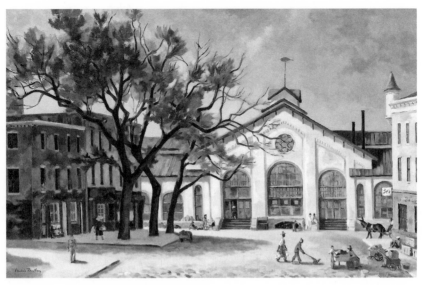

Andrée Ruellan, Savannah Landscape, *circa 1943, oil on canvas,*
26¼" x 40¼" *(The Johnson Collection, Spartanburg, S.C.)*

In 1929 Ruellan met American painter John (Jack) Williams Taylor in Paris. They married, but, because of the Wall Street economic crash, they moved back to America, settling in the hamlet of Shady, N.Y., a few miles from the art colony of Woodstock, where the Art Students League had a summer home and where artists of diverse approaches had thrived since early in the 20th century. There she rendered country scenes and views of New York City painted in an easily understood American Scene manner of vital everyday images, in vogue at the time, made popular by Thomas Hart Benton and the federal government's mural projects.

During the 1930s and 1940s Ruellan frequently made oil paintings that pictured the South, especially African American life in Savannah and Charleston, developed from exquisitely rendered sketches made on the spot and then finished in her studio in New York. Her oils of this Lowcountry region evoke quiet moods and gentle and thoughtful conversations, balanced by architectural facades and sandy land, in scenes including open markets, street gambling, and workers along the Savannah River.

As an outsider, she was sometimes met with suspicion in the South when on these sketching trips. Ruellan spoke of a visit to Savannah in 1940 when she and Jack were arrested and held in jail for a day for making drawings of the area. Suspected of being spies, they were "saved" by another New York painter, Alexander Brook, who was a part-time resident. Visiting the region became a ritual for these and many artists in the Northeast, who sought mild winters and lower living expenses in the South. During these years Ruellan herself won government commissions for murals in

southern post offices in Emporia, Va., and Lawrenceville, Ga.

In the late 1940s, like most artists stunned by world events, Ruellan exhibited a more introspective air in her paintings, drawings, and prints, creating scenes and situations that were sometimes more mysterious and personal. She died in 2006 at the age of 101, after decades spent at her home and studio in Shady, busily working and actively nurturing the Woodstock Artists Association, serving as a trustee and member of the Permanent Collection Committee. Ruellan won several awards, including a Guggenheim Fellowship in 1950, and her works are found in numerous collections, including the Metropolitan Museum of Art in New York, the Phillips Collection in Washington, D.C., the Georgia Museum of Art at the University of Georgia in Athens, and the Museum of Fine Arts in Springfield, Mass.

PATRICIA PHAGAN
Vassar College

Donald D. Keyes, *Andrée Ruellan* (1993); Pamela D. King, *Looking Back: Art in Savannah, 1900–1960* (1996); Patricia Phagan, *The American Scene and the South: Paintings and Works on Paper, 1930–1946* (1996).

Salazar y Mendoza, José Francisco Xavier de

(mid-1700s–1802) PAINTER.
José Francisco Xavier de Salazar y Mendoza was the foremost painter in Louisiana during the Spanish colonial period. Arriving in New Orleans in 1782 from Mérida in Yucatán, Salazar painted portraits in the city for 20 years and produced a visual record of its civic and religious leaders, including philanthropist Andrés Almonester y Roxas (1796), Dr. Joseph Montegut (ca. 1797), Padre Antonio de Sedella (ca. 1800), and Bishop Luís de Peñalver y Cárdenas (1801).

Inconsistencies in Salazar's painting style and drawing problems often suggest joint artistic ventures with his daughter, Francisca de Salazar y Magaña. Salazar's early life and artistic training are unknown; he arrived in Louisiana as a mature artist. His portraits underscore awareness of Mexican provincial styles and European painting traditions. Shimmering transparent glazes in his portraits bear similarities to those of Francisco Goya y Lucientes. Salazar arranged his subject frontally or in three-quarter view against a dark monochromatic ground. His portraits are characterized by a limited palette, even lighting, and warm accents in skin tones, upholstery, flowers, and symbolic attributes.

The son of Salvador de Salazar and Feliciana Ojeda y Bazquez, he married Maria Antonia Magaña while living in Yucatán. Maria Antonia was the daughter of Antonio Magaña y La Cerda and Francisca Xaviera del Hollós Conejo, an islaña. Their daughter, Francisca, was born in Yucatán. José, the second child, was born in 1781. In 1782 the couple relocated to New Orleans. José Casiano was born in 1784, the first child born to an artist in the colony. Francisca, under her father's tutelage, was the first artist to study in Louisiana. The fire of 1788, which destroyed most of the city, left the Salazar family homeless. The 1791 *Patrón* (census) gives their

address as St. Philip Street, where the couple's youngest child, Ramon Rafael de la Crus, was born. Both boys were baptized in St. Louis Church. Maria died on 24 June 1793; nine-year-old José Casiano died the next day. This close death date for mother and child suggests that the cause of death was probably yellow fever, which historically plagued the city.

In 1796 Francisca married Pedro Gordillo, a sergeant in a Spanish colonial cavalry regiment. On 4 March 1801, evidently being in ill health, Salazar made out his will. He died 17 months later on 15 August 1802. That same year Francisca painted a copy of her father's portrait of the bishop, intended for St. Louis Cathedral. Though married, Francisca signed herself "Franca Salazar." This portrait, Francisca's only known signed painting, was destroyed in the 1988 Cabildo fire. With about 70 extant paintings attributed to Salazar, a collaborative effort with his daughter is probable.

In his will Salazar named Gordillo as guardian and referred to José and Ramon as his "minor sons." The appearance of Francisca's name in court records during the probate of her father's will is the last known mention of the Salazar family in any Louisiana archive, and the fate of surviving family members after the Louisiana Purchase is unknown.

Salazar survived at a time when few artists ventured toward Louisiana. The 1791 census records only two other painters in the city—Joseph Furcoty and Joseph Herrara, of whom nothing is known. Salazar's paintings provide a unique historical glimpse into life in this difficult colony.

JUDITH H. BONNER
The Historic New Orleans Collection

Mrs. Thomas Nelson Carter Bruns, *Louisiana Portraits* (1975); Donald B. Kuspit et al., *Painting in the South, 1564–1980* (1983); John A. Mahé and Roseanne McCaffrey, eds., *Encyclopaedia of New Orleans Artists, 1718–1918* (1987); Jessie Poesch, *The Art of the Old South: Painting, Sculpture, Architecture, and the Products of Craftsmen, 1560–1860* (1983).

Sawyier, Paul

(1865–1917) PAINTER.

Paul Sawyier was born in Madison County, Ohio, the son of physician Nathaniel Sawyier and his wife, Ellen Wingate Sawyier. In 1870 the family moved to Frankfort, Ky., where young Paul took his first art lessons from Elizabeth S. Hutchins, a Cincinnati artist. From 1884 to 1885 he studied drawing in life classes at the Cincinnati Art Academy conducted by Thomas Satterwhite Noble, and for the next two years he shared a studio in Cincinnati with Avery Sharp, specializing in pastel and charcoal portraits, most of which were done from photographs.

Sawyier returned to Frankfort in 1886 to work for his father's hemp mill, but his artistic urges prompted a move to New York, where he enrolled in the Art Students League and studied with William Merritt Chase in 1889 and 1890. Chase was a major communicator of French impressionist broken brushwork and vibrant color harmonics to the American Scene at a moment when schools for teaching art were becoming

established institutions. Chase operated an atelier rather than a classroom, recalling the Académie Julian, whose tenets made it "especially attractive to enterprising young artists: the teaching was flexible, and there were no restrictions; it was open every day except Sunday from eight in the morning until nightfall," unlike other institutions that closed in the early afternoon.

Sawyier's mature style is clearly derived from these sources and from Chase's advice. "Be yourself Paul—be your individual self. Be Paul Sawyier." In 1891 he returned to Cincinnati, where he had some instruction from Frank Duveneck at the Cincinnati Art Academy—their association reputedly was one of mutual admiration. Thereafter he returned to Frankfort, where he was active painting the local scene until 1913. During that time he was also responsible for the care of his parents, whose health and financial resources had declined considerably. Following a trip to the World's Columbian Exposition in Chicago in 1893, Sawyier returned to portraiture, and the commissions he received provided the bulk of his income until the turn of the century. At this same time he was selling landscape watercolors in local stores. After his mother's death in 1908 he took up residence on a houseboat, often moored at High Bridge but frequently in Frankfort. During these years his major patron was J. J. King, a local engineer, who had a camp on the Elkhorn Creek where he photographed local color. On 18 June 1911 Sawyier wrote to King inviting him to visit his houseboat on the Kentucky River and offering to enter-

tain. "I will expect you to dinner and show you over a portion of the river that differs considerably from that in your locality," he wrote. Their shared interests in the hues of nature and the river led King to become one of the major collectors of Sawyier's work.

Perhaps discouraged by the lack of a strong market for his works in central Kentucky, Sawyier moved to New York in 1913, where he lived with his sister Lillian in Brooklyn. Many of his oils date from this period of relative stability, a time when he established an urban studio and painted scenes of Prospect Park in Brooklyn, Jamaica Bay, and Central Park, as well as of Kentucky scenes taken from photographs. He continued to correspond with King, who remained a generous patron. On 3 March 1917, Sawyier wrote King, "If you have any photographs of your various camps and outings on the river [that] you would care to use as images for paintings I would be glad to try my hand at them."

Sawyier returned to Kentucky for visits in 1914 and 1916. In 1915 he moved to the Highmount estate owned by Mrs. Marshall L. Emory, a patron of the arts who provided him with a studio in the former chapel, but Sawyier's effort to transplant his bucolic sensitivity from Kentucky to New York State was not successful. While in Highmount he began to indulge in binge drinking, using money from the rare sale of paintings. He was often in debt for his room and board, both there and in nearby Fleischmanns, where he moved in 1916. Kentucky remained the strongest market for his work—some of which

was sold at Brower & Company on Main Street in Lexington, where J. J. King and antiquarian William Townsend continued to buy his work. Depressed and financially stressed, he died from a heart attack in November 1917 and was buried in Fleischmanns, later to be reinterred in the Frankfort Cemetery in 1923.

ESTILL CURTIS PENNINGTON
Paris, Kentucky

Willard Rouse Jillson, *Register of the Kentucky State Historical Society* (October 1939); Arthur Jones, *The Art of Paul Sawyier, 1865–1917* (1976); Kentucky Historical Society, Frankfort; Estill Curtis Pennington, *Kentucky: The Master Painters from the Frontier Era to the Great Depression* (2008), *Lessons in Likeness: The Portrait Painter in Kentucky and the Ohio River Valley, 1800-1920* (2010); Special Collections Library, University of Kentucky; John Wilson Townsend, *Filson Club Quarterly* (October 1959).

Scarborough, William Harrison

(1812–1871) PORTRAITIST.
William Harrison Scarborough was born in Dover, Tenn., on 7 November 1812 to John and Sally Bosworth Scarborough. The family derived from Scarborough in the North Riding of Yorkshire, England. Apparently their ties to the old country were strong, as the artist Scarborough often displayed a coat of arms dating from the War of the Roses. Biographer Helen Kohn Hennig notes that he "sealed his letters with a white rose as a memento of the sympathies of his family in days gone by."

Scarborough originally studied medicine in Cincinnati, around 1828, before deciding to become an artist instead. He worked with Horace Harding in Cincinnati, where he may also have come under the influence of Daniel Drake, a prominent physician and cultural leader in that city. These early brief experiences may have fired his ambition, but Scarborough's most thorough training in the technique of portrait painting came from his work with John C. Grimes in Nashville in 1830.

On 8 October 1833 Scarborough married Sarah Ann Gaines. When Scarborough's wife died in childbirth, on 29 March 1835, he and his infant son, John, left Tennessee—traveling first to Alabama and then to Charleston, where he settled in 1836. John Miller, a wealthy planter and lawyer, provided Scarborough with his first commission: to paint some of his seven daughters while living in the family home at Sumterville. One of those young ladies, Miranda Eliza Miller, married the artist on 28 November 1838. The Miller family's connections provided Scarborough with a large number of sitters for the studio he had opened in Cheraw, S.C., in 1836. By 1843 patronage at that location had played out, and Scarborough moved to Columbia, S.C., where he would remain for the rest of his life. Once in Columbia, Scarborough became the local portrait artist of choice. He also pursued various itinerancies, working in Charleston and in the Nashville area.

In 1857 Scarborough launched a study tour of Europe, visiting London, Paris, and Rome. He kept a very meticulous account book of his sitters and proceeds. At the time of his death, his estate was valued at $20,000, a sure indication of the artist's prosperity, making him far more affluent than many of his

contemporaries. Scarborough, who died in Columbia, who was first buried in the graveyard of Trinity Episcopal Cathedral there. When his widow, Miranda, went to live with their daughter at Ridge Spring, S.C., she had the body exhumed and relocated to Ridge Spring so that they might be buried together, though she died on a visit to her son in Morrilton, Ark., and was interred there.

ESTILL CURTIS PENNINGTON
Paris, Kentucky

Helen Kohn Hennig, *William Harrison Scarborough: Portraitist and Miniaturist, "A Parade of the Living Past"* (1937); Estill Curtis Pennington, *Messengers of Style: Itinerancy and Taste in Southern Portraiture, 1784–1867* (1993), *Romantic Spirits: Nineteenth-Century Paintings of the South from the Johnson Collection* (2011); Jessie Poesch, *The Art of the Old South: Painting, Sculpture, Architecture, and the Products of Craftsmen, 1560–1860* (1983); Martha Severens, *Greenville County Museum of Art: The Southern Collection* (1995).

Sébron, Hippolyte Victor Valentin

(1801–1879) PAINTER.

Artist Hippolyte Victor Valentin Sébron was born on 21 August 1801 in Caudebec, France. He studied under Louis Jacques Mandé Daguerre and Léon Cogniet. Sébron, whose first name also appears at times as Hyppolite, had only one arm. He nonetheless produced an extraordinary body of large paintings. Known in his early career for his dioramas and landscapes, Sébron also painted portraits, architectural views, and interior scenes produced from his extensive travels throughout Europe, Asia, and the United States.

In June 1833 Sébron exhibited "an inimitable copy" of John Martin's painting *Belshazzar's Feast* (1820), which was well known at the time. Sébron painted the scene with dioramic effect on nearly 2,000 square feet of canvas. The scene produced a negative reaction from Martin, who tried unsuccessfully to have the diorama withdrawn from exhibition at Westminster Abbey.

From 1831 through 1878 Sébron exhibited regularly in the Salon in Paris. He also exhibited at the Royal Bazaar in London and the National Academy of Design in New York City. For 16 years he worked as an assistant to Daguerre, inventor of the photographic process, a relationship that brought Sébron considerable recognition. Sébron had the distinction of being the only one of Daguerre's assistants whose name appeared with his on "double-effect" paintings. Together they improved the visual effect of popular dioramas by painting transparent and opaque colors on both sides of works executed on calico. They created special lighting that transformed day scenes into night scenes and also made figures seem to appear and disappear.

Between 1834 and 1838 Daguerre and Sébron created five dioramas and exhibited them in Europe and the United States. A four-part diorama with scenes of Italy, Switzerland, and France, which toured America, was exhibited in New Orleans in January 1843. The diorama was later destroyed when the museum in which it was housed caught fire. Another diorama, *The Departure of the Israelites*, was also exhibited in New Orleans while it was on tour through

the United States and was offered for sale in 1849.

Sébron, who was active in New Orleans from 1850 to 1853, painted a small oil sketch of a levee scene featuring steamboats at dock. By 1853 he had developed the sketch into a large view of giant steamboats docked in New Orleans, titled *Bateaux à Vapeur Géants*, which captured the busy activities on the docks during a period of economic prosperity. Sébron exhibited the large work at the World's Exposition in Paris in 1855. He sold it in 1868 to Daniel Henry Holmes, the proprietor of a New Orleans department store, established in 1832 (and closed in 1989). The painting was exhibited later at the 1884–85 World's Industrial and Cotton Centennial Exposition in New Orleans and was subsequently donated to Tulane University in 1892.

Sébron's *Niagara Falls, the Horseshoe* (1852) received such a favorable reception that it was engraved by Friedrich Salathé and published by Goupil and Company in New York. The painting was exhibited in New Orleans at Faivre's Music Store on Royal Street between Bienville and Customhouse, along with his daguerreotypes, dioramas, and pastel drawings. Sébron died in Paris on 1 September 1879 at the age of 78.

JUDITH H. BONNER
The Historic New Orleans Collection

Helmut Gernsheim and Alison Gernsheim, *L. J. M. Daguerre: The History of the Diorama and the Daguerreotype* (1968); Donald B. Kuspit et al., *Painting in the South, 1564–1980* (1983); John A. Mahé II and Rosanne McCaffrey, eds., *Encyclopaedia of New Orleans Artists, 1718–1918* (1987);

Jessie Poesch, *The Art of the Old South: Painting, Sculpture, Architecture, and the Products of Craftsmen, 1560–1860* (1983).

Shackelford, William Stamms

(ca. 1814–ca. 1878) PORTRAITIST. Born in Kentucky in ca. 1814, William Stamms Shackelford began his painting career in the 1830s in Lexington, where it is believed he received some initial art instruction from sculptor Joel Tanner Hart. In 1833–34 Shackelford executed one of his first commissions, assisting painter Oliver Frazer with a portrait of George Washington destined for the Kentucky statehouse. Within the next year he relocated to Athens, Tenn. From this point Shackelford divided his time between the two states, living and painting intermittently in various cities and towns until the late 1870s. He worked primarily in Clarksville while in Tennessee in the 1850s and 1860s, but in Kentucky he sought work in numerous locales—Flemingsburg, Winchester, Versailles, Cynthiana, Danville, Bowling Green, and Paris.

Shackelford's more significant Kentucky commissions include portraits of two former governors, Thomas Metcalf and James Clark. But some of the most distinctive examples of his work are found in the series of likenesses he produced of his relatives, the Shackelford family of Clarksville, ca. 1857–60. These paintings display the characteristics of a competent but unschooled artisan: figures rendered with clear contours and softly modeled edges and with nearly expressionless faces that have a doll-like quality. Yet his pictures of the Shackelford children, with the inclusion of ani-

mals and delicate landscapes that appear as theatrical backdrops behind the sitters, evoke an almost surreal, dreamlike quality.

Aside from his painting career, Shackelford's other pursuits included that of an inventor. He spent years building a perpetual motion machine and also made claims of having invented the revolver prior to Samuel Colt. He died sometime after 1878 among relatives in Missouri.

MARILYN MASLER
Brooks Museum of Art
Memphis, Tennessee

Ann Goodpasture, n.d., typescript, Tennessee State Museum, Nashville; James C. Kelly, *Tennessee Historical Quarterly* (Winter 1987); Wilbur D. Peat, *Pioneer Painters of Indiana* (1954).

Shannon, Charles Eugene

(1914–1996) PAINTER.

In the 1930s and early 1940s Charles Shannon emerged as a leading painter of the American Scene in Alabama. With an urgent and expressive realism, he wrestled with the emotionally rich and socially divisive life and times around him in the rural South during the Great Depression. He engaged in a far-reaching aesthetic of American artists observing and documenting their local surroundings that became celebrated through the populist, highly promoted regionalist art of Thomas Hart Benton, Grant Wood, and John Steuart Curry. In a larger sense, this accessible, narrative American Scene art also developed from a widespread spirit of American nationalism and an interest in the ongoing, people-oriented Mexican mural renaissance.

Born in 1914 in Montgomery, Shannon studied at Emory University in Atlanta from 1930 to 1932 and the Cleveland School of Art in Ohio from 1932 to 1936. While home from Cleveland in the summer of 1935, he built a cabin studio in the small community of Searcy on plantation land given to him by an uncle. Shannon formed a close relationship with the black community, socializing with neighbors who worked alongside him to build the structure.

Upon graduating from art school, Shannon won a partial traveling fellowship, with which he went to Mexico for a few months, studying murals by José Clemente Orozco and Rufino Tamayo. Afterward, Shannon lived in his cabin in Searcy, painted, and filled sketchbooks of scenes there and in Montgomery, 40 miles north, rendering church services, fish sellers, cotton pickers, singers, strikers, courthouse denizens telling tall tales, couples, and victims of and "hiders" from the Ku Klux Klan. Turbulent brushwork, attenuated bodies, and emotion-evoking colors enlivened his oils of African Americans, the dominant theme in his work during these years. Shannon later noted that he focused on such active means of painting to resonate with his restive subjects and to get at the heart of his feelings for life at the moment.

Shannon won wide attention for his work. In 1937 the Montgomery Museum of Fine Arts gave him a one-person exhibition, followed the next year by solo shows at the Cleveland Museum of Art

and the Jacques Seligmann Galleries in New York. In 1938–39 the Julius Rosenwald Fund awarded him fellowships to study and paint southern subjects, enabling him to work from his cabin. He also traveled with friends. In 1938 he accompanied David Fredenthal on his trip to Georgia to illustrate a new edition of Erskine Caldwell's *Tobacco Road*, published in 1940.

In March 1939 Shannon cofounded the New South School and Gallery in Montgomery, a short-lived arts center encouraging artists and craftspeople and sponsoring wide-ranging activities, including exhibitions, a theater group, a magazine, and art, music, and creative writing classes. It promoted local artists, including former slave Bill Traylor, whom Shannon discovered drawing in a doorway along a city street. The group lasted until February 1940.

Shannon's involvement with New South, where he taught painting and life drawing, served as an introduction to a career of teaching. In 1940 he became artist in residence at West Georgia College (now University of West Georgia) in Carrollton. After service in the U.S. Army, as artist-correspondent in the South Pacific, he worked as a commercial illustrator and then spent much of the rest of his life teaching art. He taught privately and at the University of Alabama Extension Center, from 1958 to 1969, and at Auburn University at Montgomery, from 1969 to 1979, where he established the art department.

Shannon is represented in the permanent collections of the Smithsonian American Art Museum, the Mont-gomery Museum of Fine Arts, and the Morris Museum of Art in Augusta, Ga., and in private collections. Art-South, Inc., organized a retrospective of his paintings and drawings in 1981. His work has attracted much attention in exhibitions and accompanying catalogs on the art of the American South.

PATRICIA PHAGAN
Vassar College

Margaret Lynne Ausfeld et al., *American Paintings from the Montgomery Museum of Fine Arts* (2006); *Charles Shannon: Paintings and Drawings* (1981); William U. Eiland, in *The American Scene and the South: Paintings and Works on Paper, 1930–1946*, ed. Patricia Phagan (1996); Miriam Rogers Fowler, *New South, New Deal, and Beyond* (1989).

Shapleigh, Frank Henry

(1842–1906) PAINTER.
Frank Henry Shapleigh's early education took place at the Dwight School in Boston, followed by art study at the Lowell Institute in Boston. From 1862 to 1863 Shapleigh served in the Massachusetts regiment active in the Civil War's North Carolina campaign. He established a studio in Boston after the war and later supplemented painting sales by selling his copyrights to chromo-lithograph companies. From 1866 to 1868 Shapleigh was in Europe, where he received instruction from Emile Charles Lambinet in Paris. For six weeks during the summer of 1870 Shapleigh painted in California's Yosemite Valley. He married his wife, Mary, that same year.

A member of the Boston Art Club, Shapleigh exhibited there from 1874

to 1884. He maintained a summer art studio at Crawford House in the White Mountains from 1877 to 1893, where his work depicting Mt. Washington and other New Hampshire peaks and rivers was extremely popular with the summer tourists.

The artist was wintering in St. Augustine by 1886 and advertising his scenes of that city in the *Boston Journal*. When Henry M. Flagler's Ponce de Leon Hotel opened in January 1888, Shapleigh was among the original group of artists who painted in the hotel's well-attended studios. He became well known for his street scenes and landmarks of the "Ancient City," which were highly regarded by the winter visitors as well as the press: "Mr. Shapleigh's studio is replete with studies of the picturesque streets of this city; the quaint old houses are faithfully delineated in artistic fashion," and "the Fort, sea-wall, and bits about the city [are] treated with a strong individuality and cleverness." Additionally, Shapleigh painted on Anastasia Island and in other regions of Florida, his artwork "catching the tropical effect where the air is filled with the hum of insects and the splash of the alligator," with "subjects treated in a way sure to please." These included paintings of the Ocklawaha River, which were praised as well: "One picture of the wilds of the Ocklawaha is a charming bit of color."

Shapleigh also documented a bit of St. Augustine history. In September 1886, between 440 and 510 members of the Chiricahua Apaches—Geronimo's tribe—including men, women, and children, were captured. Geronimo and his warriors were sent to Ft. Pickens, while other tribe members were held as prisoners at Ft. Marion (Castillo de San Marcos) in St. Augustine. At the advice of a so-called Indian advocate, the Apaches at Ft. Marion were housed in teepees instead of the dark casements of the fort so that they might receive the benefits of sunshine and fresh air. They did not have adequate clothing for the St. Augustine winter, however, until a citizen appealed to the federal government. By then it was too late— numerous tribe members, including 17 children, perished. Eventually 44 of the children were removed from the fort and sent to Carlisle, Pa., and by the spring, all remaining in St. Augustine were transferred to Alabama. During the brief interim in which they were imprisoned at St. Augustine, Shapleigh recorded the historic event by rendering Ft. Marion with several teepees in evidence.

A portly fellow, Shapleigh precipitated such comments from the well-heeled St. Augustine tourists as, "You are not the least like the ideal artist; you look as though you enjoyed three meals a day, and I supposed artists lived in garrets and ate bread and cheese." He collected antique furniture, and several pieces were admired in his Ponce de Leon studio.

Shapleigh provided book illustrations as well, including one concerning his Civil War regiment, *The Campaign of the Forty-fifth Regiment, Massachusetts Volunteer Militia: "The Cadet Regiment."* After 1892 Shapleigh no longer spent winters in St. Augustine, but his Florida work endures as a legacy of

southern architecture, landscape, and history.

DEBORAH C. POLLACK
Palm Springs, Florida

Sandra Barghini, *A Society of Painters: Flagler's St. Augustine Art Colony* (1998); James Garvin, Donna-Belle Garvin, and Charles Vogel, *Full of Facts and Sentiment: The Art of Frank H. Shapleigh* (1982); Deborah C. Pollack, *Laura Woodward: The Artist behind the Innovator Who Developed Palm Beach* (2009); *St. Augustine News* (15 February 1891); *San Francisco Bulletin* (1870); Frederic A. Sharf, *Antiques* (1961); Herbert Welsh, *Apache Prisoners in Fort Marion, St. Augustine, Florida* (1887).

Silva, William Posey

(1859–1948) PAINTER.

Landscape painter William Posey Silva was born 23 October 1859 in Savannah, Ga., where he was educated at Chatham Academy; he later studied engineering at the University of Virginia. Silva devoted himself to painting at an early age but did not pursue a career in art until he was approaching the half-century mark. He joined the family's chinaware and hardware business, first in Savannah and later in Chattanooga, Tenn. He continued to paint, however, and spent the summers of 1900 through 1905 studying composition with Arthur Wesley Dow in Ipswich, Mass.

In 1906, at the age of 47, Silva sold the family business. He and his wife traveled to France, where he studied figure drawing at the Académie Julian in Paris under Jean-Paul Laurens and Henri Royer and landscape painting at Étaples with American artist Chauncey Ryder. Silva's work was well received in Europe. He was included in the Salon Grand Palais des Champs-Élysée, and in 1909 he held his first solo exhibition at Galerie Georges Petit. Returning to Chattanooga in 1909, Silva then moved to Washington, D.C., where he again earned respect in artistic circles and held office in the Society of Washington Artists.

Silva settled in Carmel, Calif., in 1913, and established the Carmelita Gallery there. Although he made California his home for the remainder of his life, Silva returned frequently to the South. He was among the founders of the Southern States Art League and exhibited regularly in Georgia and Tennessee, where he won acclaim for his atmospheric paintings executed in a lyrical impressionist style, which was well suited to depicting the gardens of the Carolina Lowcountry and coastal landscapes of Georgia and California.

The Telfair Academy of Art in Savannah hosted a solo exhibition of Silva's work in 1917, and following his death in 1948 the academy mounted a memorial exhibition of his paintings and drawings. Silva was a member of numerous art organizations, including the California Art Club, the Art Association of New Orleans, the Salmagundi Club, and the American Federation of Arts. He exhibited at the Pennsylvania Academy of the Fine Arts and the Corcoran Gallery and had solo shows in London and Paris. His work is represented in the permanent collections of a number of southern museums: the Gibbes Museum in Charleston; the New Orleans Museum of Art; Brooks Memorial Art Gallery in Memphis; Savan-

nah's Telfair Museum of Art; Greenville County Museum of Art, Greenville, S.C.; and the Morris Museum of Art, Augusta, Ga.

LOUISE KEITH CLAUSSEN
Morris Museum of Art

James A. Hoobler, *Tennessee Historical Quarterly* (Spring 2002); James C. Kelly, *Tennessee Historical Quarterly* (Summer 1985); Donald D. Keyes, *Impressionism and the South* (1988); Donald B. Kuspit et al., *Painting in the South, 1564–1980* (1983); Leila Mechlin, *American Magazine of Art* (January 1923).

Smith, Alice Ravenel Huger

(1876–1958) ARTIST.

In the decades following Reconstruction, Charleston fell on hard times and vast sections of the historic city fell into disrepair. Charlestonians, it has been said, were "too poor to paint and too proud to whitewash." For Alice Ravenel Huger Smith, the lack of resources meant that she could not go away to art school or travel, which totally suited her inclinations to mine her own environment. Through her paintings and publications, Smith spearheaded the Charleston Renaissance, a cultural reawakening that brought about the preservation and revitalization of the area.

Smith's art education was limited to classes conducted by Mademoiselle Louise Fery, who taught Smith about the transparent properties of watercolor, an important lesson that would last a lifetime. In addition she thoroughly studied the color wood-block prints of Japanese masters of the Ukiyo-e school and absorbed the artistic sensibilities and techniques of such artists as Hiro-

shige, Sharaku, and Hokusai. Smith's synthesis of watercolor and Japanese design aesthetics resulted in an individualistic style ideally suited to rendering the landscape of the Carolina Lowcountry.

Before she dedicated herself to painting watercolors of the land she loved, Smith had several digressions, which nevertheless were important for the emergence of the Charleston Renaissance. In 1914 she released a portfolio of reproductions of 20 drawings of Charleston's most impressive and historic residence, the Miles Brewton House, entitled *The Pringle House*, which included a text on the history of the house and its residents, written by her father, D. E. H. Smith, an amateur historian.

Another volume, *The Dwelling Houses of Charleston, South Carolina* (1917), gained even greater recognition and distribution. Smith's 60 line drawings of houses and architectural details accompanied her father's histories of houses, which emphasized people and genealogy over architectural history. The book was seminal to the development of the Charleston Renaissance; first, it instilled in Charlestonians a sense of pride, leading them to repair and maintain their homes and to form a preservation group that successfully sought the passage of a preservation ordinance— the country's first such legislation. Second, the volume brought national attention to the city's architectural legacy: its antiquity, variety, and quality.

Smith's art was based on the conviction that she needed to paint what she knew and loved. To this end, she made many visits to area plantations

dio...
surroun...
set out to reco... members.
...s, pen-
rice plantation, and... stu-
was a fitting eulogy for a...
The culmination of her career,...
lina Rice Plantation of the Fifties (19...
consists of 30 large-format watercolors,
complemented by a text on rice cultivation by Herbert Ravenel Sass and selections from her father's boyhood recollections of the family's plantation.

found their way to Smith's studio, they were enchanted by her rom... visions of the Lowcountry and by the artist herself.

MARTHA R. SEVERENS
Greenville, South Carolina

...mes Hutchisson and Harlan Greene, eds., ...ssance in Charleston (2003); Angela D. ...d Roberta Sokolitz, Alice Ravenel ...Mart.. 1876–1958 (2002); Estill Curtis ...outhern Collection: A Pub- Smith: An A... Museum of Art (1992); The Charleston Rice Ravenel Huger ...nd a Time (1993), ...98).

Smith is best remembered for these paintings because of this book and the regular exhibition of her artworks at the Gibbes Museum of Art in Charleston, the repository she chose for them. As a group, they do not represent her strongest output. While some are pure landscapes and are genuinely outstanding, others by necessity are narrative and illustrative. The watercolors were probably planned and painted over a period of time and do not conform to one single size. Throughout her career the most successful and evocative paintings are ones in which her Japanesque sense of design is married to her transparent watercolor technique.

Smith's books and circulating exhibitions of her work served to draw attention to Charleston and to nearby plantations at a time when the South Carolina coast was drawing increasing numbers of visitors. From 1921 to 1930, 42 exhibitions of Smith's work circulated throughout the region and to such northern cities as Philadelphia, Newport, and Ann Arbor. Many tourists

Smith, Marshall Joseph, Jr.

(1854–1923) PAINTER.
Born in Norfolk, Va., on 1 December 1854, painter-draftsman Marshall Joseph Smith Jr. was the son of Col. Marshall Joseph Smith and Mary Taylor Smith, who moved to Louisiana when young Marshall was still a child. The family then relocated to Mississippi during the Civil War, Marshall's father having joined a regiment of Louisiana volunteers. Following the war, Marshall, who showed a passion for art during childhood, attended college in Virginia, during which time he had some art training. He returned to Louisiana, where he studied art formally with Adolphe J. Jacquet and then with landscape painter Richard Clague Jr. After Clague's death, Smith worked briefly with portrait painter Theodore Sidney Moïse.

In 1873 Smith held his first solo exhibition and in October 1874 traveled to Europe, where he studied at the Accademia dei Medici in Rome and with

J. O. de Montalent in Munich. Here
Smith submitted a drawing to the board
of professors, which passed him in 187
He then traveled extensively throug
Europe, where he met many pro
artists and writers. His journe
him through Naples, Sorren
Pompeii, Herculaneum, V
Paestum in Italy. In th. Bologna,
Smith visited galleri. de made
Perugia, Venice, hberg, Ver-
Verona, Geno
visits to Dre ., and later to
sailles, an verpool. In Paris, artist
Londo. re presented Smith with an
Gus proof etching of the composer
ar
..oacchino Rossini, which bore Ros-
sini's signature. On his return trip to
America in the spring of 1876, Smith
visited the Philadelphia Centennial Ex-
position; in late 1876 he established a
studio in Atlanta, Ga.

In 1877 Smith married Bettie P. Bel-
knap in Louisville, Ky. She was the
daughter of socially prominent New
Orleanian James T. Belknap. Following
a European trip, Smith took a position
in New Orleans with his father's firm
as an insurance clerk, later becoming
an insurance agent, until 1888. While
working as an insurance agent, Smith
continued to paint coastal Louisiana
scenes and bayou scenes, particularly
fisherman's shanties and moss-laden
oak trees. One of Clague's protégés,
Smith was reportedly Clague's favorite
student.

In post-Reconstruction New Orleans,
a time when the fine arts received little
public support, a small group of art-
ists began to organize efforts. Smith was

.nry Buck, Edward
.id Andres Molinary were
.nce. Smith was also a founder
. Krewe of Proteus, a Mardi Gras
organization for which he designed
parades and the tableaux (the colorful
costumed pageants at Mardi Gras balls).
He exhibited his work at Seebold's, the
Southern Art Union, the Artists' Asso-
ciation of New Orleans, Tulane Univer-
sity, and the C. Moses Gallery.

Smith was a regular guest at the
home of fine arts dealer and patron of
the arts Frederic William Emile de Ba-
chellé Seebold, who held weekly gather-
ings for the artists, writers, musicians,
and literati of the day, including George
Inness, Samuel Clemens, and George
Washington Cable.

In 1889 Smith opened his own studio
on Carondelet Street in New Orleans
and maintained it until 1906. Smith suf-
fered from chronic ill health and was
institutionalized in Covington, La. Near
the turn of the century he alternated
working in insurance with teaching
painting classes at St. Mary's Domi-
nican Academy in New Orleans. At
this time he painted irregularly. Smith
died in Covington, La., on 20 October
1923, about six weeks short of his 69th
birthday.

JUDITH H. BONNER
The Historic New Orleans Collection

Artists' Files, Williams Research Center,
Historic New Orleans Collection; Judith H.
Bonner, *Arts Quarterly* (April–June 2008),
in *Collecting Passions*, ed. Susan McLeod
O'Reilly and Alain Masse (2005), *Louisiana*

owned by friends and family members. She would take her sketchbooks, pencils, watercolors, and brushes and studiously apply herself to observing her surroundings. In the mid-1930s Smith set out to record life on an antebellum rice plantation, and the end product was a fitting eulogy for a lost way of life. The culmination of her career, *A Carolina Rice Plantation of the Fifties* (1936), consists of 30 large-format watercolors, complemented by a text on rice cultivation by Herbert Ravenel Sass and selections from her father's boyhood recollections of the family's plantation.

Smith is best remembered for these paintings because of this book and the regular exhibition of her artworks at the Gibbes Museum of Art in Charleston, the repository she chose for them. As a group, they do not represent her strongest output. While some are pure landscapes and are genuinely outstanding, others by necessity are narrative and illustrative. The watercolors were probably planned and painted over a period of time and do not conform to one single size. Throughout her career the most successful and evocative paintings are ones in which her Japanesque sense of design is married to her transparent watercolor technique.

Smith's books and circulating exhibitions of her work served to draw attention to Charleston and to nearby plantations at a time when the South Carolina coast was drawing increasing numbers of visitors. From 1921 to 1930, 42 exhibitions of Smith's work circulated throughout the region and to such northern cities as Philadelphia, Newport, and Ann Arbor. Many tourists found their way to Smith's studio, where they were enchanted by her romantic visions of the Lowcountry and by the artist herself.

MARTHA R. SEVERENS
Greenville, South Carolina

James Hutchisson and Harlan Greene, eds., *Renaissance in Charleston* (2003); Angela D. Mack and Roberta Sokolitz, *Alice Ravenel Huger Smith, 1876–1958* (2002); Estill Curtis Pennington, *A Southern Collection: A Publication of the Morris Museum of Art* (1992); Martha R. Severens, *Alice Ravenel Huger Smith: An Artist, a Place, and a Time* (1993), *The Charleston Renaissance* (1998).

Smith, Marshall Joseph, Jr.

(1854–1923) PAINTER.

Born in Norfolk, Va., on 1 December 1854, painter-draftsman Marshall Joseph Smith Jr. was the son of Col. Marshall Joseph Smith and Mary Taylor Smith, who moved to Louisiana when young Marshall was still a child. The family then relocated to Mississippi during the Civil War, Marshall's father having joined a regiment of Louisiana volunteers. Following the war, Marshall, who showed a passion for art during childhood, attended college in Virginia, during which time he had some art training. He returned to Louisiana, where he studied art formally with Adolphe J. Jacquet and then with landscape painter Richard Clague Jr. After Clague's death, Smith worked briefly with portrait painter Theodore Sidney Moïse.

In 1873 Smith held his first solo exhibition and in October 1874 traveled to Europe, where he studied at the Accademia dei Medici in Rome and with

J. O. de Montalent in Munich. Here Smith submitted a drawing to the board of professors, which passed him in 1876. He then traveled extensively throughout Europe, where he met many prominent artists and writers. His journeys took him through Naples, Sorrento, Capri, Pompeii, Herculaneum, Vesuvius, and Paestum in Italy. In the autumn of 1875 Smith visited galleries in Florence, Perugia, Venice, Milan, Parma, Bologna, Verona, Genoa, and Assisi. He made visits to Dresden, Nuremberg, Versailles, and Cologne, and later to London and Liverpool. In Paris, artist Gustave Dore presented Smith with an artist's proof etching of the composer Gioacchino Rossini, which bore Rossini's signature. On his return trip to America in the spring of 1876, Smith visited the Philadelphia Centennial Exposition; in late 1876 he established a studio in Atlanta, Ga.

In 1877 Smith married Bettie P. Belknap in Louisville, Ky. She was the daughter of socially prominent New Orleanian James T. Belknap. Following a European trip, Smith took a position in New Orleans with his father's firm as an insurance clerk, later becoming an insurance agent, until 1888. While working as an insurance agent, Smith continued to paint coastal Louisiana scenes and bayou scenes, particularly fisherman's shanties and moss-laden oak trees. One of Clague's protégés, Smith was reportedly Clague's favorite student.

In post-Reconstruction New Orleans, a time when the fine arts received little public support, a small group of artists began to organize efforts. Smith was one of the founders of the Southern Art Union—the initial planning meeting was held in his home. Local artists William Henry Buck, Edward Livingston, and Andres Molinary were in attendance. Smith was also a founder of the Krewe of Proteus, a Mardi Gras organization for which he designed parades and the tableaux (the colorful costumed pageants at Mardi Gras balls). He exhibited his work at Seebold's, the Southern Art Union, the Artists' Association of New Orleans, Tulane University, and the C. Moses Gallery.

Smith was a regular guest at the home of fine arts dealer and patron of the arts Frederic William Emile de Bachellé Seebold, who held weekly gatherings for the artists, writers, musicians, and literati of the day, including George Inness, Samuel Clemens, and George Washington Cable.

In 1889 Smith opened his own studio on Carondelet Street in New Orleans and maintained it until 1906. Smith suffered from chronic ill health and was institutionalized in Covington, La. Near the turn of the century he alternated working in insurance with teaching painting classes at St. Mary's Dominican Academy in New Orleans. At this time he painted irregularly. Smith died in Covington, La., on 20 October 1923, about six weeks short of his 69th birthday.

JUDITH H. BONNER
The Historic New Orleans Collection

Artists' Files, Williams Research Center, Historic New Orleans Collection; Judith H. Bonner, *Arts Quarterly* (April–June 2008), in *Collecting Passions*, ed. Susan McLeod O'Reilly and Alain Masse (2005), *Louisiana*

Cultural Vistas (Winter 2007–8); Joseph Fulton and Roulhac Toledano, *Antiques* (April 1968); William H. Gerdts, George E. Jordan, and Judith H. Bonner, *Complementary Visions of Louisiana Art: The Laura Simon Nelson Collection at the Historic New Orleans Collection* (1996); John A. Mahé II and Rosanne McCaffrey, eds., *Encyclopaedia of New Orleans Artists, 1718–1918* (1987); May W. Mount, *Some Notables of New Orleans* (1896); R. W. Norton Art Gallery, *Louisiana Landscape and Genre Paintings of the 19th Century* (1981); Martin Wiesendanger and Margaret Wiesendanger, *Louisiana Painters and Paintings from the Collection of W. E. Groves* (1971).

Smith, Xanthus

(1839–1915) PAINTER.

Xanthus Smith was born on 26 February 1839 in Philadelphia, at the Locust Street home of his parents, Russell and Mary Priscilla Wilson Smith. He grew up in a family of artists, and his father was celebrated for his theatrical scene painting as well as his landscape art. His mother and sister, Mary Russell Smith, were artists as well. Their legendary stone manor house, Edgehill, was long a destination for the most ambitious collectors and earnest artists in 19th-century Philadelphia. In this nurturing environment young Smith honed his precocious skills as a draftsman accomplished in intricate detail.

In 1851–52 Smith accompanied his parents and sisters on a study tour of Europe, where he studied old master paintings, with particular notice given to the realism and naturalism of the English landscape school. Then in 1858 he spent long hours at the Pennsylvania Academy of the Fine Arts, absorbed in an exhibition of English Pre-Raphaelite paintings, the sharp focus and high finish of which inspired a response harmoniously in tune with the high Victorian aesthete John Ruskin. "Art is founded on nature," he would later comment, and "whenever it strays from its truths and beauties it is off the track."

A passionate loyalist, Smith enlisted in the U.S. Navy at the outbreak of hostilities between the North and the South. He was assigned as captain's clerk to Cmr. Thomas G. Corbin on the *Wabash*, Adm. Samuel Francis Du Pont's flagship. Throughout his life, Smith kept a meticulous and expressive journal, which would later serve as the basis for his unpublished autobiography, *An Unvarnished Life*. His account of life on the *Wabash* provides a rare glimpse of the Civil War as seen through the eyes of an artist. During his service Smith made watercolor sketches and drawings that he used for the small, meticulously detailed paintings of naval vessels he later made. At his father's request he was relieved from duty in October 1864, and he returned to Philadelphia.

After his return he began to exhibit his paintings of federal vessels and the South Carolina coast. These drew critical acclaim in the local press. One reviewer suggested that he had "inherited his father's talent to a large degree . . . and his pictures this year show a marked improvement over those exhibited a few years ago. There is a finish and delicacy about them which is very natural and charming." It was work of this type that drew the attention of Charles Rogers, a Philadelphia banker,

who gave Smith his first commission for a major marine painting, in 1868. Interest in Civil War marine painting declined in the years after the sensational display of the *Battle of the Kearsarge and Alabama* at the Philadelphia Centennial of 1876. Undeterred, Smith continued to paint in his same precise style, even as he was an active fundraiser for veteran organizations and pursued his photographic interests. In his last decade he began to refer to himself as the "oldest living and practicing artist with Civil War experiences."

A very large body of material survived at Edgehill—especially important for holdings in original manuscript materials and photographs—and the studio-home remained in family hands until the late 1970s.

ESTILL CURTIS PENNINGTON
Paris, Kentucky

Bruce W. Chambers, *Art and Artists of the South: The Robert P. Coggins Collection* (1984); Ann Ferrante, *Archives of American Art Journal* (Fall 1981); Estill Curtis Pennington, *Look Away: Reality and Sentiment in Southern Art* (1989), *Romantic Spirits* (2011), *A Southern Collection: A Publication of the Morris Museum of Art* (1989); Mary, Xanthus, and Russell Smith Family Papers, 1793–1977, Archives of American Art, Smithsonian Institution, Washington, D.C.; Russell Smith Family Papers, Old York Road Historical Society, Jenkintown, Pa.; Robert W. Torchia, *The Smith Family Painters* (1998), *Xanthus Smith and the Civil War* (1999).

Southern States Art League

The Southern States Art League (SSAL), initially named the All Southern Art Association, was created in 1921 to make possible the comprehensive exhibition of art about the South, including the best efforts of southern artists. Those artists whose works were judged excellent enough to represent the South did so at annual exhibitions, which were held in major southern cities and at traveling circuit exhibitions throughout the South.

The goals of the SSAL were to increase public awareness of the talents of southern artists, to improve the artists' status, to encourage patronage and sales of members' works, to educate the public through traveling exhibitions of members' art, to hold a yearly conference in order to address issues that were important to the artists, and to publish a monthly newsletter to keep the membership informed. The founders of the SSAL hoped to further art education in the South and therefore to assist the southern public in developing a sense of art values. The activities sponsored by the organization encouraged the formation of art programs at various southern schools and universities and stressed the need to develop southern art colonies. SSAL officers also hoped to enter the political arena and support legislation in Congress that would benefit artists.

The SSAL was chartered in 1921 in Charleston, S.C., but the administrative offices moved to New Orleans in 1923. Ellsworth Woodward (director of the Newcomb College School of Art) was at that time elected president, an office he held until his death in 1939. Ethel Hutson of New Orleans served as secretary until 1947. Membership grew steadily each year, although many members became inactive during the Great

Depression and World War II. The organization's records indicate that membership topped 600 in 1933, but the names of artists listed in the records number only 425.

Yearly conventions in major southern cities provided a place for artists to meet and discuss pertinent issues and to exhibit and sell their works and for the public to view and purchase southern art. The convention's annual exhibition drew increasing numbers of visitors every year, totaling 12,000 at the annual show held in Nashville in 1935. The traveling circuit exhibitions were the most effective means of making southern art available. Two circuits traveled every year, each displaying 30 or more works, to large cities and small towns alike. Sales at these events, however, were usually quite low.

It is difficult to evaluate the quality of the works shown; records give some titles but few photographs survive, and no more than a handful of original artworks have been traced. Landscapes, flower paintings, and genre scenes seem to have dominated. League president Woodward regularly exhorted members to submit only top quality works of art, but his admonitions often were not heeded.

The SSAL was weakened with Woodward's death in 1939. James Henry Chillman Jr., director of the Houston Museum of Fine Arts, became president, but the headquarters remained in New Orleans. When Chillman retired in 1947, Benjamin E. Shute of Atlanta became president. The last conference was held in the same year in Richmond, Va. Shute resigned within one year, and then Lamar Dodd took over, followed

by Joseph Hutchinson of the Mint Museum in Charlotte, N.C. The SSAL was officially dissolved in 1950.

AMY KIRSCHKE
UNC Wilmington

Amy Kirschke, "The Southern States Art League: An Overview" (M.A. thesis, Tulane University, 1983).

Steene, William

(1888–1965) PAINTER.

William Steene's French mother met his father, a Dutch shoe-last designer who claimed descent from the genre painter Jan Steen, on the ship taking them to America. Steene was born in Syracuse, N.Y., where he first exhibited history canvases and portraits at the age of 19 and was a denizen of the local art museum. After studying in New York City at the Art Students League and the National Academy of Design, he went to Paris for training at the private academies then favored by Americans. Back in New York he soon achieved success as a portrait painter and architectural muralist. He also painted theater scenery and enjoyed acting, often playing roles of villains, and met his wife, Eula Jackson, an actress from Lexington, Ky.

Steene developed his reputation in the South by executing portraits of Gov. James Whitfield of Mississippi, presidents George Hutcheson Denny of the University of Alabama, Marvin McTyeire Parks of Georgia State, and John C. Fant of Mississippi State University. The Steenes spent the winters of 1925 and 1926 at Tryon in the mountains of western North Carolina, a cosmopolitan colony for artists and writers, to

paint Mrs. George Canfield and a posthumous portrait of author O. Henry (William Sidney Porter) for the Asheville library. During the next two decades Steene returned frequently to Tryon, where seasonal residents sat for his elegant portraits.

In 1927 Steene set up his winter studio at the Carolina Inn in Chapel Hill, and the next year he built a new house there, where he lived until 1931. His wife ran a dress shop with her sister, Olive Jackson, a musician and impresario who put on historical pageants in towns around North Carolina. Steene painted Frank Fuller and Bowman Gray of Winston-Salem, president William Preston Few of Duke University, and North Carolina governors Luther Hartwell Hodges and Oliver Max Gardner. Steene's most notable achievement of his Chapel Hill period is *The Baptism of Virginia Dare*, a large-format history painting that hangs in the Legislative Building in Raleigh.

Steene enjoyed the southern highlands and in the 1930s painted many portraits of visitors to the fashionable mountain retreat of Hot Springs, Va. There Steene took up golf, and it remained his lifelong joy. One of his caddies at the Homestead resort was a local lad named Sam Sneed—whom he invited to play an exhibition round at Tryon Country Club. The Steenes frequently visited friends in Columbus, Miss., who enticed them to settle permanently on the coast. In 1954 they built a house on the Gulf Hills golf course at Ocean Springs.

During his career Steene portrayed some 400 prominent Americans, among them Pres. Dwight Eisenhower, Rev. William Archer Rutherfoord Goodwin (founder of the Williamsburg restoration), and Gilbert Price of the Georgia Supreme Court. *ARTnews* of June 1935 reviewed his solo exhibition at Milch Gallery in New York: "The *pièce de resistance* of the show is naturally the full-length study of America's most idolized athlete, Robert T. Jones, and Mr. Steene has done him in golfing rig standing well into the rough as he prepares to execute another of his miraculous shots."

Steene also did handsome oils of landscape and marine subjects, as well as still lifes. He was commissioned to paint a 50-foot mural on the occasion of the 150th anniversary of the Louisiana Purchase, unveiled in 1953 by Eisenhower in New Orleans at the Presbytère. Steene's murals are in buildings in Arkansas, Texas, and Virginia.

MICHAEL J. MCCUE
Asheville, North Carolina

Michael J. McCue, *Tryon Artists, 1892–1942: The First Fifty Years* (2001); William Steene, *North Carolina Teacher* (March 1930).

Stevens, Will Henry

(1881–1949) PAINTER AND TEACHER. Will Henry Stevens was born in Vevay, Ind., a small town across the Kentucky border along the Ohio River. Stevens's father was an apothecary, from whom he learned chemistry, knowledge that enabled him to experiment with his multimedia artworks. At the age of 16, Stevens entered the Cincinnati Art Academy, where he studied under Kentucky painter Frank Duveneck, impressionist landscape artist Lewis

Will Henry Stevens, Circles and Half-Circle, n.d., pastel on paper,
26″ x 22″ (The Johnson Collection, Spartanburg, S.C.)

Henry Meakin, and painter-musician
Vincent C. Nowottny. After three years
at the academy, Stevens continued his
training in Cincinnati at the Rookwood
Pottery as a tile designer. In 1901 he
moved to New York to study at the Art
Students League.

Disenchanted with the teaching
methods of William Merritt Chase,

Stevens abandoned his studies. At the
age of 20, he had his first solo exhibi-
tion at the New Gallery on 30th Street,
where he became aware of current de-
velopments in international art. There
he was also befriended by impressionist
painter Jonas Lie, tonalist painter Albert
Pinkham Ryder, and landscape painter
Van Dearing Perrine, who founded the

Hudson River Sketch Club, which flourished between 1898 and 1912.

Stevens's fascination with Ralph Waldo Emerson's theories and Walt Whitman's poetry coalesced with Ryder's advice to approach paintings as a poet, all of which had a profound effect upon his work. He assimilated the philosophies of these men, as well as elements of Asian art and Taoist philosophies, in which he became interested during a visit to the Freer Gallery in Washington, D.C. Stevens wished to not only observe art but also to understand unseen underlying principles of nature—a process that he felt was a continuous endeavor.

In early 1921, Stevens, who had exhibited his work in the Vieux Carré two years earlier, moved to New Orleans to teach at Newcomb College. His enthusiasm for the city was such that he was one of the early advocates for the establishment of an art colony in the French Quarter. From its inception in 1919, Stevens was active with the Artists' Guild and its successor, the Arts and Crafts Club of New Orleans and its School of Art. Soon after his arrival in the state, he became an instructor for the Natchitoches Art Colony's summer sessions in northwestern Louisiana. Throughout his career, Stevens exhibited his works at Newcomb and the Arts and Crafts Club. He was one of the original members of A New Southern Group, an offshoot of the Arts and Crafts Club. Additionally, he was active with the Southern States Art League and the Art Association of New Orleans.

Stevens maintained that it was unnecessary to abandon representational art in favor of abstracted interpretations, and thus he drew and painted in both styles. He summered almost annually in western North Carolina and east Tennessee, teaching and painting views of the forested hills and valleys of the Appalachians. These sylvan views manifest an atmospheric sense of depth combined with a lyricism that recalls the work of Wassily Kandinsky and Paul Klee. Stevens's striated abstract compositions, often divided into three horizontal or vertical bands, feature recognizable elements amid floating geometric forms and shapes from his personal repertoire of motifs. Foliage, trees, birds, fish, clouds, and mountains merge in harmonious well-constructed designs in which all compositional elements have equal gravity.

During his long career, Stevens was honored for his artwork with a number of awards, including a 1931 Tiffany Foundation award, a 1914 Foulke prize in Richmond, Ind., for the best landscape at the New York Painters Show, and honorable mention in a Southern States Art League exhibition. After 27 years of teaching at Newcomb, Stevens retired in 1948. In ill health, he relocated to his hometown of Vevay and died the following year. A retrospective of his work was held at the Asheville Art Museum in North Carolina in 1967.

Stevens's work is represented in museum collections, including the Smithsonian American Art Museum, the Museum of Fine Arts in Boston, the Ogden Museum of Southern Art, the New Orleans Museum of Art, the Historic New Orleans Collection, the Louisiana Art and Science Museum in

Baton Rouge, the Los Angeles County Museum of Art, Greenville County Museum of Art in South Carolina, the Hunter Museum of American Art in Chattanooga, and the Morris Museum of Art in Augusta, Ga.

JUDITH H. BONNER
The Historic New Orleans Collection

Donald B. Kuspit et al., *Painting in the South, 1564–1980* (1983); Percy North and Will Henry Stevens, *Visions of an Inner Life: Abstractions by Will Henry Stevens* (1988); Estill Curtis Pennington, *Will Henry Stevens: From the Mountains to the Sea* (1994); Estill Curtis Pennington and James C. Kelly, *The South on Paper: Line, Color, and Light* (1985); Jessie Poesch, *Will Henry Stevens* (1987); Will Henry Stevens, *Will Henry Stevens: A Modernist's Response to Nature* (1987).

Straus, Meyer

(1831–1905) PAINTER.

Originally a scene painter in theaters and opera houses, Meyer Straus became known for his luminous bayou scenes and California landscapes. He was born in Bavaria in 1831 and emigrated from Germany to the United States in 1848 at the age of 17. He lived briefly in Ohio and relocated to St. Louis, where he worked as a scene painter in the Old Pine Street Theater. Straus traveled throughout the South painting stage sets—to Mobile, New Orleans, and other places. In 1869 he exhibited in New Orleans at Wagener and Meyer's at 166 Canal Street. He was engaged by Gilbert Spalding and David Bidwell at the Academy of Music from 1870 to 1872, where he painted elaborate adornments on the ceiling and around the theater. Straus's theatrical backdrops received glowing reports in local newspapers for the design and finish, causing performances to be oversold. He also exhibited his landscapes in business establishments around the city. In 1877, at the age of 41, he moved to Chicago and painted scenery at Hooley's Theater.

Straus, who suffered from failing health in the harsh Chicago winters, sought a milder climate. In 1875 he moved to San Francisco, where he worked for Tom Maguire of the Bush Street Theater and the Grand Opera House. The following year Straus made a painting trip to Aspen, Colo.; after his return to San Francisco in 1877, he established a studio at 728 Montgomery and devoted his time to easel painting. His work includes landscapes, still lifes, figure studies, interior scenes, and views of missions. Straus made sketching trips to Yosemite, Marin County, the Monterey Peninsula, and Oregon. Through these trips he earned a reputation for his landscapes of northern California. His work was illustrated in *Century Magazine* and other national journals.

Typically, Straus's bayou scenes derived from his time in the Deep South and compare favorably with luminous works by Joseph Rusling Meeker. Landscapes by Straus generally retain a sense of theatrical backdrops; dark, moss-draped trees in the foreground appear like coulisses, while a warm ethereal light emerges from a misty background and reflects on the still bayou waters. Often a small boat or an egret serves as a focal point or a means of directing the viewer's eye inward to the swamp's dark recesses.

By 1890 Straus had achieved considerable success through his painting, and at the age of 59 he became a naturalized citizen of the United States. His works were exhibited widely, including at the San Francisco Art Association from 1875 to 1910, the Mechanics' Institute in San Francisco from 1875 to 1897, the Morris and Schwab Gallery, the Bohemian Club, and the California State Fair from 1879 to 1896. In New Orleans his works were shown at the 1884–85 World's Industrial and Cotton Centennial Exposition, where he won an award for his paintings. Straus also won prizes at the California state fairs. His works are in the collections of the Louisiana State Museum, the Ogden Museum of Southern Art, the Morris Museum of Art in Augusta, Ga., the Nevada Museum in Reno, the Oakland Museum, the California Historical Society, and the Society of California Pioneers. Straus died in San Francisco at his home at 1604 Steiner Street on 11 March 1905.

JUDITH H. BONNER
The Historic New Orleans Collection

Edan Milton Hughes, *Artists in California, 1786–1940* (1986); John A. Mahé II and Rosanne McCaffrey, *Encyclopaedia of New Orleans Artists, 1718–1918* (1987); Estill Curtis Pennington, *Downriver: Currents of Style in Louisiana Painting* (1991).

Sugimoto, Henry Yuzuru

(1900–1990) PAINTER.

Prior to World War II, Henry Yuzuru Sugimoto enjoyed success as a landscape painter in California. The future was promising until the attack on Pearl Harbor, 7 December 1941. Within seven months Sugimoto and his family were evacuated from the West Coast to inland camps where they were held for the duration of the war. It was during this time that the focus of his art shifted from landscapes to narrative paintings.

Born in 1900 in Wakayama, Japan, Sugimoto spent his youth in the care of his maternal grandparents after his parents immigrated to Hanford, Calif. His artistic ability was evident at a young age when he drew art objects and artifacts, which filled the home. He was encouraged to draw by his grandfather, a former samurai. In 1919 he joined his parents in Hanford and earned a high school diploma and a degree from the California School of Arts and Crafts in Oakland, graduating with honors in 1928. He enjoyed artistic success in the late 1920s and 1930s, and his paintings were included in statewide exhibitions. Influenced by the impressionists, Sugimoto painted peaceful landscapes in a palette of earthy browns, reds, greens, and blues.

In 1930 Sugimoto studied at Académie Colarossi, a Paris art academy that attracted American, European, and Japanese students. He painted the landscapes of Paris and rural Voulangis, and several works were included in exhibitions, including the prestigious 1931 Salon d'Automne. After returning to California the artist continued to paint and exhibit landscapes of Carmel and Yosemite.

Following the Japanese bombing of Pearl Harbor, Sugimoto was among the 120,000 Japanese Americans forced

to move to inland camps. He and his family, including wife Susie and daughter Madeleine, were evacuated to Fresno Assembly Center, where they spent the summer of 1942. It was here that the artist found purpose for his life behind barbed wire as he began to document the experience in narrative paintings. His pictures were inspired by the murals of Diego Rivera and José Clemente Orozco, which he had seen in Mexico in 1939. Like the murals, his compositions are dominated by large figures of ordinary people. Based on personal experience, these narrative works transcend family history to tell the bigger story of incarceration. With only a few tubes of paint, three brushes, and a small bottle of turpentine, Sugimoto painted on pillowcases, sheets, government-issue mattress bags, and canvas that had wrapped household belongings. He continued to record the experience of incarceration when the family was moved to Jerome and later Rohwer Relocation Centers in the Arkansas Delta.

H. Louis Freund, visiting artist at Hendrix College in Conway, Ark., met Sugimoto at Jerome, and the artist shared his paintings. Freund encouraged Sugimoto to continue his documentary work and invited him to have a one-man show at the college. The 1944 exhibit included *Arrival in Camp Jerome* (1943), which Hendrix purchased. Today it hangs in the Wilbur D. Mills Social Science Center. The painting documents the family's arrival in Arkansas. The barracks were not yet ready, and the family had to sleep on the floor of a warehouse.

Executed in dry brush with a limited palette, the composition is dominated by the large figures of a mother, child, and father. Around the family are the few belongings they were allowed to take. Through an open door, a compositional device the artist uses frequently in the camp paintings, the viewer's eye is led beyond the confines of an interior space. Outside stands the steam engine of a train that had transported some of the 16,000 Japanese Americans to Arkansas. Also visible is the barbed wire fence that surrounded the camps.

Other works from this period record the experience, which was especially difficult for young mothers and the elderly Issei, the immigrant generation. *Mother in Jerome Camp* (1943) is an empathetic portrait of the artist's mother. Sugimoto captured the emotional strain she felt when her son Ralph volunteered for the 442d Regimental Combat Team, an all-Nisei unit that trained at Camp Shelby, Miss., and fought valiantly in Europe.

After World War II the Sugimoto family settled in New York City, where their son, Phillip, was born. Over the next 40 years the artist continued to document the wartime experience of Japanese Americans as well as their immigrant story. Henry Sugimoto succumbed to cancer in 1990. His works are held in the collection of the Wakayama Civic Library, Wakayama, Japan, and the Japanese American National Museum, Los Angeles, which organized the 2001 exhibition *Henry Sugimoto: Painting an American Experience*.

SUSAN TURNER PURVIS
Little Rock, Arkansas

Allen H. Eaton, *Beauty behind Barbed Wire* (1952); Deborah Gesensway and Mindy Roseman, *Beyond Words: Images from America's Concentration Camps* (1987); Karin M. Higa, *The View from Within: Japanese American Art from the Internment Camps, 1942–1945* (1994); Kristine Kim, *Henry Sugimoto: Painting an American Experience* (2000); Robert W. Meriwether, *Faulkner Facts and Findings* (Fall–Winter 1994).

Sully, Thomas

(1783–1872) PORTRAITIST.
Known primarily as a portrait painter, Thomas Sully completed over 2,000 portraits during his successful career. His often romantically styled paintings have been compared in skill to portrait artists like Gilbert Stuart and Sir Thomas Lawrence. One of nine children, Sully was born in Horncastle, Lincolnshire, England, on 19 June 1783. His parents, Matthew and Sarah Chester Sully, worked as actors, and in 1792 Sully's family immigrated to the United States. In America, young Sully was educated in New York and then in Charleston, S.C., where the family moved following his mother's death in 1794. In Charleston, the Sully family, including Thomas, continued to perform on stage. Sully attended Rev. Robert Smith's school and trained as an artist with his classmate and future miniaturist Charles Fraser and also with his French brother-in-law, Jean Belzons, a theater set designer, miniature artist, and art teacher.

Sully moved from Charleston in 1799 and continued his itinerant training with his older brother and fellow artist Lawrence, in both Norfolk and Richmond, Va. During this period he received further training from painter Henry Benbridge and completed his first commissioned miniature portrait in May 1801. He opened his first studio in Richmond in 1804. Following the death of his brother Lawrence that same year, Sully and his brother's widow, Sarah, married in 1806. The family maintained residences in Hartford, Conn., and New York City. During this time, Sully traveled to Boston and met with renowned portrait painter Gilbert Stuart and also worked as John Trumbull's assistant. Sully and his family moved to Philadelphia permanently sometime around 1807, where he shared a studio with miniaturist Benjamin Trott.

Sully traveled abroad to London, like many artists of his time, and visited the Royal Academy of Arts and Sciences, studying under Benjamin West in 1809. While in London, he shared a room with Charles Bird King. Sully returned to Philadelphia in 1810. By the time he was 36, he had completed accomplished works, including his stately portrait of Andrew Jackson (1819), made following the battle of New Orleans, and later a full-length painting of Queen Victoria (1838). In addition to portraits, Sully also painted genre scenes, landscape scenes, and history paintings. One such example is *Interior of Capuchin Chapel* (1821), modeled after François Granet's rendering of the church, which is located on the Piazza Barberini in Rome. In March 1841 the *New Orleans Bee* advertised Sully's *Interior of Capuchin Chapel*, which was on display at the St. Charles Hotel in New Orleans.

The artist received several commissions from patrons living in the South. James Robb, an affluent businessman and avid art collector who lived in the Garden District of New Orleans, commissioned Sully to paint his wife and three children while the family was visiting Philadelphia during the summer of 1844. In addition to this painting, *Portrait of Mrs. James Robb and Her Three Children*, he painted *Louisa Werninger Robb*, a portrait of Robb's wife. This portrait is believed to be a study for the group painting of the Robb family. Other portraits of affluent southerners completed by Sully include *Portrait of Miss Frances Minor, Natchez* (1816), *Mrs. Bernard Mandeville de Marigny* (1808), and *Count Bernard Mandeville de Marigny* (1808).

Sully discusses portraiture in *Hints to Young Painters* (1873), his treatise on form, style, and content, stating that "from long experience I know that resemblance in a portrait is essential; but no fault will be found with the artist, (at least by the sitter), if he improve the appearance." In addition to writing *Hints to Young Painters*, Sully was also a skilled teacher. His pupils included William Edward West, James Reid Lambdin, and Robert Ross. Sully exhibited frequently at the Pennsylvania Academy of the Fine Arts, where he served as director for 15 years. He also exhibited at the Boston Athenaeum and at the National Academy of Design, in which he was an honorary member. Sully died in Philadelphia on 5 November 1872 at the age of 89.

KATE BRUCE
The Historic New Orleans Collection

Artists' Files, Williams Research Center, Historic New Orleans Collection; John Clubbe, *Byron, Sully, and the Power of Portraiture* (2005); Randolph Delahanty, *Art in the American South: Works from the Ogden Collection* (1996); Donald B. Kuspit et al., *Painting in the South, 1564–1980* (1983); John Frederick Lewis, foreword, *Catalogue of the Memorial Exhibition of Portraits by Thomas Sully* (1992); John A. Mahé II and Rosanne McCaffrey, eds., *Encyclopaedia of New Orleans Artists, 1718–1918* (1987); Fabian H. Monroe, *Mr. Sully, Portrait Painter: The Works of Thomas Sully, 1783–1872* (1983); Jessie Poesch, *The Art of the Old South: Painting, Sculpture, Architecture, and the Products of Craftsmen, 1560–1860* (1989); Martha R. Severens, *Greenville County Museum of Art: The Southern Collection* (1995).

Taylor, Anna Heyward

(1879–1956) WATERCOLORIST.
At the turn of the 20th century, women artists began to shed the restrictions of the Victorian age. They took their training seriously, often filling classes at art schools in Philadelphia, New York, and Boston and enjoying summer courses held in such agreeable locales as Provincetown, Mass., and Shinnecock, N.Y. Columbia, S.C., native Anna Heyward Taylor was one of the many women to pursue this course, which introduced her to a vast world beyond South Carolina, part of a South that was described by H. L. Mencken as "the Sahara of the Bozart."

Born in the state capital, Taylor descended from a long line of distinguished statesmen and planters. She graduated from college in her hometown before spending a term as a graduate student at Radcliffe College.

Taylor studied with William Merritt Chase in England and Holland and was traveling in the Far East at the outbreak of World War I. She spent the summer of 1916 in Provincetown just as other artists were inventing the white-line wood-block print, a process well suited to her skills and aesthetic leanings. That same year she joined a four-month expedition to British Guiana, where she did the floral studies she later translated into wood-block prints and batik designs.

During the 1920s Taylor resided in New York, but in 1929 she moved to Charleston, where she had the opportunity to meet tourists and other artists of the Charleston Renaissance, the artistic revival that took place in the 1920s and 1930s. The subjects of her prints most often were the Gullah population, especially street vendors. In 1949 her striking black-and-white prints served as the illustrations for *This Our Land* (1949), a history of agriculture issued by the Agricultural Society of South Carolina. In addition to printmaking, Taylor was an accomplished watercolorist, a medium she used frequently for Lowcountry landscapes and during her trips to Mexico in the mid-1930s.

MARTHA R. SEVERENS
Greenville, South Carolina

Chalmers Murray, *This Our Land* (1949); Martha R. Severens, *Anna Heyward Taylor, Printmaker* (1987), *The Charleston Renaissance* (1998); Edmund R. Taylor and Alexander Moore, *Selected Letters of Anna Heyward Taylor: South Carolina Artist and World Traveler* (2010).

Thieme, Anthony

(1888–1954) PAINTER.

Although his parents opposed an art career for their son, Anthony Thieme studied painting at the Academy of Fine Art in Rotterdam and at the Royal Academy of Art in The Hague, as well as in Italy and Germany. In 1910 Thieme designed a New York stage production starring Russian ballerina Anna Pavlova, and after immigrating to Boston in 1917 he worked there as a set designer. By 1928 he had turned his talent to easel painting; in 1929 he established an atelier in Rockport, Mass.

Thieme's fame as a Rockport artist soared during the 1930s and 1940s, and the artist was credited for the national appeal of the quaint coastal village. This reputation was largely a result of his painting *Motif No. 1*, a dark-red Rockport fishing shack along the water, reproduced in countless internationally dispersed prints and Christmas cards, from which Thieme earned a reported $200,000.

Throughout his career, Thieme was a member of several organizations, including American Watercolor Society, Salmagundi Club, Connecticut Association of Fine Art, Boston Art Club, Providence Watercolor Club, North Shore Art Association, Springfield Art League, Rockport Art Association, and Philadelphia Art Alliance. A recipient of numerous awards, including two Shaw prizes, he exhibited at the National Academy of Design, Art Institute of Chicago, Pennsylvania Academy of the Fine Arts, Salmagundi Club, Gloucester Art Association, and other prestigious venues.

In late December 1946 a fire destroyed Thieme's Rockport studio, but fortunately some of his paintings were saved. In May 1947 Thieme visited Charleston, S.C., "a 'natural' for his particular talents." Charleston and its environs inspired Thieme to paint colorful impressionist scenes of sun-dappled doorways. These were similar to works by his Boston colleague Abbott Fuller Graves that portrayed New England colonial doorways, as well as such picturesque views as an entrance to a magnolia garden. Charming street scenes were also portrayed, including *Broad Street, Charleston*, and *Meeting Street in the Rain*. Among the several paintings of "gracious houses, lovely old stairways and gates, live oaks, churches . . . with all color and technical skill which his audience has long come to expect" were *Stono River* and *Trees at Stono Bay*. The paintings were featured at Manhattan's Grand Central Art Galleries in a show aptly entitled *Old Charleston*.

Thieme traveled farther into the American South, however, and became the most important member of the Lost Colony art group, which flourished from 1930 to 1950 in St. Augustine, Fla. He arrived in St. Augustine at the beginning of 1948, established a studio, and joined the St. Augustine Arts Club (later reorganized as the St. Augustine Art Association). Thieme pronounced St. Augustine "an outstanding first choice of all Florida for artists." His scenes of the city were well received, one newspaper declaring, "The artist . . . finds tremendous inspiration not only in the gracious old city within the gates . . . but in the negro sections, at the docks,

[and] in the swamps by the rivers." He painted shanties in Palatka, beaches in Ponte Vedra, shacks along the Suwannee River, and luminous works of the St. Johns River—a favorite subject of the artist. In Florida he was consistently called "the master of light" because of his deft manner of capturing the transient play of sunlight on Florida waterways and foliage.

As he did in Rockport, Thieme helped publicize St. Augustine, and its chamber of commerce featured his work in at least one advertisement in a national periodical enticing artists to the city. Thieme won the Dow Award in St. Augustine in 1949, and that year he also won a prize at Miami Beach's Art Center. His paintings were shown in Miami Beach again at the Robinson Galleries in 1951.

Sadly, in 1954, at the age of 66, the depressed artist committed suicide in a Greenwich, Conn., hotel on his way to Florida. Grand Central Art Galleries continued exhibiting his work, as did his wife at the Thieme Galleries in Via Parigi and Via De Mario in Palm Beach. Thieme's work can be found in the Metropolitan Museum of Art, the Boston Museum of Fine Art, the Montclair Art Museum, the New Britain Museum of Art, the Morris Museum, and many other distinguished collections, both public and private.

DEBORAH C. POLLACK
Palm Springs, Florida

Bridgeport Telegram (December 1954); Bruce W. Chambers, *Art and Artists of the South: The Robert P. Coggins Collection* (1984); Jo Gibbs, *Art Digest* (May 1947); Martha R. Severens, *Charleston Renaissance*

(1998); Robert W. Torchia, *Lost Colony: Artists of St. Augustine, 1930–1950* (2001).

Thomas, Alma Woodsey

(1891–1978) PAINTER.

Alma Woodsey Thomas overcame barriers of race, gender, and age to become a respected, nationally known artist. She was born in Columbus, Ga., in 1891 into an educated, middle-class African American household; her father was a businessman and her mother was a dress designer. Her maternal grandparents had a farm nearby in Alabama, where Thomas first developed the love for nature and the environment that would become the inspiration for her artwork.

The lack of educational opportunities for their children in Columbus and fears resulting from the Atlanta race riots of 1906 convinced Thomas's parents to move to Washington, D.C. In 1907 she began studies at Armstrong Technical High School, where she was most interested in architecture, math, and science. Thomas studied to become a kindergarten instructor at the Miner Teacher Normal School and then worked for six years in a settlement house in Wilmington, Del. She returned to Washington, D.C., and at the age of 30 entered Howard University to study costume design in the economics department. Thomas was soon persuaded to enter the fine arts department by its creator, James Herring. In 1924 she was the department's first graduate and possibly the nation's first African American woman to receive a degree in fine arts.

In 1925 Thomas began teaching at Shaw Junior High School in Washington, D.C., a post she held for 35 years. She painted in her spare time and from 1930 to 1934 spent her summers in New York earning an M.A. degree in education at the Teachers College of Columbia University. During her many years of teaching, Thomas was active in the Washington, D.C., art scene. She established art galleries in the public schools and organized art clubs and lectures for her students. In 1934 Thomas helped found the Barnett Aden Gallery, the first modern art and nonsegregated gallery in Washington, D.C. She joined the Little Paris Group of painters, led by her friend and Howard University art professor Lois Mailou Jones.

Thomas's early artwork was based in realism, but her painting style changed after she was exposed to the work of modern and contemporary artists while taking evening and weekend classes at American University from 1950 until 1960. She began to experiment with abstraction, a pursuit she followed full time after her retirement from teaching in 1960. Ultimately, she discovered the vibrant colors of acrylic paint that would characterize her later paintings; she also made preparatory watercolor sketches as studies for larger paintings. Thomas developed a distinctive style of rhythmic mosaics of color applied in geometric shapes. Members of the Washington Color school were her contemporaries, and she is often associated with that group. Although her work shares their expressive use of color, it differs in significant ways, as in the use of commercially prepared rather than raw canvases. Furthermore, she did not see her work as complete abstractions,

Alma Woodsey Thomas, Air View of a Spring Nursery, 1966, acrylic on canvas, 48" x 48"
(Collection of the Columbus Museum, Columbus, Ga.; Gift of the Columbus–Phenix City
National Association of Negro Business Women and of the artist, G.79.53)

commenting that she was "painting nature."

Thomas's work was shaped by her interest in the optical effects of pure color, natural phenomena, and air and space travel. She stated that she was "inspired by watching the leaves and flowers tossing in the wind as though they were dancing and singing." *Air View of a Spring Nursery* is an interpretation of the way colorful rows of plants in a nursery would appear from an airplane. Areas of bold color are made orderly by their placement in neat rows interspersed with sections of white canvas, a technique that adds depth to a composition.

In 1972 Thomas became the first African American woman to be given a solo exhibition at the Whitney Museum of American Art. That same year the Corcoran Gallery of Art held a retrospective exhibition of her work. The Fort Wayne Museum of Art in Indiana organized a traveling show of her art in 1998. Her work is collected by major

museums, including the Art Institute of Chicago, the Metropolitan Museum of Art, and the Wadsworth Atheneum Museum of Art in Hartford, Conn. The Smithsonian American Art Museum holds Thomas's papers, and the Columbus Museum in Georgia owns a large number of her paintings, watercolors, and ceramics, as well as the family's furniture and an important archive of her family and personal papers.

KRISTEN MILLER ZOHN
Columbus Museum
Columbus, Georgia

Charles T. Butler, ed., *American Art in the Columbus Museum: Painting, Sculpture, and Decorative Arts* (2003); Merry A. Foresta, *A Life in Art: Alma Thomas, 1891–1978* (1981); Fort Wayne Museum of Art, *Alma W. Thomas: A Retrospective of the Paintings* (1998); Michael Rosenfeld Gallery, *Alma Thomas: Phantasmagoria, Major Paintings from the 1970s* (2001); *Washington Post* (25 February 1979).

Toole, John

(1815–1860) PAINTER.

Like a countless number of his peers, John Toole had to travel constantly to find customers for his portraits. While maintaining a permanent home outside Charlottesville, Va., he found work throughout the region now encompassed by the states of Virginia and West Virginia. In major cities like Richmond and Norfolk, Toole rented residences and advertised his presence in the local newspaper. While traveling in the countryside, he resided in his patrons' homes for the duration of his commission. Toole's portraits, most

of which remain in family collections, have received little scholarly attention. Nonetheless, Toole had a prolific career, producing over 300 known works in a variety of media. An 1860 obituary in the *Virginia Advocate* reported, "He was a Portrait Painter, and in that capacity was well and favorably known in many parts of this Commonwealth."

Born in Dublin, Ireland, Toole immigrated to Charlottesville in 1827. After the sudden death of his father he went to Virginia to live with his uncle George, a tailor and cobbler. Little else is known about Toole's life between the period of his immigration and 1838, at which time he took up his artistic career. Though family tradition asserts that Toole attended the University of Virginia, none of that institution's records list him as a registered student. Nonetheless, copious numbers of letters and paraphernalia indicate that he was well read and an eloquent writer.

Although Toole may have experimented with portrait painting as early as 1832, he worked during the mid-1830s as a pharmacist and tavern keeper. He did not turn to art as his primary career until 1838. His decision to take up portrait painting was possibly motivated by the desire to earn a more substantial living. No records indicate that Toole had any training other than copying fine art engravings and magazine illustrations, infrequent observations of other artists' work, and the study of books—particularly an English translation of Charles LeBrun's 17th-century lectures to the French Royal Academy on the appearance of passions in human

countenance. Toole's main patrons were upper-middle-class Virginians, whose acquaintance he sought through involvement in the Democratic Party and membership in the Freemasons.

Portrait painting was the main source of Toole's income, but he did not limit himself to that genre. A few extant landscapes and history paintings indicate that he also attempted to expand his skills. All of Toole's known landscapes, certainly inspired by contemporary illustrations, depict locales that the artist never had the opportunity to visit. These works were not commissioned but were displayed in the artist's studio as an advertisement of his skill.

During the 1850s the increasing popularity of daguerreotypes infringed upon the market of itinerant portrait painters, and in 1857 Toole entered into a partnership with the Minnis daguerreotype studio in Petersburg. Toole painted portraits after daguerreotypes, thereby eliminating the customer's need to sit for extended periods. When he died of tuberculosis in 1860 his profession was rapidly waning, as the next generation preferred the speed and lower price of photographs. Institutions holding works by Toole include the National Gallery of Art, the University of Virginia Art Museum, and the Virginia Historical Society.

CHRISTOPHER C. OLIVER
University of Virginia

William B. O'Neal, *Primitive into Painter: Life and Letters of John Toole* (1960); Papers of John Toole, 1838–92, Special Collections, University of Virginia Library, Charlottesville.

Town, A. Hays

(1903–2005) ARCHITECT.

Although he lived in Mississippi for only 13 years, architect A. Hays Town had a profound impact on the state's built environment. Town's contribution came through two very distinct phases of his long and illustrious career. During his first period of influence, when he lived in Mississippi, he helped to introduce modern architecture to the state; during his second period of influence he was influential in rekindling an interest in Mississippi's vernacular architectural traditions.

Town was born in 1903 in Crowley, La., and was educated at Southwestern Louisiana Institute (now the University of Louisiana at Lafayette) and at Tulane University. He moved to Mississippi in 1926 to work as an intern in the office of prominent Jackson-based architect N. W. Overstreet. By the time he left the state in 1939, Town had become Overstreet's partner and, with his partner's encouragement, had designed modern concrete structures across the state. Many of these structures were built under the public relief programs of the Great Depression. Of these projects, many were schools, including Church Street School in Tupelo, Bailey Junior High School in Jackson, Bowmar Avenue School in Vicksburg, and Columbus High School. This work was widely published nationally and internationally and, as Overstreet had hoped, helped to further Mississippi's reputation as a progressive state and pave the way for a broader acceptance of modern architecture.

Town's family obligations took him back to his home state of Louisiana, where he established what, after World War II, became one of Baton Rouge's largest commercial architectural offices. Despite his great success, Town took increasing interest in the firm's smaller residential commissions, where he could experiment with forms and ideas derived from childhood memories of traditional architecture in southern Louisiana. He also found inspiration in his recollections of his work with the Historic American Buildings Survey documenting Mississippi's early buildings. Beginning in the 1960s Town divested himself of most of his commercial work and much of his staff so that he could focus on the exploration of the diverse vernacular architectural traditions of the Deep South. He developed a unique and flexible architectural vocabulary that was inspired by traditional building materials and methods but which could be effectively applied to contemporary architectural problems.

Town's later, more traditional practice was centered on his home in Louisiana, but it also extended into neighboring states. After the death of Overstreet, his former partner, Town renewed his practice in Mississippi. He designed a number of homes in the suburbs of north Jackson, including the Sturgis House and the Puckett House in Eastover, as well as in other locations around the state, including the Elliott House in Brookhaven and the Lampton House in Columbia. These houses illustrate the stylistic variability and compositional flexibility of Town's later work. He often imagined his buildings to have

been built over time as a series of separate projects or subsequent additions, each of which had its own character and form. This later phase of Town's career included the design of almost 1,000 houses and continued until a few years before his death, in 2005.

Design strategies derived from the final phase of Town's career influenced architects and designers from across the Deep South and were applied, with varying degrees of success, to a wide range of building types. Town's work demonstrated the enduring relevance of vernacular traditions and set a new standard against which work of this type could be judged. His influence continues to echo in ongoing developments in Mississippi and surrounding states.

DAVID SACHS
Kansas State University

N. W. Overstreet and A. Hays Town, *Architecture and Design: Work from the Offices of Overstreet and Town* (1937); David Sachs, *The Life and Work of the Twentieth-Century Architect A. Hays Town* (2003); A. Hays Town, *The Architectural Style of A. Hays Town* (1985); Cyril E. Vetter and Philip Gould, *The Louisiana Houses of A. Hays Town* (1999).

Trivigno, Pat

(b. 1922) PAINTER AND TEACHER.
The only child of Italian immigrants, Pat Trivigno was born in Queens, N.Y. He has had a lifetime interest in art, which was encouraged by his parents. At the age of 12 he was selected to be in the first class of the new Fiorello H. La-Guardia High School of Music and Art. As a teenager Trivigno made weekly visits to local museums, including the

Metropolitan Museum of Art, to examine old master paintings. Additionally, he was able to view murals that Mexican muralist Diego Rivera was painting for the Rockefeller Center. Trivigno studied at the Leonardo da Vinci Art School and the Art Students League in New York City. He received a B.A. degree in art history from Columbia University. Continuing his schooling at Columbia, he earned an M.A. degree in painting in 1946. Trivigno also studied at the Tyler School of Art at Temple University in Philadelphia, New York University, the University of Iowa in Iowa City, and the University of California at Berkeley.

An influential teacher and artist, Pat Trivigno joined the faculty of the Art Department at Newcomb College of Tulane University in 1947 after his service in the U.S. Army. He taught at the university for over 40 years. Trivigno served as associate chair of the department and in 1978 became chair. He also taught on the art faculty of Columbia University and the University of Michoacán in central Mexico. He retired from teaching in 1990.

When Trivigno first arrived in New Orleans, there were few art galleries, the most prominent of which was the Arts and Crafts Club of New Orleans, located in the French Quarter. Although Trivigno exhibited with the Arts and Crafts Club, he continued to show his work in New York galleries as well. He has held solo shows in that city at the Rose Fried Gallery, Jacques Seligmann Galleries, Saidenberg Gallery, Bonino Gallery, Rehn Gallery, and the Luyber Gallery.

Trivigno has exhibited widely throughout the United States as well as Europe. In 1978 his work was included in a traveling exhibition organized by the Guggenheim Museum, which toured European embassies, including those in Paris and Bucharest. That same year Trivigno was elected a member of the examining committee of the National Association of Art Schools, an organization that establishes national standards for undergraduate and graduate degrees. Trivigno's former students who achieved national fame include Ida Kohlmeyer and Lynda Benglis, among a long list of others who practice their art in Louisiana.

Trivigno's early work reflects the influence of cubist painters as well as the Mexican muralists, particularly his *Seedseller* (1952), a monochromatic composition in which the poverty-stricken subject is rendered empathetically. The overall effect is one of dignity and elegance. From this point Trivigno's works proceed through a palette of earth tones and subdued abstracts to one of dramatic, colorful, friezelike harmonious explosions of color rendered in energetic brushstrokes. His large canvases include a 90-foot-long mural in the New Orleans Arena, completed in 2003, that focuses on lively athletic activities, including circus acrobats and similar scenes appropriate to a sports arena. This representational mural includes depictions of basketball players Michael Jordan, Patrick Ewing, and "Pistol" Pete Maravich, soul singer Irma Thomas, and guitarist Eric Clapton.

Many of Trivigno's compositions,

like *Fleur du Mal*, are rendered with mathematical precision. His canvases are poetic and contemplative, and the viewer cannot absorb his works in a cursory glance. Critic–art historian John Alford described Trivigno's paintings in 1960 as "based on a full recognition of a cultural heritage." In 1983 art historian, critic, and teacher John Canaday described Trivigno's large nonobjective paintings like *Firebird Rookery*, which are inspired by nature, as climatic works focusing on the four elements of earth, air, fire, and water "where expressive abstraction and motifs from nature are harmoniously fused."

Trivigno is represented in numerous public and private collections. In 1994 the New Orleans Museum of Art organized a major retrospective of his work.

JUDITH H. BONNER
The Historic New Orleans Collection

Judith H. Bonner, *Newcomb Centennial, 1886–1986: An Exhibition of Art by the Art Faculty* (1987); Peter Falk, *Who Was Who in American Art* (1999); Pat Trivigno, John Canaday, and New Orleans Academy of Fine Arts, *Pat Trivigno: Paintings* (1983); Pat Trivigno, Luba B. Glade, and New Orleans Museum of Art, *Pat Trivigno: The Search for Inner Form* (1994).

Trott, Benjamin

(ca. 1770–1843) PAINTER.
Although Benjamin Trott was born in Boston, he had a strong association with the South. His first known works are bust-length oil portraits of residents of Nottoway and Amelia counties in Virginia that he may have painted in collaboration with William Lovett in 1793. Trott advertised his drawing school,

opened late that same year in Boston, and his skill in miniature painting; in May of the following year he noted his ability to execute "miniature painting and devices in hair." By 1794 Trott had moved to New York City, where he painted miniature watercolor-on-ivory copies of Gilbert Stuart's oil portraits. It is possible that Stuart may have trained him.

Author William Dunlap notes that Trott "followed or accompanied Stuart" to Philadelphia in 1794. During Trott's early years there, his ties to Stuart provided him with commissions. He is listed in the Philadelphia directories in 1805, but Dunlap noted that "in 1805 Mr. Trott visited the western world beyond the mountains, traveling generally on horseback, with the implements of his art in his saddle-bags. This was a lucrative journey." During this trip, he worked in Lexington, Ky., producing at least seven miniatures. After returning to Philadelphia, he probably made at least one trip to Baltimore.

Trott painted miniatures in Philadelphia from 1806 to 1819, the height of his career. He taught drawing classes at the Society of American Artists and exhibited at its shows from 1811 to 1814. Trott benefited from a close association with Thomas Sully, who may have introduced him to Benjamin Chew Wilcocks. It was Wilcocks who provided both men with extensive patronage and was a pivotal figure in Trott's career. Trott's Philadelphia patrons were mostly young men and women whose families had dominated the city and state in the 18th century but who by 1800 had largely lost political control and increasingly shared

economic power with a burgeoning merchant community.

By all indications Trott traveled considerably during the 1820s and 1930s, probably in pursuit of commissions. He visited Charleston ("his prospects [were] bad," according to Dunlap) during 1819 and 1820. Trott may have painted in Newark, N.J., in 1823 and is known to have worked in New York City from 1828 to 1833. Although he is listed in the directories as a portrait and miniature painter, no late oil portraits by his hand are known. Trott lived in Baltimore in 1838 and 1840–41, where he painted at least one of his three late portraits of George Washington after Stuart's Athenaeum portrait.

Trott parlayed his ties to Stuart into commissions throughout his career, although there is no evidence that they worked together after the 1790s. His contemporaries were undoubtedly knowledgeable about the connection, as Trott's obituary notes: "It was his proud boast that he had been the intimate friend of the celebrated GILBERT STUART. . . . Trott was an enthusiastic follower of his profession. His mind was vigorous, his genius undoubted, and his reputation equal to that of any other engaged in similar pursuits. His style of miniature coloring was rich and decisive, and bore a strong resemblance to the oil paintings of his friend STUART." The obituary indicates that Trott associated himself with Stuart until the end of his life and that others recognized a similarity in their work.

ANNE VERPLANCK
Chadds Ford, Pennsylvania

Theodore Bolton, *Art Quarterly* (Autumn 1944); William Dunlap, *The Diary of William Dunlap*, vols. 2 and 3 (1931), *A History of the Rise and Progress of the Arts of Design in the U.S.*, vols. 2 and 3 (1918); Dale Johnson, *American Portrait Miniatures in the Manney Collection* (1991); Anne Verplanck, "Benjamin Trott: Miniature Painter" (M.A. thesis, College of William and Mary, 1990).

Troye, Edward

(1808–1874) ANIMAL PAINTER. Edward Troye has long been regarded as 19th-century America's most important painter of thoroughbred horses. For 40 years, from 1832 until 1872, he traveled the country painting portraits of the most noted racers, stallions, and mares. Arriving in America just as turf racing reached its peak, Troye found a ready market. It was the "palmy time of the turf," and horsemen in America, as proud of their stock as their English counterparts, followed the European practice of documenting their prized animals in oil portraits. Troye was the first of the sporting artists to firmly establish himself in America, and he became the benchmark for those who followed.

Troye was born Edouard de Troy to French parents in Lausanne, Switzerland, on 12 July 1808. Following the early death of his mother, Troye's father, sculptor Jean-Baptiste de Troy, moved the family to England, where Edward received his art training and education. Jean-Baptiste achieved great acclaim as an artist in Europe, and at least two of Troye's siblings are listed as noted artists as well. Edward, however, left Europe

and sailed for America at the age of 20 by way of a two-year stint in the West Indies. He ultimately landed in Philadelphia and began work in the shop of John Sartain, America's prominent engraver of that period. This connection eventually proved useful in promoting Troye's career.

Troye's patrons were wealthy merchants of the North and the landed gentry of the South. In 1832 a prominent Philadelphia citizen viewed three of Troye's canvases in an exhibition at the Pennsylvania Academy of the Fine Arts and commissioned him to paint a portrait of his horse. John C. Craig owned racehorses with Col. William Ransom Johnson of Virginia. A better entrance into the world of thoroughbreds could not have been planned, for the colonel was known as the "Napoleon of the Turf." Troye immediately found the most renowned thoroughbreds standing before his easel. One of Troye's earliest portraits was of Col. Johnson's "great little mare," Trifle. She won 20 of her 24 races, earning $14,380. In the early years of his career Troye painted as many as 11 horses belonging to Craig and Johnson, including the most famous: Medley, Reality, Industry, and Goliah.

Just as Troye began his profession, America's first sporting magazine, the *American Turf Register and Sporting Magazine*, was created. The periodical was primarily devoted to the turf, and over a period of 15 years as many as 21 of Troye's portraits were engraved and printed within its pages. The most talented engravers of the day reproduced his portraits in the monthly, which was carried to every important horse owner and breeder in the country. From Long Island to New Orleans, from Virginia westward to Mississippi, reproductions of Troye's work were viewed. Few important horsemen failed to have their cherished bloodstock painted by Troye. Just as itinerant portrait artists moved about painting the faces of American society, Troye traveled from racecourse to plantation, recording on canvas the likenesses of their horses. Troye was equally proficient with his renderings of landscapes; and his patrons in the agricultural South especially desired portraits of their two vital commodities: prized livestock, standing in the middle of their valuable land. Recognizable backgrounds of 19th-century America were appreciated then as they are treasured now.

Troye's popularity was established early, but his talent sustained his career. Horsemen knew their stock, and they required true representations. Troye's success hinged on his ability to delineate accurately the points of a horse. It was a time before the general use of photography, and Troye's portraits secured authentic images of the foundation sires and mares of the American thoroughbred. Edward Troye spent his life to this end. He died suddenly at the age of 66 at the Georgetown, Ky., home of his friend and patron Alexander Keene Richards. His portraits of such greats as Boston, Lexington, Kentucky, Leviathan, and the equally remarkable brood mares Ophelia, Reel, and Reality are pictorial legacies of animal painter Edward Troye.

GENEVIEVE B. LACER
Simpsonville, Kentucky

J. Winston Coleman Jr., *Edward Troye* (1958), *Three Kentucky Artists: Hart, Price, Troy* (1974); Georgetown and Scott County Museum and Georgetown College Art Department, *Edward Troye* (2003); Genevieve B. Lacer, *Edward Troye: Painter of Thoroughbred Stories* (2006); Genevieve Baird Lacer and T. J. Scott, *A Troye Legacy: Animal Painter* (2010); Alexander MacKay-Smith, *The Race Horses of America, 1832–1872: Portraits and Other Paintings by Edward Troye* (1981).

Turner, Helen Maria

(1858–1958) PAINTER.

Helen Maria Turner, the seventh child of Mortimer and Helen Davidson Turner of New Orleans, was born in Louisville, Ky., during an extended vacation. Laurette "Lettie" Turner, the eighth child, was born after the family relocated to Baton Rouge at the beginning of the Civil War. Mortimer Turner, a coal merchant, operated river and coastal cargo boats within Louisiana's waterways. His boats were confiscated by Union troops, who also burned down the family home. In 1862 the Turners lost their oldest child, 17-year-old Charles, who died while serving in the Confederate army. Two months after the war's end the family suffered an additional setback when Mrs. Turner died. Six years later the children were orphaned when their father died, after which their maternal uncle, Dr. John Pintard Davidson, assumed the care of the eight siblings. Davidson came from a family that was predisposed toward art and preservation—his grandfather was a founder of the New York Historical Society (1804) and the American Academy of Fine Arts (1816).

Turner graduated from the Louisiana State Normal School, a school for training teachers, although she was developing a serious interest in art. She made palmetto fans, paper flowers, and decorations for Mardi Gras, but the meager income did not permit her to study in New York. The 1884–85 World's Industrial and Cotton Centennial Exposition, which was organized to call attention to the business and technological advances in post-Reconstruction New Orleans, also focused attention on European and American art. A consequence of this was the arrival of Massachusetts-born William Woodward, who taught art at the exposition and then at the newly formed Saturday Free Drawing classes. Turner studied at Woodward's classes and at the Artists' Association of New Orleans, where she was encouraged by Swedish painter-teacher Bror Anders Wikström. From 1893 to 1895 she taught art at St. Mary's College in Dallas, saving sufficient money to allow her to study in New York. Her sister, Laurette, traveled with her and kept house in order for Turner to devote herself to painting.

In 1895, at the age of 37, Turner began her studies at the Art Students League, with Kenyon C. Cox, Joseph Rodefer De Camp, Douglas Volk, and Arthur Wesley Dow. From 1898 to 1901 she studied at the Women's Art School at Cooper Union, earning first prize for an 1898–99 oil portrait, and then continued studies at Columbia University. Turner taught at the YMCA from 1902 to 1919. Beginning in 1906 at the invi-

tation of fellow artist Charles Courtney Curran, she spent nearly every summer at Cragsmoor art colony in Ulster County, N.Y., from 1906 through 1941, except for student trips with William Merritt Chase to England, Spain, and Italy in 1904, 1905, and 1911. She built a summer home and studio at Cragsmoor in 1910, painting local scenes and portraits.

Turner began to receive recognition and held an exhibition at Gimbels department store in New York in 1912. The following year she was voted into associate membership in the National Academy of Design (NAD), and the Metropolitan Museum of Art purchased one of her miniature portraits. In 1915 she exhibited three paintings at the Panama-Pacific Exposition in San Francisco. Turner, Daniel Garber, and Emil Carlsen exhibited their impressionist works together in New York at the Macbeth Gallery in 1916. She then held her first solo show in that city at the E. A. Milch Gallery and was one of six American women artists, including Mary Cassatt, who were featured in a traveling exhibition organized by the City Museum of St. Louis. In 1921 Turner was selected for full membership in the NAD, the fourth woman and the first artist from Louisiana elected to academician status.

In 1926, three years after Laurette's death, Turner made her permanent residence in New Orleans, where she became known for her portrait painting, especially of women and children. She became active with the Arts and Crafts Club of New Orleans, where she taught and showed her work while continuing

to exhibit outside the city. She became close friends with Louisiana artists Angela Gregory, Ella Miriam Wood, Nell Pomeroy O'Brien, and Clarence Millet. Turner's portrait of photographer Joseph Woodson "Pops" Whitesell was painted when she was 88 years old. In 1949, at the age of 90, she held a solo exhibition at the Isaac Delgado Museum of Art (now the New Orleans Museum of Art). Turner died in the city at the age of 99.

With the 1974 centennial of the first exhibition of paintings by the French impressionists, there was a revival of interest in American impressionist artists, especially women artists. In 1983 art historian Louis Hoyer Rabbage brought attention to Turner's work with a retrospective exhibition featuring 69 of her paintings at the Cragsmoor Free Library in Ulster County, N.Y. In 1986 the Greenville County Museum of Art in South Carolina and the Gibbes Art Gallery in Charleston, S.C., celebrated the work of eight southern women artists: Turner, Blanche Lazell, Josephine Marien Crawford, Nell Choate Jones, Clara Weaver Parrish, Alice Ravenel Huger Smith, Mary Harvey Tannehill, and Anne Wilson Goldthwaite.

JUDITH H. BONNER
The Historic New Orleans Collection

William U. Eiland, Donald D. Keyes, and Janice Simon, *Crosscurrents in American Impressionism at the Turn of the Century* (1995); Jane Ward Faquin and Maia Jalenak, *Helen M. Turner: The Woman's Point of View* (2010); Greenville County Museum of Art, Gibbes Art Gallery, *Eight Southern Women* (1986); Maia Jalenak, "Helen M. Turner: American Impressionist" (M.A. thesis,

Louisiana State University, 2003); Donald Keyes, *Impressionism in the South* (1988); Lewis Hoyer Rabbage, *Helen M. Turner, NA (1858–1958): A Retrospective Exhibition* (1983); Maureen Radl, *A Century of Women Artists in Cragsmoor* (1979).

Valentine, Edward Virginius

(1838–1930) SCULPTOR.

The son of a prosperous merchant and member of a family who had lived in Virginia since the middle of the 17th century, Edward Virginius Valentine was born in Richmond, where he received his early education from tutors and private schools. He later attended the University of Virginia. Awarded a silver medal for a bust of the *Apollo Belvedere* in 1855, he began studying anatomy at the Medical College of Virginia the following year. After exhausting the resources of local artists, Valentine went abroad for further study: to London (1859), Paris (1859–60), and Italy (1861). In 1861 Valentine went to Berlin, where he studied with eminent sculptor August Karl Eduard Kiss (1802–65) until the latter's death four years later. Valentine then returned to Richmond and opened a studio as the Civil War was drawing to an end.

Although Reconstruction Richmond would seem to have been an unlikely place for a sculptor to practice his art, Valentine was successful in obtaining commissions and in selling genre sculptures. After Robert E. Lee's death in late 1870, Valentine received his most inspiring commission—the creation of a recumbent memorial statue of the general for the mausoleum attached to the Lee Chapel at Washington and Lee University. This work is undoubtedly Valentine's finest and most highly acclaimed work.

Valentine's Richmond studio teemed with activity during the 1880s and 1890s. During that period he was the South's best-known sculptor, and numerous examples of his work survive. In addition to his recumbent statue of Lee, among his best works are his bronze standing figure of Lee for the Capitol's Statuary Hall in Washington, D.C.; his statue of Thomas Jefferson for Richmond's Jefferson Hotel; and his bronze statue of Jefferson Davis atop the Davis monument in Richmond. Valentine remained active until his death in Richmond in 1930.

Post–Civil War southerners, by necessity, emphasized the practical and thereby tended to neglect—and sometimes even to smother—the creative spirit. Sculpture especially suffered from this mood and from the poverty that provoked it. Frequently viewed as exotic, sculpture was also expensive. Much of the more elaborate and impressive statuary executed in the postwar South was the work of imported hands. In Valentine, however, the South produced a native-born sculptor who created works worthy of note. He and his fellow sculptors taught a later generation of southerners that statuary could be an important source of inspiration. Through his sculpture Valentine hoped to give his ideals to the world and to remind southerners of the best of their heritage.

L. MOODY SIMMS JR.
Illinois State University

Christopher Roland Lawton, *Southern Cultures* (Summer 2009); L. Moody Simms Jr., *Virginia Cavalcade* (Summer 1970); Elizabeth Gray Valentine, *Dawn to Twilight: Work of Edward V. Valentine* (1929).

Vance, Eleanor

(1869–1954) DESIGNER AND WOODCRAFTER.

Eleanor Vance was cofounder of Biltmore Estate Industries and of Tryon Toy Makers and Wood Carvers. Her designs and teaching synthesized southern Appalachian traditions with Old World apprenticeship and craftsmanship. Vance grew up in Ohio and attended Cincinnati Art Academy, an institution that encouraged women. She studied wood arts under William Fry, son of an English carver who had worked on the Houses of Parliament, one of the major projects of 19th-century Gothic style. Fry, who emphasized organic, natural forms, was a disciple of John Ruskin and William Morris. Vance became Fry's star student. At his urging she went to England for advanced studies, working under Thomas Kendall, who was considered the best in the world. He declared her "the best amateur woodcarver of either sex I have ever known."

After a year back in the United States, Vance entered Moody Bible Institute in Chicago, inspired by missionary zeal to use her talents in the service of people. There she met her soul mate, Charlotte Yale, an artisan as well. Vance's mother, Ella, had recently lost another daughter, and Charlotte was adopted as her "replacement sister." The three resided under the same roof until their respective deaths in North Carolina. They lived briefly in St. Augustine, Fla., but a physician recommended the mountains for Ella's health. In 1901 they arrived in Asheville and discovered elegant Biltmore Village, designed for George Vanderbilt's professional employees. Together they rented a flat and began a missionary workshop to instruct youngsters in craft modeled on other "settlements" of that era run by public-spirited women. Theirs was not a typical location, however, being neither in a city slum nor in a remote poor area. The Biltmore clients were in no way underprivileged. Their youths were well-schooled and had all the benefits of living in proximity to America's grandest estate, while enjoying the generous support of George W. Vanderbilt, an unusually progressive and intellectual millionaire. Soon Mrs. Vanderbilt was subsidizing Vance and Yale's undertaking, which was anointed Biltmore Estate Industries. The Vanderbilts encouraged world-class excellence in all their enterprises. Vance supervised the wood shop, which made expensive furniture and exquisitely hand-carved accessories like bookends, hearth bellows, and monogrammed trays. Her designs often deployed such popular southern motifs as dogwood and galax. Yale supervised a weaving operation that produced fine woolen cloths using fleece from Vanderbilt's purebred sheep.

Vance taught boys and girls according to a methodical apprenticeship similar to traditional English systems. Youths were not charged tuition, but their labors were unpaid until they could produce first-rate items. At that point they became paid by the hour, not

by the piece—for that era an unusual and enlightened aspect of her regime. Biltmore Estate Industries developed a reputation for sophisticated designs and superb execution.

Tryon, 40 miles to the southeast, was emerging as an important colony for artists, writers, and intellectuals. Its cosmopolitan community of well-educated women was influential, and several art/craft entrepreneurs were active there. Vance and Yale began to get to know Tryon people, with whom they had much in common. After George Vanderbilt died of appendicitis, and coincidentally the federal income tax was instituted, his widow restructured and streamlined her enormous interests. Vance and her partner relocated to Tryon on friendly terms in 1915. Mrs. Vanderbilt sold Biltmore craft operations two years later to an Asheville entrepreneur who had built Grove Park Inn.

The citizens of Tryon welcomed Vance and Yale enthusiastically. Because war in Europe had broken out, the American market for handcrafted toys offered an intriguing opportunity that did not compete with Biltmore. Vance set to work designing delightful wood toys, delicately painted with exquisite detail. Yale recruited talented boys and girls for the work. Tryon Toy Makers proved successful immediately and received glowing publicity in the national press. Later they added commissioned furniture, and eventually the Asheville entrepreneur turned over to them their Biltmore designs and permission to renew production of the woodcrafts that had made Vance famous. Tryon

Toy House, the picturesque stucco shop and headquarters designed by Tryon architect John Foster Searles, was constructed in 1925.

Tryon Toy Makers and Wood Carvers, the organization chartered in 1930, was among the early members of the Southern Mountain Handicraft Guild. Eleanor Roosevelt, who visited several times in search of ideas for her own craft enterprise at Val-Kill, N.Y., invited Vance and Yale to a White House luncheon in their honor in 1935. The following year they turned over their operation to the nonprofit Farmer's Federation and became semi-retired—although experimenting with new media like handcrafted puppets and running a children's training atelier called Tryon Craft School.

MICHAEL J. MCCUE
Asheville, North Carolina

Bruce E. Johnson, *May We All Remember Well: A Journal of the History and Cultures of Western North Carolina*, vol. 2 (2001); Michael J. McCue, *Tryon Artists, 1892–1942* (2001), *The Tryon Toy Makers and Wood Carvers: A History, 1915–1940* (2004).

Vaudechamp, Jean-Joseph

(1790–1866) PAINTER.
French artist Jean-Joseph Vaudechamp is considered one of the foremost painters working in New Orleans during the 1830s, where he wintered annually, returning to Paris in the summers. Vaudechamp was born in Rambervillers (Vosges), France, on 20 December 1790. His father, Jean-Baptiste Vaudechamp, was a chorister for a local congregation. As a child Jean-Joseph moved to Paris, where he was under the care of his

paternal aunt Marie-Jean Vaudechamp. Her husband, prominent poet Jacques Delille, was a friend of French neo-classical painter Anne-Louis Girodet de Roussy-Trioson. Through this friendship Vaudechamp entered Girodet's atelier and studied at the École des Beaux-Arts. As a consequence Vaudechamp favored the academic traditions exemplified in the neoclassical taste.

Typically, Vaudechamp's portraits feature half-length figures shown either in three-quarter or frontal view; these are characterized by a smooth finish, attention to detail, and the essence of elegance. In his three-quarter-length portraits, the subjects are usually shown turned in three-quarter view. Vaudechamp's ability to capture the likeness of his sitters is further enhanced by a sense of inner life not found in many portraits of the early 19th century in Louisiana.

Vaudechamp is believed to have been responsible for the presence of another noted French portrait painter in New Orleans, Jacques Guillaume Lucien Amans, with whom he sailed to Louisiana in 1836 and in 1837. Both painters exhibited at the same Paris Salons, and in 1837 they occupied studios in the same block of Royal Street in the French Quarter. Vaudechamp, who exhibited portraits and landscapes in the Salon in Paris, retained a high profile in New Orleans. Unlike Amans, Vaudechamp did not venture forth into the Louisiana countryside. Instead, he enjoyed the patronage of the city's wealthy and influential clientele. Vaudechamp's commissions provided sufficient remuneration

that between 1831 and 1834 he reportedly earned $30,000, at that time a considerable sum, with which he returned to France.

Among Vaudechamp's portraits of prominent Louisianans is a three-quarter-length portrait of Jean Bernard Xavier de Marigny de Mandeville, shown in his colorful military uniform. Marigny de Mandeville served as aide-de-camp to Pierre Clément de Laussat, the colonial prefect who supervised the retrocession of Louisiana from Spain to France (1800) and its subsequent transfer to the United States in 1803. A portrait of William Charles Cole Claiborne II was painted in Paris in 1831. Claiborne, who was the son of the first governor of the Louisiana Territory and first elected governor of Louisiana after its statehood in 1812, may have influenced Vaudechamp to visit Louisiana, since Vaudechamp arrived in New Orleans in January 1832, shortly after he finished Claiborne's portrait.

Vaudechamp excelled in painting portraits depicting an adult with a child, exemplified in *Althée Josephine d'Aquin de Puèch with Son Louis Ernest de Puèch*. Painted in Paris, this portrait depicts the sitter wearing the latest elegant Parisian fashion. Her extraordinary coiffure parallels other Louisiana portraits Vaudechamp painted in the 1830s.

Now known for his Louisiana portraits, Vaudechamp exhibited in the Salon in Paris from 1819 through 1848 and won the third-class medal in 1843. He was married twice; his second wife, Marie-Rosalie Fouquet, bore him three children. Vaudechamp died in Neuilly-

sur-Seine, France, on 4 August 1864 at the age of 73.

JUDITH H. BONNER
The Historic New Orleans Collection

Artists' Files, Williams Research Center, The Historic New Orleans Collection; Judith H. Bonner, in *Collecting Passions*, ed. Susan McLeod O'Reilly and Alain Masse (2005); W. Joseph Fulton and Roulhac Toledano, *Antiques* (June 1968); William H. Gerdts, George E. Jordan, and Judith H. Bonner, *Complementary Visions of Louisiana Art: The Laura Simon Nelson Collection at the Historic New Orleans Collection* (1996); John A. Mahé II and Rosanne McCaffrey, eds., *Encyclopaedia of New Orleans Artists, 1718–1918* (1987); Jessie Poesch, *The Art of the Old South: Painting, Sculpture, Architecture, and the Products of Craftsmen, 1560–1860* (1983); William Keyse Rudolph, *Vaudechamp in New Orleans* (2007); Martin Wiesendanger and Margaret Wiesendanger, *Louisiana Painters and Paintings from the Collection of W. E. Groves* (1971).

Verner, Elizabeth O'Neill

(1883–1979) PRINTMAKER, PASTELLIST, PRESERVATIONIST. Elizabeth O'Neill Verner contributed her considerable energies to the revitalization of her birthplace. Like her mentor, Alice Ravenel Huger Smith, Verner took great pride in her native Charleston and worked diligently to promote it. After attending a Catholic girls' school in Columbia, S.C., she spent two years at the prestigious Pennsylvania Academy of the Fine Arts. Verner studied with Thomas Anshutz, from whom she gained a sound foundation in drawing, especially the human figure. She returned to South Carolina

and taught for a year in Aiken before settling in Charleston, where she married in 1907 and reared two children. Verner became involved in community activities, including the Sketch Club, which used studio space in the newly opened Gibbes Art Gallery, and the Charleston Etchers' Club, which gave her access to a printing press.

When Verner's husband died suddenly in 1925, Smith encouraged her to support herself with her art. Forced to be self-reliant, Verner quickly realized that prints were best suited to her talents and temperament, and, although laborious, they had several advantages—they were small in scale, could be priced modestly, made excellent illustrations in books, and could be reproduced and sold as postcards. Over her career Verner etched about 260 plates, with editions varying from 50 to 80 and occasionally 100, although not all editions were completely printed during her lifetime.

While some of her early prints of such landmark buildings as St. Michael's resemble architect's drawings, Verner quickly learned the picturesque potential of dappled light on stucco-covered walls and the inclusion of an African American figure. When she did venture into the countryside, her best images were those in which she portrayed gnarled old oak trees draped in Spanish moss, linear forms ideally suited to etching. Verner frequently positioned herself in a public place to study a building or a view, and people would often stop. Realizing the appeal her art had for visitors to Charleston, Verner

worked conscientiously at promoting herself and her work. Her peak season was spring, when her studio was open during the Azalea Festival, and she supplemented her income by taking in out-of-town guests. From time to time she was called upon to coordinate visiting groups, serving as an impromptu tour guide. Verner published two books of Charleston scenes, accompanied by her own writing—*Prints and Impressions of Charleston* (1939) and *Mellowed by Time: A Charleston Notebook* (1941). These endeavors promoted not only Verner but also Charleston.

Despite all these activities, Verner still had time to participate in local organizations like the Poetry Society of South Carolina, the Society for the Preservation of Old Dwellings, and the Southern States Art League, a regional membership group whose mission was to recognize and encourage southern art. She enjoyed traveling and went abroad to Europe and to Japan. In London, Verner visited the print study room at the British Museum, where she examined etchings by Rembrandt. In 1937 she traveled to Kyoto, Japan, where she demonstrated the etching technique, studied Japanese brushwork, and produced a suite of 12 etchings. In 1946 Verner published *Other Places*, which consisted of 42 illustrations of places other than Charleston, accompanied by her commentary; but in the end it was always Charleston that beckoned her home.

During the 1930s Verner began to work in pastel, a medium not widely used by Charleston artists. She was drawn intensely to color and had ex-plored color etchings; she may also have wanted to produce unique works on a larger scale. Not only did Verner apply herself to her new medium, she also expanded her repertoire with figurative work largely depicting the city's African American flower vendors. At one point the vendors' freedom to conduct business was threatened by a new ordinance, which Verner succeeded in overturning. Although her interest in preserving the tradition of the flower women was not totally selfless, Verner did treat them with compassion, and her depictions of these vendors were always rendered sympathetically.

MARTHA R. SEVERENS
Greenville, South Carolina

Lynne Blackman, ed., *Southern Masters of Printmaking* (2005); Marlo Pease Bussman, *Born Charlestonian* (1969); James M. Hutchisson and Harlan Greene, *Renaissance in Charleston: Art and Life in the Carolina Low Country, 1900–1940* (2003); A. Everette James, Dale Volberg Reed, and Everett Mayo Adelman, *Southern Women Painters, 1880–1940* (1999); Lynn Robertson Myers et al., *Mirror of Time: Elizabeth O'Neill Verner's Charleston* (1983); Martha R. Severens, *The Charleston Renaissance* (1998).

Viavant, George Louis

(1872–1925) PAINTER.
One of the better-known painters of *nature morte*, native New Orleanian George Louis Viavant was born in 1872 to wealthy Creole parents. Viavant demonstrated an early talent for art and at the age of 12 began his art training at the Southern Art Union under Italian sculptor-painter Achille Perelli. Viavant met with immediate success. He re-

ceived a diploma at the 1884–85 World's Industrial and Cotton Centennial Exposition, which took place in Audubon Park in uptown New Orleans. He also won a blue ribbon for a landscape he exhibited at the exposition that same year.

Viavant's father was a wealthy cotton broker who lost his fortune during the Panic of 1897. The family owned 80 acres in eastern New Orleans at Gentilly and Downman Road, a rural area that was originally their hunting preserve and at that time was considered too worthless to bring in sufficient money to offset debt. After the family retreated to this location, young Viavant began to paint images of birds and animals, which he sold to supplement the family's income. After establishing his home on the family property facing Bayou Sauvage (now part of Bayou Sauvage National Wildlife Refuge), he set about painting the grass-lined swamps and earned a reputation for his watercolor sketches of the native birds of Louisiana and for the flight of ducks over the marshes.

Viavant's daughter, Ruby Viavant, who also painted *nature morte* scenes, exhibited and sold her work alongside that of her father in New Orleans, Chicago, and Philadelphia. Although she reportedly sold a large number of works, few of her paintings are known today. Ruby took her first art lessons with her father when she was 14 years of age, and after four years of training, in 1922 she was reported as having a great deal of promise. She died in 1925 at the age of 21 from complications following a poorly treated throat infection. Reportedly, since Ruby was the only one of six siblings who held an active interest in

art, her death caused great grief for her father, who died a few months later in the same year.

JUDITH H. BONNER
The Historic New Orleans Collection

George E. Jordan, *George L. Viavant: Artist of the Hunt* (2004), *Historic New Orleans Quarterly* (Fall 2003–Winter 2004); John A. Mahé II and Rosanne McCaffrey, eds., *Encyclopaedia of New Orleans Artists, 1718–1918* (1987).

Walker, William Aiken

(1838–1921) PAINTER.

Landscape and genre painter William Aiken Walker of Charleston, S.C., traveled extensively throughout the South and for 30 years made annual trips to New Orleans, which he came to regard as his second home. Walker painted southern plantation life, cabin scenes, rural life, and dock scenes—with a specific focus on African Americans. He was born in 1838; his father was a cotton agent and his mother was from South Carolina. After his father died, in 1842, his mother moved the family to Baltimore, and in 1848 she relocated to Charleston. Walker, who began exhibiting his work at the South Carolina Institute Fair in 1850 at the age of 12, was painting *nature morte* scenes depicting dead fish and game that he brought home, an occupation that he continued all his life. A number of these still lifes are masterfully executed trompe l'oeil paintings.

During the Civil War Walker served as a draftsman with the Confederacy, initially under Gen. Wade Hampton in Hampton's Legion. After recuperating from a wound he received during

the Battle of Seven Pines, in 1862, Walker was reassigned to picket duty in Charleston. A member of the Confederate Engineer Corps, he made maps and sketches of the city's defenses for the next two years. After the war Walker relocated to Baltimore and began to travel extensively throughout the South during the winter.

In 1874 Walker traveled to Galveston, where he lived and painted, and then to San Antonio in 1876. The best-known paintings from Walker's two-year Texas sojourn include *View of Charleston Harbor* and *San José Mission, San Antonio*. During the summers the peripatetic Walker painted at the Arden Park Lodge in the Smoky Mountains of North Carolina, until it burned in 1919.

Walker's first trip to New Orleans occurred in 1876, after which he continued to return to the city almost annually. At first he had an uptown studio at present-day 1521 Toledano Street, and he later maintained a studio in the Vieux Carré. The gregarious Walker was active in the city's art circles and was friends with most of the painters in the area at that time. He was close friends with painter Everett B. D. Julio, with whom he shared the concept of an art league in the city. After Julio's death in 1879, the Southern Art Union was organized in 1880 by a small group of artists, and Walker participated in the organization's exhibitions. Walker began to paint images of African Americans working on the docks, on levees, and in the cotton fields. The majority of these works were executed in Florida, Louisiana, and the Carolinas and sold to tourists who visited the South. Walker

also produced topographical drawings of the east coast of Florida from New Smyrna to the Keys.

In the 1880s Currier and Ives reproduced two of his paintings as chromolithographs: *The Levee, New Orleans* and *A Cotton Plantation on the Mississippi*, after which his reputation grew considerably. Both of these works are typical of Walker's paintings of the rural South. The latter of these two prints shows a plantation with cotton pickers working in a field; in the foreground is a wagon stacked with cotton bales. Three mules stand before the wagon, and a sleeping dog lies under the wheels. The scene also shows the plantation owner and his wife, a cotton gin, and a steamboat on the Mississippi River in the distance—a reference Walker frequently made to the means of travel and of transporting products at that time.

Walker was known to set up his easel at the corner of Royal and Dumaine Streets in the French Quarter, where he sold his mass-produced views of cotton pickers and levee scenes. He adapted his canvases according to the area of the country in which he was traveling, with variations in scenes of his native South Carolina, as well as North Carolina, Florida, and Louisiana. Through the late 19th and early 20th centuries, Walker mass-produced picturesque interpretations of rural cabins, cotton pickers, and dock scenes. These works usually feature azure skies, which he reportedly rendered on his canvases first, and he then added an area of earth tone in the foreground, followed by cotton fields in mid-ground. Walker then subdivided and cut his canvases into smaller ver-

tical pieces upon which he painted male or female cotton pickers in ragged clothing. His depiction of a cotton gin, however, follows the painting tradition of Louisiana landscapes rendered in deep colors by painters Richard Clague Jr. and William Henry Buck.

Walker's paintings were included in the Artists' Association of New Orleans's annual exhibitions from the year it was founded, in 1885, through 1905. Walker felt that the city was developing far too quickly and left New Orleans permanently after his 1905 visit. He continued to paint until his death on 3 January 1921.

JUDITH H. BONNER
The Historic New Orleans Collection

Timothy Eaton, *William Aiken Walker in Florida* (2003); Cynthia Seibels, *The Sunny South: The Life and Art of William Aiken Walker* (1995); Martha R. Severens, *South Carolina Masterworks* (2009); August P. Trovaioli and Roulhac B. Toledano, *William Aiken Walker: Southern Genre Painter* (1972).

Walter, Martha

(1875–1976) PAINTER AND TEACHER. Born in Philadelphia, Martha Walter attended Girls High School and in 1894 began her studies at the Pennsylvania Academy of the Fine Arts, where William Merritt Chase would become her mentor and the major influence on her work. In 1902 she went to Paris on a Cresson Traveling Scholarship, enrolled in the Académie Julian, and joined a class at the Académie de la Grand Chaumière. In 1904 Walter exhibited two works at the Paris Salon. Soon impatient with the academicism of the Paris schools, she set out on her own and began painting *en plein air* in the manner of the French impressionists.

An avid traveler, Walter spent many summers abroad, visiting Europe and northern Africa while maintaining a home studio in Philadelphia. In 1910 she moved to New York and began exhibiting at the National Academy of Design. When World War I curtailed her trips abroad, Walter began to spend summers at the artists' colony in Gloucester, Mass., where she was an annual exhibitor, along with Cecilia Beaux, Jane Peterson, and Alice Schille.

Best known for her colorful beach scenes and landscapes, Walter also painted an intense series depicting the crowded conditions of immigrants detained at Ellis Island, as well as vibrantly colored Mediterranean street scenes with Algerian mosques and village fishermen. While much of her work is associated with New England, Walter's connection to the South developed through her frequent visits to Chattanooga, Tenn., between 1903 and 1910, where she painted commissioned portraits and taught summer classes. In 1953, the Hunter Museum of Art in Chattanooga mounted a solo exhibition of her work. Walter's last solo show was in 1975 at Hammer Galleries in New York, when the artist was 100 years old.

Walter's paintings are represented in numerous museums, including the Musée du Luxembourg, the Musée d'Orsay, the Pennsylvania Academy of the Fine Arts, the Art Institute of Chicago, the Detroit Institute of Arts, the Milwaukee Art Center, the Terra Museum of American Art in Chicago, and

the National Museum of Women in the Arts in Washington, D.C. In the South, her work is in the collections of the Morris Museum of Art in Augusta, Ga., and the Cheekwood Botanical Garden and Museum of Art in Nashville, Tenn.

LOUISE KEITH CLAUSSEN
Morris Museum of Art

Carl E. David, *American Art Review* (May 1978), *The Children of Martha Walter* (1985); William H. Gerdts, *American Art Review* (September–October 2002); Victor J. Hammer, *Martha Walter: Recent Paintings* (1969); Anne W. Schmoll, *Martha Walter (1875-1976)* (1992); Helen L. Slack, *International Studio* (April 1914).

Washington, William Dickinson

(1833–1870) PORTRAITIST. William Dickinson Washington was born in Clarke County, Va., on 7 October 1833, to John Perrin Washington and Hannah Fairfax Whiting. He was a descendant of Lawrence and Mildred Warner Washington, the grandparents of Pres. George Washington. In 1834 his father secured a position with the U.S. Post Office and moved his family to the District of Columbia. While still a youth, Washington demonstrated prodigious skills as a draftsman and began his artistic career drawing models for the Patent Office. During 1851 and 1852 he worked with Emmanuel Leutze, who encouraged him to pursue further studies at the Düsseldorf Academy. Both senators from Virginia, James Murray Mason and Robert Mercer Taliaferro Hunter, supported him in this effort. In a letter to Secretary of State Edward Everett,

20 December 1852, they refer to Washington as "a young artist of very great promise" and ask Everett to "appoint him Bearer of Dispatches to some of our foreign agents . . . near . . . Dusseldorf . . . with such moderate amount of compensation as will cover the expenses of his journey." Washington began his studies in Düsseldorf in the summer of 1853, where he attended the Kunstakademie under the direction of German Romantic artist Wilhelm von Schadow. While in Düsseldorf he began his career as a historical genre painter, commencing with *Entrance to a Castle*, *The Student*, and *Commencement of the Huguenot War*.

Washington returned to the District of Columbia in 1856 and became deeply involved in the local art scene. He was the director and vice president of the Washington Art Association for three years and entered work in its first exhibition in 1857. In that professional capacity he became acquainted with art patron William Wilson Corcoran, who appointed him to the council of the National Gallery and School of Art. His studio, at 486 12th Street NW, was over that of legendary portrait artist Charles Bird King. He remained in Washington, D.C., until 1861, painting portraits and historical works. A portrait of Chief Justice John Marshall, drawn from print sources, was commissioned by the Fauquier County, Va., Council and placed in its chambers at Warrenton, Va. At the same time he commenced a series of paintings based on the episodes of Capt. Francis Marion, the "Swamp Fox" of Revolutionary War–era South Caro-

lina. When Virginia seceded from the Union and the Civil War began, Washington went south to Richmond, where he offered his services as a draftsman to generals Robert E. Lee and John B. Floyd.

Little is known of Washington's life in Richmond after his release from service in July 1861 other than his paintings *Jackson Entering Winchester* and *The Death of Latané*, which he completed from a studio on East Leigh Street in 1864. Engraved by A. G. Campbell in New York, *The Death of Latané* depicts the burial of a young Confederate officer by a group of genteel ladies. This print became one of the most iconic images of the Lost Cause in southern homes. After the fall of Richmond in April 1865, Washington fled to England, where he remained for a year. He returned to America in 1866 and set up a studio in New York. Through the auspices of his friend W. W. Corcoran, he was called to become chairman of the Department of Fine Arts at the Virginia Military Institute (VMI) in Lexington and given the honorific title of colonel. Once there, he undertook the painting of posthumous portraits of former students and professors at VMI. He died quite suddenly on 1 December 1870 and was buried in the Lexington Presbyterian Cemetery. A dispatch from the Superintendent's Office at VMI dated 2 December 1870 "[recalls] to mind with sorrowful tenderness his genius, his accomplishments, his sensibility, his high-toned principles, and the purity and delicacy of his nature, constantly manifested in his intercourse with his brother officers. By nature he was fitted for Art, and to the cultivation of it he gave himself with unreserved love and assiduity."

ESTILL CURTIS PENNINGTON
Paris, Kentucky

William S. Ayers, *Picturing History: American Painting, 1770–1930* (1993); Andrew Cosentino and Henry H. Glassie, *Capital Image* (1983); Harold Holzer and Mark E. Neeley Jr., *Mine Eyes Have Seen the Glory: The Civl War in Art* (1993); Donald B. Kuspit et al., *Painting in the South, 1564–1980* (1983); Estill Curtis Pennington, *Look Away: Reality and Sentiment in Southern Art* (1989), *Romantic Spirits: Nineteenth-Century Paintings from the Johnson Collection* (2011); Jessie Poesch, *The Art of the Old South: Painting, Sculpture, Architecture, and the Products of Craftsmen, 1560–1860* (1983); Emily Salmon, *Virginia Cavalcade* (Winter 1979); Lauralee Trent Stevenson, *Confederate Soldier Artists* (1998).

Watson, Amelia Montague

(1856–1934) PAINTER.

Watercolor imagist of southern scenes who settled in the Tryon colony in North Carolina and painted much of her best work there, Amelia Montague "Minnie" Watson was an important link between the North's intellectuals and the South's burgeoning art communities in the early 20th century. Watson was born in East Windsor Hill, Conn., into a family related to influential reformers and academics of New England, some of whom had close ties to the South before the Civil War. Watson showed an early aptitude for art. She and her sister, Edith Sarah, were tutored by their mother, an amateur painter. At the age of 19 Amelia Watson entered the Hart-

ford atelier of Dwight William Tryon, poetic landscape tonalist and impressionist, before he went to Europe and later to New York. From a young age Watson was committed to becoming a serious artist and supporting herself in this endeavor. Connoisseurs recognized her fluency in watercolor, which emerged during the 19th century as a medium for significant creative expression. She was appointed to the faculty at Temple Grove Seminary, now Skidmore College, at Saratoga, where she simultaneously and vigorously pursued her professional painting. In the 1880s Watson became head of the art department at Martha's Vineyard Summer Institute for schoolteachers, a number of whom were from the South, a position she held for two decades.

Modest and pleasant, with a droll sense of humor, Watson was adept at cultivating contacts and profitably marketing her art. She exhibited widely in major cities. Broadway actor and playwright William Gillette, her most enthusiastic patron, declared he would purchase anything she would paint for him, at any price she asked. In 1892 Gillette invited her to spend the winter at his rustic mountaintop retreat in Tryon, which she accepted, along with companion Margaret Warner Morley, writer, illustrator, and photographer. Both women were closely associated with the Nook Farm group of Hartford, creative intellectuals like Mark Twain, Harriet Beecher Stowe, Charles Dudley Warner, and Gillette himself. Mrs. Sidney Lanier, widow of the southern poet, had settled in Tryon by this time, along with other people influential in American pub-

lishing and the arts. Their presence, and that of numerous cosmopolitan guests, brought about the sense of "colony" that made Tryon a magnet similar to country colonies emerging elsewhere, especially at Woodstock and Old Lyme.

Two or three years later, Watson and Morley visited Cape Cod together, carrying Morley's copy of Thoreau's *Cape Cod*, in the margins of which Watson painted miniature watercolors of the places described. In 1896 Houghton Mifflin of Boston published a handsome reproduction of this volume featuring high-quality chromolithography of the charming paintings. It was an artistic sensation and brought Watson much fame, as well as a good income. Both she and Morley could now afford their own places at Tryon. Watson had a picturesque home and studio constructed, which she called Under the Tupelo, designed by imaginative Tryon architect John Foster Searles, formerly of New York. There she painted vigorously—scenes discovered around the picturesque North Carolina village and places she sketched during travel farther afield.

Watson roamed the highlands of Virginia and Tennessee, where she acquired land in Bledsoe County on the Cumberland Plateau. Her sister, then a professional photographer, spent a great deal of time in Canada, and some of Amelia Watson's work depicts images of that country. She developed a close friendship with Elizabeth Allston Pringle, author of *A Woman Rice Planter* and *Chronicles of Chicora Wood*. Pringle's nephew owned a Tryon vineyard, and sojourns at Pringle's

plantation in the South Carolina rice country provided some of Watson's most appealing subjects. She pursued Lowcountry explorations in Georgia and Florida and along with her circle of creative women, made forays to New Orleans as well. Her watercolors for the cover and frontispiece of Morley's 1913 *The Carolina Mountains* are her most famous images. This book, illustrated with original artistic photography by Morley, was a great success, and a copy was placed in each room of the Grove Park Inn at Asheville, at that time newly built as one of the South's finest resort hotels. Amelia Watson's paintings evince more sympathetic imagery of regional people and landscapes than the often-patronizing stereotypes typical of earlier artists working in the South.

MICHAEL J. MCCUE
Asheville, North Carolina

Linda Smith Cohen, *Amelia Montague Watson: Painter, Illustrator, Teacher* (1987); Michael J. McCue, *Tryon Artists, 1892–1942* (2001); Frances Rooney, *Working Light: The Wandering Life of Photographer Edith S. Watson* (1996).

Way, Andrew John Henry

(1826–1888) PAINTER.
Andrew John Henry Way, who was born in Washington, D.C., began his studies in art in Cincinnati with John Peter Frankenstein around 1847, prior to studies in Baltimore with Alfred Jacob Miller. He pursued further study in the Paris atelier of Michel Martin Drolling, as well as at the Accademia di Belle Arti in Florence from 1850 to 1854.

Upon his return to the United States, Way settled in Baltimore, where he came to the attention of history painter Emanuel Gottlieb Leutze, who urged him to follow the example of the Düsseldorf Academy as a stylistic guide. Way then began to paint fruit — primarily grapes — rendered in great detail and with a particular brilliance of light. Quite often he staged the fruit against a dark background, heightening the contrast of form. His works came to the attention of Baltimore patron and art collector William T. Walters, who acquired many of his paintings and challenged him to expand upon the variety of grapes he painted.

Walters would go on to create the first art museum in Baltimore, and Way would become the most important still life painter in the mid-Atlantic area during the late 19th century. He may be seen as the beneficiary of several shifts in the tides of taste. In high art circles, the writings of English author John Ruskin and the paintings of the Pre-Raphaelite movement were enjoying high acclaim. Ruskin encouraged artists to be accurate in their depiction of nature and to create works that were at once documentary and celebratory. As though heeding the advice, Way chose to immortalize the grape in glistening tones that brought forth the most translucent quality of their thin skins set within brightly lit arbors whose leaves seem to radiate a heavenly light.

Way was also a very informed artist. His early works, often small groupings of fruit quietly gathered on a precipitous marble ledge in the Dutch manner, are reminiscent of the works of the Peale family earlier in the century. They are clearly lit and composed with a trompe

l'oeil elevation, suggesting a subtle depth of field. Walter's own conservatory became a resource for Way.

Andrew John Henry Way also executed portraits and still life paintings of oysters. He was a local figure of note in the Baltimore arts community, often mentioned in the local press. During his later years Way kept scrapbooks of clippings on Baltimore artists, which are now in the library of the Maryland Historical Society. His son, George Brevitt Way, was also an artist and art instructor in Baltimore. The elder Way died in 1888 in Washington, D.C.

ESTILL CURTIS PENNINGTON
Paris, Kentucky

Bulletin of the Walters Art Gallery (January 1951); Maryland Historical Society, Baltimore; Estill Curtis Pennington, *Gracious Plenty: American Still-Life Art from Southern Collections* (1996), *Romantic Spirits: Nineteenth-Century Paintings of the South from the Johnson Collection* (2011), *A Southern Collection* (1992).

Welty, Eudora

(1909–2001) ARTIST, PHOTOGRAPHER, AUTHOR.

Eudora Alice Welty was born in Jackson, Miss., where she lived all her life except for college studies, sojourns of one to six months in New York and San Francisco, and writing residencies at Bread Loaf Writers' Conference, Yaddo, Bryn Mawr College, and Smith College. Her father, Christian Welty, of Ohio, founding president of the Lamar Life Insurance Company, was a man of progressive ideas who inculcated in his employees and family the urge to

travel and thereby gain a worldview and empathy for others. From her mother, Chestina Andrews, a teacher from the mountains of West Virginia, Welty got a love of reading. Two younger brothers, Edward and Walter, completed Welty's family circle, although the impact of the infant deaths of a brother (Christian Webb Welty) and a sister is also evident in Welty's writing.

After attending Jefferson Davis Elementary School across from her home on Congress Street in Jackson, Welty graduated from Central High School in 1925. She contributed drawings to the *Memphis Commercial Appeal* children's pages, won awards for a drawing and a poem published in *St. Nicholas Magazine*, and contributed graphic designs and satire to her high school yearbooks. *To the Golden Gate and Back Again*, a 1924 souvenir booklet of appreciations commemorating the Lamar Life Insurance Company rail journey from Memphis to California on which Eudora was her father's guest, includes five humorous drawings by Welty and a concluding spoof addressed to "Mr. Wealty," presumably by the young wordsmith.

Welty continued drawing and writing for school publications at the Mississippi State College for Women (now the Mississippi University for Women), the "W," which she attended from the fall of 1925 until the spring of 1927 before studying at and graduating from the University of Wisconsin at Madison in 1929. At Wisconsin, she wrote a creative honors thesis, but after a year at home, with no success in finding work with publishers or journals and writing a few

pieces for the *Jackson Daily News*, Welty moved to New York City and studied advertising at Columbia School of Business, from the fall of 1930 until the fall of 1931. She returned to Jackson to the Pinehurst Street family home across from Belhaven College, where her father became ill and died.

Prior to finding success in publishing fiction, Welty worked at numerous jobs, including for the Works Progress Administration for which she traveled throughout the state, taking photographs avocationally. Her photographs, primarily of Mississippi places and people, collected in *One Time, One Place: Mississippi in the Depression: A Snapshot Album* (1971, 1996), *Twenty Photographs* (1980), *In Black and White* (1985), *Photographs* (1989), *Country Churchyards* (2000), and *Eudora Welty as Photographer* (2009), illustrate Welty's passion to show human dignity. Welty tried for three years without success to find a publisher for *Black Saturday*, a collection of photographs and stories. She had small exhibitions of her photographs in Raleigh and Chapel Hill, N.C., at the behest of her Jackson friend Frank Lyell and at Lugene Optics in New York. *Passionate Observer: Eudora Welty among Artists of the Thirties* (2002) reproduces many of Welty's youthful drawings and places her art and photographs in the context of local and national painters and photographers, revealing her talents and synchronicities with successful and trained artists.

PEARL A. MCHANEY
Georgia State University

John Bayne, *Eudora Welty Newsletter* (Winter 2002); T. A. Frail, *Smithsonian Magazine* (April 2009); Michael Kreyling, *Author and Agent: Eudora Welty and Diarmuid Russell* (1991); Suzanne Marrs, *Eudora Welty: A Biography* (2005); Pearl McHaney, *Eudora Welty: The Contemporary Reviews* (2005), *South Atlantic Review* (Spring 1999); Noel Polk, *Eudora Welty: A Bibliography of Her Work* (1994); Peggy Whitman Prenshaw, *Conversations with Eudora Welty* (1984), *More Conversations with Eudora Welty* (1996); Thomas Verich, *Special Collections, 1975–2000: A Silver Anniversary Exhibition* (2001); Ann Waldron, *Eudora: A Writer's Life* (1998).

West, William Edward

(1788–1857) PAINTER.

William Edward West was born in Lexington, Ky., on 10 December 1788 to Maria Creed Brown and Edward West Jr., a Virginian who had moved to Kentucky in 1784. At an early age William Edward West traveled the Ohio and Mississippi Rivers to Natchez and New Orleans and began an association with the Evans and Turner families of the Natchez region, whose relations and friends would provide his most important commissions.

West visited Philadelphia, possibly as early as 1808, where he met Washington Irving and Thomas Sully, two life-long friends and influences. Although it seems unlikely that West actually studied with Sully, he undoubtedly observed Sully's painting techniques, absorbing those technical aspects of coloration that Sully had witnessed in Gilbert Stuart's work. While in Philadelphia, West portrayed several members of the

Gratz family. In the second decade of the 19th century, West worked and traveled between Philadelphia and New Orleans. He had studios in Philadelphia and in New Orleans but was most productive in Natchez.

Subsequently, West undertook more formal art study in Florence, Italy, and while there George K. Bruen of New York commissioned a portrait of English romantic poet Lord Byron for the American Academy in New York. West, who went to the poet's villa in Pisa to paint Byron's portrait, lived in Florence until 1825, when he moved to Paris. One of West's best works, an allegorical portrait, *The Muses*, was painted in Paris in 1825, the year West departed for London.

Having gained notoriety as the last portraitist of Byron, West embarked upon a 12-year career as a highly successful painter. He painted portraits of the most prominent members of the American financial and diplomatic community, and several of the genre or literary paintings that West exhibited at the Royal Academy in London were well received, especially *Annette Delarbre*, a character drawn from a story of Washington Irving. West also painted a portrait of English poetess Felicia Hemans, with whom he enjoyed a warm correspondence.

From 1832 to 1837 West was involved in financial speculations that left him bankrupt. He returned to Baltimore and opened a studio on Baltimore Street. The young Robert E. Lee, stopping en route to military engineering duties at St. Louis, was portrayed by West in 1838. West's Baltimore retrenchment was the

most productive and successful period in his life. He repaid all his debts in England and amassed enough money to move into semiretirement in New York in 1841.

Throughout the 1840s West lived in New York City, portraying various members of the Delano and Astor families and occasionally other New York society figures, and he visited and traveled with Washington Irving. *The Confessional*, a religious picture, was much admired by Irving and was acquired by Thomas Jefferson Bryan for his "Christian Art" collection. In the late 1840s and early 1850s West painted the last of his Natchez commissions. In 1855 he moved to Nashville, Tenn., to live among his family, and he died there on 2 November 1857. He is buried in the old city cemetery.

West's early work has the spare elegance of the neoclassical portraits of Stuart and Sully. A superb colorist, his portraits were marked by strong characterization and freshness, and by deep and richly luminous eyes. A maturing of his style occurred during his years in Italy. An infatuation with mannerist composition revealed itself in his literary and allegorical pictures, especially *The Muses* and *The Present*, two of his finest works. His mature portraits, especially that of Lee, rank among the best work of the 19th century.

ESTILL CURTIS PENNINGTON
Paris, Kentucky

William Dunlap, *History of the Rise and Progress of the Arts of Design in the United States* (1834, 1969); Estill Curtis Pennington, *William Edward West (1788–1857), Kentucky Painter* (1985); Henry T. Tuckerman, *Book of*

the Artists, American Artist Life (1867, 1940); William Edward West Papers, Catalog of American Portraits, National Portrait Gallery, Smithsonian Institution, Washington, D.C.

Whitney, Daniel Webster

(1898–1965) PAINTER AND
ART TEACHER.

Portraitist and landscape painter Daniel Webster Whitney was born on 3 May 1898 in Baltimore on the Bloomingdale estate near Catonville, Md., which kept horses and farm animals—subjects that would appear in Whitney's later paintings. He studied at the Maryland Institute of Fine Arts, the Pennsylvania Academy of the Fine Arts, and the Académie Colarossi in Paris.

In the 1930s Whitney taught the portrait and life classes at the Arts and Crafts Club of New Orleans School of Art, located at 520–22 Royal Street in the French Quarter. He also conducted classes for the Adult Education Project of the Works Progress Administration. Active with the Arts and Crafts Club, Whitney designed and executed the decorations for the 1927 annual ball held at the American Legion Home at the corner of Royal and Conti Street, a site that served as one of the first headquarters for the club. In 1938 he opened the Whitney School of Art at 911 Chartres Street, a few blocks away from the Arts and Crafts Club. Whitney served as director of the Ocean Springs Summer Art Colony at Fairhaven, a house on the Mississippi Gulf Coast, which belonged to Annette McConnell Anderson, mother of artist Walter Inglis Anderson.

Whitney, who was a warrant officer in the U.S. Coast Guard during World War II, designed the regimental flag for the Volunteer Port Security Force for the Maritime Day Parade in March 1944. He subsequently relocated to Covington, La.

Painters Josephine Marien Crawford and Paul Ninas, who became the second director of the Arts and Crafts Club after Charles Bein resigned in 1932, are credited with introducing cubism into the city. Whitney's works, however, showed characteristics of cubism as early as 1926. Whitney differs stylistically in two portraits of the 1930s. An early 1930s bust-length portrait of an African American man in overalls and work shirt, also a straightforward presentation of a blue-collar worker, is characteristic of the social realism produced by artists during the Great Depression. His 1939 three-quarter-length *Portrait of Man* is typical of his works sympathizing with laborers. A weary seated man, clad in blue work shirt and jeans, leans forward, his shoulders hunched and his elbows resting on his upper thighs, with calloused hands clasped lightly before him.

Whitney's later work is characterized by fully developed tenets of cubism as he moved toward faceted and abstract elements in his compositions. These works manifest a conscious emphasis on symbolism and an ethereal quality of light, especially in two works, titled *Christ* and *Rebirth*. His 1959 cubist painting, simply titled *Man*, features symbolism and a sense of an otherworldly luminosity. Some of Whitney's abstractions feature recognizable subjects like horses or goats and such land-

scape elements as mountains, cliffs, rolling hills, trees, rivers, and clumps of grass.

Whitney exhibited his portraits at the Isaac Delgado Museum of Art (now the New Orleans Museum of Art) in 1924. A resident of Covington, La., for 17 years, Whitney died there on 30 November 1965.

JUDITH H. BONNER
The Historic New Orleans Collection

Judith H. Bonner, *Arts Quarterly* (January–March 2007), *The New Orleans Arts & Crafts Club: An Artistic Legacy* (2007); Mantle Fielding, *Louisiana History* (Summer 2000).

Wiener, Samuel Gross

(1896–1977) ARCHITECT.
Samuel Gross Wiener was one of the earliest practitioners of modern architecture (the International style) in the United States and introduced the style to the South. Born in Monroe, La., Wiener received his Bachelor of Architecture degree from the University of Michigan in 1920 and attended the Atelier Gromort, Paris, in 1922 and 1923. He was the Shreveport partner in the Louisiana architectural firm of Jones, Roessle, Olschner, and Wiener from 1925 to 1940, after which he established a separate practice. Wiener's work of the 1920s employs a wide range of then-fashionable historical styles as well as art deco, of which the Municipal Auditorium, Shreveport (1929), is a particularly splendid example.

In 1928 Wiener published *Venetian Houses and Details*. An increasing interest in the new European architecture he saw illustrated in architectural

journals inspired him to make a study visit to Europe for several months in 1931. After his return to Shreveport, Wiener's work shows a complete break with the past and a total commitment to the ideals and forms of European modernism. During the 1930s Wiener was responsible for all his firm's work in the modern idiom. Wiener also accepted private commissions and sometimes worked in collaboration with his younger brother, William Wiener, a 1929 graduate of the University of Michigan with an architectural practice in Shreveport.

Among the residences designed by Samuel Wiener are the Wile-Schober House (1934) and the Flesh-Walker-Guillot House (1936), both in Shreveport, and a weekend house on Cross Lake (1933) in collaboration with his brother, William. Particularly noteworthy is Samuel Wiener's own residence, which he designed in 1937. Other work includes the El Karubah Club on Cross Lake (1931); the Big Chain Store (1940); and several schools, including Bossier High School (1938–40). The very fine Shreveport Orthopedic Clinic (1936) was demolished in the 1970s. Wiener's major work was the Shreveport Municipal Incinerator, built in 1935 from Public Works Administration funds. Photographs of the incinerator were exhibited in the U.S. Pavilion at the Paris International Exposition of 1937 as one of the best examples of modern architecture in the United States and in exhibits organized by the Museum of Modern Art in New York. The incinerator photographs, also published extensively in major international and

national architectural journals, brought Wiener much acclaim.

Although in startling formal contrast to traditional southern architecture, Wiener's buildings were designed for regional climatic conditions. His use of linear plans and wraparound corner windows allows cross-ventilation; the light-colored walls have a cooling effect on the buildings; and planar overhangs protect interiors from the sun. Wiener's designs acquired a local character without reducing the ideals and formal qualities of modernism. Although Wiener maintained an active practice after 1940, his later work never matched the originality and boldness of his 1930s designs. Sam Wiener was a major contributor to and advocate for modern architecture in the United States.

KAREN KINGSLEY
Tulane University

Architectural Forum (November 1935); Karen Kingsley, *Modernism in Louisiana: A Decade of Progress, 1930–1940* (1984); Samuel Gross Wiener, *Venetian Houses and Details* (1929).

Wightman, Thomas
(1811–1888) PAINTER.

Thomas Wightman was born in Charleston, S.C., to William and Matilda Sandys Williams Wightman. His father, William, was a well-regarded amateur artist who encouraged the creative ambitions of two of his sons, Thomas and John. Matilda Wightman was born in England and grew to maturity in a family with very close ties to several leading members of the Methodist movement, including John Wesley and Adam Clarke. Although there are no accounts of Thomas Wightman's early artistic formation, he may have come into contact with miniaturist Edward Malbone, who painted portraits of his parents.

By 1834 Wightman had gone to New York, where he became a student of Henry Inman, the leading portraitist of the day and a founder of the National Academy of Design (NAD). He first exhibited his portraiture at NAD in 1836. The catalog for the 1836 NAD exhibition listed his address as 75 White Street, a well-established neighborhood just off Broadway, which may give an indication of his degree of success as an artist. He was certainly flush enough to marry New Yorker Isabella Jeanette Morris in Augusta, Ga., on 19 February 1837.

From 1837 until 1861 Thomas seems to have been based in New York, from which he made seasonal visits to Charleston and Augusta. In 1842 he lived at 117 Nassau Street, Brooklyn. His address in 1849 is listed as the corner of Willoughby and Bridge Streets, Brooklyn. His final address in New York was at 364 Broadway, New York, quite near his old White Street address. Newspaper accounts report him in Charleston in June and November 1841; March and May 1842; May and December 1843; December 1844; October 1845; and May 1858. Praise of his talents in the local press was often expressed in the fulsome language of the day. The 18 December 1843 *Charleston Mercury* observed that "he certainly stands high with those who have had an opportunity of examining his pictures. The patronage that he received during his short visit

last winter was almost exclusively from persons of the highest respectability and of acknowledged taste and judgment. His likenesses are striking, and his colouring natural, exhibiting many of the rich tints of Inman with whom he has had the advantage of several years study."

Reports of Wightman's presence in Charleston evince a long absence between 1845 and 1858 and may indicate his shift from being primarily an itinerant portraitist to being a still life painter as well. He first exhibited a "fruit piece" at the NAD in 1844 and continued to offer works of that type until records of his showings there cease in 1854. In 1850 he presented a self-portrait to the NAD and received an associate's diploma on 6 May.

Though absent from Charleston, information indicates that Wightman was in Augusta, and an extant portrait was signed and dated Sparta, Ga., 1848. His brother William became president of Wofford College, Spartanburg, S.C., in 1854, where he remained until 1859. During William's tenure Thomas spent long periods of time in Spartanburg painting numerous members of the extended Wightman family, including likenesses of his brother, mother, father, niece, and possibly sister-in-law, as well as various local citizens, notably members of the Sparkman and Manson families. The artist's itinerancy in Spartanburg ended when William Wightman resigned from Wofford to become president of Southern University in Greensboro, Ala., in 1859.

Correspondence from Frances Pemberton, a Wightman family descendant, to Leila Waring, on file in the Gibbes Museum, in Charleston, states that the "sympathy of Thomas Wightman was always with the South. He came home when the war started and remained, most of the time, afterwards." By 1871 Thomas Wightman had returned to Augusta to live with his brother John, whom he assisted by hand coloring photographs. He continued to paint still life work as well. He died in Augusta on 28 November 1888 and was buried in the family plot at Magnolia Cemetery. His eulogy, published in the 6 May 1889 minutes of the NAD, praised him as an "excellent artist and a most worthy man."

ESTILL CURTIS PENNINGTON
Paris, Kentucky

Anna Wells Rutledge Papers, South Carolina Historical Society, Charleston; David Dearinger, ed., *Paintings and Sculpture in the Collection of the National Academy of Design, vol. 1, 1826–1925* (2004); Gibbes Museum Artists' files, Charleston, S.C.; *New York Historical Society Quarterly Bulletin* (October 1930); Estill Curtis Pennington, *Gracious Plenty: American Still-Life Art from Southern Collections* (1996), *Romantic Spirits: 19th-Century Paintings of the South from the Johnson Collection* (2012); Anna Wells Rutledge, *Artists in the Life of Charleston, through Colony and State from Restoration to Reconstruction* (1980); Martha Severens, *Greenville County Museum of Art: The Southern Collection* (1995); Wade Wightman, *The Wightman Ancestry* (1994); William May Wightman Archives, Sandor Teszler Library, Wofford College, Spartanburg, S.C.

Wiley, Anna Catherine

(1879–1958) PAINTER.

Tennessee native Anna Catherine Wiley played a pivotal role in the development of the visual arts in Knoxville, Tenn. Her brief career and legacy were preserved through the efforts of her younger sister, artist Eleanor McAdoo Wiley, who felt Catherine was the better artist of the two and deserved to have her work accessible to the public.

Anna Catherine Wiley, known as Kate, was born on 18 February 1879 in Coal Creek (now Lake City), Tenn. Her father, Edwin Floyd, and mother, Mary Catherine McAdoo Wiley, were from families who had settled Anderson County, Tenn. They owned substantial holdings in land and related companies that Edwin managed. When Kate was three years old, the family, which would grow to include eight surviving children, moved to Knoxville, where she attended public school.

The University of Tennessee in Knoxville became coeducational in 1893, and Wiley attended the school from 1895 to 1897. Her artistic talent had apparently blossomed by the time she was a student there, and illustrations for the *Volunteer*, the college yearbook, are currently part of the Anna Catherine Wiley Collection at the University of Tennessee Special Collections Library. In 1903 Wiley moved to New York City and enrolled in the Art Students League, where she was a student of Frank Vincent DuMond. She also spent six months, in 1905, as a student of William Merritt Chase at the New York School of Art. There is little evidence that Wiley traveled widely, but her time spent in New York City, with its many museums and galleries, exposed her to international artistic trends. Her personal style at the time shows the influence of, and her alignment with, the American impressionists.

Returning to Knoxville in 1905, Wiley spent the following years, until 1918, as the sole art instructor at the University of Tennessee, as a faculty member of the School of Home Economics. She continued her work with the university's yearbook and spent summers in New England studying with Robert Reid and in Knoxville with Lloyd Branson. Wiley was a member of the Nicholson Art League and served as its president in 1913. She played an active role in the first expositions in the region: the Appalachian Exposition of 1910, which exhibited fine art for the first time in eastern Tennessee, the Appalachian Exposition of 1911, and the National Conservation Exposition of 1913. Wiley also exhibited work at the Pennsylvania Academy of the Fine Arts, the Cincinnati Art Museum, the National Academy of Design in New York City, where she was rejected twice for membership, and the Southwestern Fair in Atlanta in 1917. She was awarded medals for her art direction and her paintings. Her later style was expressionistic, but she continued to use friends, family members, and students as models in her paintings.

Wiley's career came to a tragic halt when she suffered a mental breakdown in 1926. Since her unmarried sisters could no longer care for her, Wiley was

institutionalized at a hospital in Pennsylvania, where she remained until her death on 16 May 1958. She is buried in the Wiley family plot at Old Gray Cemetery in Knoxville. Her paintings are part of the collections of the Greenville County Museum of Art in South Carolina, the Morris Museum of Art in Augusta, Ga., and the University of Tennessee, Knoxville, where her sister donated Catherine's paintings and drawings as a tribute to her talent.

KAREN TOWERS KLACSMANN
Augusta State University

Steve Cotham, in *Art and Furniture of East Tennessee: The Inaugural Exhibit of the Museum of East Tennessee History*, ed. Namuni Hale Young (1997); A. Everette James, Dale Volberg Reed, and Everett Mayo Adelman, *Southern Women Painters, 1880–1940* (1999); Celia Walker, *Tennessee Historical Quarterly* (Spring 2002).

Wolfe, Karl Ferdinand
(1904–1985) PAINTER.
Wolfe, Mildred Bernice Nungester
(1912–2009) PAINTER.

During the mid-20th century Mildred Nungester Wolfe and her husband, Karl Ferdinand Wolfe, were members of a group of talented artists who lived and worked in Jackson, Miss., which included Marie Atkinson Hull and William R. Hollingsworth Jr. A native Mississippian, Karl Wolfe was born in Brookhaven and spent his teen years in nearby Columbia, where he worked as a mechanic and bookkeeper to earn sufficient money for art school. Wolfe studied at the Art Institute of Chicago from 1924 to 1928 and received a Euro-

pean travel scholarship to France, England, Germany, Belgium, Switzerland, and Italy.

The Mississippi Art Association invited Wolfe, who lived in Columbia during the Great Depression, to exhibit in Jackson during the 1931 season. Despite hard economic times, Wolfe's exhibition was well received. He sold seven paintings, thereby launching his career in Jackson, where he painted portraits of debutantes, business leaders, and other notables. His commissions included a portrait of Jefferson Davis for the United Daughters of the Confederacy for their headquarters in Richmond. Wolfe was determined to make a living solely through art. Although he found portraiture more challenging, he painted genre scenes and floral still lifes to demonstrate his broader interests and artistic skills. He won prizes at the Mississippi Art Association, the Alabama Art League, and the Southern States Art League. Wolfe summered at Chester Springs, the Pennsylvania Academy of the Fine Arts, and the Dixie Art Colony in Alabama. While a student at the Art Institute of Chicago, Wolfe became friends with Hollingsworth, who worked for the Federal Emergency Relief Administration and who in 1941 founded the art department at Millsaps College in Jackson, where Wolfe also taught.

Mildred Bernice Nungester was born in Ohio, but her family moved south, to Decatur, Ala., when she was a child. There her father opened Nungester's Drug Store. After studying at the Athens College and Montevallo College for

Women, she taught history, English, and Latin in the Alabama public school system for 10 years. Having summers free, Mildred had the opportunity to pursue her interests in art by enrolling in summer classes at the Art Institute of Chicago and the Art Students League. She exhibited at the Alabama Art League and the Southern States Art League.

Mildred also made annual visits to the Dixie Art Colony near Montgomery, Ala. Here, under the direction of artist John Kelly Fitzpatrick, artists would gather to create and discuss their art, enroll in classes, and attend lectures by visiting professional artists. In the summer of 1937 Mildred met her future husband, Karl, when he was invited by Fitzpatrick to be a resident teacher. Five years later, while Mildred was studying for her M.F.A. at the Colorado Springs Fine Art Center and Karl was stationed with the Army Air Corps' Lowry Field in Denver, they began to court, and they married in June 1944.

With the end of World War II, the young couple moved to Jackson and had two children, Michael and Elizabeth "Bebe" Wolfe. Karl became widely acclaimed for his portraiture and earned commissions from prominent local citizens while Mildred focused on rearing their family. They purchased property in the countryside near Jackson on Old Canton Road and built the Wolfe Studio, which eventually included studio space for both artists, a gallery to display their work, and their home. The studio burned in 1962, and they both lost vast bodies of their work in the fire.

The studio was rebuilt afterward with the support of family and friends.

As the children grew, Mildred became more actively engaged with painting and printmaking and began accepting commissions. In the early 1950s she created a series of murals on southern themes for LaFleur's Restaurant, a mural inspired by the Mississippi timber industry, and four large paintings, inspired by Franklin Delano Roosevelt's speech on the "Four Freedoms," for Ben Stevens's general store in Richton, Miss.

From the late 1950s through the early 1970s Mildred also explored other artistic media, including ceramics, stained glass, and mosaics. Her numerous commissions included 14 mosaics of the Stations of the Cross for St. Richard's Church, a mosaic for the South Hills Branch Library, a mosaic plaque for the First Methodist Church in Richton, a terra-cotta sculpture for St. Dominic's Hospital, nine stained glass windows for Riverside Independent Methodist Church, and a stained glass window for Hazlehurst Baptist Church.

In 1988 Mildred painted a portrait of her friend, Pulitzer Prize–winning author Eudora Welty. At Welty's suggestion, she submitted the painting for review to the National Portrait Gallery in Washington, D.C. With a few requested changes, the portrait was accepted into the museum's collection. Mildred collaborated with Welty, creating illustrations for two of her books, *Morgana* and *Morgana: Two Stories from "The Golden Apples."* Although Mildred Wolfe did not embrace the abstract expressionist

movement of the mid- to late 20th century, her work frequently included modernist elements and a refreshingly bold use of color.

Karl Wolfe was one of five Mississippi artists to be represented in the early regionalist exhibition *Art and Artists along the Mississippi*, held in 1940 at the Municipal Gallery in Davenport, Iowa. The show was the museum's first exhibition. When the Mississippi Department of Archives and History opened its Hall of Fame, Karl Wolfe was one of 18 artists from that state to be represented. He is one of seven Mississippi artists to be represented in the Hall of Governors, along with Marie Hull, Marshall Bouldin III, Steven Moppert, William Dunlap, Cornelius Hankins, and William Steen. Wolfe's portraits of governors include James K. Vardaman (1936), Fielding Wright (1952), Hugh White (1954), Ross Barnett (ca. 1964), and William L. Waller (1977). Like Mildred, Karl painted murals and worked in sculpture. He painted *Crossroads* for the post office in the central Mississippi town of Louisville, receiving $310 for the painting and its installation. The Mitchell Memorial Library at Mississippi State University features a bronze sculpture titled *Tree of Life*, executed by Wolfe and other artists.

Karl Wolfe died in 1984; both artists were honored with a joint retrospective by the Mississippi Museum of Art in 1994. In 2000 the Mississippi State Committee named Mildred Wolfe a Distinguished Mississippi Artist.

CLAUDIA KHEEL
Neal Auction Company

Patti Carr Black, *Art in Mississippi: 1720–1980* (1998); Lynn Barstis Williams, *Imprinting the South: Southern Printmakers and Their Images of Region, 1920s–1940s* (2007); Elizabeth Wolfe, ed., *Mildred Nungester Wolfe* (2005); Karl Wolfe, *Mississippi Artist: A Self Portrait* (1979); Karl Wolfe and Mildred Nungester Wolfe, *The Wolfe Years: A Collection of Millsaps Memoires* (2003).

Wollaston, John

(ca. 1710–1775) PAINTER.
According to 18th-century British art patron and chronicler Horace Walpole, John Wollaston was the son of a London portrait painter named John Woollaston. Walpole indicates that the younger Wollaston, born ca. 1710, studied with a notable drapery painter in London, possibly Joseph van Acken. The latter often completed costumes and other details for portrait painter Thomas Hudson, whose style seems to have influenced Wollaston. However, Wollaston's portraits also share many similarities with those painted by London painter Bartholomew Dandridge.

Nothing more is known about his early life—when or if he married or where he resided. Information about his artistic career in England is equally sparse and includes only a handful of known works, the most famous being *George Whitfield in an Attitude of Preaching*, created in 1742. In 1749, the year of his father's death, Wollaston came to the American colonies, working first in New York, from 1749 to about 1752, followed by work in Philadelphia until about 1753. He arrived in Maryland in 1753 and subsequently worked in

Virginia until late 1757 or early 1758; he was back in Philadelphia by September 1758 and may have worked there until mid-1759. Wollaston's whereabouts from mid-1759 to September 1765 are not fully known. He was on St. Kitt's island in the Caribbean sometime between 1764 and 1765; he may have gone back to England for a brief stay in 1759.

The painter was in Charleston, S.C., by 27 September 1765, when he dined with Mrs. Gabriel Manigault. Two years later, in February, Wollaston published a notice in local papers that he would be leaving South Carolina for England; a notice some four months later indicated that he had departed. He was still alive in England, living near Bath in 1775.

Wollaston was the most prolific and successful artist to work in the southern colonies before 1775. He was probably known to virtually all artists working in the area because he was so popular and obviously posed competition to other artists for commissions. On two occasions he was praised in poems in American newspapers, one of which encouraged the young Benjamin West to follow Wollaston's example. His success was due in large part to the portrait style he practiced—a pale version of the fashionable rococo that became popular in England in the 1730s. A reliance on pastel coloration, luxurious silk fabrics with shimmering highlights, pleasant facial expressions, and more relaxed postures characterize the rococo style, requisites that are seen consistently in Wollaston's portraits.

CAROLYN WEEKLEY
Colonial Williamsburg Foundation

Wayne Craven, *American Art Journal* (November 1975); Richard H. Saunders and Ellen G. Miles, *American Colonial Portraits, 1700–1716* (1987); Carolyn Jeanette Weekley, "John Wollaston, Portrait Painter: His Career in Virginia, 1754–1758" (M.A. thesis, University of Delaware, 1976).

Woodward, Ellsworth

(1861–1939) ARTIST AND EDUCATOR. Ellsworth Woodward, younger brother of artist-teacher William Woodward, was born in Seekonk, Mass., on 14 July 1861. Ellsworth Woodward was active in a number of artistic endeavors, including Tulane University's Free Saturday and Evening Courses and the New Orleans Art Pottery, both of which were seminal efforts leading to the establishment of the Newcomb College art program and its pottery enterprise. Woodward was a directing force for many art organizations, including the Southern States Art League and the Art Association of New Orleans. He is best remembered, however, as the director of Newcomb College's School of Art. Woodward married Mary Belle Johnson, also an artist.

Like his older brother, William, Ellsworth visited the 1876 Centennial Exhibition in Philadelphia and became motivated to pursue a career in art. Ellsworth studied art at the Rhode Island School of Design and later in the studios of Samuel G. Richards and Carl Von Marr in Munich, Germany. Woodward accepted a position in New Orleans as assistant professor of painting and drawing at Newcomb in 1885, the year after his brother had

joined the Tulane University faculty. In 1890 Woodward was promoted to director of the art school, a position he maintained for 41 years, teaching at Newcomb for a total of 45 years.

Under Woodward's leadership, the newly established Newcomb School of Art developed a program that served as an education and also as a business enterprise for young women. The school focused on the principles of drawing, painting, design, and crafts. The pottery department, jointly established by Ellsworth and William, produced the internationally recognized Newcomb Pottery, particularly pieces with the matte blue glaze, which was developed by ceramicist Paul E. Cox in 1912. The Woodwards called attention to the distinctive characteristics of Louisiana by requiring pottery decorators to develop motifs based on indigenous flora and fauna. Each piece was to be individually designed, except for pieces that were clearly planned as sets. Additionally, the clay was dug from the city, the Gulf Coast, or the north shore of Lake Pontchartrain—therefore making the pottery a truly local product.

In 1931 Ellsworth Woodward retired as professor emeritus; in 1934 he was appointed by Pres. Franklin D. Roosevelt to the directorship of the Gulf States Public Works of Art Project, which employed many notable local artists. A dominant and active member of the art community, Woodward served as the first director of the Isaac Delgado Museum of Art (today the New Orleans Museum of Art) and was an influential trustee until his death. A dynamic speaker, he was one of the early advocates for establishing an art colony in the French Quarter, and after the creation of the Arts and Crafts Club of New Orleans, he served on the board of directors and exhibited in the club's galleries. He envisioned New Orleans as a cultural, industrial, and artistic center, with Newcomb College as the nucleus for the vocational training of young women and with art education as a defined study.

Woodward made numerous artworks from his European trips, but he also traveled throughout the South, lecturing, studying, sketching, and painting. He founded the Natchitoches Art Colony in Cane River Parish, La., served on the international jury for the St. Louis Exposition of 1904, and became a member of the International Union of Fine Arts and Letters of Paris. He was a member of Boston Society of Arts and Crafts, College Art Association, Artists' Association of New Orleans, American Federation of Arts, International Union of Fine Arts and Letters, Louisiana Art Teachers' Association, Minnesota State Art Society, National Society of Craftsmen, Society of Western Artists, the Philadelphia Art Guild, Providence Watercolor Club, Providence Art Club, and Royal Society for Encouragement of Art, Manufacturing, and Commerce.

Woodward illustrated a number of books, notably New Orleans author Grace King's biographical book, *Creole Families of New Orleans*, which was published in 1921. In 1887 Woodward was one of the principal figures and illustrators of the bimonthly art and literary magazine *Art and Letters*, along

with fellow artists Bror Anders Wik-
ström and Andres Molinary. Wood-
ward painted allegorical murals for the
criminal courts building at Broad Street
and Tulane Avenue. *Backyard in Cov-
ington*, depicting a tree laden with large,
luminous persimmons, painted in the
1930s, is considered to be Woodward's
masterpiece. He died in New Orleans
on 28 February 1939 at the age of 78.

In April 1970 the Historic New
Orleans Collection mounted an exhi-
bition of artworks by William Wood-
ward and Ellsworth Woodward. The
Special Collections Division of Tulane
University's Howard-Tilton Memorial
Library mounted an exhibition in 1979,
focusing on the Woodward brothers'
artistic legacy. In 1985 Newcomb Col-
lege held a joint showing of their works.
The Historic New Orleans Collection
again featured the two brothers' art-
works in a 1996 exhibition. For over half
a century the Woodward brothers were
a joint force in the promotion of art in
Louisiana and beyond.

JUDITH H. BONNER
The Historic New Orleans Collection

Judith H. Bonner, *The Hullabaloo* (16 April
1979), *Newcomb College, 1886–1986: An Ex-
hibition by the Newcomb Faculty* (1987); Jean
Moore Bragg and Susan Saward, *Painting
the Town: The Woodward Brothers Come to
New Orleans* (2004); William R. Cullison,
*Two Southern Impressionists: An Exhibit of
the Woodward Brothers, William and Ells-
worth, Selected from the Art Collection of
Tulane University* (1984); May W. Mount,
Some Notables of New Orleans (1895);
Jessie J. Poesch, *Newcomb Pottery: An Enter-
prise for Southern Women, 1895–1940* (1984).

Woodward, Laura

(1834–1926) PAINTER.

Laura Woodward, the daughter of
Jane Genung Woodward and Heze-
kiah Woodward III, lived at home
while teaching art during the 1860s. By
1872, after studying with several land-
scape painters, including William and
James M. Hart, she became a profes-
sional artist living in New York City.

It was written that Laura Woodward
was "the foremost of the foremost of
lady artists." She was a naturalist who
studied and depicted flowers, foliage,
and birds. As a member of the Hudson
River and White Mountain schools, she
painted scenes in the Catskills, White
Mountains, Adirondacks, Green Moun-
tains, New Jersey, Pennsylvania, and
Connecticut, as well as the coasts of
Maine, Rhode Island, and Massachu-
setts. From 1872 to 1891 her exhibition
halls comprised the American Art Gal-
lery, the National Academy of Design,
Boston Art Club, Brooklyn Art Associa-
tion, Pennsylvania Academy of the Fine
Arts, and the Philadelphia Centennial
Exhibition. She also displayed her works
at midwestern and southern venues,
including Cincinnati's Industrial and
Louisville's Southern Expositions.

Woodward began to spend the win-
ters in St. Augustine, Fla., in the 1880s,
and by the end of 1889 she had joined
her friend Martin Johnson Heade and
other artists at Henry Morrison Flagler's
Ponce de Leon Hotel. Woodward was
disappointed in St. Augustine because
it was not as tropical as she had hoped;
consequently she traveled in north
and central Florida, rendering rivers
and coastlines and searching for exotic

plants and flowers. After she was informed of the beauty of Palm Beach, she made the two-and-a-half-day trek from St. Augustine south and discovered the true tropical foliage for which she longed. By 1890 Woodward was in Palm Beach and Jupiter, painting *en plein air* amid what was largely jungle and swampland inhabited by panthers, bears, and numerous alligators. She brought her watercolor sketches back to St. Augustine, where she became famous for her renderings of the "curious" Royal Poinciana tree and its blossoms.

In St. Augustine, Woodward influenced her friend and patron Henry Flagler to develop Palm Beach as a resort. According to her cousin, Laura Woodward "saw immediately its promise as a winter playground, and through her eyes and paintings, Henry Flagler immediately saw it." Flagler bought Palm Beach property in the same locations depicted in Woodward's paintings and built his Hotel Royal Poinciana on one of them. When Flagler was constructing the hotel, in 1893, he first established a temporary studio there for her—and then a permanent studio when the hotel was completed in 1894.

Although Woodward often visited New York, New England, and various parts of Florida, she made Palm Beach her home from 1893 to 1926 and captured scenes from the St. Lucie Inlet to the New River in Fort Lauderdale. In 1895 Woodward visited entrepreneur Julia Tuttle in Miami, who is credited as the founder of the city, and traveled throughout its environs. Woodward was therefore one of the first professional woman artists to paint in the Everglades. She also sketched Arch Creek and Bear Cut Inlet and the Seminoles in their dugout canoes.

Laura Woodward became Florida's most important 19th-century woman artist—renowned for her delicate renderings in oil and watercolor of the unspoiled nature of the state. Flagler's newspapers continuously acknowledged her as being responsible for publicizing the allure of the east coast of Florida to the entire nation. In fact, the very notion of Florida as a tropical paradise was perpetuated by Laura Woodward through the sales of her art and chromolithographs of her originals, which were dispersed throughout the United States. The media declared, "She should be adopted by the entire state [of Florida]."

In 1920, when the Palm Beach Art League was established, Woodward became an honorary member. Sadly, because of failing eyesight, by then she was unable to continue painting, but she remained highly regarded as the famous Florida artist and the pioneer artist of Palm Beach. She continued to live in Palm Beach until 1926 when, at the age of 92, it was necessary for her to move to St. Cloud, Fla., where her caregivers lived. She died shortly thereafter.

DEBORAH C. POLLACK
Palm Springs, Florida

John P. Driscoll, *All That Is Glorious around Us: Paintings from the Hudson River School* (1997); Maybelle Mann, *Art in Florida: 1564–1945* (1999); Deborah C. Pollack, *Laura Woodward: The Artist behind the Innovator Who Developed Palm Beach* (2009); Mildred P. Seese, *Old Orange Houses,*

vol. 2 (1943), *Times Herald-Record* (29 October 1960).

Woodward, William

(1859–1939) ARTIST, TEACHER, ARTS ADMINISTRATOR, HISTORIC PRESERVATIONIST, ARTS ADVOCATE. William Woodward's influence was vital to the evolution of New Orleans as a southern arts center. Woodward was born in 1859 in Seekonk, Mass., and his early years were dominated by the history and culture of this New England town. His mother was a teacher who encouraged his appreciation of literature; her brother (Woodward's uncle), George Carpenter, who was killed in the Civil War, was an artist whose works may have been an early aesthetic influence. In 1876 Woodward and his younger brother, Ellsworth, who were both interested in art by that time, were taken by their father to the 1876 Centennial Exhibition in Philadelphia. They saw a wide range of art and architecture there, and it served as a turning point for the Woodward brothers. William soon enrolled in classes at the Rhode Island School of Design (opened in 1877) and later attended the Massachusetts Normal Art School (founded in 1873). Ellsworth followed soon after. Both were prestigious and advanced art schools, noted for introducing the emerging Arts and Crafts movement into the American art world.

While Woodward was competing his studies at the Massachusetts Normal School, William Preston Johnson, the first president of Tulane University, hired him to teach art and architectural drawing and to establish a new art program at Tulane. Woodward arrived in New Orleans in 1884, at the time of the World's Industrial and Cotton Centennial Exposition (1884–85). He recruited Ellsworth to join him in New Orleans, and the two began to offer public art classes at the exposition. When the H. Sophie Newcomb Memorial College for Women was established as a coordinate college of Tulane in 1886, Ellsworth Woodward joined its faculty. That same year, William married Louise Amelia Giesen, an art student at Newcomb, and during their honeymoon trip to Europe they went to Paris, where Woodward studied at the Académie Julian with Rudolph Boulanger and Jules-Joseph Lefebvre. Woodward learned about French impressionism in Paris and was there at the time of the final impressionist exhibition in 1886.

The Tulane University and Newcomb College art programs were offered initially in studios in downtown New Orleans and then moved to the site of the Robb Mansion in the Garden District, before the new campus opened uptown. From 1894 to 1917, as Tulane and Newcomb built a permanent home on St. Charles Avenue, across from the 1884 world's fair site, Woodward exerted a major influence on the architecture and design of the campus. He was also a founder of the Tulane School of Architecture, one of the first in the South. William and Ellsworth Woodward, who were driving forces in the founding of the art department, the Newcomb Pottery works, and the School of Architecture at Tulane, had a profound influence on generations of Tulane and Newcomb students.

In 1901, William Woodward organized the Arts Exhibition Club, which remained active until its merger, in 1903, with the older Artists' Association of New Orleans, setting the foundations for the Isaac Delgado Museum of Art (now the New Orleans Museum of Art), which opened in 1911 as one of the South's first art museums. Ellsworth Woodward also became active in the founding of the museum, was on its architectural selection committee, and then served as its director from 1925 to 1939. In their artwork and in their teaching, the Woodward brothers advanced art forms inspired by the environment and scenes of daily life in their region, before the emergence of the American Scene and regionalist art movements. In doing this, they emphasized an appreciation of "a sense of place," long before that concept became a central theme in southern literary circles during the 1920s. In turn, the art collected and exhibited at the Delgado Museum in its early years reflected their regional interests.

William Woodward is often described as an impressionist artist. His art and his professional interests, however, reflected a broader and more complex range, including the Arts and Crafts aesthetic, impressionism, realism, the American Scene, and regionalism and his ongoing work in American architecture, preservation, and design. Woodward's art reflects his discovery and use of Raffaëlli oil sticks on academy board, especially in outdoor locations, including sites in the French Quarter and landscape environments he was often discovering on the Gulf Coast. This work shows his strong interest in the architecture and architectural forms of the French Quarter, and he encouraged his Tulane students to sketch and study the French Quarter. Ultimately, his concern for the historic structures of the French Quarter, many endangered by decay, neglect, and demolition, led to the beginning of a serious preservation movement in New Orleans and the formation of the Vieux Carré Commission, still active to the present date. In the years from 1919 to 1939, when artists, writers, musicians, and performing artists moved to the French Quarter for its cheap rents, historic architecture, and Bohemian environment, they did so, in part, because of the vision and efforts of William Woodward.

In 1922, after almost four decades of teaching at Tulane and working in New Orleans, Woodward retired from his position at the university, after a medical condition and surgery left him confined to a wheelchair. In retirement, he and his wife, Louise, moved to the Gulf Coast, where his family spent an increasing amount of time, beginning in the 1890s. Living and working in Biloxi, Miss., Woodward explored the Gulf Coast environment, seeking inspiration for artistic subjects, participating in the activities of local art organizations, and serving as founder and first president of the Gulf Coast Art Association. Less well known are the series of extended automobile journeys he made in a car that was specially outfitted for his condition, including trips through the West and to California, where he painted a significant number of landscapes, in-

cluding views of the California coast and Yosemite.

Woodward died in 1939, after a long career that spanned an evolutionary period in the South, from 1884 to 1939. William Woodward and his brother Ellsworth influenced generations of art and architecture students at Tulane and Newcomb and built a solid foundation for the contemporary art world of New Orleans and the Gulf Coast.

J. RICHARD GRUBER
Ogden Museum of Southern Art
University of New Orleans

Bill Anderson *Southern Arts and Crafts, 1890–1940* (1996); Ray Bellande, Judith H. Bonner, J. Richard Gruber, Robert Hinckley, Jessie Poesch, and George Schmidt, *William Woodward: American Impressionist* (2009); Jean Moore Bragg and Susan Saward, *Painting the Town: The Woodward Brothers Come to New Orleans* (2004); Jessie Poesch, *Newcomb Pottery: An Enterprise for Southern Women, 1895–1940* (1984).

INDEX OF CONTRIBUTORS

INDEX

Page numbers in boldface refer to articles.

Catesby, Mark, 42, 121, 232, **256–57**

Cathedral of Saint John the Baptist (Savannah), 387

Catholic churches, 100

Catholicism, 245, 384

Catlett, Elizabeth, 51–52, 53, 176

Catlin, George, 123

Century Magazine, 316, 318, 433

Chalfin, Paul, 310, 311

Chambers, Bruce, 27

Champney, James Wells, **257–59**

Chandler, Clyde, 176

Chapel Hill, N.C., 88, 430

Chaplin, Joyce E., 257

Chapman, Alvam Wentworth, 42

Chapman, Conrad Wise, 126, **259–60**, 261–62

Chapman, John Gadsby, **260–62**

Charleston, S.C., 38–39, 42, 139, 428; preservation, 9, 188; itinerant artists, 16; individual artists, 20, 38, 119, 120, 123, 231, 259, 260, 261, 312–13, 328, 351, 375, 413, 417, 424–25, 438, 439, 455–56, 457, 469; decorative arts, 67, 69, 70, 71; sculpture, 176; ironwork, 179

—architecture, 2, 4, 5; industrial, 112–13

Charleston Courier, 20

Charleston Mercury, 469

Charleston Renaissance, 38, 305, 424, 438

Charleston single house, 195

Charlot, Jean, 290

Charlotte, N.C., 135, 206

Charlottesville, Va., 267, 442

Chase, John S., 187

Chase, William Merritt, 30, 268–69, 415, 416

Chattanooga, Tenn., 254, 255, 281, 459

Chicago, Ill., 116, 320

Chicago Imagist style, 248

Chillman, James Henry, Jr., 429

Chippendale, Thomas, 69

Christenberry, William, 153, 180, **262–65**

Churches, 99–100

Cincinnati, Ohio, 396

Civil rights movement, 158–59, 176, 221

Civil War, 7, 25, 29, 67, 83, 104, 125–26, 255, 259, 260, 261, 297, 317, 373; photography, 149; marine painting, 427–28

Clague, Richard, 15, 24, 127, 249, **265–66**, 426

Claiborne, Herbert, Sr., 89

Claiborne, William Charles Cole, II, 454

Clark, Eliot Candee, 38, **267–68**

Clark, Kate Freeman, 41, **268–69**

Clarke, John Hawley, 276

Clarksville, Tenn., 419

Classical realism, 364, 365

Classicism and classical architecture, 1, 3–4, 5–6, 104

Clay, Henry, 332

Clay, Mary Harris, 338

Clay, Maude Schuyler, 155

Clayton, Nicholas, 171

Clemmer, John Franklin, 45, 146

Cloar, Carroll, 36, 135, 136, 138, 145–46, **269–71**

Cocke, Philip St. George, 97

Coe, Richard Blauvelt, 132

Coffin, Howard, 171

Cogdell, John, 174–75

Collas, Louis Antoine, 17

College of Charleston, 328

College of William and Mary, 62

Colombage, 78–79

Colonial Revival architecture, **64–66**, 84, 86, 110, 115, 160, 296

Colonial Williamsburg, 8–9, **59–63**, 67, 69, 82, 84, 85, 88, 108, 188

Colt, Thomas, 241

Columbia, S.C., 21, 22, 67, 114, 366, 417

Columbia University, 445

Columbus, Ga., 229

Columns, 104

Commercial and industrial buildings, 185

Commercial style, 116

Conceptual art, 48

Confederate monuments, 175

Connell, Clyde Dixon, 53, 54

Nash, Anne Taylor, 39

Nash, Diana L., 43

Nash, Susan Higginson, 62

Nashville, Tenn., 113, 122, 129, 176, 301, 393

Natchez, Miss., 2, 18, 19, 22, 83, 151, 355, 466

National Academy of Design, 36, 38, 410

National Aeronautics and Space Administration, 291

National Endowment for the Arts, 221, 389–90

National Heritage Fellowships, **389–91**

National Park Service, 85

National Society of the Colonial Dames of America, **391–92**

Native Americans: depictions of in art, 119, 121, 123, 292; architecture, 181

Natural history, 121, 125

Nearings, Helen and Scott, 286

Negus, Joseph, 123

Negus, Nathan, 123

Neoclassicism, 1, 102, 104, 115, 116, 336

Neo-Dada, 345

Neo-Greco style, 162

Neo-Italianate style, 115, 165

New Braunfels, Tex., 94

Newcomb College, 44, 128, 136, 300, 322, 362, 445, 475–76, 479, 481

Newcomb Pottery, 15, 44, 45, 49–50, 72, 476, 479

New Deal, 131, 155, 187

Newhall, Beaumont, 136

Newman, Barnett, 48

Newman, Robert Loftin, 36, 129

Newman, Willie Betty, **392–93**

New Orleans, La., 42, 44, 428; architecture, 2, 7, 10, 79, 196, 359–60; preservation, 9, 188; French Quarter, 10, 109, 258, 280, 281, 283, 320, 333, 334, 358–59, 367, 480; itinerant artists, 16–18, 19; impressionism, 32; individual artists, 37, 38, 40, 52, 122, 129, 133, 144, 145, 146, 152, 203–4, 210–11, 212–13, 216, 223–24, 228, 239, 240, 249, 252, 265, 266, 272, 275, 278–80, 282, 295–96, 298, 308, 309, 311–

12, 320–22, 323–24, 333–34, 340, 357–58, 360–62, 372–73, 375, 376–77, 379, 382, 385, 394–95, 400–401, 414, 419, 426, 432, 445, 449–50, 453, 456–59, 475–76, 479–81; decorative arts, 71; architectural history, 109; depictions of in art, 124, 137, 151; artistic organizations, 128; Queen Anne style, 161; Eastlake style, 163; Bungalow style, 164; Renaissance style, 166; monuments, 176; ironwork, 179; iron foundries, 185; cubism, 394

New Orleans Commercial Bulletin, 127

New South, 114, 258

New South (magazine), 130

Newsweek, 251

Newton, Harold, 42

New Urbanism, 189

New York, N.Y., 35, 139, 238; artists in, 228, 236, 252, 253, 267, 283, 287, 319, 401, 469

New York School, 253

New York Times, 289

New York University, 410

Ney, Elisabeth, 176

Nichols, William, 7, 187

Ninas, Paul, 44, 278, 280, **394–95**, 467

Noble, Thomas Satterwhite, 27–28, **395–96**

Noland, Kenneth, 43, 139

Nonresidential architecture, 20th-century, **115–18**

Norfolk, Va., 5, 69, 442

Norman, B. M., 400

Norman, Earl, 151

Norman, Henry C., 151

North Augusta, S.C., 406

North Carolina: depictions of in art, 23, 24, 25, 410, 458; pottery, 50; furniture, 68, 70; farm buildings, 74, 76; individual artists, 123, 136, 314, 327, 365, 367, 411–12, 432

—architecture, 5, 8; German, 93; Greek Revival, 105; industrial, 112, 114; resort, 167; vernacular, 198

See also individual cities

North Carolina Museum, 368

North Carolina Statehouse, 7